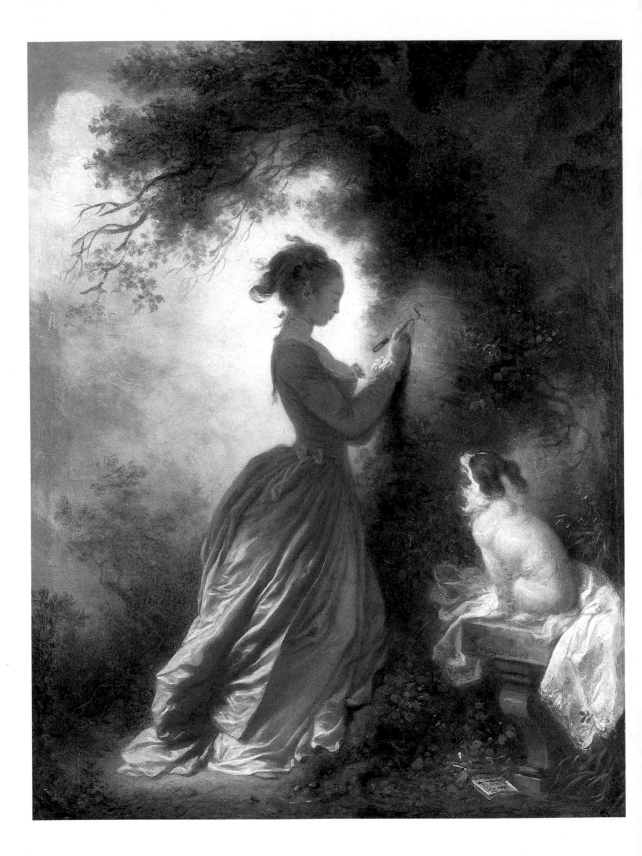

The
ART ATLAS
of
BRITAIN & IRELAND

In association with The National Trust

BRUCE ARNOLD

VIKING

VIKING

Published by the Penguin Group
Penguin Books Ltd, 27 Wrights Lane, London W8 5TZ, England
Viking Penguin, a division of Penguin Books USA Inc.
375 Hudson Street, New York, New York 10014, USA
Penguin Books Australia Ltd, Ringwood, Victoria, Australia
Penguin Books Canada Ltd, 2801 John Street, Markham, Ontario, Canada L3R 1B4
Penguin Books (NZ) Ltd, 182-190 Wairau Road, Auckland 10, New Zealand

Penguin Books Ltd, Registered Offices: Harmondsworth, Middlesex, England

First published 1991

1 3 5 7 9 10 8 6 4 2

Filmset in Bembo by Dublin University Press, 17 Gilford Road, Sandymount, Dublin 4, Ireland.

Printed and bound in Italy by L.E.G.O. Vicenza

A CIP catalogue record for this book is available from the British Library

ISBN 0-670-81925-5

FRONTISPIECE
JEAN HONORÉ FRAGONARD
The Souvenir
Wallace Collection

Dedicated to the countless people whose curiosity
and love gives meaning to the art contained in these
places. And dedicated also to those who try their
best to make that art available.

CONTENTS

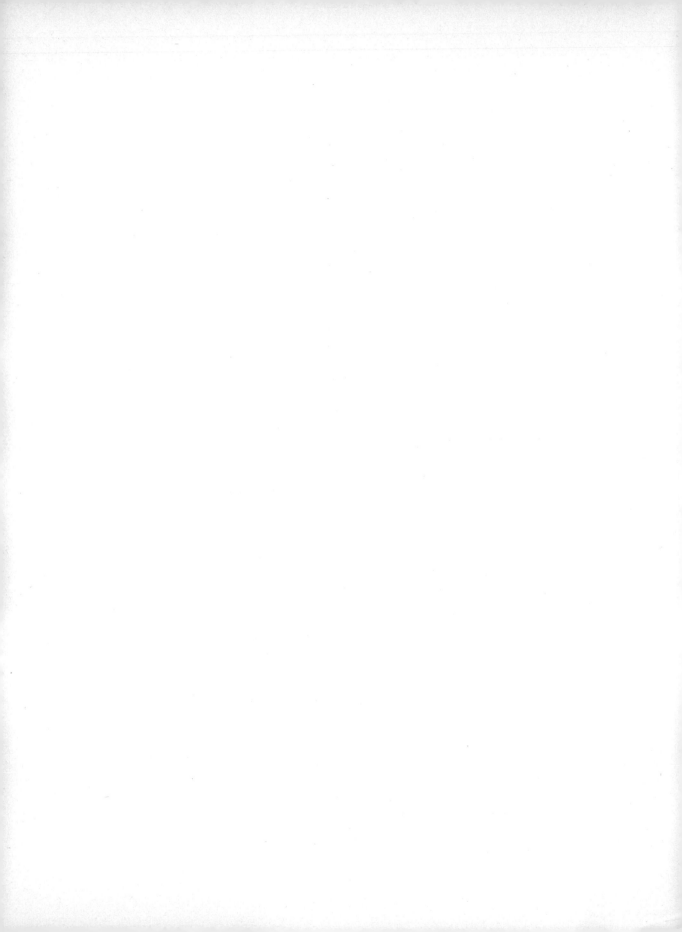

HOW TO USE
THE ART ATLAS

The Art Atlas of Great Britain and Ireland is a guide to the pictures and sculpture which can be seen in British and Irish collections open to the public. There are two basic criteria: that such collections should contain fine art as a significant part of the whole, and that they should be regularly accessible to ordinary visitors. Such collections are to be found in art galleries, museums, castles, houses, palaces, colleges and schools.

An historical and geographical outline of collections and collectors is given in the first half of the Art Atlas. There is a brief summary, in the early chapters, of the development of collecting from the sixteenth to the twentieth centuries, with reference to some of the early collectors, including Charles I. The Art Atlas then gives details about the development of national and municipal art galleries and their contents, the Royal Collection, the more important family collections, major National Trust properties, important university, college and school art collections, and certain other accumulations of art, including collections of the works of individual artists.

As befits such a book, the framework is geographical: after the introductory chapters, London is then dealt with; followed by the regions; and then Wales, Scotland and Ireland. There is a brief introduction to each region, indicating its main towns and county or area features, major artists associated with it and major places of artistic interest.

The emphasis in the first half of the Atlas is on how the more important individual collections came into existence. Some attention is given to their distinctive features as well as to the main figures responsible for acquiring the works of art.

In all cases, discussion of a collection in the first half of the Art Atlas is supplemented by further information in the Gazetteer section, which forms the second half of the book. This includes name, address, telephone number, times of opening and directions about how to get there. This is followed by a brief description of the collection. An emphasis on key or major works, or on the distinctive character of the collection, has generally been attempted.

The Gazetteer supplements the information on the major collections covered in the first half, but also deals with a large number of smaller collections which appear only in the Gazetteer. It is primarily concerned with describing the contents. However, since a number of collections are dealt with only in the Gazetteer section, there are differences of emphasis and a certain amount of overlapping has been unavoidable. The Gazetteer is arranged alphabetically, by county, and according to the Local Government Act, 1972, in the case of the United Kingdom of Great

Britain and Northern Ireland. The historical 26 counties are used for the Republic of Ireland. These are as they have been since the State's foundation. Within each county or region the institutions, of whatever kind, are arranged alphabetically.

The Gazetteer is followed by a detailed and integrated Index which lists individual properties, artists and collectors, as well as being a general Index to the whole Art Atlas. It is intended that this arrangement should suit the distinct needs of people looking for art on a regional basis, on holiday, or when travelling, and those who seek details about a single named place, collection or artist.

All collections, public and private, with the Royal Collection in the latter category, are dealt with in the ways outlined above. The public collections are mainly the museums and art galleries, though they do include a number of houses. The private collections are mainly, but not exclusively, in the houses that are open to the public during the summer season. There are about thirty local authority houses, including three major houses in London: Kenwood, Marble Hill and Ranger's House. Almost 100 of the houses are in the care of the National Trust. A somewhat larger number are privately owned, with the balance belonging to private trusts, other institutions, or administered by the Department of the Environment.

Between the first half of the Atlas, which is fully illustrated, and the second half, containing both Gazetteer and Index, there are 30 pages of full-colour maps of the British Isles on a ten-miles-to-the-inch scale. All the institutions are marked on the maps. A distinction in marking is made between public art galleries and museums, and the houses, castles and palaces which are owned privately, or by one of the numerous trusts, of which the National Trust is by far the largest.

Certain important collections, which are quite specifically 'public', are to be seen by appointment only or by obtaining a special ticket or pass. They include two of the greatest collections of drawings in these islands, in the British Museum and the Victoria and Albert Museum. They are the most famous examples of a much wider category, however, often including the specialist collections in many museums and art galleries. Public collections to be seen by appointment are therefore included. This has allowed for collections such as those of the Guildhall in London, Winchester College and Rugby to be included, in spite of the determination sometimes needed to see them.

Apart from brief reference to ownership, and to architectural and other features, the main emphasis is on fine art. As clear a distinction as possible is drawn between fine art and applied or decorative art, which does not fall within the scope of the Art Atlas. It is not a distinction without error, but the basic premise is that guidebooks, about houses in particular, have in the past placed too great an emphasis on the architecture and the gardens, even on the furniture and other functional contents, constituting a wide category of the decorative arts, to the exclusion of the fine arts, principally painting. An attempt is made here to right this balance, adversely affecting, perhaps, one's perception of a house such as Fawley Court: architect, Christopher Wren (though this is now disputed); carvings,

Grinling Gibbons; garden, 'Capability' Brown; ceilings, James Wyatt; but a limited collection of fine art.

Some attention is given at the beginning of the book to certain collections which no longer exist but which were important in the history of art collecting. There is also some discussion of the pioneer collectors and of the early development of ideas about what museums are for and how they should be run. In general, however, the purpose is to relate works of art, their collectors, public and private, and their present distribution to the actual museums, galleries, palaces, castles and houses where they may now be seen.

Any deficiencies in presenting the history of taste, of which this is a practical dimension, may be made good within the considerable literature which already exists. Indeed, in almost every field touched on, there is substantial material available, not least in the guidebooks, handlists and leaflets which vary so much from place to place. The intention in this Atlas is to make available in convenient form a thorough and wide-ranging presentation of the places with their contents based on first-hand research.

Certain factors have affected the completeness of the Atlas. A small number of owners and administrators declined on security, or other grounds to supply information or be included. Some did not reply at all. The sections that follow only give the flavour of each collection mentioned. The information derives from the owners and only attempts have been made to check attributions or to evaluate the merit of the works of art referred to in the text. Places of worship, which are not primarily there to offer their fine or applied art to the public, have not been included, even though this means omitting such masterpieces as the Rubens in King's College Chapel, Cambridge, or one of Constable's rare religious paintings in a church in Nayland, Suffolk.

The Art Atlas is illustrated entirely in colour. It contains a full and detailed Index.

PIERO DELLA FRANCESCA
The Baptism of Christ
National Gallery

Introduction

*Inscribe in any place the name of God and set opposite to
it his image. You will then see which will be held in
greater reverence.*

Leonardo da Vinci

The first picture to have an impact on me, so far as I can remember, was
Piero della Francesca's *The Baptism of Christ*, in the National Gallery in
London. I must have been nine or ten at the time, the year 1946 or 1947.
The paintings had not been long back from wartime storage. Without
understanding the technique, ignorant of symbol or imagery, unable to
identify any of the figures other than Christ and Saint John, both unaware
of and unconcerned about date or origin, all that mattered to me then was
the story the painting seemed to tell, the colours which the artist had used,
the expressions on the faces, the landscape in the distance, and the scale of
the work.

To a child, scale and atmosphere are compelling forces. What had
hitherto been a visual composition encountered perhaps in the pages of a
Bible, was here raised to quite different proportions: large in scale,
immaculate in surface texture, vivid in colour, precise in line, deliberate in
every feature of its composition, and clearly the object of a special concern
and admiration from the adults around me. They created the atmosphere,
since galleries are dead places without people. I would look as they were
looking; I would discover the cause of their enthusiasm; I would become
like them. In front of that particular painting, as far as I can recall, began
my lifelong obsession with art.

Perhaps the most difficult thing of all, forty years on, is to recapture the
simplicity with which I then looked at things. There are certain burdens
we carry in maturity. They include knowledge and experience. They
include our pretensions and our vanities as well. We acquire information:
detail about artist, period, influence, symbol and imagery, technique,
palette, school, genre, studio. We are influenced by what Kenneth Clark,
or Bernard Berenson, or E.H. Gombrich have said; often enough it is the
alternative problem of not being able to remember what they said. The
pure, uncluttered encounter, innocent, awesome, joyful, mysterious, has
been replaced by a sophisticated measurement of what we should see and
feel, dictated by the written or spoken word, rather than by the language
of paint and colour.

That language, more direct and more immediate, is also universal. The whole literature of art is no substitute for it. Command of it is partly a gift, and partly a matter of practice. It is given without reference to intellect or study. It is perfected by looking.

It leads to the most absolute of all artistic experiences. In all the arts looking at pictures and at works of sculpture is the only encounter when what the artist has made and the people for whom he might be said to have made it meet in circumstances where the experience depends on nothing more than looking.

Music, theatre, literature generally, require to be translated, through performance, through the printed word, through the spoken word, qualifying the creative intent, and either enhancing it or limiting it. A new dimension of performance is present, not to be found with painting and sculpture. Rich and splendid in their own way, the other arts are not necessarily the absolute reflection of the artist's will.

In a reasonably hung gallery where adequate light is allowed to fall on the surface of each work, the restraints and limitations are all in the eye and mind of the beholder: how long to stand in front of a work; what knowledge and comparative experience to bring to it; how free the eye and the imagination will be in exploring that surface which is the final product of another's creative endeavour.

That purity of impact is no more than an ideal starting point. The reality is that the critical apparatus of art cannot be set aside with the ease which I would wish, either indefinitely or totally, in the encounter between the work and the individual. The eyes of everyone, from the art historian with his training and expertise down to the child, whose critical equipment may consist of no more than simple comparisons, are conditioned by knowledge and experience outside the painting itself.

It is the balance that matters, between knowing and seeing. For me, the ideal circumstances surrounding the human response to the work of art are when knowledge and understanding give way to the senses, the instincts and the emotions. They create the common ground which gives us access to the limitless diversity of centuries of painting.

We respond to the wide variety of Nature's moods and seasons in the canvases of Turner, Hobbema, Constable or Monet. We respond to the detailed components of our beliefs in the religious works which constitute the largest single category of paintings in our major galleries. How can I explain the particular liking I have for Domenico Feti's *The Parable of the Mote and the Beam* other than by showing this painter's loving, and very literal, characterisation of the unequal but human argument taking place under the shadow of the splintered beam in the collection at York? It is not a great painting; but it captivates.

We respond to human dignity and power in the paintings of Velázquez. Three of the Seven Ages of Man are compellingly presented to us in *The Water-Seller of Seville*. When I look at the painting, in the Wellington Museum, I see myself as I was; I see myself as I shall be; and, dimly, between the two figures of old man and boy, I perceive something of the doubt and uncertainty of what I am. I am drawn to that gallery for that picture, above all others. It is a place of pilgrimage for a single canvas.

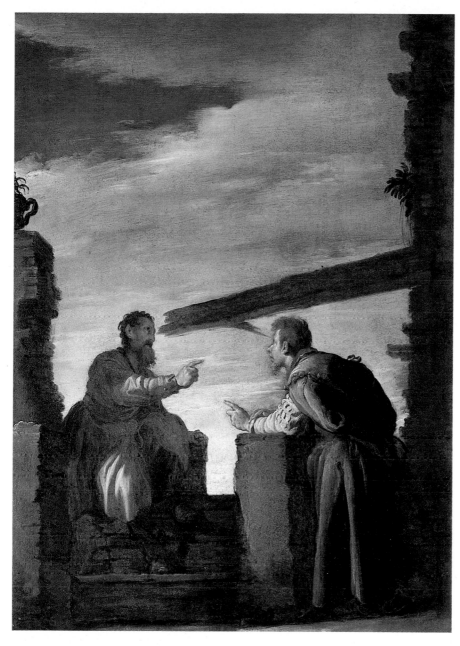

DOMENICO FETI
The Parable of the Mote and the Beam
York City Art Gallery

We respond to elegance, to beauty, to human sympathy, to an understanding of the mind and heart of the child, in Reynolds and Gainsborough. For me, the best place in England to experience this is in Kenwood House, on Hampstead Heath. In the elegant, uncluttered rooms, flooded with light, trips the elegant *Mary, Countess of Howe* by Gainsborough, painted during his Bath period, that vigorous period in his art between the early struggles in Suffolk and success in London. There, too, you will find *Venus Chiding Cupid for Learning to Cast Accounts*, by Reynolds.

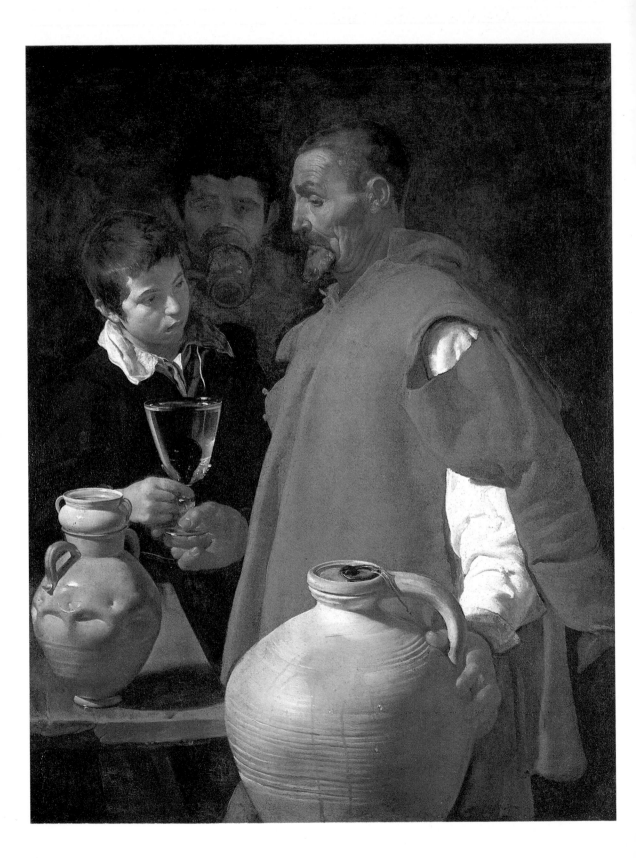

We recognise personal pain and anguish in Rembrandt's life through his art. He is the greatest of all touchstones for that impact of the artist's own human experience and emotion through his work. We seek him out, knowing the floods of human feeling which will flow over us. For this, I am drawn to *The Woman Taken in Adultery* in the National Gallery in London.

In the canvases of Vermeer we see nothing beyond what is there, perfectly displayed, or we see an entire universe. There were only six of them available to the public in the British Isles, before the Russborough robbery. They offer a sparse but magical pilgrimage: London, Windsor, Edinburgh.

The force behind these responses is emotional, just as the force which dictated their creation was emotional. Painting shares equally with the other arts that function of satisfying certain needs of the human spirit— mysticism, drama, imagination—using its own language But in no other art form does the artist so clearly anticipate the physical presence of his unknown public; and in no other art form does the spectator share so directly, and at such close quarters, the work of art itself.

It is part of human nature to try to impose order, to classify and label

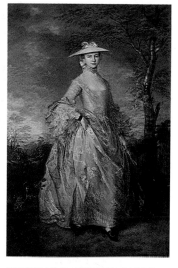

THOMAS GAINSBOROUGH
Mary, Countess of Howe
Kenwood, London

Left:
JOSHUA REYNOLDS
Venus Chiding Cupid for Learning to Cast Accounts
Kenwood, London

Far left:
DIEGO VELÁZQUEZ
The Water-Seller of Seville
Wellington Museum, Apsley House

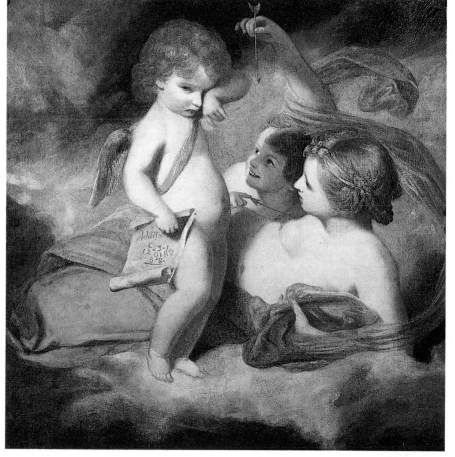

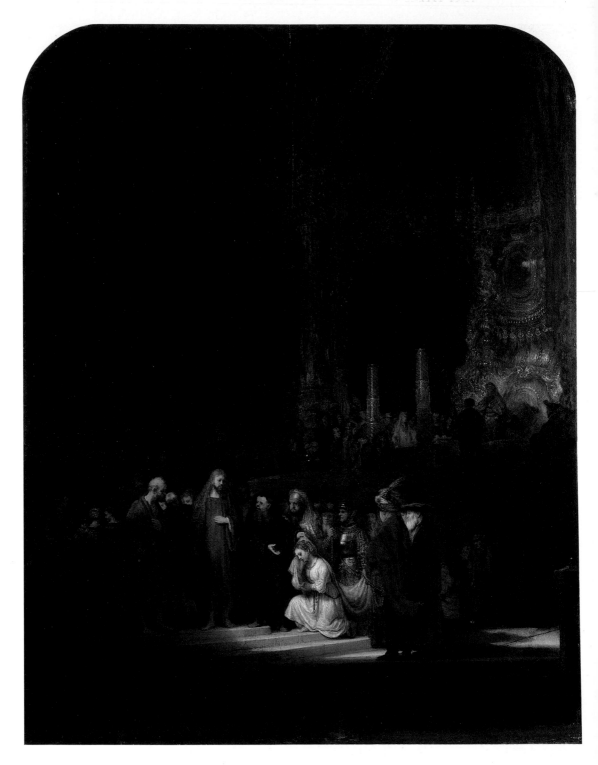

REMBRANDT
The Woman Taken in Adultery
National Gallery

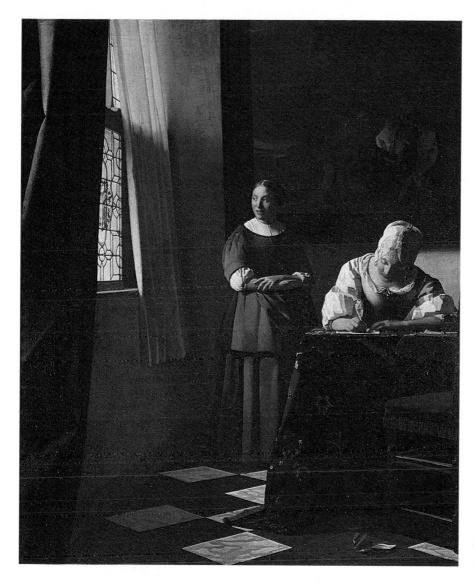

JAN VERMEER
The Letter
Russborough House, Wicklow

art, as in other areas of life. Calling it by a cliché, like 'cultural heritage', we almost assume its pre-ordained presence there, for us. We are encouraged to do this by the owners and administrators of art, whether they are organisations or individuals. They encourage us, not always on good grounds, to see an overall order and discipline, a hierarchy among houses, museums and art galleries, basic standards of excellence in the content and display of collections, in the guides and catalogues to them, and in the personal service offered by the steadily growing army of men and women who maintain and add to what is available.

The reality is not quite as it seems. The evolution of what can be termed—but only in certain respects—the overall 'national collection of fine art' has been difficult, contentious, awkward and chaotic, and as full of villains as it has been of heroes.

It is a curious kind of villainy, the villainy of neglect or indifference. Anyone who reads the history of the Roscoe Collection (see pp 91–2) must marvel at just how intolerably awful the burghers of Liverpool were, over a period of more than a century and a half. How was it that a painting like Ercole de' Roberti's *Pietà* should have taken well over 100 years to find its resting place in the Walker Art Gallery? What motivated those who did acquire it, for the Liverpool Royal Institution, in 1819? Why was it not until 1948 that it actually became the property of the City of Liverpool? And how innumerable are the parallel stories of how great works of art, in so many public collections, almost failed to become public property?

It is a selfless form of heroism, too, that arbitrarily seems to give us such wonderful collections as the Lady Lever Art Gallery, in Port Sunlight, or the Wallace Collection, in London; in each case the gift outright: gallery, completeness of contents, with masterpieces on a lavish scale.

Most museums and art galleries in these islands have come into existence in the teeth of political opposition. Most reflect shame, in varying degrees, on the cities and towns in which they stand. Inadequately housed, overcrowded, with most of their works in store, starved of funds, poorly managed, manipulated by élites, they began, and are repeatedly saved, by an odd tribe of eccentric lovers of art, of one kind or another.

In its European outline, the evolution of the collective treasure-chest of works of art goes something like this. The first great collections were the possessions of the Church. The collections were a direct reflection of power and greatness. They were emulated, for the same reasons, by the great secular rulers. In certain circumstances there was confrontation, and the transfer of the wealth, notably the case of Henry VIII with the dissolution of the monasteries. Art was marginal, in the circumstances; property and wealth, in terms of buildings, land and gold, and the power derived from them, were central.

Royal collections were a mark of power and grandeur. Henry VIII, in his attitude to Holbein, and Elizabeth I, in her attitude to Nicholas Hilliard, were motivated by mixed feelings which reflected the sense of their own importance, the needs of the State, and a certain measure of intellectual curiosity, rivalry, competitiveness and judgement. Portraits were messages sent between courts, countries or rulers; art was booty, payment, ransom. They were not 'collectors' in the sense in which Charles I was a truly great collector. He collected because he loved painting. But he also collected in imitation of the great Italian, Spanish and French ruler-collectors. Their collections reflected the magnificence and power of their courts. His would do the same. It was his destiny and character as a monarch, just as much as his belief in his own divine right. In turn, it was inevitable that he should be imitated by the nobility, some of whom, like Arundel, indeed preceded him as great collectors, and inspired him. Either way, they sought to emulate or to rival each other and indeed the king himself, who went close to bankrupting his kingdom for the sake of art.

The other vital inspiration was Charles I's elder brother, Henry, Prince of Wales, who died at the tragically early age of eighteen, having established a miniature Renaissance court of great quality and discernment.

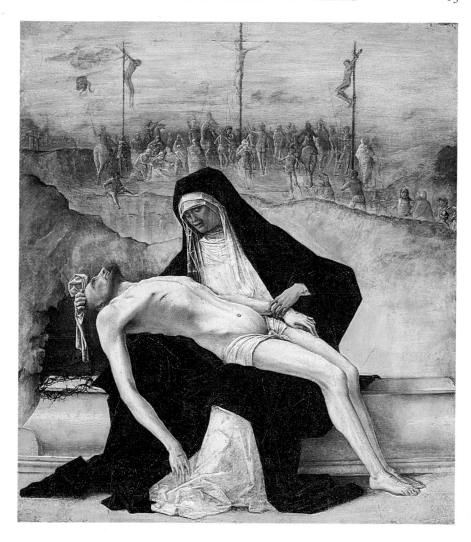

ERCOLE DE' ROBERTI
Pietà
Walker Art Gallery, Liverpool

Henry was a collector and patron who taught by example and intent, only in part fulfilling the urge to emulate others among Europe's rulers in acquiring a personal collection of works of art as an extension of himself and his court. When Henry was dying, Charles came to him with a bronze which the Prince of Wales loved, and placed it in his hands. It was an act of deep understanding, both of his brother and of himself.

Charles I, copying other monarchs, as well as exercising his innate good taste, became a patron of artists. Appointing Van Dyck court painter was the living extension of his attempts to purchase what was great and perfect out of the past. And that Van Dyck should become a considerable influence on English painting generally was a further extension of the king's power. He misjudged its context, and gave it undue attention at the expense of the more central requirements of power for a monarch.

That it should all have collapsed in Charles I's case—as it had also done with Florentine and Venetian princes, without whose impoverishment,

or fall from power, his own collection would have been the poorer—does not detract from the principles established. Notwithstanding Henry VIII's employment of Holbein, or Elizabeth I's interest in Nicholas Hilliard's way of working, it was not until Charles I that collecting for the sake of the beauty of the work of art became established in England, and was pursued as an activity by a steadily growing number of people. From being the province of the Church, then of monarchs, the tradition of collecting, in museums, private galleries, and houses, was an established activity in England by the mid-seventeenth century. Its pursuit, in education, in research and understanding, in art dealing, followed, as did the development of taste and of aesthetics.

Collecting art was still to remain in the private domain for a very long period. Although the seventeenth century, in Britain, actually witnessed the intellectual and factual transfer of power, by way of revolution, from the State as represented by the monarch to the State as represented by the people, another hundred years were to pass between Cromwell's death and the establishment of the British Museum. And even though this formalising of the State's responsibility, in the preservation of the nation's heritage, was an important watershed, a further seventy years were to pass before the commitment was extended to cover those treasure-houses of fine art which are featured prominently in this Atlas.

There were other important developments. It was as an extension of the idea that a ruler might offer patronage to the artists among his subjects that he made available his own collection for their instruction and understanding. Frederick the Great opened his Potsdam gallery of Flemish and Italian works to artists wishing to study his paintings, an echo of fifteenth- and sixteenth-century Italian encouragement of artists. In eighteenth-century England the link between the court and artists generally, based primarily on patronage and on the commissioning of portraits, led to the close relationship between George III and the Royal Academy, when it was established in 1768. The Academy collections consisted of great works of art from the past, as examples, in the same way as monarchs' collections, but in addition they included examples of work by members. Use of the collections was, however, confined to academicians and students.

It would be natural enough to think that a simple theoretical extension of these developments led to the establishment of national, provincial and regional collections for the public. Not so. If anything, there were fundamental conflicts surrounding two distinct evolutions. The first of these was patrician, associated with king and court, with the aristocracy, and their tradition of collecting fine art and having it accumulate in their houses, castles and palaces, as an expression of their power, wealth and influence. The second was more plebeian, associated with the State's responsibilities, deriving its authority from Parliament and the initiative of politicians, and motivated increasingly by social conscience. The first was dominant from the mid-seventeenth century until well after the Napoleonic Wars; the second gained ground in the nineteenth century, and produced the huge development in art galleries and museums, particularly after 1851.

The first is autocratic. The collector is answerable only to himself. He

decides when, and if, he will make what he has available to the public; when he will buy or sell; what collecting style or direction will be adopted next. Those collections which fall into this category—mainly the houses in the Art Atlas—are also vulnerable to wholesale disposal by sale or auction. The practical reality is that the majority of them have been plundered at one time or another, to pay for gambling and other debts, or, in more recent times, to pay taxes.

The second results in collections which are subject to various statutory or public controls and hence have to be answerable. It is this, among other things, that seems to annoy directors and curators, whose intellectual qualifications often lead them to forget that they are public servants.

The eighteenth century was the age of the private collector, of the development of taste, the evolution of aesthetics, the 'discovery' of classical and Renaissance art, the development of English portrait and landscape painting, the vast acquisitions of countless Grand Tours, the building of country houses and their collections of art, and the very limited concern for public collections, which saw the foundation of the British Museum.

Museums and art galleries generally were a nineteenth-century phenomenon. They came into existence as a result of waves of conscientious Victorian and Edwardian dedication to the idea of art as an educator, or in response to that idea in the benefactors who forced politicians to build places for the display of their generous gifts.

The modern era, since the First World War, has been dominated again by the stately home more than the art gallery or museum. In fact, the 1920s and 1930s were a comparatively lean period, both for the establishment of new museums and art galleries, and also for their adequate financing and the encouragement of expansion. Since the Second World War this has changed for the better.

There are, in the end, two ways of looking at all the 550 institutions open to the public in these islands, and displaying works of fine art. The two ways are not mutually exclusive.

On the one hand the collections represent, together, one huge national heritage of art, more or less permanently available, secure, safe, well displayed, well researched, and continuing to evolve.

On the other hand, they are there, constantly in a state of rivalry and competition, vying in the purchase of works of art, sometimes vying as well in the disposal of them. Uneven in what they offer, and in the ways in which they offer it, they represent a rich but incoherent store-house in which nine-tenths of everything they possess is out of sight; understaffed, short of space, they are unable to make works available; rooms are closed off, galleries are given over to local and children's art exhibitions; indifference, frustration and harassment all too often preside.

Which of these two interpretations prevails depends on the individual's point of view. Into every art gallery, museum, house, palace or castle, on each day that they are open, go visitors who, although they are unlikely to register their identity, assert their demands or voice their motives, are drawn by the magnetism of art to seek some emotional or spiritual pleasure. They are what the art was created for, in the first place. Their satisfaction should be paramount.

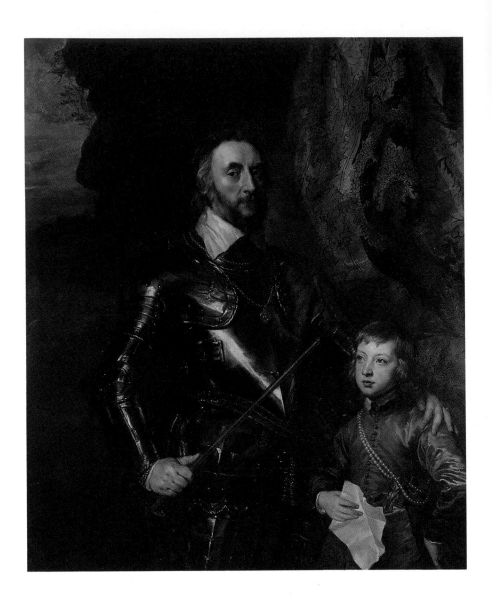

ANTHONY VAN DYCK
Thomas Howard,
Second Earl of Arundel, with his grandson, Thomas
Arundel Castle, West Sussex

I

Three Men: 'The True Nature of All Things'

In the youth of a state arms do flourish; in the middle age of a state, learning; and then both of them together for a time; in the declining age of a state, mechanical arts and merchandise.

Francis Bacon: 'Of Vicissitude of Things'

Three men at the beginning of the seventeenth century played important roles in defining the nature, purpose and direction of art collecting in England, of museums and then art galleries, and of that great treasure chest of paintings and sculpture: the English country house collection. They were Francis Bacon (1561-1626), Thomas Howard, the Earl of Arundel (1585-1646), and King Charles I (1600-49).

The first of the three was the complex philosopher of Renaissance thought in England, one of the men who charted the course of English knowledge and understanding at the beginning of the seventeenth century. In the course of doing this he also gave us the first English description of what a museum should be. It is not just this narrow interpretation of him that makes him an influence in the development of art collecting and connoisseurship; it is the much larger contribution to the central intellectual motivations of Renaissance man, motivations which are at the heart of what the other two men collected, and why.

The Earl of Arundel, 'Father of Vertu' in England, the 'magnifico' of the seventeenth century, and one of its greatest collectors, was the friend and patron of Rubens, Inigo Jones, Wenceslaus Hollar, Van Dyck, and of many others. He was also friend and agent to Charles I, and rival to his favourite, the Duke of Buckingham, particularly as a collector. He was a proud man who regarded Buckingham as an upstart, and he went to the Tower for a time as a result of this rivalry. He gathered treasures throughout Europe and in the Levant the like of which had not been seen before, and was largely responsible for turning England into a magnet for works of fine art.

The country, in the early seventeenth century, was almost a city state. Threats of Irish or Scottish rebellion or invasion had been reduced to inconsequential proportions, and society was small enough to provide suitable, if primitive, conditions for the effective working of an art market. It was intimate, and the rivalries were intense. Something of this intimacy can be gauged from the fact that the Earl of Arundel, together with Buckingham and the Earl of Pembroke, rivals or associates, made up, with the king, the main purchasers of major works.

Arundel, incidentally, was president of the committee of peers established in 1621 to investigate the charge of bribery against Francis Bacon, who confessed to 'corruption and neglect'.

As will be seen, Arundel's collections suffered substantial damage during the Civil War, part of the huge financial loss which the Earl himself met with. Part of that damage can be seen in works from his collection in the sculpture gallery in the Ashmolean Museum, to which they came from the university. It was John Evelyn who claimed credit for persuading Henry Howard, later Duke of Norfolk, to present the Arundel Marbles to Oxford University. By the time of the Civil War Arundel had left England for good, dying in Padua, where he had gone to live, three years before the execution of Charles I. His successors did not appreciate what he had left, and after the war most of what he had collected was dispersed.

Charles I was the greatest collector of the seventeenth century, possibly the greatest collector England has known. Art meant more to him than winning wars. It could be said to have meant more to him, in the end, than life itself. Certainly, among all the faults and alleged misdemeanours which led to his downfall and execution, the outstanding quality was his impeccable taste, the ruling passion of his life, that admirable instinct to acquire great works of art. In finding the money to indulge both, he bankrupted the Exchequer, entered into conflict with his people, provoked civil war, and was finally executed.

In order to find the money, for example, to buy the Duke of Mantua's magnificent collection, the financial resources for the Duke of Buckingham's attempt to relieve La Rochelle from Cardinal Richelieu's besieging army had to be reduced, with catastrophic results. Out of that single deal, negotiated in two parts for the staggering overall sum of £25,500, England is still the richer by at least one truly great work, the magnificent Mantegna cycle at Hampton Court, *The Triumph of Caesar*.

The rest, with certain important exceptions, were sold by the State after his execution. The works disposed of now enrich museums and art galleries throughout the world, though principally in Europe. The loss to Britain is incalculable.

Among other side-effects of Charles's extravagant passion is the existence in the British Isles of so many magnificent paintings by Anthony van Dyck, whose portraits gave immortality to so many great men of the age. And it is perhaps appropriate that the English king is among the most familiar of English monarchs precisely because of the splendid Van Dyck portraits, depicting that weak, sad, self-indulgent and tragic figure.

In their lives all three men suffered disaster or tragedy. For one reason or another, their contributions to the arts were flawed. In Francis Bacon's

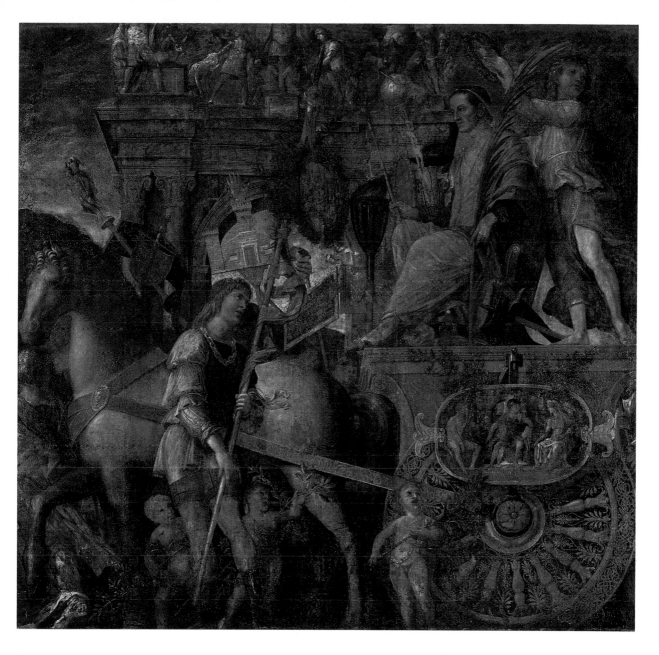

case the philosophic writing directly applicable to those concepts from which we derive our ideas about museums and art galleries is only a part of his work: we have to look more broadly at his contribution. While no consideration of the art collections in country houses could be undertaken without reference to Thomas Howard, Earl of Arundel, the irony is that such reference is only a passing one: limited to what might have been, rather than to what is. As for Charles I, the tragedy of his life, familiar to every schoolchild, embraced the tragedy of his career as a collector, dooming the collection as well.

ANDREA MANTEGNA
The Triumph of Caesar
Royal Collection

FRANCIS BACON

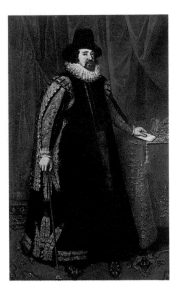

PAUL VAN SOMER
Sir Francis Bacon
Gorhambury, Hertfordshire

In that curious, unfinished work, *New Atlantis*, not published until 1627, the year after his death, Francis Bacon puts forward some preliminary idea or outline of a national museum of science and art. This has often been referred to as the earliest definition in English of a museum or art gallery. The narrator is the privileged recipient of instruction during the course of an accidental visit to an island of Utopian character. The instruction is in the form of dissertations about the way of life pursued by the inhabitants of New Atlantis.

At the end of the final dissertation, given by the Father of the College of the Six Days' Work, or Salomon's House, after he outlined what is, in effect, a constitution for a State, Bacon states this objective: 'The end of our foundation is the knowledge of causes, and secret motions of things; and the enlarging of the bounds of human empire, to the effecting of all things possible.' He goes on to recount the methods and systems by which New Atlantis works, coming ultimately to those who collect up information (the 'Merchants of Light'), those who process it ('Depredators', 'Mystery Men', 'Pioneers', 'Miners'), those who assemble and catalogue the discoveries ('Compilers'), and finally the different groups ('Dowry men', 'Lamps', 'Inoculators') who exploit the assembled information and knowledge.

He describes the places in which the State's storehouse of intellectual and creative achievement is kept and celebrated: 'For our ordinances and rites, we have two very long and fair galleries: in one of these we place patterns and samples of all manner of the more rare and excellent inventions: in the other we place the statua of all principal inventors. There we have the statua of your Columbus, that discovered the West Indies: also the inventor of ships; your Monk that was the inventor of ordnance and gunpowder: the inventor of music: the inventor of letters: inventor of printing . . . for upon every invention of value we erect a statua to the inventor . . . some of iron, some of silver, some of gold.'

In its rudimentary form, this represents the first attempt by a modern English writer to sketch out the broad concepts of a museum covering both science and art. His outline pre-dated the beginning of the first great English museum, the Ashmolean at Oxford, by more than half a century, the opening of the British Museum by more than 130 years, and the opening of the first art gallery for the public, the Dulwich Picture Gallery, by almost two centuries. Nevertheless, the intellectual seeds by which those and other collections came into being, and then became increasingly part of the public province of science and art, can be traced back to the Renaissance ideals by which the highly regarded achievements of exploration, experiment, discovery—in other words, 'the knowledge of causes', no matter how wide the interpretation of the meaning may be—could be documented, and the authors or inventors celebrated or honoured for what they had done.

It was Francis Bacon who gave to this process its first, formal clothing in his precepts for a singular form of Utopia. He sought to shape the idea

of collecting, in *New Atlantis*, by giving it a purpose that was of general benefit to the State. In this he was fulfilling an essential, if not the essential purpose of Renaissance man in the creation of the 'modern' world, which was to re-frame human achievement and endeavour in the context of the State, and give it formal, philosophic clothing.

What is clear from the passages in *New Atlantis* is that Bacon grasped the central idea of museums, that they should cover the whole field of human knowledge. To him, as to successive generations of men who developed actual museums and made collections, the idea of a separation between science and art was arbitrary. It was certainly so up to and including the foundation of the British Museum. In due course this changed. But it did so slowly. Not until the movement which led to the setting up of the National Gallery, in the 1820s, was a distinct and separate value set on art.

Some of Francis Bacon's ideas would have been put into practice at Gorhambury, in Hertfordshire, the house which he inherited from his elder brother in 1601, and of which he was very fond. It was his only country estate, and he spent much time there until his death in 1626. The original Tudor house is now a ruin in the grounds of the present, eighteenth-century house. The collection there includes *Sir Francis Bacon* by Paul van Somer and paintings by his half-brother, Nathaniel Bacon, who was a gifted artist.

Perhaps influenced by Bacon's writing, a later owner of Gorhambury, Sir Harbottle Grimston, who bought the house in 1652, created a 'Gallery of the Great', still part of the collection, and the only complete one of its kind in Britain.

THE EARL OF ARUNDEL

The earldom of Arundel, the premier earldom of England, merged with the dukedom of Norfolk in 1660, has an ancient and complicated history, involving the Fitzalan and then the Howard families. Thomas Howard, the Second Earl, was born a Catholic, in 1585, when his father, Philip, First Earl in the Howard line, was suffering persecution for his religious beliefs. In April of that year he was charged before the Star Chamber with being a Romanist, was fined £10,000 and imprisoned. He was imprisoned again in 1588, accused of praying for the success of the Spanish Armada, and though sentenced to death, died and was buried in the Tower, his death apparently caused by self-imposed religious austerities.

Not until the accession of James I did his son have his father's titles restored to him. After education at Westminster School and Cambridge he travelled abroad, acquiring his interest in art, and not long after his return, in 1611, he became a Protestant. Not only did he preside at the House of Lords investigation into Francis Bacon's alleged corruption, but was more intimately connected with Bacon's death, six years later. As is well known, Bacon caught a chill after getting down from his carriage

in freezing weather to conduct an experiment in the snow; he was taken to the Earl of Arundel's house and put to bed there, but unfortunately in a bed which had not been used for more than a year, and was damp.

Arundel opposed the Spanish War in 1624, supporting the impeachment of the Duke of Buckingham, and then, on the occasion of the marriage of his son to Lady Elizabeth Stewart, Charles imprisoned him in the Tower. The differences between the two men were reconciled, and Arundel became an emissary of the king, resuming European travel on his behalf, and engaging in extensive purchases of works of art, on his own and his monarch's behalf.

Horace Walpole, in his *Anecdotes of Painting*, said of Arundel: 'Living much within himself, but in all the state of the ancient nobility, his chief amusement was his collection, the very ruins of which are ornaments now to several principal cabinets.'

In April 1640, Arundel was made Lord High Steward of the Royal Household, a recognition of past rather than future services to the treasures it possessed. Not long afterwards he became estranged once more, moved to Padua, and died there in September 1646.

Arundel, 'to whose liberall charges and magnificence this angle of the world oweth the first sight of Greeke and Romane Statutes, with whose admired presence he began to honour the Gardens and Galleries of Arundel-House about twentie yeeres agoe, and hath ever since continued to transplant old Greece into England,' was referred to by Rubens, in 1620, as one of the four evangelists and supporters of his art. Since Rubens was then turning down commissions from princes, and had established a powerful practice in Antwerp with Van Dyck as his principal assistant, some measure of the status achieved by the great English collector can be assessed.

He employed William Petty as agent. Petty was uncle to Sir William Petty, who surveyed Ireland, and who was founder of the Lansdowne family, the remnants of whose collections are to be seen at Bowood (q.v.).

Arundel's greatest acquisitions were works of sculpture, a residue of which may be seen today in the Ashmolean Museum. He had fine drawings, including some by Leonardo da Vinci, paintings by Holbein, portraits by Van Dyck and Rubens, coins, medals, and engravings. He was responsible for bringing Wenceslaus Hollar to England from Prague, and commissioned a number of works by him.

Among the works by Van Dyck was the double portrait at Arundel Castle, *The Earl and Countess of Arundel*. Alethea Talbot, whom the earl married in 1605, shared his love of collecting. Into the bargain she brought wealth to support it. She was the granddaughter of the Countess Dowager, 'Bess of Hardwick', and daughter and eventually sole heiress of the Earl of Shrewsbury.

Arundel's relationship with Charles I, to whom he had taught much about collecting, was an uneasy one. His departure from England was in part motivated by this, and by presentiments of tragedy for the king and his court.

CHARLES I

'Charles was a scholar, a man of taste, a gentleman and a Christian: he was everything but a king. The art of reigning was the only art of which he was ignorant.' He was a gifted judge of painting. He could distinguish with ease the authorship of a canvas from the way it was painted. He argued with artists about the techniques of painting and drawing, and was said to have drawn himself, his work being corrected by, among others, Rubens. And from the time of his accession, if not before, under the influence of his elder brother, Henry, he was a collector.

Yet, as a man of his age, a true product of the Renaissance, who could say, not without disdain, on the scaffold at the end of his life, 'A Subject and a Sovereign are clean different things,' he was fatally flawed. Was it because he abandoned Truth at an early stage in his life? And having done so, engaged steadily and inexorably in that duplicity which finally was to cost him everything? As England's greatest collector, he merits some attention.

Charles I presided over a magnificently civilised court, the epitome of aesthetic discrimination and judgement. His own exalted ideas about monarchy, its divine right, and other prerogatives, deriving in part from his isolation and loneliness as a man, augmented the brilliance and success of his immediate circle. But it went further than that. It had a civilised grandeur which totally transformed and outshone the disorderly court of his father, James I. Charles I was quick to institute reform, creating a dazzling yet restrained royal environment which outshone, not just the corrupt court that was to be reinstated by his son, Charles II, but virtually every other court in English history.

Nevertheless, in most things of importance, he failed to manage his own life properly. It went out of balance for many reasons, and foundered. One of the reasons was his boundless prodigality. It is that, and the use to which he put it, that concern us most directly.

The story of Charles I as an art collector may be divided up by certain important dates. His journey with the Duke of Buckingham to Madrid in 1623 represents a starting point. Even then he did have a considerable collection, but principally of works inherited from his mother and brother, together with such paintings as the Holbein portrait of Erasmus, given him by Sir Adam Newton, and now in the Louvre, in Paris. Charles's elder brother, Henry, whose death in 1612, at the age of eighteen, made Charles heir to the throne, had himself been a discriminating collector whose influence must also have been important. Of the small circle of collectors at court, several were buyers of major continental works of art, the Earl of Arundel of paintings by Rubens, and the Earl of Pembroke of Italian art, both exercising their influence over him.

The Spanish visit, which aimed at a marriage contract between Charles and the Infanta Maria, daughter of Philip III, was politically a fiasco. But it was the first major occasion on which the Prince of Wales purchased important works of art. More important, it gave him an opportunity to see and to be profoundly impressed by the great collections of Charles V

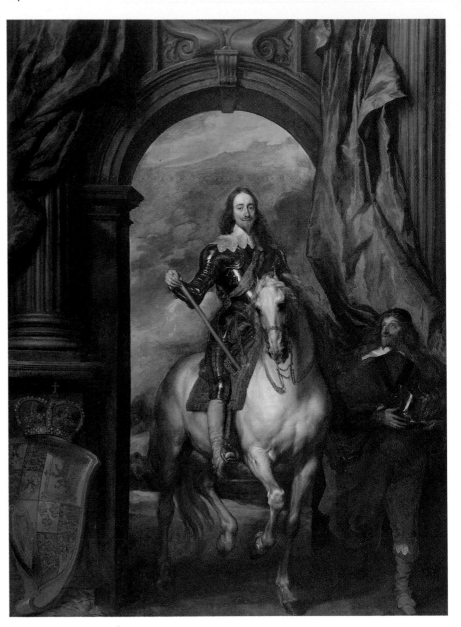

SIR ANTHONY VAN DYCK
Charles I on Horseback with
M. de St Antoine
Royal Collection

and Philip II. It would have been on this visit, in the Casa Real de la Ribera, at Valladolid, that he would have seen the Rubens equestrian portrait of the Duke of Lerma, on which was modelled, ten years later, the Van Dyck equestrian portrait, *Charles I on Horseback with M. de St Antoine.*

During the next ten years there took place a number of major acquisitions, the most splendid of which was the purchase, in two parts and for a total of £25,500, of the Duke of Mantua's collection. The first part, negotiated through Daniel Nys, was accomplished in 1627; the second slice, which included *The Triumph of Caesar*, was completed in about 1628.

Details of what was bought were offered somewhat crudely: 'A child, by Praxitiles'; 'Lucretia, naked. Titian'; 'Three heads in one picture. Titian', but the range and quality were magnificent.

In 1632 there was another important development, when Charles brought to his court at Whitehall Anthony van Dyck. Almost the same age as the king (Van Dyck was born in 1599), he was the best of Rubens's pupils, and an outstanding European painter whose impact on English art and its development in the first half of the seventeenth century has been described by Sir Oliver Millar, former Surveyor of the Queen's Pictures, as 'a revolution as dramatic in its way as any other upheaval in that turbulent age'.

Van Dyck revolutionised English portrait painting. He affected profoundly the whole course of English art. He immortalised his patron and the Caroline court, as well as stretching well beyond it in his compass of English character and the life of the country. His works are the privileged possessions of many of the great collections in these islands, and he touches on a wide range of aspects of history in such portraits as those of *Archbishop Laud* in the Fitzwilliam Museum, *Thomas Killigrew* at Weston Park in Shropshire and the double portrait at Arundel Castle (qq.v.).

He gave a central, living purpose to Charles as collector, introducing a splendid creative dimension to the king's rich backcloth of acquisitions. The two men shared a love of Titian which comes out in Van Dyck's own *Three Heads in One Picture*, perhaps his most famous portrait of the king. Yet he was also intensely moving in his treatment of religious subjects, such as *Samson and Delilah* (Dulwich Picture Gallery), of mythical subjects like *Cupid and Psyche* (the Queen's Collection, Windsor), and of children.

Van Dyck accomplished all of this in a life even shorter than the king's. When he died, in December 1641, the sombre mechanism of English seventeenth-century democracy had already set in motion, through the Long Parliament, the closing scenes of the dismal tragedy which would lead to the dismemberment of the collection at the centre of which he had found so illustrious a place. The outbreak of Civil War, the irrevocable destruction of the king's power, and his eventual execution, doomed completely what it had taken a lifetime to acquire. Within less than two months of his execution, on January 30, 1649, the House of Commons passed a resolution for the appraisal and sale of the Royal Collection, the so-called Commonwealth Sale.

Values were placed on the works of art, and they were then offered for sale, certain pictures being reserved, among them the Raphael *Cartoons* and Mantegna's *The Triumph of Caesar*. The buyers were a diverse group. Some came from the court itself, buying what they had long admired, and free to do so as long as they had not borne arms against the Parliamentarians. Other buyers included such regicides as Colonel John Hutchinson, painters like Peter Lely, collectors such as Ralph Bankes (cf. Kingston Lacy) and inevitably dealers and collectors from Europe, who were among the most highly motivated.

Sir Oliver Millar compares this 'organised holocaust' with the dispersal from the French royal and noble collections after the fall of Louis XVI in 1792, and goes on: 'In the actual dispersal there flourished in microcosm

the art trade of the future: a shadowy host of dealers, creditors, merchants, artists and foreign agents. In spite of their success, there are still in the Royal Collection many pictures which Charles I had acquired.' A brief indication may be given: *The Holy Family* by Correggio, *The Lady in Green* by Bronzino, *Portrait of a Man* by Dürer, *The Holy Family* by Dosso Dossi, *Jacopo Cennini* by Franciabigio, *The Nine Muses* and *Esther and Ahasuerus* by Tintoretto, and Holbeins, among them the miniature *Charles Brandon, Duke of Suffolk as a boy* and the portrait of *Derich Born*.

And the works that were lost? It is a painful inventory; Titians went to Vienna, Paris, Madrid; the Erasmus portrait by Holbein went to Paris;

SIR ANTHONY VAN DYCK
Cupid and Psyche
Royal Collection

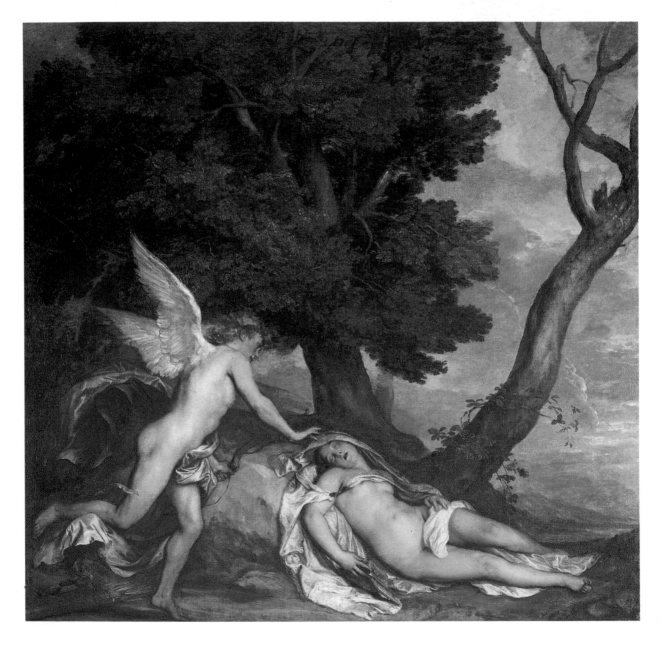

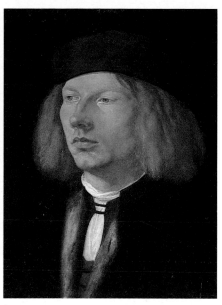

HANS HOLBEIN
Portrait of Derich Born
Royal Collection

ALBRECHT DÜRER
Portrait of a Man
Royal Collection

the Lucas Cranach portraits of Johann Cuspinian and his wife have ended up in the Winterthur Collection; *Saint John the Baptist,* by Leonardo da Vinci, in the Louvre; Pieter Brueghel the Elder's *Three Soldiers* ended up in the Frick Collection in New York; the Rembrandt *Self-Portrait* in the Walker Art Gallery, Liverpool (the three Rembrandts owned by Charles I, themselves an indication of his discriminating taste at the time, sold for less than £5 each); the Dürer *Self-Portrait* went to Madrid; and works by Raphael, Mantegna, Giulio Romano, the Carracci, Guido Reni, Caravaggio, Andrea del Sarto, Jan van Eyck and Lorenzo Lotto went to Dresden, Vienna and Paris.

By the middle of the seventeenth century it could be said that little had been achieved, in terms of art collecting in the British Isles, beyond splendid example and less splendid, but more permanent, acquisitions by the emulators of the king and of such men as the Earl of Arundel. A residual royal collection had been left. The intellectual impact of Francis Bacon had borne little fruit, beyond leaving a rudimentary outline of what museums were for, and how they should be constructed. Charles I had given an object-lesson in private and State collecting, the problems of financing such an interest, the greater problems of the loss of incomparable art treasures. In the aftermath, and for a time, the heavy hand of Puritan impatience rested on the richer flowering of painting and sculpture. A first cycle was complete; a less turbulent, more lasting, second cycle was beginning.

Three Museums: 'A Joy for All'

If only the English nation could be made to understand that the beauty which is indeed to be a joy for ever, must be a joy for all.

John Ruskin

Three museums, founded, respectively, in the seventeenth, eighteenth and nineteenth centuries, offer a framework within which we can consider the evolution and development of the collecting and public display of artefacts, including works of art. They are the Ashmolean, in Oxford; the British Museum; and the Victoria and Albert Museum. Each, in a highly distinctive way, reflects its own period.

The Ashmolean, which first opened in 1683, provides the link between the thought and feeling of that time and the present. The British Museum reflects the eighteenth century's slowly emerging sense of national heritage and a desire for preservation. And no institution evokes more firmly the ethos of the nineteenth century than the Victoria and Albert Museum.

In each of the three, fine art was not considered of central importance. Good fortune has nevertheless endowed each with collections of unparalleled richness. The irony of this emphasises the uncertainty with which such institutions, from the mid-seventeenth century to the mid-nineteenth century, stumbled towards the possession and then the display of works of art.

When the British Museum first opened its doors, in 1759, it was not the first, but it became the greatest museum in these islands. When its collection was divided in the nineteenth century, with portions being moved to South Kensington, purists deplored the fact: 'the student of museums can never fail to regret that the necessities of space and financial considerations compelled this separation, which in a measure destroyed the ideal relationship which had for so many years obtained.' [William Jacob Holland, Director of the Carnegie Institute, Pittsburgh, writing in the 1911/1926 edition of the *Encyclopaedia Britannica*.] The destruction of that 'ideal relationship' has been part of the required development of about half of the museums and art galleries throughout the British Isles, which are imitations, smaller versions, localised expressions of the three prototypes with which this chapter is concerned.

THE ASHMOLEAN MUSEUM

If you stand in front of *A Hunt in the Forest*, by Paolo Uccello, in the main Italian Room upstairs in the Ashmolean Museum, your eyes are drawn towards the dark centre of the picture. The huntsmen are riding there, some a bit reluctantly; the dogs are heading towards their quarry, followed by beaters. Because it is an unusual shape, the width almost three times the height, a physical sense of movement is emphasised: the eye is invited to traverse, from left or right into the centre. And this imposition on the mind, through the eye, is entirely consistent with Uccello's obsession with perspective. He takes it further. The unbroken horizontal bands in the painting, the dark foliage at the top, the even darker shadows stretching in, and then the vivid, frieze-like variety of figures in the foreground, all work towards a didactic purpose. As Berenson has said, this painter, 'because of his life-absorbing excitement over perspective, ranks now as an artist of the highest order, which he is but seldom'.

Turn now to another Florentine work, of perhaps half a century later, *A Forest Fire*, by that eccentric genius Piero di Cosimo, who disdained his own times, turned back to mythology, and lived on supplies of hard-boiled eggs. The scale is similar; this is an even longer, thinner painting. It also is concerned with a dramatic happening, with fear and with movement. Yet how different it is. The movement is outward, the argument more subtle, the arrangement of animals, trees, landscape, light, more diverse, less relentless. It is a persuasive, Socratically argued work, belonging to a finer order of things.

To have the two paintings in one collection, both excellent examples of the artists, their lives overlapping, their concerns part of one's education in early Italian art, is one of the many indicators of the unique quality of a great collection like that of the Ashmolean Museum, in Oxford. It is endlessly repeated in other periods, schools and media. Yet, although the collection dates back to the seventeenth century, the works of fine art are

PAOLO UCCELLO
A Hunt in the Forest
Ashmolean Museum

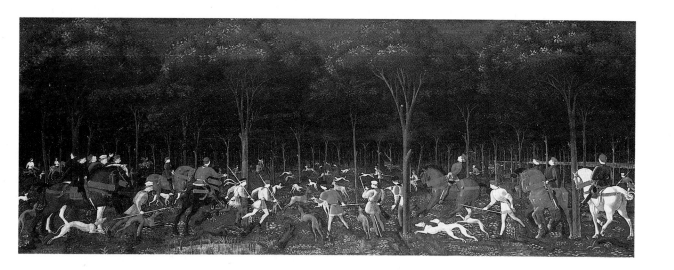

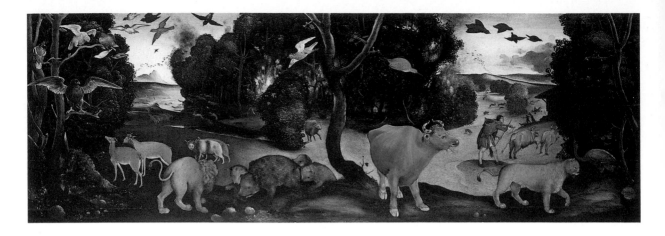

PIERO DI COSIMO
A Forest Fire
Ashmolean Museum

almost all derived from the nineteenth and twentieth centuries. Indeed, the two pictures mentioned came to the Ashmolean, respectively, in 1850 and 1933.

The museum is the oldest public museum in the British Isles. It first opened in June 1683, after a ceremonial visit by the then Duke of York, later King James II, and it has been open ever since.

It began as a collection of curiosities, developed into what the seventeenth century would have regarded as a scientific collection, was used as much for laboratory and teaching purposes as for the accumulation and display of objects, and only in the latter half of the nineteenth century took on the basic character which we know today.

The Ashmolean Museum is undoubtedly in the first rank, its collections rivalling, and in some instances surpassing, those anywhere else. Its collection of Raphael drawings, for example, is the finest in the world, larger in size and arguably more comprehensive than any other. It has wonderful drawings generally, a splendid collection of early Italian art, good French and English painting, and a fine collection of Renaissance bronzes. The nucleus of this last group of works was formed by Charles Drury Edward Fortnum, in the latter half of the nineteenth century, whose benefactions made possible the reorganisation and extension of the museum, at the turn of the century.

For many individual works of art, or for collections of works within the museum as a whole, there are numerous stories of personal endeavour and munificence not dissimilar from those which are inextricably part of the story of every public collection. What is important about the Ashmolean Museum is that we have well over three hundred years of comparatively unbroken history, including the period before its ceremonial opening, during which the collection of curiosities was gradually given order and shape. This process, typical in many ways of the seventeenth century and its culture, is of absorbing interest.

While the museum bears the name of its true founder, Elias Ashmole, its first collections were assembled by the two Tradescants, *John the Elder*, who died in 1638, and was roughly a contemporary of Francis Bacon, and his son, *John the Younger*, 1608-62. They were, in succession, gardeners

to Charles I. They were travellers and naturalists, collectors, in the first instance, of plants, and then of curiosities. The remnants of their collections are still to be seen in a special section of the Ashmolean Museum, and their unique place both in the development of this museum and of ideas about collecting generally is justly celebrated in the portraits of the family which hang in the Ashmolean, and which are among the few works of fine art in the collection directly related to the first phase of the museum's development.

By some, the Tradescants were decried. 'The aimless collection of curiosities and a bric-à-brac, brought together without method or system, was the feature of certain famous collections in bygone days, of which the Tradescant Museum, formed in the seventeenth century, was a good example. This museum was a miscellany without didactic value; it contributed nothing to the advancement of art; its arrangement was unscientific, and the public gained little or no advantage from its existence.' [Lord Balcarres, *Encyclopaedia Britannica*, 1911/1926 edition, Article: 'Museum of Art.'] While much of this is true, it represents a twentieth-century judgement about seventeenth-century culture and the *Wunderkammer* tradition out of which the modern museum grew.

As Edmund Burke wrote at the beginning of his *A Philosophical Inquiry into the Origin of our Ideas of the Sublime and Beautiful*, 'The first and the simplest emotion which we discover in the human mind is Curiosity. By curiosity, I mean whatever desire we have for, or whatever pleasure we take in novelty.' In identifying this at the outset of such a search, he justifies the basic instincts which motivated the Tradescants a century earlier. Whatever philosophic shape may be placed on collecting, in either the personal or the public interest, and whatever further philosophy may be worked out about what constitutes the beautiful or the sublime, without that deeper, more instinctive human urge to acquire the new, the unusual, the rare, and which therefore illuminates mind or spirit, no museums would have come into existence. Certainly, neither Bacon nor Burke could have wished them into being by advertising their usefulness or by demonstrating the impact their contents might have.

In their day the Tradescants were admired for what they collected. Their collections were put on display at Lambeth, and were catalogued in *Musaeum Tradescantianum*, published in 1656, the earliest published catalogue of a collection of English rarities. It was written by Elias Ashmole, in collaboration with Thomas Wharton, and published at the former's expense. This academic and financial concern seems to have been the main reason why John Tradescant gave to Ashmole his and his father's collection.

Elias Ashmole (1617-92) was a man obsessed with order, ceremony, precedence and ritual. His greatest work was his history of the Order of the Garter, and he was a loyal royalist: a seventeenth-century 'establishment' man. His view about museums, indicated in *Musaeum Tradescantianum*, was that they should be an instrument for the advancement of learning, and for perhaps the first century and a half of the existence of the Ashmolean Museum this idea took such precedence over the care of the collections themselves that they suffered as a result. Ashmole, in his collecting habits, was a man of his time, greatly interested in coins and medals, and in

books, manuscripts and prints. Fine art, in the full-blooded sense in which it now dominates the Ashmolean Museum, was virtually non-existent. He was an antiquary and a man of science, as it was then understood, and this is reflected in the collection he gave to Oxford.

His conditions for the gift were those insisted on by many subsequent benefactors to museums and art galleries: that a suitable repository be built to house the collection. This was done by the university, in Broad Street, and there the museum remained until the nineteenth century, when its present neo-classical building was put up in Beaumont Street. This led to a general reorganisation of the collections. Ashmole's books, and what remained of his collection of coins, much of which had been destroyed by fire long before the founding of the Ashmolean Museum, were transferred to the Bodleian Library; natural history material went to the University Museum, in 1860; ethnographical specimens went to the Pitt Rivers Museum in 1886. The name Ashmolean Museum remained attached to the Broad Street building for some time after the present museum building had opened as the 'University Galleries', housing pictures from the Bodleian and elsewhere. It was only at the end of the century that the collection of collections, of fine art and applied art, antiquities and archaeology, came under the title Ashmolean Museum. The coin collection was greatly enlarged in the 1920s, and rehoused; and in 1962 the Oriental Collections from the Indian Institute were moved to the museum, and became the Department of Eastern Art.

The collections of fine art, particularly of western fine art, derive mainly from the nineteenth century. Many of the splendid examples of early Italian art, including Uccello's *A Hunt in the Forest*, came from the gift of paintings made by W.T.H. Fox-Strangways, the Fourth Earl of Ilchester (1795-1865), who was a diplomat, and member of Palmerston's 1835 administration. Largely through diplomatic postings, which took him to various parts of Italy in the early years of the nineteenth century, Fox-Strangways became an enthusiastic and prodigious collector of early Italian art, mainly pre-1500, which was then to be had 'at no great expense and within small compasses to size and numbers'. [Letter from Fox-Strangways to his nephew, Henry Fox Talbot, written from Genoa in 1827.] His substantial gifts to the Ashmolean (he also gave paintings to his own college at Oxford, Christ Church) include *The Crucifixion and Lamentation*, attributed to Barna da Siena, *The Meeting of Joachim and Anna at the Golden Gate*, by Filippo Lippi, and the Studio of Botticelli *Virgin and Child*.

The Raphael and Michelangelo drawings originally belonged to Sir Thomas Lawrence, and were acquired by the museum in 1845-6, almost fifteen years after Lawrence's death. He was one of the greatest artist-collectors, amassing a magnificent range of Old Master drawings which were offered, as a collection, to the nation. The offer was not taken up, and they were dispersed, though this essential group was preserved.

Other great nineteenth-century acquisitions include the paintings and drawings bequeathed in 1855 by Chambers Hall, and the Combe Bequest of Pre-Raphaelite paintings, among them J.E. Millais's *Return of the*

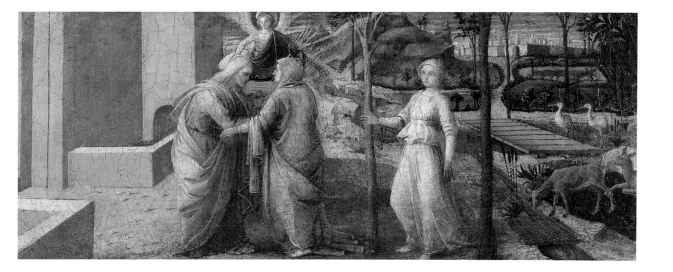

Dove to the Ark. The artist's *Portrait of Thomas Combe* is also part of that bequest.

FRA FILIPPO LIPPI
The Meeting of Joachim and Anna at the Golden Gate
Ashmolean Museum

The museum is strong in English art, with excellent collections of drawings by Wilkie and Samuel Palmer, including *The Rest on the Flight*, Edward Calvert's *Classical Landscape*, drawings, watercolours and paintings by William Orpen, Augustus and Gwen John, and good examples of the best periods of British watercolour painting, including good works by Turner, Cozens and Cotman.

The Ashmolean numbers among its former curators Sir Arthur Evans and the late Lord Clark. The first director was Sir David Piper, who retired in 1985. The present director, Christopher White, endorses his predecessor's view that it is 'the most important collection, in its range, variety and quality, of any University Museum in the world'. [David Piper: 'Elias Ashmole and his Legacy', *Apollo Magazine*, April, 1983 (Vol. CXVII No. 254 (New Series)).] He also points out, however, that past munificence is unmatched by present resources, and that it faces an economic crisis, not concerned with acquisitions, but with the wherewithal to sustain its more mundane function of opening to the public.

THE BRITISH MUSEUM

The British Museum was established by Act of Parliament in 1753. It opened to the public in 1759. A guidebook to the general contents was published in 1761, setting out, among other things, the conditions of entry: 'fifteen persons are allowed to view it in one Company, the Time allotted is two Hours; and when any Number not exceeding fifteen are inclined to see it, they must send a list of their Christian and Sirnames, Additions, and Places of Abode, to the Porter's Lodge, in order to their being entered in the Book; in a few days the respective Tickets will be made out, specifying the Day and Hour in which they are to come, which, on being

sent for, are delivered. If by any Accident some of the Parties are prevented from coming, it is proper they send their Ticket back to the Lodge, as nobody can be admitted with it but themselves. It is to be remarked that the fewer Names there are in a List, the sooner they are likely to be admitted to see it.'

The situation has changed substantially since that time; nevertheless, with a collection so immense and valuable, access formalities for researchers are essential, and in the case of watercolours and drawings in the Department of Prints and Drawings, this does present a problem. It is predominantly a collection designed for scholarly use, and this underlines its seriousness as an archive and as the greatest public record of western graphic art and drawings in these islands. There are exhibitions through the year, three on average, which make available generally works from the collection and elsewhere; attendances of 100,000 visitors or more are common, an indication of the popularity of the British Museum to the general public.

The British Museum is a museum of many areas, comprehensive, magnificently rich; yet unless its sheer wealth of material can be accommodated to one's own interests it can be a frustrating experience.

The British Museum came into existence as a result of the bequest to the nation, by Sir Hans Sloane, 1660-1753, of his collection of natural history, coins, medals, books, manuscripts, prints, drawings, paintings, and antiquities. It was left first to the king for the nation on condition that £20,000 was paid to Sloane's heirs, a sum that was said to be the value of the coins alone. Parliament favoured the purchase and an Act was passed which received the royal assent in June 1753. This provided for a public lottery to raise funds for the purchase of the collection and for a suitable repository. In its preamble the Act referred to the fact that 'all Arts and Sciences have a Connection with each other, and Discoveries in Natural Philosophy, and other branches of speculative Knowledge, for the Advancement and Improvement whereof the said Museum or Collection was intended, do and may, in many Instances, give Help and Success to the most useful Experiments and Inventions . . .' To this rounded view of its purpose and potential value, it was consistent with eighteenth-century concern with order and with systems that the development of the British Museum should have been deliberately and conscientiously along the lines outlined in the Act.

In addition to Hans Sloane's collections, the British Museum was allotted the Cotton Library which had been given to the nation half a century earlier and, for £10,000, the manuscripts collected by the Harley family, Earls of Oxford. The Trustees appointed by the Act considered several possibilities as a repository and in 1754 acquired Montagu House, Bloomsbury, on the site of the present museum.

The collection grew rapidly. The original Act provided for a Board of Trustees as the ultimate authority under Parliament. The collection was originally divided into three departments (Printed Books, Manuscripts, Natural and Artificial Productions). These developed over the years and with the departure of Natural History in the 1880s and the splitting off of the library in 1973 now consist of: Prints and Drawings (established in

1836); Coins and Medals; Ethnography (at the Museum of Mankind, Burlington Gardens) and Egyptian, Greek and Roman, Medieval and later Oriental, Prehistorical Romano-British and Western Asiatic antiquities.

Initially, in keeping with the period, there was an emphasis on the acquisition of classical works of art. In 1772, £8,400 was paid for Sir William Hamilton's first collection of Greek vases. The first major Egyptian antiquities arrived in 1802 to be followed in the 1820s and 1830s by the nucleus of the collection of Egyptian sculpture then hardly regarded as art. Another substantial sculpture acquisition was in 1805, when the money raised from the lottery set up half a century earlier—£95,000—was voted by Act of Parliament and paid for Charles Townley's collection of marbles, the greater part Roman from eighteenth-century excavations in Italy. Townley has been described as the greatest collector of his day, 'bridging the eras of Horace Walpole and William Beckford'. Unlike them, whose collections were sold and dispersed, Townley's became the nucleus of the classical antiquities in the British Museum, of which he had been a trustee. Townley's collection was, however, eclipsed by the purchase by the Government in 1816 of the Elgin Marbles which included the sculpture of the Parthenon for £35,000. In the 1840s and 1850s a magnificent collection of Assyrian reliefs and other material was acquired from excavations by Layard and others. Active interest in British and European antiquities was a product of the mid-nineteenth century. Study and active collection of oriental material and ethnography came much later.

In the broad sense all of these collections contain works of art. Only one, that of prints and drawings, is essentially of fine art, and even this emphasis has been modified by such specialist research tools as over 100,000 photographs in the Gernsheim *Corpus Photographicum*, as well as fans, playing cards, book plates and other material. The collection includes prints of documentary interest ranging from large collections of portrait, historical, satirical and topographical prints, to reproductive prints after paintings, sculpture and drawings. There are between two and a half and three million items of which 100,000 are drawings.

In addition the British Museum has transformed its twentieth-century collection in recent years with a substantial increase, particularly in modern prints, and in twentieth-century drawings.

Mention should also be made of the works of fine art which form part of the collection of Oriental Antiquities. These include miniature paintings, Chinese and Japanese scroll painting and Europe's finest collection of Japanese prints.

The nucleus of this Department came from Hans Sloane's own collection. To this was added William Fawkener's bequest in 1769, the Rev. C.M. Cracherode's in 1799, Richard Payne Knight's in 1824, and then the 1836 purchase of the John Sheepshanks Collection, 800 mainly seventeenth-century Dutch and Flemish drawings and about 7,000 prints. Further purchases followed; in 1895 the Malcolm Collection, of about 900 drawings of all schools and over 400 prints, and in 1902 the James Reeve Collection, of English drawings and watercolours, mostly of the Norwich School. In 1931, 20,000 Turner drawings were temporarily transferred from the Tate.

These have been returned to the new Clore Gallery but the British Museum retains a fine collection of Turner's watercolours made for exhibition and sale and an unsurpassable collection of engravings by and after him. In 1946 the Phillips-Fenwick Collection of 1,500 predominantly Italian drawings came anonymously to the museum, and represented the largest remaining fragment of the early nineteenth-century Thomas Lawrence Collection, parts of which, as we have seen, found their way into the Ashmolean Museum's collection. And in 1968 César Mange de Hauke left sixteen important nineteenth-century French drawings to the museum. In recent years the British Museum has greatly extended its collection of twentieth-century material, British and foreign, especially prints.

When we consider the total holdings in these islands of the works of Michelangelo, Leonardo da Vinci, Raphael, Bellini, or Dürer, a single collection which boasts the largest group of Michelangelo drawings outside Italy—more than 80—about 40 Raphaels, and the largest and most representative collection of Dürer drawings in the world, deserves some detailed attention. Naturally, the most substantial collection is of drawings of the British School.

Well-balanced and fully representative collections of Constable drawings and watercolours, of John Sell Cotman and other artists of the Norwich School, of Girtin, Cozens, Towne, Cox, Peter de Wint, Samuel Palmer and William Blake, indicate that all the glories of English watercolour painting during the period of its greatest flowering are covered. Though a clear run at the collection would take many weeks, and though full inspection is virtually impossible, time spent among works of the English School, particularly of the period which covers the Romantic Movement and which is regarded by many as the greatest contribution made by English painting to European art since the Middle Ages, is, for the lover of art, a close approximation to Paradise. From time to time, of course, the museum mounts special exhibitions of some of the drawings it holds.

The choice of works is very rich indeed, and individual works can only begin to indicate the breadth of the collection. Turner's *Caernarvon Castle* dates from around 1833. The Reynolds *Self-Portrait* is just part of the substantial collection of drawings by the artist, matched by a comparable range of work by Gainsborough. Among the splendid Cotman watercolours is *Greta Bridge*, while *Westminster from Lambeth* is a good example of Thomas Girtin's work.

If the English School is the largest represented here, the Italian School is the greatest. From fifteenth-century Florence to eighteenth-century Venice, all the great names of Italian art are to be found with superb examples of their work.

Botticelli's *Abundance*, or *Autumn*, related to the *Primavera* in the Uffizi, has come down to us as a great example of Renaissance art, and with the works of Pollaiuolo, Signorelli, Verrocchio, and the 21 drawings by Leonardo da Vinci, as well as later works by Andrea del Sarto and Fra Bartolommeo, provides us with an early nucleus of work.

ANDREA MANTEGNA
Mars, Venus and Diana
British Museum

From northern Italy works by Giovanni Bellini and Andrea Mantegna, both of them extremely rare, include the latter's *Mars, Venus and Diana*.

The careers of Michelangelo and Raphael are fully represented in every phase, and well supported by the works of their contemporaries, and, in the case of Raphael, by his pupils. There are examples of Correggio, Parmigianino, Titian (albeit only one drawing), Tintoretto and Veronese; there are works by Caravaggio and the Carracci, and, from eighteenth-century Venice, the combination of flamboyance in Tiepolo's art, and of brilliant depiction of the city by Francesco Guardi and Antonio Canaletto, both of whom are well represented throughout these islands, particularly in a number of country houses.

The unique quality of Dürer's art may be seen in several works, particularly the haunting landscapes, like his *A House in a Lake*. Examples of Hans Holbein, Kulmbach, Burgkmair and Adam Elsheimer are included. Of Flemish and Dutch art there are fine works by Jan van Eyck, Rogier van der Weyden, Lucas van Leyden and Pieter Brueghel the Elder, and the only known brush-drawing by Hieronymus Bosch. Seventeenth-century Flemish art is dominated by the superb collections of drawings by Rubens, exemplified by the magical portrait drawing of his first wife, *Isabella Brandt*, and by the unparalleled collection of Van Dyck drawings.

A single example of these would be the glory of lesser collections, as indeed would also be the case with the Rembrandt drawings at the British Museum, which are among the purest works in the collection, in the sense that Rembrandt, perhaps more than any other artist, saw pen and wash

SANDRO BOTTICELLI
Abundance
British Museum

ALBRECHT DÜRER
A House in a Lake
British Museum

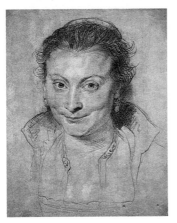

PETER PAUL RUBENS
Isabella Brandt
British Museum

work as an end in itself open to enormous exploitation for its dramatic and emotional possibilities.

The French and Spanish Schools are more modestly represented, with the notable exceptions of Claude and Watteau, both more completely represented here than anywhere else. The collection of some 50 Watteau drawings is one of the two finest in existence.

The present age is one which demands swift and comprehensive access to everything. It does not easily accept the distinction between 'people' and 'scholars', challenging it with increasing frequency on behalf of an educated and articulate public. It does so, moreover, in the realm of fine art, with the added justification that the perception of beauty by the eye has a validity quite distinct from scholarship.

As Sir John Pope-Hennessy wrote in his Introduction to the general guide to the British Museum, in 1976, 'From the time that curiosities were first assembled, it was assumed that the purpose of collecting them was to assuage curiosity.' The British Museum grew out of that tradition of the seventeenth and eighteenth centuries in Europe, in which no clear distinction was made between different categories of objects, and no special premium placed on interest in the fine arts.

Satisfying that curiosity, which should have become easier, has in fact become more difficult. There are many more people with the time, the education and the inclination to be curious; there are vastly more objects to be curious about; and even with new galleries, and the redistribution of collections, the space, the facilities and the curators for bringing people and objects together are insufficient for the task. (See also entry in Gazetteer.)

THE VICTORIA AND ALBERT
MUSEUM

If the British Museum has retained, into the twentieth century, something of the order and discipline of the eighteenth century, as well as a certain measure of the exclusiveness which was normal then, the Victoria and Albert Museum (the V & A) is surrounded equally strongly by the odour of nineteenth-century educational, instructional and utilitarian zeal inseparable from the motives which brought it into existence.

It was set up to be a decorative art museum. Fine art was marginal, not central. It is today the greatest decorative art museum in the world. Fine art is less marginal, as a result of the process of collecting, which inevitably takes on a life of its own. To some extent that life has taken over from the stricter rules about purpose and direction which were observed in the museum's early days. The results, over a period of more than a century since its foundation, have been astonishing.

Indeed, the fine art collection is a truly magnificent one. In addition to the prints and paintings housed in a department run on lines similar to those followed in the British Museum, the V & A has a splendid collection

of paintings as well. Perhaps not unrelated to the decorative art emphasis in the museum, sculpture is also strongly present.

What is much more complicated is the degree to which the very nature of the collection at the V & A places severe strain upon the definitions which are at the heart of this book. In a museum founded around the idea of the important relationship between art and manufacture, the central idea must be that of making art serve a utilitarian, decorative, or design purpose. In this, it ceases to be fine art, and becomes applied art. Yet it does so at such a high standard, and so widely, that it seems almost brutal to set aside the majority of works in the museum, concentrating only on painting, sculpture, prints and drawings.

Before doing so, however, something has to be said about the evolution of the V & A, since it is central to the more general story of this book, and to the historical evolution of museums and art galleries. Many of the collections dealt with later were formed using the V & A as their model. This is much more so than, for example, those which copied the British Museum. In this sense the British Museum was seen, from the start, as having a unique purpose as a repository of artefacts reflecting, if possible, the whole of civilisation. There was no possibility of this fundamental principle being repeated in these islands, and therefore every other museum, when and if it echoed the guidelines established by the British Museum, did so in a qualified way, specialising either as to period, subject, or range.

From the start, the approach adopted by the V & A was a didactic one, and this in turn meant that it intentionally spread its purposes, and even its material. It was established deliberately to set examples, and the fact that it also became the greatest decorative art museum in the world should be recognised for what it is: an incidental rather than a central achievement. That this is a contentious point is borne out by the fact that the museum has alternated in its attitude to the display of its collections, between its recognised first principle—that it was there to stimulate the craftsman and manufacturer—and the more general decorative museum function of displaying, attractively, and in chronological arrangements, the best and most interesting of its possessions, and to a wider public than that made up from those who were expected to learn better design and better technique from what they saw.

The Victoria and Albert Museum was not so named until 1899, when Queen Victoria laid the foundation stone of the Aston Webb building, completed in 1909. It was her last major public ceremony, and at it she referred to the museum as 'a monument of discerning Liberality and a Source of Refinement and Progress'. The museum's genesis, opening, and early expansion had spanned the whole of her long reign. The idea for it grew out of the parliamentary select committee on arts and manufactures, set up in 1835, which led to the founding of the London School of Design in 1837, followed by provincial schools of design. A library and a collection, mainly of casts, were started, as well as more commercial ventures, one of which was Felix Summerly's Art Manufactures, which involved Henry Cole, 1808-82, who was to become the museum's first head, in bringing together artists and manufacturers in joint ventures aimed at improving industrial design. Cole was subsequently appointed by the Prince Consort

to the board organising the Great Exhibition of 1851, and it was this which gave the major incentive for future development of the museum.

The outstanding success of the Great Exhibition led to an attempt to buy from it a selection of objects which was then to go to the making of a decorative art museum. Cole was the moving spirit in this. It was a focus for rivalry between Government and Crown, between Palmerston, who was then Chancellor of the Exchequer, and who consistently refused the money needed for the purchases, and Prince Albert, who equally consistently supported the proposed venture and supported Cole, his nominee, as well.

Henry Cole had the difficult task of organising a museum and assembling a collection for it at more or less the same time. The museum's first permanent home was at Marlborough House, given by Queen Victoria. It was under the Board of Trade, and it was called the Department of Practical Art. Cole was its head, assisted by Richard Redgrave, the painter, who was Art Superintendent, which meant that he was head of the Art Schools, and by John Charles Robinson, who became the museum's curator. Redgrave was later to become Surveyor of the Queen's Pictures, and, as we shall see, 'deserves without question to be enshrined in the annals of the collection as its greatest and most admirable servant' [Oliver Millar; *The Queen's Pictures*, London, 1977, p. 189]. As far as the V & A was concerned, however, the main burden of working out its destiny fell on Cole's shoulders, aided by Robinson. And by the time the museum opened at its South Kensington permanent site, then on the fringes of London, in 1857, Redgrave had taken on the additional and massive task of cataloguing the royal collections, which gave an honorary status to his position within the South Kensington Museum, as it was then known.

The collection of paintings at the museum dated from the same year, 1857, when John Sheepshanks, 1787-1863, a cloth manufacturer from Leeds, gave his collection, mainly of works by British artists, to the nation. He wanted them to be in 'an open and airy situation'. He had been a generous patron and friend to a number of living artists, among them Redgrave, as well as Wilkie, Mulready, Frith and Landseer, and he had also been both a friend and a keen collector of John Constable, at the sale of whose works, after his death, Sheepshanks bought the magnificent *Salisbury Cathedral*.

The museum was to become the greatest Constable museum in the world. In 1887 it received a gift from the artist's only daughter, Isabel, of some 390 works, and further works came a year later when she died. Constable works came later from the Rev. Henry Vaughan, who also left Turner watercolours to the National Galleries in Dublin and Edinburgh.

The V & A had a built-in buying policy from the beginning. Indeed, that policy preceded the establishment of the museum. A committee was set up, following the Great Exhibition of 1851, with the task of purchasing exhibits from it which would be the nucleus of a museum of manufactured objects. Five years later, after the successful Paris Exhibition, Henry Cole was instrumental in organising what must have been, for its day, a truly massive acquisition, the Soulages Collection shown there. Even this was

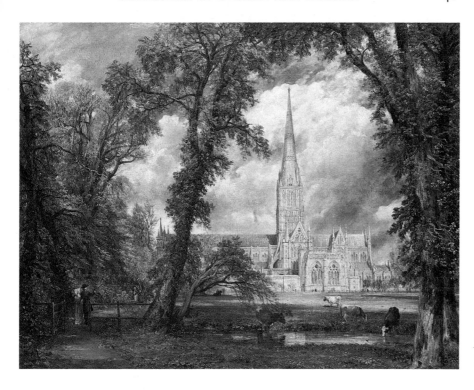

JOHN CONSTABLE
Salisbury Cathedral
Victoria and Albert Museum

controversial, stoutly opposed by the then Chancellor, and in the end bought on the instalment plan by the ingenious Cole.

Basic principles were deliberately distorted, and at an early stage. The purchase by Robinson of the Spanish altarpiece of *St George* (attributed to Marzal de Sas) in 1864 in Paris, could hardly be justified on utilitarian grounds; yet it helped to establish that breadth of content which is the chief glory of the museum. It emphasises, however, the dependence of the V & A on bequests for its fine art collections. Although the museum collected paintings until 1908, when the Tate Gallery was founded, it was not a major objective. The importance of the various gifts is therefore considerable. With the original gift by Sheepshanks of his collection of 233 oil paintings, there came almost 300 watercolours, which formed the foundation for the magnificent collection now owned by the museum. A fine collection of watercolours came from the Rev. Alexander Dyce, whose main interest was literature—he edited Elizabethan and Jacobean writers—and whose library also came to the museum. His watercolour collection included excellent examples of eighteenth- and nineteenth-century British watercolours as well as Old Master drawings.

George Salting, who died in 1909, left works to the National Gallery, the British Museum and the V & A. There was intense dispute over the destiny of his collection of miniatures, which eventually ended in legal action, and a judgement in favour of the V & A, which thereby received the nucleus for its superb collection.

The most famous miniature is undoubtedly Hilliard's *Young Man Among the Roses*, not just the epitome of Elizabethan Courtly Love but of English

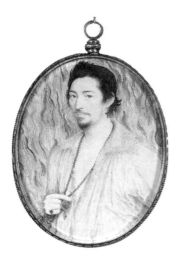

NICHOLAS HILLIARD
*Young Man Against a Background
of Flames*
Victoria and Albert Museum

Renaissance art at its finest. It is one of nine miniatures by Nicholas Hilliard in the collection, which also includes *Young Man Against a Background of Flames*.

Much rarer is the Hans Holbein of *Anne of Cleves*, painted around 1539. It was commissioned to allow Henry VIII some knowledge of his prospective fourth wife's looks. This was an important early practical function of portraiture, an element of some significance in the sometimes protracted negotiations for marriage.

The full collection, of which the original Salting Bequest forms only a small if vital part, is very extensive indeed, and rich in all periods. With the possible exception of English watercolours, it is the most complete of all the fine art collections in the V & A, and the best public collection in the world of an art form which British artists, among them the followers of Nicholas Hilliard, but including such accomplished innovators as Samuel Cooper, raised to world supremacy. The miniature rivals the watercolour as the paramount British contribution to western art.

No easy summary can be made of the fine art in the V & A. The supreme examples of applied or decorative art which are to be seen in every room, and in so wide a variety of art forms used in altarpieces, reliquaries, copes, tapestries, jewellery, crosses, plateware, furniture, ceramics and glass, and deriving from many different cultures, challenge the fundamental definition used in this book more substantially than any other museum considered. Yet it is precisely for this reason that the V & A has been taken as the third and most modern example of museum development, including a fine art component of significance.

From this huge resource, built up through gift, bequest and purchase, it is possible to single out examples of fine art from Renaissance Italy to the twentieth century, by artist, period, school, country, style, medium, and technique. Since this is the way the museum is used in any case, and is indeed the correct way of approaching its riches, it is not inappropriate to view the fine art in the same way.

Italian Renaissance art is richly represented in sculpture, the museum owning several works by Donatello in bronze, marble and terracotta, as well as works by his followers. There is a Michelangelo red wax model, the splendid *Shouting Horseman*, by Andrea Riccio, also acquired from the George Salting Bequest, and the magnificent Bernini bust in marble of *Thomas Baker*, dating from the beginning of the seventeenth century. From the Della Robbia family to the sculptures of Rodin the museum is extremely well endowed, with of course both earlier and later works.

British sculpture at the V & A should not be overlooked. Works by the alien-sounding Roubiliac, Rysbrack, Scheemakers and Nollekens, may well indicate the sources of early inspiration, but belong unquestionably to a very English tradition in the eighteenth century which produced such masterpieces as Roubiliac's bust of *Handel*, and Rysbrack's of *Newton*. Comparable examples are to be found of the work of continental portrait sculptors.

The Raphael cartoons represent important, if from our point of view somewhat ambiguous, examples of Italian High Renaissance art. Raphael

was admired greatly at the time of the foundation of the V & A for his contribution to design excellence in his ornamental work, and the cartoons, in the strictest sense, are applied art, part of the process by which the Sistine Chapel walls were to be decorated, on ceremonial occasions, with tapestries woven in Belgium. The tapestries are still preserved in the Vatican. Seven of the ten designs were acquired by Charles I and survived the sale of his collection after his execution. In the 1850s Robinson, at the museum, was offered copies but turned them down. Queen Victoria then lent the originals from Hampton Court, and they have remained in the museum's care ever since. They have a dramatic freshness and splendour of composition which make them one of the museum's great treasures.

European painting, from Botticelli to Degas, is covered in the museum, at times unevenly, but with a richness that is still overwhelming.

It was recognised, very early on, that the original concept of a museum aimed at the marriage of art and manufacture, and relying on the acquisition of modern examples of excellence in design, would have to be expanded to cover design of all periods. Almost as early came the intrusion, if that is the right word, of fine art, with the generous bequests of paintings and drawings. As the nineteenth century progressed, interest in antiques for the rarity value took possession of certain keepers, and further digression of energy and resources multiplied the objectives of the museum, with the result that its sense of purpose was weakened.

By the beginning of the twentieth century much of the clarity of thought

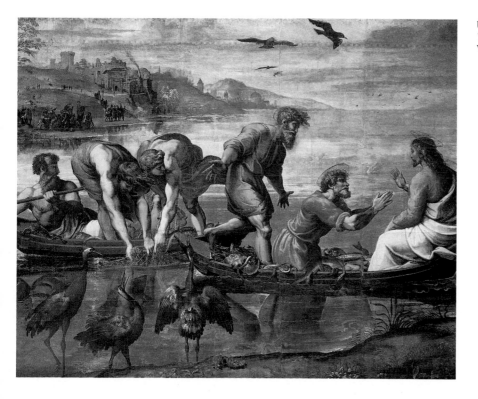

RAPHAEL.
The Miraculous Draught of Fishes
Victoria and Albert Museum

and sheer enthusiasm that had gone into the development of the V & A were lost, and the museum entered on a period of stagnation, further exacerbated by the two world wars, raising, as they did, economic, social and political barriers to development and expansion. Nor were the two intervening decades easy ones. During the 1920s and 1930s museums generally were viewed either with suspicion or that vague insouciance epitomised in Anthony Powell's *Afternoon Men*. This, in turn, led to a fundamental opposition to change, negative and stultifying in its impact.

In the last fifteen years, through the enthusiastic use of exhibitions and effective public relations, as well as adroit playing of politics, the situation has been fundamentally reversed, with the numbers of visitors to the V & A, in common with those generally to museums and art galleries, soaring to unprecedented heights, and with the general public image of the service to the nation performed by such institutions revolutionised. In addition, substantial funds have been made available for purchases, and the important involvement of business and industry in exhibitions and other promotions has been achieved as part of the replacement of the benefactors who played so important a part in the nineteenth century.

Definitions have inevitably been blurred. A stylish interest in bringing people in and entertaining them, at no matter how high an intellectual level, in a world where design consciousness no longer requires the services for which the V & A was originally founded, raises complex questions about what will happen in the future.

3

The Development of Public Collections

———— THE NATIONAL GALLERY ————

The historical development of art galleries throughout the British Isles was dictated by a number of forces, some general to all of them, some related specifically to circumstances which arose in individual cities and towns. Considerable public attention had been focused in the eighteenth century on the need for public galleries, or at least for the public display of pictures. And from the 1740s on, London auction rooms were sufficiently popular to require constables to keep people out, particularly the poor; artists sent their pupils there to see notable works of art; there were no other places for the public display of paintings or works of sculpture.

Such exhibitions as there were—for example the one at which Hogarth and other painters of his time gave works to be shown on behalf of the Foundling Hospital (now the Thomas Coram Foundation, q.v.)—were thronged, though with fashionable visitors on the whole. Certain exhibitions ended in chaos. The Society of Arts, in 1760, made their premises available to a group of painters on the condition—which was strongly opposed by the artists themselves—that the pictures should be shown free of charge for certain periods of time. Though consistent with the Society's objectives, which included the encouragement of the fine arts, this resulted in near riot conditions.

There were a number of attempts in the second half of the eighteenth century to persuade the State to establish a national collection of paintings. The politician John Wilkes, caricatured in earlier life by Hogarth, was active at the time of the proposed sale of the Houghton pictures by Robert Walpole's indigent grandson, in proposing a scheme whereby they would be bought and housed in a gallery in the grounds of the British Museum. And the idea, both for a national collection and for a place for its display, was actively pursued from then on, notably by James Barry and by the dealer Noel Joseph Desenfans, whose paintings eventually formed the first public collection, at Dulwich Picture Gallery (q.v.). Desenfans argued for such a course in a book published in 1799.

Internationally, the main capitals of Europe were well ahead of London in the establishment of 'national' galleries; Vienna had a gallery as early as 1781, Paris in 1793, Amsterdam in 1808, Madrid in 1809, and Berlin in 1823.

As already stated, the first collection to be made available to the public was the Dulwich Picture Gallery. This opened in 1814, though the works of art had mainly been acquired before 1800. The detailed story, leading to the largely accidental presence in south-east London of such a lovely group of pictures, is related to the collecting upheavals which went side by side with revolution and war in Europe between 1789 and 1815, and which were to revolutionise trends and habits during the nineteenth century, as far as art and its dispersal were concerned.

That a public art gallery emerged from this was abnormal. Essentially, the massive movement within the whole of Europe of works of art, with Britain taking over as the centre of the business—a pre-eminent position never subsequently lost—was a private manifestation, involving dealers and collectors. Public access to works of art, even to a limited extent, still less the acquisition of works of art on behalf of the public, were far from being established objectives of the State, or of any private bodies or individuals. And as for artists, their primary aim was to attract the interest of buyers or patrons.

In embryonic form a 'national gallery', displaying Old Master paintings, and allowing for free access, did emerge with the founding of the British Institution, which followed its first exhibition of modern, British art, in 1806, with the setting up of a School of Painting which displayed for the general public the collection of paintings acquired as teaching aids. A number of major exhibitions of Old Master paintings followed, and the process served an important function in raising both expectation and demand for a permanent State Collection of paintings. Subsequently a majority of the British Institution works went to the National Gallery.

The Gallery's foundation dates from 1824, when the Government provided £57,000 for the purchase of the Angerstein pictures, 38 works of art collected by John Julius Angerstein, a financier and Lloyd's underwriter, whose death the previous year put the collection on the market. Perhaps the nucleus of a national collection based on so small a group of works, and of such excellent quality, set an initial tone of discrimination for subsequent acquisitions.

The Angerstein Collection contained no early Italian paintings, and nothing from the early Netherlandish or German Schools. The most highly prized work at the time, at £8,000 valued at twice the price of any other picture, was the huge Sebastiano del Piombo's *The Raising of Lazarus*, painted in Rome between 1517 and 1519. Raphael was represented by the portrait *Pope Julius II*, the Pontiff who commissioned Michelangelo to paint the Sistine Chapel ceiling, as well as commissioning the Raphael decorations in the Vatican. Other Italian artists included were Correggio, Annibale Carracci, Domenichino, and Titian.

One of the most beautiful Rembrandts in the National Gallery, *The Woman Taken in Adultery*, was in the Angerstein Collection. This work was offered to Napoleon by the dealer Lafontaine, for the Musée Napoléon,

Opposite: SEBASTIANO DEL PIOMBO; *The Raising of Lazarus;* National Gallery

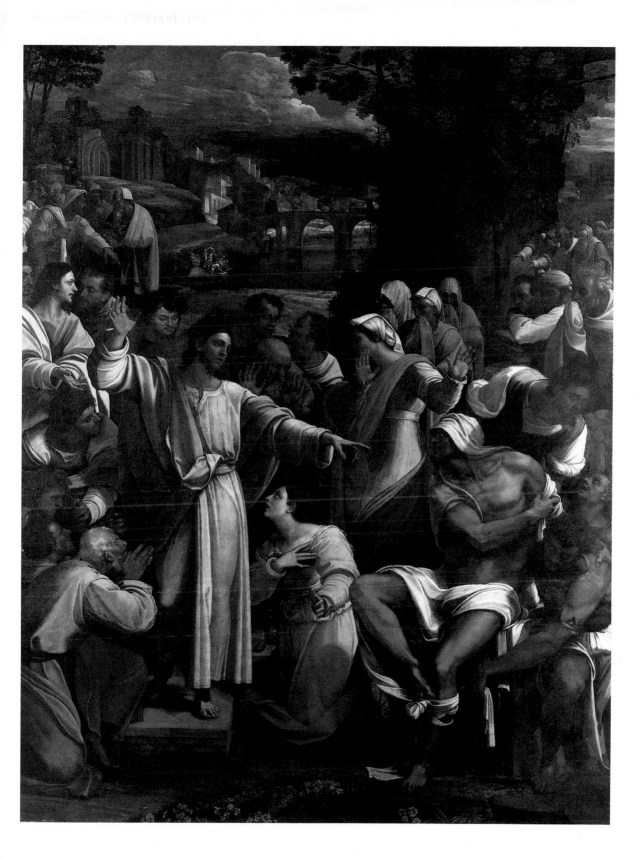

but he refused to pay the sum asked. It was then brought to London, and sold for five thousand guineas. There was also a Nativity, *The Adoration of the Shepherds*, by Rembrandt. The magnificent Claude, *The Embarkation of the Queen of Sheba*, was included, and there were works by Cuyp, Van Dyck, Velázquez and Rubens.

Angerstein had also collected English painting, so that the National Gallery, from the start, had works by Reynolds, Hogarth and Gainsborough as well as Wilkie's *The Village Holiday*, now at the Tate Gallery. The Hogarths included the series *Marriage à la Mode*.

It was the British Government's view that the honour bestowed on the Angerstein family, by the acquisition of the collection as a nucleus for the National Gallery, should lead to 'more liberal terms than if they were sold in any other manner'. The Government tried an offer of £50,000. The Angerstein price was £60,000. The Government accepted an independent valuation of £57,000, and the final figure authorised was £60,000, to include certain administrative costs. Angerstein himself had put as his lowest valuation £76,000.

The main emphasis in the development of the National Gallery in the early years was on finding the right premises. By 1834 it was necessary to move to 105 Pall Mall, although by then the Government had decided to build a gallery on the north side of what was to become Trafalgar Square, near Charing Cross. The architect was William Wilkins, and the foundation stone was laid in 1833. The first part of the building, for the Royal Academy, opened in 1837, the Gallery itself in 1838.

With the opening of the Gallery, in 1824, it would be nice to imagine that the forces for change would lead to other public galleries at a fairly rapid rate. Not so. In spite of the many different influences which had been at work, before, during and after the Napoleonic Wars, and which were to lead to revolutions in the visual arts, affecting the teaching of art and the collecting and display of paintings and sculpture, real progress over making works of art available to the public was slow. From 1824 until the Great Exhibition of 1851, which inspired so much action in the museum and art gallery field, the practical outcome of all the debate and discussion was that the Sir John Soane Museum, in Lincoln's Inn Fields, and the Fitzwilliam Museum in Cambridge, opened to the public.

The evolution of taste provided an intellectual foundation for what did happen. It was a cumulative aesthetic and philosophic phenomenon, concerned with ideas about what we like in art, and why. Since the early eighteenth-century philosophers such as Edmund Burke and Denis Diderot had set in train a variety of examinations of the force of art on human behaviour and attitudes. It led, in the nineteenth century, to the wisdom of men like Hazlitt being applied more directly to the conjunction of people and works of art in the public galleries. And he was quite caustic in his treatment of this situation, emphasising the glibness with which the gap between genius and understanding was so often bridged.

There was also a sizeable literature on more practical matters, such as the better preservation of artefacts, and their presentation.

The nineteenth century brought a political dimension which was given further impetus by the spirit of reform. Elections which preceded the 1832

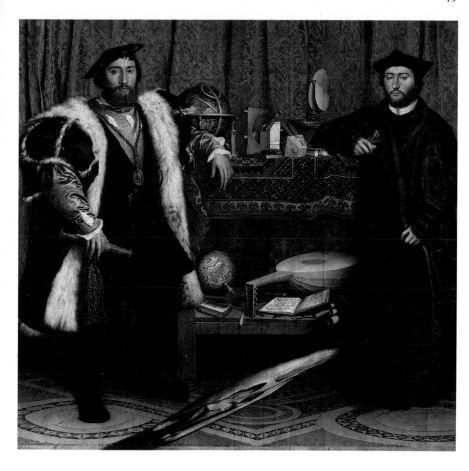

HANS HOLBEIN
The Ambassadors
National Gallery

Reform Bill had brought into Parliament in greater strength an evangelical, reformist faction. The idea of State intervention aimed at improving the conditions generally in which the mass of people lived became—comparatively speaking—less authoritarian, more democratic. Though the product of a deeper political force and instinct than this, Robert Peel, a prime mover, under Lord Liverpool's Government, for the setting up of the National Gallery, saw both moral and commercial benefits; better design, as well as better behaviour and better taste, would derive from great works of art being made permanently available to the people as part of a public service.

At the time of the Angerstein purchase the State had already been offered a group of Old Master paintings by the artist George Beaumont, on condition that a gallery be built to house them. The pressure of generosity is only moderately persuasive. Many other galleries and museums, which subsequently came into existence in the British Isles, have similar stories of works of art being offered on condition that places be provided to house them, the Burrell Collection in Glasgow (q.v.) being an interesting modern example. Beaumont was motivated by a powerful combined instinct for taste and for the moral improvement of people by means of art, as well as by the sheer love of painting, and, it should be said, of

JOHN CONSTABLE
The Haywain
National Gallery

artists themselves, for he was a painter, a collector and a friend of contemporary painters.

An evolutionary stage in the function of 'good taste' is readily discernible here, as taste becomes, or at least is seen to be, a force for public good. Buying paintings and putting them on show was an obvious means by which the State could become a direct influence for the public good. The ever increasing dissemination of art to the ordinary public during the nineteenth century had moral and social purposes aimed at improving the general lot of people. By contrast, the eighteenth century had been cóncerned merely with the acceptance of art, among a limited and wealthy section of the population, as a private encouragement for good judgement, education, intellectual and spiritual feeling, or 'sensibility', but without the dimension of public benefit.

It was by no means a universal attitude. As late as 1834, when the National Gallery had been in existence for a decade, the question of the purchase, for the collection, of Thomas Lawrence's unparalleled collection of Old Master drawings met with a stony response from the Chancellor of the Exchequer, Lord Althorp, whose view was that the National Gallery itself should be sold.

Robert Peel, who became Prime Minister in that year, but who had been an active reformist figure who believed in the public value of art, was himself a very considerable collector, mainly of Dutch paintings. He belonged to the older generation, as far as taste was concerned, advising, in respect of the National Gallery, 'I think we should not collect curiosities', by which he meant paintings executed before 1500.

Additionally there were market considerations. England, virtually throughout the nineteenth century, was the richest and most powerful

nation in the world. She became so only after the Napoleonic Wars. Well before the emergence of Bonaparte, however, the revolution in France had released on to the market large quantities of art and had set in train its movement from place to place in a way that the subsequent decade and a half of European war greatly extended.

At one level it was plunder of an unprecedented kind. In Napoleon's eyes, no less than had been the case with countless predecessors, art was an adjunct and an extension of his power and glory. Its direct plunder was to be taken as one of the rights of conquest. To escape such depredation, great owners of great collections either sent them to Britain for protection, or disposed of them to British collectors. Britain became, in the early nineteenth century, the centre of the world art trade, and has remained so ever since.

It has been estimated that, by the 1840s, at least 10,000 Old Master paintings were being imported into Britain each year. They reflected, in artists, subject matter, and their general quality, a distinct collecting conservatism. It was still only the discriminating who either went after the early Italian primitives or the more eccentric areas of collecting such as Egyptian or Greek works of art.

J.M.W. TURNER
The 'Fighting Téméraire'
National Gallery

The expanding market, possibly combined with other changes in attitude, gave rise to a dealer different in kind from the private 'agent' who had acted on behalf of individual collectors throughout the seventeenth and eighteenth centuries. Taste still dictated that the wealthy landowners should continue to purchase the kinds of paintings which their fathers and grandfathers had acquired on the Grand Tour. But though the works were similar, history and war had changed the manner of their accquisition.

Typical of the nineteenth-century dealer was William Buchanan. He was patriotic, scholarly, informed, and had some of the social commitments which inspired politicians and other public figures involved in the improvement of public taste. He was an active campaigner for the establishment of the National Gallery.

There were other influential people, too, among them George IV, a strong supporter of the acquisition for the nation of Angerstein's collection, and Thomas Lawrence, one of England's greatest artist-collectors, who advised the Angerstein executors. The growing pressure from all sides gave rise to Parliament's provision of the very substantial sum required. The money derived, in part, from the Treasury windfall of the repayment of two Austrian loans dating from the early years of those wars.

Finally, there was the Royal Academy. Its role in the nineteenth-century process by which treasure-houses of art were created and made available to the public generally, is marginal rather than central; it is also, to some extent, a negative one. In the early Victorian era it stood for élitism, not just in terms of the artists who were members, but also in terms of the Establishment, which represented its main patrons. And throughout the early years of the National Gallery's development, between 1824 and the early 1850s, minor upheavals and confrontations between the Gallery and the Academy punctuate the period.

The RA and the new National Gallery were rivals, inextricably entwined. It was a four-way involvement, at the very least, of Crown, Parliament, Gallery and Academy, and it was governed, generally, by suspicion and fear. Fundamental rights, questions of property, the services to art of the artists and of the State, were all invoked in the successive rows which are part of the history, both of the Academy and of the early years of the National Gallery.

It was a rivalry between privilege and obligation. Artists, patrons, buyers, collectors were, with honourable exceptions, ranged on the side of a privileged view of the ownership and display of works of art. And though men in the same categories were also on the side of the general public, they had a hard time of it.

As well as seeing itself as an organisation aimed at protecting and advancing the professional fortunes of its members, the Royal Academy saw a role in the teaching and education field for which it needed, and acquired, major works of art. It jealously guarded these treasures, just as it guarded what it saw as its royal prerogatives.

In his inaugural discourse, in January 1769, Sir Joshua Reynolds claimed for the Academy a role as 'a repository for the great examples of the Art', and though he saw this in terms of the educational environment for

practising artists which was inextricably part of the Academy's purpose, he set in train two distinct forms of acquisition, that of the works of members, and that of Old Masters. The Academy possesses, for example, the only Michelangelo marble in the British Isles, his *Madonna and Child with the Infant St John*, also known as *The Taddei Tondo*. It was one of the works of art owned by George Beaumont, but not included in his offer for a national gallery collection. It was left to the Academy by Beaumont's widow. Without this collecting principle, the State, two centuries later, would not have come into possession of the Leonardo da Vinci cartoon, *The Virgin and Child with St Anne and St John the Baptist*, now in the National Gallery. No doubt the State, in due course, will be obliged to find the cash to buy the Tondo as well.

The central conflict, however, was about the building of the National Gallery in Trafalgar Square. The Royal Academy claimed that it had rights to rooms provided by the Crown, and these rights, asserted by the President, Sir Martin Archer Shee, were acknowledged by Parliament. The east wing of the new building was allotted to the RA. There was a practical reason for this, in addition to the fact that it allowed the move from cramped quarters in Somerset House; the students of the Royal Academy schools would have the works of art belonging to the nation next door for study.

Parliamentary criticism of this royal and privileged institution coincided with the building of the Gallery, and provoked considerable unease among artists who for more than sixty years had run the only permanent and effective national school of art, with the best teachers available, as well as buying and preserving works of art, and exhibiting the paintings, drawings and sculpture of its members. It had done so with the encouragement, and under the protection, of successive sovereigns. The State's performance, in comparison, had been at best laggardly.

Indeed, not until 1855 was any regular grant voted for National Gallery purchases by the Government, and while any discriminatory analysis of the overall derivation of works in the Gallery, as between purchase, gift and bequest, is beyond the scope of this book, there was ample justification for the scepticism with which the Academy—fiercely proud of the degree to which it conducted its affairs in the interests of British art and under the direct patronage of the sovereign—viewed the management of the new developments affecting itself.

Shee obtained a meeting with the Prime Minister, Lord Grey, in order to counteract assertions made in Parliament by Peel, among others, that the Academy could be deprived of its rooms at any time. This was followed by further assaults on its position, and on the extent of its services to art, by the same select committee which was laying the ground for the foundation of a museum (the V & A) which would link art and manufacture. The mood was one of utilitarian and reformist zeal.

This mood was not always linked to positive action, but it did provoke lively criticism of the older art establishment, as represented by the Academy. And politicians were not embarrassed by the relatively modest progress in the management and expansion of the National Gallery. Though the purchase of the Angerstein pictures had set in train the development of

what was to be one of the greatest art galleries in the world, its actual development from 1824 into the 1870s was compromised by political suspicion and bureaucratic reluctance.

Royal patronage still provided a certain amount of protection for the Academy, which was to remain in close physical association with the National Gallery. It was in fact the Academy's east wing which was completed and opened first, in 1837, a year before the opening of the National Gallery in the west wing. The occasion was important, almost symbolically so. The Academy had asserted repeatedly its royal status in the face of parliamentary doubt and criticism, and there was considerable relief when King William IV, in April of that year, came in state to the portico of the National Gallery building in Trafalgar Square to hand over the keys of the Royal Academy's chambers to the President. His death, two months later, deprived the Royal Academy not only of a firm friend, but marked the end of a tradition which went back to the encouragement given to British art and artists by George I and George II. Queen Victoria, and more particularly her Consort, were of a different mind. In keeping with the age, encouragement of the arts was to be of a more utilitarian kind.

From the very beginnings, in 1824, there was controversy over the pictures. The great Sebastiano del Piombo *The Raising of Lazarus*, one of the largest paintings on show in the Gallery, and then the showpiece of the Angerstein Collection, was said by sceptics, on account of the poor condition it had been in when acquired, to be more the work of its restorer, the painter Benjamin West, than of the original artist. 'It was not only dead', said Thomas Lawrence's father, 'but fast sinking into the ground when Mr West was empowered to stand before it and again command Lazarus to come forth.'

In the early days the administrative requirements were limited. In addition to keeper, assistant keeper, 'a respectable person to attend in the two principal rooms', a person for the English pictures, a porter and a house-maid, 'it will be necessary to have coals, candles and a small amount of stationery'.

William Seguier was the first keeper, under a small committee which included Beaumont, Lawrence, Lord Liverpool and Sir Charles Long (later Lord Farnborough). Beaumont and Farnborough were both early bene-factors. In 1834 the Gallery was moved from its first premises, at 100 Pall Mall, to new and larger ones at 105. In 1838 the collection moved to the buildings in Trafalgar Square, which had been started in 1832, and which were to be shared with the Royal Academy.

Charles Eastlake, who was later to return as the first director, served as keeper, followed by Thomas Uwins, and their observations reveal a fairly haphazard approach to acquisition. Then, as now, Government involvement was an aspect of purchasing, for obvious reasons, though there was excessive high-handedness over the purchase of the Kruger pictures, carried out by Gladstone, in 1854, on the advice of the painter William Dyce, but apparently without consulting the Gallery itself.

By the middle of the century there was still controversy about continuing

GEORGES SEURAT
Bathers, Asnières
National Gallery

the Gallery in Trafalgar Square. Alternative proposals were numerous, and controversy was as lively about the site as it continued to be about the contents. The order that followed, albeit slowly, was the outcome of a number of historical events, beginning with the Great Exhibition of 1851.

As already indicated, Charles Eastlake played a significant part in the development of the Gallery. He enjoyed early success as a result of his painting *Napoleon on the Deck of the Bellerephon*, which was exhibited at the Royal Academy in 1815, and from which he derived sufficient fame and fortune to allow a period of painting in Rome. He translated Goethe's *Theory of Colours*, and wrote extensively about art, becoming an early art historian of ability. He also developed administrative and social skills which in time led to the support of the Queen, the Prince Consort and Sir Robert Peel.

He was Director of the National Gallery for ten years, from 1855 until his death, and the standards of professionalism in management, as well as the quality of the collection, were enormously enhanced during this period. He was an able committee man, with a highly developed skill in behind-the-scenes persuasion and manipulation, and enormous resources of energy. Among masterpieces acquired by him was Piero della Francesca's *The Baptism of Christ*.

While it is not possible, and in some cases not desirable either, to put the performance of each director under scrutiny, as far as acquisitions are concerned, it is certainly justified in one other case, that of Sir Frederick Burton, the third Director of the National Gallery, who followed William Boxall in 1874, and held the position for twenty years.

He was responsible for some outstanding acquisitions, among them the 'Ansidei' Madonna by Raphael, Holbein's The Ambassadors, from Lord Radnor's collection at Longford Castle, in Wiltshire, Leonardo da Vinci's Virgin of the Rocks, Tintoretto's The Milky Way and Christ Washing his Disciples' Feet and Botticelli's Venus and Mars.

The major collections, which were either on the market during the period when Burton was Director, or came his way by bequest or private deal, included the Alexander Barker Collection, the Wynn Ellis Bequest, the Hamilton Palace pictures, and the individual works sold by the Duke of Marlborough in 1884. The huge increase in art values is indicated by the figure of £400,000 which the Duke asked for the eleven works chosen from Blenheim for the National Gallery by Burton. He wanted, as well as the 'Ansidei' Madonna, several paintings by Rubens, and Van Dyck's Charles I on Horseback. In the end £70,000 was paid for the Raphael, and £17,500 for the Van Dyck. For the sake of context, these prices should be compared with the modest £9,000 he paid for the Leonardo and the £2,000 paid for Michelangelo's The Entombment.

Burton was helped, as indeed were the owners, by the Settled Land Act of 1882, which made possible the sale of both land and chattels previously in trust. Combined with the impoverishment of large estates through the decline in agriculture during the 1870s and 1880s, a new market opened up which in due course was to lead to Duveen's expansive art dealings, and the flow of works of art to America. Inflation in art prices had been a phenomenon throughout the period of Burton's directorship, and it was no longer possible, as it had been during previous periods, to buy whole collections. The 77 paintings in the collection of Sir Robert Peel, many of them outstanding, had been bought in 1871 for £75,000, not much more than was paid for the single Raphael fifteen years later.

From 1855 there was an annual Government grant. This rose to a ceiling of £10,000 during the nineteenth century, but by 1921, the beginning of a black period for museums and art galleries, it had been reduced to £5,000. It was supplemented by the income from bequests, of which there had been several of substantial size between the £10,000 in 1863 from Thomas Denison Lewis, and the same figure in 1916, given by Henry L. Florence. The largest was probably that of Colonel Tempest West, in 1907, of £99,909.

In the early stages, the £10,000 annual grant, which followed the 1853 Royal Commission (see earlier chapter on the V & A), was sufficient to cover such important purchases as the Lombardi-Baldi Collection, bought for £7,035 during Charles Eastlake's directorship, in 1857. But Sir Robert Peel's collection, mainly of Dutch paintings, and bought in 1871, required a special grant from Gladstone's Government. And in 1885 Lord Salisbury's Government gave all of the £87,500 for the purchase of the Raphael and

Van Dyck's *Charles I on Horseback*. A further £25,000 of Government money was given towards the Longford Castle purchase, in 1890, when £55,000 was needed, the balance, of £30,000, coming from Lord Iveagh, Charles Cotes, and de Rothschild.

Further Government grants made possible the purchase of the Saumarez Rembrandts, the Cobham *Ariosto*, and a group of paintings by Frans Hals.

In the early twentieth century, the National Art-Collections Fund became a major benefactor, ensuring that *The Rokeby Venus*, by Velázquez, Holbein's *Christina of Denmark, Duchess of Milan*, and the *Madonna and Child*, by Masaccio, remained in Britain.

The National Gallery is one of the great public collections in the world, and the leading art gallery in these islands. It is one of the most representative of all such collections, often prodigiously rich in examples from every school. In world terms it is one of the smallest, having only something over 2,000 works, but virtually all of these are always on exhibition. More than half of them came as gifts or bequests. Its collection is also virtually confined to oil paintings and tempera. It does not possess works of sculpture, drawings, prints, or other original material.

—— AN OUTLINE CHRONOLOGY ——

A brief chronological outline here of the main museum and art gallery developments from the foundation of the National Gallery through the first half of the nineteenth century to the present day will provide a useful framework for the later, more detailed consideration of individual collections.

As we have seen, the Victoria and Albert Museum followed immediately after the Great Exhibition, opening first at Marlborough House in 1852, then as part of the South Kensington Museum in 1857, but only being given its main building at the very end of the century.

Next followed the establishment of three major 'national' collections. In 1856 came the National Portrait Gallery, which, from modest beginnings, has become a uniquely important specialist collection, its art ostensibly secondary to its historic function as a visual record of great men and women, establishing a principle to be followed by other galleries. In 1859 the National Gallery of Scotland opened to the public, nine years after the Prince Consort had laid its foundation stone. And in 1864, ten years after the Act of Parliament which established it, the National Gallery of Ireland opened.

The first of the great municipal galleries, the Birmingham City Art Gallery, followed in 1867, and then, from 1870, galleries in a steady stream were founded or were opened to the public by municipalities, often under varying degrees of public pressure or because of the existence of collections of works of art which had been given or were on offer. Exeter in 1870, Bethnal Green, as an extension of the V & A, in 1872, Brighton in 1873, Dundee in the same year, and then, in 1877, another of the great galleries

of the British Isles, the Walker Art Gallery in Liverpool. This was followed by Nottingham in 1878, the year before the Shakespeare Memorial Theatre at Stratford, with its art collection, opened to the public. York in the same year completed the tally for the 1870s.

The beginning of the new decade saw the gallery in Ipswich founded. Two years later, in 1882, the third of the great municipal galleries, the Manchester City Art Gallery, opened, the same year as the Holburne of Menstrie Museum in Bath and the Harris Art Gallery in Preston. In 1884 came Wolverhampton, in 1885 Leicester and Aberdeen, in 1886 the Guildhall Art Gallery in London, and the Royal Holloway Collection, also in Greater London. Leeds City Art Gallery opened in 1888, and the Whitworth Art Gallery, in Manchester, the following year, when the Scottish National Portrait Gallery also opened in Edinburgh, a further extension of Scotland's 'national' galleries, to which, seventy years later, the Scottish National Gallery of Modern Art would be added.

The 1890s saw the establishment of galleries in Bolton and Belfast, both in 1890, the latter eventually to become a provincial collection, perhaps 'national' as well. In 1892 the Bowes Museum and Art Gallery opened, one of the earliest collections by an individual to become, and remain, a public collection. In 1894 the Russell-Cotes Museum in Bournemouth and the Norwich Castle Museum were founded.

In 1897 a national collection of modern art became a reality with the opening of the Tate Gallery in London. And in 1900, with the Wallace Collection, Britain's greatest private collection became the property of the nation.

Glasgow City Art Gallery was founded in 1902, the Cartwright in Bradford in 1904, the Laing Art Gallery in Newcastle-upon-Tyne in 1904, and Bristol City Art Gallery and Museum in 1905.

In 1903 one of the earliest of the galleries devoted to the works of a single artist was opened by the wife of George Frederick Watts as a commeration of his work. It is outside the village of Compton, in Surrey.

In 1908, after a difficult and at times bitter struggle by one of the great benefactors of modern art, Hugh Lane, Dublin established its Municipal Gallery of Modern Art. The Glynn Vivian Art Gallery in Swansea followed in 1911, the National Museum of Wales in Cardiff in 1912. In the same year the London Museum opened. In 1914 Barnsley acquired the Cooper Art Gallery, and in 1917 the only public art gallery or museum to be opened during the First World War started at Gateshead.

Appropriately, the first new art gallery after the war was the Imperial War Museum, at the Crystal Palace, in 1920, following a decision in principle made well before the end of the war, in March 1917.

In 1922 came Lord Leverhulme's magnificent memorial to his wife, the Lady Lever Art Gallery, in Port Sunlight. Civic collections followed in Kirkcaldy, in 1925, and in Lincoln, in 1927. In the same year Lord Iveagh's collection at Kenwood was opened to the public, giving London another great collection. In the following year the Williamson, in Birkenhead, was founded as well as the Pannett Art Gallery in Whitby.

Almost unbelievably late for a maritime nation, it was not until 1937

that the National Maritime Museum was established at Greenwich, a further piece in the complicated jigsaw of great 'national' specialist collections. Then, just before the Second World War, came three important collections: the Barber Institute of Fine Art in Birmingham, the Bolton Art Gallery, and the Southampton Art Gallery.

The 1940s saw the start of the Sudley Art Gallery in Liverpool (1944), the Cecil Higgins Art Gallery in Bedford, in 1949, and the Berwick-on-Tweed Gallery in the same year. In 1952 the Wellington Museum, at Apsley House, opened under V & A administration; and in 1958 the Courtauld Institute Galleries, though parts of the collection had been available since 1931.

The Scottish National Gallery of Modern Art dates from 1960, as does the Herbert Art Gallery in Coventry. In 1962 the Stanley Spencer Gallery opened in Cookham, and in 1967 the Stirling Maxwell Gallery in Glasgow.

Coming almost up to the present day the Burrell Collection, outside Glasgow, opened in 1983, almost forty years after the gift of the collection to the City of Glasgow.

The most important recent public art gallery is the 'Tate in the North', the modern art gallery opened in 1988 in Liverpool which displays modern works from the Tate Gallery collection in London.

This chronology is important in a number of ways, not least in direct relationship to the character of the collections in public ownership. There is no doubt that the establishment of the National Gallery, in 1824, quite apart from the magnificent Angerstein Collection which led directly to the decision to vote public money for the venture, led to acquisitions which would not have been possible a quarter of a century later, a fact reflected in the range of works in the next two 'national' galleries, in Edinburgh and Dublin, and the qualitative gap between them and their London prototype.

The enormous nineteenth-century wealth of such cities as Liverpool, Birmingham, Glasgow and Manchester played an important part in the range and quality of their civic collections. So did the lesser expressions of civic or municipal pride elsewhere in these islands, as well as personal, and university, concern for the setting up of art galleries and museums. But the date at which the decision to found or open a public art gallery was made remains a crucial factor. It is to be taken in conjunction with trends, fashions, taste, the availability of works from a given period, the strengths and weaknesses of contemporary British and European art. It is also to be related to the vital factor of collections either being offered free, or becoming available for purchase.

It was this last element that triggered off the National Gallery.

— ART COLLECTIONS IN LONDON —

There are almost sixty places in London in which fine art is on public exhibition. These include eight major national collections: the National Gallery, the National Portrait Gallery, the British Museum, the Victoria

LAWRENCE ALMA-TADEMA
Pleading
Guildhall Art Gallery

and Albert Museum, the Imperial War Museum, the National Maritime Museum, the National Army Museum and the Tate Gallery.

They also include City of London collections, at the Guildhall, the Museum of London, and the Geffrye Museum, as well as the Iveagh Bequest at Kenwood House, the Suffolk Collection at the Ranger's House on Blackheath and Marble Hill House.

Then there are the Royal Collections, including Hampton Court, Kensington Palace, the changing exhibitions at the Queen's Gallery, and all that is left of the splendour of Whitehall Palace, the Banqueting Hall with its Rubens paintings. Strictly speaking, the Palace of Westminster is a royal palace, and the art collection spread through it is a national collection. Its full availability is dependent on the parliamentary process, though many of the works are permanently available to visitors. And there are modest collections in such places as Lancaster House and Marlborough House, inspection of which is dependent on Government functions.

There are a number of collections made by, or related to, an individual; these include the Wallace Collection, the greatest of its kind in the country, the Sir John Soane Museum, which is the most personal, and the Wellington Museum, perhaps the grandest in setting and atmosphere. There are houses connected with artists and writers, among them Hogarth, Dickens, Keats, Evelyn, Johnson and Carlyle.

Specialist collections range from the important works of art belonging to the Royal Academy to the modest collection of the Order of St John.

Fine art in London is dealt with here selectively. Earlier in the book some of the major fine art institutions have already been noted. What follows is a sequence: first, a further group of major national collections; then the most important civic ones; then certain specialist collections as well as those associated with individual collectors, artists, or national figures; finally that part of the Royal Collection which is at Hampton Court Palace, together with a number of collections in houses.

THE TATE GALLERY

The Tate Gallery, like the National Gallery, owes its existence in the first instance to a single private collection, that of Sir Henry Tate, who made his fortune out of sugar brokerage. He was a considerable philanthropist, giving large sums of money to Liverpool University, to hospitals in Liverpool, and, after moving to London, giving four public libraries to Lambeth parish. He collected pictures only towards the end of his life, but met with difficulties when it came to presenting his collection to the nation. The standard of works was not uniformly high enough for the collection to go complete to the National Gallery, and when this handicap was initially offset by Tate's offer of a building to house his collection separately, problems arose about a site. Eventually he offered £80,000, and the Tate Gallery was built on the riverside site of the Millbank Prison, its administration coming under the Trustees of the National Gallery.

The Tate Gallery opened on July 21, 1897. Within two years a large extension was added. The gallery contained 65 pictures presented by Henry Tate. In addition, nearly all the 'modern' British works in the National Gallery—those painted between 1820 and 1880—were transferred. The Royal Academy's Chantrey Bequest pictures went also to the Tate, having previously hung in the South Kensington Museum. And G.F. Watts presented 17 large canvases to the new gallery for British art.

The Tate Gallery was a branch of the National Gallery from 1897 until 1917, concerned exclusively with British art, though for a time certain foreign works were transferred. This was seen as contrary to the terms of Tate's gift.

The twenty-year period which followed the foundation of the Gallery, enormously exciting for modern art generally as well as being a rich period in British art, culminated in a National Gallery report recommending the setting up of a gallery for modern foreign art. The bequest of nineteenth- and early twentieth-century pictures by Sir Hugh Lane, following his death in the *Lusitania* disaster in 1915, was an added impetus, as was Sir Joseph (later Lord) Duveen's undertaking, in 1916, to pay for a series of new galleries at the back of the main Millbank building.

In 1917 the Tate became both the National Gallery of British Art and the National Gallery of Modern Foreign Art, independent of the main National Gallery. Further additions were made to its collections from Trafalgar Square. And the French School of Barbizon paintings from George Salting's bequest to the nation were transferred.

It was a rich foundation in modern art, particularly the superb works bought by Lane, who had an unerring eye, among them the magnificent *Eva Gonzalès*, which Orpen included in his historic work, now in Manchester, *Homage to Manet*, which shows some of the key figures of the period, including Lane himself.

The Impressionist paintings given by Lane included Manet's *Le Concert aux Tuileries*, Monet's *Vétheuil, Sunshine and Snow*, and *Les Parapluies* by Renoir. When not in Dublin, these paintings are in the National Gallery in London, rather than the Tate.

Hugh Lane's example as collector and benefactor inspired Samuel Courtauld, in 1924, to establish a £50,000 fund for the purchase of works by artists on a specified list, he himself serving as one of the trustees of the fund. The artists listed were mainly Impressionist and Post-Impressionist, and among the great modern masterpieces which were bought in the late 1920s as a result of this were *Miss Lola at the Cirque Fernando*, *Vincent's Chair with his Pipe* by Van Gogh, and *Bathers, Asnières* by Seurat, a key work of the modern period, but now hanging, as are most of these works, in the National Gallery.

There were many other benefactors. C. Frank Stoop, for example, a Dutch collector living in London, gave a splendid group of paintings by Braque, Picasso, Modigliani, Cézanne, Degas and Matisse, in 1933. And individual works of importance came from a wide variety of sources. Mrs Wadsworth gave a fine Léger in memory of her husband, the painter Edward Wadsworth. *The Sick Child*, a superb canvas dating from 1905 by the Norwegian Expressionist artist Edvard Munch, was the single gift of Thomas Olsen, in 1939. It had once been in Dresden, but was disposed of by the Nazi regime as 'decadent'.

Montague Shearman gave *The Two Friends* by Toulouse-Lautrec and *The Three Judges* by Rouault, as well as works by Matisse, Sisley, Utrillo and Vuillard. The writer Sir Hugh Walpole gave a Renoir and a Forain in 1941, and Paul Rosenberg bought Braque's lovely *Glass and Plate of Apples* in 1925, only to give the picture to the Tate Gallery the following year.

A combination of artists themselves, of the National Art-Collections Fund and the Contemporary Art Society, and of other bodies, as well as loans like that of Rodin's sculpture from the Victoria and Albert Museum, have all added considerably to the range and quality of the Tate Gallery collection.

This was of the greatest importance, particularly during the period between the two world wars. Between the highly important 1918 purchases at the Degas sale, of works by the artist and his contemporaries, and the acquisition, in 1949, of the first analytical Cubist works, both Picassos dating from 1909-10, there was heavy dependence on gifts and bequests. Partly, this derived from the general attitude of the National Gallery Trustees, who, as early as 1915, were giving expression to serious reservations about modern art having a bad effect on British painters. It set a negative tone which found a ready echo in the approach adopted by Charles Aitken and J.B. Manson, the two men who were in charge at the Tate Gallery from 1911 until John Rothenstein's appointment in 1938. They were

EDVARD MUNCH
The Sick Child
Tate Gallery

generally conservative about art, and actually hostile towards its more innovative manifestations.

The former, Aitken, took little interest; the latter was sufficiently hostile actually to block the offer of Rouault's *The Bride* and Matisse's *Reading Woman with Parasol*, and to advise British Customs not to admit, as works of art, a group of sculptures by Arp, Brancusi, Calder, Duchamp-Villon, Laurens and Pevsner!

Implicit in this curious reversal in the fortunes of the Tate Gallery during the third and fourth decades of its existence is another problem, the balance or imbalance between foreign and British art, and the different ways in which they were regarded, prejudicial to British art much of the time.

So acute had this become by the time Rothenstein took over that he dedicated the first ten years in the job primarily to bringing the British collection up to date. In that ten-year period, adversely affected of course by the war, 189 British works, compared with only 14 foreign ones, were acquired.

In mitigation of this view of British art in crisis at the Tate, it is important to indicate the more conservative view against which the avant garde had to work. As late as 1930, in his book *Thirty Years of British Art*, Joseph

HENRI MATISSE
Reading Woman with Parasol
Tate Gallery

Duveen, while claiming British and Irish artistic talent to be better than ever before, filled that same book with illustrations of works by painters of the Victorian era.

He preferred British to continental art; he preferred 'middle-class sitting room'-size pictures to 'monster-size' canvases; he had instructions to disseminate about beauty and technique, about aloofness and buying habits, about private and public patronage. It seems very homespun stuff today, yet Duveen was at the centre of art, and a major benefactor, not only of the Tate but elsewhere. And he was at least accurate in defining a problem which the Tate's new director tackled with considerable energy, 'the paucity of State support given to buying British art'. 'Other Governments', Duveen said, 'recognise that the art products of their country are an important asset in the total of that country's wealth, and accordingly they give a great deal of encouragement to their artists. Not only do they buy far more than the State does in Great Britain, but they give their artists facilities on nominal terms for exhibiting both at home and abroad. . . The English Government has never yet backed our own artists as other Governments have done. . . we have allowed foreign artists not only to get ahead of us in the international markets of the world, but even to invade our own home markets and thus deprive British artists of some of the support they should receive on their own doorstep.'

The extent to which this has been remedied in the half-century since Duveen wrote can be measured only within the collective judgement of

modern British artists, an impossible judgement to obtain. Twentieth-century British art, according to the Tate itself, is part of the 'Modern Collection', and covers 'works by British artists born after 1850 together with foreign works from the Impressionists onwards. It incorporates the most extensive survey of British art of its period in any public collection, *including selected examples of very recent art.*'

To some extent this means that the last eighty years of British art is covered by 'representative' works, meaning, or fitting in with, the modern movement, or capable of standing up to comparison with world modern art: Bacon and Freud for the 1950s and 1960s, the Camden Town School for the 1920s, polite English Impressionism for the gaps, and a smattering of modern work for form's sake. This may relate to the overall modern collection. It has little relationship with the historic collection, of which it must inevitably become the main extension.

CHARLES GINNER
Flask Walk, Hampstead
Tate Gallery

DAVID HOCKNEY
A Bigger Splash
Tate Gallery

This historic British collection of art is the most comprehensive and balanced of all at the Tate, running from the sixteenth century to the beginning of the twentieth, and embracing sculpture, drawings, watercolours and prints as well as extensive archive material on British art. The collection on display usually takes up one-third of the sixty or so galleries on the main floor of the Millbank building, with further works in the basement. The works are arranged in part chronologically, in part by school, in one or two cases by individual artists, such as Turner, Blake, Constable, and finally by genre or style, as with the small collection of sporting pictures.

The collection is particularly strong in paintings by Hogarth, Blake, of whose work the Tate has the most representative collection in the world, and the Pre-Raphaelites. With the decision to build the Clore Gallery to house the Turner Bequest, the Tate Gallery has finally, after 130 years, fulfilled the terms of Turner's will. He left nearly 300 paintings and 19,000 drawings, including watercolours, to the nation.

The development of this scheme is matched by a second venture, the 'Tate in the North', in which part of an industrial building in the Albert Dock, Liverpool, has been converted into a second National Gallery of Modern Art, close to the major concentration of population in northern England.

THE NATIONAL PORTRAIT
GALLERY

The National Portrait Gallery comes closest to the Renaissance ideal contained at the end of Francis Bacon's *New Atlantis* and derives from a more general humanist tradition going back more than two centuries earlier than its publication in the 1620s. The tradition embraced ideas of example through historic figures, excellence in achievement, greatness in terms of power, as well as (in the case of great rulers who owned such collections, like the Medici) the implicit or explicit comparisons which were invited.

It was a tradition which related also to the classical period, through the works of sculpture which often formed a major element in art collections, and included great classical portraiture, ideals of male and female beauty, and the depiction of human strength, courage and physical achievement.

The presence of portraits was also the overwhelmingly dominant characteristic of the art collections in great houses. From the royal palaces through the great family seats to quite modest houses, portraiture represented, for the various families brought together by marriage, the domestic equivalent of national 'greatness'. The formal ties which justify the succession of paintings of ancestors are blood and inheritance; the emotional ties are love, admiration, affection, or even hatred and jealousy.

Whether in a family or a State collection, portraits are of 'those who matter most'. This was recognised in the original five 'rules for the acqui-

JOHANN BAPTIST CLOSTERMAN
Henry Purcell
National Portrait Gallery

JOHN GILES ECCARDT
Horace Walpole
National Portrait Gallery

sition of portraits' of the National Portrait Gallery, the main one of which was 'the rule which the Trustees desire to lay down to themselves in either making purchases, or receiving presents, is to look to the celebrity of the person represented rather than to the merit of the artist. They will attempt to estimate that celebrity without any bias to any political or religious party. Nor will they consider great faults and errors, even though admitted on all sides, as any sufficient ground for excluding any portrait which may be valuable as illustrating the history of the country.' Among the other original rules were those restricting portraits of living people, or of people less than ten years dead, except for the sovereign and his, or her, consort.

There were other omissions in the early days, notably of caricatures and photographs. This has changed. The scope has been widened generally. Photographs have been systematically collected since the late 1960s and there are now 10,000 portraits of various kinds.

The man who deserves the main credit for the establishment of the National Portrait Gallery was Philip Henry, Fifth Earl of Stanhope. Stanhope, who was born in 1805, was a friend both of Macaulay and of Robert Peel, whose literary executor he became. He was made a Commissioner for the Fine Arts and a trustee of the British Museum in 1846 by Peel, at which time he had been in the House of Commons for ten years. In the same year he had spoken in the Commons of his idea for a portrait gallery. He pursued it with Disraeli, who was Chancellor of the Exchequer in 1852, and was sufficiently encouraged to prepare the ground by getting the support of the Prince Consort, and of Charles Eastlake, then President of the Royal Academy as well as Director of the National Gallery.

The formal proposal for such a gallery was made in the House of Lords on March 4, 1856. And it was in the debate which followed that the broad choice of portraits designed to display the national character through people across the whole national tradition, rather than just the greatest figures, prevailed.

The general approach, emphasising subject, not artist, and attempting to give a broad picture of the national history, reflected Eastlake's belief that it would be educational, as well as Thomas Carlyle's view as an historian that a likeness of an historical subject was 'one of the most primary wants . . . I have found that the Portrait was as a small lighted *candle* by which the Biographies could for the first time be *read*, and some human interpretations be made of them.' Carlyle filled the first vacancy on the Board of Trustees early in 1857, and joined a distinguished group which included Macaulay and Disraeli, and such collectors as the Marquess of Lansdowne and Lord Elcho.

The National Portrait Gallery had three unsatisfactory early homes, in Great George Street, South Kensington and Bethnal Green, before moving to its present site. Again, we have another example of the heavy dependence of the State's art institutions on benefactors. The Gallery owes its present building, which opened in 1896, to William Henry Alexander, whose gift it was. And it owes the 1930-3 extension to Sir Joseph (later Lord) Duncan. It owed the greater part of its early collections, from the Gallery's foundation, in 1857, to well into the twentieth century, to gifts and bequests. Throughout the nineteenth century any increase in funds for purchasing works for

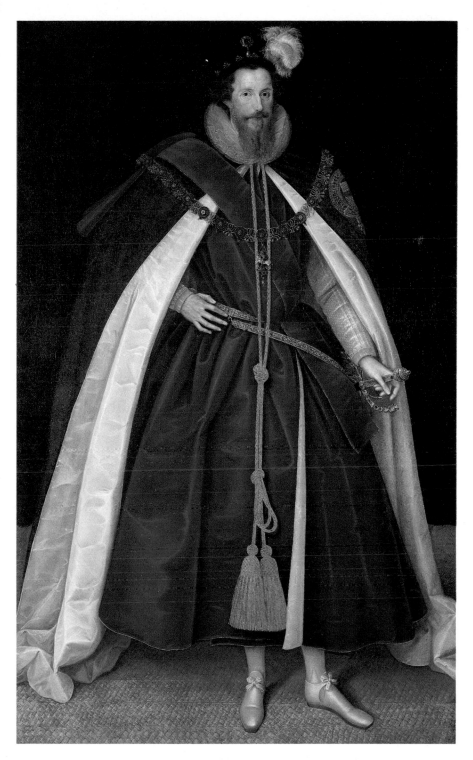

MARCUS GHEERAERTS
The Earl of Essex
National Portrait Gallery

the collection was resisted on the very grounds which had brought the Gallery into being, that artistic merit, which was not a requirement, needed no additional finance! Until the early 1950s the annual grant-in-aid remained at £750.

The Gallery was also very much in the debt of its first director, Sir George Scharf, who held the post from 1857 to 1895, and whose meticulous records, including his own careful sketches of works offered, give an unbroken account of the early years. He was followed by Lionel Cust (1895-1909), Charles Holmes (1909-16), James Milner (1916-27), Henry Mendelssohn Hake (1927-51) and Charles Kingsley Adams. Roy Strong was Director from 1967 to 1973, when he was succeeded by John Hayes, the present incumbent.

Despite the rules, the National Portrait Gallery contains an enormous wealth of art as well as presenting a stimulating and comprehensive view of British history. The arrangement is chronological, beginning from the top of the building. Considerable effort is made to introduce background material, and to encapsulate historical events within an overall presentation. The early domination of monarchs and statesmen, including Michael Sittow's 1505 portrait of Henry VII, Holbein's cartoon of Henry VIII and Henry VII, Rowland Lockey's of Thomas More and his family, and Gerlach Flicke's forceful study of Thomas Cranmer, gives way, in later centuries, to more writers, artists, actors and actresses.

—— THE IMPERIAL WAR MUSEUM ——

The Imperial War Museum contains the greatest collection—some 9,000 items—of art of the First World War in existence. There is also a comprehensive collection of Second World War art, as well as art generally of wars involving British and Commonwealth forces since 1914, consisting of a further 3,000 items. This makes it a major holding of modern British art of exceptional interest and extent, and often of an unparalleled intensity of artistic statement.

A good part of the collection is now on public display, but as with similarly comprehensive national collections, special arrangements have to be made to see individual works. These range over every possible aspect of war art, from the formal portraits and groups to the studies of troops in action, from the record of civilian support activity to the horrors of the Front, from the compelling and statuesque *The Kensingtons at Laventie* by Eric Kennington, or John Nash's *Over the Top* or Wyndham Lewis's *A Battery Shelled* or Henry Lamb's *Irish Troops in the Judaean Hills Surprised by a Turkish Bombardment* (all works from the First World War) to the generally more objective, more pragmatic paintings of the Second World War, like *Women Railway Porters in War-Time* by William Roberts or *Wellington Turrets* by Raymond McGrath.

Many great painters were brought into service under the major schemes for official war artists. The overall collection is a result of these, together with gifts, purchases and bequests. Works done for the Ministry of Information during the First World War were transferred to the museum

ERIC KENNINGTON
The Kensingtons at Laventie
Imperial War Museum

HENRY LAMB
Irish Troops in the Judaean Hills
Surprised by a Turkish Bombardment
Imperial War Museum

WILLIAM ROBERTS
Women Railway Porters in Wartime
Imperial War Museum

at the end of 1918. A similar scheme was proposed by the Director of the National Gallery, Kenneth Clark, on the first day of the Second World War, and he became chairman of the War Artists' Advisory Committee which administered it.

He made the important distinction between the art of the two wars; in the First, its record was dominated by life in the trenches, in the Second by a diversity of 'fronts', one of the most important being the 'home' front 'from grandiose deserts like the surroundings of St Paul's Cathedral, to the poor streets in Whitechapel or Battersea, which placed on record a degree of squalor and misery which is usually overlooked except by social reformers'. When to this are added such horrors as the German concentration camps and the Japanese prisoner-of-war camps, the overall record from the two main wars of the century constitutes an extension of all the bounds previously set by artists who have ever depicted or recorded war. It is more than sufficient justification for the size and scope of this superlative national collection.

The War Artists' Scheme started in the spring of 1916, with Muirhead Bone as the first official war artist. Bone was also to be an artist of the Second World War. The scheme came under the Propaganda Department, at Wellington House. It was subsequently placed under the Department of Information when this was set up as part of a process of streamlining the British war effort under Lloyd George, once he had taken over from Asquith.

It was a War Cabinet decision that there should be a 'National War Museum' (March 5, 1917), and it was regarded then as 'a memorial and record of the effort and sacrifice of the men and women of the Empire'. This began the process of moving it away from the sphere of propaganda to that of record, and George Constable, Keeper at the National Gallery, writing after the war, referred to it most accurately as 'a document,

showing what men and women did, felt and thought during the war'. Of course the propaganda dimension was not overlooked, and the fairly superficial idea that a three-week 'stint' at the Front was enough to produce 'usable work' resulted in many ineffectual visits, and such absurdities as Sargent's inquiry at the Front, where he went as Haig's guest: 'Is there any fighting on Sundays?' In general, though, a moving, dramatic and lasting artistic presentation of the many facets of war resulted from the War Artists' Scheme.

The museum opened in the Crystal Palace in 1920. From 1924 to 1936 it was in the Imperial Institute in South Kensington, from where it moved to Lambeth, opening in July 1936 in the reconstructed Bedlam Hospital.

There were many different official and public reactions to war and the artistic recording of it; what had been enthusiastically welcomed as a dimension of the war effort, in 1916, and from which the museum had been developed subsequently, faded and was replaced by the understandable anti-war reactions, coupled with official parsimony. Through much of the inter-war period its resources, cut anyway at the time of the Armistice, were derisory except for basic curatorial purposes. No effective buying policy was possible. There was no space for display. And when hostilities broke out in 1939 the recently unpackaged collections had to be put away again.

What was more galling, however, to those responsible during those years was the degree to which the museum was by-passed by other bodies and individuals in the management and control of the War Artists' Scheme in the Second World War. What had been understandable during the previous conflict—where the war gave birth to the art, and the art led to the setting up of the museum—was puzzling the second time round, when a group of specialists existed from the start. But they were totally overshadowed by Kenneth Clark, who was, for various reasons connected with his social and professional pre-eminence, in a position to exercise irresistible control over events.

Not surprisingly, with the ending of the war, the impetus was allowed to die, and no clear policy was followed until into the 1970s, when a committee was established to commission war art on a regular and planned basis. Since there has been constant war, in one or other part of the globe, since the 1930s this meant that opportunities had been lost. It was the situation in Northern Ireland which motivated the setting up of a committee chaired by Frederick Gore, and the commissioning of eye-witness records of the Northern Ireland troubles. Berlin, army recruitment, naval life, Hong Kong, and the Falklands, as well as official portraits, have been the subject of commissioned work in recent times.

RAYMOND McGRATH
Wellington Turrets
Royal Air Force Museum

Other similar 'national' collections have been created since. These include the National Army Museum, which was originally founded at Sandhurst, in 1960, and opened in Chelsea in 1971. It traces the history of the British Army since Tudor times, and includes an interesting collection of paintings, among them portraits by Gainsborough, Reynolds and Beechey, and battle scenes covering engagements in all parts of the world. These include John Wootton's *Battle of Blenheim* and Robert Home's *The Siege of Bangalore*.

Art is also an important component of the Royal Air Force Museum,

in Hendon. It includes sculpture, and paintings by such artists as Edward Le Bas, Nevinson, Epstein and Laura Knight.

In a number of public collections around the country examples of war art have been acquired, like the Blitz watercolours in Bristol, or William Scott's *Camouflaged Soldiers*. These and other works represent a recognition of this dimension of art and an extension of what is a truly 'national' collection. It covers particularly poignant periods of history in the twentieth century, though earlier works emphasise heroism and bravery, not always with objectivity and often with deliberately propagandist motives, while later works tend to show the futility and waste of war.

THE NATIONAL MARITIME
MUSEUM

Only part of the National Maritime Museum is devoted to maritime art. It is the greatest museum of its kind in the world, and its collection of fine art is similarly unique, with unparalleled seventeenth- to twentieth-century works, the largest collection of Van de Velde paintings and drawings in Europe, and outstanding individual canvases by Canaletto, Gainsborough, Romney, de Vlieger, Vroom, Wyllie, Turner, De Louther-bourg, Brooking and others.

The art collection is in part related to the other museum displays, in part displayed on its own. The beautiful Inigo Jones Queen's House, for example, is essentially an art gallery, with furnishings and models very much as an adjunct to the paintings, which include many of the Van de

WILLIAM HODGES
Tahitian War Canoes
National Maritime Museum

Veldes, as well as earlier works, and important portraits of key figures in British maritime history.

Elsewhere the paintings are more directly integrated with maritime history, and are displayed with other relics, models, uniforms and documents.

Both approaches work extremely well. The more formal canvases, particularly of the seventeenth century, and including such masterpieces of maritime art as the many Van de Velde seapieces, make the Queen's House, standing between the colonnades in the centre of the Greenwich complex, the best starting point. But throughout the museum, paintings and drawings are used skilfully as a major part of the main display. In particular, the dramatic realism of much nineteenth- and twentieth-century maritime art works well in conjunction with the exhibits of the physical environment of life at sea.

—— THE WALLACE COLLECTION ——

The Wallace Collection represents the results, sustained over a lifetime, of that personal passion for collecting which is a central theme of this book. The collection, mainly that of the Fourth Marquess of Hertford (1800-70), has been preserved, as few such collections ever are, in the form he left it at his death. There were additions by his natural son, Sir Richard Wallace, and these, though mainly in fields other than fine art, include the lovely Fragonard, *A Boy as Pierrot*. There were also pictures which the Fourth Marquess inherited. His father, the Third Marquess, was responsible for the Titian, *Perseus and Andromeda*, and the Rembrandt, *The Good Samaritan*. But essentially the Wallace Collection is the supreme example in the British Isles of one person's art collection preserved for posterity intact. Others of note include the Lady Lever Art Gallery in Port Sunlight, and the Sir John Soane Museum in London (qq.v.).

The Third Marquess was the model for Lord Steyne in Thackeray's *Vanity Fair*, and for Lord Monmouth in *Coningsby*, by Disraeli. The Fourth Marquess was more Proustian, an aesthete and a hedonist. He threw aside all social responsibility, as it might have been understood by an Englishman of his generation, turned his back not only on his country, but on the present as well, and indulged himself in a perpetual recapturing of the past of the *ancien régime*. He was a close friend of Napoleon III. He admired the arts and the habits, principally of the eighteenth century, more generally of the past—he had a taste for Saint-Simon—and his taste as a collector was unashamedly based on pleasure. He used the words 'pretty' and 'pleasing' in his letters to his agent, about the buying of particular paintings, and turned down good works on grounds which seem curious to us now. 'Blood on all the animals' was a reason not to buy a Landseer, curiously fastidious when set beside the purchase, in 1868 for £4,000, of *The Execution of Doge Marino Falieri*, by Delacroix, with its headless corpse in the foreground.

In a century in which art galleries grew steadily in number, largely

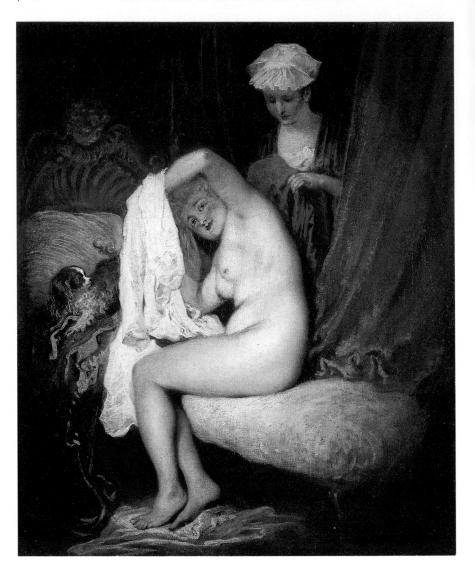

ANTOINE WATTEAU
A Lady at her Toilet
Wallace Collection

from an educational standpoint, and when many museums were founded for utilitarian reasons, the sense of pleasure with which the Wallace Collection is pervaded, almost throughout, gives it a huge appeal. Sheer quality does the rest.

Part of the pleasure has an undoubted sexual content. The Fourth Marquess loved feminine subjects. And the delicious eroticism of Fragonard's *The Swing*, of Watteau's *A Lady at her Toilet*, and of the many Boucher canvases—there are more than in any other public collection in these islands—are symptomatic of a taste which was more suited to a life in Paris in the mid-nineteenth century than in London.

The other great human delight which pervades the Wallace pictures is love of children, or at least love of children in art. This is not unrelated to love of women, since many of the Boucher subjects combine with plump girls the even plumper *putti* who attend them. The Fourth Marquess

treated his paintings at times like children, was over-protective, and pampered them.

Other pictures of note featuring children, bought by the Fourth Marquess, are Fragonard's *The Schoolmistress*, and such masterpieces as *The Infanta Margarita* by Velázquez, and that artist's two portraits of *Don Baltasar Carlos*, in infancy, and in the riding school. Several of the Reynolds canvases, like *The Strawberry Girl* and *Miss Bowles*, the Rubens *Holy Family*, the Rembrandt portrait of *Titus*, and a number of the works by Jean-Baptiste Greuze, all have a happy and wholesome impact on the visitor to the Wallace Collection.

One lovely child subject, *The Young Cicero Reading*, by Vincenzo Foppa, the fifteenth-century painter of the Lombard School, was acquired by Richard Wallace, a collector much more interested in Renaissance art, which did not excite his father at all. And, as already mentioned, it was Wallace who bought that delightful child painting, *A Boy as Pierrot*, for £913 in 1872.

The collection also contains excellent examples of landscape art, the truly superb Rubens *Rainbow Landscape*, as well as works by Ruisdael and Hobbema, and the finest collection of Richard Parkes Bonington's works in the British Isles.

Because of the principles followed by the Fourth Marquess, and indeed his son, Richard, works for the sake of their antiquity, or in order to complete a sequence, or make the holdings of a particular artist or school more complete, are refreshingly absent. In few museums in the British

PETER PAUL RUBENS
Rainbow Landscape
Wallace Collection

Isles does the pleasure principle prevail side by side with standards of excellence which challenge the greatest collections of all. The Wallace is the greatest collectors' collection we have—possibly the greatest in the world.

—— THE WELLINGTON MUSEUM ——

Within the enormous scale of the Duke of Wellington's character as soldier, politician and statesman, it is remarkable that there should also reside a collector of fine art whose taste and discrimination has left to us one of the nation's greatest one-man collections.

The Wellington Museum is unique in several ways. The collection is housed in Apsley House, at Hyde Park Corner, which was the Duke's home in the capital from 1817 until his death in 1852. It was somewhat remodelled by Wellington, using the architect Benjamin Dean Wyatt, and has been restored, with painstaking attention to detail, to the state it was in during his lifetime. This includes the positioning of all the important works of art. From the point of view of the lover of paintings this is a rather mixed blessing. It means that major canvases, like *The Water-Seller*, hang too high, and catch reflections from the window, rendering the picture difficult if not impossible to see properly.

The house was used for Waterloo Banquets, and contains much of the

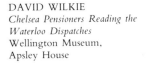

DAVID WILKIE
Chelsea Pensioners Reading the Waterloo Dispatches
Wellington Museum,
Apsley House

JAMES W. GLASS
His Last Return from Duty
Wellington Museum, Apsley
House

personal memorabilia of the Duke. This reflects accurately the period as well as the man.

The art collection divides into distinct groupings, the finest of which are the Spanish paintings, and individual pictures like the Correggio *Agony in the Garden*, the Adam Elsheimer *Judith Slaying Holofernes*, Coello's *St Catherine of Alexandria*, as well as works by Rubens, d'Arpino, Sassoferrato and Guercino. The main works came to the Duke as a by-product of his brilliance as a soldier in the Peninsular Campaign, but nevertheless by accident. They were captured from the French after the Battle of Vitoria, having been found in a coach abandoned by Joseph Bonaparte. They were part of the Spanish royal collection, and were offered back to Ferdinand VII of Spain through the British minister in Madrid. After some delay, the reply came: 'His Majesty, touched by your delicacy, does not wish to deprive you of that which has come into your possession by means as just as they are honourable.' Among the Spanish masterpieces are *The Water-Seller of Seville* by Velázquez, with other canvases by the same painter, and works by Goya and Murillo.

The second group is the extensive one of Dutch seventeenth-century paintings, chosen by the Duke himself, and covering virtually all the major figures of the second rank. There are particularly fine examples of De Hoogh, *The Intruder* and *The Musical Party*, of Jan Steen, *The Physician's Visit* and of Maes, *Lovers with a Woman Listening*, all with amorous themes. There is a fine group of work by Teniers the Younger, by Brouwer, Wouwermans, Breenbergh and Van Ostade.

A third group consists of battle scenes and military subjects, including the large *Battle of Waterloo*, by William Allan. With paintings like *Chelsea Pensioners Reading the Waterloo Dispatches*, by Wilkie, which the Duke bought in 1825 for £1,260, and *His Last Return from Duty*, by Glass, which shows the Duke leaving Whitehall on the Brown Mare for the last time

as Commander-in-Chief, there is a shift to other groupings in the collection, notably contemporary British genre works, and portraiture of the Duke himself, in which the collection, naturally enough, is plentifully endowed, and includes paintings, drawings, watercolours, miniatures and busts.

Several of these latter works were commissioned, or purchased directly from the artist. Wellington, who had a keen eye for detail, and a critical approach to inaccuracy, often made pithy comments about the works. 'Good, very good; not too much smoke!' he said of Allan's Waterloo picture, a later and larger version of which is in the Royal Military Academy at Sandhurst.

The Duke complained of the amount of time he had to spend sitting for likenesses, demand for which was unending. In spite of this, he went on with them, and artists were constant guests at his country home, Stratfield Saye. The great hooked nose, the pointed chin, the side-whiskers, the upright carriage, made him also a suitable subject for caricature.

For a man under the sort of pressures which he not only faced throughout his life, but accepted with relish almost all the time the creation of his collection of works of art is a remarkable additional achievement. It deserves an epithet from himself: 'All the business of war, indeed all the business of life, is to endeavour to find out what you don't know by what you do.'

DULWICH PICTURE
GALLERY

There is a haunting quality to Hazlitt's description of his visit to Dulwich, made in the month of November, when 'the sun shone faint and watery, as if smiling his last; Winter gently let go the hand of Summer, and the green fields, wet with the mist, anticipated the return of Spring. At the end of the beautiful little village, Dulwich College appeared in view, with modest state, yet mindful of the olden time; and the name of Allen and his compeers rushed forth upon the memory!'

Edward Alleyn should not be overlooked, in considering the overall collection of pictures in the Dulwich Picture Gallery, which dates from 1626, when the actor who founded the college gave 39 paintings, mainly portraits. There was no intention of exhibiting them separately; they were simply for the school. It is tempting to imagine that some of the ideas of Alleyn's contemporary, Francis Bacon, inspired him in the belief that the portraits of the great men and women of the period would add to the educational environment of the pupils.

Later in the seventeenth century William Cartwright bequeathed 239 pictures, though only 80 of these reached Dulwich. And later still the fine Linley family portraits, including several quite lovely Gainsboroughs, of the *Linley Sisters* and of *A Lady and a Gentleman*, were given.

The major bequest, however, came from the widow of the art dealer Noel Desenfans, whose husband had been commissioned to form a collection

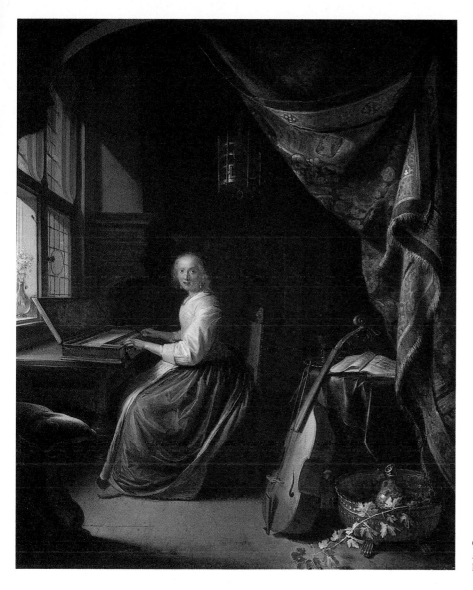

GERARD DOU
A Lady Playing at a Clavichord
Dulwich Picture Gallery

for the King of Poland for a national gallery in Warsaw. His abdication aborted the plan, and the paintings were left on Desenfans's hands.

Desenfans was an early protagonist on behalf of a National Gallery for Britain, proposing the idea in *A Plan: Preceded by a Short Review of the Fine Arts*, published in 1799. On his death, in 1807, he left his property, a house in Charlotte Street with its contents, jointly to his widow and his friend the painter Francis Bourgeois RA, who had lived with them both; while his wonderful collection of paintings went to Bourgeois. It was a condition that if his widow left Bourgeois she would forfeit her share. When the painter died everything went to Mrs Desenfans, the pictures to pass, after her death, to Dulwich College (the Bourgeois Bequest), where they were 'to be kept and preserved for the inspection of the public'. She provided £6,000 towards a new gallery, designed by

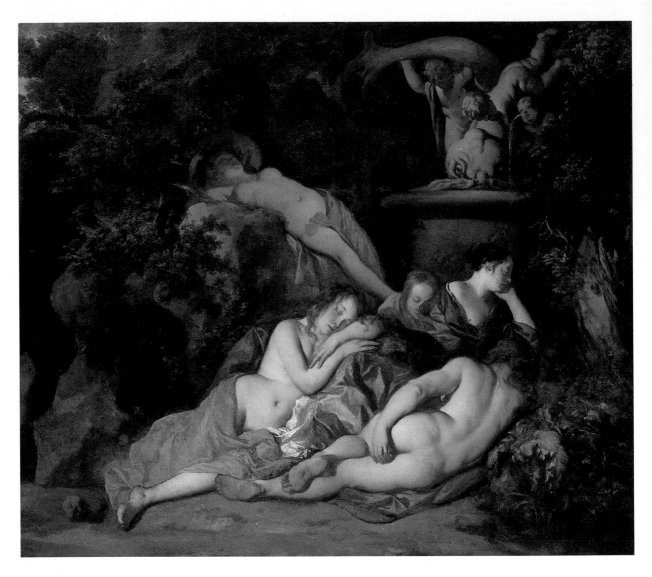

PETER LELY
Sleeping Nymphs
Dulwich Picture Gallery

Sir John Soane, and completed after her death in 1814. The bodies of the three of them, after her death, were placed in the mausoleum which is an annexe to the gallery. It was in this way that the first public art gallery in Britain came into existence.

The Dulwich Picture Gallery contains a lovely collection. It has frequently lost, through theft, one of its small Rembrandt portraits, what Lady Bracknell would call carelessness rather than misfortune; but the gallery has, as a supreme work by that artist, *A Girl at a Window*. Cuyp, Hobbema, Pynacker, Wynants, all indicate the strength of Dutch painting, symptomatic of taste in the late eighteenth century, as is the supreme work by Gerard Dou, *A Lady Playing at a Clavichord*. Rubens is well represented, there are good Van Dycks, and interesting paintings by Lely. The gallery also has a masterly canvas by Watteau and some Poussins only surpassed by the National Gallery and the National Gallery of Scotland.

—— SIR JOHN SOANE'S MUSEUM ——

The museum which Sir John Soane established by private Act of Parliament in 1833, on the north side of Lincoln's Inn Fields, four years before his death, is more distinctly his own creation, down to the smallest detail, than any of the single-person collections in these islands. Architect, antiquary, artist and connoisseur, he had an ingenious and delightful mind which expressed itself in the careful arrangement and re-arrangement of the contents of the three houses which are wholly or partly his museum.

Soane invented a system for hanging his paintings on hinged walls, allowing for layers of works of art. Attendants should be asked to display these, which reveal, behind the more important pictures in the house, which include Hogarth's *The Rake's Progress*, many of Soane's own architectural designs.

The main impact of the collection is made, however, by the works of sculpture, many of them fragments. They are everywhere. There are several Flaxman plaster models, Gallo-Roman busts, fifteenth-century

WILLIAM HOGARTH
An Election Entertainment
Sir John Soane's Museum

Flemish wood-carvings, a bust by Francis Chantrey of Soane himself, and many details and models of the architect's own design. There is a fine Italian bronze of *Hercules*, by Pierino da Vinci, a splendid terracotta full-length figure of *Charles II* by Quellin, and a torso from the frieze of the Erechtheum in Athens.

Above:
GIAMBATTISTA TIEPOLO
The Immaculate Conception
Courtauld Institute Galleries

Right:
PAUL CÉZANNE
The Card Players
Courtauld Institute Galleries

THE COURTAULD INSTITUTE
GALLERIES

The Courtauld Institute Galleries contain several distinct collections, all belonging to the University of London. The rooms are arranged in broadly chronological sequence and this reflects the range of work given by the different benefactors.

The first of these was Samuel Courtauld, who made over a collection of paintings in 1932 to which more works were added on his death, in 1947. In 1933 Roger Fry left pictures and other works of art to London University, and in 1952 Sir Robert Witt left Old Master and British drawings. Five years before, on his death in 1947, Viscount Lee of Farnham, who had suggested the Institute to Courtauld in the first place, gave his collection. There were two further bequests, in 1966 and 1967, the first of early Italian paintings from Mark Gambier-Parry, the second of English watercolours from William Spooner and a gift from Mrs Spooner. The

most recent major group of works acquired by the galleries is the Count Seilern Collection, now known as the Princes Gate Collection, of works by Rubens, Brueghel, Tiepolo, Cézanne, Pissarro and Kokoschka. The collections are moving in 1990 to new galleries in Somerset House.

With the move to Somerset House a greatly increased range of works is on display, extending the impact of the collection both with Old Master and modern paintings. There are also plans for the better display of drawings.

Courtauld was in part inspired by Roger Fry, whose bequest to the galleries included many of his own paintings, including a portrait of Nina Hamnett. There are also works by other Bloomsbury Group artists and by colleagues in the Omega Workshops, which Fry founded in 1913.

—— HAMPTON COURT PALACE ——

Hampton Court Palace was opened to the public by Queen Victoria in 1838, the year after her accession. It was the first royal palace to which people had regular access, in the modern sense, and one of the earliest great art collections of these islands to have remained on view throughout the past 150 years.

The collection is housed mainly in the State Apartments, but the great series of tempera cartoons by Andrea Mantegna, *The Triumph of Caesar*, are in a separate building, the Lower Orangery, built for Queen Anne. The nine paintings, all of which have been restored in recent years, were part of the huge collection of Ludovico Gonzaga, Duke of Mantua, bought by Charles I in two portions, in 1627 and 1628, for a total of £25,500. The paintings depict, on separate canvases, a single triumphal procession, and were regarded by Vasari as Mantegna's finest achievement.

The main collection of works of art, in the State Apartments, includes many paintings which belonged to Charles I and were not dispersed in the sale of his possessions after his execution. Much of the palace in which they are housed is of later date, however, the rebuilding having been begun by Wren.

The decorated King's Staircase is the work of Antonio Verrio, who died at Hampton Court in 1707. The subject matter is obscure, but invokes Roman Emperors and Gods for the purpose of political satire. Verrio is also responsible for decorations in several of the following rooms, the general character of which, with the exception of the Wolsey Rooms, is seventeenth and eighteenth century. Paintings of the period include Honthorst's portrait of *Elizabeth of Bohemia* ('The Winter Queen'), and portraits by Godfrey Kneller of *William III* and *Sir Christopher Wren*, who was responsible for the remodelling of the palace for the use of William and Mary.

The collection, like the palace, evokes three distinct periods: the time of Wolsey and Henry VIII, when the buildings were new; the reign of Charles I, when the greatest works were acquired; and that of William and Mary, when the palace was substantially remodelled.

——— HAM HOUSE (NT) ———

The collection at Ham House is remarkable for the fact that it presents us with more aspects of seventeenth-century life than any other house in the country. The architectural fabric has been preserved virtually unchanged since the 1670s and it still contains many of its furnishings from that period. The quality of preservation and restoration is exceptional and gives a highly memorable display.

The Duke and Duchess of Lauderdale no doubt frequently employed artists and craftsmen who had worked for the Crown since, being members of the court inner circle, they would have been familiar with the latest exercises in interior decoration and furnishing at the royal palaces. Examples of this practice can be seen in the employment of the Dutch painter Willem van de Velde the Younger, who came to England to work for Charles II, and also Antonio Verrio, an Italian who had worked on royal commissions. The Duke patronised several Dutch painters who were active in England, including Abraham Begeyn, Dirck van den Bergen and Thomas Wyck.

——— THE SUFFOLK COLLECTION ———

The most splendid of the portraits in the Suffolk Collection, in the Ranger's House on Blackheath, are those by William Larkin, described by Roy Strong as 'the most important series of portraits to survive unbroken from this period'. All are full-length. Seven of them constitute the so-called 'Berkshire Marriage Set', inappropriately named, since the title was not granted until more than a decade after the marriage in 1614 of Thomas Howard and Elizabeth Cecil. It has been suggested that the paintings might commemorate this event.

The stiffness of pose and meticulous detail of costume and carpet give them a striking grandeur. The treatment of elaborate clothing, and the powerful handling of different shades of green, make the portrait *Diana Cecil, Countess of Oxford* a particularly notable example.

The Suffolk Collection was given to the Greater London Council by Mrs Greville Howard in 1974. The house became the property of London County Council in 1902. It was restored in 1960 and is now administered by English Heritage.

The Collection may be divided into three distinct parts: family portraits; royal portraits; Old Master paintings.

The Howard family portraits came from the Jacobean House, Charlton Park, in Wiltshire, built by Katherine Knevet, wife of Thomas Howard, Commander of the British fleet in the Azores Engagement of 1591, who became the First Earl of Suffolk. Katherine's portrait by Larkin is at the Ranger's House.

The Ranger's House was built in about 1710, and enlarged in 1749-50 for Philip, Fourth Earl of Chesterfield, when it became known as Chesterfield

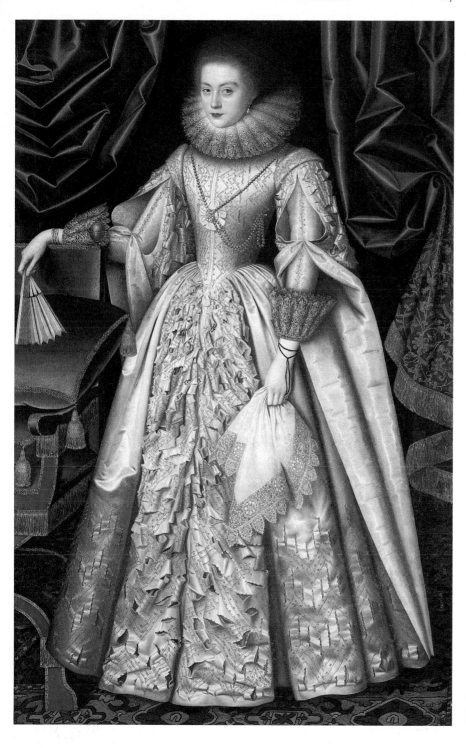

WILLIAM LARKIN
Diana Cecil, Countess of Oxford
Suffolk Collection

House. It was later the home of Queen Caroline's mother, the Duchess of Brunswick, before it became the residence of the Ranger, not of Blackheath, but of Greenwich Park.

KENWOOD

Kenwood, or Caen Wood House, dates back to the early seventeenth century. It was originally owned by the King's Printer, John Bill, and then passed through various hands, including the Second and Third Earls of Bute, the latter of whom sold it to perhaps its most famous owner, William Murray, who became First Earl of Mansfield.

He was one of England's greatest lawyers, an enlightened politician, and a man who, in Dr Johnson's words, 'drank champayne with the wits'. One of these wits was Pope, who bequeathed to his lawyer friend busts of Homer and Newton. Mansfield employed Robert Adam on the reconstruction of the seventeenth-century house, with splendid results which the later additions by George Saunders did not spoil. The estate passed through further generations of the family, down to the early years of this century, when the preservation of the house and surrounding land became a matter of wide public concern. It was finally saved for the nation by Lord Iveagh, who furnished it, and filled it with the outstanding art collection it now contains.

It was Lord Iveagh's intention to furnish the house in an appropriate late eighteenth-century manner, and he chose from his much larger collection English, Dutch and Flemish paintings with a few additional French works, including paintings by Boucher.

The two great eighteenth-century English portrait painters, Gainsborough and Reynolds, are represented with masterly works, among them examples of child portraiture, and rural subjects. Of Dutch paintings the Vermeer, the Rembrandt and the Cuyp are outstanding.

AELBERT CUYP
View of Dordrecht
Iveagh Bequest, Kenwood

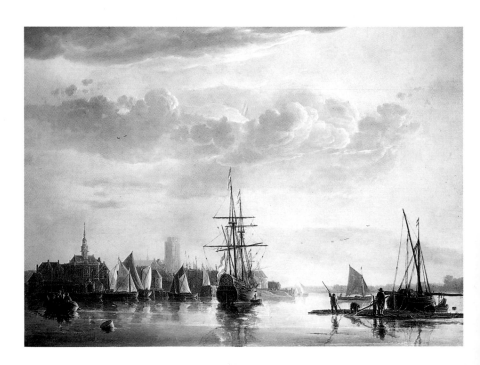

Fine Art in the North from Berwick-on-Tweed to Chester

*'Tis only painting's pow'r
Can sooth the sad, the painful hour;
Can bring the much-lov'd form to view,
In features exquisitely true;
The sparkling eye, the blooming face,
The shape adorn'd with every grace.*

William Roscoe

For our purposes, the North of England stretches south from Berwick-on-Tweed, on the Scottish Border, to Sheffield, in South Yorkshire, and Cheshire in the west. The Isle of Man, one of the larger inhabited islands, is also included in this region.

The area embraces some of the wildest and most remote parts of the British Isles, including the North Yorkshire Moors and the Lake District, and contains many areas of outstanding natural beauty. The Pennine Way links the great National Park areas in Northumberland with the Yorkshire Dales, and on the south to Cheshire and the Derby Peak District, which is in our Midlands region. The North of England as a whole has a larger area of protected natural beauty than any other region in the British Isles. It has inspired artists as diverse as Henry Moore, John Ruskin, John Sell Cotman and Kurt Schwitters.

Yet this same region also includes the densest concentrations of population in the British Isles outside London, in areas which, during the nineteenth century particularly, represented the country's main sources of wealth. These, in turn, inspired art of a different sort. Atkinson Grimshaw and L.S. Lowry are painters who, in their studies of urban scenes and people, have captured the ingrained atmosphere of England's industrial heartlands with unique impact. It is in this industrial area, across the region at its widest part, that some of the finest art is concentrated. It stretches from the steps of the Lady Lever Art Gallery in Port Sunlight, to the steps of

the equally elegant neo-classical Ferens Art Gallery in the centre of Kingston-upon-Hull, a distance of about 130 miles as the crow flies. If a generous width of fifty miles is given to this band of land across the country, then contained within it are three of the great municipal collections in the British Isles, together with their satellite houses and galleries, and a surrounding profusion of smaller municipal and university collections.

In addition, coastal geography has played its part in shaping the art of the region. From Hull and Grimsby northwards, towns along the east coast, which face both the savage north-easters as well as the rich fishing grounds of the Dogger Bank, have been inextricably engaged in the wrestle with the sea for its harvest, in the great British tradition of shipbuilding, and in the naval tradition as well. These activities have also shaped the life and development of Liverpool and Birkenhead on the west coast. Three of the five great shipbuilding centres of the British Isles (now shadows of their former selves)—at Barrow, Birkenhead, and on the northeast coast—are in this region, and the ports have tended to acquire interesting art collections; some indeed have outstanding ones. Marine wealth, in one or other of its many forms, has provided the money for at least some of the collections. It has provided also inspiration for the artists, and for the collectors as well.

The bearing geography has—or has had—on the area's art collections is considerable. Whether it is coal, blast furnaces, steelworks, the development of the woollen trade in the east in the eighteenth century, and of the cotton industry in Lancashire in the nineteenth, or the agricultural acres of Cheshire attracting country houses, their impact on art and its accumulation can be traced in innumerable ways.

The concentration of art galleries in what are now Merseyside and Greater Manchester, and in the older counties of Lancashire and Yorkshire, as well as farther north, in Newcastle-upon-Tyne, is often a direct reflection of civic pride. This contrasts sharply with the very different picture which emerges generally in the southern half of England, where such civic pride manifested itself much later, and with less outstanding results.

The northern collections sometimes seem to be slightly frozen assets. For example, while in Sheffield today the skies are generally clear of that heavy pall of sulphurous smoke which was the lot of citizens for a century or more, one is reminded, standing in front of fine, evocative paintings which depict the twelve steelworks on which the city's wealth depended, of a past era which the art very strongly reflects. The experience is almost incongruous, as though time has moved on, leaving such paintings behind, a faintly embarrassing indictment of the past, an historical record which sits uneasily within the modern city. And to some extent it has led to frantic efforts at art gallery self-denial: an emphasis on everything but the tradition enshrined in the main collections at the Mappin and the Graves Art Galleries, as though these needed to be diluted.

Keeping up with the civic Joneses has also led to certain similarities between collections. In many of the galleries in smaller northern towns there is an almost standard recipe, with Pre-Raphaelite art, Victorian genre painting, a run of Royal Academy pictures, portraits of local

dignitaries, the works of locally born painters and sculptors, and a generally uneven collection of earlier art, whether Italian, Dutch, Flemish or French, often of poorish quality.

There are, happily, outstanding exceptions, both in houses and art galleries, with some of the greatest public collections outside London being concentrated in the industrial heartland which runs along the southern border of the region. These include the galleries in Liverpool, Manchester, Leeds, Bradford and Sheffield itself as well as York, Hull and Newcastle-upon-Tyne. Great houses are harder to find, but at places such as Alnwick Castle and Harewood House there are exceptional art collections.

The finest of the civic collections is in the Walker Art Gallery, in Liverpool. Then come the city art galleries of Manchester, Leeds and York. Manchester and Leeds, as well as Liverpool, have other galleries, as well as houses, under their collective direction.

THE WALKER ART GALLERY,
LIVERPOOL

The Walker Art Gallery in Liverpool owes its existence to the generosity of a local brewer, Andrew Barclay Walker, who became the mayor of Liverpool in 1873 and was later knighted. He offered to build the Gallery for the city at his own expense some 25 years after the city had begun to collect works of art. Yet for long afterwards, the city's collection failed to match the quality and grandeur of its splendid building on William Brown Street.

The building was primarily designed for the annual autumn exhibition of local artists, mainly members of the Liverpool Academy of Arts, much of whose work now forms the extensive collection of Merseyside art owned by the Gallery.

As is so often the case, the history of the Gallery's collection, particularly its wonderful early Italian and Netherlandish paintings, sheds little glory on the city which now enjoys the art. In fact it indicates an attitude of neglect and indifference of almost monumental proportions.

The director, Timothy Stevens, says in his introduction to the Foreign Catalogue, that the paintings were acquired over a period of 150 years 'primarily in the form of gifts and in more recent years through the aid of monetary donations'. The record is one 'of the concern of local benefactors to enhance their city's cultural life'. It is a polite way of saying how little the city itself dug its corporate hand into its taxpayers' pockets for the sake of art.

What happened is instructive, since the early paintings 'constituted the first permanent notable collection of Old Master paintings in Great Britain bought in order to improve public taste'; yet it is more by luck than judgement that they are there at all, and they are incomplete as a collection, as originally gathered. This is because their owner, William Roscoe, who believed they should become part of a more extensive public collection,

SIMONE MARTINI
Christ Discovered in the Temple
Walker Art Gallery, Liverpool

was threatened by bankruptcy and had to sell what he had collected. Before the sale his paintings were offered in two groups, Italian works, lots 1-62, for £1,000 and German and Netherlandish works, lots 78-122, for £500. Even by the standards of the period, only eight years before the purchase by the British Government of the Angerstein pictures for the National Gallery in London, these prices were moderate. There were no takers.

Some of Roscoe's paintings were bought by a group of subscribers who were interested in preserving them together, as well as ensuring that they would be put to public use, as a contribution to 'the advancement of the Fine Arts in the Town of Liverpool'. They went to the Liverpool Royal Institution. Further works were added. In 1850-1 attempts were made to interest the city in the acquisition of the Institution's gallery and its collection, but without success. They were subsequently lent to the city, and only in 1948, together with the Liverpool Royal Institution's collection of drawings, were presented.

The Roscoe paintings include Ercole de' Roberti's *Pietà*, Simone Martini's *Christ Discovered in the Temple* and Jan Mostaert's *Portrait of a Young Man*.

The Walker Art Gallery deserves to be on any Pre-Raphaelite tour, its most notable work being *Lorenzo and Isabella*, by John Everett Millais, painted immediately after the formation of the Brotherhood, and characterised by that intense brilliance of colour, attention to detail, and dramatic foreboding, which became a hallmark of so many of the works painted by members and followers.

The collection includes good English works—extremely popular ones as well, like William Frederick Yeames's '*And When Did You Last*

WILLIAM FREDERICK
YEAMES
*'And When Did You Last See
Your Father?'*
Walker Art Gallery, Liverpool

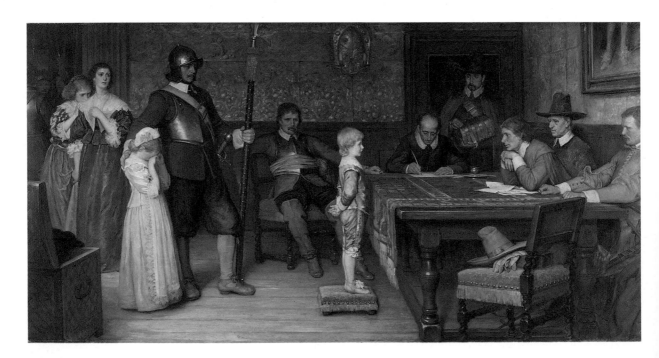

See Your Father?'—from Hogarth, Stubbs, Gainsborough and Wilson, to Gilman, Lowry and David Hockney.

A word is necessary, also, about the Liverpool collection of Merseyside art, a prodigious, interesting, and at times very exceptional collection of paintings by local artists, or of subjects connected with the city and its environs, as well as its people. The artists include notable painters—William Lindsay Windus, Richard Ansdell, William Huggins, Samuel Walters, Samuel Austin and Robert Salomon. Some of them painted marine works, though their appeal is often more idiosyncratic.

William Huggins, for example, was popular for his animal paintings. He studied animals at the Liverpool and Chester zoos, and seems to have transferred to his animals a sensitivity for character which is discernible in his earlier portraits of humans. He presents lions, donkeys, cattle and hens as serious participants in the world's affairs. His gravestone bore the inscription that he was 'a just and compassionate man, who would neither tread on a worm nor cringe to an emperor'.

Huggins was just one of a group of talented Liverpool artists. Others include the sharp-toned Frederick William Hayes and Daniel Alexander Williamson, the genre painter, Henry Benjamin Robertson, John Lee, James Campbell, Charles Towne and William Davis.

Many portrait painters also have left us with the likenesses of the worthy burghers of the city, without whose obstruction Liverpool might well have had an even greater collection of works of art than it presently has.

This and other collections now come under the administration of the

INCE BLUNDELL MARBLES
Part of the Sculpture Collection
Merseyside County Museums,
Liverpool

newly formed National Museums and Galleries on Merseyside. These include two which are separately noted, the Lady Lever Art Gallery and the Sudley Art Gallery. Croxteth Hall houses an extension of the general collection. At the same time, paintings originally the property of the Earls of Sefton are back at Croxteth, including a number of portraits of members of the Molyneux family, and sporting works.

There are important individual collections of art in unlikely places, including the Ince Blundell collection of classical sculpture, in the main

MYLES BIRKET FOSTER
A Surrey Cottage
St Helens Museum and Art
Gallery

building, Liverpool Museum, and the collection of marine paintings displayed in the huge Maritime Museum complex around the Canning Half-Tide Basin, beside the River Mersey (both are part of the National Museums and Galleries on Merseyside). The Central Library also has a huge collection of Liverpool topographical works, some on public display, but the majority seen on application.

There are interesting collections which were once in independent Lancashire towns but have been absorbed into Merseyside. The Atkinson Art Gallery in Southport is separately mentioned. That in St Helens, though primarily a general museum, possesses some interesting watercolours in the Guy and Margery Pilkington Collection. They range from the lush Victorian treatment of landscape in Birket Foster's *A Surrey Cottage* to the very English humour of *Sunday*, by H.M. Bateman.

SUDLEY ART GALLERY, LIVERPOOL

The Sudley Art Gallery, though now owned by the City of Liverpool and administered by the new National Museums and Galleries on Merseyside through the Walker Art Gallery, is quite different in origin and atmosphere. It was once a family house, and its collection is essentially that of one man, George Holt, whose daughter, Emma, bequeathed the house and its contents to the city on her death in 1944.

George Holt was a founder of the Lamport and Holt Shipping Line, and a pioneer of trade between Liverpool and Brazil. His brother, Alfred, founded the even more famous Blue Funnel Line. George was one of a large group of Liverpool merchants who bought British art extensively, and his collection is the only one of those made by the group which is still intact.

How it was put together may be accurately gauged from the receipts and letters which Holt kept, and which are still preserved as part of the collection at Sudley. He relied chiefly on Thomas Agnew and Sons, who then had their offices in Manchester, with a branch office in Liverpool. Holt seems to have begun collecting in the late 1860s, with landscapes and seascapes by Turner, Copley Fielding, William Linnell and James Baker Pyne.

In the 1870s he was buying works by Lord Leighton and Landseer and religious paintings such as William Dyce's *The Garden of Gethsemane*, a representation of the loneliness of Christ in what is clearly landscape.

It was in the 1880s and later that the most important works were acquired, Millais's *Vanessa* and a small replica of Holman Hunt's *The Finding of Christ in the Temple*; but at the same time paintings by Turner, Wilkie and Mulready were bought, as well as a number of landscapes by artists including Cox, Bonington and John Linnell.

Holt acquired work by Turner throughout his life, and there is an unsubstantiated tradition of a family friendship with the artist, presumably through George Holt's father. Works by the artist include his magnificent

RICHARD PARKES
BONINGTON
Fishing Boats in a Calm
Sudley Art Gallery

The Wreck Buoy, with its central turmoil of light, *Margate Harbour*, and *Schloss Rosenau, Seat of Prince Albert*.

He began to buy eighteenth-century English portraits and then in 1896, the year of his death, he acquired the finest work in the collection, Gainsborough's *Viscountess Folkestone*, a portrait in old age of the second wife of Jacob Bouverie, who, according to Horace Walpole, 'bought his ermine at twelve thousand pounds a yard'.

In addition to the purchases for his own collection, George Holt also bought and gave works to the Walker Art Gallery. He acquired *Juliet at the Window* by Fontana specifically for the Walker. *Martyr of the Solway*, by Millais, was a further gift in 1895. Holt also took part in the successful campaign to have Holman Hunt's *Triumph of the Innocents* acquired in 1892.

— THE UNIVERSITY OF LIVERPOOL —

AUGUSTUS JOHN
John MacDonald Mackay
University of Liverpool

Among the many university collections of art in the British Isles, that of the University of Liverpool is small and modest. Manchester and New-castle-upon-Tyne both outshine it. The art is dominated by portraits which Augustus John painted during his not entirely convivial stay in the city in 1901-2, when he taught at the University School of Architecture and Applied Art. He painted well then, and his canvases have considerable strength, though his later portrait of *Kuno Meyer*, which hangs with the earlier works, is more assured.

There are other works of note, however, among them the interesting series of oils by the great American graphic artist, John James Audubon, painted from his watercolours for friends in Liverpool on a visit he paid in 1826. He was then looking for a publisher for *Birds of America*.

The collection includes English watercolours, as well as more modern works, painting and sculpture, many of them spread round the university buildings.

LADY LEVER ART GALLERY, PORT SUNLIGHT

Lord Leverhulme did for eighteenth- and nineteenth-century British art what Lord Hertford had done for eighteenth-century French art. He collected it with discrimination, and the resource behind him of enormous wealth. He ensured that his collection should remain intact for ever by building a gallery for it and bequeathing it to the British people under terms not dissimilar from those which Sir Richard Wallace's widow applied in her bequest of 1897.

William Lever was as essentially a product of the new wealth derived from industry and trade as Hertford was of the old wealth, deriving from land. He was born in 1851, the son of a grocer. He was a Liberal in politics, a supporter of Gladstone, and a great believer in free trade and in self-help.

His wealth was founded on Sunlight Soap. His collecting began as an adjunct to this: he bought paintings which he could use to advertise soap, and justified it by claiming that the advertisements brought to art a wider public than it had enjoyed before, many of them not previously interested in art at all.

Among the paintings bought for this strictly commercial aspect of art, there are in the collection such works as *The Wedding Morning* by John Bacon, and Frith's *Vanitas Vanitatum, Omnia Vanitas*, a painting of a pretty girl holding a new frock. The Frith was reproduced with the caption 'So Clean'. Frith objected, but had sold the copyright with the picture, and was powerless to take further action.

It was the time of the public controversy over the use of *Bubbles*, the painting by Millais, for advertising Pears soap, subsequently taken over

by Lever Brothers. Paintings bought for this purpose in the late 1880s and 1890s belong still to the Lever Collection.

There was a controversy of kinds, and it brought out a certain truculence in Lever which was to be repeated with other artists, notably William Orpen, who was involved in a huge public row with Lord Leverhulme over the portrait dating from the 1920s. There was a fierce row, also, with Augustus John, over a truly execrable portrait which made Leverhulme look gross and ugly, and which he then cut up in order to store it in a strongroom. Portions were sent back to the artist, by mistake, and John gave the undoubtedly stimulating story to the papers, which led to student demonstrations.

Lever had a good eye. While it was, until relatively recently, fashionable to decry the taste reflected in the Port Sunlight collection, the collector had the merit of up-to-date conviction, as opposed to the rather safer self-indulgence of Lord Hertford, creator of the Wallace Collection.

It is perhaps unfair to compare the two. Lever, a self-made man of wealth, was also a working man, busy at his business, which grew and extended, and led him into a political life as well. He could not compete, either in money terms related to the availability of works on the market half a century after the formation of the greater part of the Manchester

FREDERICK, LORD LEIGHTON
The Garden of the Hesperides
Lady Lever Art Gallery, Port Sunlight

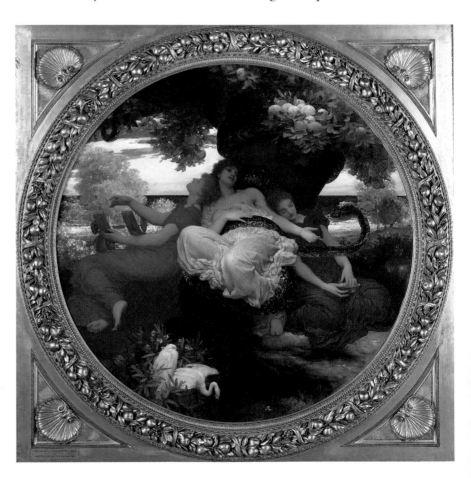

Square collection, or in terms of the time and energy he could deploy in pursuing individual works.

Lever was well advised by F.W. Fox, a dealer of Gooden and Fox, less well by James Orrock, a dealer, collector, and painter as well, from whom Lever bought many works which turned out to be forgeries, notably works attributed to John Constable, Orrock's 'favourite' artist, in more ways than one. Works by, or attributed to, Morland, Romney, Wilson, Turner, and many others, passed from Orrock to Lever. They were weeded out, following Lord Leverhulme's death.

For reasons not far removed from his meteoric rise to wealth, title and standing in the world, Lever sought to leave a clear and benign impression of himself everywhere. He began early with the revolutionary Port Sunlight town for his workpeople, complete with schools, hostels, clubs and restaurants. He filled many of these buildings with the increasingly large numbers of works of art he acquired. He bought and endowed museums elsewhere, one on the outskirts of Bolton. And from 1910 Hulme Hall, named after his wife, which had been built as a restaurant for his working girls, had become Hulme Hall Art Gallery. Used as a hospital in the First World War, it was replaced afterwards with a newly designed building and opened as the Lady Lever Art Gallery in 1922.

The Lady Lever Art Gallery is one of the great experiences for art gallery visitors. An atmosphere of assurance and self-confidence is exuded by the works of art. It is not just their High Victorian character, but the fact implicit in so many of them, that Lever was in a position to buy major works and masterpieces. Among these must be included *The Garden of the Hesperides* by Lord Leighton, *The Scapegoat* by Holman Hunt, and *Sir Isumbras at the Ford* by Millais. Among other outstanding works are *On His Holidays* by John Singer Sargent, *The Beguiling of Merlin* by Burne-Jones, *Spring Apple Blossoms* by Millais and *The Duchess of Hamilton and Argyll* by Joshua Reynolds.

There is a lush eroticism about many of the works in the collection. By contrast, delightful examples of eighteenth-century genre painting are to be found in the lovely Stubbs panels, painted on porcelain, and in many other eighteenth- and early nineteenth-century works acquired by Lever.

ATKINSON ART GALLERY, SOUTHPORT

The Atkinson Art Gallery is small, but has a good collection, only part of which is exhibited at any one time. It is strongly Victorian, with a good deal of that sentimentality which is glibly thought of as having 'afflicted' Victorian art, when in reality it served a more profound purpose, ameliorating the horror and frailty of life for as many people as could be persuaded either to visit galleries or to look at the reproductions of such works in various forms.

James Hayllar's *Happy is the Bride the Sun Shines On*, or *Scrambling for*

JAMES HAYLLAR
Happy is the Bride the Sun Shines On
Atkinson Art Gallery, Southport

Cherries by John Morgan, are typical of works whose socially beneficial purpose is unjustly laughed at today.

The Atkinson also has a good landscape collection, with muscular cattle by Thomas Sidney Cooper, and large, vivid scenes by Benjamin Williams Leader. Its holding in Scottish painting is surprisingly extensive, much of it presented or bought in the 1930s, and covering the Scottish Colourists, the Glasgow School, as well as painters working in the earlier part of the nineteenth century.

Southport was the first 'watering place' to adopt the provisions of the Free Library Act, of 1855, designed in part to encourage municipalities to establish libraries and other leisure facilities. It did so in 1875, with the Deputy Lieutenant and local JP William Atkinson putting up the money for the building, part of which was to be used for an art gallery.

When it was opened, every room was crammed with works of art, all of them lent. Gifts followed, and then in the 1880s Southport Corporation began purchasing, so that a steady enlargement of the collection went on into the 1920s, at which time the most significant of all, John Henry Bell's bequest of 178 paintings, enormously enriched the holding in several respects. It included important English watercolours, Victorian paintings and the Scottish works already mentioned. In quality and content it helped to define the gallery's acquisition policy more firmly towards English nineteenth-century and watercolour painting.

WILLIAMSON ART GALLERY, BIRKENHEAD

In this elegant building, in a quiet street in Birkenhead, is to be found a collection of good English watercolours and works by Merseyside painters, including canvases by the popular Liverpool painter William Huggins, famous for his animal studies, though it was his ambition to become an historical painter.

The Williamson's collection includes works by Philip Wilson Steer, that most lovable of English painters, who was born in Birkenhead in 1860. Described by his biographer, D.S. McColl, as 'of the dumb variety', Steer had an enormously attractive indolence, which his pupils at the Slade found almost as instructive as his advice. In fact it was Steer's preference for silence where he could not praise which gave him his endearing reticence, and added to it a measure of appealing wit. The family were not native to Birkenhead, and the painter spent only his childhood there. But the Williamson Art Gallery's loyalty to the association has meant the acquisition of a number of interesting works, including one of the Walberswick landscapes, as well as nudes and interiors like *Girl in a Muslin Dress Lying on a Sofa*.

PHILIP WILSON STEER
Girl in a Muslin Dress Lying on a Sofa
Williamson Art Gallery, Birkenhead

THOMAS PATCH
Antiquaries at Pola
Dunham Massey, Cheshire

FINE ART IN CHESHIRE

Cheshire has one museum of note, the Grosvenor Museum in Chester, which concentrates on the city and county with considerable dedication and some success. A genuine effort has been made, in recent years, to catalogue properly the large topographical collection. The most distinguished country house collection is at Tatton Park, formerly the home of the Egerton family, now the property of the National Trust.

There are two houses in which wall-paintings feature. At Bramall Hall there are decorative scenes painted over the wood and plaster, dating from 1600, which supply the main fine art feature of the house. At Little Moreton Hall there are also Elizabethan wall-paintings in the Parlour and the Chapel.

Good family and other portraits are at Lyme Park, Gawsworth Hall, Dunham Massey and Dorfold Hall. The main collection of paintings at Capesthorne Hall, owned by the Bromley-Davenport family, was sold in 1863.

GROSVENOR MUSEUM, CHESTER

The Grosvenor Museum at Chester has a good collection of local topographical views. They concentrate on the historic city of Chester, whose picturesque walls, cathedral, castle, half-timbered houses and Rows (galleries above street level) attracted many artists. The surrounding Cheshire countryside is also represented in such works as *Beeston Castle* by George Barret and *Eaton Hall* attributed to R.B. Harraden.

The museum has the largest public collection of watercolours by Louise Rayner (1829-1924). Her picturesque and detailed scenes of old cathedral cities and market towns are extremely popular.

TATTON PARK (NT)

The collection at Tatton Park has a noteworthy Van Dyck *Martyrdom of St Stephen* in the Drawing Room. It was painted in 1623 for a church in Rome, and was then taken by Godoy to Spain. Godoy was arrested in 1818 and his collection put up for sale, but this canvas was not included. The dealer William Buchanan obtained it some years later and sold it to Wilbraham Egerton, who, with his father, William, was largely responsible for most of Tatton as it is today.

Wilbraham was an avid collector of paintings. His florid countenance earned him the nickname of 'Cherry'. In addition to the Van Dyck, he bought the Guercino *Absalom and Tamar*, as well as Spanish and Netherlandish works of art. Among these latter were two after Rogier van der Weyden. The replica of Chardin's *La Gouvernante* was also bought by him.

Two Canaletto views in Venice, of the Doge's Palace and the Grand Canal, were painted for Samuel Egerton's uncle, Samuel Hill, and hang with the Van Dyck. Two works by Henry Calvert, one depicting three generations of Egertons in *The Cheshire Hunt*, the other a portrait of the First Lord Egerton, hang in the Entrance Hall. On the Staircase Hall are a set of ten portraits of the Cheshire Club, who had their portraits painted after their decision to support George I had proved sensible. The perspective is quite amusing. It is evident that the lower bodies were meant to be seen from above.

The collection is well documented, with details of provenance, and of acquisitions back into the seventeenth century.

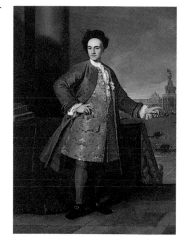

BARTOLOMMEO NAZZARI
Portrait of Samuel Egerton
Tatton Park, Cheshire

GREATER MANCHESTER ART GALLERIES

In addition to the Manchester City Art Gallery, the Gallery of Modern Art and the Whitworth Art Gallery, the first two of which belong to the city and the third to its university, the Greater Manchester area has art galleries in Bolton, Stalybridge, Oldham, Rochdale, Salford and Stockport, as well as museums in houses under the control of the City Council. The houses include the Old Parsonage, in Didsbury, which contains the Fletcher Moss Museum, and Heaton Hall, on the outskirts of Prestwich.

This neo-classical house, by James, Samuel, and Lewis Wyatt, has fine decorated interiors and a collection of paintings related to the period 1770-1830. These include works by Reynolds and Romney. The house was formerly the seat of the Earls of Wilton, but when it passed to Manchester,

in 1902, the contents were sold. It does contain a collection of James Wyatt drawings for the decorations in the house.

The collections at Stalybridge, in the Astley Cheetham Hall Art Gallery, and in the Bolton Museum and Art Gallery, are rather limited. Stockport has a late Victorian collection, but not fully on show, through lack of space. The galleries at Salford, Rochdale and Oldham are part of a larger grouping, the geographical integrity of which has been upset by the creation of Greater Manchester. Originally part of the area's cotton industry, Rochdale and Oldham should be seen in the broader context of other Lancashire towns, including Bolton, Bury, Blackburn, Preston and Burnley, all of which have collections. None outstanding, they nevertheless reflect the modest civic responses to nineteenth-century zeal about the educational value of art. The Oldham Art Gallery has an extensive collection of Victorian and Edwardian art and more modern works. It owns a notable Orpen, *In the Dublin Mountains*, as well as works by the painter F.W. Jackson, who was born at Middleton Junction, and whose father worked as a photographer in Oldham.

Jackson's work is in many of the Manchester collections, including that at Rochdale, where the Art Gallery, which opened in 1903, seems to be having a crisis of identity, exhibiting stridently modern works much of the time, to the exclusion of its own quite respectable collection of nineteenth-century and earlier works. These derive from the Handley, Ogden and Thomas Kay bequests, the first two of which came to the Art Gallery in the early part of the century, the third in 1974. These three bequests contain Victorian narrative and genre works, watercolours, and some early European paintings.

MANCHESTER CITY ART GALLERY

The Manchester City Art Gallery grew, like the Walker Art Gallery, out of an organisation of artists, parallel to the Liverpool Royal Institution, though without the added dimension of the Liverpool Academy of Arts. The Manchester Institution did exist, however, for the promotion of the arts in Manchester, and was made up of artists whose first practical objective was to have a place for annual exhibitions of art. Thus, the building, in the Greek Revival style, which is today the home of the main collection of art in the city, with the modern art collection in the building immediately behind it, was constructed for lectures and exhibitions. The members of the Institution chose as their motto, appropriately enough, *Nihil pulchrum nisi utile* (nothing beautiful unless useful), fitting in with prevailing trends.

From the first of these exhibitions, in 1827, Northcote's *Othello, the Moor of Venice*, was bought, and from the eighth, in 1832, Etty's *The Storm*. These, with other works bought by the Institution, or bequeathed to it, formed the nucleus for the City Art Gallery, and they attest to an important distinction of the Manchester collection and its strength in British art of all periods.

It was sixty years, however, between the foundation of the Manchester Institution and the opening of the Manchester City Art Gallery, which had been offered to the city in 1880, though with two important conditions, that the city should spend £2,000 a year for twenty years on acquisitions, and that seven of the twenty-one members of the art gallery committee should be nominated by the Institution's governors.

The history of the art gallery over the half-century following its opening is one of wrangles over space, site, the possibilities of a new building, or of additions to the old one. There were different schemes which continued for many years unresolved. One of the schemes was simple enough: to complete the purchase of buildings behind the art gallery, some of which had been acquired as far back as 1898, but had not been developed because of extensive arguments about a possible library and art gallery complex. It was not until 1938 that the purchase of the Athenaeum Club gave to the art gallery the whole block of buildings behind the Grecian façade of 1823, but then the war intervened, and the majority of paintings were moved to Wales for safety, the buildings being used for various war effort purposes.

The collection of modern art, though it contains interesting continental and British works, has suffered in the past from being poorly housed and perfunctory in its presentation. It gives way to temporary exhibitions from time to time, and shows signs of space pressures which are constantly the problem of public galleries throughout the British Isles.

The story of the physical vicissitudes is worth giving, not only because of the fact that its tortured nature is common to many such institutions, but also because, in the case of Manchester, it cost the city at least one fine collection of art, the Gresham Collection, which went elsewhere because the condition of the bequest included stipulation that a new building should be erected within five years of James Gresham's death. An even greater collection, that of Constantine Ionides, who was born in Cheetham Hill, Manchester, might have come to the city. Instead, its thousand or so works, including paintings by Botticelli, Rembrandt, Le Nain, Delacroix and Degas, went to the V & A.

Manchester acquired other galleries. Its parks department opened Queen's Park Art Gallery in 1884, transferred to the City Art Gallery in 1906. (This is not open at present.) In 1923 Fletcher Moss, a city alderman, left the Old Parsonage, Didsbury, to the city, and it was opened as an art gallery, named after him. Two years later Platt Hall, which was threatened with demolition, was restored by the city, and became a fourth branch gallery, though primarily as a costume museum; and in 1930 Wythenshawe Hall became a fifth branch gallery, though mainly for furniture.

The Manchester City Art Gallery has had many benefactors. Among them should be mentioned Charles Rutherston, brother of Albert, and of William Rothenstein, who carried on the family business in Bradford, and collected works by his contemporaries, including Gwen and Augustus John, Paul and John Nash, Sickert, Beerbohm, Conder, Roberts, Epstein and Pissarro. The splendid Holman Hunt, *The Lady of Shalott*, was given to the gallery by John Edward Yates, who also presented works by Lord

Above:
DANIEL MACLISE
A Winter Night's Tale
Manchester City Art Gallery

Right:
WILLIAM HOLMAN HUNT
The Hireling Shepherd
Manchester City Art Gallery

WILLIAM ORPEN
Homage to Manet
Manchester City Art Gallery

Leighton and Alma-Tadema. James Thompson Blair presented the gallery with some excellent Turner watercolours, supported by works by Cox, de Wint, Varley and Copley Fielding.

The collection is well represented in all periods. There is a particularly fine Stubbs, *Cheetah and Stag with Two Indians*, a pleasant Gainsborough of a peasant girl, the original sketch for Holman Hunt's *The Light of the World* (which is in Keble College, Oxford) and some good French and Dutch paintings. *A Winter Night's Tale*, a lovely, wholesome work by Daniel Maclise, somewhat in contrast with the atmospheric pressures of the Pre-Raphaelite glut, is also to be seen. Another Irish artist, William Orpen, is represented by one of his most important works, *Homage to Manet*.

THE WHITWORTH ART GALLERY

One of the great university collections in these islands is at Manchester. The Whitworth differs from the Fitzwilliam or the Hunterian, since it was given to the University of Manchester only in 1958, following periods of administrative and financial difficulties. Yet it was linked to the university from its beginnings through the benefactions of Sir Joseph Whitworth's legatees. The university benefited from the terms of his bequest and the Gallery was founded in his memory.

Certain periods in the history of the Whitworth have not been happy. Indecision and uncertainty about its aims, inadequate resources and under-staffing have all been chronic problems at one time or another. Nevertheless, from the start, it acquired watercolours of exceptional quality, beginning with its own purchases of works by Turner, de Wint, Cox, Prout and J.R. Cozens, followed by donations from the distinguished collection made by John Edward Taylor, which includes the Whitworth's most famous watercolour, Blake's *The Ancient of Days*. Taylor, who was proprietor of the *Manchester Guardian*, gave over 150 watercolours to the collection, including many of major importance.

The Whitworth remains outstanding for its watercolours and drawings, as well as its extensive collection of prints. Not only is the great English art of watercolour painting comprehensively represented in the Gallery, but it possesses some of the best-known masterpieces in the medium, such

PAUL NASH
Whiteleaf Cross
Whitworth Art Gallery,
Manchester

WILLIAM BLAKE
The Ancient of Days
Whitworth Art Gallery, Manchester

as Thomas Girtin's splendid *Durham Cathedral and Bridge from the River Wear* and Turner's imposing *Chapter House, Salisbury Cathedral*.

The Gallery owns fewer oil paintings, as a conscious policy of purchase in this field has only been adopted since the Whitworth came under Manchester University. It is to be hoped that this augurs well for the future and that the Gallery will continue to add to its particularly fine collection of twentieth-century British oils, which already includes important works by Bacon, Freud, Hodgkin, Nash and Nicholson.

SALFORD AND LOWRY

The city of Salford is inescapably linked with L.S. Lowry, a large collection of whose work is held in the Salford Art Gallery. The Salford Lowry collection is the largest permanent one in existence, and derives in no small measure from the sympathy between the artist and both borough and library staffs, with whom he enjoyed a close friendship. The collection is remarkably rich, ranging from early oil portraits of the artist's parents to the late and familiar mill and street scenes.

LAWRENCE STEPHEN
LOWRY
The Fight
Salford Art Gallery, Greater
Manchester

LAWRENCE STEPHEN
LOWRY
Self-Portrait
Salford Art Gallery, Greater
Manchester

The earlier works are better, notably *The Fight*, painted in 1935, the *Self-Portrait* of ten years earlier, and the pre-First World War sketches of his parents.

The twentieth-century paintings at the gallery include important war works by William Roberts, his *The Control Room* and *The Munitions Factory*, as well as good examples of Matthew Smith, Vanessa Bell, Walter Sickert and Duncan Grant.

THE ART GALLERIES OF
—————— LANCASHIRE ——————

In Lancashire there are art galleries in Blackpool, Blackburn, Bury, Chorley, Preston, Lancaster, Burnley, Rossendale and Accrington, all with small collections, mainly of Victorian and Edwardian paintings.

The Harris Museum and Art Gallery, in Preston, is the most considerable of them. It was built with a substantial bequest of £300,000 in 1877, by Edmund Robert Harris, and received two important bequests, in 1883,

ARTHUR DEVIS
Francis Vincent and Family
Harris Museum and Art Gallery,
Preston, Lancashire

from Richard Newsham, a mill owner, of mainly nineteenth-century oils and watercolours, and then, in 1924, from the clergyman John Haslam.

Such Victorian blockbusters as Francis Danby's *Pharaoh and his Hosts Overwhelmed in the Red Sea*, *The Judgment of Daniel* by J.R. Herbert, and William Etty's *By the Waters of Babylon We Sat Down and Wept* are representative of the works which came to Preston.

Arthur Devis was born in Preston, and works by him are in the collection, among them his group portrait of the Vincent family. There are also works by his brother, Anthony, and his son, also Arthur.

Burnley's Art Gallery, at Towneley Hall, dates from the early years of the twentieth century, and is mainly British, with a small group of late nineteenth-century French works.

Rossendale Museum is also nineteenth century, with a local emphasis in the collection. This is also the case with the Lancaster City Museum's collection, as well as that of Accrington, at the Haworth Art Gallery.

THE ART OF YORKSHIRE AND
———— HUMBERSIDE ————

The character of many of the collections east of the Pennines is similar to those already considered to the west, with strong emphasis on British art in the twentieth century, and on 'High Victorian' and Edwardian genre painting as its basis. But individual galleries in the area offer remarkable divergences from this general fare, in particular the collections in York, Hull, Leeds, Bradford and Sheffield.

In addition to the two galleries in Sheffield, the Mappin and the Graves, South Yorkshire also has an extensive art collection in Rotherham, mainly at the Brian O'Malley Arts Centre, but also at Clifton Park Museum, an elegant eighteenth-century house which is shown in the background to the English School portrait of Joshua Walker, the original owner.

In Barnsley, at the Cooper Art Gallery, the more general civic collection has been enriched by gifts from Sir Michael Sadler.

The main art galleries in West Yorkshire, in addition to the excellent collections in Leeds and Bradford, are those in Halifax, Brighouse, Huddersfield and Wakefield. For want of space their collections of nineteenth- and twentieth-century art, mainly British, is only partially seen, and at times is crowded out altogether by alternative or temporary exhibitions; a great pity, since local Yorkshire landscapes by Henry Raphael Oddy, in the Smith Art Gallery, in Brighouse, for example, are worth walls full of the blank canvases trundled round the countryside by branches of the Arts Council. Men like Sir John Champney, who left works to the Halifax Museum, or Alderman Smith, after whom the Brighouse Art Gallery is named, did not intend their heritage to be so frequently put in store.

Huddersfield Art Gallery's collection is mainly twentieth century, with a reasonable mixture of mainstream British works and paintings by local artists. The range is from Sickert's *View of Ramsgate*, at the beginning of

the century, to John Bratby's *Portrait of Paul McCartney*. There is a good collection of watercolours by Philip Wilson Steer.

Wakefield is a bit like Rochdale, emphasising modern art, and actively collecting contemporary British painting. It has good examples of the sculpture of Henry Moore, who was a Yorkshireman from Leeds, Barbara Hepworth and Elizabeth Frink.

The great stretch of North Yorkshire, from Harrogate in the west to Scarborough on the east coast, and then Whitby even further north, contains few collections outside the York City Art Gallery. Atkinson Grimshaw's gloomy vision is to be found in Scarborough and Harrogate, along with the odd conjunction of Herring and Frith, while in Whitby the Pannett Art Gallery, named after the alderman who left money for the building, contains a watercolour collection.

Humberside embraces not only Hull, which has the most important gallery in the area, but also the galleries in Scunthorpe, Wrawby Moor, and Grimsby, all once in Lincolnshire. There are also galleries in the area at Beverley, Bridlington and Goole. Normanby Hall is a house managed by Scunthorpe Borough Council and furnished in an appropriate Regency style.

There is an interesting and unusual collection of modern art at Burton Agnes Hall, formed by the owner, Marcus Wickham-Boynton. It is refreshing, modern and varied, containing examples of some of the main Impressionist and Post-Impressionist artists, from Boudin on. They hang in the eighteenth-century elegance of the Upper Drawing Room, in the Library, and in the Long Gallery; Renoir, Cézanne, Utrillo, Gauguin, Pissarro, Derain, Matisse, Vlaminck and Bonnard are all represented. There are works also by lesser known artists such as Henri Lebasque and Maximilien Luce.

The splendid, bold composition of *Women Resting* is the work of André Minaux, born in 1923, who is also responsible for *Church at Salins*. He exhibited at the Tate Gallery in 1955 with Ginette Rapp, two of 'Four Realists'. *The Potato Gatherers*, by the latter artist, is also in the collection.

In addition, there are more formal portrait and family collections at Burton Constable Hall and Sledmere House. Carlton Towers, the Yorkshire home of the Duke of Norfolk, contains mainly religious works, some of them important. These form the Tempest Collection, which came from Broughton Hall.

——— HOUSES IN YORKSHIRE ———

Yorkshire, North, South and West, is also rich in great houses, where the art collections are substantial. These include Beningbrough, Castle Howard, Norton Conyers—particularly for sporting pictures—Harewood House, Lotherton Hall and Nostell Priory, all of which are separately mentioned.

In addition, the following collections should be noted. At Constable Burton Hall, not to be confused with Burton Constable Hall, also in

Yorkshire, there are Wyville family pictures, including some interesting Italian and Dutch works. The paintings were collected in part during the eighteenth century, but a number were acquired from Denton Hall, near Otley, the Ibbetson family home.

At Newby Hall is the conventional Grand Tour collection of William Weddell, who was ambitious in his taste, and also had his full-length portrait painted, as so many did, by Batoni.

There are some interesting Sheffield family pictures at Sutton Park. Once Dukes of Normanby and Earls of Musgrave, the family moved from Normanby Hall, in Humberside (q.v.). It is possibly from this house that the Gainsborough portrait of *Lady Sheffield* at Waddesdon Manor (q.v.) originally came.

Cannon Hall, which is managed by the Metropolitan Borough of Barnsley, contains Dutch and Flemish art in a house which is really a museum. The collection was gathered together by William Harvey from Barnsley, who died in 1867. His collection was inherited by his nephew, who was from Leeds, and who made over the entire collection to the nation in 1917.

There are 54 paintings, 46 of which are Flemish and Dutch, the remainder Italian, French and English. Initially administered by its own Trust, as a National Loan Collection, which ensured that the paintings went on touring exhibitions around the world, and were seen in South Africa, New Zealand, Australia and Canada, it was later decided, on account of cost and security, to place them on long loan at Cannon Hall.

With the exception of the greatest of the Dutch and Flemish masters, such as Vermeer, Rembrandt, Hals and Rubens, the collection is reasonably representative of the period from 1610 to 1750. A more general collection of portraits, including work by Philip Mercier, who settled for a time in Yorkshire, is also at Cannon Hall.

LEEDS CITY ART
GALLERY

The Leeds City Art Gallery is one of the most impressive municipal collections in these islands. Its particular strength is in early twentieth-century art, and the nucleus for this came from the bequest of Sam Wilson, a local clothing manufacturer who served on the art committee of the gallery and left his collection to the city in 1918.

It provided a firm foundation for concentrating the collection on English painting of the twentieth century, and Leeds possesses splendid examples of Gwen John, Frank Brangwyn, Harold Gilman, Charles Ginner and Spencer Gore, as well as fine examples of Walter Sickert and George Clausen. Wilson also left a group of William Orpen's early works, including at least three masterpieces, *Lottie of Paradise Walk*, *The Red Shawl* and *A Woman*.

From a slightly later period comes Wyndham Lewis's *Praxitella* and

works by Innes, Gaudier-Brzeska, Bomberg, Roberts, Nevinson, Moore and Wadsworth.

The gallery itself was built in 1888, with £10,000 from the Queen's Jubilee Fund. Money from this was used for purchases and the city handed over pictures it already had. These derived from gifts made following the suggestion for an art gallery, made at the time of the opening, by Queen Victoria, of the Leeds Town Hall in 1858.

BEN NICHOLSON
Painting 1940
Leeds City Art Gallery

MARCO RICCI
Seascape
Leeds City Art Gallery
(Temple Newsam House)

The gallery has good English painting from earlier periods, a representative collection of French nineteenth- and early twentieth-century art, and a selection of continental painting back to Guido Reni, Giorgio Vasari and Matthias Stomer, whose *Adoration of the Shepherds* became part of the collection. This was later enriched by Lord Halifax's gift of Ingram family paintings which, together with the earlier works owned by the city, are now mainly hung in Temple Newsam House. Leeds also has a fine resource for research in its prints and drawings room. In 1982 the Henry Moore Centre for the Study of Sculpture, together with the Moore Sculpture Gallery and the Craft Centre and Design Gallery, was opened in a major new extension largely financed by the Henry Moore Foundation.

HAREWOOD HOUSE

The Harewood House collection contains interesting Venetian paintings, including works by Titian, Tintoretto, Veronese and Bellini, though recently one of the two works in the collection by this artist was sold.

Works have been sold from Harewood over the years, perhaps the most famous being Titian's *Death of Actaeon*, now in the National Gallery in London. This painting, originally destined for the Paul Getty Museum when it sold for £1.6 million in 1971, having hung in the Trafalgar Square Gallery for the previous ten years, was the subject of a major appeal, and, with Government assistance, was eventually acquired for the State.

The main collection came to Harewood House in the twentieth century. The house itself dates from the late eighteenth century, and its early owners were quite modest in their collecting habits, though Edward Lascelles, the First Earl of Harewood, who inherited from his childless cousin, did bring some good pictures. His son, who died before him,

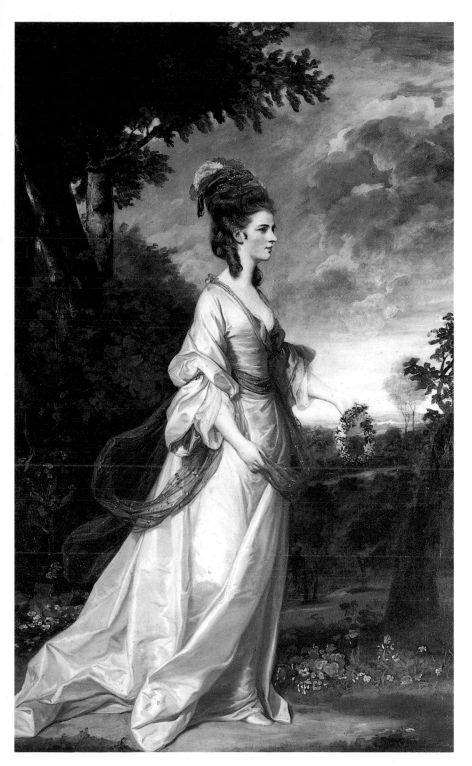

JOSHUA REYNOLDS
Jane, Countess of Harrington
Harewood House

commissioned works by Turner and Girtin, but for the rest of the nineteenth century little was added.

It was the Sixth Earl, well before he inherited the title in 1929, who was responsible for the core of the fine art acquisition. He was a Grenadier Guards officer in the First World War, and met, quite by chance, on leave in London in 1916, his great-uncle, the Marquess of Clanricarde, George Canning's grandson. When this elderly, eccentric recluse died, not long after, he left 'a fortune to the not very rich Lord Lascelles, together with the derelict Portumna Castle, in Ireland, and a fine collection of Italian and Flemish paintings.

To these the Sixth Earl added Italian works of his own choosing, and the Rose Drawing Room contains some of what is left of the combined acquisitions of these two men, including works which once belonged to William Beckford and to Robert Browning, including Catena's *Saint Jerome*.

The many full-length family portraits which hang in the Gallery and the Dining Room are particularly striking, notably the two by Reynolds of *Jane, Countess of Harrington* and *Lady Worsley*.

CARTWRIGHT HALL,
———— BRADFORD ————

The Bradford City Art Gallery is in an impressive, neo-baroque building, in the French style, put up largely at the expense of Lord Masham as a memorial to Edmund Cartwright, the inventor of the power loom, after whom it is named. It opened in 1904, in Lister Park. In addition, the art gallery has paintings in Bolling Hall, a seventeenth-century house remodelled late in the eighteenth century, and containing mainly portraits and English eighteenth-century landscapes.

The collection is impressive. Large Victorian and Edwardian canvases, often of romantic subjects taken from myth and legend, and invigorated by the faintly hot-house, turn-of-the-century imagination, fill the walls of the spacious Edwardian rooms. An aura of eroticism surrounds works like Edwin Long's *An Egyptian Feast* or Herbert Draper's *The Golden Fleece*.

Bradford escaped, if that is the word, too close an association with the Pre-Raphaelite Movement, and the works generally have a less obsessive atmosphere than in other, earlier collections. There is, however, *Wycliffe Reading his Translation of the Bible to John of Gaunt, in the Presence of Chaucer and Gower* by Ford Madox Brown. The momentous event of printing in England, associated with Wycliffe, also attracted Daniel Maclise, whose somewhat dramatic version is at Knebworth House (q.v.).

There is a good general collection of British art, from the early years of the New English Art Club onwards. Among artists who came from Bradford are William Rothenstein, a dedicated supporter of the NEAC, and David Hockney. The collection includes several works by the former, and *Double Portrait*, as well as *Le Plongeur*, by the latter.

In their childhood, the Rothensteins walked in the park in which the

Above:
HERBERT DRAPER
The Golden Fleece
Cartwright Hall, Bradford

Left:
WILLIAM ROTHENSTEIN
The Browning Reader
Cartwright Hall, Bradford

gallery was subsequently built. His lovely painting, *The Browning Reader*, is in the collection, together with the powerful *Old Quarry, Hawksworth, Bradford* and *Self-Portrait*.

The Cartwright manages to combine light-heartedness with grandeur; its fine open setting in a well-kept civic park, its vaguely baroque architecture, then the huge canvases upstairs, all manage, against one's expectation, to avoid the gloomy self-importance which seizes upon other northern galleries.

YORK

WILLIAM ETTY
Mademoiselle Rachel
York City Art Gallery

DOMENICHINO
Portrait of Cardinal Agucchi
York City Art Gallery

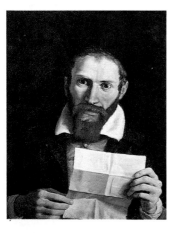

The York City Art Gallery has a well-balanced and comprehensive collection. It has good Italian, Flemish, Dutch and German paintings, a reasonable collection of British art, and representative works of local artists, of whom easily the most significant is William Etty, whose plump and frankly erotic nudes gaze dewy-eyed out of his canvases. These fill a complete room. Etty was born in York, and died there in 1849. He painted compelling portraits, notably that of *Eliza Felix* and the French tragic actress, *Mlle Rachel*. His *Bridge of Sighs* is also an interesting work. But his fame as a painter rests on such subjects as his *Reclining Female Nude*.

The York Gallery contains far more substantial work, however, and its quality and range as a collection of paintings is very largely the result of one man's generosity, F. D. Lycett Green, who in 1955, in what was referred to as the gallery's *annus mirabilis*, gave his collection. Following the gift, the whole collection was catalogued, in two volumes, followed by a third for the reserve collection, and then a supplement outlining the changes in attribution which had followed upon the considerable researches into Lycett Green's vast gift.

Until then, the gallery was undistinguished, and evoked no civic pride. It was founded following the second Yorkshire Fine Art and Industrial Exhibition of 1879, which produced the building, the York Fine Art Institution, bought by the City of York in 1890, by which time the only collection of importance acquired by York in the nineteenth century, John Burton's bequest of Victorian paintings, had already been received.

Burton was a sensible, unadventurous collector, which probably accounts for the absence of Pre-Raphaelite works, but from which, for example, came the pleasant De Loutherbourg seascape. The City of York allowed the gallery to stagnate for many decades, but possibly its devastation by bombing in the Second World War brought about a change of attitude.

Two other benefactors are worth mentioning, Dr Walter Evelyn, whose local watercolours of York, as well as prints, were acquired in 1931, and the Dean of York, Eric Milner White, who gave a number of twentieth-century British paintings in the 1950s.

Among other important works Lycett Green was responsible for the Bernardino Fungai, *Saint Clement Striking the Rock*, and the Domenichino portrait, *Cardinal Agucchi*.

—— BENINGBROUGH HALL (NT) ——

The permanent exhibition of portraits at Beningbrough, which opened in May 1979, is the second joint venture by the National Trust and the National Portrait Gallery, and follows the success of the Montacute House (q.v.) exhibition, which opened in 1975 with a display of sixteenth- and early seventeenth-century portraits.

Considerable care has been taken by the National Portrait Gallery to give a cohesive picture of English history through the paintings, and in a well-documented and separate exhibition on the top floor a broad cross-section of portraits of writers, painters, actors, and other prominent figures presents clear evidence of the range and quality of the nation's huge holding in portraits.

The paintings at Beningbrough are roughly contemporary with the early eighteenth-century house, and are of outstanding quality, particularly the Kit-Cat portraits which hang mainly in the Dining Room, and are in fine carved giltwood frames.

In keeping with the period of the house, a careful selection of baroque and Palladian period portraits has been chosen, with the additional interest of literary and artistic figures, as well as politicians and public figures.

Some works in the house are original, among them the overdoors, as well as a portrait of the wife of the builder of Beningbrough, *Mary Bourchier*, thought to be by Richardson. Several other portraits and works of sculpture are also the property of the National Trust.

The National Portrait Gallery pictures include a number of interest to those following the theme of collecting and of taste. Among them are the *Self-Portrait* by Jonathan Richardson, an early writer on art and taste, and a collector of Old Master drawings, Dandridge's portrait of *William Kent*, architect, landscape gardener and designer, *Sir John Vanbrugh*, a portrait attributed to Thomas Murray, and a Studio of Van Loo portrait of *Robert Walpole, First Earl of Orford*, who built Houghton Hall, and whose grandson sold his magnificent collection of paintings and sculpture to Catherine the Great. Those works are incorporated in the Hermitage Collection in Leningrad.

CASTLE HOWARD AND THE FIFTH —— EARL OF CARLISLE ——

Frederick, Fifth Earl of Carlisle, was the member of the Howard family who most closely followed the Earl of Arundel, that 'Father of Vertu' who founded serious art collecting in the British Isles. The Fifth Earl was, with the Duke of Bridgewater and Lord Stafford, responsible for the purchase of the collection of the Duke of Orleans. This is commemorated by a group of paintings in the Orleans Room, at Castle Howard, including *The Artist's Mother* by Bassano and *The Duke of*

Ferrara, attributed to Parmigiano. Other paintings from the Orleans Collection were bequeathed to the National Gallery by the Ninth Earl of Carlisle in 1912.

The Duke of Orleans, Louis-Philippe-Joseph, or 'Philippe Egalité', perhaps misreading the situation in France and envisaging himself reaching the throne, or perhaps reading it only too well, sold his magnificent collection of paintings in 1792. The collection was bought by the three noblemen mentioned above, who exhibited and sold off sufficient paintings to make a profit, keeping the best for their own collections. This exhibition was held in 1798-9, in Pall Mall and the Strand. Angerstein bought the Sebastiano del Piombo *The Raising of Lazarus*, now in the National Gallery, in London.

The Fifth Earl, elegant and slightly foppish, is portrayed by Reynolds in the robes of the Order of the Thistle, in the Tapestry Room, where there is also a portrait of the Fifth Earl's mother, *Isabella Byron,* great-aunt of the poet, by Gainsborough.

In the Music Room is one of Francis Wheatley's Irish pictures, showing the Fifth Earl when Lord Lieutenant, riding in a phaeton in Phoenix Park. In the same room is Gainsborough's *The Girl with Pigs.*

The Hall at Castle Howard, a splendid example of Vanbrugh's burgeoning genius as an architect (the house was his first solo building), was severely damaged by fire in 1940, and much of the work is reconstituted. There are twentieth-century murals painted by Felix Kelly for the television production of Evelyn Waugh's 'Brideshead Revisited'. These remain to satisfy the curiosity of visitors, who increased substantially in numbers as a result of the dramatisation.

GRAVES, MAPPIN AND RUSKIN

Sheffield had three benefactors of note, John Graves, John Newton Mappin and John Ruskin. They all gave generously to the city; they are all remembered by galleries named after them, the first and last in the city centre, Mappin in a park on the outskirts.

To some extent the art gallery administration would like to escape the burden of two of the names. In both the Graves and the Mappin the collections of subsequent works are greater numerically than the original bequests. Coupled with this is the pressure to put on exhibitions, often at the expense of the permanent collections. When it has a chance to show through, what Graves gave, in the way of Pre-Raphaelite painting, Barbizon School works, as well as British painting of the nineteenth century, reveals great strength.

Mappin was a Rotherham brewer, and the gallery named after him, when not given over to the rather strained exhibitions which militate against looking at paintings without fuss, possesses a fine collection of nineteenth- and twentieth-century British art.

Ruskin's contribution, which began with the establishment, in the late

nineteenth century, of a museum for the working man, is now presented
in a small but well-organised museum near to the Graves Art Gallery,
and it includes other works by Ruskin and also works formerly owned
by him, among them *Turner on Varnishing Day* by William Parrott,
painted in 1846.

WILLIAM PARROTT
Turner on Varnishing Day
Ruskin Museum (Guild of
St George), Sheffield

—— LOTHERTON HALL ——

Lotherton Hall is ten miles east of Leeds, and now contains Francis Wheatley's *The Irish House of Commons*. He painted this interior view in June 1780, three months after the historic debate there on the repeal of Poyning's Law. It was during this debate that Henry Grattan made his famous speech to the effect that 'the people of Ireland are of right an independent nation and ought only to be bound by laws made by the King, Lords and Commons of Ireland'.

The painting was the subject of early controversy. Wheatley opened a subscription, intending to publish an engraving; he charged half-price to sitters. It was said that the artist, in order to fit in sitters who had been absent from the House, rubbed out others, or superimposed new likenesses over people who had paid subscriptions. Contrary to undertakings, the picture was not exhibited, nor was the promised print made from it. An engraving did not follow until the early twentieth century. The picture itself was disposed of by raffle, then passed through

FRANCIS WHEATLEY
The Irish House of Commons
Lotherton Hall, West Yorkshire

the auction rooms in London. It was in the collection of Sir Thomas Gascoigne by the early nineteenth century, and it is appropriate that it hangs at Lotherton Hall, together with other paintings from the Gascoigne collection.

Wheatley is an important figure in Irish art. Though he stayed in the country only four years, from 1779 to 1783, his visit coincided with stirring political events. His interest in these, and his determination to paint them, gave art some standing. It encouraged self-confidence, and to some extent helped to turn the tide of artistic indifference of which so many Irish artists felt they were the victims. Indeed, the later eighteenth century saw many famous painters and engravers establishing themselves in London, with considerable success, after neglect and indifference in Dublin and elsewhere in Ireland.

NOSTELL PRIORY (NT)

Nostell Priory has belonged to the National Trust since 1953. The builder of the house, Sir Rowland Winn, married a direct descendant of Thomas More's favourite daughter, which helps explain the presence of a version of Holbein's *Sir Thomas More and Family*. The original is thought to have been lost in a fire in Germany, in the eighteenth century.

The painting, thought by Roy Strong to be the work of Rowland Lockey, is intriguing in a number of ways, and has been the subject of much speculation about its various hidden meanings. The essential message offered by one expert, though bizarre, suggests that the Princes in the Tower, Edward and Richard, the young sons of Edward IV, were not murdered

After HOLBEIN
The Family of Sir Thomas More
Nostell Priory, West Yorkshire

by Richard III, their uncle, but survived under assumed identities, and that one of them married More's adopted daughter, Margaret. This information was allegedly transmitted to Holbein during his early years in England, when he was painting under More's patronage, and he painted the 'secret' message into the picture. But any serious consideration of Holbein's drawing, in Basel, for the now-lost painting, would discount any close relationship between original and copy. Holbein conceived a profoundly religious group or family portrait, the cohesion of which is lost in the Lockey version, which is quite stiff and quite differently motivated. The painting at Nostell Priory was painted in 1593 for More's grandson. But the controversy about the picture has grown recently, with increased belief in it as Holbein's work.

The house is otherwise an elegant and richly decorated eighteenth-century mansion, deriving from various talents, including Robert Adam's interior decoration, and Antonio Zucchi's decorative paintings. Zucchi was married to Angelica Kauffmann, whose self-portrait, *Angelica Kauffmann Hesitating between the Arts of Music and Painting*, is evidence of her early struggle between two careers; she had an exceptional voice, and played a number of musical instruments as well as being a talented artist. She chose the latter career, and painted this major work much later, recalling her youth.

THE FERENS ART GALLERY, HULL

The Ferens Art Gallery opened in 1927. Its main benefactor, Thomas Robinson Ferens, had worked for an art gallery for the city since early in the century, giving money for the purchase of paintings first, and laying down a not unreasonable basic principle for this in 1910, when the first gallery was opened: 'I am quite pleased with the choice of pictures up to the present and I hope the committee will always resist any temptations to buy any work that is not likely to be enduring in its influence.' Ferens went on to provide the main finance for the building of the gallery itself, and then left sufficient endowment to provide funds for picture purchases from then on.

FRANS HALS
Portrait of a Young Woman
Ferens Art Gallery, Hull

For more than thirty years a collection of portraits, landscapes, Old Masters, and local marine paintings was built up by Vincent Galloway, who was curator from 1929 until 1960. When he was succeeded by Michael Compton, modern works were introduced, while at the same time the improvement of the Old Master holdings went on, in particular with the purchase, in 1963, of the gallery's most important canvas, *Portrait of a Young Woman*, by Frans Hals.

The gallery has a good general collection of all periods in British art, a rather more eclectic representation from other countries, strong in Dutch and Flemish art, like York, but less rich in Italian and French painting. Dutch works include *The Expulsion of Hagar* by Barent Fabritius, van der Helst's *Portrait of a Girl* and an early fragment by Pieter Stevens from a series showing the seasons.

Another fragment, from an altarpiece, is *A Bishop Saint* by Bartolommeo di Giovanni, the earliest Italian work in the collection, dating from the late fifteenth century. Two *Annunciations*, one Venetian by Francesco Maffei, one from Paris by Philippe de Champaigne, demonstrate two seventeenth-century interpretations of the subject, both of them dramatic and rich in colour and movement.

The collection of British art, from the Elizabethan and Jacobean portraits of Marcus Gheeraerts and William Segar to the examples of painting and sculpture by David Hockney, Peter Blake, Bridget Riley and Barbara Hepworth, is comprehensive and stimulating.

A backbone of portraiture in the collection was laid down under the thirty-one-year curacy of Vincent Galloway, and includes such powerful works as Wyndham Lewis's *Self-portrait as a Tyro*, the Epstein bust *Isobel*, Albert Rutherston's *Portrait of the Artist*, and works by Frank Brangwyn, John Duncan Fergusson and Gerald Leslie Brockhurst.

The Dutch influence, reflected in the collection generally, was also responsible for the development, in Hull, of a tradition of marine painting which is well represented, particularly in the work of the early nineteenth-century Hull artist John Ward, whose *The Return of the William Lee* is one of a wide range of large and careful canvases about the marine life of the city and the Humber Estuary.

THE FAR NORTH OF
ENGLAND

The far north of England is something of a wilderness for fine art galleries, so that places like the Bowes Museum, standing rather starkly as it does on the outskirts of Barnard Castle in County Durham, are beleaguered by the great distances. It, with the Laing and Hatton Galleries, in Newcastle-upon-Tyne, the Carlisle Museum and Art Gallery, and the modest collections in Darlington, Middlesbrough, West Hartlepool, Sunderland, South Shields and Berwick-on-Tweed, are all there is until one crosses the Scottish Border, a distance of well over 100 miles north of Harrogate.

Only by travelling this wild and dramatic countryside, or savouring the sharp contrasts between cities like Newcastle and Durham, are the rewards of coming upon the Bowes collection, with its fine Spanish paintings, or the huge apocalyptic canvases by John Martin, in his home town, Newcastle, appreciated fully.

Some collections, like Darlington, are disappointing. Shortage of space is made worse by a certain defeatism about the permanent collection; any visiting or local art show seems preferable.

Hartlepool has an interesting collection of Victorian paintings, with an attractive example of Daniel Maclise's work, his *Sleeping Beauty*. There are good local maritime works.

The Middlesbrough Art Gallery, like Darlington, suffers from an inferiority complex about its permanent collection, which is strong in representation of British art of the twentieth century. Pasmore, Scott, Burra, Hitchens and Auerbach are represented by good examples of their work, and there is also an extensive collection of drawings.

The Preston Hall Museum, in Stockton-on-Tees, is very much a one-painting gallery. Its Georges de La Tour, *The Dice Players*, is kept, like the Holbein *Madonna* in Darmstadt, in a locked and shaded room, to be shown to visitors on application, and from the safety of a secular version of the communion rail. It is not to be missed, however, since it is one of only three works by the artist in public collections in Britain (the others being at Leicester and Hampton Court Palace).

The Hatton Gallery is also something of a one-picture collection. It is part of the University of Newcastle-upon-Tyne, and is notable principally for a modern work, *The Elterwater Merzbau* by Kurt Schwitters, the German founder of the Dada equivalent, MERZ, who fled from Nazi Germany to England. It was painted in 1947, in a barn near Kendal, Schwitters dying near there only a year later.

The gallery does also have some early Italian paintings, as well as twentieth-century English works. There is a self-portrait by John Linnell.

There are several important country house collections, the greatest of which is at Alnwick Castle, the northern home of the Duke of Northumberland, separately noted.

One surprise is how rich in Pre-Raphaelite art this northernmost county in England is. There are two houses which not only have good

collections but have important associations with Pre-Raphaelite painters and with the intense debate and association inevitably found with the impact of the Brotherhood.

Durham County has one country house collection of interest at Raby Castle, mainly of fine sporting paintings. It was probably begun by the First Duke of Cleveland (1766-1842) and was added to by the Ninth Lord Barnard. Works include paintings by Ben Marshall, John Wootton and Francis Sartorius. There is J.F. Herring's *The Raby Stableyard with Ponies*, and H. B. Chalon's *The Raby Kennels*, a large landscape filled with hounds.

The castle itself is an extensive, nine-towered, medieval structure, and may have incorporated part of Cnut's stronghold, traditionally in Staindrop, the nearby village.

The collection at Holker Hall, in Cumbria, is largely the work of Sir William Lowther, who was the eighteenth-century owner. He was the patron of several artists, among them Reynolds, whom he knew in Rome. Reynolds painted the caricature of Lowther with three other Englishmen which hangs in the Billiard Room.

Sir William was also responsible for acquiring a pair of Vernet sea-pieces, only one of which, *Storm at Sea*, survived the fire in the house in 1871. He was a friend of Thomas Patch, who helped him purchase Claude's largest landscape, *Landscape with Apollo and the Muses*. The painting now hangs in the National Gallery of Scotland.

Callaly Castle, in Northumberland, has an interesting collection, and did once have the Forman Collection of classical sculpture. But the greater part of this was sold to the British Museum in 1899.

——— ALNWICK CASTLE ———

Alnwick Castle, in Northumberland, contains the greatest privately owned art collection in the north of England, and one of the finest in these islands.

The castle has been the property of the Percy family—with occasional breaks during royal displeasure, attainder, debt, and disruption in the line of descent—since the early fourteenth century. Historically, its position and strength have been critical factors over many centuries, and the Earls, later Dukes, of Northumberland have played a central role beside various monarchs, most notably Hotspur's in bringing Henry IV to the English throne, though Hotspur never succeeded to the earldom. He subsequently died at the Battle of Shrewsbury, in the Percy rising against the King.

The family own Syon House, across the River Thames from Kew Palace (q.v.), and did own Northumberland House, on the site of Northumberland Avenue, which runs from Trafalgar Square towards the Embankment, in London. Both houses are the subject of fine canvases by Canaletto in the Music Room and the Guard Chamber of the castle. There is, in addition, a very lovely view of the castle by the same artist, though one which reduces this great northern stronghold almost

CANALETTO
Alnwick Castle
Alnwick Castle, Northumberland

to toy proportions. The elegant, eighteenth-century figures near to the walls look quite capable of hopping over them.

Close to the painting of Syon House, in the Guard Chamber, is a portrait of *The Duke of Somerset*, the 'Proud Duke', who married Lady Elizabeth Percy, heiress to the Eleventh Earl. The main Percy home, for a generation, was Petworth; but this then passed to the Wyndham branch of the family, the Duke of Somerset's heirs taking the name of Percy once again, and the Northumberland estates. Algernon, the Tenth Earl, who was made Lord High Admiral of England at the age of 36, is the subject of one of Van Dyck's most impressive full-length portraits, also in the Guard Chamber. He was powerful, efficient and honest, but fell out with Charles I, with whose policies he disagreed, and, failing to join the Royal Cause at York, on the outbreak of the Civil War, was dismissed. He was a distinguished collector of paintings and a generous patron of Van Dyck's work. Clarendon said he was the proudest man alive.

A prouder man was to follow, in the Sixth Duke of Somerset, who

married the Tenth Earl's granddaughter. Though he lived at Petworth—indeed, Alnwick was not occupied regularly until the improvements carried out in the second half of the eighteenth century—he was responsible for further acquisitions now at Alnwick, including the fine Dobson *Portrait of the Artist with Nicholas Lanier and Sir Charles Cotterell.*

It is in the Ante-Room, however, the first of the State Rooms in the Castle, that one sees the first of the great works for which Alnwick is famous, three Titians, including the *Triple Portrait*, a Tintoretto *Ecce Homo*, Palma Vecchio's *Lady with a Lute*, and part of a fresco by Sebastiano del Piombo. Titian's *The Bishop of Armagnac and his Secretary* was recorded in Northumberland House in 1671.

A fine *Self-Portrait* by Andrea del Sarto hangs in the Red Drawing Room, which also has works by Barocci, Tintoretto, and Guido da Siena, as well as a large early classical subject by Turner, *The Temple of Jupiter Panhellenios, Aegina.*

The collection has been principally created by three members of the family: the Tenth Earl, Algernon, 1602-68; the First Duke, 1750-86, and his wife; and the Fourth Duke, 1847-65. There is also a museum of antiquities at Alnwick Castle.

PRE-RAPHAELITE ART AT WALLINGTON (NT)

Wallington, in Northumberland, is a better-ordered and more hospitable house now than it was in the mid-nineteenth century, when it served as an oasis of Pre-Raphaelite cultural interest. This was its main period of importance, during the time when it was owned by Sir Walter Trevelyan and his wife, Pauline. He was a scientist; she, the daughter of a Suffolk parson, was artistically talented, attractive to men, and determined to be the patron of artists. She was herself a writer.

Ruskin was an early influence on her. It was from Wallington that, with his young wife, Effie, and the painter John Everett Millais, he set out on the ill-fated journey to Glenfinlas in the summer of 1853 when he lost his wife to Millais. There are numerous works by him in the house, and the Central Hall, designed by Dobson of Newcastle, and built in 1853-4, was copied from a plate in Ruskin's *Stones of Venice*.

This magnificent Victorian chamber, decorated by a variety of artists, including Ruskin and Lady Trevelyan herself, is a Pre-Raphaelite work of art. And the circumstances in which it was designed, and its decorations then researched, planned and executed, constitutes an interesting event in mid-nineteenth-century English art.

The work took place against a background of powerful artistic endeavour and in an environment which was eccentric. Augustus Hare, for example, writing of one of his visits, said of his lunch that it was 'as peculiar as everything else . . . Lady Trevelyan and her artists feeding solely on artichokes and cauliflower . . .' He said the house was like a 'great desert with one or two little oases in it, where by good management you may possibly make yourself comfortable'.

WILLIAM BELL SCOTT
The Building of the Roman Wall
Wallington, Northumberland

The Trevelyans were pretty eccentric about time, as well. David Wooster was invited to visit the house in 1855, to arrange the collections. In the end he stayed 22 years, becoming Sir Walter Trevelyan's secretary and a permanent member of the household.

It was an intellectually and artistically stimulating environment, however, and a vivid picture of the house as a hive of painting and writing and researching activity is summoned up by the fact of Lady Trevelyan, Ruskin, and other friends, engaging in the physical decoration of the central hall, to the designs of William Bell Scott.

Lady Trevelyan's interest in the Pre-Raphaelite Movement probably derived from Ruskin. Since Bell Scott was near at hand, working as head of the Newcastle School of Design, she commissioned him to decorate the house. She also introduced him to Ruskin. This was a failure, since the two men did not get on, but Bell Scott's involvement with her led to the Wallington decorations, described by Rossetti as 'most encouraging for the future of history painting in England'.

The subjects are all Northumbrian; the botanical decorations reflecting Sir Walter Trevelyan's interest in botany, and Ruskin's enthusiasm for naturalism in art. Different piers in the Central Hall were worked at by

different members of the group, including Arthur Hughes, who collaborated on more than one with Lady Trevelyan.

Other artists who were introduced to the project included Thomas Woolner, Alexander Munro and two women painters, Mrs Mark Pattison, later to become Lady Dilke, and Mrs Collingwood, who became involved in the project in 1905, when Sir George Otto Trevelyan asked her to complete the decorations in the Hall by painting two piers with sweet pea and dahlia.

CRAGSIDE:
PRE-RAPHAELITE ART (NT)

This house in Northumberland originally had a Pre-Raphaelite collection belonging to the great nineteenth-century hydraulics engineer William Armstrong. He later rivalled Krupps in the field of armaments, was raised to the peerage in 1887 and died childless in 1900. His architect for Cragside was Norman Shaw and Armstrong's taste in design and art was very much of the period. Unfortunately, the greater part of his collection was sold in 1910. Fortunately, however, sixteen paintings by Evelyn de Morgan and four by her uncle, John Roddam Spencer-Stanhope, have been lent to the National Trust by the De Morgan Foundation to be hung at Cragside. Portraits of Armstrong include one by Watts.

EVELYN DE MORGAN
The Garden of Opportunity
Cragside, Northumberland

Armstrong's own taste was more conventional. He bought Academy works, and the residue of what he owned indicates a susceptibility to overblown Victorian sentiment, present in works like *Faithful Unto Death* by H. H. Emmerson, which he once owned, and *After Chevy Chase* by Herbert Dicksee, which has been given to Cragside. Both feature the devotion of dogs to their masters.

There is an association with Wallington (q.v.), which is just 13 miles away, in the latter of these two works, which incidentally is based on a local ballad. In Lady Trevelyan's house Wallington, William Bell Scott's friezes illustrate the same subject.

The Evelyn de Morgan paintings are marginally sterner stuff. *The Hour Glass* is 'an echo of a movement in the Waldstein Sonata'; *The Little Sea Maid* comes from Hans Andersen; there are heart-sick abductions, guilt-ridden agonisings, and a good deal of diaphanous drapery.

Spencer-Stanhope works include *Patience on a Monument Smiling at Grief*, which includes a portrait, as 'Patience', of one of the two beautiful daughters of the Greek Consul-General in London, who were painted by Rossetti, Whistler and others.

THE LAING ART GALLERY, NEWCASTLE-UPON-TYNE

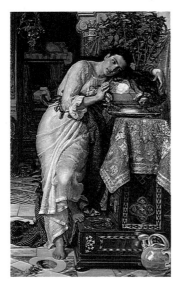

WILLIAM HOLMAN HUNT
Isabella and the Pot of Basil
Laing Art Gallery, Newcastle-upon-Tyne

The Laing Art Gallery has one of the best of the northern England collections, with most of the British Schools and periods represented, though with only a limited selection of continental art. It has a good representative collection of English watercolours. There is also an important oriental collection, including Japanese woodblock prints.

It was established in the same year as Cartwright Hall in Bradford, but without any initial bequest or gift of paintings. In building up its collection since then it has focused on Newcastle's own painter, the extravagant fantasist John Martin; on Victorian art, of which it has a broad and well-balanced collection; on twentieth-century British art; and on English watercolours, of which two minor exponents, Thomas Miles Richardson and J. W. Carmichael, are from the area. There are, in addition, a number of eighteenth-century portraits and landscapes, and some continental paintings.

John Martin's dramatic biblical works have a magnificent, apocalyptic quality which was enormously popular in Martin's own day, to the point of his being favourably compared with Raphael and Michelangelo. Works by him include *Belshazzar's Feast*, The Bard and *The Destruction of Sodom and Gomorrah*. There are good Pre-Raphaelite pictures, among them *Laus Veneris* by Burne-Jones and Holman Hunt's *Isabella and the Pot of Basil*.

JOHN MARTIN
The Bard
Laing Art Gallery, Newcastle-upon-Tyne

THE BOWES MUSEUM

The Bowes Museum was created by John and Josephine Bowes in the second half of the nineteenth century. They bought wisely, and not always too well; nevertheless, they assembled a magnificent collection which today constitutes that rarity: a major museum and art gallery in the English countryside, on the outskirts of the Durham market town Barnard Castle. Sadly, both founders were dead by the time the museum opened, in 1892.

The collection is housed in a huge, Second Empire-style building, looking for all the world like a French château, and indeed designed by a French architect, but it was intended from the start as a museum. One ascends towards the best of the fine art, which is on the second floor, in three large galleries and several other rooms.

The first floor is mainly given over to French and English decorative arts, in which appropriate paintings also feature in rooms arranged to suit the distinguished furniture. There is a Gothic Room, with an early *Crucifixion* by the Master of the Virgo inter Virgines, part of a triptych, and *Miracle of the Holy Sacrament* by Sassetta.

John Bowes was principally responsible for the paintings. He began collecting, before his marriage, and went on after his wife's death in 1874. Room 36 is given over entirely to Spanish School paintings, of

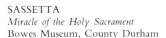

SASSETTA
Miracle of the Holy Sacrament
Bowes Museum, County Durham

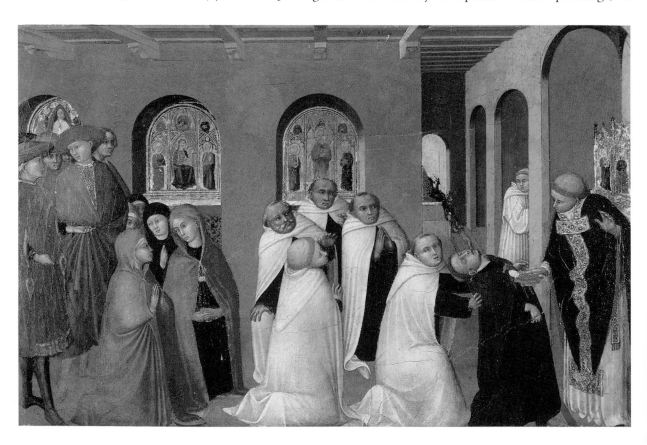

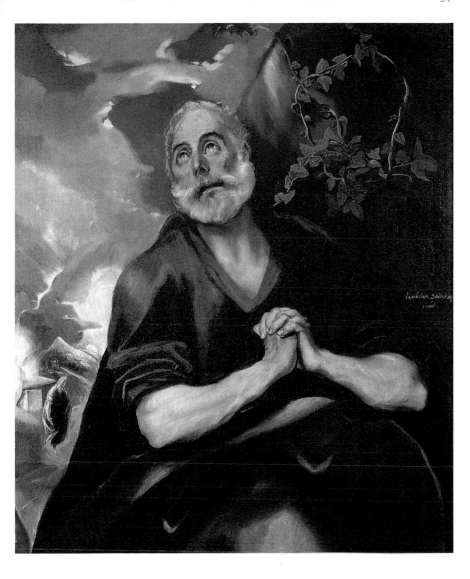

EL GRECO
Tears of St Peter
Bowes Museum, County Durham

which the Bowes Museum has a particularly good collection. It includes the magnificent El Greco *Tears of Saint Peter* and Goya's *Juan Antonio Meléndez Valdés*. There are canvases by Juan de Borgoña of the *Four Fathers of the Latin Church*, a *Saint Jerome* by Antonio de Puga, and Juan Carreño de Miranda's *Mariana of Austria, Queen of Spain*.

The collection is also strong in Italian and French eighteenth-century work, with a splendid Tiepolo, *The Harnessing of the Horses of the Sun*, and a fine Canaletto of a regatta on the Grand Canal in Venice. The Tiepolo was a preliminary sketch for a ceiling painting in the Archinto Palace in Milan. The Canaletto is one of a pair on loan to the Bowes Museum.

Eighteenth-century French works include Boucher's *Landscape with Watermill*, three imaginative landscapes, or 'Capriccios', by Hubert Robert and works by the neo-classical artist Taillasson.

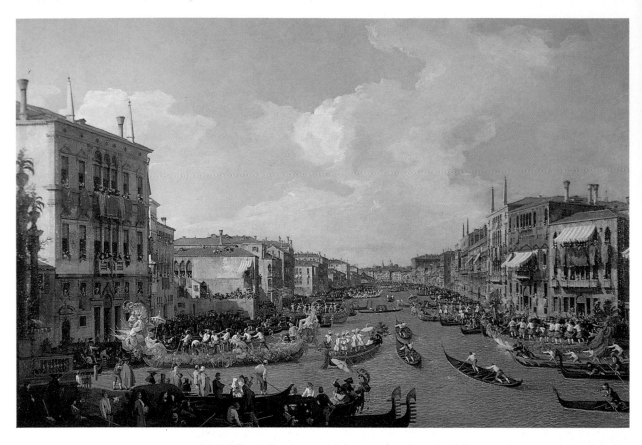

Above:
CANALETTO
A Regatta on the Grand Canal
Bowes Museum, County Durham

Right:
FRANÇOIS BOUCHER
Landscape with Watermill
Bowes Museum, County Durham

CARLISLE MUSEUM AND
ART GALLERY

The Carlisle Museum and Art Gallery dates back more than 100 years, with its true origins as early as 1834, when a Carlisle museum was established by the city's Literary and Philosophical Society. Before that, there had already been two eighteenth-century museums open to the public, though both of them were privately owned. The society's museum only lasted ten years. Nevertheless, works collected for it were kept, and became the nucleus for the present art gallery collection.

The Museum and Art Gallery opened in 1877 in the Academy of Arts, in Finkle Street. It soon outgrew the space there, and was then transferred to its present home in Tullie House. This Jacobean residence, the only house of its kind in Carlisle, came on the market in 1890, and was converted for museum use and opened in 1893.

The relatively modest collection of paintings was greatly augmented by the generous bequest, in 1949, of 600 works owned by the poet and playwright Gordon Bottomley. He had no direct connection with Carlisle. He lived at Silverdale, in Lancashire, near the Cumbrian border, and simply chose Carlisle as a 'northern' gallery to which to leave his collection.

His taste was discriminating. Included in the bequest were lovely examples of Samuel Palmer, *Harvest Moon, Shoreham*, Dante Gabriel

DANTE GABRIEL ROSSETTI
The Borgia Family
Carlisle Museum and Art Gallery

SAMUEL PALMER
Harvest Moon, Shoreham
Carlisle Museum and
Art Gallery

Rossetti, *The Borgia Family*, and works by Paul Nash, Ford Madox Brown, Arthur Hughes and Edward Burne-Jones.

In 1933 the Art Gallery commissioned William Rothenstein to advise on the buying of pictures, and he was responsible for the building up of a substantial collection of more modern works over a ten-year period. Other advisers who helped included Carel Weight, Edward Le Bas and Sir Roger de Grey. Works by Pissarro, Stanley Spencer, Walter Sickert and Lowry were among those acquired.

BRANTWOOD, RUSKIN'S HOUSE IN CUMBRIA

Cumbria has several country house and castle collections, including three associated with writers. These are Brantwood, which was the home of John Ruskin, Hill Top, the home of Beatrix Potter, and Wordsworth's home at Rydal Mount. In addition, there are substantial art collections at Muncaster Castle, Levens Hall, Hutton-in-the-Forest, Holker Hall and Dalemain. A more modest collection of paintings is at Belle Isle.

It is difficult, even now, to measure the full impact that John Ruskin had upon art and its appreciation during the nineteenth century. He expanded interest in it outside the narrow confines of the artist, the collector, the academic. And he did so without trivialising his subject or compromising his own intellectual integrity. He took art, sought out its social and human purposes, and applied to the results a set of fundamental principles most of which are still valid.

Brantwood, which overlooks Coniston Water, was his home from 1872 until 1900, the year of his death. He is buried in Coniston churchyard. He bought the house unseen, moved into it in 1872, and filled it with his art treasures, including Turners, paintings by the Pre-Raphaelites, and illuminated manuscripts.

The house passed into the hands of Ruskin's cousin and her husband. Between the First and Second World Wars the collection was sold off piecemeal.

Fortunately, John Howard Whitehouse, the founder of Bembridge School on the Isle of Wight, was an extensive purchaser, and managed to build up a large Ruskin collection. Subsequently, he managed to buy the Brantwood Estate and establish a trust to manage it as a Ruskin Memorial.

The house has a large collection of his paintings and drawings, together with work by his associates Collingwood, Severn, Burne-Jones, Albert Goodwin, Samuel Prout and others.

Works of interest include W. G. Collingwood's *John Ruskin in his Study at Brantwood*, a Ruskin self-portrait and *Ruskin's Bedroom at Brantwood* by Arthur Severn.

Fine Art in The Midlands Region

The works of art of the old masters and the modern paintings should be exhibited TOGETHER; the latter should on no account be taken away to make room for the former. Our landscape painters should be forced to stand the competition with Ruysdael and Claude; our historical composers with Carracci, Domenichino, Guido and Albano; our portrait painters with Titian and Van Dyck. Till this is the case, the marked inferiority of modern art will never become generally felt, nor the lucrative mediocrity of modern indolence ever adequately censured.

Blackwood's Edinburgh Magazine, 1836

THE GEOGRAPHY OF THE MIDLANDS

The thirteen counties in the Midlands Region, stretching from Wales to East Anglia and from the Peak District in Derbyshire to the Thames Valley, combine mainly farmland with certain heavy concentrations of industry, the largest by far being that which makes up virtually the whole county of West Midlands, the Birmingham area. It has been extensively represented, in all its diverse characteristics, by British artists over three centuries, and not always with a modern interpretation of 'spoilt' and 'unspoilt' beauty; at the time of the Industrial Revolution, the wonders of smelting and forging attracted great artistic endeavour. And since then, industrial subjects, like war art, have attracted many talented painters.

The region is drained by three rivers: the Trent, the Avon and the Thames. There is only one coastal county, Lincolnshire, and the highest land is in the Peak District to the north, which also constitutes one of the areas of great natural beauty. Others are the Cotswolds, the Malvern Hills, the Wye Valley, and areas of Shropshire and Lincolnshire.

Coal was the basis for much of the wealth of the Midlands towns, and led to urban areas the ugliness of which was in the sharpest contrast with

the surrounding countryside. But it did bring wealth, which to some extent has accounted for the outstanding concentration of art in Birmingham and elsewhere, and it did bring artists, whose interpretations are endlessly diverse.

Birmingham was the first provincial city outside London to open an art gallery, in 1867, coincidental with its commercial pre-eminence in the region. As well as the city gallery, Birmingham University has the Barber Institute of Fine Art, one of the more important Old Master collections established in the twentieth century.

Birmingham lies at the centre of the Midlands, and in the small and heavily populated West Midlands county. With the exception of the city museums of a limited number of major industrial cities north of Birmingham, the surrounding counties are sparsely provided with art galleries or major public collections. It is not until one reaches the southern edge of the area, in Oxford, that further collections in the first rank are to be found, this time as a result of the seventeenth-century concern to provide a collection for the university.

There are good municipal collections in Derby, Leicester, Nottingham, Warwick and Coventry; but great expanses of Lincolnshire, Hereford and Worcester, and Shropshire are without significant galleries.

The other great centre is Oxford, whose main museum, the Ashmolean, has already been discussed (see pp. 29-33). It has, in addition, the Christ Church Picture Gallery, with a number of significant early Italian works and an extensive collection of Old Master drawings given to the college in the mid-eighteenth century.

BIRMINGHAM CITY ART GALLERY

Birmingham City Art Gallery, the earliest to be founded outside London, has always been a Corporation gallery. Its management was financed out of the rates, its establishment was the product of civic pride and museum and art gallery legislation of the mid-nineteenth century, which itself was expressive of the growing commitment in the nineteenth century to better general education.

The Corporation, however, did not see fit to extend its benevolence to the acquisition of works of art until 1946, so that, for almost 80 of its 120 years, the gallery depended on gifts and bequests. Since that date, the purchase of major works, like the Giovanni Bellini and the pair of splendid Canalettos of Warwick Castle, have required the combined endeavour of industry, commerce, friends, the city, West Midlands County Council, Government grants and charitable trusts, as well as the Corporation.

As a gallery it is most famous for its Pre-Raphaelite paintings. It has major works by the principal members of the Pre-Raphaelite Brotherhood, as well as by artists associated with them, notably Arthur Hughes, whose *Long Engagement* is perhaps more subtle, less didactic, than many of the works of the more central figures. Major holdings in the works of Ford

JOHN EVERETT MILLAIS
The Blind Girl
Birmingham City Art Gallery

Madox Brown, William Holman Hunt, Dante Gabriel Rossetti and John Everett Millais are fully supported by a comprehensive collection of drawings.

The Blind Girl by Millais, Holman Hunt's *The Finding of the Saviour in the Temple* and his *Portrait of Rossetti*, as well as Ford Madox Brown's *An*

Above:
FORD MADOX BROWN
Pretty Baa-Lambs
Birmingham City Art Gallery

Right:
BOCCACCIO BOCCACCINO
*Virgin and Child with Saints
and Donor*
Birmingham City Art Gallery

MATTHIAS STOMER
Old Woman and Boy by Candlelight
Birmingham City Art Gallery

English Autumn Afternoon, *The Last of England* and *Pretty Baa-Lambs* are among the masterpieces of this intense and introverted group of men and their followers.

The British collection at Birmingham is generally good, though it lacks a major Turner or Constable. There are interesting examples of Italian art, including the early Simone Martini *A Saint Holding a Book* and Boccaccino's *Virgin and Child with Saints and Donor*, but the collection is uneven, with the emphasis generally on later works.

The gallery has a splendid *Nativity* by Hans Memling, and a tiny Petrus Christus, *The Man of Sorrows*, showing Christ with two angels, one with gentle face, holding a lily, the other angrily brandishing a sword. Among Dutch works is a Jan van Scorel, *Noli me Tangere*, a pleasant Matthias Stomer, *Old Woman and Boy by Candlelight*, and examples of Cuyp, Ter Borch and Ochterveldt.

THE BARBER INSTITUTE
OF FINE ART,
BIRMINGHAM UNIVERSITY

The Barber Institute is remarkable as a demonstration of how a major collection of paintings, with works from all the important European Schools, could be assembled in the mid-twentieth century. It is also an

enormous credit to the first and second directors, Thomas Bodkin and Ellis Waterhouse, who between them were responsible for the acquisition of 90 per cent of the paintings.

The present director, Hamish Miles, has been less fortunate in terms of resources, and also because of the steep rise in prices. The Institute is handicapped in this by the conditions laid down by Lady Barber, the original benefactor. Unlike that other great university collection, at the Courtauld Institute in London, the Barber is precluded from acquiring works other than by purchase. While it is the view of Hamish Miles that this was 'an act of vanity' on Lady Barber's part, it is also his view that 'nine-tenths of the dross of any museum comes to it through gifts and bequests', and on balance he welcomes the clause.

It has perhaps had the effect of freezing the Barber Institute in the past. Since its present director is also opposed to publicity, the superb collection is seen by fewer people than might otherwise be the case.

As an exercise in public collecting, however, the Barber offers a unique opportunity for the examination of taste, judgement, and the expenditure of resources in an unlikely period for great collecting opportunities, principally the years between 1935 and 1970.

If one examines only the paintings, of which there are something over a hundred, 60 were purchased by Thomas Bodkin, between his election as Professor of Fine Art in the University, in 1935, and his retirement in 1952. A further 50 were acquired by Ellis Waterhouse between 1952 and his retirement in 1970.

The Bodkin acquisitions include some of the greatest works in the gallery: the magnificent Poussin, *Tancred and Erminia*, the lovely Govaert Flinck *Portrait of a Boy*, Gainsborough's *The Harvest Wagon*, Manet's portrait of Carolus-Duran, Monet's *Church at Varengeville* and *Jockeys Before the Race* by Degas.

He also acquired such early and important Italian works as the Simone Martini *Saint John the Evangelist*, the Cima *Christ on the Cross with the Virgin and Saint John the Evangelist*, and the two Giovanni Bellini tempera paintings on wood, *Saint Jerome in the Wilderness* and *Portrait of a Boy*. Among early Flemish works, Bodkin was also responsible for the Jan Gossaert *Hercules and Deianira*, and the lovely fresh Rubens *Landscape in Flanders*, as well as the Jacob van Ruisdael *Woodland Landscape*.

His successor, Ellis Waterhouse, strengthened considerably the French eighteenth-century holdings, bought also the fine Aelbert Cuyp, *Huntsmen Halted*, and was responsible for a number of major English paintings, among them Van Dyck's *Ecce Homo*, Rossetti's *The Blue Bower* and Thomas Lawrence's *Portrait of a Lady*.

In the light of recent major acquisitions by the Courtauld, for example, the restraints left behind by Lady Barber seem inhibiting, since the considerable resources which were part of her legacy clearly have not stood the passage of time. The present director, in a period of fifteen years, has been able to add works of art at a rate of only one a year.

OTHER WEST MIDLANDS
COLLECTIONS

The Herbert Art Gallery, in Coventry, is named after Sir Alfred Herbert, who provided the money for the modern building. It opened in 1960, with John Hewitt as its first director. He collected twentieth-century British works mainly, and built up an excellent modern collection, which since 1972 has been further expanded under the keepership of Patrick Day.

Coming from Northern Ireland, he did acquire, for an English art gallery, an above average number of works by leading Ulster painters and sculptors, which gives to the collection a personal flavour. Some of the examples chosen, from the decade of the 1960s, which produced quite stimulating art in Northern Ireland, are outstanding.

The collection includes studies by Graham Sutherland for his famous cathedral tapestry, *Christ in Glory*, local watercolours and paintings, and a number of works depicting the Lady Godiva legend.

The Walsall Museum and Art Gallery contains the important Garman–Ryan Collection. This was formed by Jacob Epstein's widow, Lady Kathleen Epstein (née Garman), and her friend the American sculptress Sally Ryan. It consists of modern European and British art, and includes the work of friends such as Matthew Smith, Augustus John, Picasso and Braque, as well as some fifty works by Epstein. It is mainly figurative art, the works of a personal, intimate character quite often, but it does contain interesting works by Bonnard, Van Gogh and Matisse.

WILLIAM LEE-HANKEY
The Dancing Bear
Leamington Spa Art Gallery

There is a general collection of mainly nineteenth-century British art, with some Dutch paintings.

The Wolverhampton Art Gallery opened in 1884, its classical building paid for by Philip Horsman. The contents of the gallery, or money to buy them, came from other citizens, whose generosity never really caught up with the grandeur of the architecture.

Initially the collection was of nineteenth-century British art. Later, eighteenth-century works were acquired, and more recently an attempt has been made to form a collection of contemporary art, including works by Andy Warhol, Lichtenstein, Rosenquist and Caulfield.

Though the county of West Midlands is largely an urban sprawl, made up of Birmingham, Coventry, Walsall, Wolverhampton, Dudley and West Bromwich, it does have three houses of interest.

Wightwick Manor, due west of Walsall, has a collection which includes a number of important Pre-Raphaelite works. Aston Hall, owned by the City of Birmingham, has a collection which includes paintings related to the Holte family, previous owners, though their own collection was sold in 1817. It is maintained as an eighteenth-century period house. The third and most important country house is Hagley Hall.

This eighteenth-century house, with its rococo plasterwork, Soho tapestries and good period furniture, reflects the fact that it was largely the creation of one man, the First Lord Lyttelton (1709-73). He was a politician of some distinction, serving briefly as Chancellor of the Exchequer. It was after he was raised to the peerage, in 1756, that he pulled down the Elizabethan structure and built the present house in a style which derives its essential elegance from Colen Campbell's designs for Houghton Hall in Norfolk.

Lyttelton wrote that 'Athenian' Stuart 'has engaged to paint me a Flora and four pretty little Zephyrs, in my drawing room ceiling'; there is some possibility that Cipriani had a hand in the work. Throughout the house the period is reflected in the detail, Stuart also designing such things as candelabra.

The collection sustains the eighteenth-century atmosphere with interesting portraits, including an early Richard Wilson of *Admiral Sir Thomas Smith*, painted before the artist went to Rome. *The First Lord Lyttelton* is the subject of an austerely formal portrait by Benjamin West, giving no hint of his diverse interests and gregarious nature. He was a friend of Pope, who designed an urn in the grounds, of James Thomson, whose poem, *The Seasons*, contains a lengthy passage praising Hagley, and Horace Walpole, who wrote: 'I wore out my eyes with gazing, my feet with climbing and my Tongue and vocabulary with commending.' It is a familiar form of fatigue.

Earlier works of art in the house, notably the Van Dyck and Lely portraits, came to the collection as a result of the friendship of the Worcester royalist, Sir Thomas Lyttelton, with General Brouncker, whose portrait by Lely hangs in the Gallery, at the entrance to the Van Dyck Room. Brouncker was a founder-member of the Royal Society, and its president for seventeen years. He bequeathed works to Sir Thomas Lyttelton, uncle to the First Lord Lyttelton, whose father's marriage to Viscount Cobham's

sister was responsible for bringing further acquisitions to the house. Many of the seventeenth-century paintings have carved mahogany and boxwood frames, some carved by Thomas Johnson. One room celebrates Van Dyck and his school and includes *The Children of Charles I* and *The Second Earl of Carlisle*.

— COLLECTIONS IN DERBYSHIRE —

Joseph Wright no longer needs the addition to his name 'of Derby', which until recently was a vaguely pejorative term indicating the limited range of his reputation. In recent years he has been increasingly recognised for his talent and range as a painter, a process crowned in 1984, when the National Gallery paid £1.3 million for his portrait group, *Mr and Mrs Thomas Coltman*.

Fittingly, the Derby Art Gallery has a number of his works, including some of the most famous. The county, however, apart from the Derby City Art Gallery, is poorly provided with public collections, a situation rectified by the number of fine country house collections open to the public.

JOSEPH WRIGHT OF DERBY
Landscape with Rainbow
Derby Art Gallery

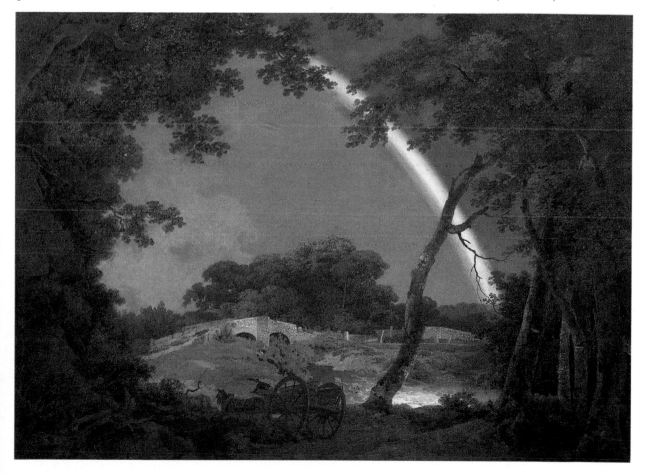

HARDWICK HALL (NT)

Hardwick Hall is the most remarkable Elizabethan house in England. The towering influence there of the woman who built it, Elizabeth Hardwick, Countess of Shrewsbury, dominates any visit. Virtually the whole of the collection reflects the history of the house, its first owner and her illustrious heirs, and the events which swirled around them, mainly during the turbulent reigns of Henry VIII, Edward VI, Mary I, Elizabeth I and James I.

Elizabeth Hardwick was the daughter and co-heiress of John Hardwick, a modest Derbyshire squire. Parts of his original house still exist in the Old Hall. She married, in succession, Robert Barley, Sir William Cavendish, who bought the Chatsworth estate, Sir William St Loe, and George Talbot, Sixth Earl of Shrewsbury.

She outlived her last husband, from whom she had separated after an irreconcilable quarrel. By the time of his death, in 1590, her combined wealth gave her an income estimated at £60,000 a year. She had already settled at Hardwick and begun building the hall. After her death her descendants, the Earls and Dukes of Devonshire, chose to make Chatsworth their principal home, and Hardwick Hall was little used. With the aid of sensitive nineteenth-century restoration work, it appears much as it was in the 1590s, with many of the original contents, including splendid tapestries, painted wall hangings, and embroideries. These, though outside the strict terms of reference of this book, are the decorative glories of the house. No comparable collection exists anywhere. Patchwork seems a derogatory term for some of the hangings, in all probability made from rich copes and vestments taken at the time of the dissolution of the monasteries. The greater part of this work is recorded in Bess's inventory of 1601.

The collection of portraits hangs in the Long Gallery, over the tapestries, with smaller ones in the Dining Room, above the panelling. Works by, or attributed to, Mytens, Larkin, Wissing, Dahl and Lockey record the associations between Bess and the families of her last three husbands, as well as Mary, Queen of Scots, who was for some fifteen and a half years entrusted to the care of the Earl and Countess of Shrewsbury.

Lady Arabella Stuart, Bess's granddaughter, and a claimant to the throne of England, is represented as a child in a portrait by an unknown artist, hanging in the Dining Room. A portrait of her as a young girl hangs in the Long Gallery, together with a group near to the High Great Chamber, of Bess, and two of her husbands. At the other end of the Long Gallery is a portrait of Queen Elizabeth, dating from about 1592 and showing her in a heavily embroidered dress.

Perhaps not inappropriately, there also hangs in the same room a portrait of the political philosopher Thomas Hobbes, who was tutor to the Second and Third Earls of Devonshire, and who died at Hardwick in 1679. His final utterance was: 'I am about to take my last voyage, a great leap in the dark.' It is a sombre comment on the multitudinous ambitions with which he is surrounded.

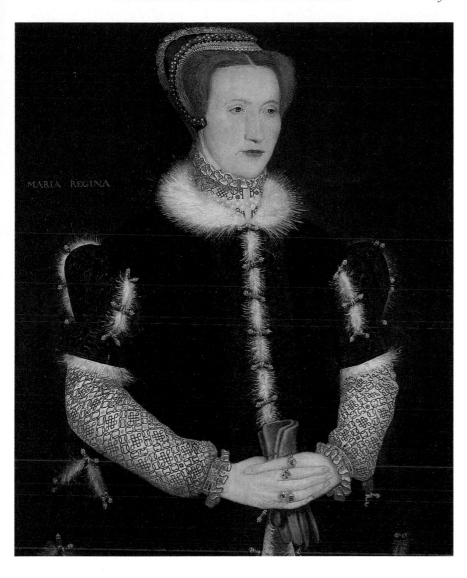

MARIA REGINA

ANON.
*Bess of Hardwick as a Young
Woman*
Hardwick Hall, Derbyshire

———— SUDBURY HALL (NT) ————

The collection at Sudbury Hall reflects the period of the house, the second
half of the seventeenth century. It was started in the year of Charles II's
return to the throne, and is a highly individual example of the period,
with copious, even extravagant decoration, including fine carvings, mainly
the work of Edward Pierce, though including examples of Grinling Gibbons
as well, plasterwork by Robert Bradbury and James Pettifer, and murals
by Louis Laguerre. The building was begun immediately after George
Vernon succeeded to the family inheritance, in 1660. From that date there
appear regular payments in family account books to painters, notably to
John Michael Wright, the London-born portraitist, responsible for a series
at Sudbury Hall.

Michael Wright, as he is generally known since he allowed the name John to lapse, was the son of a London tailor, and was apprenticed in 1636, at the age of nineteen, to the Scottish painter George Jamesone. He worked in Rome, and became a Catholic convert, to the grief of his parents. Though in style and ability he might well have rivalled Lely, he seems to have had neither the ambition nor the temperament to do so.

He is represented at Sudbury Hall by the impressive oval portraits of his principal patron there, *George Vernon*, Vernon's first of three wives, *Margaret Onley*, her parents *Edward Onley* and *Margaret Onley*, *Robert Shirley, First Earl Ferrers*, and at least four other portraits. The Michael Wright portraits are in their original 'Sunderland' frames.

Other Restoration painters represented in the collection include John Riley, Gerard Soest, Michael Dahl, the little-known William Sheppard's portrait of the much-painted playwright *Thomas Killigrew*, and Jan Griffier's *View of the South Front of Sudbury and its Original Formal Garden*. It was painted in 1681, one of the earliest such views of an English country house in its setting, and a work of considerable architectural and horticultural interest. The formal gardens were done away with in the eighteenth century.

Louis Laguerre's work includes *Juno and the Peacock*, decorating the Great Staircase, and a mural contained within a plaster frame to appear as a painting, *An Allegory of Industry and Idleness*, which represents the rewards of the former, a cornucopia, and those of the latter, a bunch of thorns.

Early eighteenth-century portraits include works by Hudson, Kneller, Richardson and Enoch Seeman.

Of a much later period are the dramatic examples of Thomas Lawrence's work, his full-length portraits of *Edward Vernon, Archbishop of York*, and *The Third Lord Vernon*, his elder brother.

——— CHATSWORTH HOUSE ———

Chatsworth House contains one of the world's great private collections. Its paintings and sculpture span several centuries; it contains fine English family portraits, Old Master paintings, neo-classical sculpture, splendid late seventeenth- and early eighteenth-century murals, and an exquisite collection of drawings. And, unlike so many of the great collections, modern acquisitions are continually being made. It has, in addition, the finest setting of any house in England, wonderfully laid-out gardens, and furniture and applied arts generally of a high order.

The First Duke of Devonshire was responsible for the present house (with extensive additions made in the nineteenth century by the Sixth Duke). He commissioned painted rooms from Louis Laguerre, Antonio Verrio, and then, in the final phase of the building of the house, from James Thornhill. Originally, few paintings were hung, the house being mainly panelled, with tapestry decorations. Some early easel pictures were in the collection, among them Vouet's *Allegory of Peace*.

The Second Duke was the real creator of the collection. He had a passion for drawings which he indulged at the dispersal of the Lely and Lankrink collections. To these he added Italian and Dutch drawings which had belonged to N. A. Flinck, the son of Rembrandt's pupil, Govaert Flinck. He also bought Claude Lorraine's *Liber Veritatis*, now in the British Museum, one of a number of former Chatsworth treasures since acquired by the nation. He was also responsible for the lifesize Holbein cartoon of Henry VIII which now greets one on the top floor of the National Portrait Gallery.

In the eighteenth and nineteenth centuries many of the major works of art which are now at Chatsworth were in the family's London home, Devonshire House, in Piccadilly. In the mid-eighteenth century, by his marriage to Charlotte Boyle, the daughter and heiress of the Third Earl of Burlington, one of the great patrons and collectors of that period, the Fourth Duke extended the collection substantially. Charlotte inherited two great London properties, Burlington House, also in Piccadilly, and Chiswick House, ten miles to the west near the River Thames. Both built by her father, they were filled with collections of fine art which included works by Rembrandt, Velázquez, Ricci and others, and a spectacular collection of drawings, among them Inigo Jones's collection of architectural drawings by Palladio, and his own drawings for masques.

Two of the three London houses remain. Burlington House, much altered, is the home of the Royal Academy; Chiswick House is a wonderful Palladian villa created by the Third Earl. Devonshire House was demolished in 1924, when its contents—down to plasterwork and mouldings, much of the work by William Kent, but also including many of the greatest works of art now at Chatsworth—were moved to Derbyshire. Chiswick House was sold to the local authority in 1927, its collection having been removed in 1892.

The Fifth Duke commissioned some of the best portraits at Chatsworth, though few are on view. And the Sixth Duke was responsible for the very fine collection of neo-classical sculpture, including important works by Canova and his European followers. The Eleventh, and present, Duke has an eclectic taste, adding nineteenth-century English watercolours, works by Lucian Freud, and a number of bronzes.

The collection has suffered losses. When the Tenth Duke died there were colossal death duties, paid by the transfer of Hardwick Hall to the National Trust, and the ceding to the nation of several other magnificent works of art, among them Claude's *Liber Veritatis*, the Holbein cartoon, already mentioned, and works by Rembrandt and Memling. There have been more recent losses, as a result of the sale of drawings from the magnificent collection.

'The most valuable treasure this mansion can boast,' wrote Passavant, in his *Tour of a German Artist in England*, published in 1836, 'is the collection of drawings, by old masters, which adorn the south gallery . . . Many of them formerly belonged to Sir Peter Lely, who collected them from the scattered cabinets of Charles I and the Earl of Arundel.' So much did he feel this to be so, that when he came to describe the house and its contents, leaving aside the drawings, which he catalogued elsewhere, Passavant

CORNELIS DE VOS
Portrait of a Little Girl
Chatsworth House, Derbyshire

concentrated on Canova sculpture, and the portraits of Henry VIII, George III and George IV. This, of course, was before the transfer of major paintings from London, in the early twentieth century.

At that time Chatsworth was to be seen only by appointment, usually with the housekeeper, the normal arrangement at the time, unless a letter of introduction and permission had been obtained. Also, then, the drawings were on exhibition, and not in the cabinets which now hold the collection. This latter point was offered as an amelioration of the sale in July 1984, from the collection; as the income from visitors pays less than half of the cost of running the house, the remainder has to be met, however reluctantly, from investments deriving from sales.

When this occurred, and the Chatsworth Old Master Drawings were sold at Christie's, in July 1984, for a total of £21 million, it focused attention, just as huge death duties have done in the past, on the perennial problem of losses to the country of works of fine art which are sold by the owners of stately homes in the British Isles. However, even this and a subsequent sale will have disposed of only 87 drawings from a total of about 2,000. In every case these have been carefully chosen so that drawings of equal or superior quality by the artist remain in the collection.

The Duke emphasised the fact that the drawings sold were not part of the collection normally seen by visitors. The Old Master drawings were once hung in the Sketch Galleries, but were then found to be fading from exposure to natural light. They were returned to their folios, and kept for the interest of the family, guests, and scholars, who were obliged to obtain written consent from the librarian, in much the same way as is necessary for drawing and print collections in art galleries and museums. The drawings are made available to public exhibitions (i.e. in the same way as those in public ownership). Permanent displays of Old Master drawings are very rare either in public or private collections, thus loan exhibitions of the kind to which Chatsworth always lends are the normal way in which Old Master drawings are seen by the public.

A third matter to emerge, on the day following the sale, was that the British Museum had negotiated for the acquisition of the collection at a quarter of the price realised at auction. The Duke of Devonshire revealed that the British Museum had made an offer of £5.25 million, while the Duke had asked for £5.5 million. The Museum had then come forward with an undisclosed backer, prepared to buy the collection, give some drawings to the Museum, and keep the rest. Understandable doubts on the Duke's part—he was quoted as saying 'Perhaps I have a nasty, suspicious mind'—prevented this deal being concluded, and the drawings went to auction.

The collection, despite these many voluntary and involuntary deprivations, is a truly magnificent one. Chatsworth also attracts diverse and very large crowds of visitors; this makes leisurely viewing difficult. It also has the effect of making one forget that this is a private house where the owner's own choice of paintings in the rooms reserved exclusively for his own use must be respected.

Among the treasures (for further details of which see the Gazetteer) are Rembrandt's splendid *Portrait of an Oriental*, also known as *King Uzziah*

REMBRANDT
Portrait of an Oriental
Chatsworth House, Derbyshire

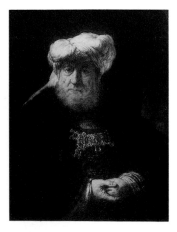

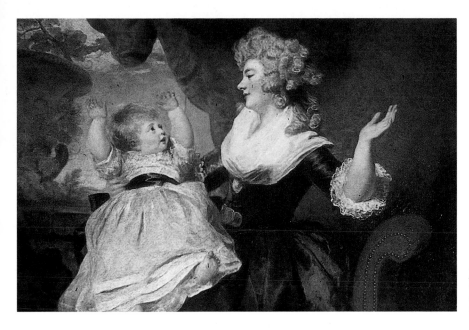

JOSHUA REYNOLDS
*Georgiana, Duchess of Devonshire,
with her Daughter*
Chatsworth House, Derbyshire

Stricken with Leprosy; two portraits by Frans Hals; Tintoretto's *Samson and Delilah*, a Simon Vouet *Allegory of Peace* and a beautiful *Portrait of a Little Girl* by Cornelis de Vos.

English paintings are well represented by family and other portraits by Van Dyck, Reynolds and Landseer and by Sir Peter Lely's *Europa and the Bull*. There is an interesting collection of modern works, acquired by the present Duke, among these a good example of Lucian Freud's work. Both Freud and the sculptress Angela Conner, whose portrait busts of artists and politicians are on the West Stairs, are friends of long standing.

The ceiling above this stairway is of *The Fall of Phaeton*, and is an early work of Sir James Thornhill. The house is rich in ceiling and mural paintings, with late seventeenth-century work by Antonio Verrio in the State Dining Room, and ceilings in the State Drawing Room, the State Music Room, and the State Bedroom (restored and cleaned by the Gibbons brothers in 1973) by Louis Laguerre. Laguerre, with the assistance of Ricard, also painted the decorations in the chapel, restored in 1986–87 by Pauline Plummer and her team, which contains Antonio Verrio's *Doubting Thomas* above the altar. The nineteenth-century English painter Sir George Hayter painted the Ante-Library ceiling with a rather wooden neo-classical scene of *Iris Presenting the Wounded Venus to Mars*. His portrait of the Sixth Duke is also in the house. There is a sumptuous grandeur about Chatsworth as a consequence of the splendid decorations and the equally splendid furnishings. The house is particularly interesting as one which has always been open to the public. The earlier building features in Daniel Defoe's *Tour Through the Whole Island of Great Britain*; the present house is generally taken as the model for Darcy's home in *Pride and Prejudice*; and not until the early part of the twentieth century was any charge made, initially for local hospitals, then for upkeep.

KEDLESTON HALL (NT)

Dr Samuel Johnson said of Kedleston, 'It would do excellently well as a town hall,' a view with which the only Marquess of Curzon's wife, Grace, was inclined to agree. 'I always thought it needed a warm sun to bring its frozen beauties to life,' she once wrote. 'If only it could have been built at Genoa or Naples.' Or, indeed, London, she might have added, since she would have liked the house nearer the city, in order to see more of her friends.

Kedleston, which is a fine Robert Adam house with characteristic decorations, is not the first house to have taken its toll on its owner.

ARTHUR DEVIS
The First Lord and Lady Scarsdale in a Landscape
Kedleston Hall, Derbyshire

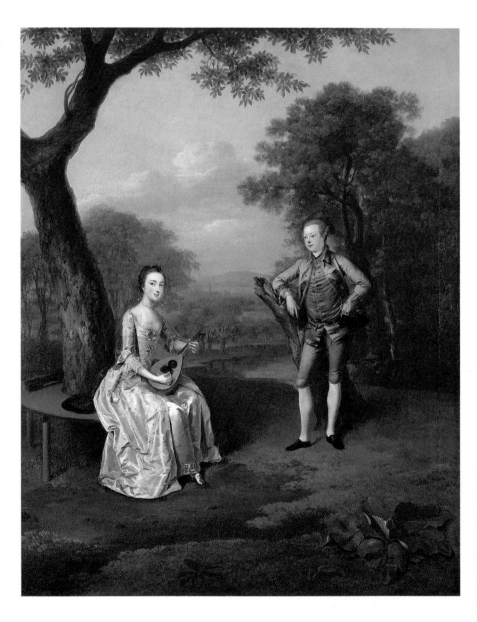

Curzon lavished enormous energy on it, wearing himself into a state of nerves that affected his performance in Bonar Law's Cabinet, and embittered his already strained relations with Lord Derby. The house has been the home of the family for over 850 years. It is now the residence of Viscount Scarsdale.

There is an impressive portrait gallery with family paintings, including one of Lord Curzon and his first wife by William Logsdail, the sitters wearing their viceregal robes. A fine full-length of Lady Scarsdale by Hudson is in the Dressing Room, and in the State Bedchamber hangs a large canvas by Richardson, *Sir Nathaniel and Lady Curzon*. A portrait by Nathaniel Hone, *The First Lord and Lady Scarsdale*, hangs in the State Boudoir, together with portraits by, or attributed to, Reinagle, Lely, Johnson and Van Dyck.

Among other works of art are *Daniel Interpreting Nebuchadnezzar's Dream* by Koninck, *Triumph of Bacchus* by Giordano, *Diogenes* by Assereto, *Ruperta, daughter of Prince Rupert* and *Catherine Sedley* by Kneller, and *Portrait of the Artist* by Joseph Wright.

MELBOURNE HALL

Two Victorian Prime Ministers lived in the house, Lord Melbourne, after whom the City of Melbourne in Australia is named, and Lord Palmerston, who married Melbourne's sister. Both were political giants, the one guiding Queen Victoria at the beginning of her reign, when he was with her almost daily, the other asserting her rule in as determined a fashion as any leader of a nineteenth-century British Government.

The collection, which has been handed down through the generations of the Lothian families, reflects the chequered history, as well as the literary and other associations.

The Dining Room contains two double portraits by Sir Peter Lely, *The Earl and Countess of Chesterfield* and *Colonel and Mrs Coke*. In the Inner Hall hangs a portrait by Lawrence of the beautiful Lady Melbourne, mother of Lord Melbourne.

The Drawing Room is dominated by three large Kneller portraits, *Queen Anne*, *George I* and *Prince George of Denmark*. A portrait of Queen Anne's elegant Vice-Chamberlain, *Thomas Coke*, by Michael Dahl also hangs in this room.

The oldest painting in the house is in the Chapel, the Lippo Memmi (1360), as well as a crucifixion by Guercino.

SHUGBOROUGH, STAFFORDSHIRE (NT)

Shugborough is the only house of note in Staffordshire, jointly managed by the National Trust and Staffordshire County Council. It contains

remnants of the Earl of Lichfield's collection. Unfortunately, his original collection was disposed of in 1842 in order to clear the First Earl's debts. What remains does include a series of topographical works, beginning with Nicholas Dall's views of the parkland at Shugborough and a neighbouring house, since demolished, called Oakedge.

Nicholas Thomas Dall was Scandinavian-born, and worked in Italy, where he is thought to have first made the acquaintance of Thomas Anson, the eighteenth-century owner who made major changes, and who commissioned Italian as well as local views from the artist. Dall in due course became an Anglicised artist, and an associate of the Royal Academy. His most interesting work in the house is the large romantic view of Shugborough painted in 1765, before the wings were enlarged. This gives it a more dramatic, starker appearance.

The house has good sporting pictures, mainly nineteenth century.

NOTTINGHAM CASTLE

Nottingham, like Derby, has a good representation of the works of artists it claims as its own, among whom must be numbered William Nicholson, who came from Newark, Laura Knight, who came to live in Nottingham

LAURA KNIGHT
Elsie on Hassan
Castle Museum, Nottingham

RICHARD PARKES
BONINGTON
Fisherfolk on the Coast of Normandy
Castle Museum, Nottingham

at the age of two, and, most exceptional of all, Richard Parkes Bonington, who was born three miles north of the city, in a village called Arnold.

The museum itself was opened in 1878 by the Prince of Wales, later Edward VII. Its collection is a fairly comprehensive one, beginning with sixteenth-century Italian works, among them a Dosso Dossi, *The Christ Child Learning to Walk*. There is an early Le Brun, *Hercules and Diomedes*, but the real strength of the Nottingham Castle collection lies in the later periods.

The eighteenth and nineteenth centuries are represented by good examples of the works of Paul Sandby and Bonington, including his last watercolour, *The Undercliff*. George Morland, David Wilkie, James Ward, William West and John Crome are all represented. Later works include *Mary, Queen of Scots, led to Her Execution* by Laslett Pott.

— NEWSTEAD ABBEY AND BYRON —

There is an almost exclusive interest in Byron at Newstead Abbey, which is managed by the Nottingham City Council, and which contains an extensive collection related to the poet's life and work.

Byron inherited encumbered family estates, together with the title of Sixth Baron, at the age of ten. For a short time he lived at Newstead Abbey, and was under the guardianship of the Fifth Earl of Carlisle, before being sent to private school, while the Abbey was let. His association with Nottinghamshire was maintained, his first book of poems being published in Newark, and his first proposal of marriage being made to the heiress of Annesley Park. In 1808 he settled at Newstead Abbey, but his interest in the property was short-lived, and in 1812 he was trying to sell it, mainly to resolve his growing indebtedness. It was eventually sold in 1817.

Though the Abbey passed out of the Byron family, interest in him was maintained by subsequent owners, and Byron material was part of the property when it passed to Nottingham. The chief collector to benefit the Byron collection was Herbert Charles Roe (1873-1923), who gave manuscripts, letters and first editions. Enthusiasm for the poet has prompted many others to make gifts and bequests.

The best Byron portrait is by Thomas Phillips. There is one of *Admiral Byron*, the poet's grandfather, by Reynolds.

COLLECTIONS IN LEICESTERSHIRE

Sheep, wolds, hosiery, Stilton cheese, hunting and horse-racing have given Leicestershire its wealth, and at least some of its art. It is famous for hunts, among them the Quorn Hunt. John Ferneley, a Leicestershire artist, painted for the Duke of Rutland, and then studied under Ben Marshall. Both artists are represented in the Leicester City Art Gallery collection. Ferneley used to bring his teacher pork pies from Melton Mowbray and Stilton cheeses. The sporting art practice which he established in Melton Mowbray was sustained by his sons.

Coleorton, though not open to the public, was the home of Sir George Beaumont, active in the foundation of the National Gallery in London. He was a Leicestershire painter, a collector and friend of many artists. Works by him may be seen in his house, by special arrangement with the Coal Board, of which it is a regional office. Further paintings are in Leicester.

Leicester itself has one of the best of the smaller public collections, with certain outstanding elements in it, such as the collection of German Expressionist paintings, as well as de La Tour's *Choirboy*. And what it has is presented with enthusiasm and flair.

MICHAEL SWEERTS
Portrait of a Woman
Leicestershire Museum and Art
Gallery, Leicester

LEICESTERSHIRE MUSEUM AND ART GALLERY

Leicester Art Gallery opened in 1885. It began with a nucleus of mainly nineteenth-century paintings, developing later a representative collection of twentieth-century British art. It has an outstanding collection of German Expressionist art. Its Italian paintings include Lorenzo Monaco's *St John the Baptist Going into the Wilderness* and *The Assumption of the Virgin* by Pittoni, and also *Youthful Bacchus* by Annibale Carracci.

The Gallery owns the splendid Georges de La Tour *The Choirboy*, one of only three works by this artist in public collections in these islands. The painting is a recent acquisition, bought in 1983. There is one other Georges de La Tour in a provincial collection in Britain, *The Dice Players*, in the Preston Hall Museum, Stockton-on-Tees (q.v.). The gallery also owns a delectable, small *Portrait of a Girl* by Michael Sweerts.

Leicester's collection of German Expressionist art was mainly acquired through the courage and perception of the gallery's wartime Director, Trevor Thomas, who, at a time of considerable anti-German feeling, followed his instincts about the importance of German twentieth-century art, and bought intelligently during the 1940s. His most important purchase, in 1944, was Franz Marc's *The Red Woman*. The Blue Rider and Die Brücke groups are represented additionally by Feininger, Nolde, Kirchner, Schmidt-Rottluff and others. Feininger's *Behind the Church*, or *The Square*, is another major work. The Neue Sachlichkeit movement is represented by Grosz and Beckmann. Extensive supporting art and documentation, including prints, catalogues and publications, are also part of the collection.

There are good examples at Leicester of sheep and cattle 'portraits', of a kind appropriate to this strongly agricultural area of England. There are also works by Ferneley, and by Ben Marshall, whose superb portrait of

Above:
GEORGES DE LA TOUR
The Choirboy
Leicestershire Museum and Art
Gallery, Leicester

Left:
BENJAMIN MARSHALL
Daniel Lambert
Leicestershire Museum and Art
Gallery, Leicester

FRANZ MARC
The Red Woman
Leicestershire Museum and Art
Gallery, Leicester

Daniel Lambert—who weighed 52 stone 11 pounds—was only recently recognised as the artist's work.

Other notable features include the group of landscapes by Sir George Beaumont, especially *Peel Castle in a Storm*. Belgrave Hall, which is a branch museum and contains paintings suited to an eighteenth-century country house, also has part of the George Beaumont collection on display. Beaumont's generosity to artists, as well as his role in establishing the National Gallery, are noted elsewhere. The most impressive group of paintings in any Leicestershire house are those at Belvoir Castle (q.v.) by Nicolas Poussin of *The Seven Sacraments*.

There is a good collection at Stanford Hall, in Lutterworth, home of Lady Braye, the main emphasis being seventeenth century.

At Rockingham Castle there are interesting sporting pictures, and a small collection of twentieth-century British paintings.

BELVOIR CASTLE

A lively programme of activities goes on at Belvoir Castle, the Leicestershire home of the Dukes of Rutland, with medieval jousting and mock battles, steam rallies, folk dancing, brass band entertainment, and Teddy Bear picnics. This should not be allowed to detract from the rich and extensive art collection, however, with its outstanding group of paintings by Nicolas Poussin.

The Seven Sacraments were painted by Poussin in the late 1630s, in fulfilment of a commission by Cassiano dal Pozzo. They are the first such series done by the artist, and the best. Poussin was delayed by other work from completing the seven canvases, the last of which was despatched from Paris in May 1642. They passed through several collections, and at one time were sold to Sir Robert Walpole, but their export from the Continent at the time was blocked.

They were eventually bought by the First Duke of Rutland, on the advice of Reynolds, with an additional canvas, *St John Baptising the People*, which was sold from Belvoir in 1958. It is now in Germany. The paintings arrived in London in 1786, being exhibited at the Royal Academy the following year.

There are only five of them at Belvoir now. *Baptism* was sold in 1939 to the National Gallery in Washington. *Penance* was destroyed by fire in 1816.

JOSHUA REYNOLDS
*Mary Milles, Wife of Lewis, Third
Baron Sondes*
Rockingham Castle, Leicestershire

THE ROCKINGHAM CASTLE
COLLECTION

The collection at Rockingham Castle covers a wide range of paintings and artists. There are particularly fine examples of works by Reynolds, Lely and Zoffany and an interesting collection of modern British works built up by Sir Michael Culme-Seymour, the present owner's uncle.

But it is for the works by Ben Marshall, including *The Sondes Brothers in Rockingham Park*, that the collection is best known. There are four in all, illustrating different aspects of his art. The large hunting scene shows the four Watson brothers, with the Second Lord Sondes in front. The more distant figure, behind the tree, is Richard Watson, who inherited Rockingham Castle. George Watson is the subject of a small, full-length Marshall portrait, which hangs between two portraits of horses.

Dickens was a great friend of Richard Watson and his wife Lavinia. He dedicated *David Copperfield* to them and used Rockingham in *Bleak House* when describing Chesney Wold. He also produced and acted in plays in the Great Hall.

BENJAMIN MARSHALL
The Sondes Brothers in Rockingham Park
Rockingham Castle, Leicestershire

COLLECTIONS IN
——— NORTHAMPTONSHIRE ———

There are two major collections of fine art in houses in Northamptonshire, at Boughton House and Althorp. There are two public galleries worthy of note, in Kettering and Northampton. The first of these two houses contains part only of the very extensive art collection of the Duke of

Buccleuch and Queensberry. The second belongs to Lord Spencer, father of Diana, Princess of Wales.

Other houses with interesting works of art include Castle Ashby, near Northampton, the home of the Marquess of Northampton, and Lamport Hall.

A sale in the late eighteenth century removed a number of good works from Castle Ashby. The Third Marquess, in particular, collected during the nineteenth century, replacing a number of the earlier losses. He was responsible for *The Holy Family* by Sebastiano del Piombo, among other works.

There is a notable display of family portraits, including the lovely William Dobson full-length of *Sir William Compton*, brother of the Third Earl and one of the finest works by the artist. Fittingly, it is of a man devoted to the Royalist cause, member indeed of a great Royalist family. Cromwell described him as 'the sober young man, and the godly cavalier'. During the thirteen-week siege of Banbury it was said of him that he never went to bed, and in the engagement which preceded the unsuccessful Roundhead assault on the town 'had two horses shot under him'.

The most interesting works of art at Lamport Hall are seventeenth century, both British and continental. They include works by Van Dyck, Paul van Somer and Guido Reni, as well as portraits of the Isham family. These range from the sixteenth-century portrait of the original owner of the estate, John Isham, who was a successful London merchant, to the seventeenth-, eighteenth- and nineteenth-century portraits by artists including Lely, Kneller, Hudson and Martin Archer Shee.

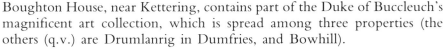

———— BOUGHTON HOUSE ————

Boughton House, near Kettering, contains part of the Duke of Buccleuch's magnificent art collection, which is spread among three properties (the others (q.v.) are Drumlanrig in Dumfries, and Bowhill).

At Boughton may be seen an early El Greco *Adoration*, works by Teniers and Frans Pourbus the Elder, Murillo, Dolci, Solimena and Annibale Carracci's *A Young Man in a Plumed Hat*.

Seventeenth-century landscape painting includes work commissioned by the Duke of Monmouth from a group of French artists, among them Jacques Rousseau. Louis Cheron was employed for decorative painting, including ceilings, murals and the staircase decorations at Boughton House. There are flower-pieces over the doors by Jean-Baptiste Monnoyer, a pupil of Le Brun's who worked with him at Versailles.

A large cartoon, with life-size figures, depicts *The Vision of Ezekiel*, and is from Raphael's studio. It is taken from an original in the Pitti Palace.

There are good views by Samuel Scott, Marlow and Willem van de Velde the Younger.

Of particular interest are the grisaille sketches by Van Dyck, studies of the most distinguished men of the age, and intended for his set of engraved portraits, published in 1641. Of the forty which hang in the Dining Room, thirty-seven were once owned by Peter Lely.

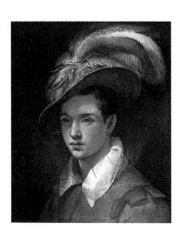

ANNIBALE CARRACCI
A Young Man in a Plumed Hat
Boughton House,
Northamptonshire

ALTHORP HOUSE

Althorp has a truly splendid collection of family portraits, with first-class examples of the work of Van Dyck, Lely, Kneller and Reynolds. *Mais où sont les neiges d'antan?* At the beginning of the nineteenth century, the house, like Blenheim, boasted one of the great English collections. Works by Raphael, his pupil, del Vaga, several by Titian, Bronzino's mannerist work, *An Allegory*, now in the National Gallery, three Holbeins, Philippe de Champaigne, Rubens, Rembrandt and Van Dyck's *Daedalus and Icarus* were all at Althorp. And, while much is made, justifiably, of the fine things that remain, successive sales should not be overlooked in assessing the collection.

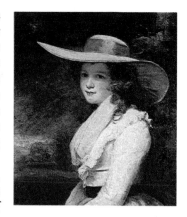

JOSHUA REYNOLDS
Lavinia Bingham, Countess Spencer
Althorp House,
Northamptonshire

In the late seventeenth century the house was owned by Robert Spencer, Second Earl of Sunderland, who served as a minister to three kings. It is surprising, in view of his vigorous and involved pursuit of the art of statesmanship, that he found time for collecting. In an age of schemes, conspiracies, plots and the intensest of jealousies, he was considered by far the most rapacious, the craftiest and the least scrupulous of politicians. His portrait was painted, early in his career, by Maratta.

His son's wife was a Churchill, and when the First Duke of Marlborough died, with no surviving sons, she was co-heiress. The Fifth Earl of Sunderland became the Third Duke and moved to Blenheim, and Althorp passed, with many of the possessions of his grandmother, Sarah Jennings, Duchess of Marlborough, to John Spencer.

It was his son, also John, who became the First Earl Spencer. He was a friend of Reynolds, from whom a number of works were commissioned spanning three generations of the family, and providing one of the chief fine art interests in the house. Works include a head and shoulders portrait of *Lavinia Bingham, Countess Spencer* as well as a striking portrait of her with her daughter. The daughter, whose name was Georgiana, became Duchess of Devonshire, a prominent figure in Whig society, glamorous, racy, 'the face without a frown'. The Duchess of Dimples, she sold kisses for votes on behalf of Charles James Fox in the 1784 elections. There is a Gainsborough of *William Poyntz*, a full-length much in the same style as the *Lord Boringdon* portrait at Saltram, by Reynolds. The Reynolds portraits, with those by Gainsborough, hang together.

The Entrance Hall is lined with Wootton's works. The canvases, fitted to the walls exactly, are like murals, and represent one of the painter's most ambitious schemes. They were painted after his visit to Rome, and indicate a sense of composition, as well as a free use of landscape design, which is impressive. He incorporates a number of different themes, not all of them, strictly speaking, sporting. Racing thoroughbreds, hunting subjects, canine pictures and pure landscape are disposed around the large Entrance Hall in a fine balanced way. Only at Longleat and Badminton (qq.v.) was anything comparable attempted.

Works by Salvator Rosa, Frans Snyders, Van Aelst, Dubbels, Maratta, Lotto and Pourbus indicate something of the glory which was once the main collection.

HOUSES IN SHROPSHIRE

Houses of interest in Shropshire include Attingham Park, to the west of the town, notable for works by minor arists. Particularly fine are the Jacob Philipp Hackert landscapes, of which there are several, mainly Roman views.

Hackert came from a large German family of painters, he being the most famous and the most successful member. He worked almost exclusively in Italy, painting views for the inexhaustible demand from English, German and French travellers. He was court painter in Naples for a time, and was much admired by Goethe, who wrote his biography.

The Earl of Bradford's collection is at Weston Park, and, in addition to the family portraits, includes a good example of Stubbs, and two Anguisciola portraits of children.

JACOB PHILIPP HACKERT
View of Pompeii
Attingham Park, Shropshire

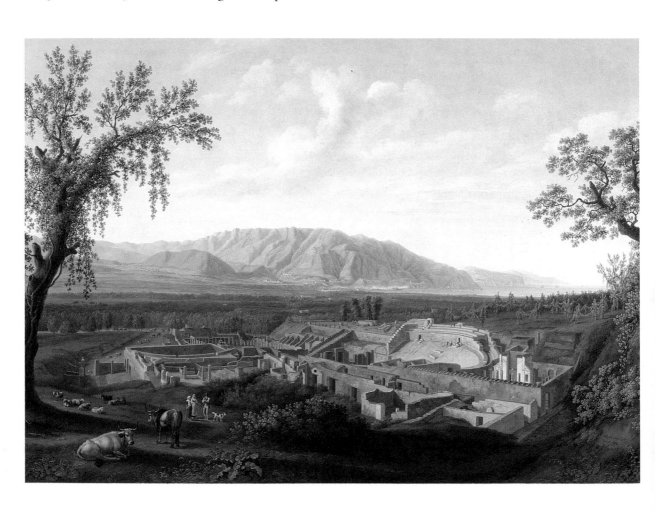

COLLECTIONS IN HEREFORD AND WORCESTER

The old West of England counties of Herefordshire and Worcestershire were amalgamated in 1972 into the composite county of Hereford and Worcester, losing land to the new West Midlands county in the process.

The most interesting house, from the point of view of fine art, is Hanbury Hall (q.v.) with its extensive mural decorations. At Croft Castle Lord Croft has a fine collection of modern art, and at Eastnor Castle, near Ledbury, there are frescoes by George Frederick Watts, who was a friend of the Third Earl of Somers, owner of a house in Carlton House Terrace from which the paintings were rescued in 1976 and installed at Eastnor. At Berrington Hall there are important large paintings of naval engagements, several by Thomas Luny.

The Hereford City Art Gallery, like many country and market town collections, grew out of a local archaeological and natural history society, the Woolhope Club, which was formed in 1852. It established a library and museum in 1870, and the premises were then enlarged to include an art gallery, which opened in 1912.

David Cox, Joshua Cristall and Joseph Murray Ince were watercolourists of note who had Hereford associations, Cox working for more than a decade in the first half of the nineteenth century as drawing master at Miss Croucher's Academy for Young Ladies, at the Gatehouse in Widemarsh Street. It is therefore not surprising that the collection should be mainly of watercolours. Among these are several excellent views of the bold, squat bulk of Hereford Cathedral. These include an early and impressive Turner, as well as versions by Edward Dayes and Thomas Girtin.

Among more modern works is Laura Knight's striking portrait of *George Bernard Shaw*.

In Hereford there is also the Churchill Gardens Museum, which houses a collection of works by Brian Hatton, who was born in Hereford in 1887 and killed in Egypt in 1916, in a surprise attack by the Turks. His sister made a generous donation towards the financing of the gallery, and gave to it the main part of the collection of his works. It represents an interesting example of how such single-artist galleries come into existence.

- MURALS AT HANBURY HALL (NT) -

Sir James Thornhill was commissioned by Thomas Vernon to decorate the house towards the end of the reign of Queen Anne. He was then at the height of his career, and already had major commissions to his credit, notably at Chatsworth. He was probably engaged, during the work for Thomas Vernon, on his masterpiece, the Painted Hall at Greenwich Hospital, which was his crowning achievement, and took him eighteen years to complete. It is the greatest work of decorative baroque art in England.

The subject-matter at Hanbury Hall is essentially classical, though with interesting political overtones. It is painted in Italian baroque style with Thornhill's characteristic exuberance. The ceiling of the Staircase Hall shows an assembly of classical deities and the walls are scenes from the life of Achilles. Mercury floating down from the ceiling points to a print of Dr Sacheverell (a preacher who was impeached and found guilty of sedition in 1710), and the print is being burnt by the Furies. Panels under the windows portray Pan, Apollo and Midas on one, and Apollo and Daphne on the other. A bust of Vernon sits above the fireplace. The ceiling of the Long Room shows the rape of Orithyia by Boreas as well as Apollo abducting a nymph.

Thomas Vernon was a staunch Whig, and would have regarded Sacheverell as a seditious monster. He was in fact an unctuous hypocrite, whose impeachment for sedition made him, quite unjustly, a popular hero, and led, in conjunction with the brilliant journalism of Jonathan Swift, to the transfer of power from the Whigs to the Tories. The original designs by Thornhill do not include the contemporary reference, suggesting that they preceded the trial, in February 1710, while the actual work in the house was completed later in that year.

A painted staircase would have been an important status-symbol in the late seventeenth century, in emulation of those at Hampton Court and Windsor commissioned by the King.

—— HOUSES IN WARWICKSHIRE ——

The main houses in Warwickshire include Warwick Castle, which offers a dramatic and stimulating experience, quite unlike any other house. Owned and run by the Tussauds Group, it contains numerous waxworks in domestic situations, and shows famous personalities associated with the house at the turn of the century. These include the Prince of Wales, later Edward VII, the young Winston Churchill, as well as the Earl and Countess of Warwick. She was one of Edward VII's mistresses. The fine art, however, is undramatic. Portraits, some of them of interest, fill most of the rooms, and there are works by, or attributed to, Van Dyck, Dobson and Rubens.

There are good portrait collections at Arbury Hall, mainly of the Newdigate family, and there is an association here with George Eliot. Coughton Court has portraits by Largillière, and Ragley Hall, owned by the Marquess of Hertford, has a good country house collection. It includes a Reynolds portrait of *Horace Walpole*. Two religious works are *The Raising of Lazarus* by Cornelius Haarlem, and *The Holy Family* by Cornelius Schut.

On the outskirts of Warwick is the Saint John's House museum. It contains three good examples of Allan Ramsay portrait painting as well as some military portraits, including a modern one of General Montgomery, and one of General John Guise, the eighteenth-century benefactor of Christ Church Picture Gallery, in Oxford (q.v.).

General Guise is an example of an unusual combination: distinguished military service and collecting ability. He matriculated twice at Oxford before the end of the seventeenth century, went on to study law and then became a soldier, fighting in Flanders with Marlborough, in the West Indies and in the 1745 campaign in Scotland. His collecting abilities, well known to George Vertue and Horace Walpole, demonstrated a distinctive perception and knowledge that they greatly admired. The paintings he gave to Christ Church were said at the time to have been damaged by overcleaning at the hands of Bonus, and there is some truth in this. Happily, however, the drawings fared better.

——— CHARLECOTE PARK (NT) ———

The most famous associations of Charlecote Park are with William Shakespeare and Elizabeth I. Both are emphasised throughout the house, to some extent compensating for the splendid works of art which were once the glory of the collection, but are now sold and dispersed.

Shakespeare is popularly supposed to have poached on the estate, to have been brought before its owner at the time, Sir Thomas Lucy, and to have been appropriately punished. In due course he took his revenge, in the creation of Justice Shallow, in *Henry IV Part II* and *The Merry Wives of Windsor*. Shallow's obsession with heraldry and blood indicates, more closely than anything else, the source for Shakespeare's character in the plays, the Lucy family having been at Charlecote as long as any English county family in one place. The arguments are more convincing than most in such circumstances.

Elizabeth I visited Charlecote for two nights in 1572, and this too is remembered, with her portrait or coat of arms being given pride of place throughout the house.

George Hammond Lucy, who inherited the house in 1823, was the main inspiration for its restoration. It was much decayed. The main finances came from his wife. They shared an interest in art, and collected the principal works of art. He attended the Fonthill Sale in 1823, at which William Beckford's great collection was dispersed.

Works by Raphael, Teniers, Hobbema, Van Dyck, Canaletto, Clouet and Holbein were once at Charlecote. Their sale went on into the late nineteenth century and in the 1940s. Family portraits, in the main, are what is left. In the Great Hall, along with other Lucys by Richardson, Kneller, Dahl and Gainsborough, hangs a portrait of the third Sir Thomas Lucy and his wife taking dessert, and surrounded by their children.

The other important works of Charlecote Park are the two portraits by William Larkin of Sir Thomas Lucy and Lord Herbert of Cherbury. They are the artist's only documented paintings.

COLLECTIONS IN
—————— GLOUCESTERSHIRE ——————

The most important collection of fine art in a Gloucestershire house is at Sudeley Castle, at Winchcombe, briefly the home of Lady Jane Grey. It was owned by Thomas Seymour, Baron of Sudeley. He had the dubious distinction of marrying Henry VIII's widow, Catherine Parr, giving him his ill-fated pretensions in royal affairs which led to his death.

The collection is that of the Dent family, famous glove-makers. It includes an important John Constable, *The Lock*, and works by Turner, Ruisdael, Greuze, Claude and Van Dyck.

Berkeley Castle has good sporting pictures and a general collection that includes family portraits.

Among the museum and art gallery collections both Gloucester and Cheltenham should be noted. The latter of these two is interesting for the collection of Dutch paintings presented by Baron de Ferrière in 1898. He also gave money towards the cost of the building, which opened the year after his gift.

It is a somewhat gloomy place, and the attributions for a number of the works should be viewed sceptically. They hang as part of a combined exhibition of furniture and paintings, the museum having an excellent and extensive range of furniture of all periods. But this somewhat detracts from the impact of the art.

In the upper galleries are nineteenth- and twentieth-century British works, including a fine Stanley Spencer, and paintings associated with the Cotswold countryside, including a good example of William Rothenstein.

The Gloucester City Art Gallery's collection is sometimes on view, sometimes not. Other activities squeeze it out, regrettably, and there is a tendency to put on varied visiting exhibitions.

COLLECTIONS IN
—————— OXFORDSHIRE ——————

In contrast to some of its neighbours, Oxfordshire has several houses with important collections, as well as the outstanding Ashmolean Museum, belonging to the University, and the Christ Church Picture Gallery, which belongs to, and is housed in, the College. The most notable of the country houses is Blenheim Palace. An interesting seventeenth-century collection, of a particularly romantic kind, is at Ashdown House. At Broughton Castle there are Fiennes family portraits.

Rousham Park, in Steeple Aston, is of interest for the association of the ancestor of the present owner with the English portrait painter William Dobson, who painted *Sir Charles Cotterell*, and included him in

a triple portrait with Nicholas Lanier and the artist, which is in the possession of the Duke of Northumberland. The single portrait, however, is at Rousham Park along with other family portraits.

There is a connection between Sulgrave Manor and the family of George Washington, and portraits of the American President hang throughout the house. Washington's great-great-grandfather was born at Sulgrave, from where his son emigrated, and bought the Mount Vernon land in Virginia.

There is a good representation of English paintings at Upton House, including sporting pictures, conversation pieces, and fine rural subjects by George Stubbs. Two from the Hogarth series, *The Four Times of Day*, are also in the collection, *Morning* and *Night*.

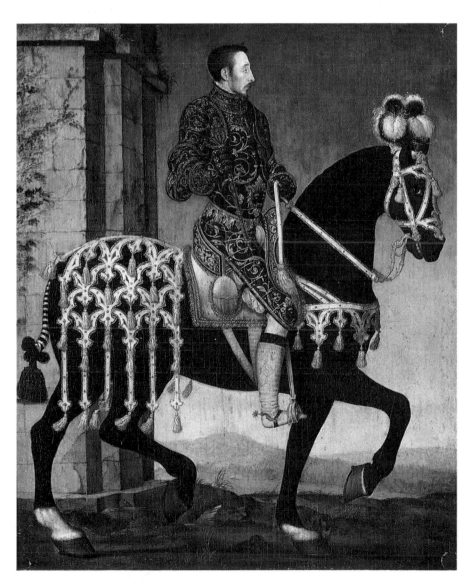

FRANÇOIS CLOUET
Henry II of France
Upton House, Warwickshire

PIETER JANSZ SAENREDAM
Interior of St Catherine's, Utrecht
Upton House, Warwickshire

BLENHEIM PALACE

Sir John Vanbrugh intended Blenheim Palace to be an expression of the greatness of England, an extension of the gratitude of the English nation to the Duke of Marlborough, in financing the house. He wrote: 'altho' the building was to be calculated for, and adapted to, a private habitation, yet it ought at the same time, to be considered as both a Royall and a National Monument, and care taken in the design, and the execution, that it might have the qualitys proper to such a monument, vizt. *Beauty, Magnificence and Duration'.*

The Duchess, determined woman that she was, had other views. She and Vanbrugh fell out, though at a late stage, and Hawksmoor took over. But the monumental character of the palace had by then been firmly established. It has the beauty, magnificence and certainly the duration originally intended. They are augmented by the interior decorations, by Laguerre and Sir James Thornhill. But it is deficient in the level of fine art which should be contained in so grand a design.

JOHANN BAPTIST
CLOSTERMAN
The First Duke and Duchess of Marlborough with their Family
Blenheim Palace, Oxfordshire

At the beginning of the nineteenth century, Blenheim was one of England's greatest private collections. It included works by Raphael, Titian, Barocci, Giordano, Carlo Dolci, Murillo, Holbein, Rubens and Van Dyck. The Rubens collection was outstanding. His work was particularly favoured by the First Duke, who was presented with Rubens works in anticipation of his protection, or as a reward for its efficacy.

Certain good things are left. They include Van Dyck's portrait of his mistress, *Margaret Lennon*, as well as the double portrait, *Lady Morton and Mrs Killigrew*, in which is featured the black dress with wide sleeves lined in rose satin, copied, on Sargent's orders, for the portrait he painted of the Ninth Duke and his Duchess, Consuelo, a Vanderbilt. In addition, there is the very fine Van Dyck above the fireplace, *Portrait of a Girl as Erminia, attended by Cupid*. This striking and unusual composition, with the two figures in an almost tense rivalry with each other, takes its subject matter from a romantic episode in Tasso's *Gerusalemme Liberato*. It was acquired early in the twentieth century, a belated effort to repair the ravages time had wrought on the collection.

There is a relationship in the composition of the three major family groups in the house, *The First Duke and Duchess of Marlborough with their Family*, painted in 1693 by Closterman, *The Fourth Duke and Duchess of Marlborough and their Family*, by Reynolds, and the Sargent group.

The splendid decorations include Laguerre's work, James Thornhill's ceiling in the Great Hall, magnificent tapestries commemorating Marlborough's victories, and fine sculpture.

——— ASHDOWN HOUSE (NT) ———

Ashdown House has the intense appeal of a single, romantic story reflected in its history and its art collection. This means that, while the paintings are mainly solemn seventeenth-century portraits, principally by two artists, they are so directly related to the story as to gain an excitement which belies their sombre colouring.

Ashdown House was built by William, First Earl of Craven, who dedicated his long life to the welfare and then memory of 'The Winter Queen', Elizabeth of Bohemia. When she died, in 1662, she left him her collection of paintings, some of which are now at Ashdown, and which record the fugitives and exiles to whom she was related, as well as herself.

She was the only daughter of James I, and sister of Charles I. She married Frederick V, the Elector Palatine, who, for one year only, 1619-20, was King of Bohemia. He was the grandson of William the Silent, and an ardent Protestant, whose acceptance of the crown of Bohemia in opposition to the Catholic Emperor, Ferdinand, led to the start of the Thirty Years War. His winter coronation in Prague, in November 1619, was followed a year later by his defeat at the Battle of the White Mountain, as a result of which he lost everything, and went into exile in Holland. His portrait, after Honthorst, is probably posthumous.

Craven first met 'The Winter Queen' at The Hague, during her exile there, when he was a young soldier in the service of the Prince of Nassau.

She returned to England after her husband's death. He commanded the English contingent under Gustavus Adolphus in 1635, in an endeavour to recover her lands in Germany, but unsuccessfully, being taken prisoner, and having to purchase his freedom. Back in England he gave the Queen help during the Civil War, when she was deserted by her children. His loyalty to the House of Stuart led to the confiscation of his estates under the Commonwealth, but after the Restoration he was again able to help her for the last two years of her life. She was charming and vivacious, and was known also as 'The Queen of Hearts'.

His devotion is without parallel, her response without a great deal of warmth, a combination difficult to explain, a bit like Courtly Love, a couple of centuries out of date. Among the Honthorst portraits are those of *Lord Craven*, in armour; of *Elizabeth, Princess Royal*, the Queen's eldest daughter, who hated Catholicism intensely, became a Protestant Abbess, and had the

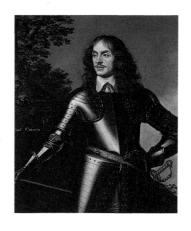

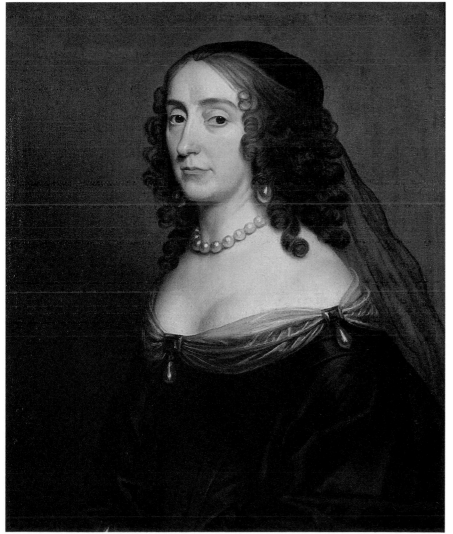

Above:
GERRITT VAN HONTHORST
Portrait of the First Lord Craven
Ashdown House, Oxfordshire

Left:
GERRITT VAN HONTHORST
Elizabeth, Queen of Bohemia
Ashdown House, Oxfordshire

Principiae Philosophiae dedicated to her by its author, René Descartes; and one of *Queen Elizabeth of Bohemia*, dated 1650.

Michiel Miereveldt is responsible for portraits of the Winter Queen's cousin, *Christian, Duke of Brunswick*, 'Friend of God, Enemy of Priests'; *Frederick Henry, Prince of Orange*; *Sir Horace Vere*; *Frances Coke, Viscountess Purbeck,* who was charged with, and found guilty of, adultery with Sir Robert Howard, in 1621; and *Sir Charles Morgan*, another Protestant warrior in the Low Countries.

A passion for horses and hunting consumed energy and money in the eighteenth century, preventing 'improvements' to the house, to which no important changes were made. It stands a curiously austere monument to an austere and difficult age, and to a woman who inspired such devotion. Not only was Craven smitten. The poet Henry Wotton immortalised her in his poem of 1620:

> *So, when my mistress shall be seen*
> *In form and beauty of her mind,*
> *By virtue first, then choice, a Queen,*
> *Tell me, if she were not designed*
> *The eclipse and glory of her kind.*

OXFORD UNIVERSITY
———— COLLECTIONS ————

The colleges which make up Oxford University possess many interesting art collections, mainly in the realm of portraiture, but only one collection is open to the public on a regular basis: the Christ Church Picture Gallery. There is also, of course, the Ashmolean Museum (q.v.).

The Christ Church Picture Gallery dates from the eighteenth century, being based on paintings and drawings presented to his own college by General John Guise in 1765. He intended them to be kept for the use of the college, which is a condition to be found with many of these college and university collections, access to which by the general public is relatively recent. In the case of Christ Church, the gallery itself is modern, opened only in 1968.

By contrast, the collection in it is not only the finest group of Italian Primitives, and sixteenth- and seventeenth-century paintings, of any college in these islands, but rivals many of the major museums. It includes paintings presented by William Fox-Strangways to the college in 1828 and 1834, and works which were collected in Italy by Walter Savage Landor, possibly at the same time as Fox-Strangways was collecting.

Among the paintings are works by Domenichino, Tintoretto and Carracci, of which the most interesting is the latter's *The Butcher's Shop*. There is a fragment by Hugo van der Goes of a *Lamentation*, showing Saint John and the Virgin Mary weeping.

The collection is particularly strong in drawings, with examples of Raphael, Leonardo da Vinci, Michelangelo, Rubens, and many early Italian masters. Michelangelo's *Woman with a Distaff, Three Children, a Sleeping Man and a Cat* is one of a number by, or attributed to, the artist.

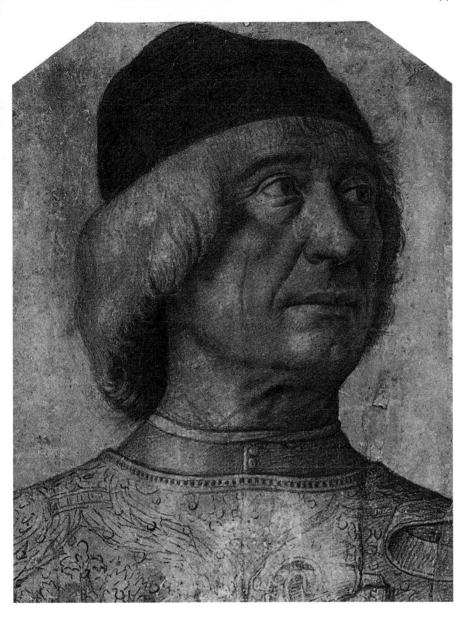

GIOVANNI BELLINI
(Attributed)
*Bust of Man Wearing Cap and
Embroidered Coat*
Christ Church Picture Gallery,
Oxford

It took about 150 years for the full extent and value of the collection to be properly assessed. Guise stipulated that it could only be viewed in the presence of 'a Master of Arts', which restricted early connoisseurs, the most prominent of whom, in terms of recognising the importance and extent of the collection, were Passavant and Waagen. As late as 1900 the drawings still needed to be properly mounted, catalogued and either placed in cabinets or framed for exhibition, the only sensible way of by-passing the Guise restriction and making the best of the drawings available for the public, which is now done by rotating what is on exhibition. The paintings and drawings were fully catalogued in 1967 and 1976 respectively.

The collection includes over 2,000 drawings.

Fine Art in East Anglia

*I have likewise made many skies and effects—for I wish
it could be said of me as Fuseli says of Rembrandt, 'he
followed nature in her calmest abodes and could pluck a
flower on every hedge—yet he was born to cast a steadfast
eye on the bolder phenomena of nature'.*

John Constable, letter, 1821

For our purposes four counties make up East Anglia. They are Cambridgeshire, Norfolk, Suffolk and Essex. The generally, though not exclusively, flat countryside is punctuated by large—at times almost cathedral-like—village churches, a residue of medieval wealth deriving from the wool trade. The low-lying fenlands are a major physical characteristic, subtle in their appeal, placing emphasis upon the skies. It is an emphasis which has not been missed by successive generations of artists. Indeed, the area has produced several great painters, and also England's most famous rural school, centred on Norwich.

Thomas Gainsborough and John Constable both came from the Stour Valley, which divides Suffolk from Essex. Gainsborough was born in Sudbury, where his house is a museum, and Constable at East Bergholt, on the Suffolk side of the river, north of Dedham, where his father had one of several mills.

Constable immortalised this landscape. Though he did the same for Salisbury, Hampstead Heath, Weymouth and other places, his art focuses more on the Stour Valley than anywhere else. Gainsborough, a frustrated landscape painter, was less localised. But his first love was landscape, his first efforts were around Sudbury, and he came back to it frequently for inspiration.

Similarly redolent of place are the delicate and sensitive landscapes of the Norwich School, led by John Crome and John Sell Cotman. Of all local manifestations of English art, theirs was the greatest. It is fitting that the art galleries of East Anglia, Norwich Castle Museum most of all, should have many of their works.

Other places which attracted artists include Walberswick, on the Suffolk coast south of Lowestoft, where Philip Wilson Steer painted many of his compelling works, and where artists such as Walter Osborne and Charles Rennie Mackintosh also worked. The brilliant illustrator Charles Keene was brought up in Ipswich, and he also worked on the Suffolk coast.

Twentieth-century artists who came to East Anglia included John Nash and Alfred Munnings, whose Castle House in Dedham is a museum to his memory and contains a comprehensive cross-section of his work. It includes, of course, many paintings of horses, though generally of the less formal, early period, including several of his lovely gipsy studies and sketches.

Horses were also the principal subject matter of the artists who worked on Newmarket Heath. John Wootton, George Stubbs and Ben Marshall were the most outstanding. Marshall lived in Newmarket for twelve years in the early nineteenth century, and the town now has a National Horse Racing Museum which has some representation of this popular tradition in British art.

East Anglia has one major art gallery, the Fitzwilliam Museum, in Cambridge. At Norwich the essentially nineteenth-century collection in the Norwich Castle Museum and Art Gallery is counterbalanced by the modern art collection at the relatively new Sainsbury Centre for the Visual Arts. There are good representative and local art collections at Ipswich, Great Yarmouth, Peterborough and Westcliff-on-Sea.

There are houses of considerable interest in East Anglia, and important art collections in several of them, including Burghley House and Anglesey Abbey in Cambridgeshire, Felbrigg Hall, Holkham Hall and Euston Hall in Norfolk, and Ickworth in Suffolk. Two houses are famous for families with great collections, one historical, the other, the Royal Collection, not represented at Sandringham by other than relatively minor Victorian and Edwardian works of art. Houghton Hall is distinguished, in fine art terms, as the place from which the great art collection of Robert Walpole, First Earl of Orford, was sold by his grandson to the Czarina Catherine II of Russia. It forms the basis for the Hermitage Collection there; Houghton now has relatively minor works, though an important early canvas by William Orpen.

THE FITZWILLIAM MUSEUM,
CAMBRIDGE

The Fitzwilliam Museum in Cambridge is, according to the Standing Commission on Museums and Galleries, 'one of the greatest art collections of the nation and a monument of the first importance', a view that hardly requires that endorsement, so widely is it held. The Museum is also perilously understaffed, to the point where the upstairs portions—which contain the paintings—are at times open for one half of the day, while the downstairs is open for the other half. And even when the upstairs is open, it is quite possible for certain of the galleries to be closed due to additional staff difficulties. This state of affairs is one of the problems inseparable from the independence of such institutions, often fiercely protected.

HENRY LAMB
Lytton Strachey
Fitzwilliam Museum, Cambridge

In the case of the Fitzwilliam Museum, its original collection of fine art and books, together with £100,000 for the building, came from the Seventh Viscount Fitzwilliam of Merrion, who took his master's degree at Trinity College, Cambridge, in 1764, was a Fellow of the Royal Society, and an author, and who died in 1816. The collections were moved to Cambridge and temporarily housed for many years. The site for the building was acquired in 1821 from Peterhouse, and in 1834 a competition was held for the best design for a new museum. George Basevi's designs were selected. He died in 1845 and C. R. Cockerell was appointed to complete the unfinished interior, though this was not done by 1848, when the museum opened to the public. It was not until 1875 that E.M. Barry finished the work.

The original collection, of 144 paintings, including works by Titian and others, has been greatly augmented by subsequent gifts and bequests, as well as purchases. A few should be mentioned.

A group of 248 pictures was added before the opening of the museum. These came from Daniel Mesman's bequest in 1834. Ruskin gave 25 Turner watercolours in 1861, and a year later the museum received works by Hobbema and Ruisdael. Throughout the second half of the nineteenth century gifts and bequests strengthened the collection, particularly with English paintings, but even in 1912, in a catalogue published by the then director, Sidney Cockerell, the Fitzwilliam was pleading that its resources for purchases were 'totally inadequate for competition in the sale rooms'.

In that year, however, the Fitzwilliam received the C. B. Marlay Bequest, which included both a large and varied art collection and £90,000, allowing for an extension, the Marlay Galleries, to be opened in 1924.

In 1931, the Courtauld Galleries were opened, paid for by the Courtauld family, and in 1936 the Henderson Galleries and the Charrington Print Room followed as a result of bequests by J. S. Henderson and John Charrington.

In 1948, Lord Fairhaven gave £30,000 for the purchase of English landscapes, and the following year the executors of W. Graham Robertson gave six works by William Blake together with £10,000 towards the cost of a room for drawings and watercolours.

In 1963 over 1,000 Dutch and Flemish drawings were bequeathed by Sir Bruce Ingram.

The collection of paintings, drawings and sculpture provides a splendid representation of the major European schools.

In the early twentieth century the truly superb Titian, *Tarquin and Lucretia*, was given by Charles Fairfax Murray. This was in addition to the one presented in the original Fitzwilliam bequest, *Venus and Cupid with a Lute Player*, one of a series by the artist, painted between 1545-65, and exploring the hierarchy of the senses. It was a classical argument, revived by the Neo-Platonists in the Italian Renaissance, and revolving around the differences between Aristotle who gave primacy to hearing, and Plato, who gave it to sight.

Opposite: TITIAN; *Tarquin and Lucretia;* Fitzwilliam Museum, Cambridge

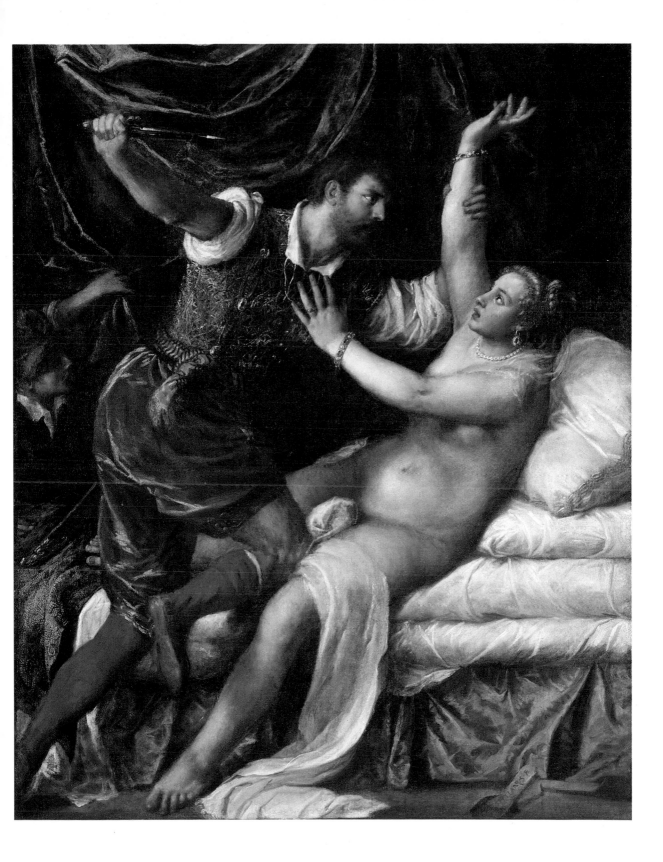

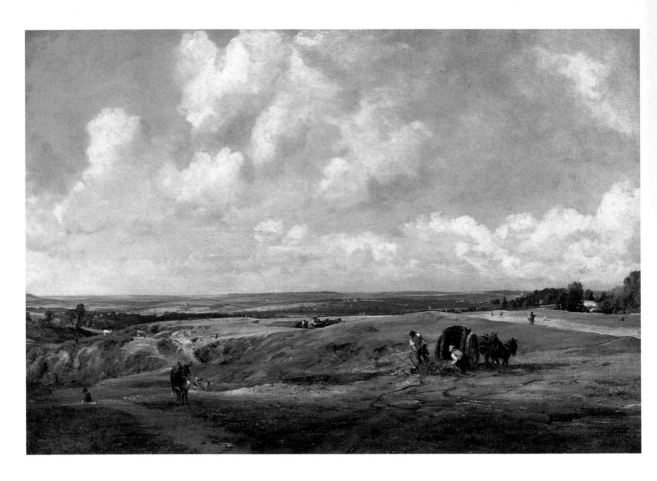

JOHN CONSTABLE
Hampstead Heath
Fitzwilliam Museum, Cambridge

The Fitzwilliam has important early Italian painting, from the schools of Siena, Florence and Venice, and the collection of drawings is also extensive, with Raphael, Leonardo and Michelangelo all represented. There are good Flemish and Dutch paintings, and the French collection includes a good Claude landscape and a Poussin figure subject among its seventeenth-century works, and representative eighteenth-century examples, though its main strengths are nineteenth- and twentieth-century.

The full range of English painting is covered, with an interesting group of Pre-Raphaelite works, though outclassed by other galleries already mentioned. English portraiture is extensively covered, from Hans Eworth and Marcus Gheeraerts to Henry Lamb's portrait of *Lytton Strachey* and Augustus John's portraits of *George Bernard Shaw*, *Thomas Hardy* and *Edward Elgar*.

KETTLE'S YARD

Kettle's Yard is a group of four small converted cottages just outside Cambridge city centre. Now owned by the University of Cambridge,

it was once the home of Jim and Helen Ede, and their collection is maintained in its original domestic setting.

Jim Ede was an assistant at the Tate Gallery in the 1920s and 1930s, residing in Hampstead, which was then the home of a number of prominent artists. He was introduced to modern art by Ben Nicholson in about 1924, at a time when the Tate Gallery was going through a thoroughly unenlightened phase. He admired Nicholson's work, and bought canvases from him for very small sums, generally the cost of canvas and frame. Alfred Wallis also sent him pictures from Cornwall, as many as sixty at a time, priced at one, two or three shillings, depending on size.

At about the same time a great quantity of work by Henri Gaudier-Brzeska was left in the Tate. Gaudier-Brzeska, who was a leading member of the Vorticist movement, and a brilliantly gifted artist, was killed in action in 1915, at the age of 24. The works, including paintings, drawings and sculpture, ended up in the Board Room, which Ede was using as an office. They were not wanted, even as a gift, and Ede persuaded a friend to buy some, acquiring the rest himself 'for a song'. These now greatly enrich the Kettle's Yard collection, in extent and importance, as far as the artist is concerned, second only to that at the Musée d'Art Moderne in Paris.

Jim Ede moved with his wife to Cambridge in 1957 and opened Kettle's Yard to the public, in the afternoons during term time. The buildings and collection were given by them to the University of Cambridge in 1966, and an extension built in 1970.

More generally, Kettle's Yard houses a good selection of British art of the 1920s and 1930s. Due to their early friendship Ben Nicholson is

CONSTANTIN BRANCUSI
Prometheus
Kettle's Yard, Cambridge

HENRI GAUDIER-BRZESKA
Bird Swallowing Fish
Kettle's Yard, Cambridge

particularly well represented. Among other artists represented are William Congdon, Barbara Hepworth, Roger Hilton, Joan Miró, John Piper, William Scott, Italo Valenti, David Jones and Christopher Wood.

The paintings, drawings and sculptures are placed in carefully conceived arrangements of furnishings, found objects, ceramics and glass. *Prometheus*, by Brancusi, lies on the piano lid; the Alfred Wallis paintings hang on the balcony wall between tallboy and corner cabinet; *Bird Swallowing Fish* by Gaudier-Brzeska has as its pedestal a huge log of wood. The Pebble Tradition in British art is everywhere; it is part of the strong appeal of this unique art gallery.

ANGLESEY ABBEY (NT)

Anglesey Abbey is of particular interest for its fine topographical collection of views of Windsor, for which a special Upper Gallery was constructed. The collection contains over 100 paintings, 150 watercolours and drawings, and 500 prints, and covers a period of 350 years, making it one of the most comprehensive topographical collections of any part of Britain on view to the public.

Lord Fairhaven's father moved house to the edge of Windsor Great Park, so that the future collector knew it well in his youth; he was also stationed there with his regiment, the First Life Guards. But the wealth on which the collection at Anglesey Abbey is based derived from the

CLAUDE LORRAINE
The Father of Psyche Sacrificing at the Temple of Apollo
Anglesey Abbey, Cambridgeshire

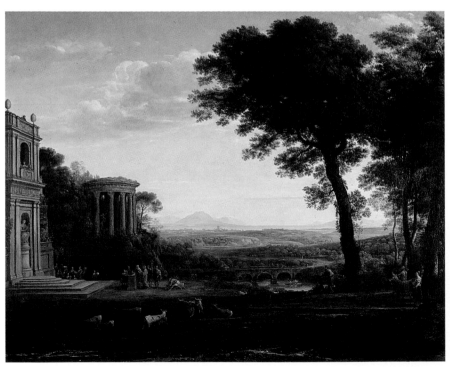

United States, where Lord Fairhaven's father made a fortune in mining and railways, and married a New York heiress, Cara Rogers.

Like all such collections it is not entirely of works of art, but of representations of places. Nevertheless, among painters included are Paul Sandby, famous for many fine watercolours of Windsor, Richard Wilson, William Marlow, John Varley, David Cox, Albert Goodwin and Watts.

Two of the most magnificent Claude landscapes in the British Isles are at Anglesey Abbey. They came from the Altieri Collection, one having been commissioned in 1675, late in the painter's life, by the prince of that family, who claimed descent from Aeneas, the other having been bought twelve years earlier by Angelo Albertoni, whose son Gasparo married the Altieri heiress and niece of Pope Clement X, taking the Altieri name and title. The landscapes came to England in 1799, and were in William Beckford's collection before he sold them for the then enormous sum of £10,000. They were subsequently bought by two Bristol merchants, became part of the collection at Leigh Court and were sold again in 1884 with the magnificent contents of that house. In 1940 they were bought by the Duke of Kent, perhaps the most discriminating British royal family collector of this century. His death in the Second World War led to the sale of much of his collection in 1947, when Lord Fairhaven bought them.

In addition to the bequest to the National Trust of Anglesey Abbey, its beautiful gardens and arboretum, and the Abbey's contents, the Fairhaven Trust was created in 1948 to enable the Fitzwilliam Museum in Cambridge to acquire English landscape paintings and drawings.

—————— WIMPOLE HALL (NT) ——————

John Wootton's painting was particularly associated with this house, which was owned in the early eighteenth century by Edward Harley, Second Earl of Oxford, the son of Queen Anne's Chief Minister, and a considerable collector. He surrounded himself with a group of artists 'of the Tory persuasion', at a time when to be politically inclined was unavoidable and, when in favour, advantageous.

JOHN WOOTTON
Antelope
Wimpole Hall, Cambridgeshire

Though the history of the house is most interesting when concerned with the early and mid-eighteenth century, it was virtually empty of contents when bought in 1938 by Captain Bambridge and his wife, Elsie, the daughter of Rudyard Kipling. The collection was mainly assembled by her, and left to the National Trust, together with the Kipling Archives, which are on loan to the University of Sussex.

Mrs Bambridge went out of her way to recover for the house suitable works of art. The Woottons, however, which are particularly appropriate, were restored on loan by Lady Anne Cavendish-Bentinck.

Works by the artist include *The Countess of Oxford's Dun Mare, Leeds*, and *Bonny Black*, winner of three gold cups at Newmarket. He painted also for Wimpole *The Countess of Oxford's Spaniel*. The collection also has studies of a wolf and antelope from the menagerie which was established in the early eighteenth century at the house by the Second Earl of Oxford.

BURGHLEY HOUSE

NATHANIEL DANCE
Angelica Kauffmann
Burghley House, Cambridgeshire

The collection of pictures at Burghley House is one of the largest in these islands. The character of the Burghley House collection derives principally from the acquisitions of John, Fifth Earl of Exeter, who went, more than once, on the European Grand Tour and bought lavishly. The collection, however, was considerably augmented by his descendant, the Ninth Earl. The Fifth Earl's portrait, by Godfrey Kneller, is in the Billiard Room.

The Burghley House collection contains a fine cross-section of religious, genre, landscape and portrait works, hung in profusion throughout the house.

The glorious Heaven Room, painted by Verrio with a mythological scene, is considered his finest achievement. The astonishing *trompe-l'œil* effect has a rainbow stretching across ceiling and wall, with wonderful contrasts of light and shade, and with such subjects as the Forge of Cyclops, watched by Verrio himself portrayed as Dante. It is the finest painted room in England and the only room by Verrio in which he carried the painted decorations to floor level, enormously enhancing the dramatic impact of the various scenes. These are peopled by Jupiter and Juno, Ganymede, Neptune, Cybele, Ceres, Minerva, Bacchus, Ariadne, Apollo, Diana, Hercules, Castor and Pollux, Mars, Mercury, Venus and Vulcan.

Antonio Verrio, a Roman Catholic, had been patronised by the court of James II. His work at Burghley followed the Glorious Revolution of 1688; but though he was in asylum during his period there, he proved a troublesome guest, demanding coach and horses, certain precise Italian delicacies, and expensive furniture to decorate his suite of rooms. In just over ten years he completed the decoration of six apartments, and began a seventh. He was reconciled to the new monarchy and by 1701 had returned to help in the decoration of the new state apartments at Hampton Court Palace.

There is a Verrio *Self-Portrait* as well as other portraits by the artist in the Billiard Room. This contains Exeter family portraits, many of high quality, by Sir Thomas Lawrence, Sir Peter Lely, Thomas Gainsborough, and Sir Godfrey Kneller.

There is also a characteristically polished and assured piece of work, showing clearly the sitter's self-confidence. There are anonymous portraits of Isaac Newton and Thomas Hobbes, also a portrait of Verrio by Kneller, thought to be members of the Order of Little Bedlam, which was re-established in this room by the Fifth Earl. He was largely responsible for the collection.

The earliest work is by Van Eyck. The political significance of the Cecil family at the court of Elizabeth I is indicated by the Gheeraerts portraits of the Queen, and of *William Cecil, First Lord Burghley*.

There are several very appealing religious works, among them the lovely Scarsellino *Virgin and Child with the Infant St John the Baptist*, and the Gentileschi *Virgin and Child in a Landscape*.

Other works in the Burghley collection include a fine altarpiece by Veronese in the Chapel; a set of four paintings *The Elements* attributed to

Jan Brueghel and an enormous *Ox Carcass*, appropriately in the kitchen, attributed to Marten van Cleve.

ROMAN VIEWS AT
FELBRIGG HALL (NT)

The quality and interest of the paintings at Felbrigg are due to the taste and collecting instincts of William Windham II on his Grand Tour. The Cabinet, specially redesigned in 1751 to display the purchases, contains the third biggest collection of views of Roman antiquities after the British Museum and the Fitzwilliam Museum. The 26 gouaches and 7 large oils by Giovanni Battista Busiri include *The Ponte Lucano and Tomb of Plautii, near Tivoli* as well as views of Frascati and Civita Castellana.

Windham was also fond of Dutch marine paintings and in the same room are *View on the Meuse* by Lucas van Valkenborch and an enormous *Blockade of Amoy* by Simon Vlieger. The drawing room contains four impressive canvases by Willem van de Velde including the *Battle of the Texel* and views by Samuel Scott of *Old London Bridge* and the *Tower of London*.

LUCAS VAN VALKENBORCH
View on the Meuse
Felbrigg Hall, Norfolk

LORD ARLINGTON AND
——————— EUSTON HALL ———————

The Earl of Arlington bought the Euston estate in 1666 and built a house 'in the French manner', which was finished by 1670. Not a great deal of this house, or its remodelling in the mid-eighteenth century, remains. An unattributed *View of Euston Hall* displays its magnificence at the end of the seventeenth century. The collection, today mainly of seventeenth- and eighteenth-century works, provides the chief attraction.

The earliest paintings, done for Euston or for Arlington House, in London, which stood on the site of Buckingham Palace, and was demolished in 1703, include works by Van Somer, Mytens, Van Dyck, Lely and Kneller.

The Mytens is a magnificent full-length of another of the great collectors of the early seventeenth century, *George Villiers, Duke of Buckingham*. The pose is almost exactly that of the Mytens portrait, in the Royal Collection, of Charles I. Though only two years separate the two works, the change in fashion is marked, Buckingham appearing almost Elizabethan in his doublet and hose, Charles wearing cavalier costume.

The most famous painting at Euston Hall comes from another era altogether. *Mares and Foals by the River at Euston*, by George Stubbs, was painted for the Third Duke of Grafton, who bred the horses.

- THE CASTLE MUSEUM, NORWICH -

The Castle Museum is unique in its emphasis on the works of a group of local artists, the Norwich School. They in turn represent a unique phenomenon in English painting, central to the tradition of landscape art, and the outstandingly English artistic skill of watercolour painting. The Norwich artists are a 'school' in the sense in which that word denotes a group of people united by a general similarity of principles and methods, and respecting the leadership of a 'master' (in this case, of two). John Crome and John Sell Cotman were not just masters in their own school; they were masters of English landscape painting, both in oil and watercolour, and, together with Gainsborough and Constable, represent part of a major East Anglian contribution to the development of English painting.

The Norwich School is unique in another respect. Allowing for fluctuations in public regard, and other minor vicissitudes, the works of the two leading painters and of their pupils have been constantly admired and collected.

While for much of the nineteenth century this interest in the Norwich School was confined to very few people, it did result in that continuity vital to provenance. And it also means that the Norwich Castle Museum's collection has long been a touchstone for dealers and collectors.

To a considerable extent this has been due to Russell James Colman, and his father, J. J. Colman, who bequeathed their unrivalled collections of Norwich School paintings, as well as providing money for the two separate galleries in the Norwich Castle Museum, one for John Crome's works, the other for John Sell Cotman's paintings. In the latter gallery there is a unique sequence of the few oils painted by John Sell Cotman in the years following his return to Norwich from London.

John Crome was born in an ale-house in 1768, the son of a journeyman-weaver. George Borrow wrote of him, in *Lavengro*: 'the little dark man with the brown coat and the top-boots, whose name will one day be considered the chief ornament of the old town, and whose work will at no distant period rank among the proudest pictures of England'. He was apprenticed to a sign-painter, began selling his work at quite a young age, and was established in the city of Norwich as 'John Crome, Drawing Master' by the turn of the century. He led his pupils into the fields. 'This is our academy!' he once cried out triumphantly to a passing friend, from the banks of the River Yare. And by 1803, when the Norwich Society of Artists was founded, Crome was its moving spirit, its most prolific exhibitor, and the city's leading painter.

JOHN CROME
Back of the New Mills
Castle Museum, Norwich

Crome's main works hang in a gallery named after him, and include *Ruins of Carrow Abbey*, two characteristic river views, *The Yare at Thorpe, Norwich* and *Back of the New Mills*. There is a fine oil sketch, *Postwick Grove*, a study of a local beauty spot, and *Yarmouth Jetty*, a favourite subject for Crome.

Not really until the twentieth century did John Sell Cotman first rival and then surpass Crome as the most significant artist in the Norwich School. Cotman, born in 1782, was much younger than Crome, and came from a different social background, his father having a business in Norwich as draper and silk mercer in which he wanted his son to succeed him. Cotman was also less gregarious, departing for London to study and make his early impact as an artist, and then later leaving Norwich for good, with the result that the Norwich Society of Artists ceased to exist.

JOHN SELL COTMAN
Baggage Wagon
Castle Museum, Norwich

Cotman's distinctive style is powerfully represented in such works as the four tree studies, *Silver Birches*, *Normandy River*, *The Mishap* and *Baggage Wagon*. Earlier drawings, often considered to be his best work, include notably *The Devil's Elbow*, *Rokeby Park*, and *Greta Bridge*.

In addition to the two masters, the Norwich School included James Stark and George Vincent, who were pupils of Crome, Robert Ladbrooke, John Thirtle, Henry Bright, Joseph Stannard and Thomas Lound, as well as John Sell Cotman's two sons, John Joseph and Miles Edmund (examples of both of whose work also hang in the Cotman Gallery), Crome's sons, John Berney (they were known as 'Old' and 'Young' Crome to distinguish them) and William Henry.

THE SAINSBURY CENTRE
—— FOR THE VISUAL ARTS ——

This is a wide-ranging and remarkable collection of international importance formed over a period of more than fifty years. Sir Robert Sainsbury has said that he has never regarded himself as a collector but has been a 'passionate acquirer of works of art that have appealed to me, irrespective of period or style, subject only to the limitation of size in relation to the space available and naturally cash'. 'My personal reaction to any work of art is mainly sensual, intuition largely taking the place of intellect. . . .'

The collection was given to the University of East Anglia in November 1973 by Sir Robert and Lady Sainsbury. The Centre, designed by

Above:
Artist Unknown
Fisherman's God
Standing Male Figure, Cook Island
Sainsbury Centre for Visual Arts,
Norwich

Far left:
HENRY MOORE
Mother and Child
Sainsbury Centre for Visual Arts,
Norwich

Left:
JOHN DAVIES
Bucketman
Sainsbury Centre for Visual Arts,
Norwich

Foster Associates and one of the most significant post-war buildings in Britain, was a gift of David, their son, and was opened in April 1978. The building has since won many national and international awards. It has an exciting modern collection and a special feature is the Tribal Art. A part of the Anderson Collection of Art Nouveau is also shown.

It is a visual arts centre, intended to give students the opportunity to see works of art in 'the natural context of their work and daily life'. The building housing the art is appropriately free from fuss, and unobtrusive in style.

Above:
PETER DE WINT
Still Life
Usher Gallery, Lincoln

Above right:
FREDERICK MACKENZIE
Lincoln Cathedral from the Castle
Usher Gallery, Lincoln

Below right:
WILLIAM CALLOW
Lincoln
Usher Gallery, Lincoln

— FINE ART IN GREAT YARMOUTH —

The Great Yarmouth collections have been built up by donation, bequest and purchase. In the post-war period a number of important works were bought out of the war damage fund. Before 1974, the museums were the responsibility of the Great Yarmouth County Borough Council. Since then they have come under Norfolk County Council and are part of the Norfolk Museums Service.

Of particular interest are *The Dutch Fair on Yarmouth Beach* by George Vincent; *Yarmouth Jetty, On the Seashore, Tetley Water, Old Jetty at Great Yarmouth, Yarmouth Beach* and *Burgh Castle*, all by Alfred or Joseph Stannard; *Shipwreck* and *Saving a Crew* by the Joy Brothers; *Mackerel Market on Yarmouth Beach* and *Yarmouth Beach and Jetty* by R. Ladbrooke; and *Marshes at Bramerton* and *Haycutting on Norfolk Marshes* by J. Arnesby Brown.

Nineteenth- and twentieth-century Broadland watercolourists C. H. Harndon and S. J. Batchelder are represented, the former particularly so. The main twentieth-century works are by Arnesby Brown, Campbell Mellon and Rowland Fisher. The Maritime Museum for East Anglia houses an important collection of primitive 'Pierhead Paintings'. There is also a collection of portraits of local worthies a few of which are of more than local interest.

— THE AUDLEY END COLLECTION —

Audley End, in Essex, a derivation of Audley-Inn, was originally a house erected in the reign of James I, 'one of the wonders of that age,' says Horace Walpole, deserving of little notice, however, 'but for the prodigious space it covered'. It was the work of Bernard Jansen, and had a gallery 95 yards long. It was built by Thomas Howard, Earl of Suffolk, much of it, however, demolished in the same century.

The collection at Audley End is not well documented. It seems to have been formed mainly by Lord Howard, who lavished a fortune on the house after the death of his aunt, Lady Portsmouth. Lord Howard was created Lord Braybrooke in 1788. After his death in 1797 pictures were added from the Neville collection at Billingbear in Berkshire whence came a further collection of both pictures and furniture in 1916.

The third Lord Braybrooke married Jane, daughter and co-heiress of the Marquis Cornwallis and to her devolved some 18 portraits from the Cornwallis properties of Culford and Brome Hall in Suffolk. These portraits became part of the Braybrooke collection.

Since 1916 the collection has remained virtually static. The majority of the pictures belong to the Hon. R. H. C. Neville. The present Lord Braybrooke has loaned a number of pictures back to Audley End.

Of particular interest is Hans Eworth's *Margaret Audley, Duchess of Norfolk*, and *Portrait of the Artist with Hugh May*, by Peter Lely. The two

men were friends of long standing when the work was completed, around 1675. Two years earlier May had been appointed by Charles II to complete the alterations to Windsor Castle. The painting was owned by *Richard Neville*, whose portrait by Zoffany is in the collection, as is *Naples Harbour* by the same artist.

SIR ALFRED MUNNINGS MUSEUM
IN DEDHAM

Alfred Munnings lived at Castle House, Dedham, on the Essex side of the River Stour, from 1920 until his death in 1959. He originally came from East Anglian farming stock. His house has been turned into a museum, and contains an excellent cross-section of his work, from early academic studies, and gipsy paintings, to the racing and portrait canvases out of which he made an enjoyable and reasonably profitable livelihood.

His studio, which is in the garden, is a major attraction for visitors with its informal atmosphere and profusion of works as well as the tools of his trade. But interest now has centred more on the formal arrangement of the house, and on the large, finished canvases, rather than the oil sketches and drawings.

He was outstandingly controversial, and extremely witty. Technically brilliant, his contribution to twentieth-century sporting art is appropriately located in East Anglia, where painters of the horse have always found appreciation as well as subject-matter.

There is, in Munnings's art, a curious gap between the impeccable

ALFRED MUNNINGS
A Study For a Start
Sir Alfred Munnings Art Museum,
Dedham

'language'—almost a form of shorthand—with which he captured everything to do with racing, hunting, and horses generally, and a lack of 'finish' or 'depth' in his work. Motion, articulation, stance, 'character', anatomy, are all precise and exact. But less frequently does one respond fully to an emotional experience. It is the price for specialisation; it is a limitation on sporting art which painters of the stature of George Stubbs overcame.

ICKWORTH (NT)

Ickworth, in Suffolk, is of particular fine art interest. This not just because of its collection, though it contains a number of outstanding works, but because it is one of the few houses in England built primarily for the housing of works of art.

The house is the creation of its first owner, the Earl-Bishop of Derry, Frederick Augustus Hervey, Fourth Earl of Bristol. He intended the splendid central rotunda of the house to be the living quarters, the wings to contain galleries for pictures and sculpture. He died in Rome, in 1803, and did not therefore see the house completed. Its demolition was contemplated by his son, but mercifully, and at huge cost financed by extensive Hervey family properties, it was completed, though the original scheme was reversed, the living quarters being placed in the east wing, the main collection located in the state rooms in the Rotunda. It came to the National Trust in 1956, with most of its contents.

Part of the collection derives from the enthusiastic purchase of works of art by the Fourth Earl, who travelled extensively in Europe, and after whom are named the many 'Hotel Bristols'. But in no sense have there survived what the Earl-Bishop described as the works of 'chiefly Cimabue, Giotto, Guido da Siena, Marco da Siena and all that old pedantry of painting, which seemed to show the progress of art at its resurrection'. He collected at a particularly difficult time, while the Napoleonic Wars were going on, and his works of art were confiscated and expensively redeemed, as well as being plundered, as if he were a French, rather than an English, nobleman. It is certain that some were acquired by William Roscoe, and may form part of the Walker Art Gallery collection (q.v.).

Important paintings were commissioned and bought by the two elder brothers of the Bishop of Derry through whom the title passed in succession. It is not clear whether it was the Second Earl, who was ambassador in Madrid in 1758, or the Second Marquess of Bristol, who was secretary to the Legation there in the 1830s, who acquired one of the masterpieces in the collection. This is *Portrait of the Infante Baltasar Carlos*, by Velázquez. This celebrated masterpiece, a version of one in the Prado and painted in 1635, shows Philip IV's son, with three dogs and holding a musket, as a young sportsman.

Eighteenth-century portraits of the Hervey family, which constitute one of the great groups of country house portraits, include a Gainsborough masterpiece, his *Augustus John Hervey*, who became Admiral

HUBERT GRAVELOT
The Hervey Family
Ickworth, Suffolk

WILLIAM HOGARTH
Holland House Group
Ickworth, Suffolk

of the Blue and later succeeded his brother as Third Earl. Known as 'the English Casanova', a deserved sobriquet, he led a colourful professional and private life, and married the bigamous wife of the Duke of Kingston, Elizabeth Chudleigh.

There are additional Gainsborough portraits of members of the family,

as well as works by Romney, Angelica Kauffmann and Reynolds. The best known of the portraits of the Earl-Bishop is by Vigée-Lebrun, who was commissioned by him also to paint her own self-portrait, which hangs in the Smoking Room.

There are, in the same room, several of the works acquired by the Second Earl, while in Italy, and they include *Portrait of an Unknown Man* by Titian and *Classical Landscape* by Gaspard Dughet.

Interesting portrait groups from the eighteenth century, displayed in the Library, include Gravelot's of *The Hervey Family*, in which both Liotard and Hayman had a hand, and Hogarth's *Holland House Group*, painted in 1738. This work includes the figure of the eccentric clergyman, Peter Lewis Willemin, who is peering at the church spire of Eisey, near Cricklade, to which rich living he was appointed by Stephen Fox, who is also in the picture. Willemin is standing on a chair to get a better view through the telescope in his hand, but seems to be falling off again with excitement at the prospect of the gift.

The house has splendid decorations, neo-classical in the main, and some excellent works of sculpture, including the wonderful Flaxman group, *The Fury of Athamas*. Sadly, this is the only piece of sculpture—originally commissioned by the Earl-Bishop in Rome—to make its way to Ickworth and still to be part of the house's collection.

———— FINE ART IN IPSWICH ————

Christchurch Mansion, owned by Felix Cobbold, who later became MP for Ipswich, was given to the town, and used as a museum. Then, in 1931, the Wolsey Gallery was built. In addition, there are seventeenth-century portraits in the Town Hall, and also there hangs a series of paintings by the eighteenth-century marine painter Dominic Serres of naval engagements. Ipswich Art Gallery was originally built in 1880, as part of the town's museum, and primarily for the exhibitions of the local Fine Arts Club. It did not have the motivation of a benefactor giving paintings.

Cobbold did bequeath money for the purchase of paintings, and the collection of British art is reasonably good, with strong representation of the works of the two major 'local' artists, Gainsborough and Constable.

Gainsborough moved from Sudbury, when he failed to make a living there from portraiture, and lived and worked in Ipswich from 1752 to 1759. The development of his style is indicated in a number of portraits, ranging from the early *Tom Peartree*, *John Sparrowe*, and *George Dashwood*, all from the Ipswich period, and then those of *Mrs Kilderbee* and *The Duchess of Montague*, which date from after his departure. There are also landscapes, among them *Country Cart Crossing a Ford* and *A View near the Coast*.

Constable's work includes portraits of his father and Abram his brother, as well as two delightful landscapes, *Golding Constable's Kitchen Garden* and *Golding Constable's Flower Garden*, and a painting of *Willy Lott's House, Flatford*.

Fine Art in the 'Home' and Southern Counties

It is in the country house that the Englishman gives scope to his natural feelings . . . His country seat abounds with every requisite, either for studious retirement, tasteful gratification, or rural exercise. Books, paintings, music, horses, dogs, and sporting implements of all kinds, are at hand. He puts no constraint, either upon his guests or himself, but in the true spirit of hospitality provides the means of enjoyment, and leaves everyone to partake according to his inclination.

Washington Irving

As a broad generalisation, it could be said that the southern and Home counties of England, in fine art terms, are the opposite of those in the north. Riches are contained in country house collections, while the art galleries and museums are not so well endowed. While there is an intense concentration of every kind of art in London itself, separately considered, the counties which surround it are remarkably impoverished in terms of major museum collections. There are good art galleries, notably at Southampton (the best), Brighton, Guildford, Maidstone, Portsmouth and Bedford, all sufficiently far from London not to be completely in its shadow. But they do not really compare with the great northern public collections.

The reasons are not far to seek. The counties in the south-east of England, in the nineteenth century, when the greatest strides were made in the creation of art galleries and museums elsewhere, constituted a depressed area. While successful, first-generation industrialists in northern England, in the Midlands, in Glasgow, and elsewhere, were building museums and collecting works of art to fill them, often as their own memorials, the southern half of the country was static in this respect. Heavily dependent on agriculture, the economic structure of the Home Counties concentrated wealth in the hands of very few people, mostly landowners, and it is their art collections, and not the public ones, which are important. Furthermore, the main towns, with only one or two exceptions, had no industrial base on which to expand.

The area under consideration divides naturally into two groups of

counties, those around London to the north and west, and the southern counties.

In the first group Berkshire can boast the major part of the Royal Collection on public display, at Windsor Castle. Crowded, and far from well displayed for the lover of paintings, since many of the pictures are on three walls of rooms which are viewed from behind a rope barrier, there is nevertheless nowhere else in the region where some of the greatest works of such painters as Van Dyck, Rubens, Holbein, Lely, Vermeer, Rembrandt, Dürer, Clouet and Andrea del Sarto can be seen.

In addition, the Queen owns the greatest private collection of drawings in England, indeed the greatest in the world. A small part only of this comprehensive and magnificent collection is on public display.

The diversity of the great country house collections in Berkshire, Bedfordshire, Buckinghamshire and Hertfordshire is immense. Some of them, such as the Woburn Abbey and Hatfield House collections, cover many generations of the families of the Duke of Bedford and the Marquess of Salisbury. Others, such as Luton Hoo, Ascott and Waddesdon, are nineteenth-century collections, more single-mindedly of fine art, and without the heavy concentration on family portraits which can become a burden to the visitor. One of the truly great country house collections in the southern counties is at Petworth, in West Sussex. Other good collections include Arundel Castle, Goodwood, Knole and Broadlands.

In Bedfordshire there are the two great country house collections already mentioned, at Woburn Abbey and at Luton Hoo. The first of these is a traditional, 'great family' collection, going back over many centuries, and substantially free from the depredations of past generations which have reduced the range and quality of fine art in so many of such houses. Luton Hoo is quite different; the collection of a single great mining magnate of the nineteenth century, it reflects the limited period during which the works of art were assembled. It is no less impressive for that.

Berkshire has some interesting country house collections, though none in the first rank. The first of them is at Mapledurham, which has Blount family portraits. Basildon Park, restored following the Second World War, and furnished in an Italianate style, has pictures to suit.

In Buckinghamshire there are excellent fine art collections at Ascott and at Waddesdon Manor. In addition, there is Claydon House, which has an association with Florence Nightingale, whose sister was married to Sir Harry Verney. Her portrait is among pictures in the house. Winslow Hall and West Wycombe Park have collections.

In Hertfordshire, there are noteworthy collections at Hatfield House, owned by the Marquess of Salisbury, at Knebworth House, where Edward Bulwer-Lytton lived and wrote, and at Gorhambury, the site, though not the building, of Francis Bacon's home and containing portraits of him and his half-brother, the artist. All three houses are separately noted. Shaw's Corner, in Ayot St Lawrence, contains some portrait material of the playwright.

Kent has a number of interesting country house collections, including that of Britain's only prime minister who made a success of painting in oil, Winston Churchill. His work, in landscape and still life, hangs at Chartwell, separately noted. Also the subject of more detailed mention are the collections at Squerryes Court, Knole, Hever Castle and Leeds Castle.

There is a mixed but interesting collection at Boughton Monchelsea Place, near Maidstone, ranging from sixteenth- to twentieth-century works. The collection at Chiddingstone Castle is also diverse, including Egyptian and Tibetan antiquities and a number of seventeenth-century British and continental canvases. Down House has a collection related to Charles Darwin. The Godington Park collection is strongly seventeenth century; that at Lullingstone Castle has a sixteenth-century emphasis; while at Penshurst Place the works range over the eighteenth century as well. Quebec House has a collection relating to General Wolfe.

There are few houses of note in Surrey. An interesting Hogarth painting, *The House of Commons with Speaker Onslow in the Chair*, is at Clandon Park, a National Trust house near Guildford, which has other eighteenth- and nineteenth-century paintings. Hatchlands, which is nearby, contains a loan collection of the work of Henry Lamb. There is a good general collection at Loseley Park, including a vast group portrait, which was painted in the house by Van Somer. Polesden Lacey, for almost forty years the home of Mrs Greville, contains a richly varied collection.

Public collections in Surrey include the Guildford House Art Gallery. Its small permanent collection includes works by the eighteenth-century Guildford artist John Russell. These, at their best, as in *Rebekha Gines*, have a Greuze-like quality. There are also nineteenth- and twentieth-century paintings and drawings by British artists in the main, as well as topographical pictures.

The Royal Holloway Collection was accumulated in 26 months by Sir Thomas Holloway, who founded the Royal Holloway College, opened by Queen Victoria in 1886. It is now a constituent school of London University, open to a mixed community of 2,000 students in the sciences and arts, and is located in Egham, 20 miles south-west of London. Holloway's intuition for a bargain, mainly at Christie's and Agnew's, was unsurpassed in Victorian times, although he sometimes strayed into the maudlin and sentimental. One notable work is *The Railway Station* by Frith. Holloway also collected the Scottish painters, including McWhirter, Hardy and Erskine Nicol.

In both East and West Sussex there are numerous houses with interesting art collections. Not to be missed are the extensive collection of British and European art at Firle Place, and the Edwardian house in Brighton, Preston Manor. In addition, there are the collections at Glynde Place, which has the portrait of 'The Beauty of Holiness', the title given to *The Bishop of Durham* by George III, and at Lamb House, which was owned by Henry James, and contains portraits of the American novelist.

There is also a fine sporting collection at Bentley.

Perhaps the best of all country house art collections is that at Petworth.

Its merit does not lie simply in the works of art, but in their primacy, ease of access, historical integrity and the association of the house and previous owners with artists, most notably the Third Earl of Egremont's with Turner. Arundel Castle and Goodwood House also contain exceptional works of art.

There is a notable collection of paintings at Uppark, near Petersfield, some of which are Grand Tour acquisitions, others commissioned views and battle subjects. At Standen, East Grinstead, a house associated with the Pre-Raphaelite Movement, though the original collection was dispersed, a serious attempt to replace works of art in keeping with the history and background has been made.

Hampshire has four important country house collections, at Mottisfont Abbey, Stratfield Saye, Broadlands and Breamore House. Avington Park has a modest collection which includes decorated walls and ceilings. Work is attributed to Verrio and Valdre. Mainly eighteenth-century pictures are to be seen at The Vyne.

With the exception of the Southampton Art Gallery, public collections are modest. That at Portsmouth was rehoused in 1972, when a collecting policy was worked out. This has led to some intelligent purchases, and there have been important gifts and bequests. But the gallery suffers from too little space, and the need to give it over, in whole or in part, to visiting exhibitions.

In 1987 the collection at the Pallant House Gallery, in Chichester, was considerably enlarged by an anonymous bequest of paintings from 'a distinguished collector'. Works by Picasso, Paul Nash and Ben Nicholson are among sixty paintings given through the National Art-Collections Fund. The gallery's main strength is in twentieth-century British art, collected by the principal benefactor, Walter Hussey, though in addition to works by John Piper and Graham Sutherland there are already paintings by international figures such as Picasso.

There are a number of places in the Home Counties which attracted painters, over the years, and in certain cases collections have been left by artists, or in their memory, which are interesting. The most notable of these are the Watts Gallery, in the village of Compton, outside Guildford, and the Stanley Spencer Gallery in Cookham.

Several houses have associations with notable figures, including politicians, though with a fine art dimension to their activities. In the case of Churchill, it is of the unique combination of a great national leader who was also a competent painter, and whose output is extensively displayed at Chartwell, in Kent. In the case of the Duke of Wellington, though the principal result of his collecting is to be seen at the Wellington Museum, in Apsley House, there is a further extension of it at Stratfield Saye.

At Knebworth, in Hertfordshire, there is the only considerable collection of a successful English novelist, Bulwer-Lytton, whose friendship with the notable nineteenth-century painter Daniel Maclise is recorded in more than one work in this splendid Victorian Gothick house.

LUTON HOO AND JULIUS WERNHER

The Julius Wernher collection at Luton Hoo, in Bedfordshire, is a good example of informed late nineteenth-century taste, comparable in many respects with the art at Russborough (q.v.), which was also assembled by a diamond magnate, and with the collections formed by the Marquess of Hertford and his natural son, Richard Wallace, and by John Bowes (Wallace Collection and Bowes Museum respectively, qq.v.).

Julius Wernher was born in Darmstadt, the son of an engineer who came to England and became a close friend of the Stephenson brothers. The son emigrated to South Africa in 1871, and subsequently brought out British mining experts to modernise the techniques then being used. He formed the firm of Wernher, Beit and Company with Alfred Beit and subsequently became one of only five life-governors of the De Beers Company.

He began collecting in about 1890, buying widely—the Bartolomé Bermejo *Saint Michael Slaying the Dragon* was bought in Berlin—and ranging widely in choice as well.

The early Primitives, depleted as a result of the sale of the Altdorfer to the National Gallery in 1980, still include a fine Memling and Filippino Lippi, in addition to the Bermejo, and they are handsomely supported by the extensive collection of Dutch art.

This includes *Head of a Boy* by Frans Hals, a Metsu *A Gentleman and Lady at the Harpsichord*, a fine Isaac van Ostade *Halt at an Inn*, and an impressive *Wooded Landscape* by Meindert Hobbema.

There is a spirited Rubens oil-sketch, *Diana and her Hounds*, in the Main Gallery.

WOBURN ABBEY

The art collection at Woburn Abbey is vast, rich and sumptuous. It is worth addressing with care, since the quality of many of the works repays detailed attention. It is enormous in size, ranging over five centuries of British portraiture, with additional continental works. These paintings are essentially the record of a single family, the Russells, whose contribution to British public life, particularly under the Tudors and again in the nineteenth century, was considerable.

Coming to grips with the collection is comparable to the task of picking out and putting into some kind of order the multitude of jewels in the George Gower portrait of *Elizabeth I*, known also as *The Armada Portrait*. All are splendid; many at first glance look alike; they constitute an overall design; they are arranged in regular patterns; and they serve an ultimate purpose—in the case of the Gower, the adornment of the Virgin Queen, in the case of Woburn Abbey, the grand decoration of a great house.

The house contains family and other portraits going back over several centuries. There are, for example, four portraits signed by Marcus

JOSHUA REYNOLDS
Lady Elizabeth Keppel
Woburn Abbey,
Bedfordshire

Gheeraerts and a further three attributions. Portraits by or attributed to George Gower, Hieronimo Custodis, Robert Peake the Elder and John de Critz indicate the strengths in the sixteenth- and early seventeenth-century collection.

The dominance of portraiture goes on with works by Van Dyck, Riley, Hoppner, and then by Reynolds, whose paintings fill a room named after him. In it hangs the magnificent portrait *Lady Elizabeth Keppel*, who was the daughter of the Earl of Albemarle. She married *Francis, Marquess of Tavistock*, also painted by Reynolds. They both died young, though not before this only son of the Fourth Duke had fathered three sons, the eldest of whom succeeded to the title. Reynolds's *Self-Portrait*, as well as his *Oliver Goldsmith*, hang in the Reynolds Room.

The portraits reflect the long history of the Russell family, owners of Woburn Abbey since 1550, when it was given to John Russell, who had been Henry VIII's Lord Privy Seal. The expansion of the art collection beyond the portraits was undertaken mainly by the Fourth Duke and his son. The former was British Ambassador to Paris, Lord Lieutenant of Ireland and Secretary of State under George III. He commissioned the 24 Venetian views by Canaletto which hang in the state dining room, called the Canaletto Room.

Woburn Abbey has an interesting collection of self-portraits, by Frans Hals, Aelbert Cuyp, Tintoretto, Jan Steen, William Hogarth, Rembrandt and Murillo. Several of these artists are represented by other works as well. Jan Steen's *Twelfth Night Feast* depicts a typical roisterous Dutch festivity, the children and animals behaving a good deal better than their elders or betters.

There are works by, or attributed to, Velázquez, Claude, Van Goyen, Teniers, Poussin and Vernet.

— CECIL HIGGINS ART GALLERY —

Cecil Higgins was a successful brewer and lover of art. When the family brewing business was sold in 1928 he began to extend his already fine collection with a view to founding a museum for the benefit of his home town. He invested enough money to ensure that acquisitions could continue to be made after his death.

The Cecil Higgins Art Gallery was opened to the public in 1949 and combines the original home of the Higgins family and a new extension built in 1974. The Gallery has won several national awards and in 1981 was awarded the Sotheby's prize for the 'Best Fine Art Museum'.

In 1952 the Trustees of the Cecil Higgins Art Gallery began to collect English watercolours and have built up a collection fully representative of the English watercolour tradition. The works trace the development of English watercolour painting and include Turner's *Norham Castle, Summer's Morn*, as well as Constable's *Coal Brigs on Brighton Beach* and classical and landscape studies by Gainsborough. Cotman is well represented and among his works are the two interiors of Norwich

J.M.W. TURNER
The Great Falls of the Reichenbach
Cecil Higgins Art Gallery,
Bedford

Cathedral and the delightful *Rokeby Woods*. There are notable works by Cox and fine examples of Millais's art including *The Huguenot* and *Gentleman Retrieving a Lady's Hat*.

Cecil Higgins's original holding of eighteen oil paintings has been considerably augmented. The National Art-Collections Fund presented twenty-one small Italian pictures from the estate of the Seventh Duke

DAVID COX
The Mill
Cecil Higgins Art Gallery,
Bedford

of Wellington. Also included in the collection are a number of important
Victorian oil paintings. In 1976 the Standing Commission on Museums
and Galleries presented Alfred Sisley's *Le Quatorze Juillet à Marly* (a
painting accepted by the Treasury in lieu of death duty) to the Gallery
in recognition of the Bedford Corporation's outstanding achievement in
building the extension.

—— WINDSOR CASTLE ——

The first great impact which art has on the visitor to Windsor Castle is
in the Waterloo Chamber. One is confronted there with the studied
splendour of Sir Thomas Lawrence's portraits of the leaders of the
campaign against Napoleon. They are the artist's most substantial
achievement. Taken collectively, they represent a special kind of
patronage, possible only when a number of quite distinct conditions
come together at one and the same time.

Individually, they include the finest examples of Lawrence's work
ranging from the magnificent full-length portrait of the Austrian
Commander-in-Chief, the Archduke Charles, to the masterpiece of them
all, the seated portrait of Pope Pius VII.

This is the largest group of major paintings by Lawrence in any
collection, public or private, and clearly indicates that special relationship
between patron and artist which reaches its apogee when talent and
connoisseurship are evenly matched. How evenly the dash and bravura
of Lawrence's style, his brilliant ability to make his sitters 'think higher
of their own perfections', and the equally brilliant collecting gifts of the

THOMAS LAWRENCE
Pope Pius VII
Windsor Castle, Berkshire

Prince Regent, later George IV, are matched, are the subject for a study on its own. What is demonstrated here is a critical relationship in the formation of the British Royal Collection. And it is one brought to a splendid conclusion in every respect.

The paintings are a unique historical document. They record a triumph of British military history followed by an unprecedented diplomatic

occasion, and they confirm Lawrence as the painter of the day, and a
true representative of the age. It had seen revolution and tradition in
conflict, and in Lawrence himself the eighteenth-century British portrait
tradition is raised by his own brand of Romanticism to heights which
echo correctly the flamboyance of the Regency period, and of the
monarch in all but name, who was to become George IV in 1820.

Even the Waterloo Chamber itself was specially reconstructed to house
the portraits, though it was not completed until after the deaths, in 1830,
of both George IV and Thomas Lawrence. It serves as a memorial to
one of the most discriminating of the royal collectors, and to a great
English portrait painter.

George IV is one of two outstanding examples, in the history of the
British monarchy, of how bad kings make good collectors (the other
being Charles I). George IV had all the moral defects of character which
contribute to the great collector: he was self-indulgent; made others
indulge him as well; he had no sense whatever of financial restraint; nor
did he have any serious understanding of the responsibilities which went
with being heir to the throne.

His great assets, superficial and largely irrelevant in a ruler, included
an eye for a picture—indeed for the arts generally, particularly
architecture—and a sense of proportion and design which was instinctively
brilliant, and made him think of paintings both for, and in, particular
settings and environments. Other questionable assets in a potential ruler
were his capacity for friendship, for affairs of the heart, for the arts
generally. The constraints of his position operated hardly at all upon his
choice of friends or mistresses, to the almost permanent distress of his
father; but the fact that they reflected his enthusiasms and his taste, and
that, into the bargain, their portraits were painted by the artists he liked
and admired, added a further extraordinary dimension to English art,
and left an additional token of human colour and vivacity on the Royal
Collection.

In absolute terms, George IV must be judged by posterity as the most
successful of all the royal collectors. His most serious royal rival in this
respect was Charles I. More discriminating—indeed to be numbered
among the greatest art collectors the world has known, from the point
of view of taste and judgement—Charles I fails to qualify as all that
successful since most of what he acquired was subsequently dispersed
because of his own extravagance. It was George IV who succeeded, in
real terms, and handed down to posterity a substantially improved Royal
Collection. Perhaps not quite as bad a king as Charles, or lucky to have
lived in a period when it mattered less, George IV left as a legacy the
greater part of a lifetime of enthusiastic acquisition.

There were two periods of collecting. The first was from his coming
of age, in 1783, when he moved into Carlton House, until the end of
the Napoleonic Wars. This was followed by the disposal of substantial
numbers of works, and the weeding out of Italian and religious paintings.
From then until his death in 1830, George IV acquired those works for
which he is justly renowned.

He was a generous patron of English artists. The works by

ANTHONY VAN DYCK
The Five Children of Charles I
Windsor Castle, Berkshire

Gainsborough, Reynolds, Stubbs, Sawrey Gilpin, Thomas Lawrence, David Wilkie, Richard Cosway and William Mulready reflect a variety of enthusiasms for his friends, for pretty women, for sporting subjects, for family likenesses and for genre scenes, as well as for battle subjects— but they include a large number of masterpieces as well. Among these must be numbered the Gainsborough portrait of *The Duke and Duchess of Cumberland with Lady Elizabeth Luttrell*, the Reynolds self-portrait, given by the artist's niece after his death as a token of gratitude, the Lawrence portraits already mentioned, as well as the fine seated portrait of *Sir Walter Scott* by that artist.

George's collecting habits, and the debts he ran up to finance them, left a rather different legacy: moral inhibition, or aesthetic blindness, about collecting paintings at all. His brother, William IV, when shown a picture which George IV had much admired, made the remark, 'Ay, it seems pretty—I dare say it is—my brother was very fond of this sort of nicknackery. Damned expensive taste though.'

Though her motivations were rather different, Queen Victoria's attitudes to the collecting of works of art were not over-inspired. Domestically, she and the Prince Consort bought paintings to please each other. Nationally, their interests, where art was concerned had, as we have seen earlier, a utilitarian purpose. An important result of this was the development of major public collections of decorative art, which in turn became equally important repositories of painting and sculpture. And this, in turn, led to the rapid spread of museums and art galleries throughout the British Isles, examined in an earlier chapter. But for the

HANS HOLBEIN
William Reskimer
Windsor Castle, Berkshire

separate pursuit of the Royal Collection, the example of George IV, comprising as it did the accumulation of magnificent examples of art but at too high a cost financially, and in terms of his reputation as a monarch, became a disincentive of substantial and lasting proportions. No king or queen, since George IV's death in 1830, has attempted to collect in the same way, mixing enthusiasm and brilliance, self-indulgence and prodigality.

The casualties of this lack of royal patronage have been many. Towards the end of his life, George IV seemed about to take an increasing interest in British painting, responding to the anecdotal spirit which was inspiring artists like William Mulready and David Wilkie. But, in Sir Oliver Millar's words, 'caprice and indolence had prevented him fulfilling his declared aim of forming a representative collection of British painting', and no monarch since has revived the interest which he expressed. Indeed, during the very period when all the major art galleries in these islands were being founded, built and richly endowed, no British monarch made use of the undoubted opportunities to establish a contemporary collection of British art.

Little enough work by other artists was collected, either. With the exception of the substantial acquisition of portraits by Winterhalter, there is no theme, there are no dominant names, there is no stylistic thread, to the works added under William IV, Victoria, Edward VII, George V and VI, and Queen Elizabeth II.

—— STANLEY SPENCER GALLERY ——

STANLEY SPENCER
Self-Portrait
Stanley Spencer Gallery,
Cookham, Berkshire

The collection is dedicated entirely to the works of Sir Stanley Spencer. The pictures are changed regularly, with a Summer and Winter exhibition, but the underlying themes of Spencer's paintings are evident: episodes from the life of Christ, set among characters and scenes in the village of Cookham; identification of ordinary life and love with religious themes, and an intensely personal view of nature and of men and women, contemporary to Spencer, but set in mythical or religious situations.

The gallery contains major paintings, drawings, scrapbooks and memorabilia of the artist. Most of the paintings reflect the locale, even in the more intensely religious pictures. *The Last Supper* is set in a Cookham malthouse, and the association is brought closer in *Christ Preaches at Cookham Regatta*.

Secular paintings depict houses and gardens in and around the village in a most detailed and individual style, as do his depictions of local people; his imaginative themes, *Christ Overturning the Money Changers' Table* and the companion picture, *Saint Veronica*, are highly skilled technical compositions in a unique style and colour. Cumulatively, these works reflect a diversity and love of life, which is a vivid and a continuing memorial to the artist.

— THE ASCOTT COLLECTION (NT) —

The collection at Ascott, in Buckinghamshire, given to the National Trust in 1950 by Mr and Mrs Anthony de Rothschild, would merit a place in several different specialist collections. It has good Dutch paintings, examples of eighteenth-century French art, two major Italian works, at least one English masterpiece of the eighteenth century, and important sporting works by Stubbs.

The collection derives from several generations of the Rothschilds. Baron Lionel's original collection of paintings, which included some of the Dutch works, and was split between his country home, Gunnersbury Park, and his house at 148 Piccadilly, was divided between his three sons, Nathan, Alfred and Leopold. Leopold, who lived at Gunnersbury Park and Ascott, added to the collection before it passed to his son.

The Stubbs paintings span nearly three decades of his art, from the mid-1760s to the 1788 *Two Horses in a Paddock*, which was given to Anthony de Rothschild by his brother James, as part of his wedding present, in 1926. The first owner, who commissioned the work, was John Hanson. He was considered mad because he paid eighty guineas for it. It has as theme, or initial idea, the face-to-face encounter of two horses, one in which Stubbs was interested in the late 1780s. It is dated 1788.

An additional part of the wedding gift was the larger Stubbs portrait of *Pumpkin*, a racehorse owned in 1776, three years after the painting was completed, by Charles James Fox. The third and most beautiful work by the artist is also the earliest, *Five Mares*, painted probably in 1765, in which year Stubbs exhibited *Brood Mares* at the Society of Artists exhibition. Since this is the only known Stubbs in which mares appear without foals it has been assumed that it is that work.

The Dutch paintings include some bought *en bloc* when Lionel de Rothschild acquired the Heusch Collection, though not the Cuyp *Dordrecht on the Maes*, which Anthony de Rothschild bought through Agnew at a Christie's sale in 1928. He bought the second Cuyp, *A Landscape with a Horseman on a Road*, in the same year.

AELBERT CUYP
Dordrecht on the Maes
Ascott House, Buckinghamshire

There is a fine Dutch interior in the collection, Ludolph de Jongh's *A Lady Receiving a Letter*, thought until 1938 to be the work of de Hoogh.

The greatest work of all in the collection is Andrea del Sarto's *Madonna and Child with Saint John*, a painting full of movement, surprise and spontaneity. The figure of Christ seems to be wrestling its way out of the canvas and into the world; the pose of the Madonna offers a perfect frame for this energy. Goethe records that Angelica Kauffmann had the chance of buying the work, and regretted not doing so; it went instead to Count Josef von Fries, from whose family the Marquess of Londonderry bought it.

———WADDESDON MANOR (NT) ———

The James A. Rothschild Bequest at Waddesdon Manor is a closely integrated one. The fine and applied arts complement each other in absolute terms, as they do in the Wallace Collection. But in addition, in their careful arrangement within Ferdinand de Rothschild's French Renaissance-style house, built between 1874 and 1889, this particular quality of cohesion is additionally emphasised. It seems perverse to attempt a disentanglement of the paintings and sculpture from the rest. Such an attempt may, by focusing attention on one area, heighten the overall effect.

The collection is a combined one. Baron Ferdinand de Rothschild (1839-98) was the great-grandson of the founder of the Rothschild banking empire in Frankfurt. His grandfather was one of the five sons sent to extend the business in France, Austria, Italy and England. He came from the Austrian branch, married the daughter of the first Jewish member of the House of Commons, Lionel de Rothschild, and bought the Waddesdon estate from the Duke of Marlborough.

He died at the age of 59 and was succeeded by his sister, Alice. When she died in 1922 the property went to her great-nephew, James de Rothschild, the grandson of the banker who started the French branch of the family business. He bequeathed Waddesdon to the National Trust.

All were collectors. Ferdinand de Rothschild, like other wealthy nineteenth-century collectors, indulged his love for French art of the eighteenth century, but bought also English eighteenth-century portraits and also earlier Dutch and Flemish paintings. Alice added some paintings, as well as china and arms and armour. James inherited part of his own father's Paris collection, of equal interest to the works of art already at Waddesdon, and possibly responsible for the sense of saturation which pervades the house.

The French art includes a fine Antoine Watteau of *Harlequin, Pierrot and Scapin* dating from about 1720, and a lovely Boucher portrait, *Philippe Egalité as a Child*, painted in 1749. There are canvases by Lancret, Pater, Greuze, Vigée-Lebrun; gouaches by the Swedish artist Lavreince, who worked in Paris in the second half of the eighteenth century; and a fine drawing by Boucher, one of his illustrations for La Fontaine.

The titles of many of these works—*La Courtisane Amoureuse, Le Billet*

ANTOINE WATTEAU
Harlequin, Pierrot and Scapin
Waddesdon Manor,
Buckinghamshire

Doux, *Le Repentir Tardif* and *La Reprimande*—hint at the pervasive, innocent, Arcadian or courtly eroticism which inspired so much French art of the period. It inspired also the fine, small-scale sculpture of artists like Clodion, Falconet and Lemoyne, all represented with interesting examples.

Dutch and Flemish art at Waddesdon includes *The Garden of Love* by Rubens, *A Game of Ninepins* by Pieter de Hoogh, and *The Duet* by Gerard Ter Borch. There are also several of Francesco Guardi's works in the collection.

The largest paintings at Waddesdon are English, mainly portraits, and almost all of them splendid examples of eighteenth-century portraiture at its best. They include major works, like the Reynolds portrait of *Anne Luttrell, Duchess of Cumberland*, whose elopement and marriage at Calais to the brother of George III led to the Royal Marriage Act of 1772, restraining subsequent royal marriages without the consent of the sovereign.

Horace Walpole described her as 'extremely pretty, not handsome, very well made, with the most amorous eyes in the world, and eyelashes a yard long, coquette beyond measure, artful as Cleopatra, and completely mistress of all her passions and projects'. It is the last of these, her command over her own destiny, which Reynolds captures so well in his full-length portrait, done a year or so after the marriage, when she was 26 years old. The painting of the playwright's wife, *Mrs Sheridan as Saint Cecilia*, which Reynolds described as 'the best picture I have ever painted', is in the Baron's Room, along with George Romney's portrait, *Lady Hamilton*.

Equally fine, and typical of the younger portraitist in style, is the full-length *Lady Sheffield* by Gainsborough. He is also responsible for a portrait in the Baron's Room of the actress *Mrs Robinson*, who became paralysed after a successful stage career at Drury Lane. She was the mistress for a time of the Prince of Wales, whose miniature, on her own instructions, was buried with her.

The Waddesdon Collection is superbly catalogued, probably better than any other collection of its type, with its extensive riches separated out into furniture, china, gold boxes, and so on. Unfortunately, the Ellis Waterhouse catalogue of paintings is out of print.

——— BROADLANDS ———

The Broadlands Collection, in Hampshire, is principally that of the Palmerston family, with later additions by Lord Mountbatten. The family connections are reflected in a number of portraits.

Works by Van Dyck include *Charles I*, his wife *Henrietta Maria* and *Madame Vinck*, probably a friend of Van Dyck's from Holland. The outstanding double portrait *Lord John Stuart with his Brother, Lord Bernard Stuart, later Earl of Lichfield* has gone to the National Gallery in London.

They were the younger sons of the Third Duke of Lennox. Their eldest brother, who became First Duke of Richmond, is the subject of the less dramatic seated portrait at Kenwood. The Broadlands painting is known as the Darnley Van Dyck. It passed to the sister of the last Duke of Richmond and Lennox, then to her granddaughter, the First Countess of Darnley, and eventually to Countess Mountbatten of Burma, by whom it came into the Broadlands Collection. It inspired Gainsborough to make a copy, which is in America. He greatly admired the seventeenth-century portrait painter. 'We are all going to Heaven', he said on his deathbed, 'and Van Dyck is of the company.'

The extraordinary elegance of the two figures, particularly the younger brother, Bernard, with his foot up on the step and his head turned sharply over his shoulder, belies the courage of both men. The elder brother, John, died as a result of wounds received at the Battle of Cheriton, in 1644; Bernard a year later at Rowton Heath, 'a very faultless young man, of a most gentle, courteous and affable nature, and of a spirit and courage invincible'.

Seventeenth-century works by Lely include beauties from the court of Charles II. Among them is *La Belle Stewart* (Frances Teresa Stewart). Married to the First Duke of Richmond, she became the model for Britannia on the coins of Charles II, and thereafter. Other Lely subjects are *Lady Annabelle Howe, Barbara Villiers, Lady Anne Digby* and *Lady Dorothy Sidney*.

The nineteenth-century political connections with the families of two prime ministers are shown in portraits by Sir Thomas Lawrence, including the Third Viscount Palmerston and Emily Lamb, aged 16, later Palmerston's wife, and in works by John Hoppner and George Romney. (Melbourne Hall, in Derbyshire, contains further works of art associated with the Lamb and Palmerston families.)

ANTHONY VAN DYCK
Lord John Stuart with his Brother,
Lord Bernard Stuart, later
Earl of Lichfield
National Gallery, London

——— STRATFIELD SAYE ———

The country home of the Dukes of Wellington for over 150 years offers a haphazard and charming representation of the history of the Iron Duke, his family and his descendants. The First Duke (1769–1852) purchased the house, which is near Basingstoke, in Hampshire, in 1817 with money voted to him by Parliament.

A number of the paintings were originally owned by Ferdinand VII of Spain. They were taken by the French but recovered by the Duke, following the Battle of Vitoria in 1813. Further works were added by the Reverend Henry Wellesley, the illegitimate son of Marquess Wellesley, and by Gerald, the Seventh Duke. The Duke of Wellington's main collection has always been at Apsley House, now the Wellington Museum (q.v.).

A James Thorburn painting on ivory shows the Duke with his grandchildren, and there are portraits by Hoppner, Lawrence and William Owen.

Fine equine studies include two by James Seymour, and John Wootton's portrait showing Sir Philip Medows teaching the future George III and his brother to ride.

——— BREAMORE HOUSE ———

Ten generations of the Hulse family are responsible for the collection at Breamore House, which they acquired in the mid-eighteenth century, though the works of art go back earlier. Indeed, the varied strengths of the collection focus on Dutch art, though by no means exclusively.

One of the most striking paintings in the house is the *The Boy with Bat*, a portrait of Walter Hawkesworth Fawkes. It was formerly thought to be the work of Thomas Hudson, and has been attributed more recently to William Hoare of Bath, though not with certainty. Together with a similar work in the Long Room at Lord's, this painting is one of the earliest cricketing subjects. It was a popular upper-class sport in the eighteenth century, and many country houses had their own cricket pitches, the one at Knole being quite famous.

An unusual group of works painted in Mexico by the illegitimate son of Murillo portrays the different races and their intermingling. The emphasis on facial characteristics makes the painting ethnologically important.

The Dutch connection goes back to the seventeenth century, when Edward Hulse, a doctor who had studied at Cambridge, became physician to Prince William of Orange, later to become William III. His grandson, the Second Baronet, married a Dutch wife, Hannah Vanderplank. As well as the paintings there are other Dutch works of art in the house. Paintings include *The Coming of the Storm* by David Teniers, a typical and spirited village scene made more atmospheric by the light from the distant tempest.

REX WHISTLER AT MOTTISFONT (NT)

Rex Whistler, and his two assistants Bowen and Willats, created at Mottisfont Abbey, for the Russell family, a Gothick *trompe-l'œil* fantasy. Originally an eleventh-century priory, Mottisfont was much altered in the mid-eighteenth century. It was bought by the Russells in 1934, and the Whistler commission dates from 1938. The simulated stucco work of the ceiling is painted in grisaille, as are the colonettes which stand out most elegantly against the pale pink walls. These are enhanced by trophy panels depicting ecclesiastical, sporting, musical and military subjects, as well as the Russell coat of arms and motto.

The alcove, which portrays a smoking urn draped with an ermine stole and piled around with books, a lute, a small purse, a black glove and a wedding ring, is believed to be the artist's tribute to Mrs Russell, who commissioned the project.

Whistler's work was unfinished at the outbreak of the Second World War. As a token that he would return, he painted on the feigned cornice left of the South Window a small paint pot, brush and box of matches. Sadly, he was killed in Normandy in 1944.

——— SOUTHAMPTON ———

Southampton City Art Gallery was first opened in 1939. It then closed during the war, and re-opened in 1945 to develop into one of the most interesting provincial galleries in these islands. It is the best municipal collection in the southern and Home counties.

Though its late start as a gallery precluded extensive collecting in a number of areas, it probably had the beneficial effect of concentrating attention on modern British art of which it has an outstanding collection.

There were earlier efforts to establish a gallery. Two of the three main benefactors were Robert Chipperfield, who died in 1911, and Frederick William Smith, who died in 1925. They were both early enthusiasts for a gallery for the city, and gave substantial funds for building it and providing it with pictures. The third, Arthur Tilden Jeffress, left on his death in 1961 a fine collection of modern European and British paintings.

Of these three principal benefactors, the first, Robert Chipperfield (1817-1911), a chemist, came to Southampton in 1842. Thus began a long and beneficial association for the city. He left substantial money which was used for the building of the present Gallery. The income from his bequest still, unusually, contributes towards the Gallery's maintenance.

Frederick William Smith (1861-1925), a timber merchant and avid supporter of local 'arts', was the second benefactor, while Arthur Tilden Jeffress (1905-61) bequeathed to the Gallery 99 modern European paintings, including works by Bonnard and Vuillard. There is a portrait of him by Graham Sutherland.

As a guide to modern British art, Southampton is outstanding. Within reason, naming the artist summons up powerful and sometimes key examples of their work. Matthew Smith's *Dulcie*, Stanley Spencer's *Patricia Preece*, William Ratcliffe's *The Coffee House*, Henry Lamb's *Edie McNeill*, Gwen John's *Mère Poussepin* and *Girl in a Mulberry Dress*, Augustus John's *Brigit*, Mark Gertler's *Seated Nude*, Malcolm Drummond's *Saint James's Park*, Edward Burra's *Café*, and Henri Gaudier-Brzeska's *Sophie* are all exceptional examples of work by the artists concerned.

HENRI GAUDIER-BRZESKA
Self-Portrait
Southampton Art Gallery

MATTHEW SMITH
Dulcie
Southampton Art Gallery

Nor should this isolation of certain individual works take from the substantial range of lesser-known English artists and of lesser works by major painters.

Notwithstanding this emphasis on British art of the twentieth century, other periods are also well represented. Renaissance art, and portraits and landscapes from the seventeenth and eighteenth centuries are included. There are Impressionist and Post-Impressionist paintings, a good cross-section of sculpture, and such special-interest groups as the ten twentieth-century Edward Burne-Jones cartoons. They depict the heroic adventures of Perseus, and are major examples of his work.

Old Masters are well represented, and there are fine English paintings of the seventeenth and eighteenth centuries, including Gainsborough's *George Venables Vernon, Second Lord Vernon, Cornet Nehemiah Winter* by Reynolds, *Mrs Morton and her son Oliver* by Romney, and Hayman's *Robert Lovelace Preparing to Abduct Clarissa Harlowe*.

The Gallery owns a fine Turner seascape, two Tissots, Monet's *Church at Vétheuil* and Sisley's *Chestnut Trees* as well as works by Pissarro, Renoir, Vuillard and Bonnard.

FRANCIS BACON AND
———— GORHAMBURY ————

The house built in Hertfordshire by Sir Francis Bacon no longer stands, though its ruins are in the Park. Sir Robert Taylor designed the present house, built between 1777 and 1784 for James Bucknall, Third Viscount Grimston. It was primarily designed to accommodate the twin collections of pictures that the Bacon and Grimston families had accumulated and for which there was no longer room on the walls of the old Tudor house. The family motto, 'Mediocria Firma' (Strength lies in Moderation), expresses the atmosphere to be found at Gorhambury, where the collections have survived the centuries, well cared for and restored with discretion by each generation, who have each added their own contribution.

The Great Hall contains two groups of portraits; those in the Gallery represent the last four generations of the Grimston family, from the middle of the nineteenth century onwards. But it is the second group, below, which is of greater interest, since it represents a 'Gallery of the Great': distinguished men of the seventeenth century, most of them probably collected by Harbottle Grimston, the Second Baronet. Such galleries were recommended by Francis Bacon in *New Atlantis* (see pp. 20–21).

The Dining Room contains *Sir Francis Bacon* by Paul van Somer. The philosopher is shown in his robes as Lord Chancellor. And in the Ballroom, with the splendid portrait *Queen Elizabeth I* by Nicholas Hilliard, is another, perhaps more attractive portrait attributed to Agnolo Bronzino of *Francis Bacon* as a baby.

Francis Bacon's half-brother was Sir Nathaniel Bacon, a gifted amateur painter. Four pictures of excellent quality by him are displayed; they include a self-portrait, a portrait of his wife, and two portraits of the cookmaid.

In the Library can be seen the unique coloured terracotta busts, *Sir Nicholas Bacon*, *Anne Cooke*, his second wife, and their second son, *Francis Bacon*, aged about nine.

———— KNEBWORTH HOUSE ————

There are surprisingly few houses open to the public in the British Isles belonging to writers, and containing substantial art collections. Knebworth, which belonged to Edward Bulwer-Lytton, is exceptional, not only having the art, but having as well the associations, notably with Daniel Maclise. His portrait of the Victorian novelist is in the collection.

Bulwer-Lytton took a lively interest in the arts, and in *England and the English*, published in 1833, when he was already well established as a novelist, he gives a vigorous picture of the controversies surrounding the Royal Academy, then seen as an impediment to art rather than its guardian. 'I shall reiterate none of the just attacks which of late have been made against that institution,' he says, and then goes on to do just

that. He lists the artists who had *not* been trained there, and claims 'it has excluded and persecuted many of the greatest we possess'.

Writing at a time of high artistic endeavour, he was able to claim, quite justly, England's rivalry with Munich and Paris. He follows current fashion in his book, appearing somewhat eccentric to modern judgement. For example, he compares John Martin with Raphael and Michelangelo, finding Martin 'more original, more self-dependent than either'. He picks out Wilkie and Leslie for praise, and identifies his future friend, Maclise, as 'the most rising painter'.

Writing of Wilkie's *Distraining for Rent* he perpetuates the amusing anecdote that for years the engraving of this work was blocked by the nobility, 'lest it should excite an unpleasant feeling towards the country gentlemen'.

Perhaps not surprisingly, his stamp on Knebworth House is comprehensive and emphatic. It crowds out all other considerations and family associations. It has its most forceful artistic dimension through the work of the Cork-born painter Daniel Maclise (1806-70), whose *Edward IV Visiting Caxton's Printing Press at Westminster* is the most important work in the collection.

In 1849, when Maclise was working on the painting, which was eventually exhibited at the Royal Academy in 1851, he wrote to Bulwer-Lytton: 'I have derived every idea I have required as to my personages

DANIEL MACLISE
Edward IV Visiting Caxton's Printing Press at Westminster (detail)
Knebworth House, Hertfordshire

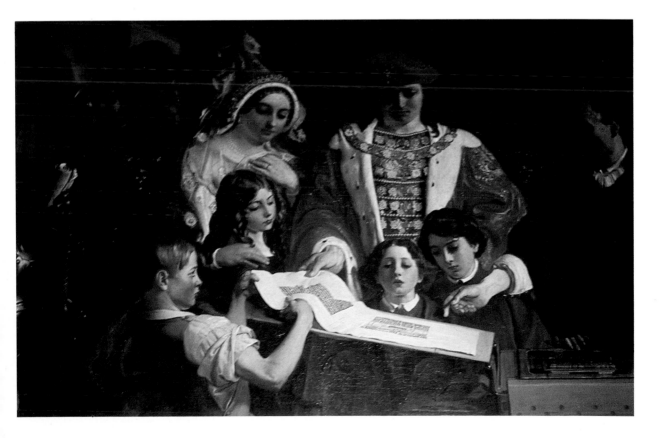

from *The Last of the Barons*.' And as a tribute to the novelist he depicted him as Lord Rivers, on the left, in armour.

The two men shared an artistic purpose in their work: to bring to popular understanding romantic events out of history in a simple and dramatic way. Like Lytton, Maclise was careful about the detail in his works, and went to considerable lengths to obtain copies of Caxton's monograms, pasted on the pillar in the painting. The work was universally popular; Turner admired it, and discussed it with Maclise; and it was engraved.

Daniel Maclise's full impact in this field of art has not been fully recognised or appreciated. He applied the same careful scholarship to diverse periods of history, all characterised by enormous attention to detail. He ranged from biblical history through Celtic and Saxon history, to the near contemporary visual epics, his frescos in the House of Parliament.

Maclise's full-length portrait *Edward Bulwer-Lytton*, one of the artist's most sensitive works, is at Knebworth, given to Lytton by Maclise. It was done after the painter had given up portraiture, a tribute to friendship and admiration.

The writer's son, who became First Earl of Lytton and was Viceroy of India, is the subject of a portrait sketch by G. F. Watts. The finished portrait is in the National Portrait Gallery. It was at the 1877 Delhi Durbar that Queen Victoria was proclaimed Empress of India, and a painting of the splendid occasion hangs in the House.

The association between Bulwer-Lytton's family and the original Lytton family which owned the house from 1490 seems to have been tenuous, with the novelist employing genealogists to prove lines of descent. Nevertheless, good Lytton family portraits also hang at Knebworth, by Gheeraerts, Lely and Riley. There is also a portrait of Sir Philip Sidney by John de Critz.

Twentieth-century works at Knebworth include June Mendoza's portrait of the younger members of the present family and Winston Churchill's painting of the Banqueting Hall.

Edward Bulwer-Lytton is of interest for the light he sheds on mid-nineteenth-century perceptions about the development of the art of painting among the English. He devotes a chapter in *England and the English* (first published in 1833) to 'State of the Arts', in which he gives a robust and straightforward account of how painting developed from Thornhill and Hogarth onward.

He goes so far as to claim that painting in England surpassed France and Italy in about 1760! He becomes quite lyrical when dealing with Joshua Reynolds and the birth of the Royal Academy, but saves his most laudatory words for artists of his own time. Writing of the contemporary scene, he gives English landscape painting pre-eminence over that in every other country, citing Turner, Danby, Copley Fielding and de Wint; he rightly picks out for special praise English watercolour painting; and he raises John Martin to unheard-of heights: 'I see in him the presence of a spirit which is not of the world—the divine intoxication of a great soul lapped in majestic and unearthly dreams.'

While some modification of the novelist's view of the art of his times is of course necessary, it does give a trenchant insight into contemporary national pride.

KNOLE (NT)

Knole, in Kent, is probably the largest country house in England, one of the oldest, and historically one of the most interesting. It was owned in its early days by archbishops of Canterbury and Tudor monarchs, the last of whom, Elizabeth I, gave it to Thomas Sackville, the First Earl of Dorset, whose descendants gave it to the National Trust.

WILLIAM DOBSON
Gentleman with his Page
Knole, Kent

Sackville was a poet, playwright, lawyer and statesman, among other things pronouncing the death sentence on Mary, Queen of Scots, and presiding at the trial of Essex. His portrait, attributed to John de Critz, is in the house. He was not the only poet of distinction among the Sackvilles. There is a Kneller portrait of *The Sixth Earl of Dorset*, a Restoration poet and courtier who was the author of *To All You Ladies now at Land*, a ballad suited to the uncertain naval escapades of Charles II's reign. He was patron of Dryden and others, and paid for Matthew Prior's education.

The collection reflects the history of the family, but also includes a head of another poet, Sir Philip Sidney, blond and striking, the epitome of the courtier–poet. He had a brief but direct association with nearby Penshurst Place.

Works by Daniel Mytens include full-length portraits of *Lionel Cranfield, Earl of Middlesex* and of his daughter, Martha, compelling for their sense of presence, and the latter interesting for her unusual costume. There are also some fine portraits by Kneller, including, in the Ball Room, the Sixth and Seventh Earls of Dorset in their Garter Robes (dated 1694 and 1717). They can be compared with interest: the one, coarse, sensual and magnificent, epitomising the Restoration; the other equally splendid, but characterised with graver, eighteenth-century dignity. Also in the Ball Room is *Frances Cranfield*, wife of the Fifth Earl, attributed to Van Dyck. Vigée-Lebrun's painting *Arabella Diana Cope* is in the same room.

The theme of poetry is continued in Poets' Parlour, one of the private apartments, where there are a number of portraits by Kneller, Opie, and others, of literary figures such as Dryden, Congreve, Pope and Isaac Newton. The poetic theme continues in the Reynolds Room, in portraits of Oliver Goldsmith, Garrick and Dr Johnson. There is also, unusually for Reynolds, a macabre scene from Dante's *Inferno*, and *Wang-y-Tong*, the Chinese page.

— SCULPTURE AT HEVER CASTLE —

The collection at Hever Castle is one of the few in the British Isles primarily of sculpture. It is set in the magnificent Italian Garden, created for the collection between 1904 and 1908.

The layout of the formal Italian Garden and the collection of classical statues was the work of William Waldorf Astor, an American who served in the 1880s as Ambassador for his country in Italy. He became a naturalised Briton and was created First Viscount Astor of Hever.

The sculpture is mainly Roman; good Roman copies of a large range of classical Greek works of many of the principal figures of Greek mythology are to be found spread through the more formal areas of the garden. There are also urns and fountains, columns and well-heads. The triumphal relief from the Arch of Claudius is housed in the Castle.

CHARTWELL (NT)

Winston Churchill believed that the stress of exceptional responsibilities was best alleviated by change. 'Change is the master key.' Painting was not a hobby he acquired late, as many amateurs do. Nor was it taken lightly. 'One ought to have at least two or three hobbies, and they must all be real,' he believed. He credited Lady Lavery with weaning him away from an uncharacteristic timidity about paint and canvas. She taught him audacity. William Orpen gave him advice, suggesting at one stage that he should visit Avignon for the sake of the light there. He sent his studio assistant, James Sleator, the Armagh artist, to give him lessons.

Perhaps also characteristically, Churchill likened painting's requirements to those when fighting a battle: to make a good plan and keep a strong reserve. How successfully he campaigned may be seen at Chartwell, his home in Kent. There are paintings by him in nearly every room and one can visit his studio.

Churchill was also a great friend of Walter Sickert and William Nicholson, both of whom used to come and stay, painting with him.

Churchill mainly limited himself to landscapes and still lifes but one finds the occasional portrait. His style was impressionist; his talent more than competent for someone whose main interests lay elsewhere.

MODERN WORKS AT LEEDS CASTLE

The Leeds Castle collection divides into three main areas: the group of fine Impressionist and associated paintings; the mainly foreign works of the fifteenth to seventeenth century; and the portraits and miniatures associated with the Culpeper, Fairfax and Wykeham-Martin families of Leeds Castle.

Not overly large, Leeds Castle contains some outstanding works. Many of the paintings belonged to Olive, Lady Baillie, by whom the Castle was restored: these are supplemented by works on loan and by the Wykeham-Martin Collection, including a number of miniatures

connected with the family which owned Leeds for 300 years and belonging to its descendants.

The nineteenth-century works include pictures by the precursors of Impressionism: a landscape by Théodore Rousseau, a marine and a beach scene by Boudin, the *Little Shepherdess* by J. F. Millet. The Millet is small, the figure of the cloaked girl brooding and solidly sculptured, lit by the glowing red of her kerchief.

Impressionist paintings include two Pissarros; an early snowscene in pewter tones, and a street in Rouen looking towards the Cathedral, painted a quarter of a century later and providing an interesting contrast, with its warm opalescent colours. There is a Fantin-Latour: a glass globe full of the Aimée Vibert roses still grown at Leeds, a plume of pearly white; an exquisite Vuillard still life; and works by Degas and Toulouse-Lautrec. Outside the room, a dozen sketches by Constantin Guys depict contemporary Parisian society.

—————— SQUERRYES COURT ——————

Squerryes Court came into the possession of the Warde family in 1731, and John Warde, son of the purchaser, was responsible for the collection of paintings of the Netherlandish and seventeenth-century Italian schools, made between 1747 and 1774. Various members of the Warde family have added portraits of later generations, dating mainly from the seventeenth and eighteenth centuries.

The Dutch collection includes pictures by Brouwer and Teniers, a pair of Ruisdaels and two Van Goyens, notable for their soft, clear colouring and sense of repose. There is a lively *Family Group* by Van

PIETER DE RING
Still Life
Squerryes Court, Kent

der Helst, and a sixteenth-century interior by Frans Francken the Younger. A genre scene, attributed to the younger Pieter Brueghel, is *The Lawyer's Room*, crowded with a chaos of documents and Hogarthian plaintiffs. There are two works by Horremans.

With the Brueghel, in an L-shaped upper gallery, hangs the large, breathtaking *Still Life* by Pieter de Ring: a profusion of flowers, fruit and vegetables, flagons, gold plate and a thieving monkey, in glowing, vibrant colours.

—— TUNBRIDGE WELLS MUSEUM ——

The Ashton Bequest at the Tunbridge Wells Museum reflects the tastes of its middle-of-the-road, middle-class, mid-Victorian legator: pleasant landscapes, pretty females, genre scenes. It has its own integrity as a result.

It also has considerable historic interest as the expression of unrefined taste.

Ashton, who formed the collection between 1852 and 1863, bought directly from the Royal Academy, the British Institution, and less frequently from the artists themselves. None of the works went through the salerooms. Ashton was safe and orthodox in his choice of paintings by Thomas Sidney Cooper, Frederick Goodall, George Clarkson Stanfield, Henry Nelson O'Neil and Abraham Solomon, whose *Waiting for the Verdict* and *The Acquittal* are perhaps most typical of the works in the collection. There are versions of these subjects by the same artist in the Tate Gallery. Ashton did not venture into the Pre-Raphaelite domain.

Ashton's son and daughter gave the collection to Tunbridge Wells in 1952, exactly a century after it had been started. By then the museum collection had been in existence for a number of years, having been handed over by the Natural History and Philosophical Society in 1918, and eventually deposited in the Civic Centre which, like so many such projects, took upwards of 20 years to complete.

—— MAIDSTONE MUSEUM AND ART GALLERY ——

Maidstone has a comparatively important collection, when considered in the context of this region of England.

The town inherited its first group of paintings on the death in 1855 of Thomas Charles, a surgeon, whose friend, Edward Pretty, became curator of the Maidstone Museum, which was founded three years after the death of its first benefactor. That first bequest included a work by Bernardo Strozzi and a number of interesting portraits.

Edward Pretty gave his own collection, including Frans Francken's *Mocking of Christ* as well as Old Master drawings, collected while he was art teacher at Rugby School.

The next bequest, perhaps the most important received by Maidstone, was from Julius Lucius Brenchley, and included what are regarded as the gallery's finest works, the topographical views by Panini of *The Colosseum* and *The Basilica of Constantine*.

Somewhat belatedly, and again as a result of private generosity, Maidstone was given its art gallery building by Samuel Bentlif who first gave the money for the building as a memorial to his brother, George, and then bequeathed the collection which had passed to him on his brother's death. It contained 200 pictures, and a curator was funded as well, leading to the publication of a catalogue, not, however, of all the possessions of the Gallery.

In 1909 Hazlitt family material, including miniatures, came from William Carey Hazlitt.

The first proper catalogue of the overall collection appeared in 1976, after a major period of work on the collection, including restoration.

The works include an important example of the church interior paintings of Hendrick van Steenwyck the Younger, possibly his masterpiece, the *Cathedral Interior*.

The Art Gallery has recently been modernised and renovated in order to provide a much more sympathetic background for the display of the works in the collection.

THE WATTS GALLERY

The Watts Gallery, in Compton, Surrey, is an eccentric, idiosyncratic memorial to one of the larger-than-life artists of Victorian England, created by his strong-minded wife. George Frederick Watts was successful and famous during most of his long life; he was also extremely prolific, and this rambling gallery in its country garden houses a large, representative selection of his work.

GEORGE FREDERICK WATTS
Self-Portrait
Watts Gallery, Surrey

He is appreciated now for his superb portraiture; he painted many of the most celebrated figures of the later nineteenth century, building up a 'Hall of Fame' of which much is on display in the National Portrait Gallery. At Compton his range can be seen in the vivid portrait of *Lillie Langtry* shown in profile; a sombre *Garibaldi*, painted in a subtle scale of warm and earth colours; and a powerful study of Gerald Balfour (brother of A. J.), terrier-like and alert.

His ability as a portrait painter was evident from the early portrait of his father and was sustained right through to his shrewd observation of Balfour, painted in extreme old age. It appears also in the group of self-portraits, from the romantic *Self-Portrait as a Young Man*, painted when he was seventeen, to the unfinished patriarch of 1903.

The collection also includes landscapes, a group of 'Realist' pictures, and a number of the religious, mythological and allegorical works which Watts considered his proper subject matter. There are paintings by some of his contemporaries, including work by Burne-Jones, Albert Moore and Lord Leighton.

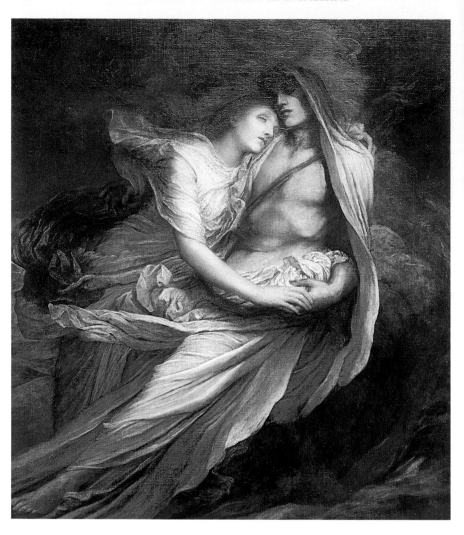

GEORGE FREDERICK WATTS
Paolo and Francesca
Watts Gallery, Surrey

The Watts Mortuary Chapel is an extravaganza of Art Nouveau and Celtic symbolism designed by Mrs Watts, and built between 1895 and 1906. It provides a startling counterpoint to the Gallery itself.

POLESDEN LACEY (NT)

Margaret Greville owned Polesden Lacey, near Dorking, Surrey, from 1906 until her death in 1942, when the house was bequeathed to the National Trust. She collected extensively, buying at top market prices from the best dealers in London. She inherited a number of works from her father, William McEwan, brewer and Member of Parliament for Edinburgh, including two Raeburn portraits and scenes by Cuyp, Ter Borch and Teniers. These he had acquired for more modest sums.

Early Italian works include an interesting small panel by Perugino, *The Miracle of the Founding of Santa Maria Maggiore*, in Rome, and three triptychs of the *Madonna and Child with Saints*. A later religious work is the beautiful *Madonna* by the Flemish artist Bernard van Orley showing strong Italian influence.

Dutch and Flemish art of the sixteenth and seventeenth centuries is represented by landscapes, portraits and interiors by Teniers the Younger, Ter Borch, De Hoogh and Cuyp. The portraits include the large and charming *Boy with a Sheep* by Caesar Boetius van Everdingen. There is one later Italian portrait, *A Cavalier* by Bernardo Strozzi.

Mrs Greville, whose husband, the Hon. Ronald Greville, died in 1908, was largely responsible for re-modelling the house, including the lavishly exotic Edwardian decoration of the Drawing Room. Here she entertained Edward VII, in 1909. The future George VI, then Duke of York, with his bride, Elizabeth Bowes-Lyon of Glamis Castle in Scotland (q.v.), spent part of their honeymoon at Polesden Lacey.

The house contains fine collections of furniture, china, maiolica, and silver. Mrs Greville was particularly keen on chinoiserie, reflected in various aspects of the house.

SPORTING PAINTINGS AT BENTLEY:
—— A MODERN COLLECTION ——

The collection at Bentley, in East Sussex, has been assembled since the Second World War. It reflects the owners' particular interests, hence the sporting pictures. The late Gerald Askew was a well-known racehorse breeder and had been a brilliant horseman. There are good examples of British sporting art, including *Cartouche* by Wootton, *Orville* by Herring, *The Godolphin Arabian* by Seymour, *A Hunter in a Landscape* by Charles Towne, and *Saint Thomas* by Sartorius.

Askew was also interested in wildfowl protection. His friendship with the notable Sussex artist Philip Rickman set in train the creation of the Bentley Wildfowl Collection and the 170 or so portraits of wildfowl species painted by Rickman, many of which are hung in the house.

———————— FIRLE PLACE ————————

The collection at Firle Place has benefited from three families beside that of Viscount Gage, who is descended from the Knightley family, of Fawsley, in Northamptonshire. In addition there are works from the original Firle Place collection, from the Cowper family collection at Panshanger, in Hertfordshire (the family from which the Sixth Viscount's wife is descended) and the collection, at Taplow Court, in Buckinghamshire, formed by Charles Pascoe Grenfell, from whom Imogen Gage is descended. The catalogue indicates sources for works of art.

JOHANN ZOFFANY
George, Third Earl Cowper
Firle Place, East Sussex

The British School is well represented. Outstanding among its portraits is Johann Zoffany's *George, Third Earl Cowper*, painted in Florence, in the 1770s. In the dramatic pose, Lord Cowper holds his hat above his head to give shade from the Italian sun. He married there in 1775, and a Zoffany portrait of his wife is also in the collection.

As well as buying paintings for himself Lord Cowper acted as self-appointed agent, through Zoffany, for George III, persuading him to buy the Raphael *Self-Portrait*, still at Hampton Court.

In the Great Hall hangs a remarkable Van Dyck group, *John, Count of Nassau and his Family*. It was part of the collection formed by Lord Cowper at Panshanger, in Hertfordshire. He also acquired the Fra Bartolommeo, *Holy Family and the Infant Saint John*. It is thought to be one of only two works by the artist remaining in private hands. The Panshanger Collection included works by Raphael and Andrea del Sarto.

Other important portraits at Firle include the Reynolds portrait of *Sampson Gideon, First Lord Eardley*, son of a Jewish financier whose faith prevented his ennoblement.

——— MUSEUMS IN BRIGHTON ———

Brighton enjoys three distinct public collections of fine art: the Art Gallery and Museum, the Royal Pavilion, and Preston Manor, an Edwardian house maintained as a period home. The first two are related, in the sense that the first moves towards a public collection date from 1853, when the Royal Pavilion Estate was bought from the Crown. It served, from then on, as an exhibition place for annual art exhibitions. Among painters who showed their work in the early years were Copley Fielding and Frederick Nash.

Sculpture was also exhibited, though in the hallway of the Royal Pavilion. One contemporary critic wrote: 'In course of time, this gallery will become the Westminster Abbey of Brighton.'

Ownership of the Royal Pavilion by Brighton also encouraged gifts and bequests. Two years after the purchase, W. J. Leatham's massive *Battle of the Nile*, measuring 7 by 14 feet, was presented, making more urgent the demands for a gallery. But the management was under the control of two organisations, the Brighton Society of Arts and the Brighton Art Union, both concerned for the welfare of living artists through the sale of their works. From the entrance fees, however, a purchasing fund was established, and the first tentative moves towards a permanent collection for Brighton were made.

In 1858 Lawrence's full-length portrait of George IV was presented by the Athenaeum Club. It was not until a further ten years had elapsed that space was finally allocated for a museum and art gallery, which opened in 1873, with further additions in 1902. For many years the new premises retained the old associations, being referred to as 'The Royal Pavilion Gallery'.

Although there had been important individual works presented or left to the Brighton collection during the second half of the nineteenth century, the best of the Old Masters in the collection came in 1903 from Henry Willett, in celebration of the new galleries and the reconstruction of the old ones. He gave, at the same time, important pottery and fossil collections.

The collection is broadly representative of all schools of English painting, with quite impressive examples of eighteenth-century portraiture,

ROBERT BEVAN
The Cab-Yard, Night
Brighton Art Gallery and Museum

including an attractive Zoffany portrait, *John Maddison*, and works by, or attributed to, Hogarth, Kauffmann, Opie, Romney and Wilson.

Brighton also has an extensive collection of watercolours, and of Brighton views. Some of these are usually on exhibition in the Royal Pavilion, though the chief appeal here is decorative in character, with murals by Robert Jones and Lambelet, and with Chinese paintings. Portraits and caricatures of men and women associated with George IV also hang in the Royal Pavilion.

The third public collection is at Preston Manor. This house was given to Brighton in 1932 by Sir Charles and Lady Thomas-Stanford. The family had lived there for two centuries. The house is fully furnished and illustrates the way of life there before the First World War.

The paintings include *Virgin and Child* by Poussin, *The Lamentation*, attributed to Jan Mostaert, *The Madonna and Child with Saint Joseph and Saint Catherine*, attributed to Van Oostsanen, and a portrait, *Philip de Montmorency, Count de Horn*, attributed to Hans Eworth.

HOVE MUSEUM AND ART GALLERY

GWEN JOHN
Two Nuns and a Woman Praying
Hove Museum and Art Gallery

Hove Museum and Art Gallery is housed in one of the town's finest late Victorian villas, surrounded by lawns, and only a stone's throw from the seafront. The building was opened as a museum in 1927, and contains collections of remarkable variety and richness for a museum of its size. The upstairs galleries display the spectrum of English painting and decorative arts from the seventeenth century to the present day, including fine furniture and textiles. There are important paintings by Angelica Kauffmann, Gainsborough and Bonington and a striking group of twentieth-century British works, including Sickert, Lamb, Christopher Wood and Richard Eurich.

The ground-floor galleries include space for changing displays of drawings and watercolours, and a comprehensive group of English ceramics, the amalgamation of two substantial bequests, reopened in the autumn of 1987.

PETWORTH HOUSE (NT)

Petworth, in West Sussex, comes close to being an ideal country house collection. Its collection is rich in all periods; the personal discrimination made by different generations of owners is at times vivid; there is a constant reflection of the taste of different eras; and the overall effect is wholesome, integrated and original.

The true spirit of the collector pervades many of the works; and the associations with different artists, most notably with one of England's greatest painters, Turner, give a special appeal. It is also secure for posterity in a way that houses like Chatsworth have, in recent years, been demonstrated not to be. Eight centuries in one family, no major fires or other disasters, no major dispersals of works of art, are all factors which render Petworth an example of, and which justify its pride of place among, country house collections open to the public.

The collection was acquired over three centuries, principally by three men, all members of the Percy family, or related branches of it. They are Algernon Percy, Tenth Earl of Northumberland (1602-68), Charles Wyndham, Second Earl of Egremont (1710-63) and his son, George, the Third Earl (1751-1837).

The Manor of Petworth is an ancient one, from about 1150 in the hands of the Percy family. It was bequeathed by Henry I to his second

wife, who gave it to her brother, Joscelyn. He married Agnes de Percy, taking her name. Her grandfather had accompanied William the Conqueror to England in 1066, being substantially rewarded with grants of land in many parts of the country. Petworth was therefore one of several Percy seats. In the late seventeenth century it passed by the female line to Lady Elizabeth Percy, who married Charles Seymour, Duke of Somerset.

'The Proud Duke', as he was known, was obsessed with his lineage and status, made his children stand up in his presence, and used to send outriders to clear the roads around Petworth before setting out on a journey, so that none of the peasants should look on him. On one occasion, having fallen asleep, he woke to find one of his daughters sitting down in his presence. He is said to have disinherited her. His grandson-in-law was the First Duke of Northumberland, from whom is descended the present Duke.

Lady Elizabeth Percy's daughter, Catherine Seymour, who inherited Petworth, married Sir William Wyndham, whose son, Charles, and grandson, George, the Second and Third Earls of Egremont, were two of the three main collectors, mentioned above.

The house remained a family property until after the Second World War. In 1947, the Third Earl's great-grandson, Charles Wyndham, who was the Third Lord Leconfield, gave the house to the National Trust. Five years later, when he died, the Treasury acquired the majority of the paintings in lieu of death duties.

Shortly afterwards, Anthony Blunt, who was then Director of the Courtauld Institute, was asked to supervise the rehanging of the collection, as well as necessary restoration work. He, in turn, brought in three restorers, Isepp, from the Kunsthistoriche Museum in Vienna, Horace Buttery and John Brealey, who became resident restorer. Among other things, this led to the confirmation of the Titian, formerly ascribed, and of the Van Dyck portrait of Strafford.

The restoration work benefited, according to Brealey, as quoted by Blunt, from the fact that the pictures in the house had been cleaned during the nineteenth century by 'Grandfather' Holder, of the London firm of restorers, and had always been treated sympathetically. Blunt described himself as 'somewhat ruthless' in his rehanging schemes for the house, since he attempted to put right what he saw as an arbitrary scheme in which members of the family had placed paintings in bedrooms and elsewhere, simply to suit their own taste.

Today, Petworth is a house where the collection is supreme. It is the most famous collection owned by the National Trust, and one of the most distinguished art collections in the country, so rich and varied as to constitute a fairly comprehensive art gallery, rather than paintings and sculpture typical of a country house. At the same time it retains much of the country house atmosphere (indeed, part of it is still occupied by the present Lord Egremont).

Its collection reflects three quite distinct approaches to the acquisition of works of art. In the seventeenth century, a majority of the splendid portraits by Van Dyck and Lely were commissioned or bought, mainly

by the Tenth Earl of Northumberland, but also by his father. They include the *Thomas Wentworth, Earl of Strafford* and the Lely painting of *The Three Youngest Children of Charles I*. The striking, full-length portrait of *Sir Robert Shirley* by Van Dyck, in turban and embroidered cloak, as well as the portrait of his Circassian wife, *Elizabeth, or Tiresias, Lady Shirley*, were acquired later; they are not recorded in the 1671 inventory of pictures, and in fact are not recorded at Petworth before 1775. Blunt moved them from a bedroom to their present position, either side of the fireplace in the Square Dining Room.

Subject pictures also date from the period before 1671, including the series of religious paintings by Adam Elsheimer. Possibly acquired by the Tenth Earl, but not recorded as such, are a number of other works, including the Titian portrait *Man in a Black Plumed Hat*, the Rogier van der Weyden *Virgin Annunciate* and *St James with a Donor,* and the *Adoration of the Kings* from the studio of Hieronymus Bosch, as well as works by Hobbema, Cuyp, Bellotto and Le Nain.

The Second Earl of Egremont (1710-63) was a classic eighteenth-century collector, whose Grand Tour acquisitions were augmented by works obtained on his behalf by his agents in Rome, among them Gavin Hamilton, and by purchases at London auctions. He was responsible for the classical sculpture at Petworth, the finest such collection in any country house in these islands (but see the entries for Newby, Hever Castle, Chatsworth and Holkham). The sculpture includes the *Leconfield Aphrodite*, the head of the goddess attributed to Praxiteles, and many classical works including Hellenistic Greek examples, and fifth- and first-century BC Greek friezes. Most of the busts are Roman portraits.

The Second Earl also acquired paintings by Ruisdael, Horst, Bourdon, Millet, Snyders, Van Goyen and Van der Meulen. He was a politician of virtue and honesty, rare in the eighteenth century, but succumbed to the duties of office which, in his case, included frequent official banquets. 'I have but three turtle dinners to come,' he said, late in life, 'and if I survive them I shall become immortal.' He did not survive, however, and left a widow with a twelve-year-old son, George, who was to preside over the third and most interesting phase of collecting at Petworth for sixty-five years.

Before considering him a brief word is appropriate about the acquisitions of the Sixth Duke of Somerset, the 'Proud Duke', the other eighteenth-century owner of the house, who was responsible for a number of important works of art as well as for the rebuilding of Petworth, financed by the inheritance of the granddaughter of the Tenth Earl of Northumberland, whom he married. He had to wait until she came of age, and was able to dispose of her money. He bought the Claude, *Jacob and Laban*, commissioned the 'Petworth Beauties', by Michael Dahl, probably added further works of the period, and in 1714 had the murals painted on the main staircase by Louis Laguerre.

Petworth's most famous collector was George Wyndham, Third Earl of Egremont. He decided, early on, only to buy works of art from his

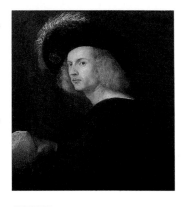

TITIAN
Man in a Black Plumed Hat
Petworth House, West Sussex

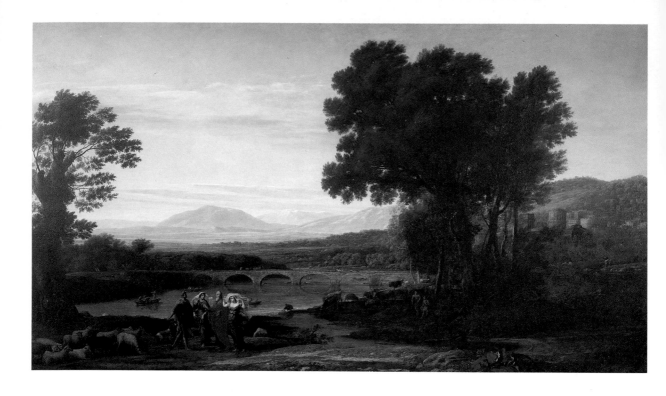

CLAUDE LORRAINE
Jacob and Laban
Petworth House, West Sussex

own time. In due course he became not just a great and original collector, but a generous and perceptive patron to a number of artists, the most famous of whom was J. M. W. Turner.

The Turner paintings hang in both the Turner Room and the North Gallery. There are thirteen in the former, a further six in the latter. They fall into two groups, those from 1802-12, and those from 1827-32. The paintings from the first period were probably bought by Lord Egremont at exhibitions in London. By the late 1820s Turner was a frequent visitor to the house. He was given the old library, above the chapel, as his studio, and completed commissions for the Earl, including the two wonderful landscapes of Petworth Park at sunset, and two other large works, of *Chichester Canal* and *Brighton Chain Pier*, in both of which the patron had a financial interest.

Turner's visits to Petworth are also recorded in sketchbooks of watercolours in the Clore Gallery, remarkable examples of the artist at the very frontiers of watercolour technique. They were reputedly very happy visits for the artist, although he was not thought to have had a particularly close relationship with his patron, who left him much to his own devices. These were inspired and highly productive.

Egremont, to his credit, did for contemporary British sculpture what his father had done in the acquisition, for a British collection, of classical sculpture. And the two enterprises may not have been unconnected, in that the influence generally of sculpture in the house must have been considerable during the period of the Third Earl's adolescence. He bought and commissioned widely. The most important piece was John

Flaxman's *Saint Michael and Satan*, carved from a single piece of marble, and completed at the end of the artist's life, in 1826. It is to be seen in the setting built for it, and is depicted there also in the Thomas Phillips portrait of the Earl. Works by Sir Richard Westmacott are also in the collection, and a number by the Irish sculptor, John Edward Carew, indicate a special degree of patronage; Carew was employed exclusively from 1822. A portrait bust of the Earl himself by William Behnes is in the Oak Hall, and one of his horse, *Whalebone*, by Robert Henderson, is in the Somerset Room.

Egremont also bought works by Reynolds, *Macbeth and the Witches*, Gainsborough, Wilson, Fuseli, Zoffany, Wilkie, Northcote, Opie, Romney, and the American artist Washington Allston. Two watercolours and a large tempera work on canvas by William Blake were also acquired, *The Last Judgement* being painted for the Countess in 1808.

The Third Earl of Egremont compares with another great nineteenth-century collector, the Marquess of Hertford, in one unusual respect: both men left their estates to their natural heirs. In the Earl's case he did not make 'Mrs George Wyndham' his wife until after she had borne him six children. This meant that the title passed to a nephew and became

J.M.W. TURNER
Dewy Morning
Petworth House, West Sussex

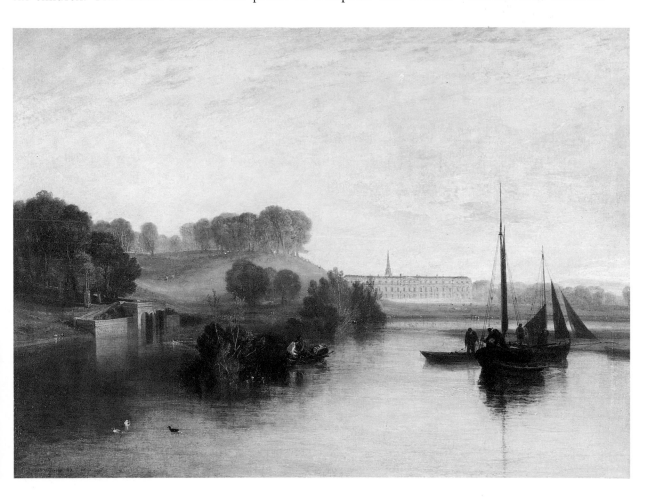

extinct. His eldest son, who inherited Petworth, was subsequently made Baron Leconfield in 1859. There have been no great acquisitions to the collection in the twentieth century.

ARUNDEL CASTLE

The collection in no sense reflects the range and magnificence of the works originally acquired by Thomas Howard, Fourteenth Earl of Arundel and Surrey, whom Lionel Cust described as the pioneer of English art collectors. His collecting methods are of critical importance in the history of art collections generally, and are noted elsewhere (see pp. 21-22).

There is a fine Mytens portrait of 'The Collector Earl', dating from 1616. But the most important work is the splendid Van Dyck double portrait, *The Fourteenth Earl and his wife, Alethea*. She was a Talbot, whose dowry included estates in Sheffield, and in part it was her wealth which financed their early visits to the Continent, and the purchase of works by Dürer, Holbein and Titian.

As a result of Arundel's several tours, artists such as Mytens, Van Dyck and the engraver Wenceslaus Hollar visited England to work. The

ANTHONY VAN DYCK
The Fourteenth Earl of Arundel and his Wife, Alethea
Arundel Castle, West Sussex

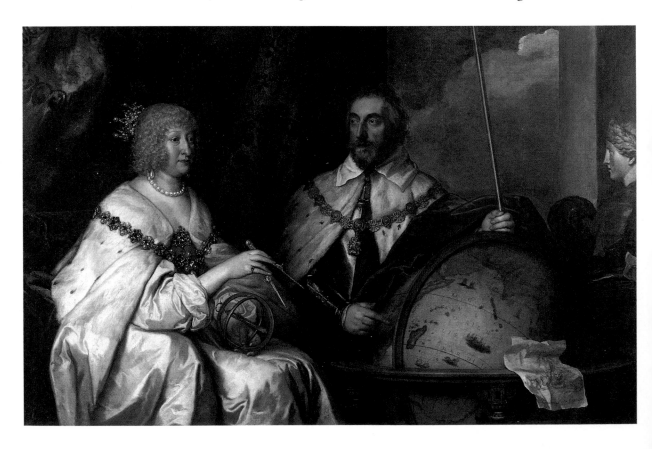

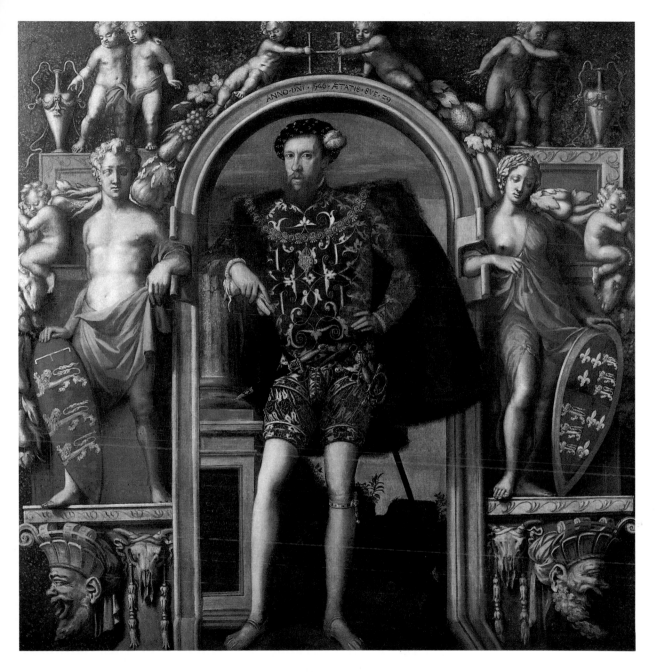

riches acquired in the seventeenth century, which were never concentrated at Arundel, are now widely dispersed.

The castle does contain important works of art, and portraits of the dukes of Norfolk, among them fine examples of Lely's work. The castle also contains the earliest version of the portrait of *Henry Howard, Earl of Surrey*, eldest son of the Third Duke, and, with Thomas Wyatt, responsible for introducing the sonnet form into English poetry. The painting is thought to be the work of William Scrots.

WILLIAM SCROTS
Henry Howard, Earl of Surrey
Arundel Castle, West Sussex

GOODWOOD

Various dukes of Richmond and Gordon are responsible for the Goodwood collection. An Elizabethan picture showing the Court of Wards in session and some of the portraits by, or after, Van Dyck, Lely and Kneller, would have been acquired by the First Duke of Richmond, on whom the king bestowed various honours and titles. The Second Duke also brought from his French château the painting of *Cardinal Fleury*, in its baroque frame, by Rigaud.

The Second Duke (1694-1750) was not only a collector, on the Grand Tour and on military and diplomatic missions to the mainland of Europe, but a patron. Proof of this resides in the Wootton paintings of his hunters with a local or Goodwood background. The Second Duke was one of the first English patrons of Canaletto, which accounts for the two Venetian scenes painted on copper and two very fine views of Whitehall and the Thames, from the windows of Richmond House.

The Third Duke was certainly Goodwood's biggest benefactor. He twice made architectural changes to the house and was always adding to the contents. He patronised the Smith brothers of Chichester and brought George Stubbs to Goodwood. Three of Stubbs's earlier works are on view, one; *Racehorses Training at Goodwood*, shows the Third Duchess

CANALETTO
Whitehall from Old Richmond House
Goodwood, West Sussex

GEORGE STUBBS
Shooting at Goodwood
Goodwood, West Sussex

and Lady Louisa Lennox with Buckner the bailiff. Chichester Cathedral can be seen in the background. The Third Duke's purchases of fine French furniture and Sèvres porcelain adorn the house.

The Duke had himself painted by Batoni and Mengs on the Grand Tour, and his family painted by Reynolds and Romney.

PALLANT HOUSE GALLERY, CHICHESTER

At Pallant House, in Chichester, is Dean Walter Hussey's art collection. Hussey was Dean of Chichester Cathedral for twenty years, and influential in developing the city's cultural life. He commissioned works by Graham Sutherland, John Piper and Marc Chagall for the Cathedral, and encouraged the use of the building for musical and dramatic entertainment.

On his retirement to London he offered his collection to Chichester, to be housed in the eighteenth-century Pallant House, built by another man of taste, Henry Peckham, in 1713, and restored for use as a gallery.

The collection includes two Hitchens landscapes, Henry Moore 'shelter' drawings, and good examples of Ceri Richards.

Graham Sutherland's development is shown from the early etchings to the best of his landscapes, and *Thorn Head* of 1947. There is a fine head of Hussey by him, and a study for *Northampton Crucifixion* which was commissioned by the Dean, as was John Piper's design for the Chichester Cathedral tapestry.

GRAHAM SUTHERLAND
Walter Hussey
Pallant House Gallery, Chichester, West Sussex

Fine Art
in the West of England

Sir Joshua Reynolds, at one of the Academy dinners, speaking of Gainsborough, said to a friend, 'He is undoubtedly the best English landscape painter.' 'No,' said Wilson, who overheard the conversation, 'he is not the best landscape painter, but he is the best portrait painter in England.'

Anecdote from Hazlitt

The West of England has only one major public collection—the Bristol City Art Gallery—but good collections are also to be found in Bath, Exeter, Plymouth, Falmouth, Truro and Bournemouth. There are more modest, but still interesting galleries in Salisbury, Devizes, Newlyn, Bideford and Swindon, though often these are reduced in their impact by the predilection for displacing the permanent display with local or travelling shows, often of indifferent quality.

The Bristol City Art Gallery has under its administration three other institutions with fine art, among them St Nicholas Church, in which hangs the splendid Hogarth altarpiece for St Mary Redcliffe. The other two are houses, one with mainly sixteenth- and seventeenth-century paintings and decorations, the other the house of an eighteenth-century merchant.

The best museum in Bath is the Holburne of Menstrie, more diverse and more interesting, as well as being better endowed, than the Victoria Art Gallery, which is the city's own.

Avon has one house of note, Dyrham Park, which has late seventeenth-century associations and interesting paintings of the Restoration period.

Cornwall, the westernmost county in England, has a number of interesting country house collections, of which Antony House is worth special note. Lanhydrock House, owned by the National Trust, has a mainly Victorian and Edwardian collection. There are good Molesworth family portraits by Reynolds at Pencarrow. The works at Saint Michael's Mount are late eighteenth century. Those at Trelowarren cover five centuries of ownership by the Vyvyan family, while the paintings at Trerice have all been acquired during the past thirty years or so.

No less than eleven houses in Devonshire contain interesting fine art collections. Reynolds is represented extensively at Saltram. He was

a close friend of Lord Boringdon, the owner in the latter half of the eighteenth century. At Arlington Court is a single major work by William Blake. Buckland Abbey, jointly managed by the City of Plymouth and the National Trust, has a Francis Drake collection, including portraits of him and his associates, as well as later historical works. At Cadhay there is a very specialised Lutyens collection of his drawings for the house. Works of art are also to be found at Compton Castle and Knightshayes Court.

There is a more extensive art collection at Powderham Castle, with numerous eighteenth- and nineteenth-century portraits, including works by Reynolds and Opie, both West Country artists. Torre Abbey is a local authority house; its collection, at present mainly nineteenth century in character, is still being formed. Ugbrooke has an important group of Lely portraits as well as other late seventeenth-century paintings.

Montacute House contains an extensive collection of portraits, the majority of which are sixteenth century and seventeenth century, and are on long loan from the National Portrait Gallery. They are augmented by some family portraits. Dunster Castle has the impressive allegorical portrait of Sir John Luttrell by Hans Eworth.

Other houses include Brympton d'Evercy and the Bishop's Palace, in Wells, which has portraits of the bishops of both Wells and Bath.

Wiltshire has several impressive collections, two of which, at Wilton House and Corsham Court, are in the first rank. Also to be noted are Bowood, owned by the Earl of Shelburne, Longleat House, owned by the Marquess of Bath, and Stourhead, which is a National Trust house.

Portraits at Avebury Manor include one of Henry VIII's brother-in-law, Thomas Seymour, who was subsequently beheaded. At Chalcot House there is a modern British collection. Lacock Abbey has family portraits, and additionally is associated with one of the early pioneers of photography, W. H. Fox Talbot. Willis and St John family portraits hang at Lydiard Park, and at Mompesson House there are pictures on loan from the Stourhead collection. New House has an interesting fantasy picture, in which hares persecute humans. Sheldon Manor has a collection which includes Dutch and Flemish works of the seventeenth century.

Exeter, Plymouth and Bournemouth all have civic collections of considerable local interest and diversity, and with both individual works and groups or 'schools' of significance.

But throughout this remote south-western region of Britain there have been missed opportunities, sometimes of tragic proportion. The Newlyn Art Gallery, for example, has only an embryonic collection. With even modest expenditure at various times over the past 100 years a unique collection could have been built up. The same is true of St Ives, though it does have the only collection in this region of England devoted to the work of one artist, the Barbara Hepworth Museum.

Certain museums have made a concerted effort to acquire works by artists from their own region. Exeter, in particular, has good examples of work by Francis Towne, Benjamin Robert Haydon, John White Abbott and Thomas Patch, all Devon artists. And the Plymouth City Art Gallery has work by these local painters, as well as Reynolds and Samuel Prout.

In Yeovilton, in Somerset, there is the Fleet Air Arm Museum, in which are oils and watercolours illustrating ships and aircraft associated with the history of naval flying, including Linda Kitson's drawings done during the Falklands War.

Many artists were drawn to the south-west of England. Those born there usually wanted to get away, and, if they were good, managed to do so. But the competition was stern, and local 'schools' developed, notably in and around Bristol.

Bath was rather different, in that it attracted artists because it was a spa, and allowed fashionable portrait painters to pursue their practice, often using and encouraging local painters as well. Gainsborough spent fifteen years in Bath, from 1759 to 1774.

The artists' colonies in Newlyn and St Ives were of a different order. Newlyn attracted a group of figurative painters who sought to apply common principles and practice to their work, and therefore congregated together with that in view. St Ives, which lasted much longer, and became a haven for painters in the 'Pebble Tradition', like Ben Nicholson and Christopher Wood, was also where Alfred Wallis was 'discovered' by them.

—— BRISTOL CITY ART GALLERY ——

The Bristol City Art Gallery contains a representative collection of European paintings, with some outstanding examples, good English paintings of all periods, and one of the finest collections of local and topographical art of any art gallery in the British Isles. There are splendid examples by Bristol marine artists like Nicholas Pocock and Joseph Walker, and an extensive collection illustrative of the impact Francis Danby made on Bristol art at the beginning of the nineteenth century.

Francis Danby was an Irishman, the son of a Wexford squire. With two other Irish painters, George Petrie and James Arthur O'Connor, he travelled to England, and then to Bristol. He abandoned ties with his own country: 'Ireland to me is a desert without interest.' Yet he maintained what was useful in his Irishness, including his brogue. He was a fine painter on the grand scale, as his *The Delivery of Israel out of Egypt* indicates, but he also painted more intimate scenes which have considerable appeal, and he was an excellent watercolourist, as in his *View of the Frome at Stapleton*.

He spawned a large artistic progeny, and Bristol should not be visited without inspection of works by artists such as Edward Bird, Edward Villiers Rippingille, Samuel Jackson, James Johnson, Samuel Coleman, whose *Saint James's Fair, Bristol* is a charming example of his work. There was also Rolinda Sharples, one of a family of local artists, whose *Trial of Colonel Brereton* is a stirring example of Bristol history—the 1831 Riots—brought to canvas.

More purely tographical than these were the drawings contained in the Braikenridge Bequest. This collection, in 22 folios, came to the gallery in 1908. It had been commissioned in the 1820s, and consists of views and

landmarks in and around Bristol. It is almost certainly the most complete visual record of any provincial English town. Local views also formed part of the Heber Mardon Gift, though this also included European engraved views.

But the Bristol gallery also contains major works, among them a fine Giovanni Bellini, *Descent of Christ into Limbo*, a Lucas Cranach, *Martin Luther*, and *The Withypool Triptych* by Antonio Solario, which takes its name from Paul Withypool, a Bristol merchant, who is the donor depicted in the painting.

In spite of a strong artistic tradition, dating back to the early years of the nineteenth century, and a much older mercantile tradition giving the city considerable wealth and importance long before the growth of industrial centres elsewhere, an art gallery was late in coming, and did not open until 1905. That it did so then was almost entirely as a result of the generosity of Sir William Henry Wills, later Lord Winterstoke, of the tobacco firm. His family was later to fund enlargement, and the purchase of works of art.

The gallery acquired an important group of 22 paintings by James

FRANCIS DANBY
Avon Gorge, Bristol
Bristol City Art Gallery

ROLINDA SHARPLES
The Artist and her Mother
Bristol City Art Gallery

GIOVANNI BELLINI
The Descent of Christ into Limbo
Bristol City Art Gallery

Muller, and then, in 1911, the Winterstoke Collection, mainly of large-scale narrative works. Probably the finest acquisition came in 1946, when the Schiller Collection, including the Bellini and Cranach, already mentioned, came to the gallery.

The Bristol City Art Gallery has under its control the Georgian House, the Red Lodge, and Saint Nicholas Church Museum.

HOLBURNE OF MENSTRIE MUSEUM, BATH

The Holburne of Menstrie Museum is, essentially, the collection of one man, Sir Thomas William Holburne.

Holburne was born in 1793, the second son of the Fourth Baronet, Sir Francis Holburne. He followed an early career in the Navy, but when his elder brother died during the Peninsular Campaign he became heir, and on his father's death in 1829 committed himself quite seriously to collecting and connoisseurship.

When he died, in 1874, he left the collection to his sister, and it was she who established the trust which then set up the museum. It was on her insistence that it was called the Holburne of Menstrie, after the castle in Stirling where the family had lived in the seventeenth century.

Not until 1916 did the museum open in its present location, a fine, late eighteenth-century building which had once been part of the fashionable Sydney Gardens, had then become a residential hotel, but was derelict by the time the trustees took it over for the Holburne collection.

It has many interesting works, among them Jagger's sensitive miniature portrait, *Thomas William Holburne*, Gainsborough's full-length *Dr Rice Charlton*, and Thomas Hill's enchanting *Garton Orme at the Spinet*.

CHARLES JAGGER
Thomas William Holburne
Holburne of Menstrie Museum, Bath

THOMAS GAINSBOROUGH
Dr Rice Charlton
Holburne of Menstrie Museum, Bath

THOMAS HILL
Garton Orme at the Spinet
Holburne of Menstrie Museum, Bath

VICTORIA ART GALLERY, BATH

Bath has a good general collection, though its full display is periodically interrupted since the Main Gallery is frequently given over to local and visiting art exhibitions, leaving the Small Gallery and Staircase for the permanent collection. The paintings on the staircase, not the most satisfactory place for seeing works of art, are changed on average once a year.

The Gallery shares space with the city's library, a common situation throughout the British Isles, and one which has contributed to the pinched and inadequate premises for the display of paintings.

The collection represents an interesting if mixed bag of pictures, mainly nineteenth and twentieth century. Thomas Barker of Bath, not surprisingly, is well represented with *The Woodman at his Door*, *The Old Matchwoman*, *The Sand Girl* and *The Gipsy Girl*. The spirit of Bath's period of fashionable life is captured in some works, including *The Fishing Party*, attributed to Farington and Hoppner. There are also works by Lawrence, Opie and Lambert.

JOSEPH FARINGTON and
JOHN HOPPNER (Attributed)
The Fishing Party
Victoria Art Gallery, Bath

DUTCH ART AT DYRHAM PARK
(NT)

Dyrham Park dates from the late seventeenth century, a time when everything Dutch was in high fashion, following the 'Glorious Revolution' of 1688. The building of the house almost exactly coincided with the thirteen years of the reign of William and Mary. And this is clearly reflected in the fine works by Dutch artists, as well as in the Delft-ware, the urns, tulip-vases, and in the leather wall-hangings. The house is an excellent example of baroque planning.

The connection between the house and the monarchy was much closer, however, than simply their contemporaneity; William Blathwayt, whose wife, Mary Wynter, inherited the old Tudor house and estate at Dyrham Park just two years after their marriage, was William III's Secretary at War and acting Secretary of State when the King was in Holland.

Blathwayt's taste in art derived mainly from his uncle, Thomas Povey, a friend of Pepys, and of John Evelyn. Povey was a man of fashion at the court of Charles II, and in his house in Lincoln's Inn Fields Pepys admired 'above all' Samuel van Hoogstraeten's *View Down a Corridor*, in a house which he thought was 'beset with delicate pictures'. A second interesting *Perspective View of the Courtyard of a House* by the same artist hangs on the staircase.

Other Dutch works include a pair of seascapes by Hendrik van Minderhout (1632-96), of Antwerp and of an oriental harbour scene, a number of bird subjects by Melchior de Hondecoeter (1636-95), and landscapes, seascapes and flower pieces typical of the late seventeenth century.

It is, unfortunately, a residual collection, a number of works having been sold, both at the beginning of the century and in 1956, when the house was acquired by the Ministry of Works, through the National Land Fund, in memory of those who died in the Second World War. It was subsequently transferred to the National Trust.

SAMUEL VAN HOOGSTRAETEN
View Down a Corridor
Dyrham Park, Avon

MICHAEL WRIGHT
Portrait of Thomas Povey
Dyrham Park, Avon

WILTON HOUSE

The chief glory of Wilton House, in Wiltshire, is the suite of State Rooms, for which Inigo Jones was largely responsible, following a disastrous fire in 1647. The greatest of these rooms, the Double Cube Room, was specifically designed for the paintings of Van Dyck which still hang there. They include *The Fourth Earl of Pembroke and his Family*, Van Dyck's largest family group, in which the three angels represent children who died in infancy. It is one of his greatest works, sumptuous yet dignified, mannered yet human, its composition coolly elegant, hinting faintly at the vanity of human wishes.

Its central figure was one of the great seventeenth-century English collectors, who gave to Charles I Raphael's *Saint George*, and was given in return an album of Holbein drawings, which he then promptly passed

on to the Earl of Arundel, whose collecting enthusiasm for them was greater than his own.

Other Van Dycks include *Charles I*, *Queen Henrietta Maria*, *The Third Earl of Pembroke*, said to have been painted posthumously from Le Sueur's statue in the Bodleian Library, in Oxford, *The Children of Charles I*, an oval group portrait, other members of the family, and the Studio of Van Dyck *Duke of Richmond*.

Inigo Jones's design was revolutionary from the point of view of the paintings. Jacobean tradition limited hanging space by virtue of the constraints of panelling. Inigo Jones changed this; his concealed joints and flat areas of painted wall, even with the elaborate decorations, allowed for large paintings to become the overwhelmingly powerful feature of the rooms. The scale, design and decoration of his rooms were then able to play their dramatic but ultimately subordinate role.

The ceiling contains paintings on the theme of the legend of Perseus, supposedly by Thomas de Critz, which date from the 1630s. The actual mural decorations are thought to be the work of Edward Pierce.

The Fourth Earl of Pembroke is an interesting figure in English seventeenth-century art and collecting, in spite of the fact that he 'pretended to no other qualifications than to understand horses and dogs very well'. The survival of at least part of his collection—certainly including the magnificent paintings by Van Dyck, of whom the Earl was a major patron—has a political dimension, in that the Earl, having served Charles I in a number of capacities, became a supporter of the Parliamentary side in the Civil War, and was one of the few great earls whose position and fortune were stable enough for him to commission the work at Wilton in the late 1640s.

LUCAS VAN LEYDEN
The Card Players
Wilton House, Wiltshire

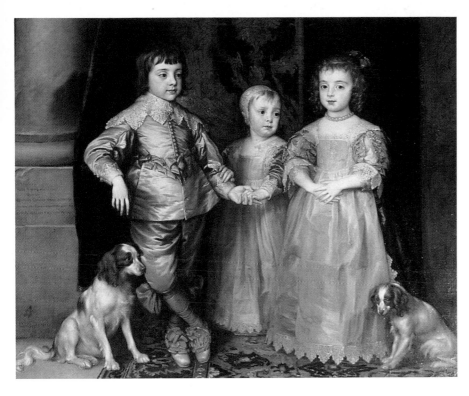

ANTHONY VAN DYCK
The Children of Charles I
Wilton House, Wiltshire

It was to limited avail. His son, the Fifth Earl, sold off major works during the next two decades, a downward period of transition which continued at the death of the Seventh Earl, when further works of art had to be sold to pay his debts. He was a good-for-nothing spendthrift, twice accused of murder, found guilty of manslaughter, and committed to the Tower. He was succeeded by his younger brother, Thomas, the Eighth Earl, an outstanding statesman, scholar and collector. It is from his period as head of the Herbert family that some of the greatest acquisitions date. One of these was the *Wilton Diptych*, now in the National Gallery, and one of its great treasures.

The Eighth Earl, as well as being Lord High Admiral, and Lord Lieutenant of Ireland, Wales, Monmouth and Wiltshire, at different times, also represented the Government abroad, and made numerous diplomatic missions. Buying through agents, he acquired paintings, sculpture, drawings and books from the Arundel Collection, from Cardinal Mazarin's collection, and from the Giustianini Marbles.

'The Architect Earl', who succeeded, concerned himself with the property and the grounds; his son, the Tenth Earl, commissioned, among other works, the Reynolds portrait, and married Lady Elizabeth Spencer, daughter of the First Duke of Marlborough.

The Sixteenth Earl, born in 1906, was responsible for much of the research done into the Wilton House collections, and for the publication of catalogues.

The collection of drawings at Wilton House, second only to those at Chatsworth, was sold in 1917, though with the notable exceptions of

GIOVANNI BATTISTA SALVI
and MARIO NUZZI
The Madonna
Wilton House, Wiltshire

works by Holbein, Dolci, Carriera, and the outstanding *Portrait of a Cleric* by Raphael. They had mostly been acquired by the Eighth Earl.

The art at Wilton House constitutes one of the great and unspoilt collections of painting and sculpture in British country houses.

———— CORSHAM COURT ————

The Corsham Court collection derives from two main sources, Sir Paul Methuen (1672-1757) and John Sanford, a clergyman, whose only daughter, Anna Horatia Caroline, married in 1844 Frederick Henry Paul, later the Second Lord Methuen. The second of these two collectors, while resident in Florence between 1815 and 1837, acquired the very beautiful Francesco Granacci *Annunciation*, painted for an altarpiece depicting the life of Saint Apollonia in a Florentine convent named after the saint. Another of Sanford's remarkable acquisitions, the Guercino *Infant Christ*, hangs in the State Bedroom.

Sir Paul Methuen had a distinguished political and diplomatic career, following in the footsteps of his father, who had been Lord Chancellor of Ireland at the end of the seventeenth century. Both men had been involved in treaty negotiations with Portugal, and in the important early eighteenth-century expansion of trade between the two countries. He was unmarried, and made clear his intention of leaving his property to his godson and cousin, also called Paul, who redesigned and enlarged an older house for this purpose. The main works collected by the godfather dominate the principal room in the house.

In addition to those already mentioned, they include works by Jusepe de Ribera, Guido Reni, Bernardo Strozzi, Carlo Dolci and William Dobson's *Head of a Cavalier*.

A sensible emphasis has always been put on the art collection, at the expense of the house, its furnishings and its grounds.

Indeed, the main rooms were designed by 'Capability' Brown, in the mid-eighteenth century, with the paintings in mind. And their overwhelming impact is still, today, the most striking thing for any visitor. Nor is it confined to the magnificent scale and design of the triple-cube Picture Gallery. In this room are hung the great Van Dycks, including *The Betrayal of Christ, The Three Gaddi Children* by Sofonisba Anguisciola, and the lovely Caravaggio *Tobias and the Angel*.

Anguisciola is often referred to as 'the first of female painters'. She lived to a great age, though blind at the end, and Horace Walpole claimed she was painted by Van Dyck.

The impact of the magnificent works of art continues into the Cabinet Room, through the door of which one first sees *The Annunciation* from the Studio of Fra Filippo Lippi, one of the loveliest of all works in English country houses. And it goes on thereafter, in the rich and crowded hangings throughout the house.

Of equal, if not greater importance, in the eyes of Lord Methuen, the owner, is the completeness of the collection. 'Any serious interference, even through the sale of chattels, let alone pictures', he says, 'would be a

SOFONISBA ANGUISCIOLA
The Three Gaddi Children
Corsham Court, Wiltshire

disaster to the whole collection.' And it is a matter of obvious and justified pride that this has not occurred on any major scale, though from time to time pictures have been sold. The most recent sale sets an interesting standard for the future of such collections. The Van Dyck *Betrayal of Christ*, bought by the Bristol Museum and Art Gallery, has been left on permanent loan at Corsham Court.

The collection still deserves the praise heaped on it during the nineteenth century. While not flawless, the works of art at Corsham Court are a remarkable credit to those main nineteenth-century collectors.

The hanging of the paintings follows the original eighteenth-century scheme. This tiered approach, long out of fashion in public galleries, is now increasingly in vogue among a new wave of directors. It makes a splendid impact at Corsham and is as appropriate now as it was originally.

The collection also contains family portraits by Reynolds, Romney and Gainsborough, as well as earlier works of the English School. Particularly attractive are the Reynolds portraits of *Thomas Methuen as a Child* and of his brother and sister, *Paul Cobb and Christian*; she became Lady Boston.

Particularly attractive also are the many small works, among which can be found exciting and out-of-the-ordinary paintings, the Andrea del Sarto *Saint John the Baptist*, and the Jan Brueghel *Flower Piece*. There is a prettily painted Turchi *The Massacre of the Innocents*.

After the Second World War a part of the house and its main outbuildings were converted for the use of the Bath Academy of Art. The experiment, which began in 1946, involved a number of innovative and stimulating British painters as teachers, including William Scott, Kenneth Armitage, Peter Lanyon, Terry Frost and Bryan Wynter. Unfortunately, none of their works hangs in the public rooms.

BOWOOD HOUSE

The fine paintings and sculpture at Bowood are largely from the collection of the Third Marquess. It was during his time, in 1838, that Miss Berry wrote of Bowood: 'Much as I have heard of the good style of Bowood in every respect, both as to the arrangement of life and of society, it much exceeds my expectations. I have never seen such comfortable and elegant luxury pervading in every department, without any cumbrous pomp.' In the eighteenth and nineteenth centuries Bowood and Lansdowne House, in London, were indeed famous for their hospitality and the intellectual and artistic company that gathered in the drawing rooms of the enlightened Whig politicians of the Lansdowne family.

The first great Lansdowne art collection was formed by the First Marquess, a leading politician and patron of the arts. An interesting and complex figure in eighteenth-century politics, Lord Shelburne, as he was throughout his political career, had a turbulent and frustrating time, with, among other things, responsibility as prime minister in 1783 for negotiating independence for the United States after the War of Independence. Unpopular among his colleagues, he was much admired by his friends. He enjoyed the company of gifted and intellectual men; Dr Johnson, Oliver Goldsmith, Joseph Priestley and Benjamin Franklin were among those who stayed at Bowood. It was the First Marquess who employed the Adam brothers to extend and improve his houses and 'Capability' Brown to landscape the park at Bowood.

At his death in 1805, almost all of the great art collection was sold to meet his debts, leaving Bowood virtually empty for the Third Marquess, who inherited from his half-brother only four years after his father's death. Over a long lifetime in government he built up a second and interestingly diverse collection at Bowood which included paintings by Raphael, Titian, Andrea del Sarto, Bronzino and Claude as well as the works of eighteenth- and nineteenth-century painters and sculptors. He was tempted to fill the gaps with the purchase of Lord Radstock's collection for £16,000 in 1810. He sought advice from, among others, Thomas Lawrence. It was guarded, and even the one picture he did acquire, attributed to Titian, turned out to be a copy. The Radstock collection sold for little when it was auctioned in 1826. Lord Lansdowne's judgement and discretion about art were deployed more publicly, in his role as a trustee of the National Gallery, to which he was appointed in 1834. Through his influence, Bowood gained a number of 'Victorian' features; additions and improvements to the house and gardens were made by Barry, Cockerell, Smirke and Kennedy.

From the mid-nineteenth century onwards, the Lansdowne estates were in financial and political trouble, with Irish rents being withheld, and with the London and Wiltshire properties being leased to William Waldorf Astor among others. Dereen, in Ireland, was burnt down; Lansdowne House was sold in 1930 and in due course Bowood itself was demolished, the courtyards and Orangery being remodelled into the 'Little House'. Sales during this century further depleted the second Bowood collection.

The best of what is left is well presented, and includes a particularly fine English watercolour collection, which has been enlarged by the present Earl of Shelburne. There are some interesting works of classical and Victorian sculpture and certain of the original British paintings commissioned by the Third Marquess, including works by Wilkie, Eastlake and Clarkson Stanfield. Among the Reynolds portraits are *Sir Horace Walpole, Fourth Earl of Orford*, a considerable connoisseur and author of *Anecdotes of Painting*; *Mrs Baldwin*, *The First Marquess of Lansdowne* and *Hope Nursing Love*. Also of interest is the remarkable collection of jewels presented to Admiral Lord Keith in the early nineteenth century and the collection of Indian paintings and silver formed by the Fifth Marquess, who was Viceroy from 1888 to 1894.

THE HOARE FAMILY AND STOURHEAD (NT)

Stourhead was in the Hoare family from the time of its purchase, in 1717, by Henry Hoare I (1677–1725) until it was presented to the National Trust

after the Second World War. It suffered two major tragedies, from the point of view of the collection. In 1883, as a result of agricultural depression and a large mortgage, certain major works of art were sold, including Nicolas Poussin's *The Rape of the Sabines*, now in the Metropolitan Museum in New York, and Turner's *Lake Avernus with Aeneas and the Cumaean Sibyl*, which also went to America, although another version is in the Tate.

Other paintings sold then included *Pietro Landi, Doge of Venice*, attributed to Titian, and a set of ten drawings of Venice by Canaletto, purchased by Colt Hoare, 'by mere accident, having found them carelessly dispersed in the portfolio of a bookseller in Venice'. Then, in 1902, a fire gutted the central part of the house. Although it did not destroy either the Library or the Picture Gallery, the Saloon was burnt, and four very large paintings lost.

The house was reconstructed, mainly along the original Palladian lines of Colen Campbell's design, which he published in the third volume of his *Vitruvius Britannicus* in 1725, when the house was completed.

It was not until 1741, when his mother, the widow of the first owner, died, that Henry Hoare II moved to Stourhead and began work on the landscaping of the gardens. This was to remain a major preoccupation for the rest of his life, resulting in what is often regarded as the chief glory of the estate.

He was also a collector, however, responsible for the purchase of *The Bloody-Shouldered Arabian* by John Wootton, the Carlo Maratta *Marchese Pallavicini and the Artist*, landscapes by Gaspard Poussin, and the Mengs *Caesar and Cleopatra*, all still in the collection. In addition, he bought the two Nicolas Poussins, one later sold, and works by Rysbrack, of whom he was a generous patron. Rysbrack's last work for Hoare was *Alfred the Great* in the Saloon, and he left the terracotta, *Hercules*, to Hoare in his will.

Colt Hoare, his grandson, inherited in 1783, and became, for Wiltshire, one of its noted historians, seeking 'to possess the past by painstakingly recording it'. Equally a believer in 'facts, not theory', he for a time thought to become a painter himself. Not a great success at this, he did patronise others, including Turner, whose *Lake Avernus with Aeneas and the Cumaean Sibyl* derived from one of his drawings.

He bought works in Italy, including Cigoli's *Adoration of the Magi*, in the Picture Gallery, and was himself painted by Woodforde, with his son, Henry, one of a number of sensitive works by this Wiltshire artist from nearby Castle Cary. His son predeceased him, and he became increasingly lonely and pessimistic in his old age. A late diary entry reads: 'still house bound, deaf and lame'.

He also bought 'a pleasing selection of fancy pictures', by which he meant contemporary British paintings, including Woodforde's *A Shepherdess with a Lamb in a Storm*.

He it was who arranged the family portraits in the Entrance Hall because 'they remind us of the genealogy of our families, and recall to our minds the hospitality &c. of its former inhabitants, and on the first entrance of the friend, or stranger, seem to greet them with a SALVE, or welcome'.

And he also arranged the Picture Gallery, in the traditional, crowded style in vogue at the time.

Stourhead is one of the best-integrated of English collections, in spite of earlier losses, deliberate or accidental. And again, in spite of substantial Edwardian reconstruction because of the fire, it has an attractive atmosphere. The extensive collection of pastel portraits by William Hoare of Bath, who was no relation, is of considerable local interest.

The landscaping at Stourhead is very distinguished. While it does not rate inclusion on those grounds, it did inspire many artists, among them John Constble, Francis Nicholson and Samuel Hieronymus Grimm.

— THE MUSEUMS OF WILTSHIRE —

Salisbury, Devizes and Swindon seem to confirm the depressed nature of public concern about fine art during the nineteenth century in the southern half of England. Coupled with the picture of the hardship and poverty in Wiltshire and Dorsetshire which emerges from the pages of such writers as Thomas Hardy and W. H. Hudson, it is easier to understand the limited contents of the museums. The collections at all three of them are local, antiquarian and limited.

Devizes has good topographical works, and a reasonable cross-section of British watercolours. There is also a vast collection of watercolours of Wiltshire churches and houses. Salisbury's collection is also essentially topographical.

Swindon has a fine representation of twentieth-century British art, mainly from the David Bomberg Bequest.

PLYMOUTH CITY MUSEUM AND ART GALLERY

Plymouth focuses on artists who came from the city, or nearby, the most famous of whom was Joshua Reynolds, and on painters in Devon and Cornwall, including the Newlyn School, and artists from the later, post-war St Ives group.

Good examples of work by Devon portrait painters include early studies of members of his family by Reynolds, and a later portrait, completed in 1777, of the art collector, *Charles Rogers*, who was Custom House clerk of certificates. His collections passed, on his death, to William Cotton; but then they came to the Plymouth Proprietary Library, later enriching the Art Gallery and Museum.

There are paintings by James Northcote, Benjamin Robert Haydon, Charles Lock Eastlake, who was later to be Director of the National Gallery in London, and watercolours by Francis Towne and J. W. Abbott, all Devon artists.

A good general collection includes British art from the late nineteenth century on. Among the St Ives painters whose works are included are Wynter, Frost and Heron. Among Newlyn School paintings is *Fish Sale on a Cornish Beach* by Stanhope Forbes.

ROYAL ALBERT MEMORIAL
MUSEUM
AND ART GALLERY, EXETER

The story of the institution and its collections does not reflect too well on the City of Exeter. The Museum was established as a result of the inspiration which Prince Albert the Prince Consort exercised widely in England in the middle of the nineteenth century. The local MP, Sir Stafford Northcote, wishing to commemorate the Prince after his death in 1861,

PETER LELY
The First Lord Clifford
Ugbrooke, Devon

persuaded the city to bring together in one building a library and museum, as well as schools of art and science. The building opened in the early 1870s.

No one thought out its collecting policy; no money was made available for acquisitions; its first full-time fine art expert was not appointed until 1968. Works of art were mainly gifts or bequests, the most important of which were the Kent and Jane Kingdon Collection, given in 1892, the Harry Veitch Collection, given in 1924 and the John Lane Collection, presented the following year.

The last of these contained virtually all the Devon works at Exeter, and forms the valuable and interesting nucleus for Devon art. This includes important works by the Exeter painter Thomas Hudson, who taught Reynolds, an attributed example of Francis Hayman, another Exeter artist, and an example of the caricature groups by Thomas Patch, another Exeter artist who is also represented by landscapes and maritime works.

Like other collections in Cornwall and Devon, the contribution of the West Country to British art is underlined at Exeter by the presence there of interesting works by Northcote, Eastlake, Haydon, Thomas Luny, James Leakey, Richard Crosse and Samuel Prout.

Eastlake, who became the first and one of the best directors of the National Gallery in London, was Haydon's pupil. No two artists could have been more different. Haydon, moody, depressed, and eventually a suicide; Eastlake, confident, able, gifted and generous in temperament. A Haydon *Self-Portrait* is in the collection, as is his pupil's *Cypresses at L'Arricia*.

There is a good general British collection. It was somewhat reduced in the 1950s, when paintings which had come from the Harry Veitch Collection were sold in order to form a trust fund for the purchase of work by Devon artists; this became Exeter policy. At the time Victorian art was unappreciated, and the art market was depressed. In 1968 this policy was reversed, just when the art market was gathering pace. It was only then that a Curator of Fine Art was appointed, and her work has greatly improved the situation in Exeter.

SIR JOSHUA REYNOLDS
—— AND SALTRAM HOUSE (NT) ——

Sir Joshua Reynolds is so much part of country house collections throughout these islands, that it may seem a little perverse to link him so extensively with one house and one collection. Nevertheless, the association with Saltram House, outside Plymouth, and with its main fine art collector, justify this approach.

The paintings at Saltram House were mainly collected in the last quarter of the eighteenth century by John Parker, who was created Lord Boringdon in 1784. And, from 1770 onward, Boringdon was a close friend and associate of Joshua Reynolds, his name appearing more frequently in the painter's pocket books than anyone else. They may have been friends from

JOSHUA REYNOLDS
*John Parker and his Sister Theresa
as Children*
Saltram House, Devon

much earlier. The house is two miles from the village of Plympton, where Reynolds's father taught, and where the painter was born in 1723. It is clear that the painter's calls at Saltram were social, and there is a story that he received his first drawing lessons from Boringdon's mother, Lady Catherine Parker.

Such is the nature of collecting—a combination of crucial factual evidence about provenance and acquisition with the hidden and secret motives that prompt the choice of a particular work—it is not possible to measure completely the impact of Reynolds on the paintings at Saltram. But he certainly contributed himself, with an array of splendid and interesting portraits, ten in all; he is the subject of an uncharacteristically benign three-quarter length by Angelica Kauffmann; he played a part in the presence of works in the house by her and by Northcote, who was also a Devon artist who worked at the beginning of his career for Reynolds; and there

is at least circumstantial evidence for his guidance and advice about many other paintings. One of his masterpieces now at Kenwood, *Kitty Fisher*, was once at Saltram.

His own works at Saltram cover the period from the 1749 portrait of *Paul Ourry* to the 1779 double portrait of his patron's offspring, *John Parker and his Sister Theresa as Children*. John became Lord Morley; Theresa married George Villiers, third son of the First Earl of Clarendon. Other Reynolds portraits include one of the engraver Bartolozzi, and portraits of Devonshire neighbours of Lord Boringdon.

The role played by Reynolds in other aspects of the Saltram collection is largely a matter for speculation. He may have advised on the commissioning of the Gilbert Stuart portraits, of which there are nine. He may also have helped Lord Boringdon in the acquisition of certain Italian works at Saltram, but the evidence, though in certain respects strong, is circumstantial.

One further work of particular interest to those concerned with the wider aspects of collecting is the early Rubens portrait head of Francesco Gonzaga, a member of the Mantuan family from which Charles I bought a major part of his collection. The painting was once in Charles I's collection.

The hanging of the paintings at Saltram is much as it was in Lord Boringdon's time, two and three deep, using all wall space, portraits and landscapes mixed, a natural expression of the exuberant taste of Grand Tour collecting. In his full-length *John Parker, Lord Boringdon*, Reynolds gives something of the flavour of this high-living gambler's lively and engaging personality. The Duchess of Devonshire wrote of Parker 'as dirty, as comical and talking as bad English as ever'. One almost hears the Devon accents of painter and patron coming out of the canvas.

ALFRED AARON DE PASS, GIVER EXTRAORDINARY

The great benefactor of West Country public collections was Alfred Aaron de Pass (1861-1952). Not only the Falmouth Art Gallery, but also Plymouth and Truro, benefited enormously from the generosity of this South African collector. So too did the National Gallery, National Portrait Gallery, Tate Gallery, Fitzwilliam Museum in Cambridge, Bristol City Art Gallery, Portsmouth City Art Gallery, and other places, notably the National Gallery of South Africa, where de Pass spent his last years.

He was a prodigiously generous man, spontaneous and instinctive in his acquisition of works of art, and in his giving. He went once to an exhibition of maritime art, in Falmouth. Immediately afterwards he went out and bought the same kind of art, filling an annexe in his house; later, he gave the whole collection to Falmouth.

Well before his death he had given everything away. A typical instance of his impetuous approach was his gift of the portrait of Alexander Pope,

JOHN WILLIAM
WATERHOUSE
The Lady of Shalott
Falmouth Art Gallery, Cornwall

then thought to be by Kneller, now attributed to Jonathan Richardson, in the National Portrait Gallery. 'Lord Ronald Gower, a trustee, on a visit to us while staying in Falmouth, said it ought to be there, so I gave it.'

He was a great friend of the Falmouth painter of the male nude, Henry Scott Tuke, and bought much of his art during Tuke's lifetime, acquiring the greater part of his studio after his death. These works also he gave away, stocking several West of England collections with their Tuke holdings.

His first wife was Michel Salaman's sister. Salaman was a contemporary of Orpen and John at the Slade, and de Pass bought Orpen's 1907 portrait of *Grace Orpen*, now in the Tate, presented by him in 1920. He also gave works by Blake, Rossetti, Ford Madox Brown and Frederick Walker to the Tate.

Between 1914 and 1935 he concentrated much of his attention on the collection at the Royal Institution of Cornwall, at Truro, the best collection of fine art in the county, and now known as the County Museum and Art Gallery.

As far as Falmouth itself is concerned, the association with de Pass is somewhat indicative of the difficulties which can often affect adversely the acquisition of works of art by local authorities. They permitted the building of garages beside the collector's home, for which he never forgave the town council. He dealt only with its public library, and the librarian, Tregoning Hooper, through whom all the gifts were made.

Among other works, de Pass gave to Falmouth a study by John William Waterhouse for his *The Lady of Shalott*. (The main painting is in the Leeds City Art Gallery.) He gave a work by the same artist to Plymouth. His giving to Truro was magnificent.

ANTONY HOUSE (NT)

Antony House, in Cornwall, has been associated with the Carew family since the late fifteenth century, passing to the National Trust only in 1961, though a member of the family still lives there.

Many generations of Carews are depicted in family portraits, and there are good sporting pictures. Works include an important painting by Jan Wyck, *The Earl of Coventry in the Hunting Field*. Another work by Wyck shows two spaniels barking at a jay. His influence on English sporting and landscape art, as well as on Wootton's painting, was considerable.

Jan Wyck established his reputation in England in the 1670s, painting martial subjects in the manner of Wouwermans, battle-pieces, equestrian and martial portraits. His work is also to be seen at Drumlanrig, in a series of battle-pieces, at Blenheim, and elsewhere. He is a fluent and attractive painter, many of whose qualities as an artist of equestrian subjects are not recaptured until a century later, with such painters as Stubbs.

John Wootton, though much influenced by Wyck, paints on a larger, more open, arguably more English scale. The sense of drama is more

powerful, though less cohesive. It runs to life-size portraits of horses, and sometimes huge canvases of huntsmen grouped together in the field. He is represented in the Antony House Collection by an equestrian portrait of Lord Coventry.

PORTRAIT GALLERY PICTURES
—— AT MONTACUTE HOUSE (NT) ——

After WILLIAM SCROTS
Portrait of Edward VI
Montacute House, Somerset

This late sixteenth-century house belonged to the Phelips family for over 300 years, before passing to the National Trust, which in 1972 asked the National Portrait Gallery for the collection which now hangs in the Long Gallery and adjoining rooms. Over eighty Tudor and Jacobean portraits are on display. The gallery is the longest of its kind to survive.

The collection contains copies of late fifteenth-century royal portraits in a 'set'. Such sets were a feature of galleries like the Long Gallery, though few of the paintings were of earlier date than 1500.

The main part of the collection is of Renaissance and later painting, with a good version of Holbein's *Thomas More* as well as copies of later portraits. Examples of Van der Meulen, George Gower, Marcus Gheeraerts the Younger, Paul van Somer and Michiel Miereveldt, are to be found.

—— KINGSTON LACY (NT) ——

Kingston Lacy has a number of important works of art, and is notable as a collection for the Spanish paintings. These were mainly acquired by William John Bankes, who visited the country during Wellington's campaigns, staying at the Duke's headquarters.

His interest in Spanish art was in direct contrast with general country house taste, not only of his own time, but really of the whole of the eighteenth century, when Italian paintings had been the main objective of Grand Tour travellers. It was not until the mid-nineteenth century that collectors like John Bowes and Sir William Stirling Maxwell gave popularity to Spanish art, reviving interest in it at a time when writers were also exploring Spanish themes.

In the 1840s and 1850s, as part of the protracted improvements to the house, he created the Golden Room, with its carved, gilded and painted ceiling. In it he hung works by, or attributed to, Velázquez, Zurbarán and Murillo. The Velázquez is a striking portrait of *Cardinal Camillo Massimi.*

The collection also includes other masterpieces, this time of Flemish art, though with an Italian theme. They are the outstanding, full-length portraits of members of the Grimaldi family, painted in 1606 by Rubens. The captivating beauty of *Marchesa Caterina Grimaldi* is accentuated by the grandeur of her dress, and the whole composition is redolent of the qualities which so impressed Van Dyck, shaping his style. They hang in the Saloon, together with *Holy Family with St John*, acquired as by Raphael, but now attributed to Giulio Romano, the Sebastiano del Piombo *Judgement of Solomon*, and Titian's portrait of *Francesco Savorgnan della Torre*, all acquired by William John Bankes.

Other portraits include Van Dyck's of *Sir John and Lady Borlase*; she was the eldest daughter of Sir John Bankes, who purchased Kingston Lacy. There are Peter Lely portraits, and works by Lawrence and Henry Bone.

— RUSSELL-COTES ART GALLERY — AND MUSEUM, BOURNEMOUTH

The villa which houses Bournemouth's main art collection redeems one's faith in Victorian opulence and decorative prodigality. It justifies the ways of the aspidistra and antimacassar to modern man, and does so with a sense of fun and richness which is entertaining. The villa was built for Sir Merton Russell-Cotes in 1894, his year in office as mayor of Bournemouth. It was to house an art collection brought mainly from abroad.

The house and contents were given to Bournemouth in 1908, though it did not open to the public until 1922, the year after its owner's death. In the meantime extra galleries had been built. Though there have been subsequent bequests and gifts, the collection is basically as made by the original owner.

It includes a number of interesting works, from eighteenth-century artists like Morland and Wheatley, through the main emphasis, which is nineteenth-century, to a modest holding of modern art. A major work is *Venus Verticordia* by Rossetti, and there is a fine Turner, his *St Michael's Mount*, dating from 1834.

EDWIN LONG
The Chosen Five
Russell-Cotes Art Gallery, Bournemouth

Fine Art in Wales

Wild Wales has always attracted painters.

Its great mass of dramatic mountains, its wonderful coastline, particularly in Pembrokeshire, and its comparatively easy access, compared with Scotland, Ireland, or the Alps, has made it something of a mecca for painters ever since landscape painting became an established and profitable pursuit. In the eighteenth century they sought to test out the theories on the Sublime and the Beautiful, for which Wales was eminently suited. Indeed, so popular had the practice of artistic tours become, by the end of the century, that it was the subject of part of Rowlandson's satire in *Dr Syntax's Tours.*

Most English watercolourists of note during the eighteenth and nineteenth centuries painted at one time or another in Wales. Some were regular visitors, like David Cox. Others, such as Paul Sandby, Samuel Palmer, Thomas Girtin and Francis Towne, made tours which produced impressive work. Turner painted in Wales. So did the eighteenth-century Irish artist George Barret, who was particularly influenced by Edmund Burke's views on art, and found the wildness of Wales well suited to the exploration of the philosophic principles put forward by his early patron.

In the nineteenth century Wales offered great challenges for watercolour painters. In the twentieth century it has encouraged artists such as Graham Sutherland, who made his home in Pembrokeshire, where there is still a gallery devoted entirely to his art.

The country's own artists, with the exception of David Jones and Ceri Richards, tended to be indifferent. Gwen John, and her brother, Augustus, were happy to leave Tenby firmly behind them from their student days on. But their casual rejection was more than compensated by the almost obsessive interest in the country of artists like J. D. Innes.

Wales produced, however, in Richard Wilson, an eighteenth-century artist suited by temperament and period to its many landscape resources, and numerous examples exist, including paintings of Snowdon. He favoured North Wales.

The input of visiting painters and the output of artists from an under-populated area of the British Isles, is not matched by the residue of fine art left to posterity in museums, art galleries and houses in Wales. Modest is the best word to use.

There is one major art gallery in Cardiff, more modest ones in Newport, Llanelli, Tenby and Swansea. There is an interesting Graham Sutherland

collection near Haverfordwest, the only single-artist collection in Wales, though Swansea Council has created something of a memorial to Brangwyn in the Guildhall in Swansea, where his *Empire Panels* hang. There are smaller collections in Haverfordwest and Merthyr Tydfil.

There are collections in a few houses, thinly spread through Gwent, Gwynedd and Powys. The most interesting are Tredegar and Plas Newydd, through Powis Castle has the association with Lord Herbert of Cherbury, commemorated in the exquisite miniature by Isaac Oliver.

THE NATIONAL MUSEUM OF WALES
— IN CARDIFF —

The National Museum of Wales was founded in Cardiff in South Glamorgan, in 1912. Its collections of art reflect a set of objectives not dissimilar from those pursued in the Ulster Museum: in other words, a strong emphasis on Welsh artists, Welsh subject-matter and Welsh people, with a good general collection of painting and sculpture, some areas of which are outstanding.

Not surprisingly, the Welsh painter Richard Wilson is well represented, with works from all periods, including portraits, showing both his own highly individual development as an artist, and his significant stylistic impact on later generations of English painters. *Valley of the Mawddach with Cader Idris* is one of his more classical treatments.

English painting, particularly of the nineteenth century, is well represented, and another noisier but far less loyal son of Wales, Augustus John, is in evidence, appropriately enough, with his portrait of *Dylan Thomas*.

Overleaf, above:
RICHARD WILSON
Pembroke Town and Castle
National Museum of Wales, Cardiff

Overleaf, below:
CLAUDE MONET
Rouen Cathedral, Sunset: Symphony In Grey and Rose
National Museum of Wales, Cardiff

Above:
AUGUSTUS JOHN
Dylan Thomas
National Museum of Wales, Cardiff

VINCENT VAN GOGH
Rain at Auvers
National Museum of Wales, Cardiff

Appropriately also a casting of Epstein's head of *Augustus John* is in the collection.

The museum owns an outstanding collection of nineteenth- and early twentieth-century French art, much of it given to the museum by Margaret and Gwendoline Davies, who began collecting in 1908, and had more or less completed their collection by 1924, though it did not come to Cardiff until 1952 and 1963, in two portions. They were very much ahead of their time, and in the 1920s theirs was the largest collection of its kind in the British Isles.

It includes wonderful examples by Berthe Morisot, *Femme et Enfant dans l'Herbe à Bougival,* Monet's *Rouen Cathedral, Sunset,* several of his studies of waterlilies, *Montagnes, L'Estaque* by Paul Cézanne, as well as a still life and other subjects. Daumier is represented too, as is Millet, and there are several of Rodin's sculptures.

The Cardiff Museum is a splendid building, but has been out-grown by its collections. An extension currently being built will increase its exhibition space by fifty per cent.

TREDEGAR HOUSE

The general character of the art collection at Tredegar, in Gwent, could by no means be termed outstanding. What is outstanding is the lavishness of the interior decoration of the house. This includes nine overmantel canvas paintings contemporary with the rebuilding of the house, which took place between 1664 and 1672, and a series of panel paintings, again dating from this same period, which constitute part of the fixed decoration of the grandest of the State Rooms—the Gilt Room. None of these paintings can be attributed to any known artist, but they are largely derived from mid-seventeenth-century Dutch engravings of contemporary paintings and sculpture.

The contents of Tredegar House, including paintings and sculpture, were dispersed in 1951, but a substantial number of paintings, about 44 portraits, and a few items of sculpture that were originally part of the Tredegar collection, have been acquired over the last few years. The paintings are for the most part family portraits ranging from the early seventeenth century through to the 1940s.

The collection of early seventeenth-century panel portraits is particularly interesting, especially from a costume and textile point of view, but again, very few are attributable to any particular artist and sitters cannot always be positively identified.

ERDDIG

From the early eighteenth century until the house passed to the National Trust in 1973, Erddig was owned by successive generations of the Yorke family, the male heir either Simon or Philip, and identified by number. It was Philip III who gave the house, near Wrexham in Clwyd, to the Trust. He and his predecessors recorded the affairs of both house and estate carefully, and commissioned portraits of their servants. The earliest of these is of a Negro coachboy who served John Mellor, an earlier owner, and uncle of the first Simon Yorke.

The best of these portraits, hanging in the Servants' Hall, date from the late eighteenth and early nineteenth centuries. They are large, primitive paintings, showing woodman, carpenter, gamekeeper, housemaid, with their tools and equipment, or about their work on the estate or in the house.

They provide a fascinating record of social history. Though there are portraits of servants in other houses, the series at Erddig is unusual in its completeness. Moreover, these portraits were painted as a record, and not

ANON.
Tom the Butcher and Publican
Erddig, Wales

because their subjects were notable individuals. Incorporated in the portraits are verses about the sitters by their masters, several of the Yorkes having been inveterate rhymers.

There are portraits of the Yorke family, notably the Gainsborough *Philip Yorke I* and *Elizabeth Yorke* by Cotes, which hang in the Dining Room.

LORD HERBERT OF CHERBURY
—— AND POWIS CASTLE (NT) ——

The collection at Powis Castle contains a superb example of the work of one of England's greatest miniaturists, Isaac Oliver. It is his full-length, reclining portrait of *Lord Herbert of Cherbury*, whose descendant, Henry Arthur Herbert, briefly revived the title in the mid-eighteenth century.

The First Baron Herbert was the quintessential Renaissance man, poet,

ISAAC OLIVER
Lord Herbert of Cherbury
Powis Castle, Wales

soldier, courtier, wit, philosopher and, in this portrait, the epitome of the melancholic, as presented in Robert Burton's *The Anatomy of Melancholy*.

Lord Herbert was the friend of John Donne and Ben Jonson. He acted as diplomat on a number of occasions.

Isaac Oliver, somewhat older than his sitter, came from Rouen as a child, was three times married, his second wife, Sarah, being the daughter of Susanna de Critz and Marcus Gheeraerts the Elder. His friends included late-sixteenth-century portrait painters John de Critz the Elder and Robert Peake. (There is also a Peake of Lord Herbert in the collection.) It placed him at the heart of Elizabethan and Jacobean portraiture, though he never really succeeded in displacing Nicholas Hilliard as the leading exponent of 'painting in little'.

Lord Herbert was frequently painted, and it is his record of sitting to William Larkin which provides the documentation for this artist's work at Charlecote (q.v.).

Powis Castle is richly decorated, with mural paintings by Lanscroon, and a ceiling by Verrio. A good collection of portraits hangs throughout the house. Apart from the Oliver, the outstanding painting in the Castle is Bernardo Bellotto's *A View of Verona from the Ponte Nuovo*, collected late in life by Clive of India, whose son, Edward, married the heiress to the Powis estates.

Above:
GWEN JOHN
Portrait of Winifred John
Tenby Museum, Wales

Right:
GRAHAM SUTHERLAND
Road at Porthclais with Setting Sun
Graham Sutherland Gallery,
Picton Castle, Wales

REX WHISTLER AT PLAS NEWYDD
(NT)

The Marquess of Anglesey's home, on the Menai Strait, in Gwynedd, is an impressive building with a good collection which includes a number of family portraits, military subjects, marine paintings, sporting pictures and landscapes. In addition, it contains Rex Whistler's finest *trompe-l'œil*, a mural, together with the best public collection of material by, and on, the artist, much of it lent by his younger brother, the poet and glass engraver Laurence Whistler.

Commissioned in 1936, the decoration took a year to complete, and is more extensive, accomplished and unified than either of the other great Whistler works, in the Tate Gallery restaurant and at Mottisfont. It is painted on one canvas 58 feet long. Much of the work is light-hearted pastiche, with family nuances reflecting his friendship with his patron.

Since the house is famous for its Whistler mural, it is perhaps appropriate to mention the works there by another mural artist of distinction, Laguerre. In the Staircase Hall hang a series of canvases depicting scenes from the Duke of Marlborough's campaigns, *modelli* for his murals at Marlborough House in London.

REX WHISTLER
Trompe-l'Oeil: The Dining Room
Plas Newydd, Wales

Fine Art in Scotland

The first thing you have to do is find out whether art can be encouraged or repressed . . . I should like you to enquire into the origin of art, and, facing that question boldly, I should like you to ask yourselves if you really believe that the cause of art can be advanced by collecting pictures, and presenting them to the nation.

George Moore

Scotland has its national collections of art in Edinburgh, its great civic collections, led by Glasgow, and certain individual treasure-houses such as the Burrell Collection. There are, in addition, university collections, of which the most notable, the Hunterian, is also in Glasgow.

Outside the uneasy fine art rivalries between Edinburgh and Glasgow, the main art gallery collections are in Aberdeen and Dundee, then Perth; more limited collections are to be found in Kirkcaldy, the Dick Institute in Kilmarnock, Arbroath, Montrose, and on the Island of Orkney, in the Pier Arts Centre in Stromness.

The National Trust for Scotland has extensive fine art holdings in its many properties and maintains also the Georgian House in Edinburgh, furnished as a late eighteenth-century period house. The City of Edinburgh has a much earlier period house in Canongate; called Huntly House, it is sixteenth century, and contains portraits and topographical works. There are more literary associations at Lady Stair's House, which has memorabilia, including portraits, of Scott, Stevenson and Burns.

More splendid than either of these is Pollok House, in Glasgow, also a branch of the city's museums and art galleries, but famous above all for a single collection of mainly Spanish paintings, formed in the mid-nineteenth century by Sir William Stirling Maxwell, an authority on Spanish art. The collection was given to the City of Glasgow in 1967 by his granddaughter. In both quality and extent it is to be compared with the fine collection at the Bowes Museum, at Barnard Castle, in County Durham, the other notable British collection, outside the National Gallery, of Spanish art.

Similar houses elsewhere in Scotland are managed by local authorities, including Mary Queen of Scots' House, in Jedburgh, which belongs to the Roxburgh District Council, and Broughton House, the home of the Scottish painter Edward Atkinson Hornel, which is run by a trust.

Twentieth-century collections associated with single artists include the William Lamb Memorial Studio, in Montrose, and the much more modern Stonypath, created as an extensive art gallery in a garden by Ian Hamilton Finlay. Hopetoun House, in South Queensferry, on the outskirts of Edinburgh, is also managed by its own preservation trust.

Some of the royal palaces are also jointly managed, among them Falkland Palace, which the National Trust manages for the Queen.

Scottish art of all periods has been energetically collected by art galleries and museums, and by private collectors, among whom must be numbered many of the greatest benefactors of galleries in Scotland.

Apart from a strong tradition in portrait painting, beginning with George Jamesone, and reaching its highest expression in the works of Raeburn and Ramsay, Scotland's most notable contribution to fine art came towards the end of the nineteenth century. In a succession of variously named schools and groupings, Scottish painters exercised a formidable influence on art in these islands generally.

NATIONAL GALLERY OF
SCOTLAND

The National Gallery of Scotland derived from three main sources. The first of these was the Board of Manufactures, formed in 1727 to administer Scotland's annuity under the Treaty of Union and the

JACOPO BASSANO
The Adoration of the Kings
National Gallery of Scotland
Edinburgh

DIEGO VELÁZQUEZ
An Old Woman Frying Eggs
National Gallery of Scotland,
Edinburgh

Revenue of Scotland Act of 1718. The Board had built the Royal Institution, which in turn had become a repository for an art collection as well as renting exhibition rooms to the Royal Scottish Academy, the second main source for the gallery, and responsible for its first nucleus of Scottish art. The third was the collection which had been bequeathed to the College of Edinburgh by Sir James Erskine of Torrie, in 1835, and which was passed to the Board of Manufactures ten years later.

By an 1850 Act of Parliament the gallery was founded, and the Prince Consort laid the foundation stone for the building in August of that year. It was designed by William Henry Playfair and completed in 1857. It is one of Edinburgh's finest classical buildings.

It opened in 1859, and management was vested in the Board of Manufactures. As with the National Gallery in London, the building had a dual purpose; it was designed to house the art collections from the various sources indicated, and it was also the home of the Royal Scottish Academy.

The gallery received no purchase grant until 1906, so that its early development was almost entirely dependent on gifts and bequests. Its early works cannot be described as outstanding, and it is relatively recently that the gallery's collections have been raised to the high quality they now undoubtedly possess. This was in part due to the loan of the Duke of Sutherland's pictures.

The lovely *Adoration of the Kings* by Bassano is one of the Royal Scottish Academy pictures, acquired by the academy in 1856, though not formally handed over to the gallery until 1910.

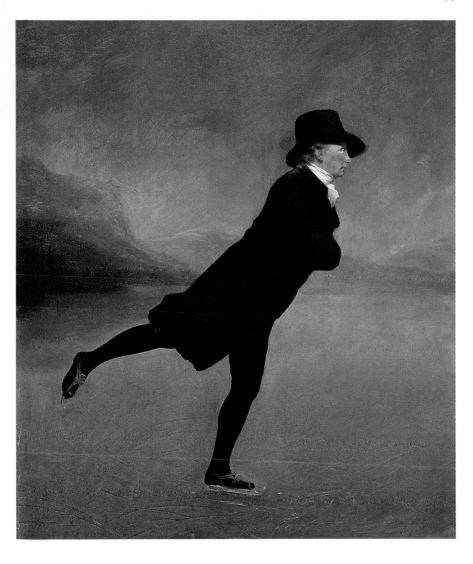

HENRY RAEBURN
The Reverend Robert Walker Skating
on Duddingston Loch
National Gallery of Scotland
Edinburgh

The gallery's strength, across a broad range of schools, can be indicated by the fact that it has an early Vermeer, one of only six in these islands, a splendid early Velázquez, *An Old Woman Frying Eggs*, two fine examples of Watteau's work, particularly his *Fêtes Vénitiennes*, Rembrandt's *Woman in Bed*, a portrait of *Geertje Dircx*, and a fine, late *Self-Portrait*, works by Raphael which are part of the magnificent group of paintings lent to the gallery by the Duke of Sutherland, which also include important Poussins and Titians, and a good collection of French works, many from the Maitland gift. On loan from Her Majesty The Queen is *The Trinity Altarpiece* by Hugo van der Goes.

The gallery is rich in works by Scottish artists, perhaps the most famous being Raeburn's *Reverend Robert Walker Skating on Duddingston Loch*. It has several by Allan Ramsay, including his very delicate portrait of his second wife, Margaret, with whom the artist eloped.

SCOTTISH NATIONAL PORTRAIT
— GALLERY —

The Scottish National Portrait Gallery was founded in 1882. Half of its endowment fund, £10,000, was given by John Ritchie Findlay, a newspaper proprietor who owned the *Scotsman*, and was a considerable public benefactor. He was a graduate of Edinburgh University. He offered the money anonymously, on the condition that the Government would provide the same amount. He went on to give a further £50,000 for the building, designed by Rowland Anderson.

Between the decision to start the collection, and the building of the gallery, two loan exhibitions of portraits were organised, in 1883 and 1884, and these were followed by gifts and bequests which gave an early impetus to the formation of the collection.

WILLIAM DOBSON
Charles II
Scottish National Portrait Gallery,
Edinburgh

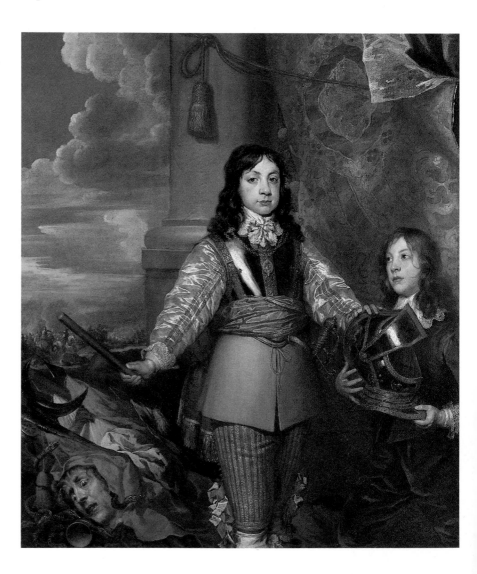

The collection is, naturally enough, mainly of Scottish subjects, and equally naturally this produces a strong emphasis on Scottish artists. But the earlier works in the collection tend to be undistinguished in their authorship. Sixteenth-century works include *Mary, Queen of Scots* attributed to Peter Oudry, and *Mary of Lorraine*, her mother and wife to James V, is attributed to Frans Pourbus.

The earliest Scottish portrait painter of note, George Jamesone, is represented by several works, including *William Drummond of Hawthornden* and *The Duke of Argyll*. Michael Wright, who was believed to have been apprenticed to Jamesone, is represented.

One of the finest seventeenth-century works in the collection is William Dobson's portrait of *Charles II when Prince of Wales*, a splendidly rich and dramatic example of the artist's work, and his most important royal commission, thought to have been painted to commemorate the prince's participation in the Battle of Edgehill. It once belonged to Grinling Gibbons, and was acquired by the Gallery in 1934.

There are interesting portraits of Scottish writers and artists, the latter grouping augmented by numerous self-portraits, among them works by McTaggart, Peploe, Runciman and Grant. Allan Ramsay's powerful, full face study of *David Hume*, Henry Raeburn's sensitive and serious portrait of the older *Walter Scott*, Alexander Nasmyth's *Robert Burns* and a fine full-length of *Sir David Wilkie* by Andrew Geddes are more notable studies of Scotland's creative genius.

ALEXANDER NASMYTH
Robert Burns
Scottish National Portrait Gallery,
Edinburgh

HENRY RAEBURN
Walter Scott
Scottish National Portrait Gallery
Edinburgh

SCOTTISH NATIONAL GALLERY OF MODERN ART

The Scottish modern collection began as a transfer of twentieth-century works of art from the National Gallery of Scotland, and was initially designated as the Department of Twentieth Century Art when it opened, in Inverleith House, in 1960. It was mainly dependent then on Scottish work, though Kokoschka's *High Summer* was already part of the National Gallery's holding, having been given to Scotland by the Government-in-Exile of Czechoslovakia, in 1942. Paul Klee's *Threatening Snowstorm* was also one of the transferred works.

From 1959 the Scottish National Gallery of Modern Art has had its own purchasing grant, and it has been built up steadily to include representative examples of European, American and British art of this century. It is strong in the German Expressionists, with good examples of Nolde and Jawlensky, and there are works by Matisse, Picasso, Derain, Léger, Gris and the Russian Constructivists.

In 1967 the R. R. Scott Hay Bequest of 43 paintings and watercolours, mainly of Edinburgh School artists, greatly strengthened the national part of the collection. There has also been careful and steady attention to modern British art, which is well covered.

Among American works Lichtenstein's *In the Car* stands out.

PAUL KLEE
Threatening Snowstorm
Scottish National Gallery of
Modern Art, Edinburgh

OSKAR KOKOSCHKA; *High Summer;* Scottish National Gallery of Modern Art,
Edinburgh

ROY LICHTENSTEIN; *In the Car;* Scottish National Gallery of Modern Art, Edinburgh

OTHER EDINBURGH
GALLERIES

There is an Edinburgh collection, in the City Art Centre, more than somewhat overshadowed by the three great Scottish national collections. It is primarily topographical and historical, but the Scottish Modern Arts Association made a gift of paintings to the city in 1964, and these works are a substantial asset. Mainly of the Glasgow School and Scottish Colourists, they include *Poppies* by George Henry, *The Blue Hat, Closerie des Lilas, 1909* by J. D. Fergusson, and works by McTaggart, Pringle and Gunn.

Though it does not compare with the great university collections, or rival the Glasgow University Hunterian Art Gallery, the city has, in the Talbot Rice Arts Centre, an interesting collection of seventeenth-century Dutch painting, including works by Pynacker, Teniers and Van de Velde. Modern Scottish art is also included in the collection.

The Royal Scottish Museum, which is housed in a splendid example of Victorian Gothick architecture, has a stimulating collection of Oriental, Classical, Byzantine, Egyptian and Medieval sculpture. It is primarily a decorative art museum, however, though its diversity flows over and embraces the fine arts in most of its departments.

ANNE REDPATH
Black and White Checks
City Art Centre, Edinburgh

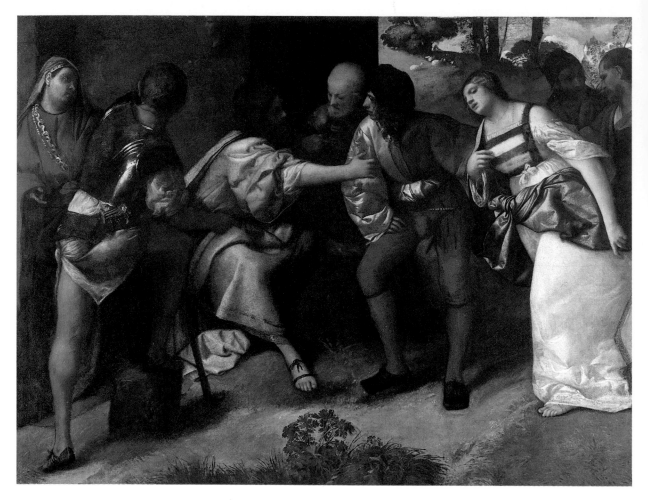

GIORGIONE
Woman Taken in Adultery
Glasgow Art Gallery and Museum,
Scotland

GLASGOW ART
GALLERY

The Glasgow Art Gallery and Museum's collections preceded the existence of the gallery itself by an embarrassing period of time, as did the whole idea for a collection of works of art for the people of the city. Glasgow was the first city in the British Isles to have an Academy of Art, which existed from 1761 to 1775, and which had a collection of paintings. It came to grief however, long before civic efforts were applied to the creation of a museum and art gallery.

It was not until the mid-nineteenth century that Archibald McLellan's scheme for housing his own collection of paintings resulted in a public gallery, known as the McLellan Galleries, but owned by Glasgow Council, which paid £44,500 for it, though with some reluctance. In due course a public competition led to the building of a new gallery, which was opened in 1902.

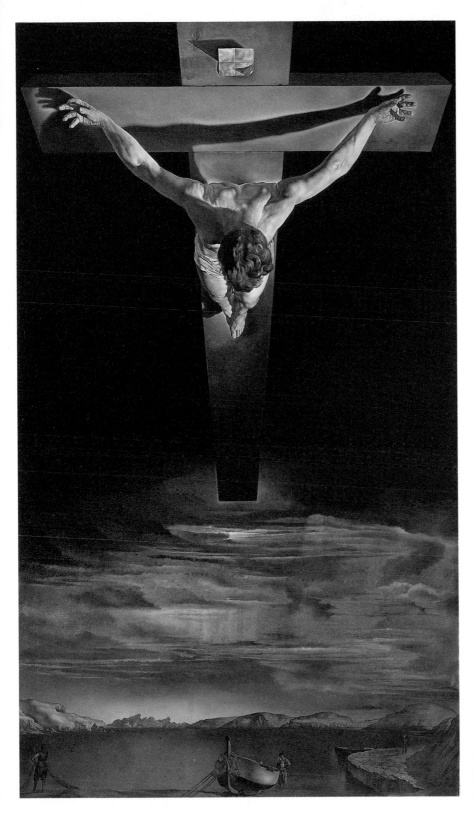

SALVADOR DALI
Christ of St John of the Cross
Glasgow Art Gallery and Museum,
Scotland

The Glasgow Art Gallery has several branch museums, including Pollok House and the Burrell Collection (q.v.), given to Glasgow in 1944, but not housed and made available to the public until 1983.

The main art gallery has good Venetian and Florentine paintings, including an important work from the former group by Giorgione, *Woman Taken in Adultery*, and from the latter Filippino Lippi's *Madonna and Child with the Infant St John*.

The gallery is strong in Dutch art, with works by Cuyp and Ruisdael, and with an excellent Rembrandt, *Man in Armour*, and *The Carcase of an Ox*, by Fabrituis.

There are comprehensive collections of French and English art, strong in eighteenth- and nineteenth-century works, and Scottish art is fully covered in the collection, particularly the Glasgow School and the Scottish Colourists. Glasgow has its proportion of Pre-Raphaelite works.

Over-exposed in every sense of the word is the gallery's most famous and most popular painting, Dali's *Christ of St John of the Cross*. Glasgow also owns Augustus John's portrait of *William Butler Yeats*, and Whistler's of *Thomas Carlyle*, at the first sitting for which Carlyle instructed the artist: 'And now, man, fire away; if ye're fighting battles or painting pictures, the only thing to do is fire away.'

—— THE BURRELL COLLECTION ——

The Burrell Collection is of enormous interest for what it tells us about collecting habits over the first half of the twentieth century. It is Scotland's greatest one-man collection, rivalling in this Lord Leverhulme's in Port Sunlight, and the Wallace Collection in London (qq.v.).

Sir William Burrell was born into a shipping family in Glasgow in 1861. The established source of that wealth, at the time of Burrell's birth, was confined to inland canal shipping; but he grew up during a period of great expansion, and the extent of the operation, by the time he took over management with his brother, George, in 1885, was sufficient to include ocean-going liners and a worldwide tramping business.

Well before the end of the century, Burrell was an established Glasgow collector, one of a group of discriminating buyers who dealt with, among others, an equally shrewd dealer, Alexander Reid. 'He did more than any other man has ever done', Burrell said of him, 'to introduce fine pictures to Scotland and to create a love of art.'

By 1901, when the second Glasgow International Exhibition was held, Burrell was a substantial source for loans, providing more than 200 works, which indicate the vast range of his collecting, and show his interests, as far as painting was concerned, to have been those very much of the period: Maris, Couture, Géricault, Monticelli and Jongkind. In addition, he owned works by Manet and Daumier, and was shortly to acquire works by Degas.

Burrell sold works as well, so that a comprehensive view of the development of his taste is not always possible. But from 1911 until the

EL GRECO
A Lady in a Fur Wrap
Pollok House, Glasgow

year before his death in 1958, he kept in school exercise books detailed records of his purchases, and they provide an invaluable insight into his acquisitions, showing the rising graph of expenditure, the areas of specialisation, and the impressive totals. On average, £20,000 a year was spent between 1911 and 1957. In 1936 the total reached £80,000; in 1948, £60,000.

It was in the period between 1930 and the war that he resolved to give his collection to Glasgow, and the decision was made formal in 1944. It was followed with the gift of £450,000 for a building to house the collection, which by the end of the war numbered more than 6,000 items, and this was accompanied by conditions which included the stipulation that it should not be less than sixteen miles from central Glasgow. Burrell, quite properly, feared the city pollution, which was then extensive. He did not foresee the changes which would render that particular problem largely a thing of the past. The gift to Glasgow of another fine collection at Pollok House provided the estate in which the Burrell Collection would find its home.

The decision having been made, Burrell then took a considerable interest in recalling works which had been on loan, and in adding quite extensively to what he had given.

When the Burrell Collection opened to the public, in 1983, it was received with all the usual superlatives, which swamped what should have contained at least a little righteous indignation at the many years which had elapsed since the making of the gift.

In his introduction to the splendid catalogue, John Julius Norwich claims: 'let there be no mistake about it: in all history, no municipality has ever received from one of its native sons a gift of such munificence . . .' The claim has an extravagant ring to it. Examples in this book tend to show that native sons meet with indifference, obstruction and hostility on the whole, a small share of which went Burrell's way. In his case, he was stubborn enough to stay with Glasgow. Others, equally generous, spread their gifts abroad.

The facts should not, however, be allowed to take from the quality of what Sir William and Lady Burrell gave to Glasgow, though it is possible to argue against the separation of certain masterpieces from the broader range of related works. This applies, of course, generally to everything in the Burrell Collection, which has become an entity on its own, having for forty years contributed to the wider aspects of the main art gallery.

The collection is exceptionally varied. Its particular character, which includes ceramics, glass, silver, and tapestry, puts something of a strain on the dividing line which has been applied throughout this Art Atlas. And the sheer quality of such divisions as the medieval art, second only in importance to the holdings of the Victoria and Albert Museum, deserves special emphasis.

The paintings in the Burrell Collection are worth considering from two points of view. In terms of quality, Burrell had a shrewd eye and the resources to match his discrimination. He was buying against much wealthier men than himself, in a market which was highly active, and where the range was immense. This brings one to the second point of

GIOVANNI BELLINI
Virgin and Child
Burrell Collection, Scotland

view, Burrell's actual taste in art. The late nineteenth century had seen the rise in popularity of Dutch art, and this is reflected in certain works, just as it is in collections as diversely located as the Beit Collection, at Russborough, and the Wernher Collection at Luton Hoo (qq.v.). In part, it was the result of the market in Italian art running dry. Later Italian paintings were available, and it is interesting that Burrell should have bought such a lovely Bellini as the *Virgin and Child*. Also outstanding, as purchases from the fifteenth or early sixteenth centuries, are the Lucas Cranach *The Stag Hunt*, and *The Annunciation* by Hans Memling.

Also reflective of late nineteenth- and early twentieth-century taste was his interest in the Hague School, and in such French artists as Couture, Géricault, Delacroix, Fantin-Latour, Daumier and Millet. Even Chardin was a possible artist for the collector eighty years ago.

This is not to disparage the presence in the Burrell Collection of such lovely works as the Chardin *Still Life*, *The Dog*, by Oudry, and Géricault's *Prancing Grey Horse*. With the progress through the twentieth-century years of collecting, the development of these interests and the acquisition of such masterly works as *The Rehearsal*, *Edmond Duranty* and *Jockeys in the Rain* by Degas, the fine Cézanne, *The Château de Médan*, chart the evolution of collecting itself.

—— HUNTERIAN ART GALLERY ——

Opposite:
JAMES GUTHRIE
To Pastures New
Aberdeen Art Gallery, Scotland

JEAN BAPTISTE SIMÉON
CHARDIN
The Scullery Maid
Hunterian Art Gallery, Glasgow

Glasgow University is the fourth oldest in these islands. Among its distinguished students was Adam Smith, whose *Wealth of Nations* contributed in no small measure to the climate as well as the conflict in which private and State enterprise struggled for the next hundred years. This had a modest effect on collections and on art galleries.

We have already seen how the city tried, and failed, to establish an effective academy for artists with a collection of paintings. In that venture were involved the Foulis brothers, printers to the university. Their huge collection, which they believed to include something like 38 Raphaels, 21 Titians and eight Rembrandts, was sold eventually at Christie's for a total of just £398.

While this delayed the foundation of the Glasgow Art Gallery for eighty years, it occurred less than ten years before the death of another eminent Glaswegian, William Hunter, who bequeathed to his university his magnificent collection of Old Masters. Hunter was a medical man, and Professor of Anatomy at the Royal Academy. At a time when there was no fashion for it, he collected Chardin's work, and the three in the Hunterian Museum are among its chief glories, particularly *The Cellar Boy* and *The Scullery Maid*.

Hunter's gift also included a fine Rembrandt, not dissimilar in its light from the small Dublin *Rest on the Flight into Egypt*, as well as works by Reynolds and Stubbs, both of whom were Hunter's friends.

The collection changed little in the next century and a half, but in 1935 and 1958 it received groups of paintings by James McNeill Whistler, on whom the University had conferred an honorary degree in 1903.

Further twentieth-century gifts strengthened the collection's holdings in Scottish paintings, and in the works of later French and English artists.

In 1946, through the family of one of Charles Rennie Mackintosh's major patrons, William Davidson, the University received the original contents of Mackintosh's Glasgow house. At the same time, Sylvan MacNair, the architect's nephew, presented Mackintosh's estate of drawings, designs and archival material to the University. These two gifts established the largest single holding of Mackintosh's work anywhere.

Thanks largely to the gifts this century from Dr J. A. McCallum and the bequest of Professor W. R. Scott, the Gallery has the most extensive print collection in Scotland spanning the fifteenth century to the present day. All the major masters are represented from Mantegna and Dürer to Picasso and leading living printmakers.

Above:
JAMES McNEILL WHISTLER
Red and Black: The Fan
Hunterian Art Gallery, Glasgow

——— ABERDEEN ART GALLERY ———

The Aberdeen Art Gallery was built in 1885, but initially for local and industrial exhibitions. It did not have a collection of its own until later, with the most important early bequest coming from Alexander Macdonald.

Macdonald was a local businessman, a granite merchant, who died in 1884, before the Gallery was built, having collected most of his pictures from living artists. In his will he provided that his own collection

JAMES COWIE
Two Schoolgirls
Aberdeen Art Gallery, Aberdeen

HENRI DE TOULOUSE-
LAUTREC
Charles Conder
Aberdeen Art Gallery, Scotland

should pass to the Gallery, but in addition he included funds to purchase works of art. He stipulated that such purchases should be of works painted within the previous twenty-five-year period. 'I purchased all my pictures direct from the artists, and . . . doing so was the avenue to much pleasant intercourse and association.'

His collection did not go to the Gallery until 1901, on the death of his widow. By then some works had been acquired, but Macdonald's paintings, together with those acquired as a result of the funds he left to the Gallery, are largely responsible for its outstanding holdings of Victorian and Edwardian art.

Another important donor was Sir James Murray, who became chairman of the Art Gallery Committee, and, among other works, gave to Aberdeen the Lavery masterpiece *The Tennis Party*. He also gave money towards the purchase of Monet's *La Falaise à Fécamp*.

The watercolour collection is a good one, and to it there came important additions when, in 1921, Alexander Webster, a lawyer, left his collection, together with purchasing funds. With the money, Samuel Palmer's *Harvesting* and Michael Angelo Rooker's *Cast Iron Bridge* were bought. Outstanding additional works include William Blake's *The Raising of Lazarus*. There are also four superb Turner watercolours.

The Gallery has received generous public gifts, its Francis Bacon *Pope—Study After Velázquez* coming from the Contemporary Art Society, and other gifts being supported by the National Art-Collections Fund and the Government's Local Museums Purchase Fund, under the administration of the National Gallery of Scotland.

The collection, which celebrated its centenary in 1985, is a splendid representation of British art over three centuries. Balanced, vigorous, with a good regional spread, and containing a number of masterpieces, the Gallery is one of Scotland's finest.

——— McMANUS GALLERIES ———

The Dundee City Art Gallery opened in 1873. It was an extension of the Albert Institute. The Albert Institute's purpose was the promotion of literature, science and art. It was named in memory of the Prince Consort, who had died in 1861, and was founded the following year. It bought the land on which the City Art Gallery was eventually to stand, and its initial purpose was to provide library facilities. The Institute was built and open by 1867, when it was handed over to the city. That year the British Association met in Dundee, and a large art exhibition was held.

Further extensions followed. Between 1871 and 1873 a new 'permanent' art gallery was built and opened, and in 1887 the Victoria Galleries were

FRANCIS CAMPBELL
BOILEAU CADELL
Still Life
Dundee Art Gallery, Scotland

ALFRED MUNNINGS
The Poppy Field
Dundee Art Gallery, Scotland

added to commemorate Queen Victoria's Jubilee. For this, £100,000 was donated by John M. Keiller.

In 1978 the library was moved out, and an extensive reconstruction took place, completed in 1983, providing a number of new galleries.

The collection is predominantly Scottish. Bequests are responsible for many of the more important works, beginning with the George Duncan Bequest in 1878. In 1896 John Morris left £3,400 for the purchase of paintings, though the money was left unused for several years.

It was not until 1949 that the Gallery had a full-time curator, and not until 1968 that a keeper of the art collection was appointed.

Among eighteenth-century works of interest are John Crichton's portrait of *John Zephaniah Bell*, Allan Ramsay's of *Edward Harvey*, and Horemans's *Killing a Pig*. Among nineteenth-century works are many topographical paintings and drawings of Dundee and its environs. Twentieth-century British painting includes examples of Sickert, Spencer, Lavery, Park, Crawhall and Cadell.

In recent years there has been a strong emphasis on the acquisition of contemporary Scottish art, which now forms a major part of the collection. Works by younger artists, as well as more established figures, such as Sir Robert Philipson, Elizabeth Blackadder, Alberto Morrocco and Will McLean, are to be seen.

In 1980 the Orchar Art Gallery, at Broughty Ferry, was closed, and, after a good deal of controversy, the fine collection there passed in 1987 to the McManus Galleries. It consists of over 400 oils, watercolours and

prints, and 45 of the oil paintings are to be on permanent exhibition in the Victoria Galleries. The works make up the largest single collection of works by the Scott Lauder Group, including 26 by William McTaggart, among them his superb *All the Choral Waters Sang*.

BUCCLEUCH COLLECTION AT BOWHILL AND DRUMLANRIG

The Duke's art collections are contained in three houses open to the public, two of them in Scotland, and the third, Boughton House, in Northamptonshire. The overall collection rivals any in these islands. It represents the combined heritage of the Scott, Douglas and Montagu families, involving originally three dukedoms. The present head of the family is the Ninth Duke of Buccleuch.

The amalgamation of the families and titles is complicated, the Scott succession passing through the female line when the heiress to the estates married the ill-fated natural son of Charles II, James, whose titles included two dukedoms, of Monmouth and Buccleuch, as well as the earldom of Dalkeith. Though he was executed in 1685 after his unsuccessful rebellion against James II, her titles and estates were not attainted, and passed in due course to her great-great-grandson, the Third Duke of Buccleuch. Apart from her, the Scott succession, since the eleventh century and through some thirty generations, has passed from father to son. The Third Duke married the eventual heiress of Boughton, Lady Elizabeth Montagu, whose portraits by Reynolds are at Drumlanrig Castle and Bowhill. Her great-grandfather, the First Duke of Montagu, was a patron and collector.

Henry, the Third Duke, inherited through his mother and aunt, daughters of the Duke of Argyll, further properties and possessions.

Bowhill has associations with *Sir Walter Scott*, whose portrait by Henry Raeburn shows him seated, his dog, 'Camp', at his feet. He was a kinsman. Dogs feature in two other appealing and popular works. The first of these is the supremely enchanting child portrait done by Sir Joshua Reynolds, and entitled *Winter*. It is of Lady Caroline Scott, sister of Charles, Earl of Dalkeith, later the Fourth Duke, whose portrait by Reynolds hangs on the same wall. Their father, Henry, was painted by Gainsborough. She had just arrived for her sitting, in muff and hat, her cheeks scarlet with the cold, and was so painted. *The Pink Boy*, also by Reynolds, is in the collection.

There are fine works by Venetian painters in the house, including one of Canaletto's London masterpieces, his *View of Whitehall, showing Downing Street and Montagu House, and a Distant Prospect of Saint Paul's Cathedral*. It hangs in the Dining Room, with eight splendid works by Guardi, the *Interior of the Pantheon in Rome* by Panini, and views in Naples and the south of Italy, by Antonio Joli, adorn the Italian Rooms.

JOSHUA REYNOLDS
Winter
Bowhill, Scotland

PAUL SANDBY
Windsor Castle
Drumlanrig, Scotland

REMBRANDT
Old Woman Reading
Drumlanrig, Scotland

The collection is extensive and varied. The Duke of Buccleuch has an outstanding collection of miniatures, one of the largest and finest in the world, with works of all the principal miniature painters, including Nicholas Hilliard's *Queen Elizabeth I*, Hans Holbein's *Catherine Howard*, work by Holbein's teacher, Horenbout, *Mary I* by Hans Eworth, and the splendid, prototype and therefore unfinished, head of *Oliver Cromwell* by Samuel Cooper.

Samuel Cooper, 'commonly stil'd the Van Dyck in little', according to John Aubrey, did many versions of Cromwell's head, and this is regarded as his source study. Horace Walpole said of it: 'If a glass could expand Cooper's pictures to the size of Van Dyck's they would appear to have been painted for that proportion. If his portrait of Cromwell could be so enlarged I don't know but Van Dyck would appear less great by the comparison.' Of Cooper's work alone the Duke owns more than twenty miniatures.

A substantial collection of family portraits records the interrelationships of families, combining the dukedoms of Buccleuch and Queensberry, the families of Scott, Douglas and Montagu.

For those interested in art, Walter Scott's sobriquet, 'Sweet Bowhill', is eminently appropriate.

Drumlanrig Castle is beautifully situated in south-western Scotland. It contains further treasures of the collection, parts of which are also available to the public at the third home, in England, Boughton House, in Northamptonshire.

Drumlanrig Castle is late seventeenth century, a palace rather than a castle, combining Gothic and Renaissance styles, both inside and out. Its dignified exterior combines austere Palladian elements with the graceful curves of the double staircase rising from the forecourt.

Rembrandt's *Old Woman Reading*, painted in 1655, hangs in the Staircase Hall, the glow of light emanating from the pages of the book in which she is so engrossed. The painting has been in the Buccleuch collection since 1750.

HANS HOLBEIN
Sir Nicholas Carew
Drumlanrig, Scotland

Near to the Rembrandt, at the foot of the stairs, is Holbein's *Sir Nicholas Carew*. Carew was a courtier of Henry VIII and received numerous honours and positions, including being made Master of the Horse. He carried out several diplomatic missions, but became involved in the Marquess of Exeter's treason, and was beheaded. *The Madonna with the Yarnwinder*, attributed to Leonardo da Vinci 'and to associates' by some, and definitely described as such by Kenneth Clark and confirmed by Professor Kemp's spectrography in 1986, faces the table. The painting of such a picture by the artist is the subject of an eye-witness account, though its acquisition is a mystery. There are also works by Claude, Jacob van Ruisdael and Annibale Carracci.

Like Erddig, in Wales, Drumlanrig contains an interesting series of portraits of the Buccleuch household. They were painted by John Ainslie during the time of the Fourth and Fifth Dukes of Buccleuch, and include one aged retainer of 113 years, Signor Giustinelli, as well as the castle chef, Joseph Florence, much admired by Walter Scott.

HOPETOUN HOUSE

GIULIO CESARE
PROCACCINI
William, Second Marquis of Annandale
Hopetoun House, Edinburgh

The earliest paintings at Hopetoun House are part of the decoration, and add to the outstanding architecture and furniture. They are the 37 overdoor paintings by the Dutch artist Philip Tideman. They were commissioned in 1702, and represented the most complete series of moralistic baroque decorative paintings to have been provided for any house in these islands.

In 1984 the original early eighteenth-century ceiling painting on the cupola of the stairwell (painted 1700-1710) was discovered and restored. This work, designed to tie in with the Tideman canvases that were beneath, represents the *Apotheosis of the Hope Family*, with scenes from the Labours of Hercules and the story of Troy. The authorship of the painting is not clear, but the idea and the composition are very much in agreement with contemporary Dutch practice, for example in the decorative work of de Witt, and recall the exhortations of Tideman's master, Gerard de Lairesse. It is, however, extremely improbable that it is by Tideman himself, since the painting is directly on the cupola plaster, and Tideman is not recorded as ever having left Holland. The discovery is considered to be of great significance in the art world, being the only major ceiling painting of the baroque period in any Scottish home.

The second group of paintings came to the house in 1730 on the death of the 2nd Marquess of Annandale, brother-in-law of the 1st Earl of Hopetoun. A noted connoisseur of the arts, he brought back from his travels to Italy over 300 paintings, some of which are on view in the public rooms.

The third part of the collection consists of family purchases, some as a result of Grand Tours undertaken by the young men of the family. Portraits are on view by Nathaniel Dance, including his interesting conversation piece of 1763, commissioned by two of the family as a gift for their tutor who had accompanied them. He is shown with the young men against a background which includes St Peter's, Rome, and a vase from the Borghese gardens. The Hope family recently bought back this picture, which was one of those selected for the 1986 'Treasure Houses of Britain' exhibition in the National Gallery of Art in Washington, DC as being a typical representation of the period. Another family purchase on view is a Teniers *Temptation of St Anthony*.

In the 1820s, the fourth alteration to the collection occurred, and that a major one. Andrew Wilson, Edinburgh art dealer and member of the Scottish Academy, was commissioned to advise on the paintings, resulting in about forty being sold, and others purchased to form what was his own personal idea of a balanced selection. Mistakes were made; for example, the Scottish artist Gavin Hamilton's *Oath of the Brutii on the Death of Lucretia*, which may now be seen on the staircase of the Theatre Royal, Drury Lane, once hung in Hopetoun. Wilson was given authority to travel to Genoa, where the wealthy Spinola family, following the Napoleonic Wars, had been obliged to sell some of the contents of their palace. From there came a massive Rubens studio painting, the *Adoration of the Shepherds*, engraved in 1620, another by Bernardino Lucinio of *Venetian Nobleman*

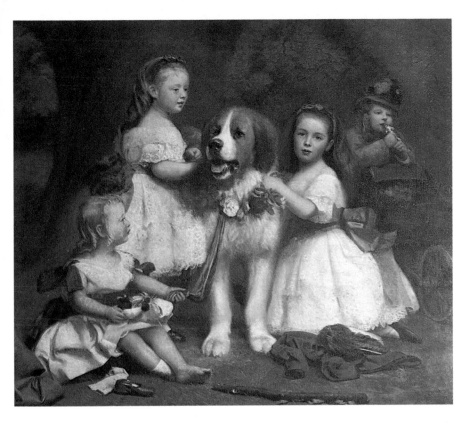

CHARLES LUTYENS
Sir William Miller's Children and their dog 'Lion'

EDWARD ATKINSON HORNEL
Seashore Roses
Kirkcaldy Museum and Art Gallery, Scotland

THOMAS FAED
A Lowland Lassie
Kirkcaldy Museum and Art Gallery, Scotland

Hunting and a portrait of the Doge of Venice, *Marcantonio Memmo*, painted by Jacopo Palma, and other works. Back in London, he acquired Dutch portraits and seascapes, including those by Koninck, Verbruggen and Backhuysen.

There is a good collection of family portraits.

BRODICK CASTLE
(NTS)

Brodick Castle houses a superb collection, a large portion of which was acquired by William Beckford, the early-nineteenth-century connoisseur. It has been augmented by the Dukes of Hamilton and the Earls of Rochford.

Beckford's younger daughter, Susan Euphemia, married the Tenth Duke of Hamilton. She was co-heiress of the Beckford Collection, or such of it as remained after the Fonthill Sale, and paintings which belonged to him, as well as other works of art, are in the castle. The Fonthill connection is reflected in Turner's watercolour of the Gothic house, now regrettably gone, and Gainsborough's landscape sketches, which also came from Fonthill.

It was not the only prudent marriage. Their son William, who became the Eleventh Duke, married Princess Marie of Baden, daughter of the Grand Duke of Baden, extending both the family relationships and the inheritance.

JOHN FREDERICK
HERRING (Senior)
The Dirtiest Derby in History
Brodick Castle, Scotland

The considerable interest which the Dukes of Hamilton had in sport—they are referred to as being much in the company of 'heavy swells', pugilists, gamblers and racing men—is responsible for the good sporting pictures at Brodick Castle. Most notable of these, perhaps, is *The Dirtiest Derby in History*, by J. F. Herring (Senior).

The collection has interesting eighteenth-century French paintings, including works by Watteau, and a much earlier Clouet, once in Charles I's collection, and bearing the royal cipher.

FYVIE CASTLE

The fine art collection at Fyvie Castle is dominated by the magnificent Pompeo Batoni portrait of *Colonel William Gordon of Fyvie*, full length in Highland dress, and holding his splendid sword (still at the castle). Though he was responsible for much rebuilding work at Fyvie, he did not add to the fine art.

Essentially, the collection belongs to the late nineteenth century, and was assembled by the millionaire steel magnate Alexander Forbes-Leith, Lord Leith of Fyvie, founder of the Illinois Steel Company, the largest in the world at the time, who bought the castle in 1889, and filled it with exceptional works of art, many supplied through the London firm of Thomas Agnew. Forbes-Leith was born near Fyvie, and was able to buy many genuine family portraits, which he loved and held on to. He treated his less personal acquisitions a bit like stocks and shares, consulting his dealer about buying and selling, and under financial pressures sometimes disposing of great works, among them Gainsborough's *The Countess of Sussex and her Niece.*

The collection, nevertheless, still contains a splendid cross-section of what was most popular at the close of the nineteenth century—portraits by the best Scottish and English artists from Gainsborough to Luke Fildes.

Among the finest are Henry Raeburn's *Isabella MacLeod, Mrs James Gregory*, one of an extensive series by the artist in the collection, and works by Reynolds, Lawrence, Hoppner, and Nathaniel Dance.

CAWDOR CASTLE

The collection at Cawdor Castle is notable for its fine series of portraits of members of the family by Francis Cotes, a formidable rival, in his day, to Joshua Reynolds, and shown to excellent advantage by these paintings. Those of the men tend to be 'official', in the sense of showing them in formal robes, *John Campbell-Hooke* as Lyon King of Arms, *Pryse Campbell* in Highland dress, *Alexander Campbell* in military dress, holding a pike. The women are painted with care and perception.

The great collector was John Campbell, born in 1755, and the subject of a magnificent Reynolds full-length, showing its subject with arm outstretched pointing, at his feet a dog with upturned head. Campbell,

JOSHUA REYNOLDS
John Campbell
Cawdor Castle, Scotland

under the influence of the great connoisseur and guide in the extensive eighteenth-century business of Grand Tour collecting, Charles Greville, acquired numerous works of art, filling both his London house and a private museum adjacent to it with antiquities and paintings. All had to be sold, however, including works by Cuyp, Andrea del Sarto, and Masaccio, whose two predella panels are now respectively at Liverpool and Polesden Lacey.

Campbell was married to Caroline Howard, the daughter of another great collector, the Fifth Earl of Carlisle, and grand-niece of yet another legendary collector, the Second Duke of Bridgewater.

The house has splendid hangings and tapestries, and a good general collection of works of art.

— THE CHAPEL AT GLAMIS CASTLE —

For some of his tormented life this was the home of Macbeth, and scene of the main start to the tragedy, the murder of Duncan. The castle's main fine art treasure is the Chapel. In 1673 Jacob de Wet, a Dutch artist, was commissioned by the Third Earl of Strathmore to decorate his private chapel with scenes from the life of Christ. De Wet based his work on engravings by Boetius Bolswert from an old Bible or service book. The ceilings and walls are covered in brilliant panels, recently restored.

The work is crude, but powerful. The ceiling is filled with a mass of panels, the smaller ones showing angels and symbols, including the listening ear of God, the larger spaces containing scenes from the life of Christ, among them Christ as a gardener, after His resurrection, wearing a hat and holding a spade. The whole chamber, since its restoration in 1980, glows in righteous colour.

The castle has other interesting connections. Queen Elizabeth The Queen Mother grew up here, and it has been the home of the Strathmore and Kinghorne families since 1372. Outside the Queen Mother's bedroom hang several family portraits. The Third Earl and his sons are portrayed in a splendid group portrait in the Drawing Room. They are wearing skin-coloured armour in the fashion of the day.

Fine Art in Ireland

You that would judge me, do not judge alone
This book or that, come to this hallowed place
Where my friends' portraits hang and look thereon;
Ireland's history in their lineaments trace;
Think where man's glory most begins and ends,
And say my glory was I had such friends.

W. B. Yeats, 'The Municipal Gallery Revisited'

The Cinderella of the arts in Ireland has always been painting, and its fine art associate, sculpture. Compared with literature and music, the plastic arts have been handled gingerly, as though politically active in some way. At the very least there is a tinge of privilege associated with those who painted and sculpted. At worst they had to belong to the artisan class, and this has invoked faint hints of the sectarian divide between a Protestant, English, 'establishment' minority, and a Catholic, Irish, Celtic majority from which, over much of the past four centuries, painters or sculptors could not possibly emerge. It is a view full of inconsistencies, but held nevertheless. As a result it is only recently that an Irish tradition in the visual arts, other than that of Celtic art during the Dark Ages, has been at all widely recognised and accepted.

Real society, infinitely more complex than prejudice would allow one to believe, produced all forms of art, from prehistoric times to the present, including vigorous expressions in paint and wood and stone, of people, of history, of myth, of life in every possible aspect.

Nevertheless, the prejudices militated against the strong development of schools of painters, and the contiguity of Ireland to Britain led to different forms of subservience and dependence; many Irish artists moved to Britain, a few travelled in the other direction, and inevitably Irish art was seen as a provincial branch of British art.

Within the island as a whole, art, no matter of what period, has a cohesion which is fully recognised by museums in the Republic and in Northern Ireland. Mercifully, they do not recognise the political Border. The Ulster Museum is rich in paintings from the south and west; the National Gallery and the Hugh Lane Municipal Gallery of Modern Art in Dublin, as well as smaller public collections elsewhere, display little

or no chauvinism. It is therefore sensible to deal with Irish art on the basis of the island as a whole.

There is an understandable cohesion about country house collections, though they are thinly spread, just as the main public collections are unevenly concentrated.

In the south, Dublin has the lion's share of what there is. A capital city long before Belfast existed, it had the traditions which gave birth to academies and art galleries in the eighteenth and nineteenth centuries comparable to developments in Scotland. And it is with Edinburgh that the main developments in Dublin should be compared.

In the National Gallery in Merrion Square, the country possesses one of the major art galleries in these islands, comparable in many of its schools and individual works with the national galleries of England, Scotland and Wales, as well as countries elsewhere. It has particularly good Dutch, Flemish, French and Italian works.

The city's collection of art, in the Hugh Lane Gallery of Modern Art, in Parnell Square, had a tempestuous evolution which sheds negligible credit on successive civic administrations. And this continues to be so. Founded as a municipal collection, in the early years of the twentieth century, and intended also to be the country's main collection of 'modern' art, it has existed for much of that time in cordial companionship with the National Gallery, but in quiet stagnation as well.

Some attempts have been made to resolve the anomaly of a modern gallery which does not have the resources to be such, and has an increasingly dated collection, with the successfully directed National Gallery. But there is an unresolved hiccough. The national collection of Irish art is divided between the two institutions, one under the Government, one under Dublin Corporation, and therefore with no coherent presentation of what Ireland is, through what Irish artists have produced.

Dublin also has an additional collection of works from the National Gallery in Malahide Castle, where a number of portraits hang.

A modest addition to the civic collection, with even more modest contents, is the small Civic Museum, in South William Street.

The other great collection owned by the Irish people, and located in Dublin, is the Chester Beatty Library, an essentially oriental collection of fine art and manuscripts given to the State by Sir Alfred Chester Beatty. In a number of its specialist collections it equals and occasionally surpasses the finest collections in the world. Chinese and Japanese paintings and calligraphy, Persian miniatures, Indian art, scent bottles and jade, all indicate that most perfect combination in a benefactor, great judgement, great wealth, and great generosity.

Though not predominantly fine art collections, the National Museum and the Library contain some works of fine art, including Celtic and medieval sculpture, illuminated books and manuscripts. There are drawings and watercolours in both collections, though major holdings of art have been transferred to the National Gallery.

Other collections in Dublin include the theatrical paintings in the Abbey Theatre; those belonging to both of the universities, though not on permanent exhibition; and the modern Irish art owned by the Bank

of Ireland. This is not permanently available to the visitor, other than by appointment.

Outside the city, though actually in County Kildare, is Castletown House, possibly the greatest eighteenth-century house in Ireland, though with a collection rather more limited than its magnificence would require.

Also outside the city, this time in County Wicklow, but associated in particular with the National Gallery of Ireland by virtue of the fact that some of its finest paintings have passed to the National Gallery, while others spend at least some of each year on exhibition there, is Russborough House, the home of Sir Alfred Beit, whose uncle collected splendid works of art at the end of the nineteenth and the beginning of the twentieth centuries. Vermeer, Hals, Metsu, Ruisdael, Goya, Gainsborough, Romney, Murillo are among the painters represented, and all examples are major in quality. The collection has been intelligently extended by the present owner. The greatness of the Russborough collection is enhanced by the fact that it was made relatively late, though with the substantial wealth of Otto Beit, whose fortune was made in diamonds, in South Africa.

Of the remaining 25 counties in the Republic of Ireland, depressingly few have substantial art galleries and museums containing representative collections of art, either Irish or international. The most important are the Cork Municipal Art Gallery, the Limerick Municipal Art Gallery, and the Sligo County Museum, justly celebrated for its collection of Jack Yeats works. More modest art galleries or museums, or both, exist in Kilkenny, Galway, Clonmel and Waterford. In Kilkenny the Castle has a collection of eighteenth- and nineteenth-century art, and the Butler Gallery a collection of modern Irish works.

In addition to the Limerick Art Gallery, there are two 'national' collections outside the city, at Kneafsey, where the National Institute for Higher Education houses the Irish Self-Portrait Collection, and the Hunt Collection. The first of these is in its infancy, but nevertheless contains some interesting examples of self-portraiture by Irish artists. The collection formed by John Hunt, an art expert and connoisseur who came from Limerick, is a modest but interesting one, reflecting his wide and catholic taste. Crucifixes, ornaments, jewellery, paintings and sculpture, all indicate a discriminating mind.

No more than a scattering of houses and castles, open to the public as well as containing collections of art, are spread across the country. In sharp contrast to the prodigality with which England is filled with mansions, many containing huge collections of art, Ireland is poorly provided with places to visit, fewer still of which contain more than residual art of the past.

In County Cork there is an increasingly impressive collection being assembled at Fota House, on Fota Island in Cork Harbour. Surrounded by a huge and fascinating estate of rare trees and plants, the house itself, though not very old, has an extremely well-chosen collection of Irish landscape art, as well as portraits, genre works, and continental paintings assembled by Richard Wood, a Cork collector who has made his collection available for display in the house.

The Irish art includes works by the principal painters of the eighteenth

century, among them George Barret, Thomas Roberts, William Ashford, Nathaniel Grogan and James Arthur O'Connor.

County Cork also has Riverstown House, Bantry House and Dunkathel, though with modest collections of art.

Muckross House, in Killarney, also has a modest and mixed collection, including nineteenth- and twentieth-century paintings, among them a pair of Orpen portraits.

Outside Limerick is Glin Castle, the home of Desmond Fitzgerald. It contains an interesting and diverse collection. In County Mayo is Westport House, owned by Lord Altamont. It has a small collection of works of art, among them paintings by James Arthur O'Connor, who enjoyed the patronage for a time of the Marquess of Sligo, and did a number of Mayo canvases, including paintings of Clew Bay.

Slane Castle, Castle Leslie, Clonalis House, Lissadel House and Tullynally Castle are, respectively, the only houses open to the public in Meath, Monaghan, Roscommon, Sligo and Westmeath. Other counties fare even less well: Wexford, Waterford, Tipperary, Offaly, Louth, Longford, Leitrim, Laois, Cavan and Carlow have no houses or castles open to the public and offering works of art to divert, entertain or educate.

In Donegal there is Derek Hill's recent and generous gift to the Irish

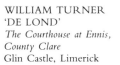

WILLIAM TURNER
'DE LOND'
The Courthouse at Ennis,
County Clare
Glin Castle, Limerick

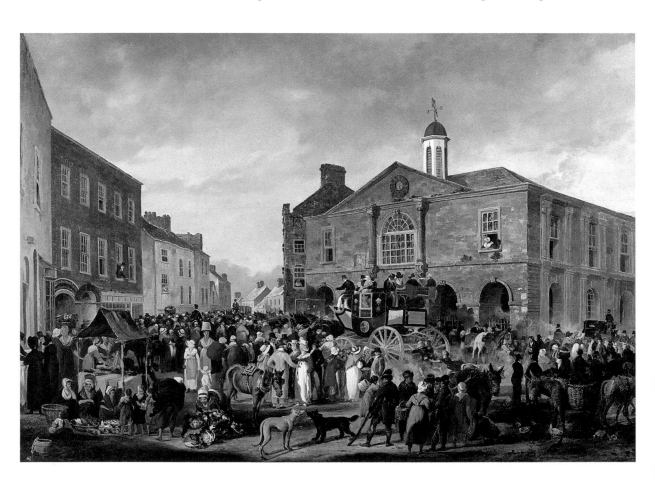

people, the Glebe Gallery at Churchill, near Letterkenny, to which he has added the Glebe House as well, with its fascinating collection of art, wallpaper, and many objects of interest collected over a lifetime of travel and painting by this Anglo-Irish portrait and landscape artist.

Northern Ireland's main art collection is the Ulster Museum, in Belfast (q.v.). Modelled on the Bristol City Art Gallery, it was only during the second half of the twentieth century that it developed its representative collection of Irish art.

Belfast also has the Linen Hall Library collection, of paintings, drawings and graphics, mainly of a topographical nature. And the Arts Council of Northern Ireland runs a gallery at its headquarters for the exhibition of the works of living artists, mainly Irish.

The provincial galleries in Northern Ireland include the lively and stimulating Armagh County Museum, the Lisburn Museum and the Fermanagh County Museum, which also houses the regimental museum of the Inniskilling Fusiliers.

The National Trust for Northern Ireland has a number of properties, but with very limited fine art collections. Mount Stewart has the most extensive collection, including a George Stubbs masterpiece, his *Hambletonian*.

THE NATIONAL GALLERY OF IRELAND

As early as 1766, almost a century before the National Gallery of Ireland actually opened, the Irish Society of Artists contemplated such a project, and in the 1780s plans were drawn up, a director appointed, and a campaign launched with the Viceroy, the Duke of Rutland, leading it. On his death he was replaced by the Speaker of the Irish Parliament, John Foster, who enlarged the scheme with proposals to include an Academy of Arts, a Repository for Manufactures and a Museum for Mechanical Works, as well as a National Gallery—an Irish answer supremely designed to sink permanently any simple set of objectives—with the inevitable result that the whole plan collapsed.

It put off the foundation of a national gallery for seventy years. This was not altogether a disadvantage, since the eventual moves to form such a collection had a clarity and singleness of purpose which, in turn, led to a far better start for the Dublin gallery than had been enjoyed in Edinburgh, in terms of the works of art collected, and the resources made available for their acquisition.

The National Gallery of Ireland was in part a memorial to a single, dynamic individual, William Dargan. He had been responsible for the Irish railway system, and had also financed the Great Industrial Exhibition in Dublin in 1853. This had included, at Dargan's insistence, a collection of Old Master paintings.

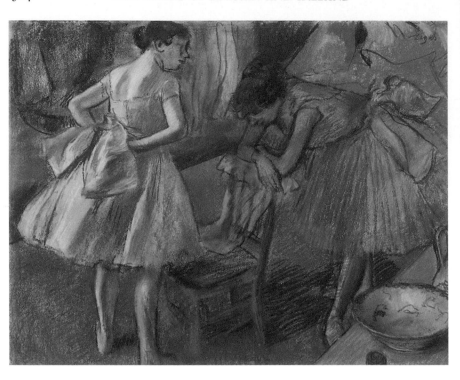

EDGAR DEGAS
Ballet Girls
National Gallery of Ireland,
Dublin

Widespread and fairly spontaneous pressures for a national collection of art led to the establishment, in November 1853, of the Irish Institution, 'for the promotion of art in Ireland by the formation of a permanent exhibition in Dublin and eventually of an Irish National Gallery'. Its early exhibitions led to the formation of the nucleus of a national collection. A fund was set up, and an Act passed at Westminster for the establishment of a national gallery. Agreement was reached with the Royal Dublin Society for the building of a gallery on the lawns of Leinster House, where the society then was, and Lord Eglinton, the Lord Lieutenant, laid the foundation stone in 1859.

After various proposals had been made and rejected, the architect Francis Fowke, later to be responsible for the first South Kensington Museum and the Royal Scottish Museum, in Edinburgh, completed the gallery's design. It is not ideal. The lofty upper rooms, with good top lighting, are too enormous for the majority of paintings, being more suitable for the huge and rather boring canvases which hang in them; and there is too much space dependent on light from side windows.

Dargan was appropriately commemorated with a memorial tablet and a statue, though the earlier idea, of calling the gallery the Dargan Institute, was abandoned. The gallery was put under the administration of a board of seventeen governors and guardians, and this remains as it then was, five of them being ex-officio, and including the president of the Royal Hibernian Academy, the president and senior vice-president of the Royal Dublin Society, and the chairman of the Board of Works,

two more being practising artists, nominated by the RHA, and the remainder being Government appointees. In the nineteenth and early twentieth centuries they were effectively appointed by the Lord Lieutenant; since independence, they have been appointed by the Government.

At the start the gallery had funds for purchase, empty walls to fill, and enthusiastic collectors runnings its affairs. The combination was a not unqualified blessing, though disastrous purchases from this period have been exaggerated. Thomas Bodkin, a later director of the gallery, refers to the regrettable haste with which the first works were purchased, 'remarkable for their area rather than their authenticity'. Bodkin was wrong. It may have been accidental, but in fact many of the extensive canvases bought then proved to be important acquisitions, mainly Italian.

Among the earliest works acquired were sixteen paintings from a Signor Aducci, in Rome, some of which had been in the celebrated collection of Cardinal Fesch including works by Lanfranco, Coypel and Procaccini.

ORAZIO GENTILESCHI
David and Goliath
National Gallery of Ireland,
Dublin

George Mulvany was appointed the first director of the gallery in 1862. Until then he had been secretary to the Board. He died in 1869, and was replaced by Henry Doyle, under whom great strides were made in extending the collection. Doyle was director until 1892, and the work of the gallery became his entire life.

He was particularly astute in the acquisition of Dutch and Flemish paintings, which constitute strong schools in the gallery, and which include the lovely Rembrandt, *Rest on the Flight into Egypt*, which Doyle bought for £514 in 1883. He also ventured into Italian paintings, and paid only £73, three years later, for Fra Angelico's *The Attempted Martyrdom of Saints Cosmos and Damian with their Brothers*.

He also bought fine works by Tiepolo, *The Allegory of the Immaculate Conception*, Joshua Reynolds's portrait of *The Earl of Bellamont*, the Titian, *Ecce Homo*, and the Frans Hals *Young Fisherboy of Scheveningen*. At the end of his period as director, the gallery received as a gift from the Fifth Duke of Leinster the large Francis Wheatley, *The Dublin Volunteers in College Green, 4th November, 1779*, the work of an artist claimed, as so many others were, as Irish, though in fact he was an expatriate in flight from debts in England. Notwithstanding this, Wheatley was an influential figure in the development of Irish art.

Doyle was succeeded by Sir Walter Armstrong, during whose directorship the gallery received the Milltown Bequest, for which an extension was built. This group of paintings, given by the Countess of Milltown as a memorial to the Sixth Earl, included works by Poussin and Batoni, and caricatures by Reynolds.

FRA ANGELICO
*The Attempted Martyrdom of
SS Cosmos and Damian with
their Brothers*
National Gallery of Ireland,
Dublin

JEAN BAPTISTE SIMÉON
CHARDIN
Les Tours de Cartes
National Gallery of Ireland,
Dublin

Armstrong himself was also responsible for a number of important purchases, including the Gainsborough portrait of *James Quin*, the splendid Chardin, *Les Tours de Cartes*, *The Dilettanti* (portrait of Jeronimus Tonneman and his son) by Cornelius Troost, and the gallery's Mantegna, *Judith with the Head of Holofernes*.

Armstrong was succeeded by Hugh Lane, who was to remain director for only fifteen months before being drowned in the *Lusitania* disaster, off the Cork coast, in 1915. In that brief period, and in the benefits he showered on the gallery by bequest, Lane's 'noble passion of generosity became unbridled' (Thomas Bodkin). 'At each meeting of the Board he came forward with gifts of the rarest kind. He gave no fewer than twenty-one pictures to the National Gallery while he lived, and when his will was read it was found that he had left it almost all his property outside his modern pictures.' Titian, Rembrandt, El Greco, Goya, Gainsborough, Hogarth, Chardin and Romney were among the artists whose works were given by Lane.

The National Gallery of Ireland also benefited from the generosity of Sir Alfred Chester Beatty, and, after his death, from the huge income from George Bernard Shaw's writing, particularly after the stage and film success of *My Fair Lady*.

Shaw, as a boy growing up in Dublin, spent much time in the gallery, and later claimed that his 'whole life was influenced by the Dublin National Gallery, for I spent many days of my boyhood wandering through it, and so learned to care for art'. His fortune was subsequently divided between the British Museum, the Royal Academy of Dramatic

CONRAD FABER
Katherina Knoblauch
National Gallery of Ireland,
Dublin

Art and the gallery. Out of the income the gallery bought, among other works, the important early canvas by Jacques-Louis David, *The Funeral of Patroclus*, as well as more controversial acquisitions, like the disputed School of Avignon *Annunciation with St Stephen and Donors* and a presumed Georges de La Tour, since reattributed, with reservations, to his son, Etienne.

Of the twentieth-century directors of the National Gallery of Ireland, after Hugh Lane, perhaps the most outstanding was Thomas Bodkin, who held the post from 1928 to 1935. Bodkin's predecessors were Walter Strickland, Langton Douglas and Lucius O'Callaghan; he was succeeded by George Furlong, Thomas MacGreevy, and James White and Homan Potterton.

Bodkin belonged to a period in which few purchases were possible, and when the social and cultural function of art, and of public galleries, were the subject of reassessment, much of it somewhat severe and critical. He was himself an enthusiastic and enlightened exponent of painting, endeavouring in his writings to make art readily understandable, and in at least one of his books, *An Approach to Painting*, presenting a broad yet well-informed view of how to come to grips with paintings and sculpture. He held to what might be regarded as old-fashioned values. He once wrote: 'A National Gallery is a prime part of the response to the need which every citizen has for beauty in his daily life. It helps to gratify that laudable curiosity which urges him towards the widening of his experience and the increase of his knowledge; and it stimulates that essentially humanistic sense which makes him desire to take an interest in the continuity of the race and to relate himself and his age to the development and achievements of earlier generations. The man who constantly visits his National Gallery will soon find himself deeply influenced, whether consciously or unconsciously, by the ideals of order, fitness and accomplishment which are inherent in all great works of pictorial art.'

Bodkin recognised the gallery's limitations, and was as openly critical of them as he was of himself. The most significant are those by which

JACQUES-LOUIS DAVID
The Funeral of Patroclus
National Gallery of Ireland,
Dublin

all too many galleries are judged, and judged dismissively: the major gaps, most of which are beyond remedy. The National Gallery of Ireland is without works by Giotto, Filippo Lippi, Leonardo da Vinci, Masaccio; there is nothing by the Van Eycks, Van der Weyden, Holbein, Dürer, Memling, Altdorfer; there is no undisputed Velázquez; though there is a splendid selection of Turner watercolours, bequeathed to the gallery by Henry Vaughan (he did the same for the National Gallery of Scotland), neither Turner nor Constable is represented by first-class oils; and good though the Dutch collection is, it lacks the crowning perfection of a Vermeer.

In 1932 Bodkin wrote: 'Works by Vermeer are so scarce and so enormously expensive that I despair now of ever filling this gap. The lovely Vermeer in the late Lord Iveagh's collection (now at Kenwood) was one of the last of his paintings left in private hands, and it must be a source of deep regret to many of us that this picture is now the property of the English people. Lord Iveagh did much for Ireland in his day. He was a trustee of the Dublin National Gallery at the time of his death and for many years previously. He possibly thought that our lack of pride and interest in our great pictorial possessions justified him in

NATHANIEL HONE
Banks of the Seine
National Gallery of Ireland,
Dublin

leaving his pictures to a people who he expected would appreciate them more than his countrymen.'

Periodically, the gap has been filled when the paintings at Russborough (q.v.), or a selection of them, are deposited in the National Gallery in Dublin. Before the 1986 robbery this included not only the last Vermeer in private hands in these islands, but also an early Velázquez, a Goya, six beautiful Murillo canvases, and several other works of international importance.

The collection is particularly strong in Dutch paintings, has a fine collection of French works, including canvases by Chardin, Poussin, Robert and David, and has also a good selection of Spanish work. But much wider than that, it offers quality and comprehensiveness in virtually every direction, as well as possessing the country's national art up to the beginning of the twentieth century.

HUGH LANE MUNICIPAL GALLERY
——————— OF MODERN ART ———————

The Municipal Gallery in Dublin, which opened in 1908, was always intended to be a modern collection. It is an intention still inadequately fulfilled. There are three strands to what the Gallery now has: nineteenth-century art, mainly French, which came from Hugh Lane; Irish art of the nineteenth and twentieth centuries, including some modern work; and selected works by international painters of the twentieth century.

In the 1970s the name of the Gallery's founder was added to the Gallery's title, making it cumbersome, and underlining one of its more glaring faults: it remains largely a Hugh Lane memorial gallery because no one, since Lane, has managed to move it forward in its thinking or its collecting policies. Its rooms are still dominated by the substantial number of Lane pictures, including those which are the subject of the historic dispute over Lane's will.

It is a sorry story. At the turn of the century a series of loan exhibitions aroused an interest in the formation of a modern collection of paintings for Dublin, then seen as the only European capital city without such a gallery. In 1904 an exhibition of Irish art was put on at the Guildhall, in London. Coinciding, as it did, with the widespread revival of interest in Irish arts of every kind, and combined with a tide of nationalism, artists and benefactors committed themselves and their pictures to the gallery.

James Staats Forbes, the railway magnate and collector of modern art, died in 1903, and stipulated that, if his collection, or portions of it, went to a public gallery, the price would be reduced. Twenty-five paintings were acquired for Dublin, and to those various other gifts were added. Hugh Lane was the moving spirit behind almost all the activity which went into the accumulation of works, and the eventual opening of a gallery in Harcourt Street.

Lane was one of the great collectors of all time. Born in 1875 of a Cork family, he joined the firm of Colnaghi's at the age of eighteen,

and by the end of the century had set up in London as a dealer. He organised exhibitions, including one in 1902 in Dublin of Old Master paintings, was responsible for the 1904 Guildhall exhibition of Irish art, and brought the Staats Forbes pictures to Dublin in 1905.

His efforts on behalf of the city's modern gallery were unremitting throughout these years, and in his generous way he implies, in a note of introduction to the catalogue which was published at the time of the opening of the Municipal Gallery of Modern Art, in 1908, that the process had been reasonably smooth. 'Part of the opposition we had to contend with was, no doubt, due to the fear that the gallery would be managed, as many other Municipal Galleries are, by people with no practical experience in Art matters.'

The reality behind these carefully chosen words was a set of experiences which came close to breaking Lane's heart, and caused many of his friends, among them William Orpen, to advise him against wasting his prodigal generosity on a city whose main motivations seemed to be the discrediting of Lane himself, who was sneered at as a dealer, and the obstruction of his principal aim, which was to get a permanent gallery built to house the pictures he had given, or was prepared to give.

The premises in 1908, in Harcourt Street, were temporary. In 1933 the Gallery moved to Charlemont House, in Parnell Square, a distinguished building of Sir William Chambers, dating from the 1760s. It had been envisaged that a new gallery would be constructed, and various resolutions, of Dublin Corporation and of the Dail and Senate, indicate an intent which was never fulfilled, though Edward Lutyens did excellent designs for a gallery spanning the River Liffey.

The Lane pictures include those he gave and those he bequeathed, though in a defective, unwitnessed codicil to his will, and the subject of dispute since the 1920s between the National Gallery, in London, and

NORAH McGUINNESS
Garden Green
Hugh Lane Municipal Gallery of
Modern Art, Dublin

ROBERT BALLAGH
Third May—Goya 1970
Hugh Lane Municipal Gallery of
Modern Art, Dublin

LOUIS LE BROCQUY
Homage to Clonfert
Hugh Lane Municipal Gallery,
Dublin

ÉDOUARD MANET
Eva Gonzalès
National Gallery

Dublin. It is a complicated story, partly resolved by an agreement to divide the paintings into two groups, for exchange between the two cities.

In 1970 an Irish Government arrangement was made whereby those pictures in the Municipal Gallery which were painted by artists born before 1860 would be transferred to the National Gallery, while later works would be moved to the Municipal Gallery. This did not affect the Lane pictures. More seriously, it did not recognise the imbalance between the two collections, and between their financial resources. There was no way in which the Municipal Gallery could compete with the Shaw Bequest, and its buying policy has been a restricted one.

The collection is therefore rich in certain French works, on loan from their legal owners in London. These include Renoir's *Les Parapluies*, Berthe Morisot's *Jour d'Eté*, *La Plage* by Degas, *Eva Gonzalès* by Manet, Monet's *Vétheuil: Sunshine and Snow*, and works by Ingres, Fromentin, Daubigny, Forain, Corot and Courbet. Since these are changed after a period of years, no certainty exists about which of the 39 works will be in Dublin; but if there, they are generally on display.

Lane persuaded artist friends to paint and give works to the Gallery, and there is a good collection of Irish and British art from the early part of the twentieth century. Among other works this includes the Sargent portrait of Lane, as well as Orpen's portrait of his close friend, and the portrait of Lane by Sarah Cecilia Harrison, who compiled the first catalogue for the Gallery, and was in love with Lane. In the absence of a portrait gallery, Lane also concentrated some of his energies on commissioning or acquiring portraits of famous Irish men and women, a scheme in which Orpen gave him assistance.

The modern collection is uncertainly balanced between the rooms which contain Irish art from the 1930s to the 1950s, international art of the last thirty years, and modern Irish painting and sculpture. The most

stimulating work includes the Jack Yeats paintings, good examples of Louis le Brocquy, Norah McGuinness, W. J. Leech and a number of other artists of the 1950s. Uncertainty prevails over Irish painting of the past 25 years, and the acquisition of international work of the same period has been inhibited, and made very uneven, by limited funds.

—— CHESTER BEATTY LIBRARY ——

Sir Alfred Chester Beatty was one of the world's greatest collectors of Islamic and Far Eastern art, and his gift to Ireland of the Chester Beatty Library, in Shrewsbury Road, Dublin, has provided the country with one of its most important collections of fine art, and certainly the most important collection in the country made by one person.

Chester Beatty—he did not like the name Alfred—was born in New York. He was of Irish descent on both sides of his family, his great-grandfather, David Beatty, coming from Armagh, his grandparents from Mountrath, in County Laois. His first collecting instincts, as a boy, were for mineral samples, and it was into mining that he went at an early age, well equipped to recognise and exploit metals and precious stones. It is appropriate that one of the Persian masterpieces in the collection is the painting of *Shah Jahan with his Four Sons*; Jahan, who was himself a connoisseur of precious stones, is being handed a tray of jewels by a courtier.

Beatty settled in England in 1913, becoming a British citizen in 1933, and commencing his main period as a collector in the 1920s. He was later given a knighthood. He moved to Ireland in 1950, settling in Dublin. In that year he presented 33 paintings to the National Gallery, mainly nineteenth-century French works, including fine Barbizon School paintings. His decision to give his main collection to the Irish nation had been made before he settled in the country, and was the subject of legislation setting up the Library, which was opened in 1954. He became the country's first honorary citizen in 1957.

He had a pithy approach to collecting, and relied on the best dealers, though he was shrewd in his own judgements. He saw the advantage the private collector enjoyed: 'the best policy is to insist on having things of fine quality in very fine condition even if it means having only a small collection.'

He once gave the advice: 'If you want to be a collector you must make yourself an expert on forgeries—learn to study them, get to know dealers who are expert forgers. But remember, the trouble with the forger is that he nearly always gives you too much for your money—and that gives him away . . .'

His collecting notebooks, preserved at the Library, indicate his approach. He styled individual works by A, B and C categories, and in general collected only A, or 'excellent condition' works. He would designate items D.C.F.I. or N.F.F.C.— 'Don't Care For It' and 'Not Fit For Collection'— and his A-scaling of works went through A+, A and A−, as well as from A1 to A50.

The greatness of the collection, from a fine art point of view, lies in its Persian, Indian and Turkish miniature paintings, its French and Flemish illuminated manuscripts and Books of Hours, early woodcuts and engravings, including a magnificent collection of Dürer's graphic work, and some Chinese, Japanese and Indian carvings.

Works by the greatest of all Persian artists, Riza Abbasi, include his *Coronation of Shah Abbas the Great*, *Rustam Killing the White Elephant* and *Painting of a Page*.

THE ULSTER MUSEUM

At its inception it was intended that the Ulster Museum would be modelled on the Bristol City Art Gallery, an indication of how the city assessed itself, in terms of its fine art and public collecting needs and responsibilities. Its origins, as a collection, were mainly of natural history, going back to the early nineteenth century and the Belfast Natural History Society. It was not until 1890 that a city art gallery was opened, as an annexe to the library, and it was only with the growth of bequests and the amalgamation of different collections that the museum itself became a reality. The older part of the present building, delayed by the First World War, eventually opened in 1929.

THOMAS BATE
Lord Coningsby
Ulster Museum, Belfast

GEORGE BARRET
Waterfall at Powerscourt
Ulster Museum, Belfast

The Ulster Museum was taken over by the Northern Ireland Government from the City Council in 1961, becoming a national institution, being further enlarged in 1972. It remains a museum, art being one of six departments. Its collection is good of Irish art, and otherwise interesting, if a bit uneven, with some outstanding works. Among these are *The Holy Family with St John and St Elizabeth* by Van Ost, and *St Christopher* by Jacob Jordaens.

It has a substantial holding of work by John Lavery, and good examples of other leading Irish artists, including Yeats, Orpen, Osborne, as well as earlier works. This emphasis on Irish art, particularly during the post-war period, has resulted in an extensive collection of work. From the seventeenth-century *Lord Coningsby in a Landscape* by Thomas Bate, to modern Irish works like Edward McGuire's portrait of the poet *Seamus Heaney*, it offers a comprehensive cross-section of art on the island of Ireland over three centuries.

Indeed, one of the more gratifying aspects of the Ulster Museum collection is the degree to which it has asserted, with consistency and determination, the existence of a visual tradition in Ireland. A sense of landscape in painters like Paul Henry, Basil Blackshaw, Dan O'Neill and

JACOB JORDAENS
St Christopher
Ulster Museum, Belfast

JEAN DUBUFFET
Femme et Bébé
Ulster Museum, Belfast

Gerard Dillon is reflected in the collecting policies of the museum, and more modern traditions, represented in works like Mainie Jellett's *Abstract*, are also covered.

English painting, sometimes with an Irish flavour, particularly in the portrait collection, is well represented in all periods, with outstanding examples of Turner, Reynolds, Gainsborough, and Wilson. Among the drawings are good examples of Fuseli and Sandby. And more modern artists well represented include Paul Nash, Ben Nicholson and Graham Sutherland. International artists in the collection include Dubuffet and Appel.

The museum's collection of paintings and sculpture is the finest in Northern Ireland. Over a period of thirty years a careful buying policy,

guided by a succession of conscientious keepers of fine art, has led to the acquisition of good examples representative of modern Irish painting, British art, and works of importance both historically to the province, and aesthetically in art generally.

—————— RUSSBOROUGH HOUSE ——————

Perfect house, perfect setting, perfect collection: one is tempted to make these claims with an easy conscience for the splendid eighteenth-century house by Richard Cassells, set in rolling Wicklow countryside, in sight of the mountains, contains an exceptionally fine collection of art.

Magnificently restored and maintained, the house and land have been vested in a charitable and educational trust, the Alfred Beit Foundation, which Sir Alfred Beit, in his own words, 'established with the object of keeping the house and art collection intact, making a centre for the arts and open to the public'.

The fine quality of what the house contains is even more remarkable in view of the fact that it is a late nineteenth-century collection, the bulk of it acquired in the space of roughly twenty years, and by a self-made merchant adventurer, Alfred Beit. He was born in Hamburg in 1853 and went to South Africa at the age of 22. He met Cecil Rhodes there, and formed with him the De Beers partnership.

By the late 1880s he was established in London, and in 1895 built himself a house in Park Lane. He had already started collecting, under the guidance of Wilhelm Bode, director of the Kaiser Friedrich Museum in Berlin, who did much more for him than would be allowed by today's conventions, acting as agent or dealer in important acquisitions, and being substantially responsible for the major purchases.

Early on, Beit bought the lovely series of Murillo canvases, *The Parable of the Prodigal Son*, as well as the fine early Velázquez. Spanish art was an unusual departure at the time for a British collection, remaining so today, and giving to the Russborough pictures an additional dimension of interest, strengthened much later by the acquisition of the dramatic Goya portrait *Dona Antonia Zarate*.

In Italian art the opportunities for buying the work of early Primitives, or indeed of great painters of the Quattrocento, which had existed in the first half of the nineteenth century, and had been exploited by collectors like Sanford, whose Lippi is at Corsham Court, or by Fox-Strangways for the Ashmolean, had passed beyond recall. Beit concentrated on later masters, like the Venetian artists, Bellotto, Canaletto and Guardi, and the strange haunting work of the Genoese painter Magnasco. Even more restrained were his French purchases.

British art is well represented by two contrasting works of Thomas Gainsborough, the dramatic and fetching *The Italian Dancer, Madame Bacelli*, and the beautiful *Cottage Girl with Dog and Pitcher*. There is a fine example of Raeburn, his large double portrait *Sir John and Lady Clerk of Pennycuik*.

BARTOLOMÉ ESTEBÁN
MURILLO
The Return of the Prodigal Son
Russborough House, Wicklow

But the outstanding works at Russborough are Dutch, and the greatest masterpiece of all *The Letter* by Jan Vermeer. This work focuses so much of one's attention that it tends to overshadow the wonderful small pair of interiors by Gabriel Metsu, the exceptionally fine Jan Steen, *Marriage Feast at Cana*, and *The Lute Player* by Frans Hals. The greatest seventeenth-century Dutch landscape painter, Jacob van Ruisdael, is represented by one of his finest and most dramatic compositions, the very large *Castle Bentheim*. Another landscape painter represented is Hobbema, once so highly regarded; the cattle in the foreground are by Adriaen van de Velde. There is a Flemish work of note: the Rubens portrait of the academic *Ericius Puteanus*.

The high quality of individual works in the collection is largely a result of the skill and judgement of Bode. The high standard overall—that absence of 'dross' which is so much harder to achieve in country house collections, if not in all collections—derives from the fact that it was made essentially by one man whose collecting activities followed after a busy professional life, and came at a time when he could afford to buy at the top of the market, following sound, experienced advice. Art at Russborough is uncluttered by any inheritance of family portraits, by any of the generally uneven Grand Tour gatherings of many country houses, or by fitful indulgence by other members of a family.

Alfred Beit was responsive to scholarship, to advice, to market availability, and to a certain hedonism about the acquisition of pictures. He sought those which were a genuine pleasure to live with, rather than 'important' works, like those of the great Italian Masters, for example.

While Russborough's strength lies in the fact that it is basically one man's collection, respected and refined by his nephew, it can also be regarded as an 'ideal' country house collection, by modern standards. Thus, the strong element of personal choice, impossible in the museum, often disastrous in its accumulative impact on country house art, is here represented at its economical best. The masterpieces are there, the support for them is there; one is in no sense exhausted by the experience, but elevated and enormously enriched.

THE JACK YEATS COLLECTION —— IN SLIGO COUNTY MUSEUM ——

'Sligo was my school, and the sky above it,' Jack Yeats wrote, in expression of that most wonderful of all inspirations for the artist, a territory fixed in memory as ideally happy. He drew on Sligo all through his life. It inspired his earliest drawings, it created in him the instincts and feelings of the journalist, which were so much a part of his early manhood, and it fed his mature vision with an understanding of the Irish character which flows from even the most obscure and difficult of his later paintings. 'From the beginning of my painting life,' he wrote towards the end of that life, 'every painting which I have made has somewhere in it a thought of Sligo.'

It is fitting that the Sligo County Museum should have such a fine collection of Yeats's work, fitting also that much of it should have derived from Jack Yeats, his family, and his supporters and friends.

It was in 1954, three years before his own death, that the artist wrote the words quoted above, in a letter which accompanied the gift to Sligo of *Leaving the Far Point*. He was then not well enough to travel to Sligo himself, but, as with all the other years of his life, he was there in spirit.

The earliest pictures in the collection date from the 1890s, and include the watercolours *The Metal Man*, *Red Hanrahan's Vision*, *A Sunday Morning in Sligo* and *The Star Gazer*.

Many depict figures drawn from the Sligo countryside, the quayside in Sligo town, and the roads of the county and of Mayo. The Ganger, the Stevedore, the River Pilot, all impinged on the young Jack Yeats.

The magic of distant places, summoned up by the ships and their captains, remote and filled with adventure, never entirely vanished from his mind. That childlike innocence, which inspired the strange pirate games invented with John Masefield, as well as the miniature theatre plays, derived from Sligo in the days at the turn of the century.

More weighty portraiture, cartoons for banners in the new Cathedral of Loughrea, for which the Dun Emer Guild received an important commission, and the incipient appearance of politics in Yeats's painting, are all recorded in works which belong to the period 1900-10.

The Sligo County Museum is rich in oil paintings from the 1920s. The most important of these are *Shruna Meala*, *Rosses Point*, *Singing 'The*

Minstrel Boy', *The Island Funeral*, *Communicating with Prisoners* and *Singing 'The Beautiful Picture'*.

In all of these works Yeats gives expression to Irish character in a way that has puzzled, and still puzzles, critics of his art. The imagery, the symbol, the mysticism, are all faithfully explored, and with so close a familiarity with rural, west of Ireland roots, that the understanding is impeded unless there is a full commitment to it.

Unlike so many famous and great artists, Yeats does not easily transpose from the particular to the universal. He demands a substantial effort of will. He deserves to get it.

The later period is represented by few canvases, though great ones. *Leaving the Far Point* is a 'memory' painting. It records, in the year it was painted, 1946, a visit to Rosses Point made thirty-five years earlier, and it includes old George Pollexfen, Yeats's uncle, with a stick, the artist wearing a wide-brimmed hat.

The Sligo County Museum has other works of art, mainly by twentieth-century Irish painters, including Paul Henry, Louis le Brocquy, Patrick Collins, Percy French and Sean Keating. But above all it is a museum devoted to its most famous artistic son. There are few better things for a town to celebrate.

KEY TO MAP SECTIONS

REFERENCE TO PAGES

	A	B	C	D
1				
2				
3				
4				
5				
6				

REFERENCE TO SPECIAL SYMBOLS

▲ Locations Containing More than One Institution

● Museums, Art Galleries

■ Houses, Palaces, Castles and Abbeys

REFERENCE TO COMMON SYMBOLS

Symbol	Description
YES TOR 2027	Spot Heights (feet)
___🚢___	Car Ferry
▬▬▬	National Boundaries
▬▬▬	County/Regional Boundaries
✈	Airports
⊕	Airfields
STAFFORD	Primary Route Destination
⊤	RAC/AA Telephone Boxes

GENERAL MAPS

Scale 1:625 000

Miles: 0 2 4 6 8 10 miles
Km: 0 4 8 12 16 Km

Interchanges Service areas Access to or exit from motorway limited Limited interchange Services (limited access) Access from motorway limited

Motorway

Primary Route — 25

Other 'A' Roads — 40

Dual Carriageway — 498

'B' Roads

Unclassified Roads

Distances in Miles — 5

CENTRAL SCOTLAND MAP

Scale 1:330 000

Miles: 0 1 2 3 4 5 6 miles
Km: 0 2 4 6 8 10 Km

Unrestricted Interchanges Service Areas Access or exit from motorway only in direction of arrow Access ← Exit ←

Primary Route — 2

4012

653

2

FOR REFERENCE TO IRELAND AND LONDON SEE PAGES 26-27,30

MAPS ©1987 GEORGE PHILIP & SON. LTD., LONDON

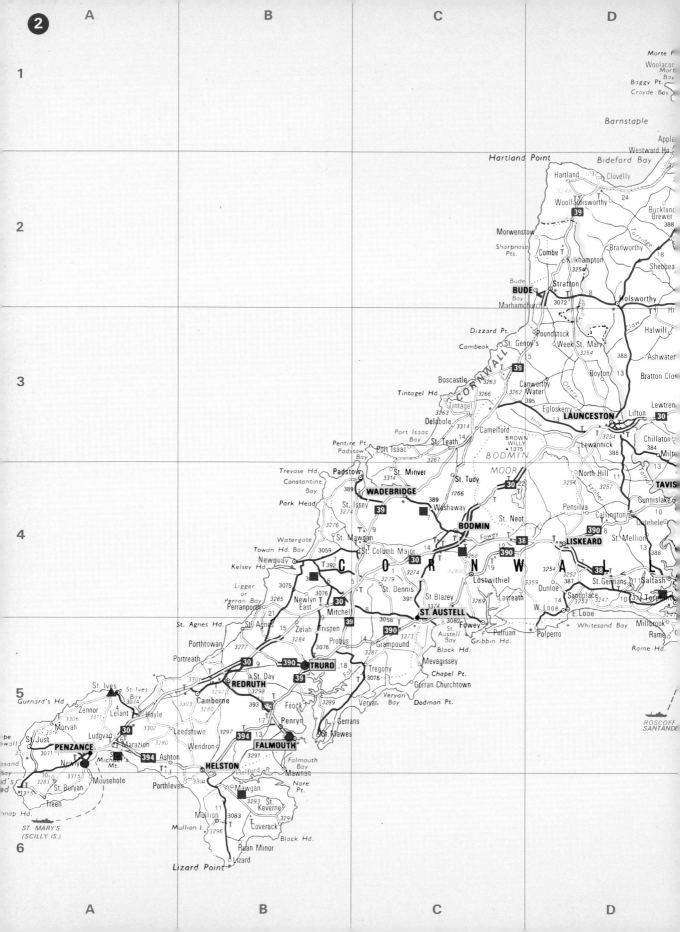

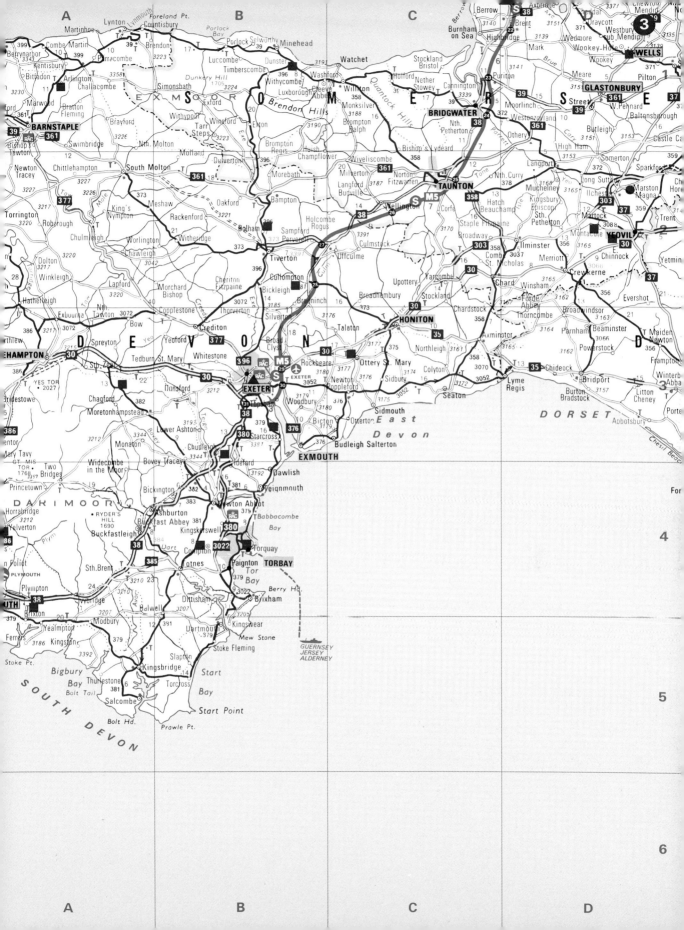

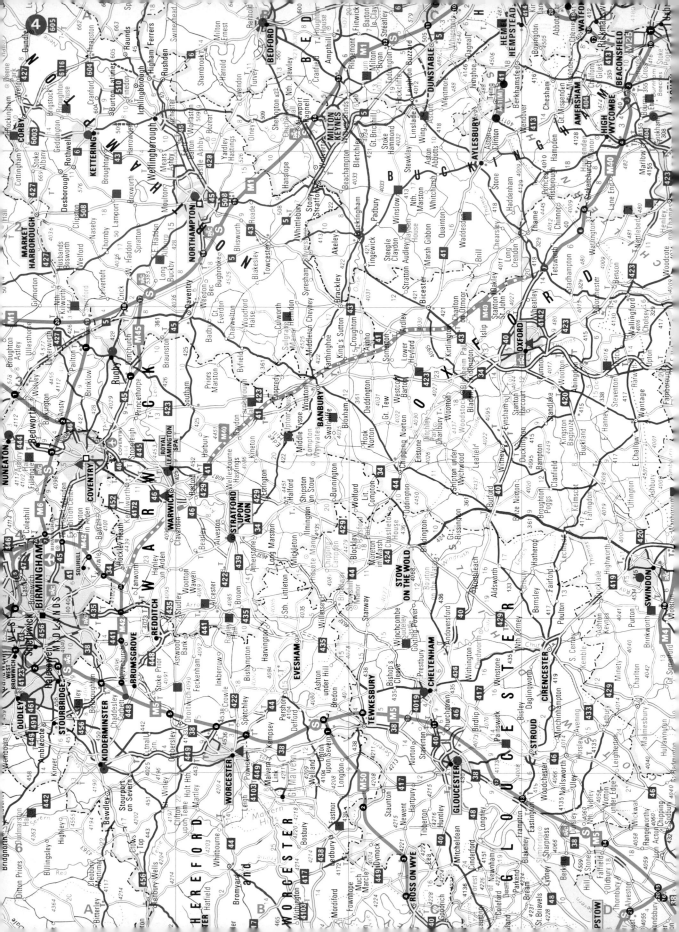

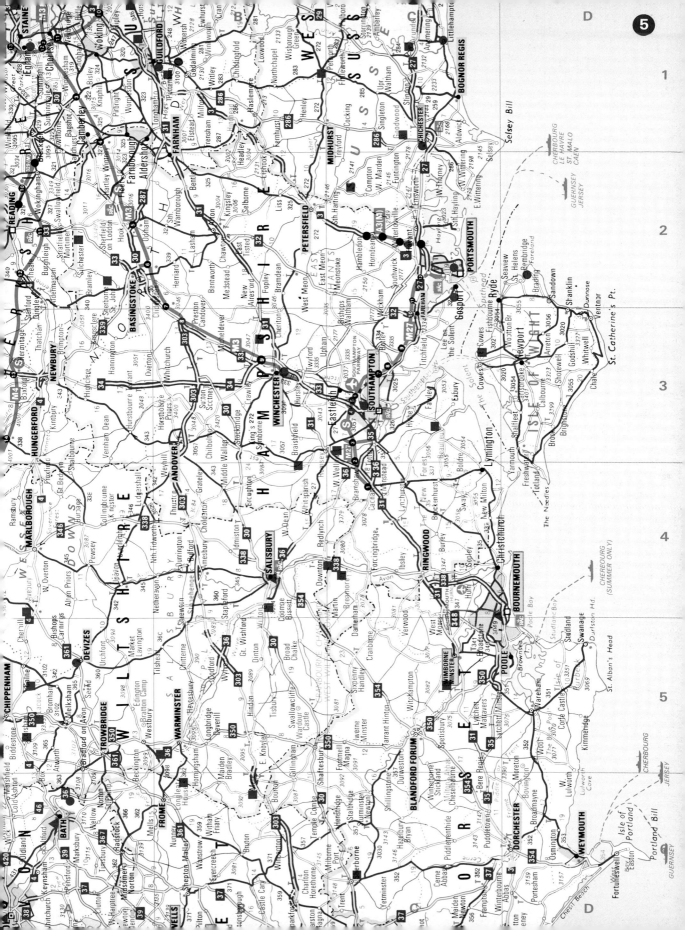

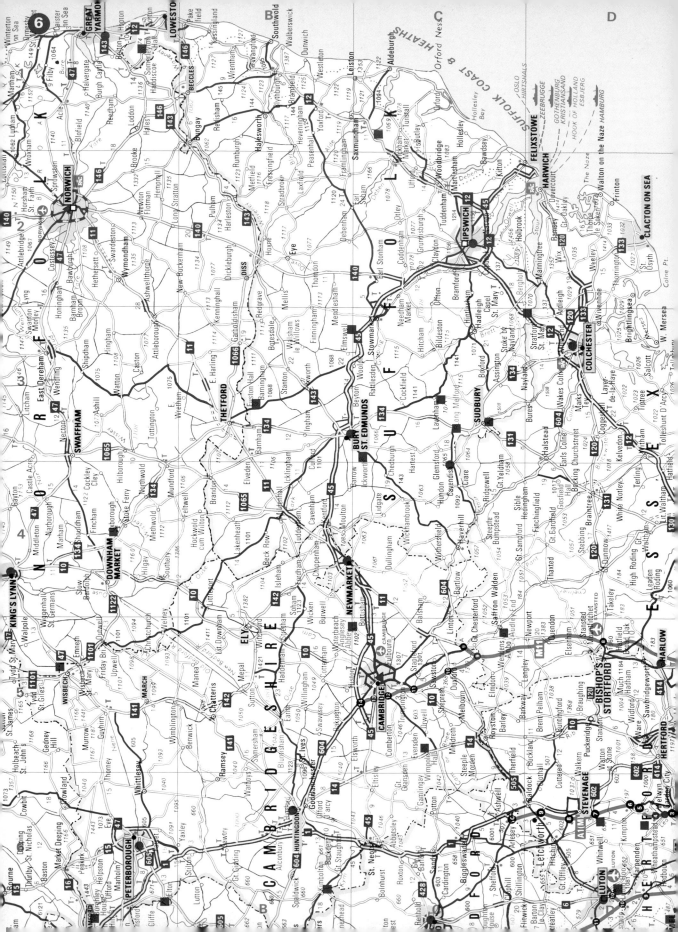

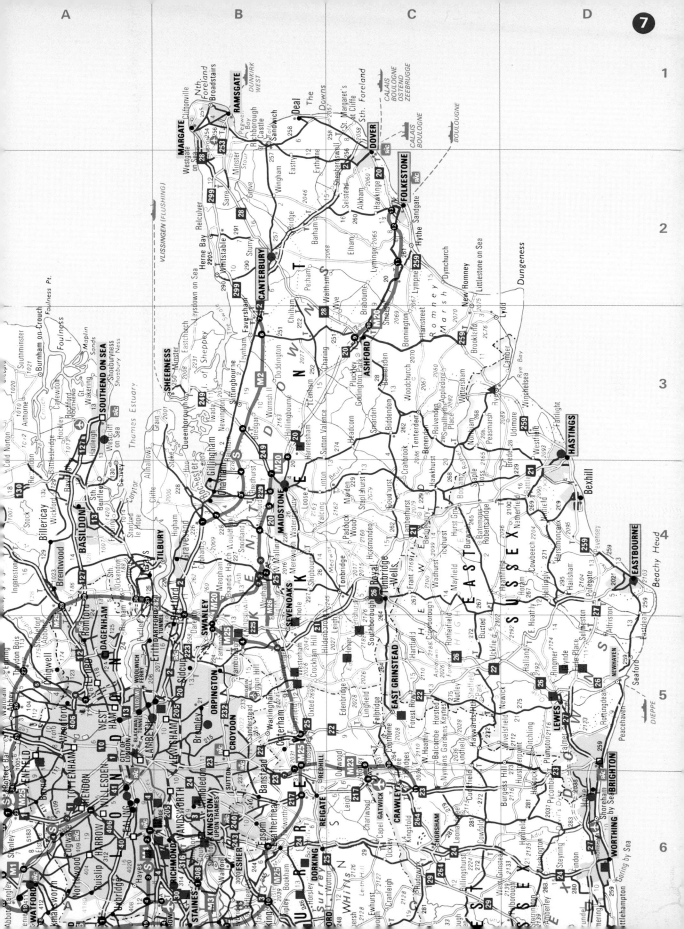

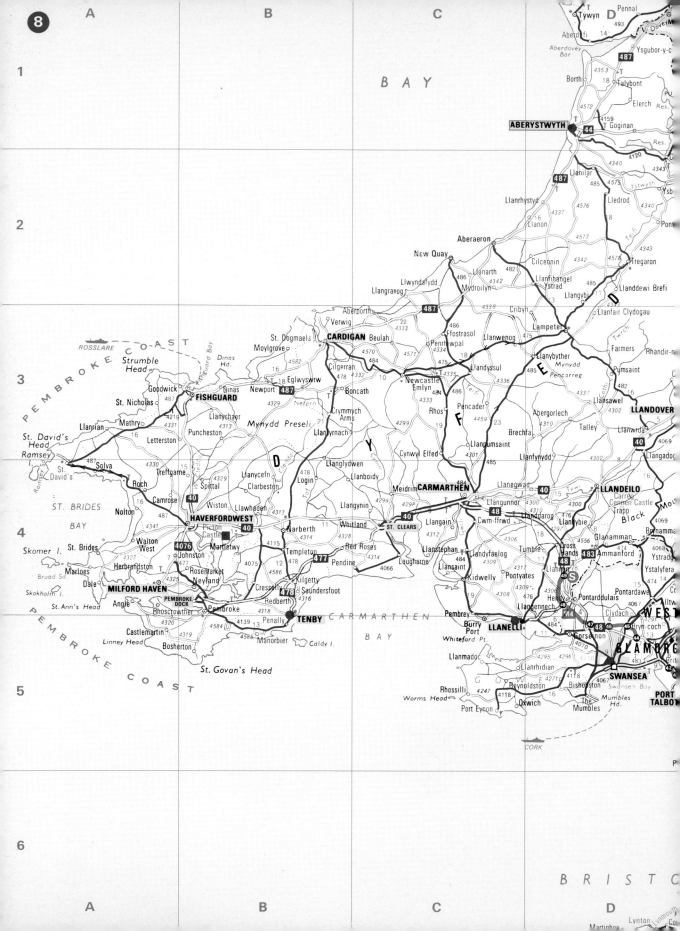

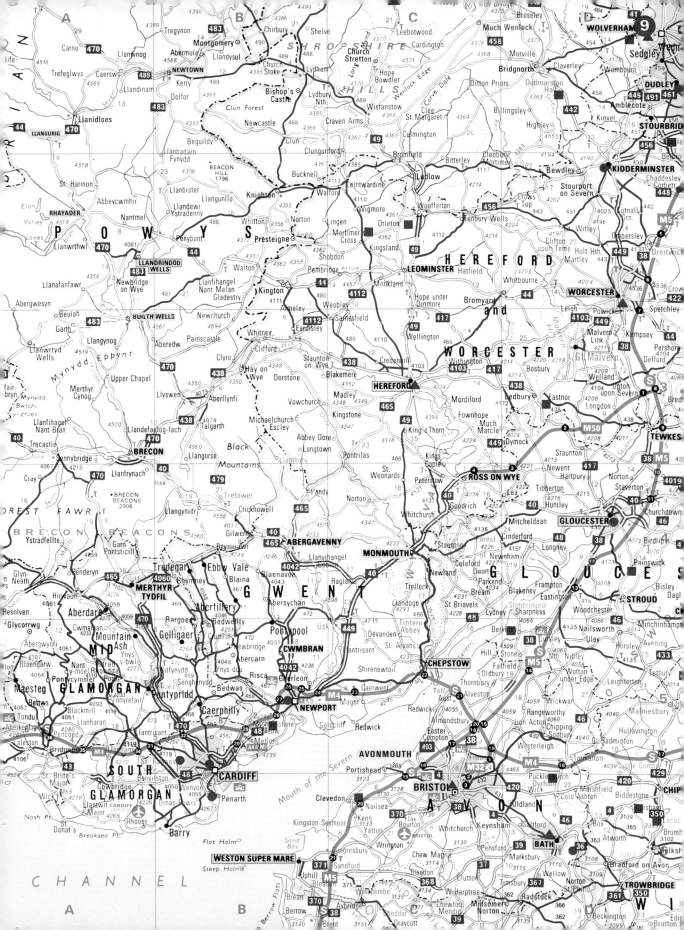

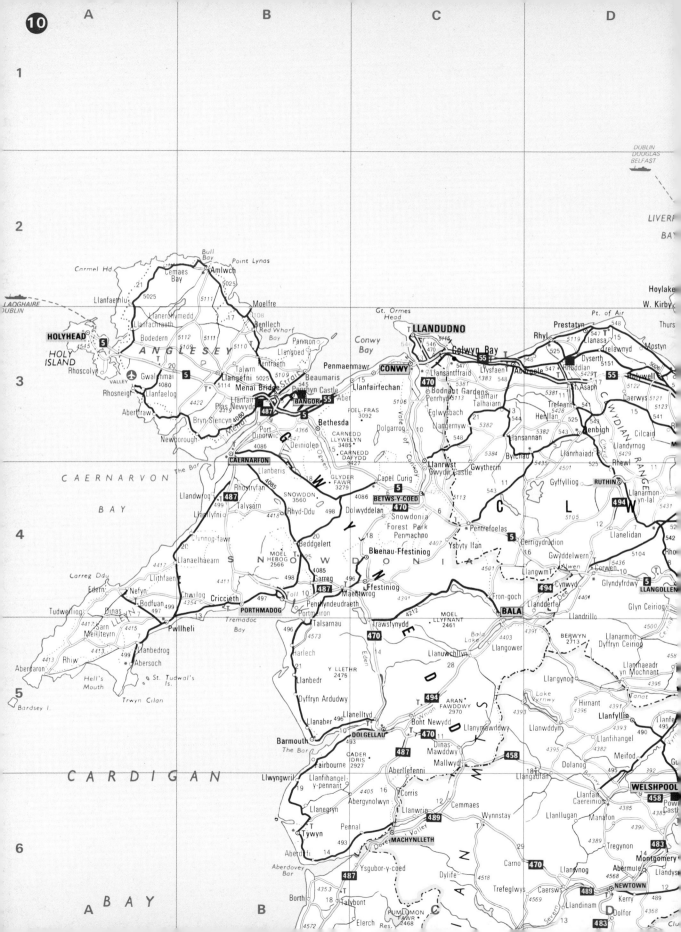

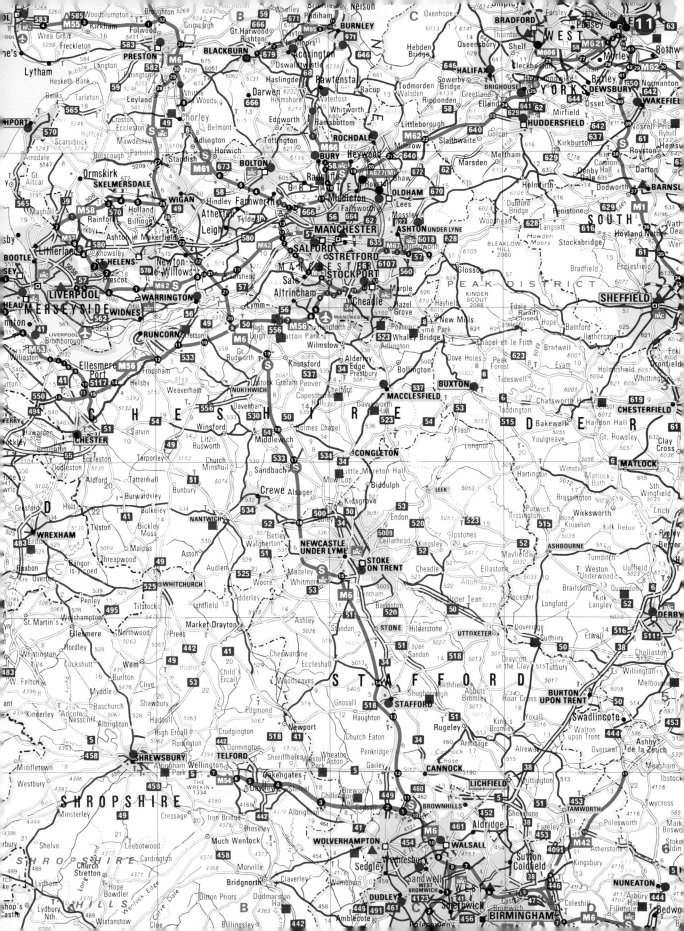

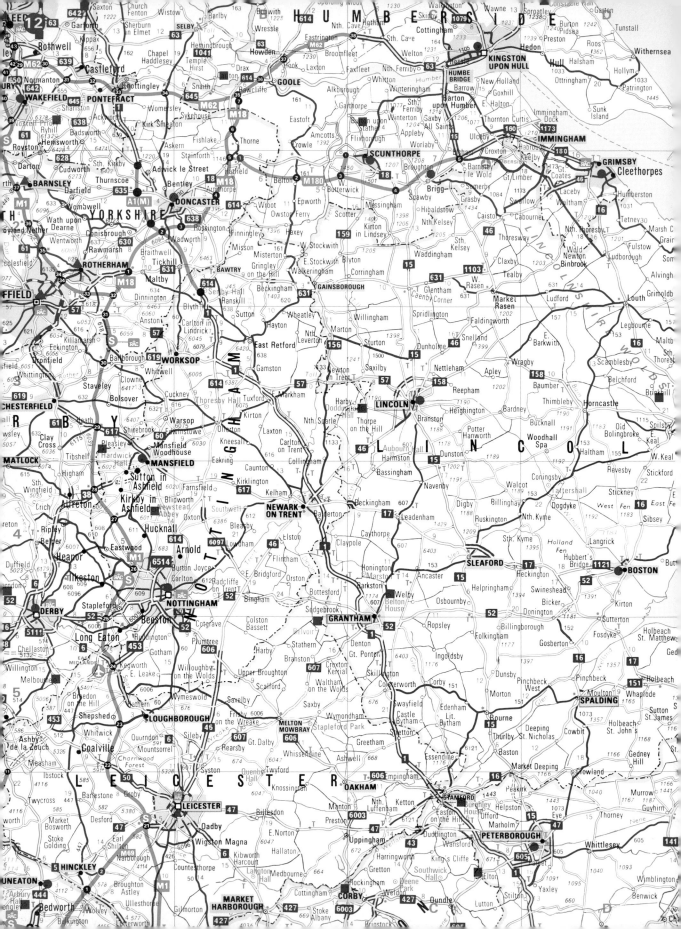

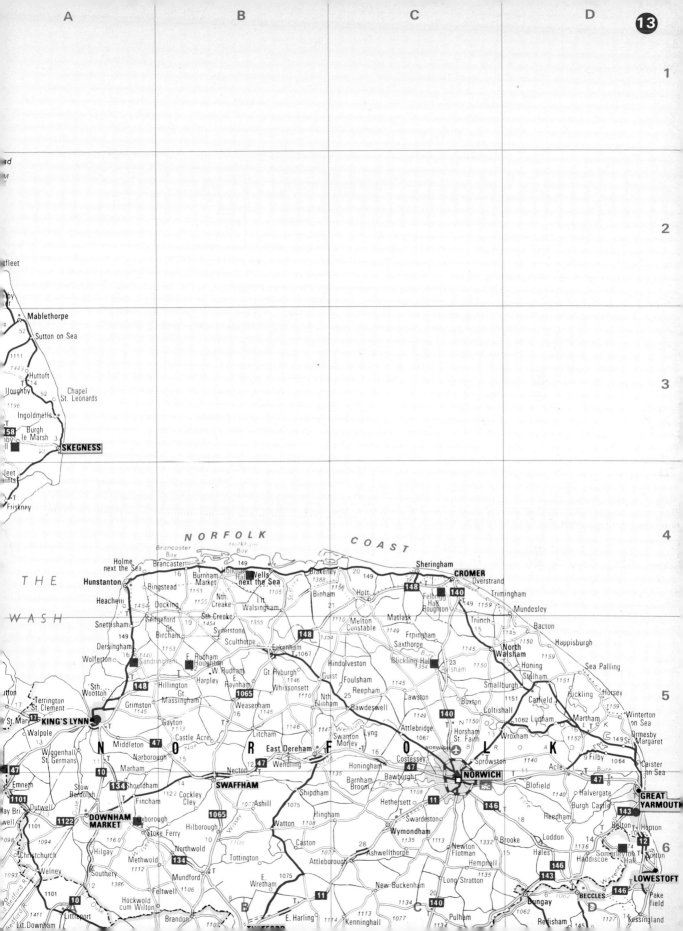

A B C D

1

2

3

Mablethorpe

52 Sutton on Sea

1111

1443 Huttoft
T 14
Lloughby 52 Chapel
1196 St. Leonards

Ingoldmells

58 Burgh
le Marsh 3
52 **SKEGNESS**

Friskney

N O R F O L K *C O A S T*

4

T H E

W A S H

Holme
next the Sea Brancaster
Brancaster 16
Bay Holkham
Bay
Hunstanton Burnham Holkham Wells
Ringstead Market Hall next the Sea Blakeney 20 Sheringham
Heacham 1153 1105 1388 1156 Holt **148** **CROMER**
1454 Docking 1155 Nth. Binham 21 Overstrand
Snettisham Sedgeford Gt. Creake Lit. Matlask Felbrigg **140** Trimingham
 19 Bircham 6th Creake Walsingham 1110 Melton Hall 149 1159 Mundesley
Dersingham 1454 Syderstone 1355 Constable 1149 Frpingham Trunch Bacton
Wolferton 1153 Sculthorpe **148** 1354 Saxthorpe 1145 1150 Happisburgh
16 1440 Houghton Fakenham Hindolveston Blickling Hall North 1159
Sandringham E. Rudham T 1067 23 Walsham Honing Sea Palling
Sth. Hillington W. Rudham Gt. Ryburgh Guist Foulsham Cawston 1354 Aylsham 1150 Stalham 1151
Wootton **148** Harpley E. 1146 Reepham 1145 Smallburgh Catfield Hickling Horsey
Grimston Gt. Raynham Whissonsett 1110 Nth. 25 Coltishall 1151 1159 Winterton
KING'S LYNN 1145 Massingham Weasenham Elmham Bawdeswell 1149 **140** Ludham 1062 Martham on Sea
Gayton 1145 1145 Attlebridge Norwich Horsham Wroxham 1152 Ormesby
Walpole 1153 Castle Acre Litcham Swanton Lyng 1067 St. Faith St. Margaret
Middleton **47** Nar East Dereham Morley 16 Costessey Sprowston 9 Filby 1064 Caister
N Narborough 15 **47** Wendling Honingham **47** Acle on Sea
47 Marham Necton Bawburgh Blofield 1140 **47** T
Emneth Stow Shouldham **134** **SWAFFHAM** Barnham **NORWICH** Halvergate **GREAT**
Wiggenhall Bardolph 1122 Cockley Shipdham Broom Hethersett 1108 Burgh Castle **YARMOUTH**
47 St. Germans 11 **10** Fincham Cley 1077 Ashill 1075 Hingham **11** Reedham **143**
1101 Outwell **134** **1065** Hilborough Watton 1108 Swardeston **146** Loddon Belton Hopton
Bri 1101 **1122** Oxborough 1108 Wymondham 1135 1113 Brooke Hales **12**
Christchurch 1094 **DOWNHAM** Stoke Ferry 1108 Newton 1332 Somerleyton **LOWESTOFT**
1098 **MARKET** Hilgay Northwold Caston Ashwellthorpe Flotman Haddiscoe Norton
Welney 116.0 Methwold **134** 1077 28 Hempnall 1135 Hall
1093 Southery 1112 Tottington E. 1075 Attleborough Long Stratton **146**
10 Feltwell Mundford 1386 Wretham New Buckenham 1135 **143**
1101 Hockwold 1106 **11** Pulham **146**
1411 **A** Littleport cum Wilton Brandon **B** **THETFORD** E. Harling 1114 Kenninghall **C** **140** Bungay **BECCLES** **146**

6

5

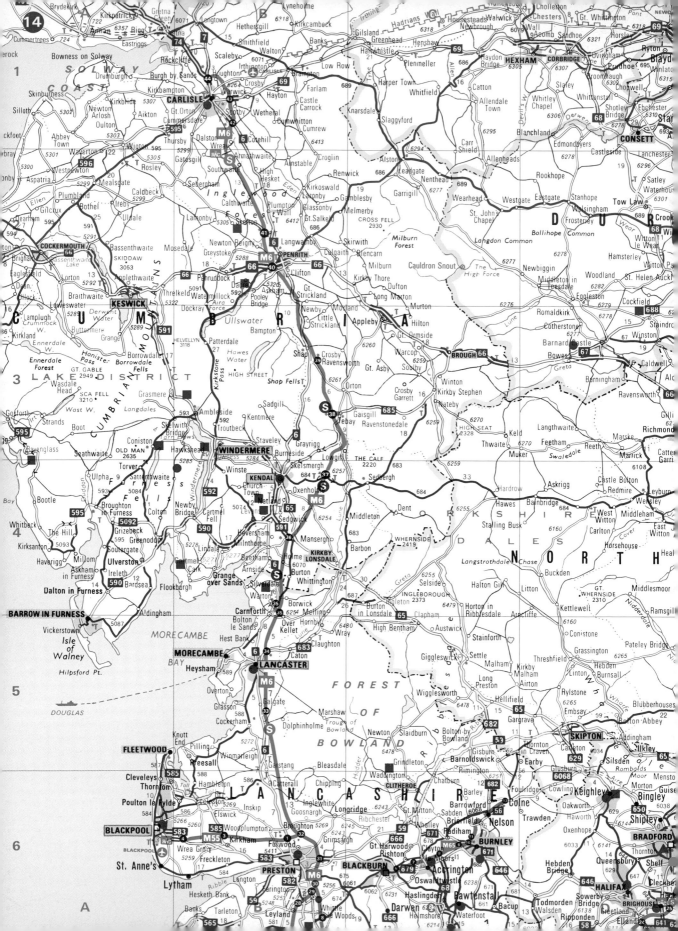

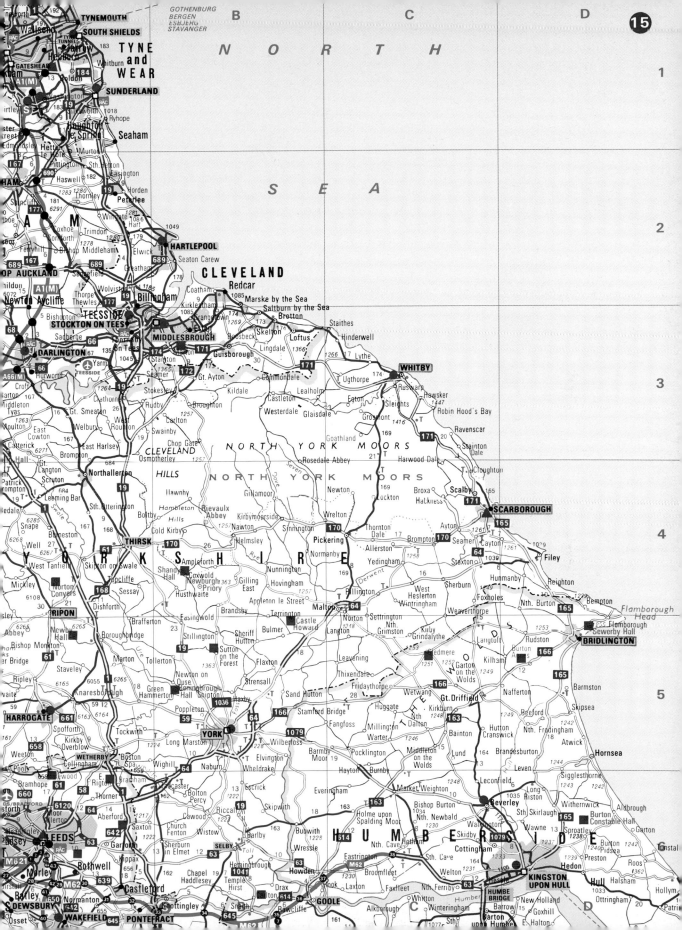

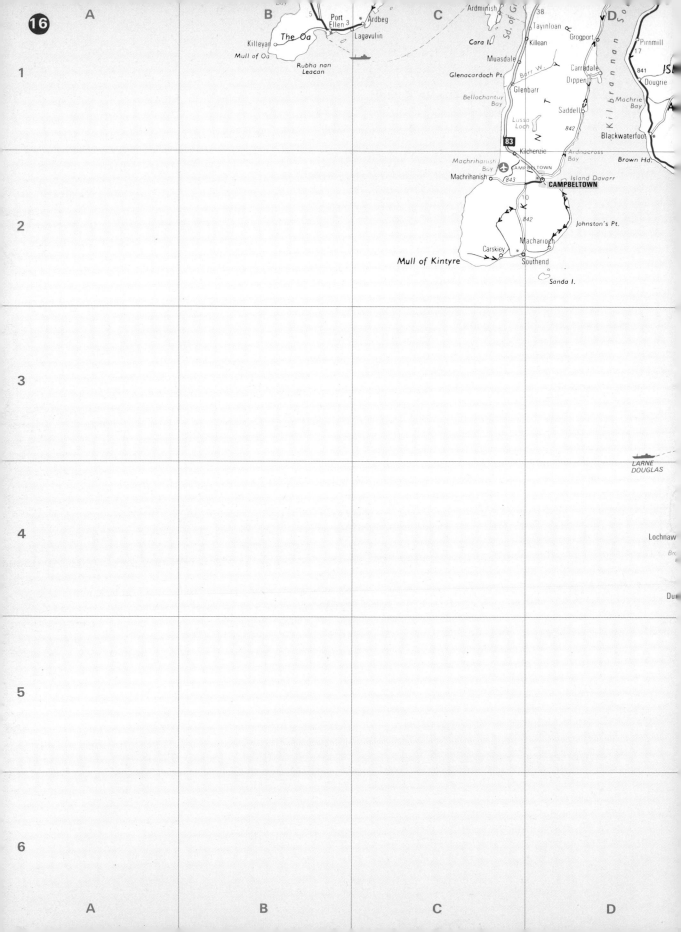

A B C D

1

2

3

4

5

6

A B C D

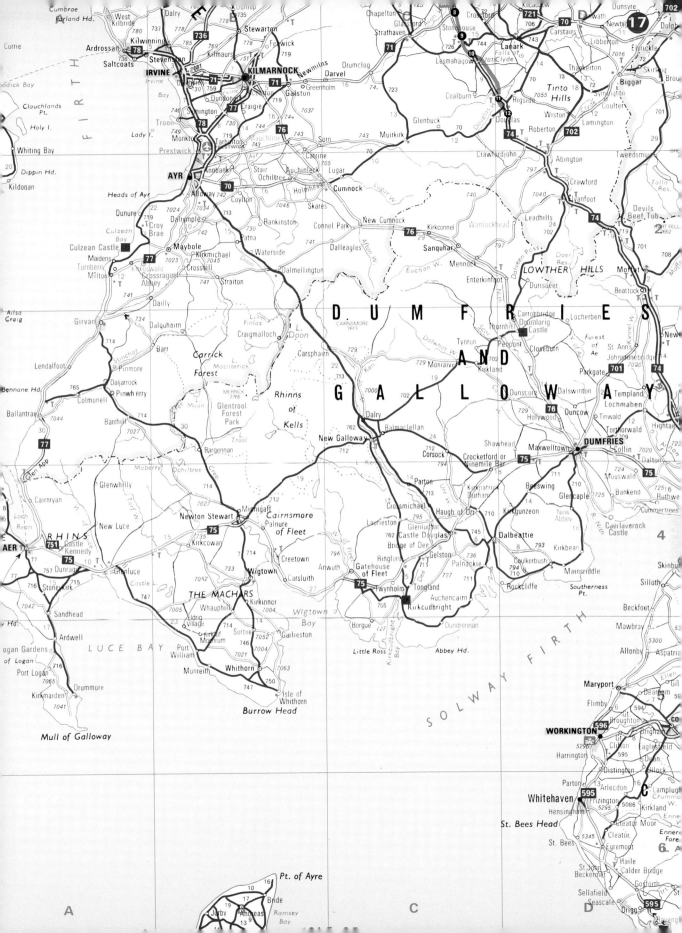

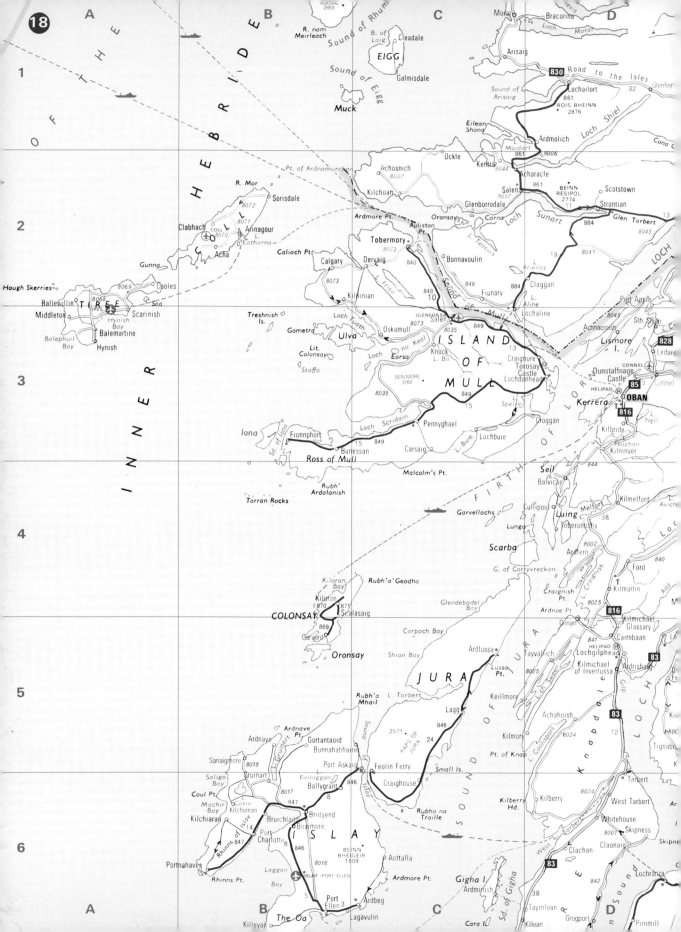

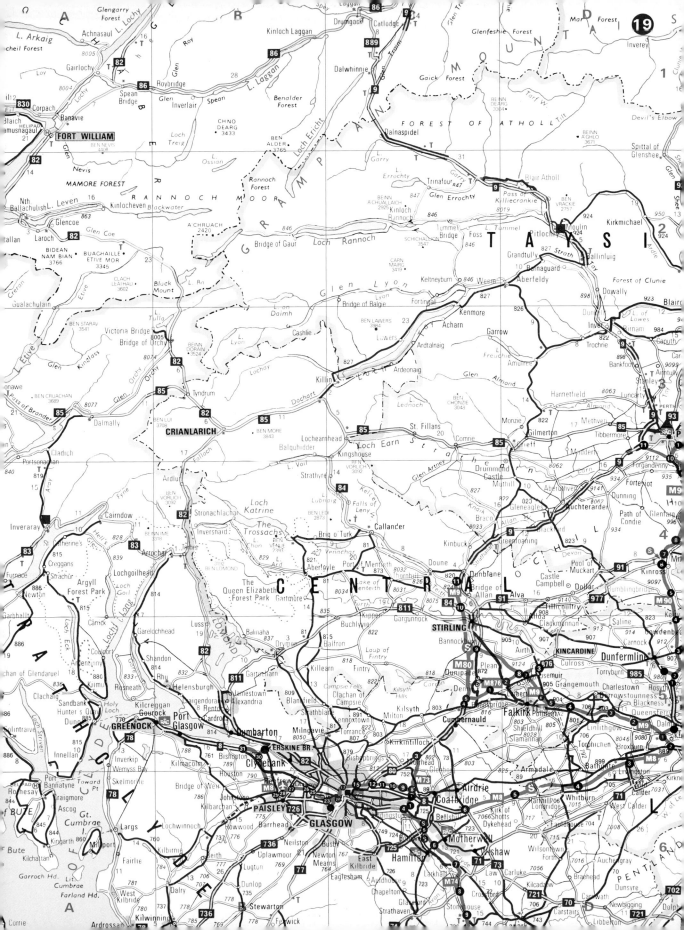

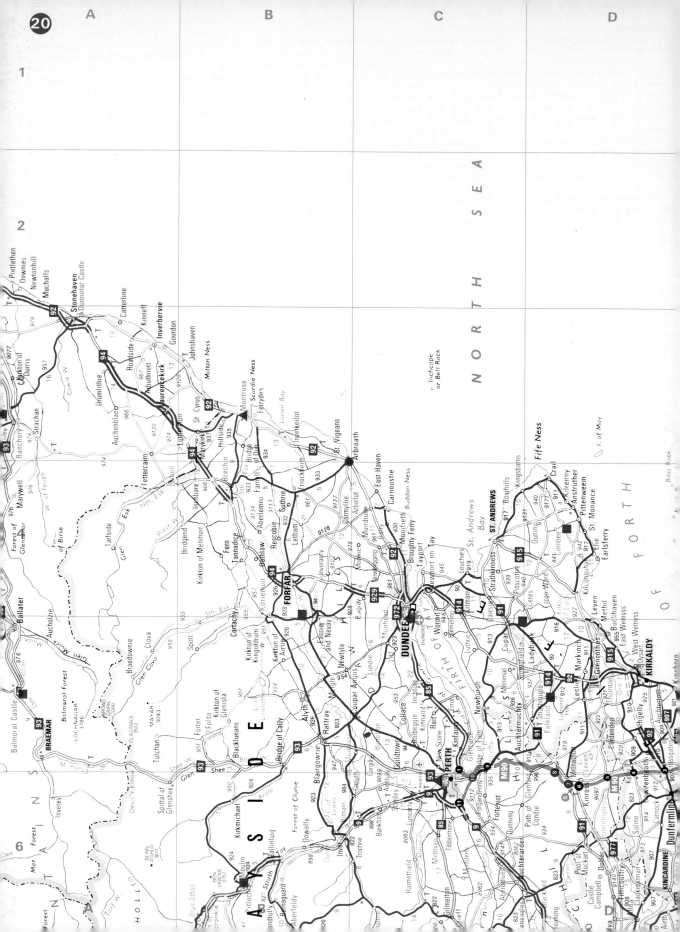

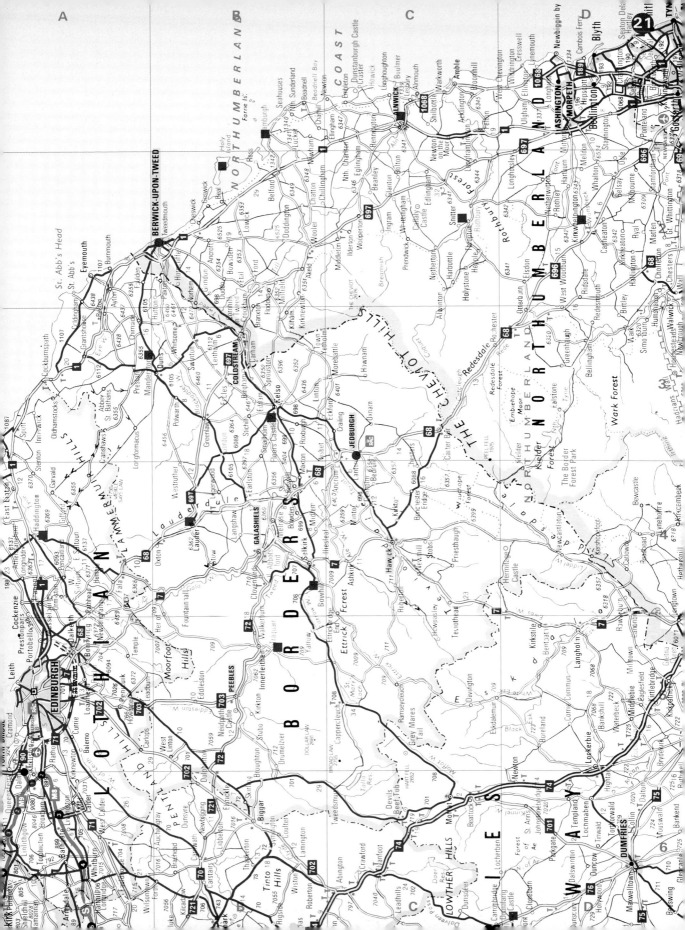

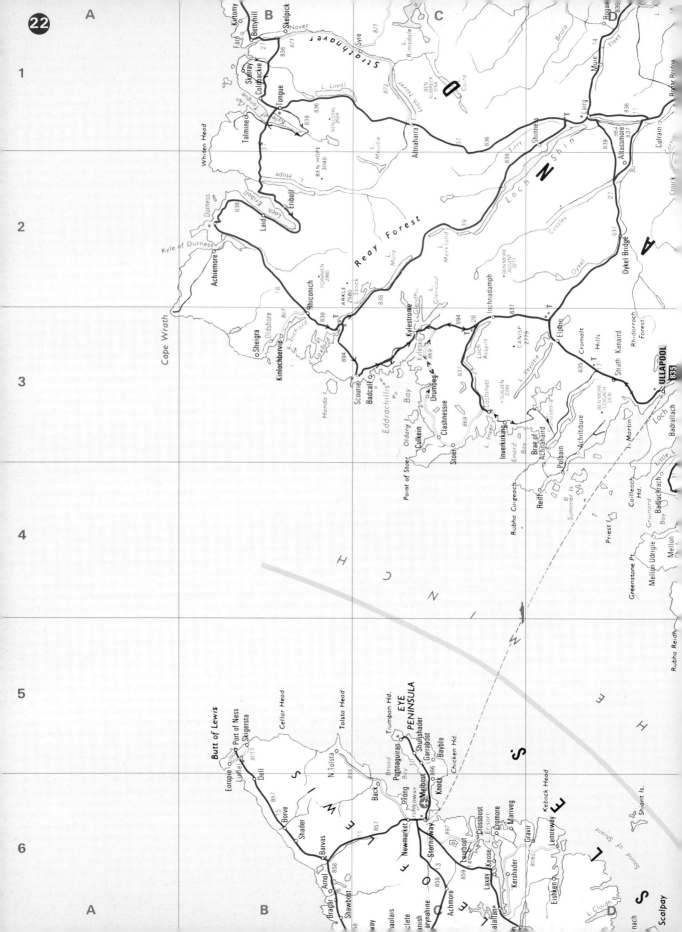

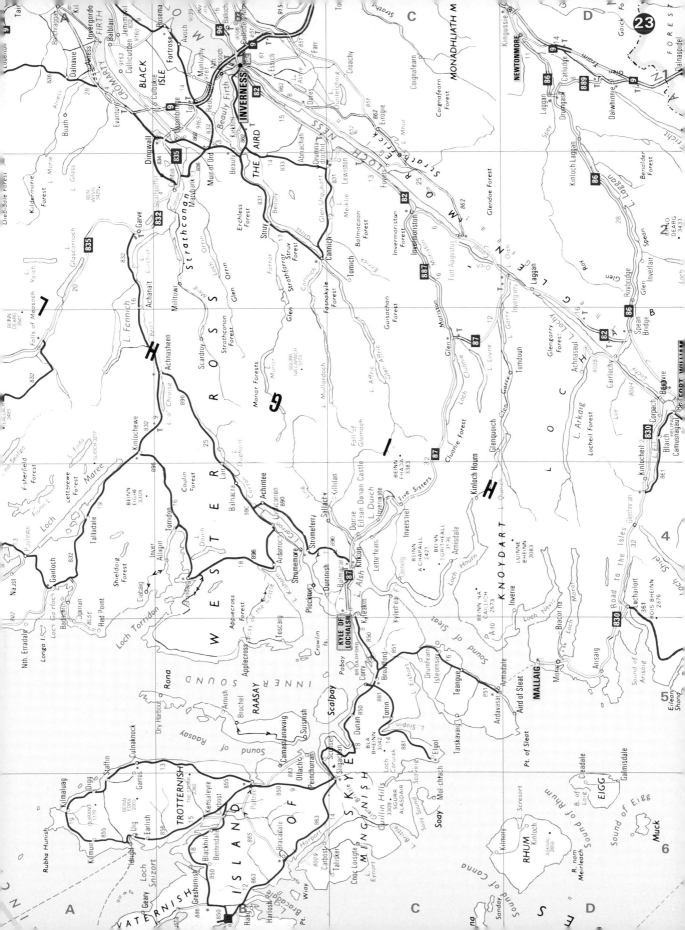

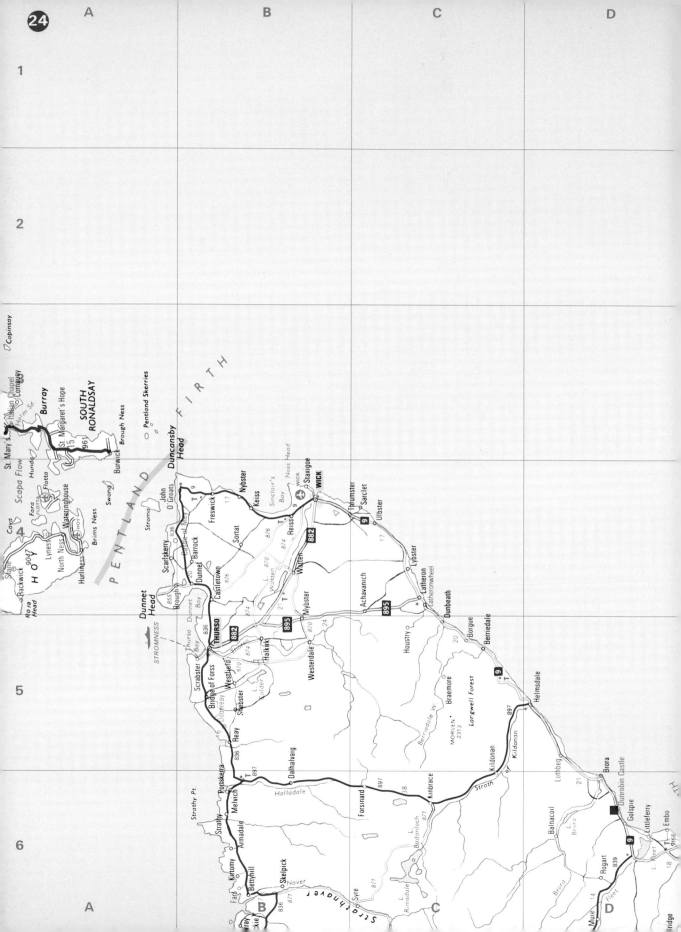

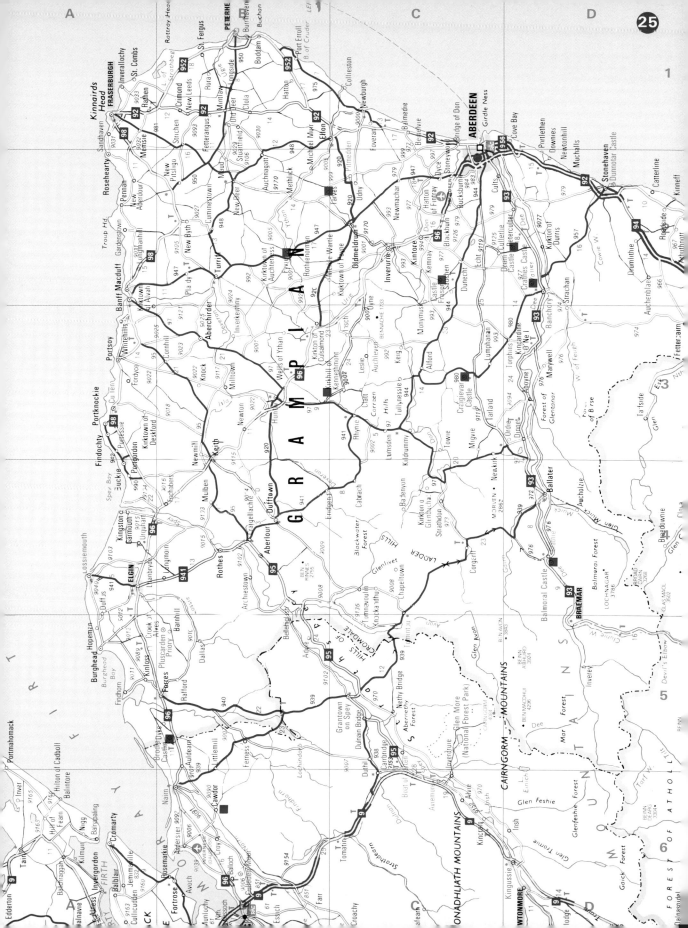

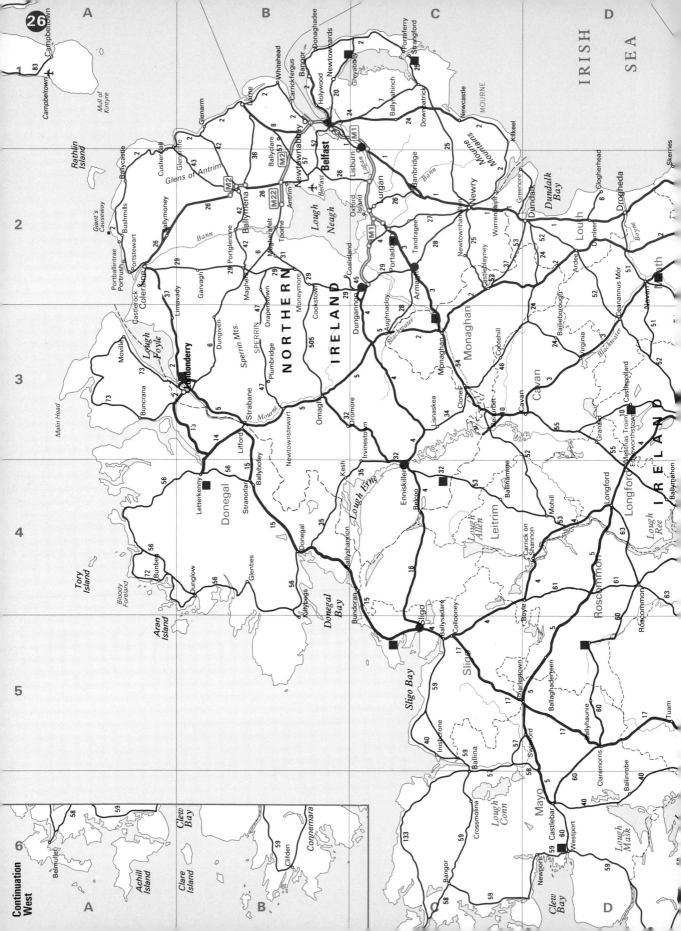

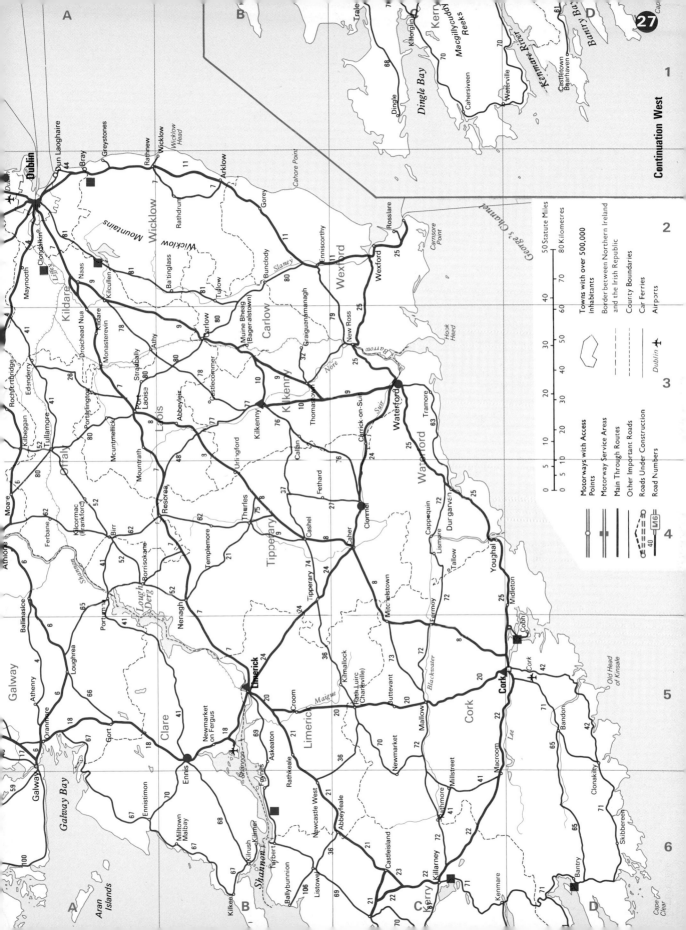

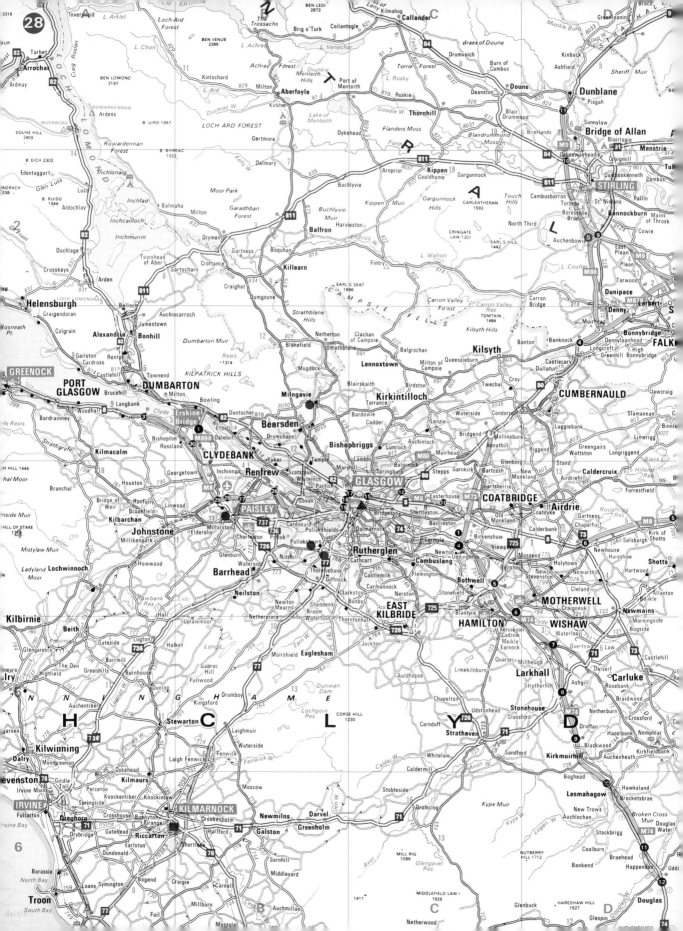

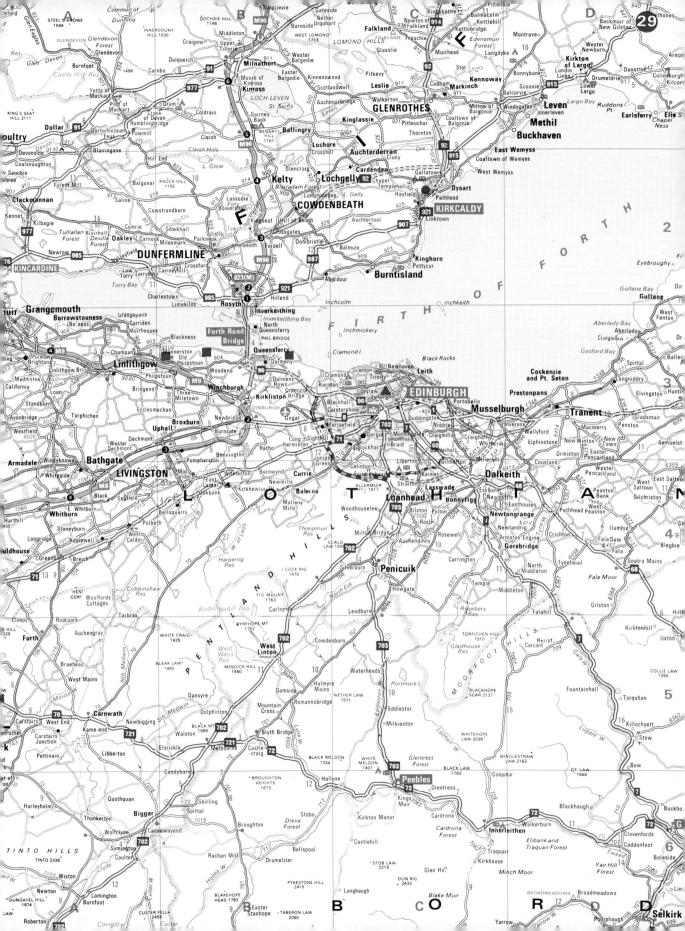

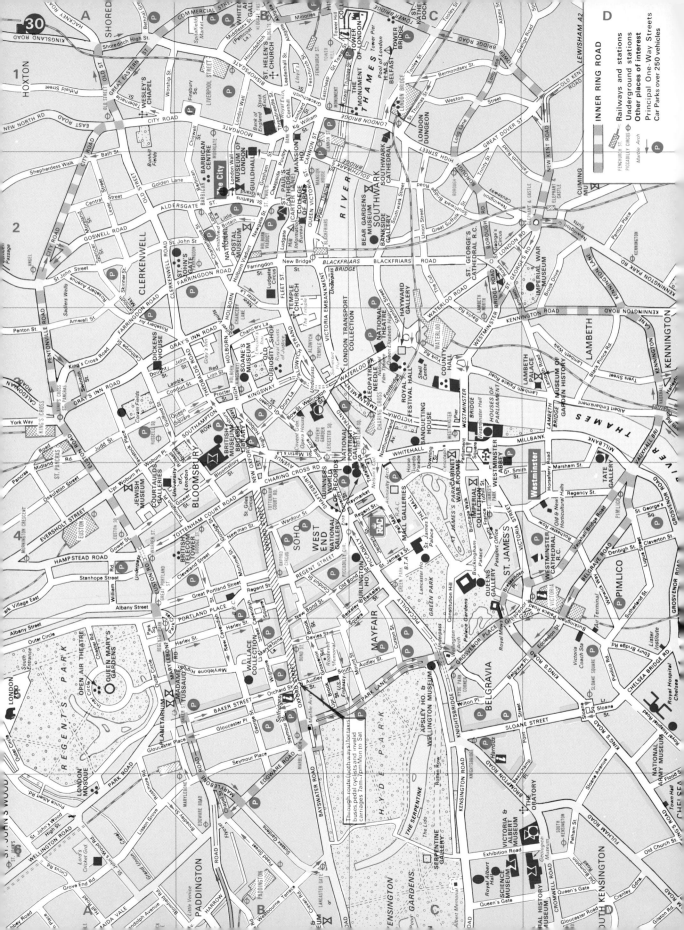

— INTRODUCTION TO GAZETTEER —

The entries that follow are necessarily brief. They attempt to give an overall impression of each collection, placing emphasis on works that are regarded as important by the staffs responsible for them, or are popular with visitors. Since the information in general has derived from owners and curators, all of whom have had the opportunity to check and correct the details, their attributions are followed.

Judgements about individual works, schools and the general presentation of collections are the author's. There are approximately 550 fine art collections in Britain and Ireland, a slightly larger number than houses than museums and art galleries. Eighty-one are National Trust properties, and these are indicated with the oak leaf symbol.

The order, already explained at the beginning of the Art Atlas, is by county, and alphabetically within each county. England is followed by Wales, Scotland, Northern Ireland and the Republic of Ireland.

Gazetteer

ENGLAND

AVON

THE AMERICAN MUSEUM
Claverton Manor, Bath 2 7BD
Telephone: (0225) 60503

THE HALCYON FOUNDATION
Open: Apr–Oct daily 2–5; BH Mon and
preceding Sun 12–5
Closed: Mon
Limited access for disabled

Two and a half miles from Bath station,
via Bathwick Hill, three miles south-east
of Bath via Warminster Road (A36) and
Claverton village. **9 D6**

Claverton Manor houses the only Amer-
ican museum in Britain. It was the first
such museum outside the United States,
and was founded to foster Anglo-
American understanding.

There are works by American artists,
including characteristic naïve paintings,
and examples of folk art. Portraits suited
to the sixteen period rooms are to be
found throughout the house.

**CITY OF BRISTOL MUSEUM
AND ART GALLERY**
Queen's Road, Bristol 8
Telephone: (0272) 222000

BRISTOL CITY COUNCIL
Open: Mon–Sun 10–5
Admission Free: Access for disabled

In Queen's Road close to the city centre.
9 C6

The Bristol Art Gallery and Museum is
the most important art gallery in the west
of England, with a good general collection
as well as an excellent group of local
Bristol work.

Early Italian paintings include Giovanni
Bellini's *Descent into Limbo* and Taddeo
Gaddi's *Crucifixion and Lamentation*. A
triptych of 1514 by Antonio da Solario
features the portrait of a Bristol merchant's
son. Among later Italian paintings are
Pietro da Cortona's *Laban Seeking his
Idols*, Sebastiano Conca's *Education of the
Virgin* and Crespi's *Flight into Egypt*. There
are large canvases by Mola, Luca Giordano,
Trevisani and Solimena, as well as Venetian
views and capriccios by Marieschi and
Bernardo Bellotto.

The Dutch and Flemish collection
contains Brouwer's *Interior of a Tavern,
Peasants Carousing* and a large *Nativity* by
Jacob Jordaens. The nocturnal *Annunciation
to the Shepherds* by Nicolaes Berchem
hangs beside a *Still Life* by Berchem's
father, Pieter Claesz. There is a portrait
of *Martin Luther* by Lucas Cranach, and
works by Quentin Massys, Pieter de
Hoogh (*The Jacott-Hoppesack Family*),
Jacob Ruisdael and Salomon de Bray.

There is a good collection of French
paintings. Highlights include the Le Nain
brothers' *The Visiting Musicians*, the
original version of Lebrun's *The Brazen
Serpent*, Delacroix's *Head of a Woman in
a Red Turban* and Forain's bold *Court
Scene*. Portraits range from a sixteenth-
century *Unknown Man* by Corneille de
Lyon, Philippe de Champaigne's austere
Abbé St-Cyran and Baron Gros's *Mme
Bruyère* to the bright Renoir pastel of the
Lerolle Sisters and an informal Vuillard:
Mme Hessel and her Dog at Home. Sisley's
L'Entrée du Village and early works by
Corot and Monet (*Pointe de la Heve*, St
Adresse) are among the landscapes. There
is a powerful seascape by Courbet,
L'Eternité, and a fantasy by C.-J. Vernet
which transfers the Temple of Minerva
Medica from Rome to the Italian coast.
Eugène Boudin, better known for his
beach scenes, is represented by a *Still Life
with Oysters,* and there is a Hubert Robert
view of the *Loggia of the Villa Albani,* as
well as works by Gustave Moreau, Seurat
and Odilon Redon.

British paintings begin with seven-
teenth-century full-length portraits: Rob-
ert Peake's *Charles I as Duke of York,* and
a magnificently dressed *Unknown Lady*
(by Marcus Gheeraerts?). The Georgian
Pot Boy contrasts with the princely *Duke
of Portland* by the Bristol-born Thomas
Lawrence; Lawrence's *Lady Caroline Lamb*
is unfinished. The lively *Four Elder Children
of Thomas Penn* is by Reynolds; his group
portrait of *The Committee of Taste* was

once in Horace Walpole's collection. There are portraits by Zoffany and Gainsborough, a violent sea battle by De Loutherbourg which records *The Cutting-Out of the French Corvette 'La Chevrette'*, and James Ward's *The Swineherd*. Georgian landscapes include works by Richard Wilson and Thomas Barker of Bath.

Nineteenth-century artists working in Bristol included W. J. Muller, who studied in the Bristol Museum (his father was the first curator), and Francis Danby, whose small panels depicting scenes of country pleasure include *Boys Sailing a Little Boat*. Many responded to the city and surrounding countryside with oils and watercolours remarkable for their handling of light. The Gallery owns fine examples of topographical work by Samuel Jackson, James Johnson and J. B. Pyne. Two of the most interesting works here are the visionary *Israelites Passing through the Wilderness, Preceded by the Pillar of Light* by William West, and *David Dancing before the Ark of the Covenant* by Samuel Colman.

The better-known Victorians are represented as well: Burne-Jones by *St George and the Dragon: The Return*, a version of his *Briar Rose: The Garden Court*; Alma-Tadema by *Unconscious Rivals*; Tissot by *Les Adieux*; and Frank Dicksee by *La Belle Dame sans Merci*. Civic pride was a strong purchasing motivation: Ernest Board's *The Departure of John and Sebastian Cabot from Bristol* and Wilde Parson's *Queen Elizabeth Passing down the Avon* remain popular acquisitions. Stanhope Forbes's *Home-along, Evening*, purchased in 1910, was progressive for its time. *Stranded* was Munnings's first painting accepted for the Royal Academy. The predictable eroticism of William Etty is overshadowed by Lord Leighton's *The Mermaid (The Fisherman and the Syren)*.

Twentieth-century British painting forms one of the gallery's outstanding collections, with most of the major artists represented, from Sickert on. His *Horses of St Mark's, Venice*, with a fine *Nude Figure on a Bed* by Spencer Gore, are among the early works. Still lifes include a flamelike *Flowers* from war-time London, by David Bomberg, and Matthew Smith's *Three Pears*. Other striking paintings are Ben Nicholson's *Oval and Steeple*, Eric Ravilious's *Tennis* (decoration for a London flat), William Roberts's *The Palms Foretell* and Barbara Hepworth's *The Hands*. There are landscapes by Christopher Wood, who was born in Wiltshire, and Roderic O'Conor (*Promontory, Brittany*). William Scott, John Piper, Peter Blake (*The Owl and the Pussycat*), David Inshaw and Richard Long – who lives in

the city – are some of the many modern and contemporary artists whose works hang here.

See entry in main text, pages 244–6.

CLEVEDON COURT ❧

Clevedon BS21 6QU
Telephone: Clevedon (0272) 872257

NATIONAL TRUST
Open: 1 Apr–30 Sept Wed, Thurs, Sun, BH Mon 2.30–5.30; last admissions 5
No access for disabled

On the B3130 Bristol Road, one and a half miles east of Clevedon. **9 C6**

The collection is modest, reflecting the eighteenth-century taste of the Elton family. The Great Hall contains works by artists such as Thomas Hudson, Nathaniel Hone, Thomas Beach and Johann van Diest. There are portraits also by Emmeline Deane and William Gush.

The house has several literary associations, one with Thackeray, whose full-length cartoon by the sculptor Boehm hangs at the top of the stairs. Part of Sir Arthur Elton's collection of prints and drawings of industrial archaeology hangs on the staircase.

DYRHAM PARK ❧

Near Chippenham SN14 8ER
Telephone: Abson (027 582) 2501

NATIONAL TRUST
Open: 1 Apr–4 Nov daily except Thurs, Fri 12–5.30; last admissions 5
Limited access for disabled

Eight miles north of Bath, entrance on A46, two miles south of M4 (Exit 18) Tormarton interchange with A46. **9 D6**

The works of art at Dyrham Park, mainly Dutch in character, reflect the taste of William Blathwayt, Secretary of State to William III. The portrait of *William Blathwayt* by Michael Dahl indicates his confidence and ambition, and is one of many portraits in the house, which he rebuilt. That of the seventeenth-century playwright *Thomas Killigrew* by William Sheppard (another version is in the National Portrait Gallery) once belonged to the collector *Thomas Povey*, who was himself painted – twice – by John Michael Wright.

Povey was William Blathwayt's uncle, and owned the illusionistic *Perspective View of the Courtyard of a House* by Samuel van Hoogstraeten. Samuel Pepys visited Povey's London collection in 1663

and admired 'above all things' the van Hoogstraeten *View Down a Corridor* which now hangs in the Gilt Leather Closet, where it appears as a real corridor in a Dutch seventeenth-century house.

Murillo's *Peasant Woman and Boy* stands out from a collection of Dutch and Flemish works, many in original frames, which includes a fine group of paintings of ornamental fowl by Melchior de Hondecoeter, Frans Snyders's *Lion Hunt* and *Bear Hunt,* and Hendrick van Minderhout's *Antwerp from across the Scheldt* and *Oriental Harbour*.

The allegorical ceiling paintings by Andrea Casali were originally done for Fonthill Splendens, the house that William Beckford pulled down in order to build Fonthill Abbey.

See entry in main text, page 249.

THE GEORGIAN HOUSE

7 Great George Street, Bristol BS1 5RR
Telephone: (0272) 299771

BRISTOL CITY COUNCIL
Open: Mon–Sat 10–1, 2–5
Admission Free: Limited access for disabled

On Great George Street, near the city centre. **9 C6**

This late eighteenth-century merchant's house, built for John Pretor Pinney, who made a fortune in the West Indies from sugar, has been restored by the Bristol City Museum and Art Gallery, and refurnished with period furniture. The pictures are also of the period, many of local interest.

Wordsworth and Coleridge were friends of John Pinney and may have first met at the house. In the basement is a cold-plunge bath used throughout his life by Pinney.

HOLBURNE MUSEUM AND CRAFT CENTRE

Great Pulteney Street, Bath BA2 4DB
Telephone: (0225) 66669

TRUSTEES OF HOLBURNE MUSEUM AND CRAFT CENTRE
Open: mid Feb–mid Dec Mon–Sat 11–5, Sun 2.30–6, incl. BHs
Closed: mid Dec–mid Feb, and Mons Nov–Easter
Limited access for disabled

Across Pulteney Bridge, to the west of the city. **9 D6**

The nucleus of the museum collection was formed through the efforts of Sir Thomas William Holburne.

There are a number of interesting pictures by Flemish, Dutch and Italian sixteenth-, seventeenth- and eighteenth-century artists. Holburne's taste for English painting of the eighteenth and early nineteenth centuries, with his particular penchant for the genre compositions of Thomas Barker of Bath, provide a strong element in the collection.

It has been further strengthened by recent gifts and bequests. There are portraits by Allan Ramsay, a Gainsborough, works by Zoffany, Raeburn, and Morland, and *The Reverend Robert Carter Thelwall and his Family* by George Stubbs.

Earlier portraits include *The Earl of Rochester* by Wissing.

See entry in main text, page 247.

THE RED LODGE

Park Row, Bristol BS1 5LJ
Telephone: (0272) 299771

BRISTOL CITY COUNCIL
Open: Mon-Sat 10-1, 2-5
Admission Free: No access for disabled

On Park Row near to the city centre.
9 C6

The only house in Bristol with sixteenth-century interiors, on the first floor, though the ground floor was remodelled in the eighteenth century. Both floors are appropriately furnished, with paintings from the City Museum and Art Gallery collection.

The house was also the first girls' reform school in Britain, and a room is retained as a memorial to the founder, Mary Carpenter.

1 ROYAL CRESCENT

Bath BA1 2LR
Telephone: (0225) 28126

BATH PRESERVATION TRUST
Open: Mar-Christmas Tues-Sat 11-5; BH Mon and Sun and during Bath International Festival 2-5; last admissions 4.40
No access for disabled

Within walking distance of the centre of the town. **9 D6**

This eighteenth-century end-house of Royal Crescent, in Bath, was reputedly where Marie-Antoinette stayed on her visit in 1786. Ten years later it was taken for a short time by the Duke of York. It

has been restored and furnished in eighteenth-century style, with paintings which both match and extend one's appreciation of fashionable Bath society. There is a slight Irish flavouring in some of the furniture and in the interesting early eighteenth-century *Panoramic View of Dublin from the Liffey* by the otherwise rare artist Thomas Bate.

A majority of the paintings are portraits, including William Beechey's striking *George III,* a number by the West Country pastellist William Hoare (1706-92), among which is his portrait in oil of the *Four Bath Worthies,* the men responsible for the building of Georgian Bath, and works by the Devonshire portrait painter Thomas Hudson. Works by Francis Cotes, Allan Ramsay and John Opie also hang in the house.

ST NICHOLAS CHURCH AND CITY MUSEUM

St Nicholas Street, Bristol 1
Telephone: (0272) 299771

BRISTOL CITY COUNCIL
Open: Mon-Sat 10-5
Admission Free: Limited access for disabled

On St Nicholas Street in the city centre.
9 C6

This museum is administered by the Bristol City Museum and Art Gallery. It is chiefly remarkable for the triptych by Hogarth which was commissioned as an altarpiece for St Mary Redcliffe. The three large paintings depict *The Ascension, The Sealing of the Sepulchre* and *The Three Marys at the Tomb.* The triptych was completed in 1756 and Hogarth signed a receipt for £525.

The museum also has a good collection of watercolours, among them outstanding examples of J. B. Pyne and T. L. Rowbotham. The museum also has a good collection of Church plate.

VICTORIA ART GALLERY

Bridge Street, Bath
Telephone: (0225) 461111

BATH CITY COUNCIL
Open: Mon-Fri 10-6, Sat 10-5
Closed: Sun, BH
Admission Free: No access for disabled

In the city centre, near Pulteney Bridge on the first floor above the public library. **9 D6**

A good art collection, though somewhat handicapped by space and staff limitations. There are too many temporary exhibitions. These take over the Main Gallery hanging space, leaving only the Small Gallery and Staircase for works from the permanent collection. The Staircase is rearranged annually. The collection contains a good representation of art connected with Bath and the surrounding area, as well as works by local artists, particularly Thomas Barker of Bath.

The most important early work in the collection is *Adoration of the Magi,* probably a Flemish copy of a Hugo van der Goes (1435-82), but there are a number of early Dutch and Flemish works. Topographical and subject pictures of Bath are numerous and a residual collection on the staircase indicates a promising representation of late nineteenth- and twentieth-century art.

See entry in main text, page 248.

—— BEDFORDSHIRE ——

CECIL HIGGINS ART GALLERY

Castle Close, Bedford MK40 3NY
Telephone: (0234) 211222

NORTH BEDFORDSHIRE BOROUGH COUNCIL
Open: Tues-Fri 12.30-5, Sat 11-5,
Sun 2-5
Admission Free: Access for disabled

Off Newnham Street in the town centre.
6 C6

Although first opened only in 1949, this gallery has a good general collection of mainly British art, ranging from the seventeenth century to the present, and including an extensive representation of watercolours and graphics.

It is rich in European prints as well, and this collection includes works by Rembrandt, Dürer, Matisse, Picasso and the Impressionists. Noteworthy are Renoir's *The Pinned Hat,* Miró's *La Revue* and Picasso's *The Frugal Meal.*

There are fine examples of Thomas Girtin, among them his *Jedburgh Abbey from the River,* works by Bonington and several by Turner. There is Constable's *Coal Brigs on Brighton Beach* and examples of David Cox, Samuel Palmer, John Linnell and Edward Lear.

The gallery boasts two notable sculptures: *Four Figures Waiting* by Barbara Hepworth and *The Helmet* by Henry Moore.

See entry in main text, pages 204-6.

LUTON HOO

Luton LU1 3TQ
Telephone: (0582) 22955

THE WERNHER FAMILY

Open: mid Apr–mid Oct daily except
Mon but inc BH Mons. Ring for times.
Access for disabled

Thirty miles north of London via Exit 10
of the M1. Entrance at Park Street gates.
6 D6

The works of art at Luton Hoo were
mainly collected by Sir Julius Wernher,
who made his fortune from diamonds.
He was given a baronetcy in 1905.

The finest paintings in the collection
are from the fifteenth and sixteenth
centuries, and include the magnificent
Spanish altarpiece dating from 1470, *Saint
Michael Slaying the Dragon*, by Bartolomé
Bermejo. There are paintings by Filippino
Lippi and Hans Memling. A fine collection
of Dutch pictures includes works by
Rembrandt, Metsu, van Ostade and Frans
Hals.

Luton Hoo also contains excellent
Renaissance bronzes, ivories, and a splen-
did group of Carl Fabergé's work,
originally the property of Nicholas I's
grandson, the Grand Duke Michael of
Russia, whose daughter married Sir
Harold in 1917. The Russian rooms
contain some Russian paintings, mainly
portraits.

See entry in main text, page 202.

LUTON MUSEUM AND ART GALLERY

Wardown Park, Luton LU2 7HA
Telephone: (0582) 36941

BOROUGH OF LUTON

Open: All year except Christmas Day
Mon-Sat 10-5, Sun 1-5
Admission Free: Limited access for disabled

The art gallery is in Wardown Park,
Luton. **6 D6**

The museum is biased towards ethnogra-
phy of the eighteenth and nineteenth
centuries. Paintings are topographical and
genre works of life in the Bedfordshire
countryside such as A. C. Cooke's *Luton
Plait Merchants Buying Straw Work from
French Prisoners of War*. Lacemaking was
a major Bedfordshire cottage industry and
there is a whole gallery devoted to the
craft.

WOBURN ABBEY

Woburn MK43 0TP
Telephone: (0525) 290666

TRUSTEES OF THE BEDFORD ESTATE

Open: 30 Dec-1 Apr Sat, Sun 11-4, open
NYD; 2 Apr-28 Oct daily 11-5
Access for disabled subject to prior
permission from administrator.

Eight miles north-west of Dunstable on
the A4012. Entrance to house is in town
centre; Exit 13 on the M1 is three miles
from Woburn. **4 C1**

Woburn Abbey has been the home of the
Russell family, Earls and then Dukes of
Bedford, since the middle of the sixteenth
century. This is reflected in the rich
collection of early English portraits, in the
rooms of Van Dyck and Reynolds
portraits and in an Old Master collection
that includes many works by Canaletto.

There is an abundance of portraits from
the sixteenth and early seventeenth century
on the Grand Staircase and in the Long
Gallery. On the staircase is John de Critz's
portrait of *Lucy Harrington, Countess of
Bedford*, shown wearing a dress designed
by Inigo Jones. Fine anonymous portraits
of her husband the 3rd Earl, of *Anne
Russell, Countess of Warwick* and of the
sons of the 2nd Earl also hang here.

The Long Gallery houses the splendid
Armada Portrait of Elizabeth I by George
Gower, and many superb full-lengths by
Marcus Gheeraerts, ranging from the
Robert, Second Earl of Essex (painted from
life in 1590) to the late *Sir William Russell*
and *Lady Russell*, painted in 1625. The
portrait of *Elizabeth Brydges, Lady Kennedy*,
is one of the finest Elizabethan portraits,
dating from 1589. There are delightful
children's portraits: Robert Peake's so-
called *Elizabeth, Queen of Bohemia*, painted
with her shock-dog and parrot, and a set
of likenesses by Johann Priwitzer of the
children of the 4th Earl of Bedford.

The fine full-length of *William, First
Baron Russell* is by an anonymous artist;
Anne, Countess of Warwick is attributed to
Gower and the portrait of *Frances Howard,
Countess of Essex* to William Larkin. The
soldierly *Earl of Rutland* by Gheeraerts
and *Henry Danvers, First Earl of Danby* by
an anonymous artist are shown in their
tents. *Elizabeth Vernon, Countess of South-
ampton* is by Cornelius Jonson. Together,
these portraits form a remarkably fine
collection of early English painting.

Later portraits are to be seen throughout
the house: Gainsborough's *Fourth Duke of
Bedford* in the Duke's former bedroom, a
large Charles Jervas group portrait of
Elizabeth Howland, Duchess of Bedford with

her Children in Paternoster Row, and Van
Dyck's full-lengths of the *Fourth Earl of
Bedford* and his Countess, *Anne Carr* on
the Grand Staircase. The rows of portraits
in the Dukes' Corridor include fine
nineteenth-century portraits like Sir Fran-
cis Grant's *Lord John Russell*. One Duchess,
Gertrude Leveson Gower, Duchess of Bedford,
sat to Thomas Hudson and to Reynolds,
with memorable results.

In the Yellow Drawing Room are
paintings connected with William, Lord
Russell, who was executed in 1683; John
Downman's painting of 1790 shows Lord
Russell's farewell to his family. His father
appears in *Lord William Russell with his
Dwarf* by Johann Priwitzer, and his sisters
in *Anne and Diana Russell*, attributed to
John Hayls.

The Flying Duchess's Room features
Victorian and Edwardian animal and bird
paintings; the Racing Room, racing
pictures from the eighteenth to twentieth
centuries by Boultbee, Sartorius, Sawrey
Gilpin, Herring, Susan Crawford and
Stephen Pearce.

Queen Victoria's Bedroom contains her
own etchings, portraits by Heinrich von
Angeli of her daughter and son-in-law
the Crown Prince and Princess of Prussia
and history paintings by Hayter and
C. R. Leslie *(Pilgrims in sight of Rome)*.
Other notable nineteenth-century paint-
ings at Woburn include Hayter's fine *St
John in the Island of Patmos* in the Parlour,
and a large seapiece by J. C. Schetkey,
*The Victory of La Hogue won by Admiral
Russell*.

Seventeenth-century Dutch and Flemish
paintings are in Queen Victoria's Dressing
Room: landscapes by Cuyp, Jan van
Goyen and Paulus Potter *(Hawking Party)*
and Jan Steen's *Twelfth Night*. In the Blue
Drawing Room are French and Italian
paintings: Claude's *Pastoral Landscape with
Peasants Dancing*, Canaletto's *Regatta on
the Grand Canal* and Poussin's *Infant Moses
with Pharaoh's Crown*, with a landscape
by Gaspard Dughet.

In the State Saloon are modern murals
by Roland Pym which incorporate scenes
from Russell family history and portraits
of the present Marquess and Marchioness
of Tavistock in eighteenth-century dress.
The State Dining Room is hung with
portraits by and after Van Dyck. Of
particular quality are *A French Nobleman,
Albert Lemire, Dean of Antwerp, Lady
Herbert*, and *Princess Margaret of Lorraine,
Duchess of Orléans*.

There is an extra charge for visiting the
Private Apartments, open to the public
when not in family use. The magnificent
group of Reynolds portraits has a room
to itself, and includes Reynolds's dramatic

and powerful composition, *Lady Elizabeth Keppel,* and the flamboyant *Mr Peter Ludlow.* The Canaletto Room is celebrated for its fine Venetian views, which include Canaletto's *The Laguna and Grand Canal, Ascension Day.*

See entry in main text, pages 202–4.

———— BERKSHIRE ————

BASILDON PARK ⚘

Lower Basildon, Reading RG8 9NR
Telephone: Reading (0734) 843040

NATIONAL TRUST
Open: Apr–end Oct Wed–Sat 2–6,
Sun and BH 2–6; closed GF and
Wed after BH; last admissions 5.30
Limited access for disabled

On the west side of the A329 between Pangbourne and Streatley, seven miles north-west of Reading. **4 D2**

The paintings are predominantly Italian. They include works by Batoni, Pittoni, Galeotti, Bonavia, Panini and Orizzonte. English views of Venice by Marlow offer an additional dimension to the collection. A more modern work is Graham Sutherland's *Lord Iliffe.*

The restoration of the house was undertaken by Lord and Lady Iliffe, who chose Italian paintings as most suited to the late eighteenth-century architecture. Batoni, for example, valued in his day as a portraitist by those on the Grand Tour, is here seen in the unfamiliar but interesting guise of painter of religious subjects, most notably *God the Father* and seven of the Apostles. There is a fine *Rebecca at the Well* by Galcotti, and a pair of mythologies by Charles de la Fosse, originally painted for Montagu House (subsequently the first British Museum).

HENRY REITLINGER BEQUEST

Oldfield, Guards Club Road,
Maidenhead SL6 8DN
Telephone: (0628) 21818

TRUSTEES OF THE HENRY REITLINGER
BEQUEST
Open: Apr–Sept Tues and Thurs
10–12.30, 2.15–4.30; the first Sun
in each month 2.30–4.30; other times by
request
Admission Free: Limited access for disabled

On Guards Club Road in Maidenhead, close to the River Thames. **4 D1**

Captain H. S. Reitlinger developed an interest in prints and drawings while an undergraduate at Cambridge, subsequently extending his taste into sculpture, woodcarving, porcelain and pottery. He bought principally at auction, and his eye for line as well as a bargain brought some phenomenally rare, primitive and in some cases unique examples of Inca, Chinese, Japanese, Korean, early Italian, Persian and German Renaissance art forms.

The collection is a personal one. Reitlinger indulged his own taste, the main characteristic of which, and one which seldom failed him, was for line and simple form in very early art.

Paintings include an excellent Hendrik Goltzius, *Vertumnus and Pomona.* The artist was an engraver who influenced Rembrandt. *Captain Reitlinger* by Neville Lewis, a Turner drawing of Windsor Castle, a Constable landscape and a Sienese tondo (1470) are among other works of fine art. There is a small collection of drawings upstairs. There is a German marble head of a man dated 1540 and a remarkable collection of Chinese ceramics.

READING MUSEUM AND ART GALLERY

Blagrave Street, Reading
Telephone: (0734) 399809

BOROUGH OF READING
Closed for rebuilding until 1991

SANDHAM MEMORIAL CHAPEL ⚘

Burghclere, near Newbury
Telephone: (063 527) 394

NATIONAL TRUST
Open Apr–Oct Wed–Sun 11.30–6;
Nov–end Mar Sat, Sun 11.30–4
Access for disabled

Four miles south of Newbury, half a mile east of A34.

The paintings that decorate this chapel are Stanley Spencer's greatest achievement and rank among the finest mural schemes produced anywhere in Europe this century. Commissioned to commemorate a soldier who died in the First World War, the nineteen scenes also draw on Spencer's own wartime service in Salonika. On the side walls he depicted the typical activities of a soldier's life behind the lines with energy and humour. The scheme reaches a memorable climax on the altar wall, which celebrates the resurrection of the fallen amid a sea of white crosses.

STANLEY SPENCER GALLERY

King's Hall, High Street,
Cookham-on-Thames SL6 9SJ
Telephone: (062 85) 20043/24580

TRUSTEES OF THE STANLEY SPENCER
GALLERY
Open: Easter–Oct daily 10.30–1, 2–6
Nov–Easter weekends and public
holidays 11–1, 2–5
Access for disabled

From the M4 take Exit 7 (A4 to Maidenhead).
Over Maidenhead Bridge turn right towards Cookham Village. **4 D1**

The gallery contains a major memorial collection of the work of Stanley Spencer, RA, the eccentric, highly original and visionary British twentieth-century artist who was born in the village of Cookham in 1891, the seventh son of a music teacher and organist. He came back to live and work in it from time to time, more or less making it his permanent home from the early years of the Second World War.

Early religious works, major paintings from the 1930s, and examples of Spencer's art of the 1950s are in the collection. Some of the more outstanding works are on long-term loan. The exhibition is changed twice yearly.

WINDSOR CASTLE

Windsor SL4 1NJ
Telephone: (0753) 868286

HER MAJESTY THE QUEEN
Open: Precincts every day except 19 June
(Garter Day)
State Apartments: 28 Oct–end Apr Mon–
Sat 10.30–3; 1 May–27 Oct daily 10.30–3.
State Apartments closed 3 June–3 July
Access for disabled

The Castle, which dominates the town, is on rising ground above the River Thames. **5 A1**

Windsor Castle is the largest inhabited castle in the world, begun 900 years ago by William the Conqueror. It soon became a Royal residence for England's Kings and Queens, who lived in it continuously, progressively improving its amenities. Little remains of its fortified character. In style, it is principally a mixture of medieval, Stuart, Regency and Victorian.

The contents consist in part of the greatest private art collection in the world, started by Henry VIII, who employed Hans Holbein to paint for him. It was continued by Charles I, the greatest

collector of his time, who commissioned Van Dyck for his own and many other contemporary portraits.

George III added works by Gainsborough, Copley and Zoffany as well as an unequalled group of Canalettos. George IV furnished the interior with French furniture and decorative art, also collecting Dutch paintings of the seventeenth century. He was a patron of Lawrence and Wilkie. Prince Albert, Queen Victoria's Consort, extended the collection to medieval art and added examples of early Italian painting. Limited additions have been made during the twentieth century.

The State Apartments are the principal interior area of the castle open to the public, although Queen Mary's Dolls' House and (changing) exhibitions of drawings, as well as St George's Chapel and the Albert Memorial Chapel, within the precincts of the castle, are of considerable interest to visitors.

The Waterloo Chamber contains the first major group of paintings which the visitor sees, the unrivalled collection of mainly full-length portraits by Thomas Lawrence. They were commissioned by George IV, and are of the soldiers, statesmen and rulers who contributed to Napoleon's downfall. The finest include *Pope Pius VII,* a seated portrait, *The Archduke Charles,* the Austrian Commander-in-Chief, and *The Duke of Wellington.*

Saint George's Hall contains a number of Royal portraits by Mytens, Van Dyck, Lely and Kneller. Of particular interest are the many busts, including Francis Roubiliac's *George II,* and portrait busts by Francis Chantrey, Michael Rysbrack, Joseph Nollekens and Christopher Hewetson.

The Queen's Ballroom contains an important group of works by Van Dyck including his magnificent *The Five Children of Charles I* and the joint portrait of *Thomas Killigrew and Lord Crofts.* In the Queen's Drawing Room are Holbein's portraits of *Sir Henry Guildford, Thomas, Third Duke of Norfolk,* and *Hans of Antwerp.* The Tudor and Stuart portraits in this room also include works by Mytens, Dobson and Wissing.

The King's Closet contains Hogarth's *David Garrick and his Wife,* Canaletto's *Santa Maria della Salute,* and work by Reynolds and Ramsay. A magnificent group of paintings is seen in the next room, the King's Dressing Room, which includes Holbein's *William Reskimer,* Dürer's *Portrait of a Young Man,* Van Dyck's *Henrietta Maria* and *Triple portrait of Charles I,* Rembrandt's *Portrait of a Man* and his study of an old lady, known as

The Artist's Mother. There are also Rubens's portraits of Van Dyck and of himself, and works by Clouet, Memling and del Sarto. A clear view of the paintings is unfortunately inhibited by the limited space.

The works in the King's State Bedchamber are eighteenth-century with four more Canaletto views and portraits by Gainsborough, while in the King's Drawing Room there is the final moving pleasure of the Rubens landscapes, *Winter Scene: Peasants in a Barn* and *Summer: Peasants Going to Market,* together with a fine Van Dyck, *Saint Martin Dividing his Cloak.*

The Print Room at Windsor generally has a changing exhibition of treasures from what is one of the greatest collections of watercolours, drawings and prints in the world.

See entry in main text, pages 206–10.

— BUCKINGHAMSHIRE —

ASCOTT ❧

Wing, Leighton Buzzard LU7 oPS
Telephone: Aylesbury (0296) 688242

NATIONAL TRUST
Open: 14 Apr–20 May, Sept Tues–Sun 2-6; BHs, 16 Apr, 7 May 2-6
Closed: 17 Apr, 8 May
Limited access for disabled

Two miles south-west of Leighton Buzzard and the entrance is by the Lodge Gates on the Leighton Buzzard–Wing road. **4 B1**

Dutch seventeenth-century art dominates this splendid collection, assembled or inherited by Anthony de Rothschild, who gave it to the National Trust. Aelbert Cuyp is represented by a fine evening river scene *Dordrecht on the Maes,* Hobbema by *Cottages in a Wood* and Ludolph de Jongh by *A Lady Receiving a Letter.*

English art includes works by Stubbs, *Five Mares,* Gainsborough, Reynolds, Romney and Hogarth. Italian works by Lotto and Tiepolo are also in the collection. There is a very lovely *Madonna and Child with Saint John* by Andrea del Sarto. And a later, more spirited religious work is Giovanni Battista Tiepolo's *The Ascension of the Virgin.*

There is an important collection of Chinese porcelain and fine French and English eighteenth-century furniture.

See entry in main text, pages 211–12.

CLAYDON HOUSE ❧

Middle Claydon, near Buckingham MK18 2EY
Telephone: Steeple Claydon (0296) 730349

NATIONAL TRUST
Open: Apr–Oct Sat–Wed 2-6; BH Mon 1-6; last admissions 5.30
Closed: GF. Access for disabled

In Middle Claydon village, thirteen miles north-west of Aylesbury, three miles south-west of Winslow, signposted from A41. **4 C2**

Owned by the National Trust since 1956, Claydon House has been the seat of the Verney family since 1620. Florence Nightingale, sister-in-law of Sir Harry Verney, was a regular visitor to Claydon in the mid-nineteenth century. In the Saloon hangs one of only two signed paintings by Marieschi: *The Rialto Bridge and Palazzo dei Camerlenghi;* also portraits, some in Sunderland frames, by Van Dyck, Michael Wright, Lely and Mytens. *Florence Nightingale,* a portrait by W.B. Richmond, should be noted.

CLIVEDEN ❧

Taplow, Maidenhead SL6 oJB
Telephone: Burnham (0628) 605069

NATIONAL TRUST
Open: Three rooms only shown;
1 Apr–28 Oct Thurs, Sun 3-6;
last admissions 5.30; entry by timed ticket
Access for disabled

Three miles upstream from Maidenhead and two miles from Taplow on the B476 on the north bank of the Thames. **4 D1**

The house is let as a hotel and only three rooms can be visited. Among the distinguished people who lived at Cliveden was Nancy, Lady Astor, wife of the Second Viscount Astor. She was the first woman to take her seat in the House of Commons, and her portrait by Sargent hangs in the house. There is also Herkomer's *First Viscount Astor.*

The Staircase is hung with portraits of George II, Frederick, Prince of Wales and Augusta, Princess of Wales by Hudson, and *The Duchess of Sutherland* by Winterhalter.

Philippe Mercier's conversation piece, *Frederick, Prince of Wales with his Sisters,* and showing the Dutch House, Kew, in the background, hangs in the Hall to the left of the door to the French Dining Room.

The grounds contain an outstanding collection of sculpture.

WADDESDON MANOR ✤

Waddesdon, Near Aylesbury HP18 0JH
Telephone: Aylesbury (0296) 651211

NATIONAL TRUST

Open: 4 Apr–28 Oct, Wed–Sun 1–6 (closes at 5 on weekdays in Mar, Apr, Oct); GF and BH Mons 11–6
Closed: Mons (except BHs), Tues, Wed following BH
Access for disabled

Six miles west of Aylesbury, on the A41 to Bicester. **4 C2**

The collection of fine and applied art at Waddesdon Manor, which has a strong French atmosphere, was gathered together by three members of the Rothschild family. It contains fine French art of the eighteenth century, an extensive collection of British portraits from the same period and Dutch and Flemish paintings, all in a setting of magnificent decorative arts.

Yet the first major paintings that the visitor encounters are Italian – Guardi's enormous *Views of Venice,* hanging in the East Gallery which may have been designed to hold them.

In the Red and Grey Drawing Rooms are an array of full-length portraits by Reynolds and Gainsborough. The Red Drawing Room, with a ceiling by Jacob de Wit, contains the beautiful *Lady Sheffield* and *Mrs John Douglas* by Gainsborough. In the Grey Drawing Room is Reynolds's charming *Mrs Abington,* shown holding a mask of Comedy. His full-length of the wind-beset *Lady Jane Halliday* contrasts with the dignified *Duchess of Cumberland.*

The West Gallery holds smaller French paintings: Watteau's original version of *Harlequin, Pierrot and Scapin,* Pater's attractive *Cadeau des Pecheurs* and *La Danse.*

Georgian actresses grace the Baron's Room, including a head-and-shoulders portrait of *'Perdita' Robinson* by Gainsborough, *Mrs Sheridan as St Cecilia* (which Reynolds once called his best picture) and the amateur *Lady Hamilton as Calypso,* a fine work by Romney. Visitors can appreciate the quality of eighteenth-century French drawing in Boucher's *La Courtisane Amoureuse* and in Fragonard's *L'Education fait tout.*

In the adjoining Tower Room there are four of the heads of girls so frequently painted by Greuze; *A Bacchante* is a particularly good example. *The Allegory*

of Water and *The Allegory of Fire* come from a set of four elements by Lancret, who also painted the village scenes. Here and in the Baron's Room are landscape miniatures of extraordinary delicacy by van Blarenberghe.

French painting begins to yield to British and Dutch in the West Hall. Almost contemporary with Mme Vigée-Lebrun's *Duchesse de Polignac* is Francis Wheatley's 1783 crowd scene, *The Second Earl of Aldborough on his Horse Pomposo,* reviewing volunteers at an Irish country house.

In the Morning Room the quality of the paintings is extraordinary: Rubens's *The Garden of Love,* which inspired Watteau and seems perfectly at home in this very French place, Gainsborough's *Master Nicholls* (better known as *The Pink Boy*), Reynolds's highly theatrical *Emily Potts as Thaïs* and de Hoogh's *Game of Ninepins.* The three splendid works by Cuyp include *Landing Party on the Maas.* Other excellent Dutch paintings are *Girl at a Window* by Dou, *Tête-à-Tête* by Metsu and *The Duet* by Ter Borch.

Upstairs, the Drawings Room displays seventeenth- and eighteenth-century decorative drawings from France, Italy and Germany. Boucher's delightful portrait of *Louis-Philippe d'Orléans* was painted in 1749 when the sitter, later 'Philippe Egalité', was only two. In the Music Room are good portraits by Hudson of *Dr Clerke Willshaw* and his wife, which are perhaps less immediately appealing than *The Daughters of Lady Boynton,* attributed to Cosway. The handsome grisaille overdoors in this room are by Jacques Lajoue, and it is worth examining the lively gouaches of 1793 by J. Beugnet, *Revolutionaries Rejoicing.*

A Zoffany double portrait, *The Third Duke of Dorset and Mr Petley,* hangs in the Pastime Room with hunting scenes by Sartorius. The miscellany of Dutch and French works in the corridors upstairs includes huge panels by Oudry of *Fallen Masonry in a Park with Hens, Ducks and Oriental Geese.*

The Bachelor's Wing, open on Fridays, contains earlier paintings; in the Smoking Room are portrait miniatures like Samuel Cooper's *Unknown Gentleman* of 1662, Bernard van Orley's *Madonna and Child* and a fifteenth-century *St John on Patmos* from southern Germany. The sixteenth-century portraits attributed to Corneille de Lyon include one of *Georges de Selve,* who also sat to Holbein as one of *The Ambassadors* (National Gallery). In the Armour Corridor outside is Utewael's

little oil on copper, *c.*1600, of *The Judgement of Paris.*
See entry in main text, pages 212–14.

WEST WYCOMBE PARK ✤

West Wycombe, High Wycombe HP14 3AJ
Telephone: High Wycombe (0494) 24411

THE NATIONAL TRUST AND
SIR FRANCIS DASHWOOD

Open: June, July and Aug Sun–Thur 2–6; last admissions 5.15
Limited access for disabled

The house is owned by the National Trust. It has a small collection of paintings, owned by Sir Francis Dashwood, and typical of an eighteenth-century family house. Mostly Italian, they are the result of Grand Tour acquisitions by two Dashwood ancestors and include Hell-Fire Club pictures.

WINSLOW HALL

Winslow MK18 3HL
Telephone: (029 671) 2323

SIR EDWARD TOMKINS

Open any time by arrangement
Limited access for disabled

At the entrance to the town of Winslow, midway between Aylesbury and Buckingham on the A413. **4 C2**

Possibly built by Sir Christopher Wren, the Hall contains works by Van de Velde, Teniers and Vernet. Large decorative panels, on canvas, decorate the Main Bedroom. They are attributed to Daniel Marot.

—— CAMBRIDGESHIRE ——

ANGLESEY ABBEY ✤

Lode CB5 9EJ
Telephone: Cambridge (0223) 811200

NATIONAL TRUST

Open: 31 Mar–14 Oct Wed–Sun and BH Mons 1.30–5.30
Closed: GF
Limited access for disabled

Six miles north-east of Cambridge on the B1102 in the village of Lode. **6 B/C 5**

The collection at Anglesey Abbey is wide-ranging and eclectic in character, with a specialist interest in Windsor Castle, of which there are numerous views, constituting one of the most impressive topographical collections in the British

Isles. Together with the Old Master paintings, they indicate the range of collecting still possible in the twentieth century, during which virtually all the works were acquired. The Abbey itself, then a property in ruins, was bought in 1926 by Huttleston Broughton, a dedicated and immensely wealthy patron of the arts. Most notable among his many achievements was the creation of a magnificent garden.

Landscapes and seascapes include works by Claude, two of whose finest paintings are in the collection, Bonington, Canaletto, Cuyp and Constable. There are good sporting paintings, including works by Wootton and Munnings.

BURGHLEY HOUSE
Stamford
Telephone: (0780) 52451

BURGHLEY HOUSE PRESERVATION TRUST
Open: Easter-1 Oct daily 11-5; GF 2-5
No access for disabled

The house is one mile east of Stamford off the B1443. **6 A6**

The Burghley House collection, among the largest and finest in Britain, has the enormous appeal of being almost unchanged since the eighteenth century. The 5th Earl of Exeter assembled one of the most important collections of seventeenth-century Italian art outside Italy while travelling on the continent in the late seventeenth century, and was an important patron of Louis Laguerre and Antonio Verrio. His great-grandson, the 9th Earl, undertook his own Grand Tour in the second half of the eighteenth century, adding to the collection such treasures as the Veronese altarpiece now in the chapel.

The tour begins in the Old Kitchen, where an enormous *Ox Carcass* by Marten van Cleve hangs. In the Ante-Chapel are Mattia Preti's *Triumph of Time,* Domenichino's small but beautiful *Assumption of the Virgin* and a nocturnal *Agony in the Garden* by Francesco Bassano. The unusual *Virgin and Child* is by Jean Tassel, whose works are rare in England. Over the Chapel altar is the Veronese: *Zebedee's Wife Petitioning Our Lord.* Large canvases by J. C. Loth, Pietro Liberi and Antonio Zanchi decorate the side walls.

The Billiard Room portraits are dominated by Lawrence's group portrait of *Henry, First Marquess of Exeter, his Wife Sarah and their Daughter.* Oval portraits of members of the Tory 'Little Bedlam' club, which met at Burghley, include Kneller's *Self-Portrait with a Unicorn* and

his portrait of Verrio. A double portrait of the *Fourth Earl of Exeter and his Countess,* by Robert Walker, reflects the influence of Lely.

Gainsborough's portraits of *Sir Christopher Whichcote* and *Lady Whichcote* are in the Brown Drawing Room; the pastoral landscape may also be by him. Carlo Maratta *(Narcissus)* and Luca Giordano *(Marcus Curtius Leaping into the Chasm)* were artists particularly favoured by the 5th Earl. He commissioned Liberi's *Logic between Vice and Virtue* (now in the Black and Yellow Bedroom, along with an exceptionally rare work by Agostino Scilla, *Ariadne Abandoned by Theseus*). Another of the Earl's favourites was Jacopo da Castello, whose *Birds and Beasts* is with other Castello works in the Marquetry Room. Here are paintings by Weenix, Savery and Teniers on animal themes, as well as van Orley's *Christ Disputing with the Doctors* and the well-known version of *Rent Day* by Pieter Brueghel the Younger.

A Lorenzo Pasinelli *Magdalene* and Pietro della Vecchia *Envy Plucking the Wings of Youth* continue the Italian theme into Queen Elizabeth's Bedroom. Here Trophime Bigot's *Reconciliation of St Peter and St Paul* anticipates the northern European art in the Pagoda Room next door. Among the Pagoda Room portraits, the political significance of the Cecil family at the court of Elizabeth I is indicated by Gheeraerts's *William Cecil, First Lord Burghley,* and *Queen Elizabeth in Old Age* in the style of Gheeraerts. Other interesting paintings here include *Henry VIII* by Joos van Cleve, a version of Nathaniel Dance's *Capability Brown* and one of Robert Walker's portraits of *Oliver Cromwell.* On display nearby is Lely's beautiful *Susannah and the Elders.*

Early in his career, Kneller painted *John, Sixth Earl of Exeter when a Boy,* which hangs in the Blue Silk Bedroom. In the adjoining Dressing Room is Liberi's amusing portrait of the same sitter: *The Sixth Earl of Exeter, when a Child, Pulling Fortune by the Hair.* One of the highlights of the collection is Orazio Gentileschi's little oil on copper of the *Virgin and Child.* A Ruisdael *Rocky Landscape with a Waterfall,* and a spirited *Cavalry Engagement* by van der Meulen are surrounded by more Italian paintings, notably Zuccarelli's *Flight into Egypt.*

The state apartments begin with the First George Room. Most of the paintings are Italian, by seventeenth-century artists like Cavaliere Tempesta, a significant exception being Joos van Cleve's *Virgin and Child.* The beautiful *St John the Baptist* is attributed to Andrea del Sarto, the

Virgin, Child and the Infant St John by Scarsellino, and *Christ in the House of Martha and Mary* by G. B. Gaulli. Girolamo da Treviso, who worked for Henry VIII, painted the superb *Mystic Marriage of St Catherine.* Other delights include a fine portrait of *An Old Man* by Sofonisba Anguisciola, the *Agony in the Garden* sketch by G. B. Tiepolo and a *Head of a Carthusian* by Annibale Carracci (on paper covered with handwriting).

The Italian collection continues in the Third George Room, where Saraceni's *St Gregory* hangs over the fireplace. Among the most important works here are Giordano's *Rape of Europa* and *Death of Seneca,* and a landscape by Antonio Travi da Sestri. The highlights of the Fourth George Room begin with Guercino's superb *Jacob Receiving the Bloody Coat of Joseph* and *The Triumph of David. Judith with the Head of Holofernes* is by a pupil of Reni, Elisabetta Sirani, who died before the potential evident here was fully realised. Other major canvases include *Gathering Manna in the Wilderness* from the Bassano family.

The sheer profusion of works in these rooms includes fine paintings like Michelangelo Anselmi's *Christ and the Woman of Samaria,* Dolci's *St Lucy* and *St Sebastian,* Gennari's *The Prophet Isaiah* and Lanfranco's *God the Father.* There are paintings attributed to Domenichino, Valentin and Carlo Maratta, as well as Maratta's *Virgin and Child with the Infant St John.*

The sequence of six Verrio rooms, magnificently decorated on classical themes, begins with *Phoebus and Morpheus* (gods of the sun and sleep) in the First George Room. It extends beyond the Heaven Room (where Verrio included a portrait of himself as Dante) to the gloomy Hell Staircase. Verrio spent from 1686 to 1697 working for the 5th Earl, with spectacular results.

In the Great Hall are family full-lengths and large paintings like Francheschini's *Annunciation.* The corridor beyond contains a striking portrait of the 6th Marquess of Exeter by Oswald Birley.

See entry in main text, pages 186–7.

CROMWELL MUSEUM
Grammar School Walk, Huntingdon PE18 6NS
Telephone: (0480) 425830

CAMBRIDGESHIRE COUNTY COUNCIL
Open: Apr-Oct Tues-Fri 11-1, 2-5, Sat, Sun 11-1, 2-4; Nov-Mar Tues-Fri 2-5, Sat 11-1, 2-4, Sun 2-4
Admission Free: No access for disabled

The museum is on Grammar School Walk in the centre of the town. **6 B6**

Huntingdon's museum documents its Cromwelliana with an interesting collection of pictures relating to the Protector and his contemporaries. The thirty or so works are by, or attributed to, Mary Beale, Michael Dahl, William Dobson, Adrian Key, Peter Lely, Edward Mascall, John Riley, James Ward and J.M.Wright.

There is the full-length portrait of *Oliver Cromwell* attributed to Robert Walker. It shows him in bell-shaped boots, grey frills and bell-bottomed, three-quarter-length trousers. There is also a Christian Dusart of *Henry Cromwell*. There is a copy of Lely's portrait which hangs in the Palazzo Pitti, Florence, in which Cromwell requested an honest portrait, 'warts and all'.

Battle scenes include James Ward's *The Battle of Marston Moor,* an imaginative interpretation of the crucial first major defeat of the Royalists, which was followed by the emergence of Cromwell as the leading Parliamentary general.

ELTON HALL

Elton, Near Peterborough PE8 6SH
Telephone: (083 24) 468

THE PROBY FAMILY
Open: Jun–Sep Wed 2–5; Jul–Sep
Sun 2–5; BH
No access for disabled

Eight miles west of Peterborough on the A605 road to Oundle. **6 A6**

The 1st and 5th Earls of Carysfort were the particularly notable collectors of the family. Their acquisitions include numerous portraits by Reynolds, including a version of *Snake in the Grass* (possibly from the Hermitage) and an unfinished portrait of Kitty Fisher which was formerly banished from the house, as she was considered a 'lady of ill-repute'. A Gainsborough and landscapes by Constable, Hobbema and Gaspard Dughet comprise the rest of the collection.

Victorian paintings are well represented by Lawrence Alma-Tadema, whose *A Dedication to Bacchus* was the most expensive picture in the sale of the Victorian dealer Edward Gambart's collection in 1903. It was bought then by the Earl of Carysfort, whose acquisitions were financed by his extensive estates south of Dublin. The development of the city in the direction of Stillorgan gave him considerable income at a time when the major collectors were brewers and

bankers, like the Guinness and Rothschild families. Other Victorian works include *The Minuet* by Millais, *Eastward Ho!* by Henry Nelson O'Neill, and others. A large painting by Cesare da Sesto and German panel paintings of the fifteenth century and earlier are also on show. A unique collection of liturgical books is housed in the Library.

FITZWILLIAM MUSEUM

Trumpington Street, Cambridge CB2 1RB
Telephone: (0223) 332900

THE SYNDICS OF THE FITZWILLIAM
MUSEUM
Open: Tues-Sat (Lower Floor) 10-2,
(Upper Floor) 2-5, Sun (both floors),
2.15-5, also Spring and Summer Bank
Holidays
Closed: 24 Dec-1 Jan inc. and GF
Admission Free: Access for disabled
(advance notice required)

On Trumpington Street on the south side of the city centre, much of which is a pedestrian area. It is close to the city ring road at the junction with the A10, the old London road. **6 C5**

The Fitzwilliam Museum, one of the country's outstanding museums, was established in 1816 through the generosity of Richard, 7th Viscount Fitzwilliam of Merrion (1745–1816), who bequeathed money and his collection, which included a Titian, a Veronese and a Palma Vecchio, and an excellent collection of prints, music autographs and illuminated manuscripts. Further benefactions and bequests have provided the Fitzwilliam with a splendid representation of the major European schools of painting, its celebrated collections of portrait miniatures, illuminated manuscripts and Indian and Persian miniatures, and the most important British collection of prints outside the British Museum. Selections from the collection of prints and drawings are exhibited in special galleries in the Museum.

Italian paintings include an unusually large number of early works, many from Florence and Siena: Simone Martini's *St Geminianus, St Michael and St Augustine,* an early Filippo Lippi triptych, the *Virgin and Child with St John the Baptist and St George* of about 1434 and Domenico Veneziano's *The Annunciation.* There are good examples of the work of Luca di Tommè, Cosimo Roselli and Crivelli. *St Lanfranc Enthroned between St John the Baptist and Liberius,* a late work by Cima da Conegliano, comes from a Venetian

church; some unusual regions of Italy are also represented.

Also from Venice are the two magnificent paintings by Titian: his late *Tarquin and Lucretia,* and *Venus and Cupid with a Lute Player;* the latter, like Veronese's *Hermes, Herse and Aglauros* and Palma Vecchio's *Venus Returning to Cupid his Arrow,* belonged to Viscount Fitzwilliam. The Tintoretto *Adoration of the Shepherds* and the Jacopo Bassano *Journey to Calvary* are other outstanding sixteenth-century Italian works.

The seventeenth century is well represented, with two original paintings by the much-copied Guido Reni, *The Resurrected Christ appearing to the Virgin* and a *Man of Sorrows* of c.1639. *The Betrayal of Christ* by Guercino is a companion to his *Incredulity of St Thomas* in the National Gallery. *St Roch and the Angel* and *The Penitent Magdalen in a Landscape* are both by Annibale Carracci, while the allegory on the theme of death, *L'Umana fragilità,* is by the tormented Salvator Rosa. Also in the collection are works by Pietro da Cortona, Domenichino, Sassoferrato and a beautifully fluid sketch by Ludovico Cardi (Il Cigoli).

The eighteenth-century Italian paintings include examples of the art of Canaletto, Bellotto, Guardi and Marieschi. The splendid full-length of *Charles, Seventh Earl of Northampton* is by Batoni, and there are a pair of Carlo Dolci portraits of Englishmen who visited Florence *(Sir Thomas Baines* and *Sir John Finch)* as well as an intriguing *Allegorical monument to Isaac Newton* (an early mark of his reputation on the Continent) painted by G. B. Pittoni with D. and G. Valeriani.

There are some 400 Dutch and Flemish paintings, among which are superb portraits by Van Dyck *(Rachel de Ruvigny, Countess of Southampton* and *Archbishop Laud)* as well as the humorous *Village Festival in Honour of St Hubert and St Anthony* by Pieter Brueghel the Younger. Rubens works include *The Death of Hippolytus,* painted in oil on copper, and a title-page design for the *Pompa Introitus . . . Ferdinandi,* a book commemorating a state entry into Antwerp for which Rubens made many designs. Other sketches include seven studies by Rubens for his *Triumph of the Eucharist* tapestries, commissioned for a Madrid convent. Note also the Joos van Cleve *Virgin and Child.* The Dutch paintings include Marten van Heemskerck's *Portrait of the Painter, with the Colosseum Behind* painted in 1553, an oval *Sunset after Rain* by Cuyp, *Woman Tuning a Lute* by ter Brugghen, and *A Man* by Frans Hals – a fine example of his late style. Several of the many

landscapes are of particular interest: a *Winter Landscape with a Hunting Party* by Esaias van de Velde, Salomon van Ruysdael's *Farm Buildings in a Landscape* and a *View on the Amstel, looking towards Amsterdam* by the latter's nephew Jacob van Ruisdael. These are accompanied by good examples of landscape paintings by Pieter Molijn, Jan van Goyen, and Hobbema, and even a pair of views by Berckheyde which, unusually, have remained together. The Rembrandt portraits, like the *Panoramic Landscape* by Koninck and Pieter de Hoogh's *Courtyard with an Arbour in Delft*, are loans, but the Fitzwilliam owns superb Rembrandt drawings and prints – Lord Fitzwilliam's collection of Rembrandt etchings was outstanding – as well as a large collection of works on paper by other Dutch and Flemish artists. *The Baptism of Christ* is by Aert de Gelder, who studied with Rembrandt; another Rembrandt follower painted *A Man in Military Costume*.

The Fitzwilliam's Dutch and Flemish still lifes include works by Pieter Claesz and Adriaen Coorte, as well as the Fairhaven Room of floral paintings. Many of the floral oils, drawings and watercolours in the Museum were bequeathed by Henry Broughton, 2nd Lord Fairhaven. The highlights in the Fairhaven Room include Rachel Ruysch's *Stone Niche with Thistle, Lizard and Insects,* a big *Vase of Flowers with a Monkey* by Ambrosius Bosschaert II, and *Group of Flowers* by Simon Verelst, a good example of his late style. The artists represented range over three centuries, from Balthasar van der Ast and Willem van der Ast, Jan van Huysum and Elias van der Broeck, to the little-known Melanie de Comolera, flower painter to Queen Victoria.

The German paintings are far fewer, but include an *Adam and Eve in Paradise* by Johann Koenig and two of Elsheimer's exquisite little paintings on copper: *Venus and Cupid* and *Minerva as Patron of Arts and Sciences.* The Spanish collection, also small, ranges from fifteenth-century Andalusian painting to the *Vision of Friar Lauterio* by Murillo – an appropriate subject for a university gallery, as the Friar received miraculous help in his studies.

French painting is much better represented, with a *Pastoral Landscape with Lake Albano and Castel Gandolfo* by Claude and *Eliezar and Rebecca at the Well,* a Poussin formerly in the collection of Anthony Blunt. There is a modello for one of Vouet's most popular compositions, *The Entombment,* a *Holy Family* by Charles Le Brun, and a Dughet *Landscape near Rome.* The tiny *Italian Landscape* by Karel

Dujardin is so brilliantly lit that in the eighteenth century it was known as 'Le Diamant'. Monnoyer, flower painter to Louis XIV, has contributed a beautiful *Urn of Flowers,* and Alexandre Desportes, Louis's painter of hunting scenes, lively *Sketches of a Kitten.* Perhaps the most theatrical of the French paintings is *King Asa of Judah Destroying the Idols* by 'Monsu Desiderio', who may have been two painters, François de Nome and Didier Barra.

Eighteenth-century French work includes a fine portrait by François-Xavier Fabre, pupil of David: *Allen Smith Seated Above the Arno, Contemplating Florence. The Reader* is a collaboration between Fragonard and his sister-in-law, Marguerite Gérard. Nineteenth-century art is more plentiful, with a group of interesting small oils by Courbet, Corot, Diaz de la Peña, Harpignies, Daubigny and Théodore Rousseau. Some works of particular interest include an *Odalisque* by Delacroix and a *Wounded Soldier* by Géricault, Bonington's sparkling *Boccadasse, Genoa, with Monte Fasce,* and a study by Pissarro for his early *Tow-Path along the Seine at Bougival* (Glasgow Museum and Art Gallery). There is a carefully observed *Head of a Girl* by Fantin-Latour, as well as his enchanting little *White Cup and Saucer* and *White Candlestick.* The collection of early nineteenth-century works on paper by French artists includes drawings by David and Ingres.

French Impressionism is represented by Renoir, Monet, Pissarro and Sisley. A recent acquisition is Renoir's *Place Clichy,* which joins *The Gust of Wind,* as fresh a landscape as Renoir ever painted. Pissarro's wintry *Effet de Neige, Eragny* is from the collection of the Very Revd E. Milner-White, who also left paintings to York City Art Gallery. The Fitzwilliam's Monets include one of his many views of *Poplars.* There is a study by Degas for *David and Goliath,* as well as a pastel of *Danseuses aux jupes violettes, bras levés* and *Au Café.* The museum owns many Degas works on paper. Landscapes include Van Gogh's *L'allée en automne;* the more solid approach of Paul Cézanne can be seen in his beautiful *La Forêt.* Paintings on loan include the superb *Still Life with Apples* by Cézanne from the Keynes Collection at King's College, and a Seurat study for *La Grande Jatte, Couple Walking.*

Among the twentieth-century French paintings are one of Vuillard's loveliest interiors, *Intérieur, Dame avec un Chien,* and a *Cubist Still Life* by Braque. The *Reclining Nude* by Braque is another Keynes loan, as is one of the Picasso still lifes. *Still Life: Bowl and Apples* (1924) by

Picasso, like his pre-World War I *Bust of a Woman* belongs to the Fitzwilliam, and they are displayed with paintings by Bonnard, Odilon Redon, Matisse and Modigliani.

There are over 300 British paintings. Notable are William Hogarth's erotic *Before* and *After,* Gainsborough's *Heneage Lloyd and his Sister* and one of Reynolds's last portraits, *The Braddyll Family.* The genius of William Blake is nowhere better represented than at the Fitzwilliam, thanks to bequests of Blake material from the Blake scholar and collector, Sir Geoffrey Keynes. First class portraits are numerous: the beautiful *A Lady* by Lely, Stubbs's *Isabella Saltonstall as Una in Spenser's 'Faerie Queen'* and Raeburn's *William Glendonwyn.* There is a *Crucifixion* by Kneller, Stubbs's *Gimcrack* and Francis Wheatley's *Benjamin Bond-Hopkins,* and a portrait of the founder, *The Hon. Richard Fitzwilliam* by Wright of Derby. The *Four Scenes from Richardson's 'Pamela'* in their fine rococo frames are part of a set by Joseph Highmore, scattered between this museum, the Tate and the National Gallery of Victoria in Melbourne.

Victorian painting at the Fitzwilliam includes Ford Madox Brown's *The Last of England,* Rossetti's *Girl at a Lattice* and Millais's *The Bridesmaid* and *Mrs Coventry Patmore.* The Holman Hunt portrait of *Cyril Benoni Holman Hunt* is in a frame of apples and apple-blossom designed by the artist. *The Temple of Apollo at Bassae in Arcadia* is a fine example of Edward Lear's large-scale landscapes in oil. There are cloud studies by Constable, and sketches by him of *Hampstead Heath* and *Salisbury Cathedral seen above the Close Wall,* an early Turner, and landscape work by Landseer, John Martin and John Brett. Alma-Tadema's *94° in the Shade* is set in an English summer field. *On the Brink* by Alfred Elmore is a polished piece of moral comment from the 1860s. There is an outstanding collection of British drawings and watercolours, including works by Cozens, Constable, Girtin, Cotman and Cox; it includes Romney drawings bought from Romney's son and Turner watercolours given by Ruskin.

Modern British painting at the Fitzwilliam is of considerable interest, with a large group of Sickert paintings (among them, *The Lion of St Mark*), a Gilman *Nude on a Bed* of 1914, a pretty interior by Philip Wilson Steer, *Hydrangeas,* and Gwen John's *The Convalescent.* The Museum owns two of Augustus John's finest portraits *(Thomas Hardy* and *Sir William Nicholson),* as well as some of his small paintings, including *Dorelia and the Children at Martigues.* John Singer Sargent's

portrait of *Dorothy Barnard* (who previously posed for *Carnation, Lily, Lily, Rose* in the Tate Gallery) is accompanied by Sargent's *Sicilian Peasant*. From the inter-war years there is a Spanish religious procession of 1935, painted at night by David Bomberg and Paul Nash's *November Moon* dates from 1942. Among paintings by Stanley Spencer are *Cottages at Burghclere* and one of the artist's riveting self-portraits – *Self-Portrait with Patricia Preece*.

The museum is rich in English portrait miniatures, among them one of the earliest to survive: Lucas Hornebolte's *Henry VIII*. Some of the highlights of a fascinating collection include Isaac Oliver's superb *Unknown Lady* of c.1605, shown wrapped in delicate veils, his earliest known portrait of *Henry Frederick, Prince of Wales*, Hilliard's *Unknown Woman*, the *Three Children of Charles I* by John Hoskins and an *Unknown Lady* of about 1660 by Hoskins's nephew, Samuel Cooper. Georgian miniatures include *George IV as Prince Regent* by Richard Cosway and John Smart's *Charles, First Marquess Cornwallis*.

See entry in main text, pages 179—82.

KETTLE'S YARD

Castle Street, Cambridge CB3 0AQ
Telephone: (0223) 352124

UNIVERSITY OF CAMBRIDGE
Open: Tues-Sat 12.30-5.30; Sun 2-5.30
Closed: 24 Dec-1 Jan
Admission Free: No access for disabled

The collection is housed in buildings off Castle Street on the north-west side of Cambridge. **6 C5**

The collection is as it was when Kettle's Yard was the home of Jim and Helen Ede, with works of art arranged among furnishings, found objects, ceramics and glass. It includes a major group of works by Henri Gaudier-Brzeska, including *Bird Swallowing a Fish*, and a large number of drawings.

British art of the 1920s and 1930s generally, with Ben Nicholson, Christopher Wood, Alfred Wallis, and David Jones particularly well represented, constitutes the main character of Kettle's Yard. Nicholson's works include *Musical Instruments, Still Life with Knife and Lemon and Apples*. David Jones is represented by *Vexilla Regis* and *Flora in Calix-Light* among other paintings. There is a Constantin Brancusi, *Prometheus*, Naum Gabo's *Linear Construction* and *Self-Portrait* and *Building the Boat, Treboul*, by Christopher Wood.

In addition to the permanent collection there is a virtually continuous series of exhibitions of painting and sculpture each lasting 5-6 weeks throughout the year.
See entry in main text, pages 182–4.

KIMBOLTON CASTLE

Near Huntingdon, Cambridgeshire
Telephone: (0480) 860505

GOVERNORS OF KIMBOLTON SCHOOL
Open: Mid-July to August Sun 2-6; BH, except 1 May BH and Easter Sun and Mon
At other times by appointment

Entrance directly from A45 in Kimbolton. **6 B6**

Kimbolton Castle has had an interesting and chequered history. It was the last abode of Henry VIII's first queen, Catherine of Aragon. It was the family home of the Earls and Dukes of Manchester from 1615 to 1950. It had as architect, in the early eighteenth century, John Vanbrugh.

The castle contains fine decorations by the early eighteenth-century artist Giovanni Antonio Pellegrini. He was an ambitious and prolific Venetian painter who was brought to England by the First Duke, and whose work at Kimbolton is perhaps his best in these islands. He also worked at Castle Howard.

He did scenes based on the Mantegna paintings at Hampton Court of *The Triumph of Caesar*, which are on the staircase.

MUSEUM OF CLASSICAL ARCHAEOLOGY

Sidgwick Avenue, Cambridge CB3 9DA
Telephone: (0223) 337733

UNIVERSITY OF CAMBRIDGE
Open: During University term Mon-Fri 9-5
Admission Free: No access for disabled

On Sidgwick Avenue, a turning off Queens Road, west of the Fitzwilliam Museum. **6 C8**

This is probably the largest and finest collection of plaster casts of Greek and Roman sculpture in the country, from the Daedalic through the Classical and the Hellenistic styles. Examples are taken from the Parthenon, the pediments of the Temple of Zeus at Olympia and all well-known examples of Greek and Roman work, to illustrate the development of sculpture.

PECKOVER HOUSE ❧

North Brink, Wisbech PE13 1JR
Telephone: Wisbech (0945) 583463

NATIONAL TRUST
Open: 31 Mar-end Oct; Sat, Sun and BHs 2-5.30
Closed: GF
No access for disabled

On the north bank of the River Nene in the centre of Wisbech off the B1441. **6 A5**

Peckover is an attractive Georgian house built in 1722. There are paintings of members of the Peckover family, the original occupants of the house, but the bulk of the collection is a series of portraits of the Cornwallis family which are on loan. A portrait, by Gardiner, of Charles, 1st Marquis Cornwallis, who surrendered to the Americans in the War of Independence, hangs in the Ante Room along with his brother, the Hon. Sir William Cornwallis KCB, also by Gardiner.

In the Library, among the portraits by Henry Pickersgill, is *Lady Jemima Isabella Mann*, daughter of the 5th Earl. There are works by Johan Georg Ziesenis, including *Charles Ferdinand, Duke of Brunswick and his Son*. A Van Loo portrait of Richard Cornwallis hangs in the Dining Room. The Breakfast Room contains a Van Dael flower picture.

PETERBOROUGH CITY MUSEUM AND ART GALLERY

Priestgate, Peterborough PE1 1LF
Telephone: (0733) 43329

PETERBOROUGH CITY COUNCIL
Open: May-Sept Tues-Sat 10-5; Oct-Apr Tues-Fri 12-5; Sat 10-5
Admission Free: No access for disabled

In Priestgate on the south-west side of Peterborough. **6 A6**

Since the intention of the museum is to relate the story of Peterborough and its surroundings, it is appropriate to find topographical works and local portraits. There are two watercolours of Peterborough Cathedral by Turner, three local scenes by Nathan Theodore Fielding and etchings and drawings by the Peterborough artist Thomas Worlidge.

The earliest local portrait is a painting on panel of Sir Edward Montagu, executor of the will of Henry VII. Sickert's *The Third Republic: View of Porte St Denis*, and Abraham van der Schoor's *Concert Party* are among the non-Peterborough

works. There are also works on copper by Jan van Huysum; his *Classical Landscape* and *Rest on the Flight into Egypt*. Twentieth-century paintings came to the collection by way of the F. Hindley Smith Bequest, and six portraits were bought from the Duke of Manchester's collection at Kimbolton Castle. Six Books of Hours date from the fifteenth and early sixteenth centuries.

The City Art Gallery's three galleries are now predominantly used for the display of temporary exhibitions encompassing all aspects of the visual arts. This incorporates exhibitions from the permanent collection from time to time, although it is possible to see works from the collection not thus displayed by special appointment with the curator.

WIMPOLE HALL ❧
Arrington, Royston SG8 0BW
Telephone: Cambridge (0223) 207257

NATIONAL TRUST
Open: 31 Mar–4 Nov daily except Mon, Fri 1–5, BH, Suns, Mons 11–5
Closed: GF
Limited access for disabled

Eight miles south-west of Cambridge on the A603 and six miles north of Royston on the A14. **6 C5**.

The chief fine art interest at Wimpole Hall lies in the Chapel, which was decorated by Sir James Thornhill for the 2nd Earl of Oxford. The collection was mainly assembled by Rudyard Kipling's daughter, Elsie, whose husband, Captain Bambridge, bought the house in 1938. Certain works painted in the house in the early eighteenth century by the sporting artist John Wootton have been lent back to Wimpole Hall by Lady Anne Cavendish-Bentinck.

— CHANNEL ISLANDS —

—— ISLE OF GUERNSEY ——

GUERNSEY MUSEUM AND ART GALLERY
Candy Gardens, Saint Peter Port
Telephone: (0481) 26518

GUERNSEY MUSEUM SERVICES
Open: Every day 10.30–5.30, During winter months 10.30–4.30

Candy Gardens is in the island's capital.

The collection, recently opened to the public, contains local topographical water colours and drawings. Renoir, who visited the island, and was greatly taken by it, is represented by a single canvas.

—— ISLE OF JERSEY ——

JERSEY MUSEUM
9, Pier Road, Saint Helier
Telephone: (0534) 30511

JERSEY MUSEUM SERVICES
Open: Mon–Sat 10–5
Closed: Sun

Near to seafront in Saint Helier.

John Everett Millais is Jersey's most famous artist, a fact reflected in a number of late works belonging to the Barreau Art Gallery, among them *The Picture of Health*, a portrait of one of his daughters.

Ellen Terry, whose life is commemorated at Smallhythe Place in Kent, had associations with Jersey, and the gallery has Poynter's portrait of her.

—— CHESHIRE ——

BRAMALL HALL
Bramhall, Stockport SK1 4JR
Telephone: (061 485) 3708

METROPOLITAN BOROUGH OF STOCKPORT
Open: Apr–Sept Tues–Sun 1–5; Oct–Mar Tues–Sun 1–4; BHs except CD, BD
Closed: Jan
Limited access for disabled

Four miles south of the town centre off the A5102. Only entrance for vehicles off Bramhall Park Road. **11 C3**

The wall paintings are the chief fine art feature at Bramall Hall and are in both the Ball Room or 'Solar' and Chapel. They date from about 1600, although the costumes would suggest a period at least a century earlier, and they are done in imitation of tapestry, running over woodwork and plaster.

More work has been recovered in the Ball Room than in the Chapel, where only the vestiges of a pre-Reformation *Passion* can be seen. The main subjects in the Ball Room are secular, and include a boar hunt.

The house also contains portraits of the Davenport family, who have owned the manor for 500 years.

CAPESTHORNE HALL
Macclesfield SK11, 9JY
Telephone: (0625) 861221

THE BROMLEY-DAVENPORT FAMILY
Open: Apr Suns only; May and Sept Wed, Sat, Sun; June-Aug Tues-Thurs, Sat, Sun inc GF and BHs
Limited access for disabled

Off the A34 Manchester to London road between Wilmslow and Congleton. **11 B3**

The Reverend Walter Davenport Bromley collected most of the paintings, the cream of which were sold in 1863. Many of the remaining works are seventeenth-century English School. Paintings include a charming portrait, *Lucy and William Davenport Bromley as Children*, by George Knapton; eighteenth-century Italian landscapes, including *The Arno, Florence* by Zocchi; and an elegant work by E. Dubufe portrays the passionate pug-lover *Miss Caroline Davenport Bromley*.

There is a collection of Americana, including works covering the struggle for independence. Allan Ramsay's portrait of Jean-Jacques Rousseau is in the house as well as a portrait of Sir Walter Raleigh. Edward Davies Davenport was the collector of the Roman and later marbles.

DORFOLD HALL
Nantwich
Telephone: (0270) 625245

MR R.C. ROUNDELL
Open: Apr–Oct Tues and BH Mon 2–5; other times by appointment
No access for disabled

One mile west of Nantwich on the A534. **11 B4**

The collection is small. A portrait of Ralph Wilbraham, who built this house in 1616, by Cornelius Johnson, hangs in the Dining Room along with *A Dutch Lady* by Cuyp, two country scenes by Morland, and *Henry Tollemache and his Sister Julia* by Hurleston. Julia was the great-grandmother of the present owner. In the Drawing Room are two small portraits above the doors of Sir Francis Bacon and Lord Burleigh.

DUNHAM MASSEY HALL ❧
Altrincham WA14 4SJ
Telephone: (061 941) 1025

NATIONAL TRUST
Open: 31 Mar–31 Oct Sat–Thurs 1–5; Sun, BH Mon 12–5; last admissions 4.30
Limited access for disabled

Three miles south-west of Altrincham off the A56, approach from the M6 at Junction 19, and from the M56 at Junction 7. **II B3**

Dahl, Romney and Hoppner are represented among the Booth and Grey portraits. The main collectors of the family were George Booth, 2nd Earl of Warrington (1675-1758) and George Harry Grey, 5th Earl of Stamford (1737-1819). The latter's Grand Tour paintings include works by Mengs (the Earl's portrait) and two amusing caricatures by Thomas Patch: *The Voyage from Venice to Pola in Istria* and *A Punch Party: A Caricature Group with Lord Grey*.

Other Grey portraits include a Reynolds of the 4th Earl of Stamford and a portrait thought to be of Lady Jane Grey. *A Pug at Dunham Massey* shows the Tudor house in 1696 with 'Old Vertue' in the foreground. Cornelius Johnson painted the 1st Earl of Stamford and there is a Lely likeness of George Booth, 1st Lord Delamer.

GAWSWORTH HALL

Gawsworth near Macclesfield
Telephone: (0260) 223456

THE ROPER-RICHARDS FAMILY
Open: Apr-early Oct daily 2-5.30; one week at Christmas

South-west of Macclesfield off the A536. **II C3**

The portrait ascribed to Zuccaro in the Hall of Anne, Lady Fitton and her two children, Edward and Mary, is claimed as the only painting to portray from life the intriguing Mary Fitton. Renowned for her beauty, she was Maid of Honour to Queen Elizabeth and is possibly the 'Dark Lady' of Shakespeare's sonnets. Other family portraits are to be found, including *Walter Stanhope, First Earl of Harrington* by Allan Ramsay and more recent works.

Pictures by Wilkie, Turner and Constable and Sneyd family portraits hang in the Long Hall. In the Gold Room is an alabaster bust of Charles Gerard, 1st Earl of Macclesfield, sculpted in 1661. The Billiard Room contains later marble sculptures by Alfred Gatley, including *Echo*, a figure of a girl, and a bust of Milton. Gatley's family papers, diary and letter books are all kept in the house.

GROSVENOR MUSEUM

27 Grosvenor Street, Chester CH1 2DD
Telephone: (0244) 321616

CHESTER CITY COUNCIL
Open: Mon-Sat 10.30-5; Sun 2-5
Admission Free: No access for disabled

Near the castle on the southern approach to the city centre at the junction of Grosvenor and Nicholas Street. **II A3**

The Museum owns an extensive collection of paintings, watercolours, drawings and prints of Chester, Cheshire and North Wales. The oil paintings include topographical views by George Barret, Henry Pether and Pieter Tillemans, sporting scenes by Daniel and Henry Clowes and William Tasker, and portraits by Arthur Devis, Edward Penny and John Michael Wright. The watercolours include works by Moses Griffith and Louise Rayner, and many fine examples by T. S. Boys, W. Crane, J. Nash, F. Nicholson, J. 'Warwick' Smith and J. Varley.

See entry in main text, pages 102–3.

LITTLE MORETON HALL ❧

Congleton CW12 4SD
Telephone: (0260) 272018

NATIONAL TRUST
Open: 3 Mar-8 Apr and Oct Sat, Sun 1.30-5.30; 14 Apr-30 Sept daily except Tues 1.30-5.30; last admissions 5
Access for disabled

On east side of the A34 Newcastle-under-Lyme to Congleton Road, four miles south-west of Congleton. **II C4**

Fascinating Elizabethan wall paintings decorate the Parlour wall and the Chapel of this half-timbered late fifteenth-century manor. As figure subjects were discouraged in churches, biblical wall paintings of this period are occasionally to be found in houses. In the Parlour are scenes from the Apocrypha. The frieze recounts the story of Susanna and the Elders in which the characters all wear Elizabethan costume. The borders are elaborately ornamental and it is interesting that the decorators should have gone to such pains, in a house where there was no shortage of wood, to paint almost an entire room to look like panelling.

LYME PARK ❧

Disley, Stockport SK12 2NX
Telephone: Disley (0663) 62023

NATIONAL TRUST AND THE
METROPOLITAN BOROUGH OF
STOCKPORT

Open: GF, 13 Apr-30 Sept, Tues-Thurs, Sat, Sun 2-5; BH Mons 2-5; last admissions 4.30; Sun and BH 1-6; last admissions 5.30; Oct Sat, Sun 2-4 Limited access for disabled

On the A6 Stockport to Buxton Road, six miles south-east of Stockport, the entrance is west of Disley. **II C3**

The house was formerly the home of the Legh family, pictured in portraits by William Bradley, George Richmond and Attilio Baccani. In the Entrance Hall is a portrait of Edward the Black Prince. The copy of *Las Meninas* after Velázquez by Raoul Millais seems to have been painted because James I presented to Philip III in 1605 a pair of mastiffs from Lyme, one of which is in the foreground of the Spanish painting. The particular breed was renowned for its size.

An interesting group of seventeenth-century portraits is on loan from the National Portrait Gallery.

TATTON PARK ❧

Knutsford WA16 6QN
Telephone: Knutsford (0565) 54822

NATIONAL TRUST
Open: 1 Apr-end June,
3 Sept-end Oct daily except Mon 1-4, Sun, BH Mon 1-5;
1 July-2 Sept daily 1-5, Sun, BH Mon 12-5
Access for disabled

Three miles north of Knutsford, four miles south of Altrincham: entrance on Ashley Road one mile north-east of junction A5034 with A50. It is three and a half miles off the M6 at Exit 19 and half a mile south of the M56 at Junction 7. **II B3**

The collection contains a number of important works. A portrait of the founder of the family fortune, Sir Thomas Egerton, hangs above the fireplace in the Dining Room. Apart from other family portraits by Beechey, Owen and Lawrence, the most interesting is Bartolommeo Nazzari's superb portrait of Samuel Egerton.

There are some outstanding works: Van Dyck's *Martyrdom of Saint Stephen*, and two views in Venice, by Canaletto, of the Doge's Palace and the Grand Canal. Sporting pictures include *The Cheshire Hunt* by Henry Calvert, a good example of the genre.

See entry in main text, page 103.

WALTON HALL
Walton Lea Road, High Walton, Near
Warrington WA4 6SN
Telephone: (0925) 601617

WARRINGTON BOROUGH COUNCIL
Open: Easter-end Sept Thurs-Sun and
BH 1-5; Oct-Easter Sun and
BHs 12.30-4.30
Limited access for disabled

High Walton is 3 miles south of
Warrington on the A56, 2 miles north of
Junction 11 on the M56. **11 B3**

The oil paintings include works by Sir
Samuel Luke Fildes, *Fair Quiet and Sweet
Rest, Between the Tides* by Walter Langley,
Our Poor by James Henry Charles, *Venetian
Water Seller on the Steps of San Giorgio* by
Henry Woods, and *The Rescue* by Sir
Frank Brangwyn.

There are marble statues by John
Warrington Wood. Upstairs, occupying
two rooms, are a selection of paintings
mainly of the eighteenth and nineteenth
centuries donated to Warrington Borough
Council. The works are by Sir Edwin
Landseer, Frederick Sandys, Ford Madox
Brown, R.M. Lloyd, John Thistle, John
Sell Cotman, Daniel Maclise and others.

The collection at Walton Hall is an
extension of the Warrington Borough
Council collection, administered by War-
rington Museum and Art Gallery (q.v.).

WARRINGTON MUSEUM AND
ART GALLERY
Bold Street, Warrington WA1 1JG
Telephone: (0925) 30550

WARRINGTON BOROUGH COUNCIL
Open: Mon-Fri 10-5.30; Sat 10-5
Closed Sun and BH
Admission Free: Access for disabled by
prior appointment

Bold Street is in central Warrington,
which is on the A49 between the M62
and the M56, west of Manchester. **11 B2**

The collection consists mainly of works
by local artists, some of national repute.

There are important works by Jan van
Os, George Morland and J. Sidney
Cooper. A good collection of mainly
nineteenth-century watercolours has been
built up in recent years, including examples
by Peter de Wint, J. F. Lewis, J. Burrel
Smith, J. H. Mole, Copley Fielding, M.
Birket Foster, John Varley, T. M.
Richardson, Senior, John Sell Cotman
and a sketch by Ford Madox Brown.
Limitations of space mean that only a

small number of works are on show at
any one time.

WEST PARK MUSEUM AND ART
GALLERY
Prestbury Road, Macclesfield
Telephone: (0625) 24067

MACCLESFIELD MUSEUMS TRUST
Open: Tues-Sun 2-5
Closed: Monday (except BHs)
Admission Free: Access for disabled
11 C3

The main benefactors were the Brockle-
hursts, a local family which presented
many of the works of fine art 'for the
education and refinement and pleasure of
the people for all time to come'. The
paintings are mainly English, of the
nineteenth century. There is, however, a
collection of etchings, oils and watercol-
ours by Charles Tunnicliffe, who was
born in Macclesfield.

——— CLEVELAND ———

GRAY ART GALLERY AND
MUSEUM
Clarence Road, Hartlepool TS24 8BT
Telephone: (0429) 268916

BOROUGH OF HARTLEPOOL
Open: Mon-Sat 10-5.30, Sun 2-5
Admission Free: Limited access for disabled

In Hartlepool on Clarence Road. It can
be reached via the A19 then A689, or
A179, or A178. **15 B2**

Sir William Cresswell Gray, a member of
a local shipbuilding family, gave the
building and the original collection of
paintings to the town. The museum's
strength lies in works from the Victorian
and Edwardian periods. Examples of
British nineteenth- and early twentieth-
century watercolours and oils are *Sleeping
Beauty* by Daniel Maclise, *Gala Day at
Newlyn* by Stanhope Forbes, and *Shipping
off West Hartlepool* by J. W. Carmichael.

Frederick Shields, born in Hartlepool
in 1833, is represented by a number of
works. He became a friend of at least two
major Pre-Raphaelite artists, working
with Dante Gabriel Rossetti in his studio.
He was obsessively religious, setting great
store by this work at the expense of
commercial success.

MIDDLESBROUGH ART
GALLERY
320 Linthorpe Road, Middlesbrough
Telephone: (0642) 247445

BOROUGH OF MIDDLESBROUGH
Open: Tues-Sat 10-6
Admission Free: Access for disabled

The gallery is in a house close to the
centre of the town. **15 B3**

The collection is a good one, though
hardly 'the finest collection of twentieth
century British Art in the north of
England', as it claims. It is mainly of
twentieth-century British art, and includes
work by Gaudier-Brzeska, Pasmore and
Stanley Spencer. Its policy is to continue
expanding the collection of 'the art of
our time'.

There is also local topographical work.
Visiting exhibitions, some of dubious
value or merit, preclude the permanent
possessions from being adequately or
frequently shown.

ORMESBY HALL ✿
Ormesby, Middlesbrough TS7 9AS
Telephone: Middlesbrough (0642) 324188

NATIONAL TRUST
Open: Apr, Oct Wed, Sun,
Easter Sat, Sun, Mon;
May-30 Sept Wed,
Thurs, Sun, BH Mon 2-5.30
Access for disabled

Off the B1380, three miles south-east of
Middlesbrough, west of the A171. **15 B3**

Reynolds's portrait of *Sir James Pennyman,
Sixth Baronet,* painted in 1762, for which
the artist was paid £20, is one of the
Dining Room portraits. The Drawing
Room contains other Pennyman ancestral
portraits.

PRESTON HALL MUSEUM
Yarm Road, Stockton-on-Tees
Telephone: (0642) 781184

STOCKTON BOROUGH COUNCIL
Open: Mon-Sat 9.30-5.30; Sun 2-5.30
Admission Free: Limited access for disabled

In a large city park, off Yarm Road.
15 A3

The Preston Hall Museum has a single
outstanding painting, *The Dice Players,* by
Georges de La Tour.

The painting was left to Stockton-on-
Tees in 1930 by Annie Elizabeth
Clephan, then stored in an outstation of

the Teesside Museums in Middlesbrough, and rediscovered only recently. It is a signed work, one of only three paintings in these islands by this splendid French artist from Lorraine, whose total accepted output numbers only in the region of thirty works. Other de La Tour paintings are at Hampton Court Palace and at Leicester.

In addition to *The Dice Players*, the museum does have a collection of watercolours, the Clephan Bequest of 1930, including Turner's *Mustering of the Warrior Angels*, of 1833.

——— CORNWALL ———

ANTONY HOUSE ✳
Torpoint PL11 2QA
Telephone: Plymouth (0752) 812191

NATIONAL TRUST
Open: 1 Apr-end Oct Tues, Wed, Thurs and BH Mon 2-6, also Sun Jun-Aug (last guided tour 5.30)
No access for disabled

North of the A374, two miles west of Torpoint, five miles west of Plymouth by car ferry at Torpoint. 2 **D4**

The house has an extremely wide collection of portraits, both family and general. Notable are an anonymous portrait of the historian Richard Carew and Bowyer's moving portrait of Charles I at his trial. There are also examples by Reynolds, Ramsay, and Gilbert Stuart. Several works indicate the family's tragic ambivalence during the Civil War.

There are sporting works, including paintings by Jan Wyck, a significant influence on the seventeenth-century development of English sporting painting, and on John Wootton in particular.
See entry in main text, pages 262-3.

THE BARBARA HEPWORTH MUSEUM
Barnoon Hill, St Ives
Telephone: (0736) 796226

THE TATE GALLERY
Open: July and Aug Mon-Sat 10-6.30, Sun 2-6; Apr-June and Sept 10-5.30 (closed Sun); Oct-Mar 10-4.30 (closed Sun)
Access for disabled limited

On Barnoon Hill, St Ives, ten miles north-west of the A30 off the A3074.

The museum is devoted entirely to Dame Barbara Hepworth, one of Britain's foremost twentieth-century sculptors. The works cover the period 1928-74 and were in her possession at the time of her death in 1975. The building where she lived and worked, and the garden, together with the works of art, were given by her family and executors to the nation in 1980. The museum is administered by the Tate Gallery. There are forty sculptures in wood, stone and bronze, as well as drawings and paintings.

COUNTY MUSEUM AND ART GALLERY
River Street, Truro
Telephone: (0872) 72205

ROYAL INSTITUTION OF CORNWALL
Open: Mon-Sat 9-5
Limited access for disabled

In the centre of Truro. 2 **B5**

Truro contains Cornwall's finest art gallery with an extensive collection of paintings by John Opie, who was born near Truro. He was a youthful prodigy who came to be known as 'the Cornish wonder', though to some extent he was managed by the somewhat unscrupulous John Wolcot, a Truro writer, who was responsible for launching him on London society. Among the paintings by him is *A Gentleman and a Miner*, his *Self-Portrait*, and a portrait of *David Wilkie*.

Godfrey Kneller's portrait of *Arthur Payne*, the Cornish giant, who grew to seven feet six inches, a painting commissioned by Charles II, hangs on the staircase.

Nineteenth-century works include a number of Newlyn School pictures, including works by Stanhope Forbes and Norman Garstin.

Alfred de Pass, Cornwall's outstanding benefactor, gave to Truro a fine collection of drawings, and a selection of these is generally on view.
See entry in main text on Alfred de Pass, pages 261-2.

FALMOUTH ART GALLERY
The Moor, Falmouth TR11 2RT
Telephone: (0326) 313863

FALMOUTH TOWN COUNCIL
Open: Mon-Fri 10-4.30. Closed between exhibitions
Admission Free: No access for disabled

In the Municipal Buildings, in Falmouth, which is off the A39 from the A393 or A394. 2 **B5**.

In keeping with the gallery's location, the bias is towards late eighteenth- and nineteenth-century maritime paintings and prints. Much of the collection came through the Falmouth Free Library, the major benefactor being the South African collector Alfred de Pass (1861-1952).

The collection includes works by Waterhouse, Munnings, Tuke, Laura Knight, Luny and drawings by Burne-Jones. There are a few paintings by local artists such as Tresidder, Rowbotham and Holgate.
See entry on Alfred de Pass in main text, pages 261-2.

LANHYDROCK HOUSE ✳
Bodmin PL30 5AD
Telephone: Bodmin (0208) 73320

NATIONAL TRUST
Open: 1 Apr-end Oct except Mon but including BH and GF 11-6; Oct 11 5; last admission 30 mins before closing
Access for disabled

Two and a half miles south-east of Bodmin signed from the B3268 Bodmin to Lostwithiel road, and the A38 Bodmin to Liskeard road. 2 **C4**

A large solid house, the contents of which are principally Victorian and Edwardian. There are portraits of the 1st Lord and Lady Robartes by George Richmond and a portrait of the 1st Baron in Stuart court finery. In the Drawing Room hang portraits by George Romney and Arthur Devis.

NEWLYN ART GALLERY
Newlyn, Penzance
Telephone: (0736) 63715

NEWLYN ORION GALLERIES
Open: Mon-Sat 10-5 (except between exhibitions)
Admission Free: Limited access for disabled

On the seashore on the Penzance side of the village. 2 **A5**

The art gallery is a relic of the time when the Newlyn School of painters enjoyed considerable artistic as well as social success. It was for the exhibition of their work that it was built at the end of the nineteenth century. Today the gallery is used for exhibitions of contemporary art of regional and national significance. There are plans to expand the building and incorporate a small permanent collection of Newlyn School works and larger contemporary galleries.

PENCARROW
Washaway, Bodmin
Telephone: (020 884) 369

THE MOLESWORTH-ST AUBYN FAMILY
Open: Easter Sat–1 June Sun–Thur and
BHs 1.30-5; 1 June-10 Sept Sun–Thur and
BHs 11.30-5; 10 Sept-15 Oct Sun–Thur
and BHs 1.30-5

Four miles north-west of Bodmin off the
A389 at Washaway. **2 C4**

The eleven Reynolds portraits of the
Molesworth family in the Dining Room
are one of the rare series of family
portraits which still remains intact. The
Ante-Room contains a very fine conver-
sation piece by Arthur Devis of the four
daughters of Sir John St Aubyn, 3rd
Baronet. There are portraits by the Dutch
artist J. S. C. Schaak and a Richard
Wilson landscape in the same room.

The picture on the Upper Staircase
wall of Charles I seated at his trial was
painted by Edward Bower. Northcote,
Samuel Cook and Sir Oswald Birley are
among the other artists represented in the
collection.

PENWITH GALLERIES
Back Road West, St Ives
Telephone: (0736) 795579

PENWITH SOCIETY OF ARTS
Open: Tues–Sat 10-1, 2.30-5
Closed: Sun, Mon

Part of a group of fish-packing factories
in the lower town. **2 A5**

The Penwith Galleries, associated with the
more modern painters working in St Ives
from the 1940s on, was intended as an
exhibition place for current work and for
a permanent collection. Though the basis
for a permanent collection is owned by
the gallery it is rarely on show. Paintings
may be seen by appointment.

ST MICHAEL'S MOUNT 💐
Marazion, nr Penzance TR17 oHT
Telephone: Penzance (0736) 710507

NATIONAL TRUST
Open: 1 Apr-end Oct Mon–Fri 10.30-
5.45; last admission 4.45;
Nov-end Mar guided tours only
No access for disabled

Three miles east of Penzance, half a mile
from the shore, at Marazion (A394). It is
connected by causeway, usable only at
low tide. **2 A5**

Originally a Benedictine monastery colon-
ised by monks from Mont St Michel,
Normandy, the castle later became the
home of the St Aubyn family.

Most of the paintings were acquired by
Sir John St Aubyn, 5th Baronet (1758-
1839). Some of the portraits were
purchased from the Townshend Art
Collection by Lord St Levan at the
beginning of the nineteenth century.

The collection includes several portraits
by John Opie, and others by, or attributed
to, Dobson, Walker, Gainsborough, Devis,
Hudson, Kneller, Cornelius Johnson, Van
Somer and Bower. There is also a notable
collection of eighteenth-century miniatures
and ten scenes of the Mount by John
Miller depicting incidents in its history.

TRELOWARREN
Mawgan, Helston TR12 6AD
Telephone: (032 622) 366

SIR JOHN AND LADY VYVYAN
A Christian house open all year for
individual retreats, church groups, etc.
Open: For guided tours Easter-Oct Wed
2.30-5; Aug Sun 2.30-5; all BH Mons
2.30-5
Access for disabled

Mawgan is on the Lizard peninsula, east
of the A3083. **2 B6**

A small group of Vyvyan family portraits
indicate the five centuries of ownership,
as well as the many interesting historical
events involving Vyvyans. Among the
portraits is *Mary Bulteel*, by Cornelius
Johnson.

TRERICE 💐
St Newlyn East TR8 4PG
Telephone: Newquay (0637) 875404

NATIONAL TRUST
Open: 1 Apr-end Sept daily 11-6; Oct
11-5
Last admission 4.30
Access for disabled

Three miles south-east of Newquay in St
Newlyn East between the A3058 and
A3075 (turn right at Kestle Mill). **2 B4**

The contents of the house were gathered
during the last thirty years to reflect the
life of a small manor house in Cornwall.
The portraits are of people who would
have known the Arundells or Aclands of
the period, and also of members of the
Stuart family, to whom the Arundells
were loyal. An enormous *Still Life* by
Snyders hangs in the Drawing Room.

——— CUMBRIA ———

ABBOT HALL ART GALLERY
Kendal LA9 5AL
Telephone: (0539) 22464

KENDAL CORPORATION
Open: Mon–Fri 10.30-5, Sat and Sun 2-5
Access for disabled

Beside the parish church in Kendal, which
is on the A6, west of Junction 36 on the
M6. **14 B4**

Abbot Hall was bought by Kendal
Corporation in 1897. Lack of money kept
the house closed until 1962, when it was
turned into an art gallery. Since no
collection existed, it was decided to
acquire high-quality items of local origin
or association, such as works by George
Romney and Daniel Gardner, both of
whom were patronised by the eighteenth-
century occupants.

George Romney, who was the son of
a builder and cabinet-maker from Dalton-
in-Furness, was first apprenticed to a
Kendal portrait-painter, and at the end of
his life returned to the town. The
association is reflected in several works
which do justice to his qualities as an
artist. The simple and spacious handling
of light and colour is notable in his
Captain Robert Banks, and his splendid
group portrait, *The Gower Family,* indi-
cates why Romney became so sought
after among American collectors a century
ago.

The scope of the collection has gradually
been widened and there are a number of
watercolours and sketches by Ruskin, as
well as Turner's *The Passage of the Saint
Gothard.* The upper storey features modern
works by such artists as Ben Nicholson,
Hans Arp, Anne Redpath, Elizabeth Frink
and Barbara Hepworth.

Kurt Schwitters, the German Dadaist,
lived in Ambleside until his death in 1948,
and there are several works by him in the
collection, though his main *assemblage* is
at the Hatton Gallery, in Newcastle-upon-
Tyne, Tyne and Wear. (q.v.).

BEATRIX POTTER GALLERY 💐
Main Street, Hawkshead LA22 oNS
Telephone: (09666) 355

NATIONAL TRUST
Open: 1 Apr-4 Nov Mon–Fri 10.30-4.30;
last admission 4
No access for disabled

In the Square.

A selection of the original illustrations from Beatrix Potter's famous Peter Rabbit books are shown here as part of an exhibition telling the story of her life. The exhibits are changed annually. Many of these delicate watercolours were produced at her nearby seventeenth-century farmhouse, Hill Top (also National Trust).

BELLE ISLE
Bowness on Windermere
Telephone: (096 62) 3353

MRS E. H. S. CURWEN
Open: to pre-booked parties of 25 or more for guided tour
Limited access for disabled

On an island on the western shore of Lake Windermere opposite the town and a mile north off the B5284. **14 B3**

Owned by the Curwen family, the house contains a collection which includes portraits by Romney and a view of the house by Philip de Loutherbourg.

BRANTWOOD
Coniston
Telephone: (053 94) 41396

BRANTWOOD TRUST
Open: Mid-March-mid-Nov daily 11-5.30, Winter season Wed-Sun 11-4
Access for disabled

Six miles south-west of Ambleside off the B5285, on the edge of Coniston Water. **14 A3**

Brantwood was the home of John Ruskin, 1872-1900. The collection is mainly of his paintings and drawings with work by minor associates. It is hoped to acquire further Ruskin archives and extend the collection. A major development has been the opening of the Wainwright Gallery.
See entry in main text, page 140.

CARLISLE MUSEUM AND ART GALLERY
Tullie House, Castle Street, Carlisle
CA3 8TP
Telephone: (0228) 34781

CARLISLE CORPORATION
Closed in 1990

Due south of Carlisle Castle, and off Castle Street. **14 B4**

The collection derives from the bequest of over 600 works by Gordon Bottomley in 1949, together with subsequent pur-

chases made by William Rothenstein.

The paintings are mainly British, from the late nineteenth century onwards, with strong holdings of the work of Paul Nash, who was much admired by Bottomley, and by Winifred Nicholson, who lived for many years on a farm near Carlisle.

Some Pre-Raphaelite paintings, and watercolours by English artists of the first half of the nineteenth century, including Samuel Palmer, are also in the collection.
See entry in the main text, pages 139-40.

DALEMAIN
Dacre, near Penrith
Telephone: Pooley Bridge (085 36) 450

MR AND MRS BRYCE McCOSH
Open: Easter Sun-2nd Sun in Oct Sun-Thurs 11.15-5
Access for disabled

Between Penrith and Ullswater on the A592, two miles from Exit 40 on the M6. **14 B2**

Among the portraits are: *Sir Edward Hasell,* who bought the estate in 1697, by Lely; *Captain John Hasell* (reputedly marooned on an island by his crew) by Zoffany; his brother, *William Hasell,* squire of Dalemain, by Devis. Also in the collection are works by Van Dyck, Dahl, Richardson, Romney, Margaret Carpenter and Sir Francis Grant.

The house has close connections with Lady Anne Clifford, Countess of Dorset, Montgomerie and Pembroke, and one of her several portraits by John Bracken of Kirkby Stephen hangs in the old Tudor panelled room on the first floor of the Pele Tower.

An important work on show is a large Venetian townscape of St Mark's Square by Michele Marieschi dating from the 1740s.

GRIZEDALE
Grizedale Forest, Cumbria

FORESTRY COMMISSION, WITH THE ARTS COUNCIL
Open: At all times

The forest lies between the A591 and A5091, in central Cumbria. **14 B1**

The commissioning of outdoor works of sculpture by young British artists is undertaken in the Grizedale Forest by the Arts Council, in combination with the Forestry Commission. The works are scattered around in this imaginative

undertaking. Details may be obtained from the Grizedale Forest Centre.

HOLKER HALL
Cark in Cartmel, Flookburgh
Telephone: (044 853) 328

THE CAVENDISH FAMILY
Open: Easter-last weekend in Oct daily except Sat 10.30-6; last admissions 4.30
Limited access for disabled

Twelve miles south-west of Kendal, towards Barrow-in-Furness and just north of Cark off the Haverthwaite road. **14 B4**

Mainly the collection of Sir William Lowther, who was the eighteenth-century owner of the house and patron of several artists, including Reynolds. Though he inherited the house only a short time before his death, he brought to it important works of art which passed subsequently to the Cavendish family. A number of these have since been sold; the great Claude, *Parnassus,* is in Edinburgh, the Rubens, *Landscape with Cattle and Duck-shooters,* in Berlin.

The Library contains a drawing, *Lady Moyra Cavendish,* by Sargent, *James II* by Riley, and several family portraits by Richmond. Among these is his striking portrait *Lady Frederick Cavendish,* a woman of clear and forthright opinions about art, and wife of the Chief Secretary for Ireland, who was murdered in Phoenix Park on the day he took the oath. His portrait is also at Holker.

A notable battle scene by Salvator Rosa hangs in the Drawing Room along with paintings by Gaspard Poussin and W. J. Muller.

The Dining Room contains portraits by Lucas, Hoppner and Richardson as well as a self-portrait attributed to Van Dyck. The pictures in Queen Mary's Bedroom include drawings by Gainsborough. The Hall is hung with portraits, some by Scougall and Wissing.

HUTTON-IN-THE-FOREST
Skelton, Near Penrith
Telephone: (085 34) 449

LORD INGLEWOOD
Open: 1 June-1 Oct Sun, Mon, Thur and Fri 1-4, also open all BHs; Parties every day from 1 Apr by arrangement.
Limited access for disabled

Six miles north-west of Penrith on the B5305, M6 Exit 41. **14 B2**

The building is of many different periods and styles. The portraits are mainly of the Vane family. Some came from Fairlawn in Kent. The Hall contains sixteenth- and seventeenth-century pictures. The Ante-Room is hung with works by Lady Diana Beauclerk, a member of the family.

LEVENS HALL
Kendal LA8 oPD
Telephone: (053 95) 60321

C. H. BAGOT
Open: Easter Sun-30 Sept Sun-Thurs
11-5
No access for disabled

The house is situated 5 miles south of Kendal on the A6. The nearest motorway access is Exit 36 from M6. **14 B4**

Levens Hall is the Elizabethan home of the Bagot family.

In the Great Hall hangs a picture of *The Madonna and Child surrounded by Saints,* by Bicci di Lorenzo (*c.*1430) and one of *The Holy Family* by Pieter Koeck van Aelst.

In the Drawing Room there is a portrait of *Anne of Hungary* by Peter Paul Rubens, together with *Colonel James Grahme and his wife* by Peter Lely, and *Catherine, Countess of Suffolk and Berkshire* by Thomas Hudson. The Small Drawing Room contains pictures by Narcisse Virgile Diaz, a French landscape artist of the Barbizon School.

Watercolours by Peter de Wint decorate the walls of the bedrooms, and there are portraits by John Michael Wright and John Glover.

A large picture of *Birds in a Park Setting,* by Melchior de Hondecoeter, dominates the staircase leading back into the Hall.

In the Library are family portraits, *Sir Charles Bagot* by William Owen and a charcoal drawing of *Colonel Charles Bagot* by George Richmond. There is a lovely pastel of *An Unknown Lady* by John Russell and a magnificent portrait of a *Young Boy* by Aelbert Cuyp.

MUNCASTER CASTLE
Ravenglass, CA18 1RQ
Telephone: (065 77) 614

MRS P. GORDON-DUFF-PENNINGTON
Open: Daily, except Mon, Good Fri-30
Sept 1.30-4.30, open all BHs
Limited access for disabled

One mile south-east of Ravenglass village on the A595. **14 A3/4**

This beautifully situated pink granite castle stands among the Cumbrian hills. It has, among its works of art, *Boy with a Falcon* by Velázquez and *Charles I,* attributed to Van Dyck.

In one of the passages hangs a portrait of Thomas Skelton, the 'late fool of Muncaster', with his last Will and Testament. The Hall contains horse studies by John Ferneley. Paintings in the Library include portraits by Lely and pictures by Sir Alfred Munnings. The finest portraits of the Ramsden family hang in the Drawing Room and include works by Kneller, Hudson, Lely, Gainsborough, Reynolds, Lawrence, Watts and de Laszlo.

RYDAL MOUNT
Ambleside
Telephone:(096 63) 3002

MARY HENDERSON NÉE WORDSWORTH
Open: 1 Mar-31 Oct daily 9.30-5;
1 Nov-end Feb 10-4, closed Tues

1½ miles north of Ambleside on the A591. **14 B3**

The home of William Wordsworth from 1813 to 1850.

The house contains a fine collection of family portraits by Henry Inman and Margaret Gillies, also some of the poet's furniture and personal possessions. There are 3½ acres of garden landscaped by Wordsworth and magnificent views.

SIZERGH CASTLE ✖
Near Kendal LA8 8AE
Telephone: Sedgwick (053 95) 60070

NATIONAL TRUST
Open: 1 Apr-31 Oct Sun, Mon, Wed, Thurs 1.30-5.30; last admissions 5
Closed: GF

Three miles south of Kendal north-west of the A6 and A591 interchange. **14 B4**

The Strickland family were sympathisers of James II, which accounts for the Stuart portraits in the Dining Room. There is a portrait of *Sir Thomas Strickland,* who went into exile with the Stuarts, by Sir Godfrey Kneller. Other portraits include works by Riley, Romney, Opie, Dobson and Ferneley. Very fine early Elizabethan carving and panelling can be found throughout the house.

DERBYSHIRE

BUXTON MUSEUM AND ART GALLERY
Terrace Road, Buxton SK17 6DJ
Telephone: (0298) 4658

DERBYSHIRE COUNTY COUNCIL
Open: Tues-Fri 9.30-5.30, Sat 9.30-5
Admission Free

Buxton is off the A6 between Derby and Manchester. It can also be reached via the A54, A53 and A515. **11 C3**

The museum dates originally from 1891, its present site being a former spa hotel, to which it moved in 1928. The art gallery opened in 1979, with new accommodation presently being planned.

The gallery's holdings are mostly by British artists; oils by Brangwyn, Wilson Steer, Duncan Grant, B. Nichols, Lowry, Dawson and Morland and watercolours by Cox, Prout, de Wint and A. Pollitt.

CALKE ABBEY ✖
Ticknall DE7 1LE
Telephone: (0332) 863822

NATIONAL TRUST
Open: Apr-end Oct Sat-Wed 1-5.30
Last admission 5
Closed: GF
Access to some parts of the house difficult for disabled

Nine miles south-west of Derby, on A514 at Ticknall between Swadlincote and Melbourne.

The works of art at Calke cannot compare with the great Derbyshire collections, but there are nevertheless several paintings of considerable interest, notably Tilly Kettle's full-length portrait of *Lady Frances Harpur* and *The Council of Horses,* perhaps John Ferneley's masterpiece. The Caricature Room should not be missed.

CHATSWORTH HOUSE
Chatsworth, Bakewell DE4 1PP
Telephone: (024 688) 2204

THE DUKE OF DEVONSHIRE
Open: Apr-Oct Daily 11.30-4.30
No access for disabled

Ten miles west of Chesterfield, five miles east of Bakewell and two miles south of Baslow on the B6012. **11 D3**

Chatsworth House contains one of the world's most distinguished private art collections. The house has been open for

people to see since it was originally built in the seventeenth century.

Landseer's *Bolton Abbey in the Olden Times* hangs in the North Entrance Hall. Above the fireplace is *Diana and her Nymphs Surprised by Actaeon*, by Maratta and Dughet.

A number of small paintings by Old Masters line the North Corridor, including works by Ludovico Carracci, Pietro da Cortona and Solimena. This leads to the magnificent Painted Hall, decorated in 1692–4 by Louis Laguerre with *Scenes from the Life of Julius Caesar* on walls and ceiling. The flower paintings here, formerly attributed to Monnoyer, include a fine still life by Jacob Bogdani.

Upstairs, in the lobby of the Queen of Scots' Apartments (an optional part of the house visit, which is not always accessible), hang Reynolds's full-length of *William, Duke of Cumberland in Coronation Robes*, Carlo Maratta's *Pope Clement IX* and the huge group portrait of *Frederick, Prince of Wales, the Duke of Cumberland and their Sisters* by Mercier. Sebastiano Ricci's *Susannah and the Elders* is the first of several paintings by this artist in the house.

The Leicester Passage in the Apartments contains Sir Charles Eastlake's frenetic *Isadas at the Siege of Thebes*, painted in Rome in 1826. A self-portrait attributed to Annibale Carracci is in the Green Satin Dressing Room, with a set of four Dughet landscapes, while portraits in the Green Satin Bedroom include Benedetto Luti's *William Kent*.

The State Rooms contain a series of superb painted ceilings, with subjects taken from classical mythology. That in the State Dining Room is by Verrio. Laguerre was responsible for *An Assembly of the Gods* in the State Drawing Room, *Phaeton and Apollo* in the State Music Room, and *Aurora Chasing Away Diana* in the State Bedroom.

Paintings in the State Dining Room include the lovely *Portrait of a Little Girl* by Cornelis de Vos, and a sixteenth-century equestrian portrait of *Henry Fitzalan, 1st Earl of Arundel*.

The State Music Room contains Jan van der Vaart's effective *trompe-l'oeil, Violin and Bow Hanging on a Door*, Paris Bordone's *Family Group*, Giordano's *Acis and Galatea* and a sixteenth-century processional painting by Andrea Vicentino: *Dogaressa Grimani Leaving her Palace in Venice*.

Lely's *Europa and the Bull* is in the State Bedroom, with J. B. Huysman's *A Lady as St Catherine* and works by Luca Giordano. The octagonal *Venus and Adonis* is by Simon Vouet.

A small but interesting group of Dutch and Flemish works hangs in the China Closet, including paintings by Bril, van Ostade, Brouwer and Van der Meulen. The *Presentation of the Virgin* is attributed to Frans Pourbus, and the *Wheel of Fortune* (1533) to a follower of Dürer, Hans Schauffelein.

The ceiling over the West Stairs, *The Fall of Phaeton*, is one of Thornhill's earliest. Here are a number of large works: Cortona's *Call to St Peter*, Tintoretto's *Samson and Delilah* and Salvator Rosa's *Jacob's Dream*, which despite its size is painted on copper. Domenichino's *Expulsion of Adam and Eve* is another oil on copper. Sebastiano Ricci's grisaille incorporates a design for the tomb of the 2nd Duke of Devonshire, while Simon Vouet's *Allegory of Peace* contains the arms of Anne of Austria, the seventeenth-century Queen of France for whom it was presumably painted. Topographical paintings by Richard Wilson and William Marlow, with the Edward Halliday *Chatsworth in Wartime* painted in 1940 (in the State Drawing Room) illustrate the history of the house. The amusing group portrait, *The English Club House at Florence*, is by the Georgian caricaturist Thomas Patch.

The West and Chapel Corridors contain further works; large still lifes by J. B. Monnoyer, whose two versions of *Flowers in an Urn on a Draped Table* hang over the fireplaces, and by Largillière; and the group portrait by Isaac Fuller known as *Sir Thomas Browne and his Family*. Note the Veronese *Adoration*.

The decorations on walls and ceiling of the Chapel, unaltered since 1693, involved Laguerre and Richard, while Verrio painted *Doubting Thomas* above the altar.

Fifteen generations of the Cavendish family have commissioned a large number of portraits by distinguished artists of four centuries. The most famous, Reynolds's *Georgiana, Duchess of Devonshire with her Daughter Georgiana* and Sargent's *The Acheson Sisters*, are kept in the private rooms of the house, but on view to the public are works by Lely, Knapton, Ramsay, Reynolds, Hayter, Watts and Millais, among others.

On an easel in the Library is a sixteenth-century copy of *Henry VIII* by Holbein. The Ante-Library ceiling is Sir George Hayter's *Iris Presenting the Wounded Venus to Mars*, much admired at the Royal Academy in 1823, while in the Vestibule is a cartoon of *The Holy Family with St John* by Domenichino, part of Chatsworth's great collection of prints and drawings which for conservation reasons is not on public display.

The finest ensemble of portraits in the public rooms of Chatsworth is in the Great Dining Room, where Daniel Mytens's *Countess of Devonshire with her Children* hangs over the fireplace, surrounded by portraits by or attributed to Van Dyck. These include *Jeanne de Blois* and *Arthur Goodwin* (both formerly owned by Sir Robert Walpole), *William, 3rd Earl of Devonshire, Elizabeth, Countess of Devonshire* and *Thomas Killigrew the Poet with his Dog*.

Another group of portraits is on the Oak Stairs, where the centrepiece is *The 1st Duke of Devonshire on Horseback* by the school of Van der Meulen, with works by Cornelis de Vos and Lely among the many surrounding canvases.

The most modern portraits on view are in the West Sketch Gallery, including de Laszlo's *9th Duke of Devonshire*, Sargent's *Evelyn, Duchess of Devonshire* and Pietro Annigoni's *Deborah, Duchess of Devonshire*.

Some of the most important paintings hang in the Sculpture Gallery, including Rembrandt's *King Uzziah Stricken with Leprosy*, Frans Hals's *A Gentleman* and *A Lady* and Jacopo Bassano's *Three Marys at the Foot of the Cross*. Here, too, are Ricci's *Presentation in the Temple* and *Flight into Egypt*, Ermanni Stroiffi's *Men Making Music* and Hayter's portrait of the sculptor Canova. The visit ends, as it began, with Landseer; his satirical *Trial by Jury* substitutes dogs for judge and lawyers.

The current Duke's interest in art collecting has brought modern paintings and sculpture to Chatsworth. Most are in the private part of the house, but the *Large Interior, W. 9* in the West Stairs is one of the many works by Lucian Freud which he owns.

See entry in main text, pages 152–5.

DERBY ART GALLERY
Strand, Derby DE1 1BS
Telephone: (0332) 2931111

DERBY CITY COUNCIL
Open: Tues–Sat 10–5, Mon 11–5; Sun and BHs 2–5
Admission Free: Partial access for disabled

Near the city centre, in the Strand. **11 D4**

Joseph Wright of Derby is the principal attraction of the Derby Art Gallery, and its collection of his work the largest anywhere, including a number of masterpieces. However, they should not be allowed to obscure other fine works of art, mainly English.

The Wright paintings are well housed in their own gallery on the first floor. There are three galleries on the second floor devoted to temporary exhibitions, and works from the gallery's reserve collection.

Examples of his portrait painting, by which he earned his living, are included in the collection, among them sitters local to the Derby area.

The Art Gallery also contains the Alfred Goodey collection of pictures of Old Derby, donated in 1936, which is too large to be displayed all at one time. The Gallery also owns some 3,000 pieces of Derby porcelain, the largest public collection in existence.

See entry in main text on Joseph Wright, page 149.

HARDWICK HALL ✺

Doe Lea, Chesterfield S44 5QJ
Telephone: Chesterfield (0246) 850430

NATIONAL TRUST
Open: 1 Apr-16 Sept Wed, Thurs, Sat, Sun and BH Mons 1-5.30 or sunset if earlier; last admissions 5
Closed: GF

Off the Chesterfield to Mansfield Road, A617, midway between the two towns; approach from M1, Junction 29. **12 A3**

At the wish of the present Duke of Devonshire, Hardwick Hall was accepted by the Treasury in part payment of death duties and passed to the National Trust in 1959. Home of the redoubtable Bess of Hardwick, it is the most resplendent Elizabethan house in England. Its magnificent collection of sixteenth- and seventeenth-century needlework and tapestries are its chief glory.

The Long Gallery contains a remarkably extensive collection of portraits of the Cavendish family, and of members of British and European royalty with which it was connected. Notable also is the portrait of the political philosopher Thomas Hobbes who served the family and died at Hardwick in 1679.

See entry in main text, page 150.

KEDLESTON HALL ✺

Near Derby DE6 4JN
Telephone: (0332) 842191

NATIONAL TRUST
Open: 1 Apr-31 Oct Sat-Wed 1-5.30; last admission 5
Open to private parties Mon-Thurs
No access for disabled

Four miles north-west of Derby, two miles north of the A52. **11 D4**

Kedleston Hall, the home of Viscount Scarsdale, has an excellent collection of Italian, Dutch and English artists with paintings by Giordano and Strozzi, Cuyp and de Momper, Lely and Hone, including the last's delightfully informal portrait of the 1st Lord and Lady Scarsdale walking in the grounds of Kedleston.

As one would expect with this Robert Adam house, the neo-classical decorations and wall-paintings are particularly elegant. The ceiling of the State Dining Room incorporates paintings by Antonio Zucchi while the Great Hall and the Saloon are inset with decorative paintings by Biagio Rebecca and William Hamilton.

The Indian Museum at Kedleston holds the oriental works of art collected by Marquess Curzon when he was Viceroy of India (1898-1905).

See entry in main text, pages 156–7.

MELBOURNE HALL

Melbourne, near Derby DE7 1EN
Telephone: (0332) 862502

LORD RALPH KERR
Open: Every day in Aug except 1st 3 Mons 2-5
Limited access for disabled

In Melbourne, eight miles south of Derby off the A514 to Ashby-de-la-Zouch. **11 D5**

Melbourne Hall was the home of two Victorian Prime Ministers, Lord Melbourne and Lord Palmerston, who married Melbourne's sister. The collection includes portraits by Lely, Dahl, Huysmans and Lawrence, and drawings probably by Rembrandt and Gainsborough. In the Library hangs *Moses Striking the Rock* by Bassano, an architectural capriccio by Giovanni Paolo Panini and *St John the Baptist Preaching* by Susstrice.

There are three large Kneller portraits in the Drawing Room.

See entry in main text, page 157.

SUDBURY HALL ✺

Sudbury DE6 5HT
Telephone: Sudbury (028 378) 305

NATIONAL TRUST AND DERBYSHIRE COUNTY COUNCIL
Open: 1 Apr-Oct Wed-Sun and BH Mons 1-5.30 or sunset if earlier; last admissions 5
Closed: GF and Tues following BH Mon
Access for disabled to museum and tea room

Fourteen miles west of Derby at Sudbury and six miles east of Uttoxeter at the junction of the A50 and A515. **11 D5**

The collection in this Restoration mansion was formed over 300 years by the Vernon family. There is an important group of portraits from the early 1660s by John Michael Wright.

The Great Hall is hung with family portraits, two of which are by Sir Thomas Lawrence. There is a mural, *An Allegory of Industry and Idleness,* by Louis Laguerre. The same artist is responsible for the huge mural *An Ancient Battle* on the Great Staircase. Other works by Laguerre are elsewhere in the house.

Enoch Seeman is responsible for several portraits, including a full-length of the 1st Lord Vernon. Kneller, Hudson, Hoppner, Dahl, Soest, Vanderbank and Richmond are also represented in the collection.

A Museum of Childhood is housed in a wing of the house and the seventeenth-century stable block.

See entry in main text, pages 151–2.

─── DEVON ───

ARLINGTON COURT ✺

Arlington, Near Barnstaple EX31 4LP
Telephone: Shirwell (0271) 850296

NATIONAL TRUST
Open: 1 Apr-end Oct Sun-Fri, BH Sats 11-6; last admission 5.30; Oct 11-5
Limited access for disabled

Seven miles north-east of Barnstaple, off the A39. **3 A1**

William Blake's watercolour, *A Vision of the Cycle of the Life of Man* painted in 1821, is an outstanding example of the artist's work, found on top of a cupboard when the house was being sorted out for the National Trust in 1949.

The house also contains portraits and miniatures and some landscapes, as well as a variety of miscellaneous collections of pewter, model ships and shells. The National Trust has also established its own collection of over forty horsedrawn carriages in the stables.

BUCKLAND ABBEY ✺

Near Yelverton PL20 6EY
Telephone: (0822) 853607

NATIONAL TRUST AND PLYMOUTH CITY COUNCIL
Open: 1 Apr-end Oct daily except Thurs 10.30-5.30; Oct 10.30-5;

Nov-27 March Sat and Sun 2-5;
last admission 45 mins before closing
Limited access for disabled

Half a mile south of Yelverton between
the River Tavy and the A386 Tavistock
to Plymouth Road, six miles south of
Tavistock, eleven miles north of Ply-
mouth. **3 A4**

The Abbey was founded as a Cistercian
monastery in the thirteenth century. At
the Dissolution it was secularised and
bought by Sir Richard Grenville whose
family sold it to Sir Francis Drake in
1581. Buckland is run jointly by the
National Trust and Plymouth City Coun-
cil and contains exhibits relating to the
history of the monastery, Sir Francis
Drake and his family. On show are
Drake's portrait, attributed to Marcus
Gheeraerts, and the Hieronymo Custodis
of Sir John Hawkins, one of Drake's
companions. There are two portraits of
Queen Elizabeth I, one in the Gallery and
one in the Drawing Room.

 Other paintings in the house are *Sir
William Cecil, Lord Burghley, Lord High
Treasurer of England* attributed to Gheer-
aerts and a Seymour Lucas rendition of
The Surrender showing the moment when
Drake received the sword of surrender
from De Valdes during the Armada battle
of 1588.

BURTON ART GALLERY

Victoria Park, Kingsley Road, Bideford
Telephone: (023 72) 76713

TORRIDGE DISTRICT COUNCIL
Open: Oct-Mar Tue-Sat 10-1, 2-4; Mon
10-1; Apr-Sept Mon-Sat 10-1, 2-5; Sun
2-5; BHs
Admission Free; Access for disabled

On Kingsley Road in Bideford which is
nine miles from Barnstaple on the A39.
From the south it is just after the junction
of the A388 and A386. **2 D2**

The gallery, set in Victoria Park near a
tidal estuary, opened in 1951. It consists
of two large rooms of paintings of the
late nineteenth and early twentieth cen-
turies. There are paintings by Reynolds,
Lavery, Belcher, Sims, Wilson and Mark
Fisher. The Hubert Coop collection of
paintings is also to be seen here. Coop,
an able local watercolourist, and a
collector, was also a benefactor of the
gallery, together with Thomas Burton, a
businessman and lay preacher, after whom
it is named.

CADHAY

Ottery St Mary
Telephone: (0404) 812432

LADY WILLIAM-POWLETT
Open: Spring and Summer BH Sun and
Mon; July-Aug Tues, Wed, Thurs 2-5.30
Limited access for disabled

Between Honiton and Exeter on the A30,
just outside Fairmile and north of Ottery
St Mary. **3 C3**

This Tudor house has undergone various
architectural modifications, surviving
many changes of inhabitants. One of the
owners, Robert Haydon, had statues of
Tudor monarchs Henry VIII, Edward VI,
Mary and Elizabeth (dated 1617) placed
over the doors in the courtyard. There
are several marine paintings.

CASTLE DROGO ⅏

Drewsteignton, Exeter EX6 6PB
Telephone: Chagford (06473) 3306

NATIONAL TRUST
Open: 1 Apr-end Oct daily except Fri
11-6; last admission 5.30, Oct 11-5
Limited access for disabled

One mile west of Drewsteignton, three
miles north-east of Chagford and four
miles to the south of the A30 road
(Exeter-Okehampton). Turn off the A30
at Whiddon Down, towards Moreton-
hampstead. **3 A3**

Drogo is a twentieth-century castle
designed by Edwin Lutyens and one of
his more remarkable achievements in this
country. There are over a dozen portraits
dating from the eighteenth, nineteenth
and twentieth centuries, including some
of the Drewe family, for whom the castle
was built.

COMPTON CASTLE ⅏

Marldon, Near Paignton TQ3 1TA
Telephone: Paignton (0803) 872112

NATIONAL TRUST
Open: 2 Apr-end Oct Mon, Wed, Thurs
10-12.15, 2-5; last admissions 30 mins
before closing
Limited access for disabled

Four miles west of Torquay, one mile
north of Marldon between the A3022 and
A381. **3 B4**

Once the home of Sir Humphrey Gilbert,
coloniser of Newfoundland and half-
brother to Sir Walter Raleigh. Gilberts
still live here in the fortified manor. Only

the Great Hall, Chapel, solar, old kitchen
court and rose garden are open to the
public. Elizabethan portraits hang in the
hall.

GUILDHALL

High Street, Exeter
Telephone: (0392) 265500

EXETER CITY COUNCIL
Open: Mon-Sat 10-5
Closed: Sun and for civic functions
Admission Free

In the centre of Exeter. **3 B3**

The paintings in the Guildhall are on loan
from the Royal Albert Memorial Museum
and Art Gallery, and include a portrait of
George II by the Exeter-born artist Thomas
Hudson, who was the pupil, and then the
son-in-law, of Jonathan Richardson. Lely's
portrait of *General Monck* is also in the
Guildhall.

KILLERTON HOUSE ⅏

Broadclyst, Exeter EX5 3LE
Telephone: (0392) 881345

NATIONAL TRUST
Open: 1 Apr-end Oct Wed-Mon 11-6;
Oct 11-5; last admissions 30 mins before
closing
Access for disabled

Seven miles north-east of Exeter imme-
diately west of the B3181 Exeter-
Cullompton road and M5 (Exits 28 and
29). **3 B2**

The home of the Aclands since the period
of the Civil War, the house was rebuilt
for the 7th Baronet in 1778 to the design
of John Johnson; it houses a notable
collection of drawings which hang in the
Corridor and Conference Room. They
are portraits commissioned by Sir Thomas
Acland of members of the Grillion's Club,
which he founded in 1813. Joseph Slater
and George Richmond drew every
member; they include Gladstone, Lord
John Russell and Lord Ashley. Family
portraits hang throughout the house. Most
interesting is *Sir Thomas Acland, Tenth
Baronet,* known as 'The Great Sir Thomas',
by William Owen.

 The Paulise de Bush costume collection
is displayed in a series of room tableaux
of different periods; these are changed
each year and range from the eighteenth
century to the present day.

KNIGHTSHAYES COURT ❦
Bolham, Tiverton EX16 7RQ
Telephone: Tiverton (0884) 254665

NATIONAL TRUST
Open: 1 Apr-end Oct daily except Fri
1.30-6; open GF; last admissions 5.30, Oct
1.30-5; Gardens open daily
Access for disabled

Two miles north of Tiverton off the A396
at Bolham. **3 B2**

As well as the Heathcoat-Amory family
portraits by John Gray and Mary Eastman,
there are pictures by Evelyn and William
de Morgan and Spencer-Stanhope. The
Lobby contains *The Heathcoat Works
Outing, Teignmouth, August 10th 1854* by
W. P. Key, together with a portrait of
the founder of the textile factory, John
Heathcoat (1783-1861).
 A Russian seascape, presented to Vis-
count Amory by Marshal Bulganin and
Mr Khrushchev during their visit to
Britain, also hangs here. Old Master
paintings include works by, or attributed
to, Claude, Constable, Turner, Holbein,
Raphael, Rembrandt.
 The house also has an important
collection of majolica and Devon pottery.

PLYMOUTH CITY MUSEUM
AND ART GALLERY
Drake Circus, Plymouth PL4 8AJ
Telephone: (0752) 264878

PLYMOUTH CITY COUNCIL
Open: Tue-Sat 10-5.30; Sun 2-5
Admission Free

Plymouth can be reached from the A386,
A38 or A379. **3 A4**

Many paintings in the collection are by
artists born in or near Plymouth, or from
Devon. Among these are Reynolds, his
pupil James Northcote, Samuel Prout,
Francis Towne, J. W. Abbott and
Benjamin Robert Haydon.
 Among works by Reynolds is his
portrait of *Charles Rogers,* a Plymouth
collector, part of whose collection, pre-
sented to Plymouth in 1953, includes
some fine Old Master drawings.
 Outstanding collections of ceramics are
displayed, including eighteenth-century
Plymouth porcelain.

POWDERHAM CASTLE
Kenton, Exeter EX6 8JQ
Telephone: (0626) 890243

EARL OF DEVON
Open: Late spring BH-Sept Sun-Thurs 2-
5.30; last admission 5 pm

Four miles south of Exeter, on the west
bank of the River Exe estuary, north of
Starcross. **3 B3**

The Courtenay family has owned and
lived in the castle since 1390. Among the
portraits in the Anteroom is one by
Kneller of *The First Earl of Abingdon,* and
another of his daughter, *Lady Anne Bertie,*
who married a Courtenay.
 The First Library contains works by
Richard Cosway, Downman and Hudson.
A portrait of *Louis XVI* by Callet and a
full-length portrait of the 3rd Viscount
by Cosway hang in the Music Room.
The Staircase Hall contains several portraits
by Hudson and Watson, including one of
Lord Somerset, who eloped with Elizabeth
Courtenay, daughter of the 2nd Viscount,
and later became Governor of the Cape
of Good Hope.
 The Gold Drawing Room contains a
Samuel Scott, a Jan Fyt and a Wootton
in addition to further family portraits by
Hudson.

ROYAL ALBERT MEMORIAL
MUSEUM
Queen Street, Exeter EX4 3RX
Telephone: (0392) 265858

EXETER CITY COUNCIL
Open: Tues-Sat 10-5.30
Admission Free: Access for disabled by
prior arrangement

For Exeter, from the north approach via
the M5, from the south and west the A38
or A30. **3 B3**

The collection is particularly strong in
Devon art and contains a group of
important paintings by Francis Towne,
John White Abbott, Francis Hayman,
B. R. Haydon and Thomas Patch. The
collection of their works was given early
impetus after the 1932 loan exhibition of
work by Devon painters.
 It was not until the 1960s that a broader
collecting policy was adopted, aimed at
British and European art generally. Paint-
ings by Wilson, Nash, Wright of Derby,
Reinagle, James and William Gandy,
Reynolds, Hudson, Northcote, Opie,
Muller and Thomas Barker of Bath
indicate the range of the collection.

Watercolours and drawings, in addition
to the many local topographical works in
the collection, include examples by Turner,
Rowlandson, Constable, Nicholas Pocock
and an extensive group of drawings by
Samuel Prout.
 See entry in main text, pages 258—9.

SALTRAM HOUSE ❦
Plympton, Plymouth PL7 3UH
Telephone: Plymouth (0752) 336546

NATIONAL TRUST
Open: 1 Apr-end Oct Sun-Thurs, GF and
BH, Sat 12.30-6; last admissions 5.30; Oct
12.30-5
Access for disabled

Three miles east of Plymouth south of
the A38 and two miles west of
Plympton. **3 A4**

Saltram is essentially an eighteenth-century
building created around a Tudor core and
later enlarged by Robert Adam. The
collection, formed by the First Lord
Boringdon, a friend of Sir Joshua
Reynolds, who helped advise him, remains
fairly well intact.
 There is an emphasis on English
eighteenth-century painting and a number
of Italian topographical views, probably
acquired by Lord Boringdon on the
Grand Tour. Throughout the house are
fine portraits by Reynolds and Angelica
Kauffmann, including a portrait of Rey-
nolds by Kauffmann. Reynolds painted
the full-length portrait of *Theresa Parker*
as a pendant to Gheeraerts's *Sir Thomas
Parker* in the Saloon, the climax of the
house, where eighteenth-century portraits
were hung beside copies of such Italian
Old Masters as Titian and Raphael.
 In the Staircase Hall is a Rubens of
Francesco Gonzaga, Duke of Mantua.
 The Boudoir contains six portraits by
John Downman. The Library is hung
with a number of Gilbert Stuart portraits
as well as a few by Northcote. J. N.
Sartorius equestrian portraits, William
Tomkins landscapes and views of Saltram
hang in the Garden Room.
 See entry in main text, pages 259—61.

TORRE ABBEY
The King's Drive, Torquay TQ2 5JX
Telephone: (0803) 293593

TORBAY BOROUGH COUNCIL
Open: Apr-Oct Daily 10-5 (last
admission 4.30); Nov-Mar weekdays
only by appointment
No access for disabled

North of Torbay, in Torquay, on the King's Drive. **3 B4**

Torre was built in the twelfth century and was gradually converted into a private residence. The local authority purchased it in 1930. The contents are still being donated, which accounts for the variety and character of the collection. There are several fine nineteenth-century watercolours, including works by Burne-Jones, Holman Hunt and John Martin.

UGBROOKE PARK
Chudleigh TQ13 0AD
Telephone: (0626) 852179

LORD AND LADY CLIFFORD
Open: Sat, Sun, BH Mons from 2 May-Aug BH
Access for disabled

Signposted off the A380 Exeter to Torbay road. **3 B3**

Ugbrooke contains an interesting group of Lely portraits, including that of *The First Lord Clifford of Chudleigh*, ancestor of the present owners. The Drawing Room portraits by Lely include, in addition, *The Duke of York*, later James II, *Charles II* and *James Duke of Monmouth*.

An elegant portrait of Catherine of Braganza portrayed as *Saint Catherine of the Wheel* by Jacob Huysmans is also of note. Among the paintings in the Dining Room are *The Kitchen Maid at Work* by Joris van Schooten, and a farmyard scene by Jan Siberechts.

The large painting on the Staircase is by G. Jones of *Cardinal Weld Receiving his Hat from Pope Clement VII*. The Cardinal's illegitimate daughter and her children are observing the scene from a box on the right of the painting.

———— DORSET ————

KINGSTON LACY ✂
Wimborne Minster, BH21 4EA
Telephone: Wimborne (0202) 883402

NATIONAL TRUST
Open: 1 Apr-4 Nov Sat-Wed 12-5.30
Limited access for disabled

On B3082 Wimborne-Blandford road, one and a half miles west of Wimborne.

Kingston Lacy was bequeathed by the Bankes family to the National Trust in 1981, along with its outstanding art collection. William Bankes, whose substantial architectural changes to the house

in the early nineteenth century gave it superb decorative stonework and wood-carving, added important paintings to the seventeenth-century collection of Sir Ralph Bankes.

William Bankes bought the great unfinished *Judgement of Solomon* by Sebastiano del Piombo as a Giorgione, and the *Holy Family with the Infant St John in a Landscape*, now attributed to Giulio Romano or G. F. Penni, as a Raphael. Several of William's finest purchases are in the Saloon: a Titian portrait thought to be of *Francesco Savorgnan della Torre* and Rubens's full-length portraits of the *Marchesa Caterina Grimaldi* and the *Marchesa Maria Grimaldi*. Ralph Bankes's paintings, recorded in 1659, include Lely's *St Mary Magdalene*, Nicolaes Berchem's *Landscape with Herdsmen* (bought through Lely) and a pair of early works by Sebastien Bourdon: the *Judgement of Midas* and *Rape of Europa*. Portraits of interest include Salvator Rosa's *Edward Altham as a Pilgrim*, Lely's *N. Wray* (Ralph Bankes's art dealer) and Kneller's of his mistress, *Mrs Voss with her child*.

The Library contains a group of fine Lely portraits of the Civil War generation of Bankeses; *Mary Bankes*, *Lady Jenkinson* and *Mr Stafford* are outstanding. Other Bankes portraits include Massimo Stanzione's *Jerome Bankes* and Batoni's *Henry Bankes*. In the corners of the room are Gerard Seghers's *Four Latin Fathers of the Church*.

The Spanish Room (also called the Golden Room after its gilded Venetian ceiling and leather) was created by William Bankes to display the Spanish paintings bought during his travels in Spain between 1812 and 1814, when the Peninsular War displaced many works of art. Velázquez's *Cardinal Massimi* is the highlight of an ensemble of works bought as originals but now thought to include paintings from the studios of Zurbarán and others.

The Edwardian Drawing Room contains Van Dyck's portraits of *Sir John* and *Lady Borlase*, Romney's full-length *Mrs Bankes* and Lawrence's *Mrs Riddell*. A line of enamels by Henry Bone, copies of portraits of famous historical figures, circles the room.

See entry in main text, pages 264-5.

ROTHESAY MUSEUM
8 Bath Road, Bournemouth BH1 3AA
Telephone: (0202) 21009

BOURNEMOUTH BOROUGH COUNCIL
Open: Mon-Sat 10.30-5.30; last admissions 5
Access for disabled by appointment

On Bath Road, near the seafront, in Bournemouth.

Housed in a modern building, this museum has a small, but good and detailed, collection of marine paintings. There are fine examples of works by Gribble, Wyllie, Luny and Webb and some good non-marine paintings, including *Moorland Scene*, by Sir David Murray and *The Haymakers* by Anderson Hague.

Among the works by Wyllie is *The Pool of London*, and an outstanding example of Gribble's work is *The Royal Yacht leading the Fleet at Spithead*.

RUSSELL-COTES ART GALLERY AND MUSEUM
East Cliff, Bournemouth BH1 3AA
Telephone: (0202) 21009

BOURNEMOUTH BOROUGH COUNCIL
Open: Mon-Sat 10-5.30; last admissions 5
Access for disabled only by appointment

In Russell-Cotes Road, in the centre of Bournemouth seafront area. **5 C4/5**

The collection is housed in a fine building which was originally designed as a villa for Sir Merton Russell-Cotes. It has mainly Victorian paintings although there are some works by eighteenth-century artists. These include: *The Peasant's Repast* by George Morland, *The Sailor's Return* by Francis Wheatley, and *View in the Strada Nomentana* by Wilson.

Etty, Frith, Moore, Landseer and Long are all well represented, and the permanent collection of watercolours includes works by Turner, Cox, Cotman, de Wint and Varley.

Among notable nineteenth-century works are *Venus Verticordia*, by Rossetti, Landseer's *A Highland Flood*, *Ramsgate Sands* by Frith, *Home from Work* by Hughes, and Etty's *The Dawn of Love*.

See entry in main text, page 265.

SHERBORNE CASTLE
Sherborne
Telephone: (0935) 813182

MR SIMON WINGFIELD DIGBY
Open: Easter Sat-end Sept Thurs, Sat, Sun and BH Mon
Access for disabled only by appointment

Five miles east of Yeovil, south of Sherborne off the A30. **5 C6**

The collection at Sherborne Castle closely reflects the fortunes of the Digby family,

and consists mainly of portraits. There are several sporting paintings and *A Procession of Queen Elizabeth,* attributed to Robert Peake the Elder, should be noted.

Works by, or attributed to, Lely, Van Dyck, Johnson, Walker, Hudson, Maratta, Batoni, Mytens, Kauffmann, Kneller and Gainsborough hang throughout the house.

DURHAM

THE BOWES MUSEUM

Barnard Castle DL12 8NP
Telephone: (0833) 37139

DURHAM COUNTY COUNCIL
Open: 10-5.30 daily, Sun 2-5.
Closed at 5 Mar, Apr, Oct and at 4 Nov-Feb
Closed: During Christmas period and NYD
Access for disabled

Four miles off the A66 from Greta Bridge or Bowes; fifteen miles from Scotch Corner. **14 D3**

A rare example of a major museum in the middle of moorland countryside, this is situated on the outskirts of the small town of Barnard Castle, in the beautiful Upper Teesdale countryside.

Over a thousand paintings, not all of them good, were acquired between 1840 and 1880. The collection includes French paintings, among them Boucher's *Landscape with a Watermill* and works by Fragonard, Robert, Oudry, Desportes and Van Loo.

The Spanish works are among the museum's finest possessions, particularly the El Greco, *Tears of Saint Peter,* and two works by Goya.

There are also good Italian paintings, among them a predella panel by Sassetta, and Solario's *St Jerome in the Wilderness.*
See entry in main text, pages 136-8.

DARLINGTON ART GALLERY

Crown Street, Darlington
Telephone: (0325) 462034

BOROUGH OF DARLINGTON
Open: Mon-Fri 10-8, Sat 10-5.30
Admission Free

Darlington is reached from the A1(M) or A66(M). **15 A3**

The gallery houses a permanent collection of over 350 pictures owned by the Borough of Darlington. The picture collection has been gathered together by donation, bequest and purchase, and

includes several important contemporary works as well as a representative selection of nineteenth-century and early twentieth-century northern artists. Artists include Sutherland, Carmichael, Vicat Cole, Russell Flint, John Dobbin, Spencer Gore and Patrick Nasmyth.

Space is limited, and is used for temporary exhibitions. There is no certainty that the permanent collection will be on view.

DARLINGTON MUSEUM

Tubwell Row, Darlington
Telephone: (0325) 463795

BOROUGH OF DARLINGTON
Open: Mon-Wed, Fri 10-1, 2-6; Thurs, Sat 10-1, 2-5.30
Closed: Sun, BH
Admission Free

This small local museum contains a collection of watercolours and drawings associated with Darlington and the immediately surrounding countryside. Among its individual works is an extensive watercolour by John Dobbin, a local artist, of *The Opening of the Stockton and Darlington Railway,* 1825. Works not directly related to local history include caricatures by Bernard Partridge and George du Maurier.

RABY CASTLE

Staindrop, Darlington, DL2 3AH
Telephone: (0833) 60202

LORD BARNARD
Open: Easter weekend Sat-Wed; May & June Wed & Sun; July-Sep daily except Sat 1-5
Limited access for disabled

Eleven miles west of Darlington on the A688, between Bishop Auckland and Barnard Castle. **14 D3**

The lively collection of sporting paintings was probably begun by the 1st Duke of Cleveland (1766-1842) and was added to by the 9th Lord Barnard.

The Library contains a Batoni of *William Banks* and works by David Teniers the Younger, Lely and Pieter de Hoogh. A Giordano, a Reynolds and a Lely hang in the Dining Room.

The Barons' Hall contains a Hoppner portrait of Elizabeth, 1st Duchess of Cleveland.

ESSEX

AUDLEY END

Saffron Walden
Telephone: (0799) 22399

DEPARTMENT OF THE ENVIRONMENT
Open: Apr-Sept 1-5.30

One mile west of Saffron Walden, off the A11. **6 C5**

The collection does not rank among the finest private collections in England but it contains many paintings of historical and artistic interest. Particularly good are the works by Canaletto, Van Goyen and the Eworth portrait.

Works of interest include *Sir John Griffin* by Benjamin West; *Richard Neville* by Zoffany; *Lord Sandwich* by Emmanuel de Critz; *Rear Admiral Matthew Whitwell* by Reynolds; *Sir Peter Lely and Hugh May* by Lely; *Marquis Cornwallis* by Beechey; *Duchess of Norfolk* by Hans Eworth; *A River Scene with a Ferry Boat* by Jan van Goyen; *Naples Harbour* by Zoffany.
See entry in main text, page 193-4.

BEECROFT ART GALLERY

Station Road
Westcliff-on-Sea
Telephone: (0702) 347418

BOROUGH OF SOUTHEND-ON-SEA
Open: All year except BHs, Mon-Thurs 9.30-5.30, Fri 9.30-5, Sat 9.30-5.30
Admission Free: Limited access for disabled

Westcliff-on-Sea is west of the centre of Southend-on-Sea, which is reached via the A13 or A127. Opposite to the Cliffs Pavilion. **7 A3**

The gallery was purchased through a trust fund set up by Walter George Beecroft of Leigh-on-Sea. It opened in October 1953. Works from the permanent collection are usually on display. A variety of temporary exhibitions are held throughout the year.

A number of Dutch and Flemish oil paintings of the seventeenth century include characteristic landscapes, genre, still lifes and portraits. There is *Wooded Landscape with a Shepherd* attributed to Jacob van Ruisdael.

Italian works, including a School of Francesco Solimena *Rebecca at the Well,* are represented, also Spanish, English and French schools. There are works by the French nineteenth-century painters Henri-Joseph Harpignies, Paul Désiré Trouillebert and Edmond Yon.

The Marchioness of Dorset (sixteenth century) is among the English paintings. The collection of English paintings from the nineteenth and twentieth centuries includes *The River Stour looking towards Manningtree* by Constable. There are also works by William Etty and Sir Frank Brangwyn. Among twentieth-century British painters, Tristram Hillier, Ruskin Spear, John Nash and Carel Weight are represented. Included in the watercolours and drawings are two satirical works by Thomas Rowlandson, a portrait by Dante Gabriel Rossetti, and *The Temple of Jupiter* attributed to J. M. W. Turner.

In January 1960 a newly built extension to the gallery was opened to accommodate the 'Thorpe Smith Gallery', which contains Southend-on-Sea topographical works.

CHELMSFORD AND ESSEX MUSEUM

Oaklands Park, Moulsham Street, Chelmsford CM2 9AQ
Telephone: (0245) 353066

CHELMSFORD BOROUGH COUNCIL
Open: Daily 10-5, Sun 2-5
Admission Free: Limited access for disabled

Chelmsford is on the A12 north-east of London. **6 D4**

Chelmsford and Essex Museum was started by Thomas Clarkson Neale, a collector, who was honorary secretary of the Chelmsford Philosophical Society in 1832. It was established and opened to members in 1835 with Mr Neale as its curator. After various moves and changes in its fortunes the museum was presented to the Borough Council in 1899 and was revived in 1906. Its modern history began in 1930, when it moved to its present premises in Oaklands House, built in the 1860s for a local brewing family. In 1973 an extension was built to the house, for the collection of the Essex Regiment.

The art collection has about 500 pictures from the late eighteenth century to the present day. Works include *Shire Hall, 1794* by Reinagle, *Stream by a Mill* by John Nash, and works by Cedric Morris, Peter Coker, Edward Bawden, Reginald Brill, John O'Connor and Roderic Barrett. The collection includes a large number of topographical watercolours by Alfred Bennett Bamford painted between 1890 and 1920.

Temporary exhibitions mean that the collection is not always on view.

HARLOW MUSEUM

Passmores House, Third Avenue, Harlow CM18 6YL
Telephone: (0279) 446422

HARLOW BOROUGH COUNCIL
Open: Fri, Mon and Wed 10-5, Tues and Thurs 10-9, Sat, Sun 10-12.30, 1.30-5
Admission Free: Access to ground floor only for disabled

For Harlow, exit at Junction 7 of the M1, or by way of the A414. **6 D5**

The collections belonging to Harlow District Council are housed in the Museum and Town Hall. In addition to the local history and archaeology collections, of particular interest in the museum is the oil *River Stort at Harlow* by Henry Moon.

In the Town Hall is a collection of English watercolours dating from the second half of the twentieth century. Among the artists represented are John Piper, Graham Sutherland, Laura Knight, John Nash, Hugh Casson and Elizabeth Frink.

THE MINORIES

74 High Street, Colchester CO7 1UE
Telephone: (0206) 577067

THE VICTOR BATTE-LAY TRUST
Open: Tues-Sat 10.30-6, Sun 2-5
Admission Free: Limited access for disabled

In the centre of Colchester in the High Street. **6 D3**

The Minories attempts to reconcile the need to 'benefit and advantage the inhabitants of Colchester . . . who take an interest in the artistic and antiquarian features of the town', and visitors who want to see the permanent collection. Frequent exhibitions make the fulfilment of the latter aim difficult. The collection is strong in local work, particularly by Paul and John Nash, whose private libraries may be consulted by arrangement. Some of Constable's earliest work, his life drawings, are in the collection as well as work by Cedric Morris, Maggi Hambling, Leon Underwood and Rodin.

It is only recently that a clear collecting policy has been worked out.

SIR ALFRED MUNNINGS ART MUSEUM

Castle House, Dedham, Colchester CO7 6AZ
Telephone: (0206) 322127

Open: First Sun in May to First Sun in Oct, Wed and Sun; Aug Sat, Thurs and BHs 2-5
Limited access for disabled

On the outskirts of Dedham on the road to Manningtree. **6 C/D 2/3**

The house contains a major collection of paintings by Munnings, changed from time to time as works go out for exhibition, but covering every aspect of his art. There are major canvases connected with the Turf, such as the lively *Under Starter's Orders*; with the Hunting Field, such as *Nobby Gray*; and with the portraiture of both horses and riders.

Early student work includes *Nude* painted at Julien's in 1901. *Augereau and Shrimp* is also an early work; the horse and the gipsy appear in several early paintings by Munnings.

'My last painting before the war started' is how the artist described *The White Canoe*, an example of his natural and attractive realism, as is *Barge on the Stour, Dedham*.

See entry in main text, pages 194–5.

— GLOUCESTERSHIRE —

BERKELEY CASTLE

Berkeley, near Stroud
Telephone: (0453) 810332

MR AND MRS BERKELEY
Open: Apr daily except Mon 2-5; May, June, July, Aug Tues-Sat 11-5, Sun 2-5; Sept daily except Mon 2-5; Oct Sun only 2-4.30; BHs 11-5; last admissions half an hour before closing time
No access for disabled

In Berkeley between Bristol and Gloucester off the A38. From the M5 turn off at Junction 13 or 14. **4 D6**

Edward II was murdered in the keep of this rather grim castle. The Picture Gallery contains a few seascapes by Van de Velde, many with ships owned by the Berkeley family. They also owned Berkeley Square in London. Money from the sale of the London properties went towards castle maintenance. Among the sporting pictures are works by Stubbs and the *Old Berkeley Hounds* possibly by Ben Marshall.

The Small Drawing Room contains a bird painting by David de Koninck. Among the members of the family portrayed are *Sir William Berkeley*, who was Governor of Virginia in 1641, *The*

First Earl of Berkeley by Mary Beale, *The Eighth Earl of Berkeley* by William Orpen and *Admiral Sir Cranfield Berkeley* by Gainsborough. There are other portraits by Lely, Paul van Somer, Hoppner, Reynolds and Kneller.

CHELTENHAM ART GALLERY AND MUSEUM
Clarence Street, Cheltenham
Telephone: (0242) 237431

CHELTENHAM BOROUGH COUNCIL
Open: Mon–Sat 10–5.30
Closed: BHs
Admission Free: Access for disabled

From the M5 exit at Junction 10 or 11. Cheltenham can be reached via the A40, A46 or A435. **4 C5**

In 1898 the Baron de Ferrières presented an extensive and interesting collection of Dutch and Flemish paintings to the town of Cheltenham together with money to be put towards the building of the Art Gallery and Museum, which was opened in 1899.

The collection includes works by seventeenth-century masters such as Gerrit Dou, J. D. de Heem, Gabriel Metsu, Rachel Ruysch, Godfried Schalcken, H. M. Sorgh and Jan Steen. Particularly fine are *A Man and a Women at Wine* by Metsu and *The Fat Kitchen* and *The Lean Kitchen,* both by Steen. The Baron also collected eighteenth- and nineteenth-century pictures, among which are a dramatic storm scene by B. C. Koekkoek, an *Interior of a Tavern with a Blind Fiddler* by Baron Leys, and charming townscapes by Cornelis Springer and J. H. Verheyen.

Highlights of the British collection are a *Portrait of Mary Colby* by Francis Cotes and a pair of panoramic landscapes showing Dixton Manor in Gloucestershire and harvesters working in the fields nearby, painted by an unknown early eighteenth-century artist. Complementing these are twentieth-century works by, amongst others, Charles M. Gere, William Rothenstein, Graham Sutherland, Stanley Spencer and Stephen Cox. Spencer is represented by *Village Gossips, Gloucestershire,* while Gere's *The Tennis Party,* painted in 1900, is highly important not only in the history of tennis but also in its portrayal of several leading members of the Cotswold Arts and Crafts movement.

Of local interest is the group of watercolours by Dr Edward Wilson, who was born in Cheltenham and died with Scott during the expedition to the South Pole in 1912.

GLOUCESTER CITY MUSEUM AND ART GALLERY
Brunswick Road, Gloucester
Telephone: (0452) 24131

GLOUCESTER CITY COUNCIL
Open: Mon–Sat 10–5
Admission Free: Access for disabled

In city centre, near car parks; from M5 exit at Junction 11 or 12. **4 C5**

The main period of art represented is the English eighteenth and nineteenth centuries and more especially the landscape tradition of this time. There are also examples of sixteenth- and seventeenth-century Dutch and Flemish paintings, many with biblical and religious themes. Abraham Storck, Ary de Voys, Jacob van Ruisdael, Johannes Volterman, Wouwermans and Van de Velde are among the more important artists to whom works are attributed.

Cottage and Covered Haystack by Jacob van Ruisdael, a landscape by William Adolphus Knell, five superb seascapes by W. Van de Velde, and *Portrait of Charles I* attributed to Van Dyck are among works in the collection.

The National Art Collections Fund produced the money, along with a grant from the Victoria and Albert Museum, to purchase a magnificent William Turner of Oxford, *Newnham on Severn from Dean Hill.* Three delicate watercolours by J. M. W. Turner and a set of eight engravings from illustrations of topographical books by Johannes Kip of Amsterdam are all works not to be missed.

English works include Richard Wilson's *Tomb of the Horatii and Curatii,* a landscape by Thomas Gainsborough, Philip Wilson Steer's *The Stroud Canal, Glencora* by Walter Richard Sickert and Joseph Farington's *Westgate Bridge, Gloucester.*

SUDELEY CASTLE
Winchcombe GL54 5JD
Telephone: (0242) 602308

MRS DENT-BROCKLEHURST
THE DENT-BROCKLEHURST FAMILY TRUST
Open: Mar–Oct daily including BHs
12–5.30
Limited access for disabled

Six miles north-east of Cheltenham on the A46. **4 C5**

An excellent small collection which includes works by Claude, Rubens, Van Dyck, Ruisdael, Hogarth, Greuze, Turner and Constable. It represents only a small selection from the paintings assembled by the Dent family, well-known glovemakers.

Constable's *The Lock,* which was exhibited at the Royal Academy in 1824, is an important and powerful example of the artist's work. The early and magical Turner *Pope's Villa on the Thames* is a visual lament for the needless demolition of the poet's house at Twickenham, while the sweetly down-turned eyes of Greuze's model in *Innocence* makes this a splendidly moving example of his work.

— GREATER LONDON —

THE BANKSIDE GALLERY
48 Hopton Street, Bankside SE1 9JH
Telephone: (071) 928 7521

ROYAL SOCIETY OF PAINTERS IN WATER-COLOURS AND THE ROYAL SOCIETY OF PAINTER-ETCHERS AND ENGRAVERS
During exhibitions Tues 10–8; Wed–Sat 10–5; Sun 2–6
Closed: Mon
Access for disabled

Underground: Blackfriars
Buses: 17, 45, 63, 70, 76, 109, 141, 155, 168A, 184. **30 C2**

The gallery is the home of the Royal Society of Painters in Water-Colours and the Royal Society of Painter-Etchers and Engravers. The works exhibited are principally watercolours and prints. In addition to the exhibitions by these two Royal Societies (they each have two exhibitions per year – Spring and Autumn) the gallery holds other exhibitions concerned mainly with works of art on paper, including open exhibitions.

There are over 700 works in the extensive permanent collections. They include pictures by most of the leading nineteenth- and twentieth-century English watercolour artists, with outstanding examples in many cases. Included are watercolours and prints by Samuel Palmer, David Cox, Sargent, Burne-Jones, de Wint, Graham Sutherland, Sickert and Gerald Brockhurst. Many of the works are presented by members as diploma pictures plus numerous bequests.

Currently there is a scheme of sponsorship aimed at financing the restoration and reframing of works which are sent out as loan exhibitions — 'Adopt a Picture Campaign'.

THE BANQUETING HOUSE
Whitehall SW1A 2ER
Telephone: None

DEPARTMENT OF THE ENVIRONMENT
Open: Tues–Sat 10–5, Sun 2–5
Closed: GF, CD, BD

Underground: Westminster, Charing
Cross

Buses: 3, 11, 12, 24, 29, 53, 77, 77A, 77C,
88, 159, 168, 170, 172. **30 C3**

Inigo Jones's Banqueting House, in
Whitehall, is all that remains above
ground of the Palace of Whitehall. It was
from one of its windows, probably the
centre one, that Charles I stepped on to
the platform where he was executed.

During the course of its construction
the King, then Prince of Wales, had
dreamed of great paintings for the interior,
and was responsible for commissioning
the Rubens ceiling canvases during the
diplomatic mission which the Antwerp
painter led to the English Court, between
June 1629 and April 1630. Owing to his
enforced diplomatic work, Rubens was
unable to complete the commission until
1635, and was not paid until 1638, just
two years before his death.

The ceiling contains nine panels, painted
on canvas in Antwerp, and now arranged
as the artist intended them. They depict
in rather over-stated terms the allegorical
Apotheosis of James I, the first showing his
translation into Heaven on the back of an
eagle, and supported by Religion and
Justice. Mercury and Minerva attend him
on his journey.

Other panels, such as *The Benefits of the
Government of James I, The Triumph of
Reason*, and *The Triumph of Royal Bounty*,
attest to James's great success as a monarch
in his son's eyes. From the south end of
the Hall, looking back as it were from
the throne on which Charles I would
have sat in audience, the central canvas,
The Union of England and Scotland, depicts
James I blessing the good fortune which
put him on the throne.

The nine great canvases, the largest of
which is 28ft by 20ft, are the finest and
most fully realised of Rubens's ceiling
paintings, painted at the height of his
powers, and with complete success.

As an early example of conservationist
care, Charles I discontinued the masques
which had been a major entertainment in
the Banqueting Hall, for fear that the
smoke from the lights would damage the
ceiling paintings. Portraits, and a Rysbrack
bronze of Rubens, are also on display.

BRITISH MUSEUM
Great Russell Street WC1B 3DG
Telephone: (071) 636 1555–8

TRUSTEES OF THE BRITISH MUSEUM
Open: Mon–Sat 10–5, Sun 2.30–6
Closed: CE, CD, BD, NYD, GF, BHs
Admission Free: Access for disabled

Underground: Holborn, Tottenham
Court Road, Russell Square
Buses: 7, 8, 14, 19, 22, 24, 25, 29, 38,
55, 68, 73, 77, 77A, 134, 170, 176, 188,
239. **30 B3**

The British Museum is a museum of
civilisation, the greatest of its kind in the
world. Culture, in the sense of the
intellectual and social development of a
people, is in part the subject of much of
the material assembled over more than
two centuries. Fine art forms only part of
this. Applied art is often a greater
component of the material on display.
Both are, in turn, aspects of the historical
and cultural relevance of the objects.

The collection of prints and drawings
is only one of the nine categories into
which the British Museum's collections
are divided. The main emphasis here is
placed on this collection, which could be
described as 'purer' fine art than the truly
magnificent collections of antiquities
which form the overwhelming majority
of objects on display. Nevertheless, within
each category there is a fine art dimension.

Coins and medals illustrate artistic
trends in most classical and post-classical
cultures and are displayed in the relevant
galleries. Changing exhibitions on a range
of historical and artistic themes are
mounted by the entrance to the Depart-
ment.

Egyptian antiquities include sculpture,
tomb paintings and reliefs, papyri, funerary
objects, figurines, carvings and inscribed
stelae, of which the famous Rosetta Stone
is an example. The rooms are arranged so
that the visitor works backwards from
the magnificent Ptolemaic and Roman
periods, beginning with works of sculp-
ture, almost all for religious purposes,
involving the worship of deities, kings,
for intercessionary or funerary purposes,
and as monuments.

Of special interest are the statues of
*Hapi, King Ramesses II, King Sesostris III,
Granite Ram bearing an inscription of King
Taharqa* and *Red Granite Lion from the
Temple at Soleb*. Egyptian wall paintings,
dating from 3000 BC, follow a strict and
unchanging convention, rarely varied;
figures are shown with heads, torsos, arms
and legs in profile, eyes and shoulders
frontally. The paintings were generally

tomb decorations, reproducing the earthly
environment after death.

The Greek and Roman Collections are
the best in the world outside their areas
of origin, and include what have been
regarded, through history, as among the
finest works of sculpture ever executed,
those done by Phidias, in the Athens of
Pericles, for the decoration of the
Parthenon.

These *Elgin Marbles* are named after
Britain's Ambassador to Constantinople,
Lord Elgin, who, horrified by their
continuing destruction, transported them
from Greece to Britain at the beginning
of the nineteenth century and then sold
them to the British Government. They
include parts of the surviving frieze, some
metopes and some sculptures from the
pediments of the great Doric temple of
Athene, and represent different aspects of
Greek mythology and history. Especially
beautiful are the horses and riders; the
seated and reclining figures from the
pediments, however, are also finely carved
in great and meticulous detail. They
justify Plutarch's claim: 'Each of them as
soon as finished had the venerable air of
antiquity, so that now that they are old,
they seem fresh and newly made. Such is
the bloom of youth on them they look
always untouched by time, as if they were
suffused with unfailing life, and a spirit
that cannot grow old.' Though written
in the first century AD, the words still
ring true. Greek Art from 3000 BC is
included in the collection, from the
Cycladic marble carvings and bronze
ornaments to such Hellenistic masterpieces
as the bronze *Head of Sophocles*. The
Roman antiquities include further sculp-
ture, terracotta and bronze statuettes and
frescoes from Pompeii and Herculaneum.

The Medieval and Later Antiquities
include both secular and religious objects,
incorporating applied and decorative art
of a very high order, in precious metals,
ivory, bone, crystal, enamel and wood.
Of special interest are the reliquaries, such
as the gold-enamelled *Reliquary of the
Holy Thorn* dating from the early fifteenth
century, and such works as a *Painted
Triptych*, dating from about 1510.

The Oriental Antiquities include galler-
ies of the Indian sub-continent, the art
and antiquities of the Islamic world,
South-east Asia, Central Asia, China and
Korea. The collection is particularly rich
in Indian art, with magnificent and
comprehensive collections of Indian sculp-
ture and painting, the earliest dating from
the sixth century BC and including all the
main developments, from early Buddhist
art, through the great flowerings at
Gandhara, then the art of the Gupta

Empire, the Mathura School, and the later regional developments based on these early manifestations. Persian, Mesopotamian, Syrian and Turkish art account for the great area of South-west Asia; an equally rich collection covers South-east Asia, with such early Chinese masterpieces as a ritual bronze vessel of the Shang dynasty, dating from the twelfth–eleventh century BC, to a Glazed Earthenware Camel of the Tang dynasty, eighth century AD. Finally there is the Japanese Collection, beginning with the Jomon Period (first millennium BC) through to the seventeenth century, when Japanese art began to impinge decisively on European culture. Separate galleries of Japanese and Islamic material are being constructed. The Department normally mounts a programme of changing exhibitions which may include scroll painting, miniatures, etc.

Prehistoric and Roman-British antiquities include Palaeolithic engravings on bone and antler, the chalk carved Neolithic 'Folkton Drums' masterpieces, early Celtic art in gold and bronze, wall paintings, mosaics and silver plate from Roman Britain, and sculpture such as the bronze statuette of *The Emperor Nero* from Barking Hall, Suffolk.

Western Asiatic antiquities include superb Assyrian sculpture, the greater part of it in the form of wall slabs, sculpted in shallow relief, detailing Assyrian history, but doing so in the context of nature and ordinary life. The British Museum collection contains many objects which are unique. They were discovered and brought back from Mesopotamia in the nineteenth century. Included are such splendid, monumental works as the colossal *Human-Headed Winged Bulls*, the *Lion Hunt of Ashurbanipal* and *Ashurbanipal Feasting in a Garden*.

The Ethnographic Collection (in the Museum of Mankind, Burlington Gardens) duplicates, geographically, some areas of the world, dealing with prehistoric cultures in South-east Asia, Palestine, Assam and Baluchistan, but is primarily concerned with the magnificent primitive art of the Pacific cultures, Polynesia, Melanesia, Micronesia, with North and South American art, from the Eskimos to Peru, and with African art.

The Department of Prints and Drawings has no permanent display, though on average three exhibitions from the collection and/or elsewhere are mounted each year. Its collection of western graphic art, which ranges from the fourteenth century to the present day, while not the largest in the world, is nevertheless vast, and is arguably the best balanced and most representative. It is rich in all periods, and magnificently endowed with the works of certain individual artists, such as Rubens, Dürer, Claude, Michelangelo, Rembrandt and Raphael. The collections of prints of individual masters in the different graphic art media are mostly comprehensive. The collection is the one most closely related to the various other collections of fine art dealt with in this Art Atlas, and its development, together with its main attributes, is covered more fully in the first part.

Each section is itself a huge museum, the minor masterpieces in which would be outstanding in any other location. For the visitor it should be treated as a series of museums, every one of which deserves the amount of time, and more, that might be given to virtually any other institution covered in this Atlas.

See entry in main text, pages 33–8.

THE BROOMFIELD MUSEUM

Broomfield Park, Palmers Green N13 4HE
Telephone: (081) 882 1354

LONDON BOROUGH OF ENFIELD
Open: Easter–30 Sept Tues-Fri 10-6; Sat, Sun 10-8; 1 Oct-Easter 10-5
Closed: Mon
Admission Free: Limited access for disabled

Underground: Arnos Grove
Buses: 29, 34, 102, 112, 123, 244, 251, 261, 298, 298A. **7 A5**

The Broomfield Museum contains an interesting series of wall paintings by Gerard Lanscroon, a pupil of Verrio. They are painted in oil directly on to the plaster. The subjects are: *The Liberal Arts*, *Education of Cupid*, *The Seasons*, *Bacchus and Ariadne*, and *Fame*.

CARLYLE'S HOUSE ☙

24 Cheyne Row SW3 5HL
Telephone: (071) 352 7087

NATIONAL TRUST
Open April-end Oct Wed-Sun and BH Mons 11-5; last admissions 4.30
Closed: GF
No access for disabled

Off Cheyne Walk between Battersea and Albert Bridges on Chelsea Embankment. Underground: Sloane Square, then Buses 11, 19, 22; South Kensington, then Buses 45, 49; also Bus 39. **7 A5**

The house contains a collection of furniture, pictures and relics which once belonged to Thomas Carlyle and his wife, Jane. The art is interesting rather than distinguished, and closely related to Carlyle's character and intellectual preoccupations, with portraits of the subjects of his writing. There are striking Samuel Laurence drawings of the writer and his wife and an interesting watercolour by Helen Allingham of the Back Dining Room, painted in 1881, shortly after Carlyle's death.

CHISWICK HOUSE

Burlington Lane, Chiswick W4
Telephone: (081) 995 0508

ENGLISH HERITAGE
Open: GF-30 Sep 10-6; 1 Oct-Mar Thurs 10-4
Closed: daily 1-2, also Mon, Tues Oct-March, CE, CD, BD, NYD
Limited access for disabled

Underground: Hammersmith, then Bus 290 **7 B6**

Chiswick House was the temple of the arts created by the 3rd Earl of Burlington, patron of the philosophers, writers, musicians, artists and sculptors of his day. The villa was not intended as a residence, but had a gallery for Burlington's art, a library for his books and rooms for entertaining his friends. Among them were Alexander Pope and William Kent, the architect who designed the gardens and much of the interior decoration of the house, including the Domed Saloon and the 'Architecture' ceiling in the Blue Velvet Room. Burlington's collection on his death passed to his daughter and her husband, the 4th Duke of Devonshire; it included major works now at Chatsworth.

Portraits at Chiswick include Jan Wyck's *Moroccan Ambassador*, Ferdinand Elle's *Louis XIII and Anne of Austria* and a triple portrait by Michael Dahl: *Charles, Earl of Burlington; John, Lord Berkeley of Stratton and Evelyn, Duke of Stratton*. Mythological painting is represented by Sebastiano Ricci's *Venus and Cupid* and Daniel Seiter's *Apollo and Daphne*.

Other paintings of interest are the small portrait roundels of notables of Lord Burlington's day, among them *Alexander Pope* by William Kent. William Aikman's *Lady Burlington* is in the bedchamber where she died. The older portrait of *Inigo Jones* by the seventeenth-century artist William Dobson is, like Rysbrack's statues of *Inigo Jones* and *Palladio* which stand before Chiswick House, a mark of

Lord Burlington's admiration for these architects.

COURTAULD INSTITUTE GALLERIES
Somerset House
The Strand WC2R ORN
Telephone: (071) 873 2526

UNIVERSITY OF LONDON
Open: Mon-Sat 10-6; Sun 2-6
Closed: BHs 25, 26 Dec; 1 Jan and Easter
Access for disabled

Underground: Temple, Covent Garden, Charing Cross, Waterloo
Buses: 1, 4, 6, 9, 11, 13, 15, 68, 77

The Courtauld Institute Galleries contain several distinct collections, all belonging to the University of London. The Galleries moved in June 1990 to Somerset House, to occupy the neo-classical Fine Rooms designed by William Chambers in 1776–80 for the Royal Academy.

Samuel Courtauld, founder of the Courtauld Institute of Art, in 1932–3 gave paintings and works on paper from his collection of great Impressionist and Post-Impressionist art. Highlights include Manet's *Bar at the Folies-Bergère* and study for the *Déjeuner sur l'Herbe*, Renoir's *La Loge*, a group of fine Cézannes, among them *Lac d'Annecy*, Gauguin's *Nevermore* and *Te Rerioa* and Van Gogh's *Self-Portrait with Bandaged Ear*. The Seurats, including *Young Woman Powdering Herself*, demonstrate the development of his Neo-Impressionist style, and there are good works by Daumier, Degas, Monet, Pissarro (*Lordship Lane Station*), Sisley and Toulouse-Lautrec.

The international reputation of the Courtauld for French art should not lead the visitor to neglect the Old Masters, particularly the superb Rubens bequests from the Seilern and Lee collections. Count Seilern's Princes Gate collection is rich in portraits, including the warm *Family of Jan Brueghel the Elder*, and in sketches. *Esther and Ahasuerus* was designed for the now-lost Jesuit Church ceiling, in Antwerp, and *The Death of Achilles* for a tapestry series. The poetic *Landscape by Moonlight* was admired by Reynolds and Constable. The study for the great Antwerp Cathedral altarpiece, *The Descent from the Cross*, comes from the Lee collection (see below).

Count Seilern's tastes were broad: the Bernardo Daddi tabernacle of 1338, Quentin Massys's *Madonna with Child and* Angels and Pieter Brueghel's *Landscape with the Flight into Egypt* were his, as was Kokoschka's 1920s *Market in Tunis*. So were the early Netherlandish masterpieces, the *Entombment* triptych by the Master of Flémalle and the Giovanni Battista Tiepolo studies, including *The Immaculate Conception* and four other altarpiece designs.

Viscount Lee of Fareham left the Courtauld his Old Masters in 1947. Italian paintings include Botticelli's *Holy Trinity with Saints* and Veronese's *Baptism of Christ*. The dreamlike *Assassination of St Peter Martyr* is a variant of a Bellini in the National Gallery. Lucas Cranach the Elder's *Adam and Eve*, Jacques Blanchard's *Charity* and Lely's early *Concert* are Lee paintings, like the British portraits, from Hans Eworth's *Allegorical Portrait of Sir John Luttrell* to Romney and Beechey.

Mark Gambier-Parry in 1966 bequeathed his grandfather Thomas Gambier-Parry's pioneering collection of early Sienese and Florentine art, including Lorenzo Monaco's *Coronation of the Virgin* and Fra Angelico's *Dead Christ with Saints*.

The art critic Roger Fry left his own Bloomsbury Group collection: paintings by Vanessa Bell, Duncan Grant and Fry himself include their portraits of *Lytton Strachey*, and there are Omega Workshop decorative arts as well as African and Pacific sculpture.

Dr Alistair Hunter in 1984 gave his modern British collection of work by Ben Nicholson, Ivor Hitchens, John Hoyland, Prunella Clough, Larry Rivers, Keith Vaughan and others, and there have been recent bequests from Lillian Browse and Anthony Blunt.

The Galleries' holdings of works on paper are large and of outstanding quality. Besides gifts from the collectors already named, it incorporates the Witt Collection of 4,000 British and Old Master drawings, and the Mr and Mrs W. W. Spooner Collection of English watercolours. Mantegna, Bellini, Hugo van der Goes (*Female Saint*), Michelangelo (*The Dream of Human Life*), Pieter Brueghel the Elder, Rubens (*Helena Fourment*), Rembrandt, Lely (*Two Heralds*), Gainsborough, Constable, Turner, Daumier, Degas, Seurat (*Standing Female Nude*), Toulouse-Lautrec and Cézanne are only a few of the artists represented in a collection particularly rich in Netherlandish and modern French works.

See entry in main text, pages 84–5.

THE CRICKET MEMORIAL GALLERY
Lord's Cricket Ground,
St John's Wood Road NW8 8QN
Telephone: (071) 289 1611

MARYLEBONE CRICKET CLUB
Open: During the cricket season on match days Mon-Sat 10.30-5. Other times by appointment
Limited access for disabled

Underground: St John's Wood
Buses: 13, 74, 82, 113, 159 **30 A6**

The museum is at the Marylebone Cricket Club and related mementoes are on display as well as cricket paintings, several dating from the eighteenth century.

DICKENS HOUSE MUSEUM
48 Doughty Street WC1N 2LF
Telephone: (071) 405 2127

DICKENS HOUSE TRUSTEES
Open: Mon-Sat 10-5
Closed: Sun and public holidays
Limited access for disabled

Underground: Russell Square
Buses: 5, 17, 18, 19, 38, 45, 46, 55, 172, 259 **30 A3**

The Dickens House collection is largely Victorian and features works painted either for, or in celebration of, the writer. Paintings, drawings and busts are situated throughout the house. There is a portrait of Dickens by W. P. Frith, a drawing and a painting by J. E. Millais and a painting by R. W. Buss. *Charles Dickens in 'Used Up'* is by Augustus Egg, and there is a bust by Henry Dexter. The original sepia drawings for illustrations of scenes and characters in the novels by Fred Barnard can be seen in the entrance hall, passages, staircases and landings.

DR JOHNSON'S HOUSE
17 Gough Square EC4A 3DE
Telephone: (071) 353 3745

DR JOHNSON'S HOUSE TRUSTEES
Open: May-Sept Mon-Sat 11-5.30;
Oct-Apr Mon-Sat 11-5
Closed: Sun, CD, BD, NYD, GF, Easter Mon, BHs

Underground: Blackfriars, Chancery Lane
Buses: 4, 6, 9, 11, 15, 168, 502, 513 **30 B2**

A small collection, of limited artistic merit, is interesting for its close association with the writer. It includes the striking

study for the portrait of Johnson by James Barry, incorporated in his murals at the Royal Society of Arts. Other portraits include one of Boswell, a copy of Opie's portrait and W. P. Frith's *Dr Johnson and Mrs Siddons* painted in 1887. Other copies of portraits of the writer, as well as prints once owned by his biographer, Boswell, are also in the house. They are part of a good collection of eighteenth-century portraits.

DULWICH PICTURE GALLERY

College Road, Dulwich SE21 7AD
Telephone: (081) 693 5254

DULWICH COLLEGE

Open: Tues-Fri 10-1, 2-5, GF and Sat 11-5, Sun 2-5
Guided tours Sat and Sun 3 pm.
Closed: Mon, Christmas and New Year
Access for disabled

Underground: Brixton (Victoria line) then
Bus 3 to Thurlow Park Road
Train: West Dulwich
Buses: 37, 12, 12A, 78, 176, 176A, 185
7 B5

The Dulwich Picture Gallery, Britain's oldest, is able to show about half its 600-plus paintings in the intimate atmosphere of the fine neo-classical building designed by Sir John Soane. (For his own Soane Museum, see p. 365.) Despite the outstanding paintings (some intended for a National Gallery in Poland), the gallery is refreshingly uncrowded, due to its site in the Dulwich Village area of London, outside the city centre.

The collection belongs to Dulwich College School. It includes a bequest of paintings from the actor William Cartwright; some of these, as well as paintings associated with his friend, the actor Edward Alleyn who founded the College in 1619, hang in the *Entrance Hall*. S. P. Denning's delightful *Queen Victoria Aged Four* is here, too.

Room 1: The Linley family portraits were painted by Gainsborough, a family friend, and bequeathed by the handsome *William Linley* (portrait by Lawrence). The elder of the lovely *Linley Sisters* eloped with Sheridan the playwright.

Flanking Room 1, in *Rooms 9 and 10*: Lely's *Nymphs by a Fountain*, Van Dyck's early *Samson and Delilah* and a rare *Landscape*, Soldi's *Roubiliac*, Canaletto's *Old Walton Bridge*, Hogarth's *Fishing Party*, and a replica of Reynolds's *Mrs Siddons as the Tragic Muse*; portraits by Lely, Soest, Hudson, and Kneller (*Two Children*). Rubens's sketches include *St*

Barbara, for the lost Jesuit Church ceiling.

Room 2: Among good Flemish and Dutch paintings, Van Dyck's *Emmanuel Philibert of Savoy*, *Madonna and Child* and *Earl of Bristol*, van Huysum's *Vase of Flowers*, Teniers's *Chaff-cutter* and Hobbema's *Landscape with Watermill* are outstanding.

Leading off Room 2, in *Room 9*: More Dutch paintings, among them Rembrandt's beautiful *Girl at a Window*, his *Jacob de Gheyn III*, and so-called *The Artist's Son, Titus*; Gerard Dou's *Lady Playing at a Clavichord* and Aert de Gelder's *Jacob's Dream*.

Room 3, adjoining the Mausoleum where the benefactors of the Gallery, Mr and Mrs Desenfans and Sir Francis Bourgeois lie buried: Murillo's charming *Flower Girl* (his daughter?), Rubens's *Hagar in the Desert*, Lely's pastoral *Young Man as a Shepherd* and Van Dyck's *Venetia, Lady Digby on her Deathbed*.

Rooms 4 and 5: Some of Dulwich's numerous Poussins, including the fine *Triumph of David*, the *Nurture of Jupiter* and *Venus and Mars*; Le Brun's *Massacre of the Innocents* and spirited *Horatius*; Murillo's picaresque *Two Peasant Boys* with its pendant, *Two Peasant Boys and a Negro Boy* (the most famous Murillos in Victorian England), and Italian paintings, including a Cortona sketch for the Pitti Palace, and a Veronese.

Leading off Room 4, in *Room 12*: More Poussins, among the most beautiful being *Rinaldo and Armida* and the mysterious *Roman Road* (attributed to him); Claude's *Jacob and Laban*; works by Tiepolo, Watteau and Swanevelt.

Leading off Room 5, in *Room 6*: A fine ensemble of Italianate Dutch landscapes by Berchem, Both, Pynacker (*Landscape with Sportsman*) and Cuyp (*Herdsmen with Cows*).

See entry in main text, pages 80–82.

FENTON HOUSE ✲

Windmill Hill
Hampstead NW3 6RT
Telephone: (071) 435 3471

NATIONAL TRUST

Open: March Sat, Sun 2-6; Apr to Oct Sat-Wed 11-6; last admissions 5
Limited access for disabled

Underground: Hampstead
Buses: 210, 268 pass nearby **7 A5**

George Salting was a famous connoisseur-collector who bequeathed the bulk of his collections to the Victoria and Albert Museum, the National Gallery and the

British Museum. The remainder passed to Mrs M.E. Salting, Lady Binning's mother, and thence to his niece, Lady Binning, at Fenton. There are relatively few paintings apart from a three-quarter-length portrait of *William IV* by Lawrence and two watercolour river scenes by Marlow, neither of which came from the bequest. On the staircase is a portrait, supposedly of *Sebastian Snow*, a famous trumpet player who often played at the first nights of Handel's operas. In the Porcelain Room are several bird-and-flower studies by the eighteenth-century Dublin artist Samuel Dixon. There is a drawing of a river landscape by Jan Brueghel the Elder and a Dürer engraving of a sea monster.

Here also is the important Benton Fletcher Collection of early keyboard instruments, given to the Trust in 1937, and a fine collection of china, which was Mr Salting's special interest.

FORTY HALL

Forty Hill, Enfield EN2 9HA
Telephone: (081) 363 8196

LONDON BOROUGH OF ENFIELD

Open: Easter-Sept Tues-Sun 10-6; Oct-Easter Tues-Sun 10-5 (or park closing time)
Closed: BHs

British Rail: Enfield Town
Buses: 191, 231 **7 A5**

An early seventeenth-century house with a small collection of local topographical works, including eighteenth-century watercolours and drawings. A portrait of *Sir Nicholas Raynton, Lord Mayor of London*, in 1632, and the man for whom the house was built, hangs in the room named after him. It is ascribed to William Dobson.

Temporary exhibitions are held.

GEFFRYE MUSEUM

Kingsland Road
Shoreditch E2 8EA
Telephone: (071) 739 8368

INNER LONDON EDUCATION AUTHORITY

Open: Tues-Sat 10-5, Sun 2-5
Closed: Mon (except BHs), CE, CD, BD, GF
Admission Free

Underground: Liverpool Street then
Buses 22, 48, 149, 243A
Buses: 67, 243 **30 A1**

The Geffrye Museum consists of a series of period rooms ranging from the Elizabethan age to the mid-1930s. The

decorations include appropriate paintings. Among these should be noted Mary Beale's *Self-Portrait with her Husband, Charles, and Son, Bartholomew*. She was a friend and pupil of Lely. In the chapel is a portrait of Bishop Hoadly, painted by his first wife Sarah (Curtis), a pupil of Mary Beale. A fine example of Pompeo Batoni's work, *Portrait of John Monck*, is in the Lecture Theatre.

GUILDHALL ART GALLERY

Guildhall, King Street EC2P 2EJ
Telephone: (071) 606 3030

CITY OF LONDON

Open: by appointment only

Underground: Bank, Mansion House
Buses: 4, 6, 8, 9, 11, 15, 21, 22, 23, 25, 43, 76, 133, 141, 149, 501, 502, 513

The substantial and important collection of fine art owned by the Corporation of the City of London has been without permanent exhibition space since the old Guildhall Art Gallery was destroyed during the Second World War. A new gallery is planned for 1992. Until then, the City's art is in storage or displayed in City buildings like the Mansion House, Old Bailey or the Guildhall.

The Guildhall Art Gallery collection is known for its nineteenth-century art, with excellent examples of Pre-Raphaelite and High Victorian painting. There is an emphasis on London topography and Victorian genre. Among the outstanding Victorian works are Millais's *The Woodman's Daughter*, Rossetti's *La Ghirlandata*, Lord Leighton's *The Music Lesson*, scenes of contemporary life by Tissot and Sir Edward Poynter's famous panorama from the Book of Exodus, *Israel in Egypt*. Millais used his daughter Effie for a model in *My First Sermon* in 1863, following it a year later with *My Second Sermon*.

There are many historical subjects. The early *Pomegranates* of 1866 by Albert Moore, G. F. Watts's *Ariadne on Naxos*, and Alma-Tadema's exquisite *Pleading* all take inspiration from the ancient Greek world; the City also owns Alma-Tadema's stirring *The Pyrrhic Dance*, despised by Ruskin.

English history features in *The Wounded Cavalier* by William Shakespeare Burton, *Rescued from the Plague* by F. W. W. Topham, *George Herbert at Bemerton* by William Dyce and many paintings by Sir John Gilbert. French history is treated in *The Burgesses of Calais* by Henry Holiday and in a Napoleonic subject by Marcus Stone, *On the Road from Waterloo to Paris*.

Married for Love is more typical Marcus Stone fare, and contrasts nicely with *The Garden of Eden*, a scene of love in the grimy London of 1900 by Hugh Goldwin Riviere. There are varying approaches to religious painting, from the symbolism of J. R. Herbert's *The Youth of Our Lord* to the seeds of social realism in *The Lord Gave and the Lord Taketh Away – Blessed be the Name of the Lord*, by the young Frank Holl.

English literature is another theme, handled in Daniel Maclise's *The Banquet Scene in 'Macbeth'*, in Holman Hunt's *The Eve of St Agnes* and in *The Blessed Damozel* by John Byam Shaw. Country life in mid-Victorian Britain is sentimentalised in paintings by Thomas Webster (*The Smile* and *The Frown*).

Pre-Victorian painting is less well-known, but includes John Singleton Copley's enormous *The Defeat of the Floating Batteries*. This was commissioned by the City in 1783 to commemorate the successful defence of Gibraltar by British troops, some of whom appear in the painting.

Predictably, there are portraits of City dignitaries, including Daniel Mytens's *Sir John Garrard* and *Sir John Robinson* by John Michael Wright. The Gallery owns Lely's superb *Sir Edward Hales and his Family*, portraits by Reynolds, and eighteenth-century portraits from the collection of Alderman John Boydell, who founded Boydell's Shakespeare Gallery in Pall Mall and was both artist and Lord Mayor. One of the most impressive portraits is *John Philip Kemble as Coriolanus*, painted by Kemble's friend Sir Thomas Lawrence. The Guildhall also owns Sir John Lavery's glamorous portrait of his second wife *Lady Lavery*, a Twenties vision also known as *Hazel in Rose and Grey* or *The Silver Swan*.

Topographical paintings are plentiful: Balthazar Nebot's *Covent Garden Market with St Paul's Church*, c.1735–7, Jan Griffier the Younger's *The Thames during the Great Frost of 1739–40*, *The Thames by Moonlight with Southwark Bridge* by Atkinson Grimshaw. One of the best-known landscapes is not, however, of London, but Constable's full-size sketch, *Salisbury Cathedral from the Meadows*, dating from Constable's last visits to Salisbury in 1829.

The magnificence of City ceremonies is commemorated in several paintings, including *St Paul's Cathedral with the Lord Mayor's Procession* by David Roberts and *The Ninth of November* by William Logsdail.

The Harold Samuel collection of seventeenth-century Dutch and Flemish paintings was bequeathed to hang in the Mansion House, and consists of small but attractive pictures from about 1600–75: landscapes, genre scenes and still lifes rather than historical or religious pictures. Highlights include Frans Hals's *The Merry Lute Player*, Jan Steen's *The Sleeping Couple*, and *The Water Pump* by Adriaen van Ostade. Particularly interesting are the townscapes by Gerrit Berckheyde and Jan van der Heyden. The Flemish paintings include a set of *The Five Senses* by David Teniers the Younger. A curiosity of the collection is the presence in it of both *The Young Copyist* by Michael Sweerts and the painting by Anthonie Palamedz, that he is shown copying.

The opening of the Barbican Art Gallery on the eighth level of the Barbican Centre has given the City of London space for temporary art exhibitions. During these exhibitions, visitors with tickets can also gain entry to a room within the exhibition gallery which is used to display part of the City of London's Matthew Smith collection.

In 1974 over a thousand paintings from the studio of Sir Matthew Smith were given to the Corporation of London, along with Sir Matthew's drawings, watercolours and sketchbooks, by his heir, Mrs Mary Keene. A changing selection of his works is exhibited. Among the finest are a *Self-Portrait* of 1909, *Standing Nude holding a Fan* (c.1925), portraits and many of the remarkable still lifes and decorative pieces from the 1950s (*Still Life with Yellow Fish*, *Large Decoration* I and II, *The Lovers*) as well as from earlier periods of Smith's career (*Still Life with Clay Figure III*, c.1938–9).

HAMPTON COURT PALACE

East Molesey
Telephone: (081) 977 8441

HISTORIC ROYAL PALACES
Open: Apr–Sept 9.30–6, Oct–Mar daily 9.30–5, last admission half an hour before closing
Closed: CE, CD, BD, NYD
Access for disabled

Train: Hampton Court
Buses: 131, 152, 201, 206, 216, 264, 267; also 14, 27 on Sun in summer
Launch: from Westminster Pier in summer **7 B6**

Hampton Court Palace contains the second most important selection of works on public display from the Royal Collection, after Windsor Castle (q.v.). Unquestionably the greatest work of art is the cycle of paintings by Mantegna, *The Triumph*

of *Caesar*, displayed in the Lower Orangery.

Following the fire of 1986, some of the Palace rooms have been temporarily closed to the public. Paintings that hung there are on view elsewhere in the Palace; a few are undergoing conservation treatment and are not exhibited.

In the Renaissance Gallery is the intriguing Marcus Gheeraerts *Portrait of a Lady in Persian Dress*, and a portrait of *Edward VI* attributed to William Scrots. Italian works, moved from the damaged State Rooms, include Bronzino's *Lady in Green*, Franciabigio's *Jacopo Cennini*, Veronese's *Mystic Marriage of St Catherine*, and works by Correggio and Savoldo. The *Noli me tangere* by Holbein is displayed with Joos van Cleve's portraits of himself and his wife, and paintings by Cranach.

In the Wolsey Rooms is a copy by Remigius van Leemput of the Holbein wall-painting of *Henry VIII and Henry VII with their Queens* burnt at Whitehall. (Holbein's cartoon for part of this survives at the National Portrait Gallery.) Wolsey's Closet contains a fine early Renaissance ceiling, and wall-paintings dating back to the sixteenth century.

The Palace is rich in royal portraits, many of the Stuart court. The Queen's Staircase is decorated with a large allegorical painting by Honthorst, *Apollo and Diana*, in which Charles I and members of his court are cast in the roles of leading participants. Daniel Mytens's work is well represented by *Charles I as Prince of Wales*, *Charles I and Henrietta Maria*, and *Charles I and Henrietta Maria Depart for the Chase*. There are two scenes of royalty dining in public: Houckgeest's *Charles I and Henrietta Maria* and Van Bassen's *King and Queen of Bohemia*. Lely's appealing *Portrait of Queen Anne as a Child* hangs in the Queen's Bedchamber. His famous portraits of the women of the court of Charles II, known as the 'Windsor Beauties', are exhibited, as are the Kneller 'Hampton Court Beauties', which they inspired. Of historical interest are Robert Streeter's *Boscobel House and White Ladies*, commemorating Charles II's escape from Worcester, and Leonard Knyff's *Hampton Court in the Reign of George I*.

Among continental paintings on display are Simon Vouet's *Diana*, Orazio Gentileschi's *Joseph and Potiphar's Wife*, Tintoretto's *Esther and Ahasuerus*, Domenichino's *St Agnes*, and Eustache Le Sueur's *Nero Depositing the Ashes of Germanicus*. *St Jerome Reading* is one of the rare De La Tours in the British Isles.

Large Italian canvases hang in the Public Dining Room, including Sebastiano Ricci's *Adoration of the Shepherds* and *Christ in the House of Simon*, and Pietro da Cortona's *Augustus and the Sibyl*, alongside Knapton's huge *Family of Augusta, Princess of Wales*. Ribera's *Duns Scotus* is in the Haunted Gallery. Among portraits sent by foreign powers to the Stuarts are Pantoja de la Cruz's *Margaret, Queen of Spain* and Philippe de Champaigne's *Cardinal Richelieu*.

See entry in main text, page 85.

HOGARTH'S HOUSE
Hogarth Lane, Chiswick W4 2QN
Telephone: (081) 994 6757

LONDON BOROUGH OF HOUNSLOW
Open: Apr-Sept Mon-Sat 11-6, Sun 2-6; Oct-Mar Mon, Wed-Sat 11-4, Sun 2-6
Closed: 1-15 Sept, 8-31 Dec, and Tues throughout year
Admission Free: Limited access for disabled

Underground: Turnham Green then walk. **7 B6**

The collection is entirely of graphic works by William Hogarth, who lived in the house for the last fifteen years of his life. He was first trained as an engraver, and made a huge impact on English life with his moral narratives, such as *A Harlot's Progress* and *Marriage à la Mode*, designed to expose the vices and follies of the age in which he lived.

These groups of prints, together with other series, hang in the various rooms of the house. Individual prints, book illustrations, and other engraved works, including a series of his portrait engravings, hang in his Bedroom, Library, Dining Room and Second Best Parlour.

IMPERIAL WAR MUSEUM
Lambeth Road SE1 6HZ
Telephone: (071) 735 8922

TRUSTEES OF THE IMPERIAL WAR MUSEUM
Open: Mon-Sat 10-5.50, Sun 2-5.50
Closed: CE, CD, BD, NYD, GF
Access for disabled

Underground: Lambeth, Elephant and Castle
Buses: 3, 10, 12, 44, 53, 109, 133, 155, 159, 171, 172, 177, 184 **30 D2**

Though the fine art constitutes a major and impressive part of the huge collection at the Imperial War Museum, it is mainly in store, with only a small proportion of works on exhibition. The display is changed regularly, but with a very limited selection of works. Individual twentieth-century British artists are in many cases represented by larger collections of their works than are held in any other gallery. The largest collection in the world of William Orpen's work, for example, was given by him to the museum, the greater part of it not exhibited since 1918.

Because of the primary purpose of the works of art, which was as a record of the First and Second World Wars, and only latterly of war generally, the secondary artistic impact – of a superlative collection of modern British art – seems at first incidental. Yet works by Sargent, Lewis, McBey, Roberts, Lamb, Nevinson, the two Nash brothers, Muirhead Bone, William Rothenstein, Kennington and Lavery capture both war and the spirit of British art at the time of the First World War, with remarkable vigour, poignancy and faithfulness to the sacrifice.

There was a similar achievement in the Second World War by artists like Topolski, Ardizzone, Stanley Spencer, Piper, Moynihan, Ruskin Spear, Anthony Gross and Henry Moore, whose drawings of the London Underground, when it was used for shelter during bombing raids, are justly famous.

As if to emphasise the closeness of the two appalling conflicts, many artists were involved in both wars, the first official artist of the 1914-18 war, Bone, being also a contributor to the second, as were the two Nash brothers, Lamb, Nevinson, Rothenstein and Stanley Spencer.

The tendency is to hang the consciously dramatic works, such as Sargent's *Gassed*, which rather misses the point of war art: the faithful and dignified record of horror and sacrifice, often at its most telling in the many series of paintings and drawings of campaigns or encounters, with their usually far more frightful aftermaths.

When so much is so moving it is difficult to pick out individual works; nevertheless, of particular merit are Paul Nash's *The Menin Road*, and *We Are Making a New World*; Eric Kennington *The Kensingtons at Laventie*; C. R. W. Nevinson *The Road from Arras to Bapaume*; John Nash *Over the Top*; Orpen's Somme landscapes; and Henry Lamb *Irish Troops in the Judaean Hills, Surprised by a Turkish Bombardment*.

See entry in main text, pages 70-4.

THE IVEAGH BEQUEST, KENWOOD
Hampstead Lane NW3 7JR
Telephone: (081) 348 1286/7

ENGLISH HERITAGE
Open: Daily (including Sun) 10-6 in summer; 10-4 in winter
Closed: CE, CD, GF

Admission Free: Access for disabled

Underground: Archway or Golders
Green then Bus 210 **7 A5**

In 1927 the 1st Earl of Iveagh, Edward
Cecil Guinness, bequeathed to the nation
Kenwood, near Hampstead Heath, with
its parklands and part of his collection of
paintings, mainly acquired during the
1880s.

The two great masterpieces at Kenwood
are Rembrandt's *Self-Portrait* and Ver-
meer's *Guitar Player*, but Dutch art is also
superbly represented by Cuyp's glowing
View of Dordrecht and Hals's *Pieter van den
Broecke*, Flemish by Van Dyck's *James
Stuart, Duke of Richmond* and *Henrietta of
Lorraine*, Italian by Batoni's *Mrs Sandilands*
and French by Boucher pastorals.

English painting's great strength at
Kenwood lies in superb society portraits:
Gainsborough's *Mary, Countess Howe,
Lady Brisco* and *Lady Mendip*; Reynolds's
Lady Chambers and *Angerstein Children*;
Romney's *Countess of Albemarle and Son*,
and Lawrence's *Miss Murray*. Portraits
déguisés include Reynolds's *Kitty Fisher as
Cleopatra* and Romney's *Lady Hamilton as
a Spinstress*.

Gainsborough's rural subjects, *Going to
Market, Shepherd Boys with Dogs Fighting*
and the late, great *Greyhounds Coursing a
Fox* (from Mentmore) are on show, as
are Landseer's *Hawking in the Olden Times*,
and works by Angelica Kauffmann from
the Cook collection. Of particular interest
to Londoners is Claude de Jonghe's *Old
London Bridge*.

See entry in main text, page 88.

THE WIMBLEDON SOCIETY MUSEUM
Village Club, Ridgway, Wimbledon SW19
Telephone: none

THE WIMBLEDON SOCIETY (FORMERLY
THE JOHN EVELYN SOCIETY) FOR
IMPROVING THE AMENITIES OF
WIMBLEDON
Open: Sat 2.30-5
Admission Free: No access for disabled

Underground and train: Wimbledon
Buses: 93, 200 **7 B6**

The small collection is of material relating
to Wimbledon, including topographical
watercolours and prints. There is also a
reference collection of early photographs
of the area.

KEATS HOUSE
*Wentworth Place, Keats Grove,
Hampstead NW3 2RR*
Telephone: (071) 435 2062

CAMDEN BOROUGH COUNCIL
Open: Apr-Oct Mon-Fri 2-6, Sat 10-1, 2-
5, Sun 2-5; Nov-Mar Mon-Fri 1-5, Sat
10-1, 2-5, Sun 2-5
Closed: CD, BD, NYD, GF, Easter Sat
Conducted tours may be arranged in
advance
Admission Free: No access for disabled

Underground: Belsize Park, Hampstead
Train: Hampstead Heath
Buses: 24, 46, 168, 268, C11 **7 A5**

The Keatsiana includes portraits of the
poet, reading in his sitting room and
listening to the nightingale on Hampstead
Heath, both by Joseph Severn, and the
posthumous bust by the American artist
Anne Whitney. Other portraits are of the
poet's circle.

KENSINGTON PALACE
Kensington Gardens W8 4PX
Telephone: (071) 937 9561

HISTORIC ROYAL PALACES
Open: Mon-Sat 9-5, Sun 1-5
Closed: CE, CD, BD, NYD, GF
Limited access for disabled

Underground: Queensway
Buses: 9, 12, 27, 28, 31, 52, 73, 88 **7 A5**

The State Apartments were opened to the
public in 1889. The William Kent interiors
include the earliest example of arabesque
'Pompeian' decoration in England – the
Presence Chamber ceiling of 1724 – and
the Roman-style Cupola Room. On the
King's Grand Staircase, Kent's *trompe-l'œil*
murals feature recognisable personalities
of the Hanoverian age 'watching' visitors
mounting the stairs.

The pictures shown are from the Royal
Collection. Of special interest are the
seventeenth-century paintings in the King's
Gallery: *Cupid and Psyche*, painted by Van
Dyck for Charles I, Rubens's early *Jupiter
and Antiope* and Snyders's *Boar Hunt*,
along with works by Ribera, Jan Porcellis,
Dolci, Dosso Dossi, the art historian
Giovanni Baglione, Orazio Gentileschi
and his daughter Artemisia *(Self-Portrait
as Pittura)*. Portraits in the Queen's Gallery
include Lely's *Anne Hyde* and Kneller's
fine *Peter the Great*.

John Martin's *Eve of the Deluge*, Daniel
Maclise's *Midas* and Watts's *Lady Holland*
are in the Duchess of Kent's apartments,
while downstairs in the Costume Collec-

tion hang Lavery's studies for his *Royal
Family at Buckingham Palace, 1913* (National
Portrait Gallery), with Winterhalter's
Leopold, King of the Belgians on a staircase
nearby.

KEW PALACE
Kew Gardens, Richmond
Telephone: (081) 940 3321

DEPARTMENT OF THE ENVIRONMENT
Open: Apr-Sept daily 11-5.30
No access for disabled

Underground: Kew Gardens; train:
Kew Bridge
Buses: 27, 65, 7
Launch: to Kew Pier **7 B6**

One of the homes of George III and
Queen Charlotte, though their favourite
was the White House (now gone). This
one contains their portraits by Zoffany, as
well as portraits of other monarchs. An
early eighteenth-century *Ducks Flying* by
Jakob Bogdani hangs in the Breakfast
Room.

There are several views of Kew by
J. J. Schalch and many other landscape
and general subjects, mainly by eighteenth-
century artists. Two conversation pieces
by Marcellus Laroon are *A Dinner Party*
and *A Musical Tea Party*. In the Queen's
Bedchamber is a sketch by Sir Joshua
Reynolds, *Marriage of George III*, showing
the royal couple in the Chapel Royal.

There is an interesting group of
miniatures of all the children.

LEIGHTON HOUSE MUSEUM
12 Holland Park Road W14 8LZ
Telephone: (071) 602 3316

ROYAL BOROUGH OF KENSINGTON AND
CHELSEA
Open: Mon-Sat 11-5 (Mon-Fri until 6
during exhibitions)
Closed: CD, BD, NYD, GF, Easter Sat
and Mon, May BH, Spring and late
Summer holiday Mons
Admission Free: Limited access for disabled

Underground: High Street Kensington
Buses: 9, 27, 28, 31, 33, 49, 73 **7 A5**

The house, a splendid example of
'Aesthetic' design, was built as the studio
and home of Frederic, Lord Leighton, the
Victorian artist. The Arab Hall contains
an unrivalled collection of Islamic tiles,
with Victorian tiles by William de Morgan
and mosaics by Walter Crane. The
collection of nearly 1,200 works of art
includes a study collection of 684 Leighton

drawings and an archive of his papers.

Lord Leighton's large *Syracusan Bride*, *Dante in Exile* and early *Death of Brunelleschi* are on display, along with smaller works: *Vestal Virgin*, *Pavonia*, *Portrait of Mrs Evans Gordon* and a group of his remarkably free landscape sketches. The collections (and loans) include paintings by other Victorian artists: G. F. Watts's *For He Had Great Possessions*, Millais's *Shelling Peas* and Burne-Jones's designs for *King Cophetua and the Beggar-Maid*.

A cast of Leighton's *Athlete Wrestling with a Python* stands in the garden.

LINLEY SAMBOURNE HOUSE
18 Stafford Terrace W8 7BH
Telephone: (081) 994 1019

THE VICTORIAN SOCIETY
Open: Mar–Oct Wed 10–4, Sun 2–5 Other times by special arrangement
No access for disabled

Underground: High Street Kensington
Buses: 9, 9A, 27, 28, 31, 33, 49, 73 **7 A5**

The home of the *Punch* cartoonist, Edward Linley Sambourne, survives virtually unchanged since his death in 1910. Subsequent inhabitants of the house, his bachelor son, and the Countess of Rosse, granddaughter of Linley Sambourne, made few alterations. The result is an eclectic collection representing 'artistic' taste of the late nineteenth century.

Drawings and photographs by Linley Sambourne, and some examples of work of his contemporaries and friends, including John Tenniel, Luke Fildes, Kate Greenaway, George du Maurier, Walter Crane, Charles Keene, Edwin Abbey and Birket Foster, are shown throughout the house.

MARBLE HILL HOUSE
Richmond Road, Twickenham TW1 2NL
Telephone: (081) 892 5115

ENGLISH HERITAGE
Open: 19 Mar–30 Sept 10–5; 1 Oct–18 Mar 10–4
Closed: CE, CD
Admission Free: Limited access for disabled

Underground: Richmond then Buses 27, 90, 90B, 202, 270
Train: St Margaret's, except Sundays
Buses: 33, 37, 73 **7 B6**

Built for George II's mistress, Henrietta Howard, later the Countess of Suffolk.

The ornate Great Room contains Panini's capriccios of Rome, among them his *Statues in a Ruined Arcade;* these form England's earliest set of such imaginary architectural views still in their original setting. Panini's portrait by Gabriel Blanchet is also displayed (a loan). The charming *Le Lecteur* by Gravelot, *Letter Writer* by Mercier and *Girl at a Spinning Wheel* by Hayman accompany the van der Kuyl *A King Charles Spaniel*. Other paintings on view include the early Reynolds *Unknown Man* and the *Acland* portraits by Hudson, as well as works by Hogarth, Vanderbank, Laroon and Thornhill. On loan are Richard Wilson's *The Thames at Twickenham* and the earliest known landscape by George Lambert. The top-floor Gallery contains Battaglioli paintings of eighteenth-century operas by Metastasio.

MARIANNE NORTH GALLERY
Kew, Richmond

KEW GARDENS
Open: Daily (except CD, BD, NYD) 10–11.45, 1–7 summer and 10–11.45, 1–4.45 winter
Admission Free: Limited access for disabled (Entry fee for Kew Gardens)

Underground: Kew Gardens
Train: Kew Bridge
Buses: 27, 65, 7 (Sun in summer)
Ferry: from Westminster Pier to Kew Pier (Apr–Oct) **7 B6**

The Marianne North gallery contains 848 oil paintings mainly of plants but including landscapes and miscellaneous fauna. They are rich in colour, stylish in execution and arranged in a frieze-like way around two rooms in a building designed to house the collection.

THE MAUGHAM COLLECTION OF THEATRICAL PAINTINGS
National Theatre, Upper Ground,
South Bank SW1 9PX
Telephone: (071) 633 0880

NATIONAL THEATRE
Open: Mon–Sat 10 a.m.–11 p.m.
Closed: Sun, CE, CD
Admission Free: Access for disabled

Underground: Waterloo
Buses: 1, 4, 5, 68, 70, 76, 149, 168A, 171, 176, 188, 239, 501, 502, 513 **30 C3**

Somerset Maugham left his collection of theatrical paintings to the National Theatre, handing over the oil paintings in 1951, when they were first exhibited in

the Victoria and Albert Museum. The collection consists of 42 oil paintings, 40 watercolours and 1 engraving. They include 43 paintings and drawings by Samuel De Wilde, some of the finest of these being single-figure costume studies, including *William Charles Macready in Richard III*, and *Thomas Collins in The Merry Wives of Windsor*.

Paintings by John Zoffany are in the classic tradition of theatre art, showing scenes from *Love in a Village, Venice Preserv'd* and Charles Macklin as *Shylock in The Merchant of Venice*.

MUSEUM OF LONDON
London Wall EC2Y 5HN
Telephone: (071) 600 3699

CITY OF LONDON
Open: Tues–Sat 10–6, Sun 2–6
Closed: Mon, CD, BD, NYD
Advance booking required for parties of more than 20
Admission Free: Access for disabled

Underground: Barbican, St Paul's, Moorgate
Buses: 4, 141, 279A, 502 **30 B2**

This very popular and well-run museum covers the history of London. The art collection reflects this; the works cover the topography, life and character of Greater London. The paintings, prints and drawings range in date from the sixteenth century to the present day and include about 250 oils and about 30,000 prints and drawings.

Notable works include: Dirck Stoop's *Entry of Charles II into the City on 22 April 1661, The Horseferry* after Jan Griffier the Elder, *The River at Chiswick* by Jacob Knyff and works by Canaletto, Samuel Scott, and William Marlow, among other topographical painters. Francis Hayman's *A Scene from 'The Suspicious Husband'* was commissioned in 1752 by David Garrick, who appears in it. Another theatrical painting is Walter H. Lambert's *Popularity*, an extraordinary crowd portrait of 1901–1903 that shows leading Edwardian musichall performers and includes the artist, the female impersonator 'Lydia Dreams'.

On an altogether more sombre note is *An East End Poor House* of *c*.1870 by Gustave Doré, whose East End visits culminated in his famous illustrations to *London. A Pilgrimage* (1872). The display of War Artists' work from the Second World War features David Bomberg's *Evening in the City of London*, John Piper's *Christ Church, Newgate Street, after its Destruction in 1940* and Henry Moore's

drawing, *Women in a Shelter*, 1941.

The Lord Mayor's State Coach, commissioned in 1757, is decorated with allegorical panels attributed to G. B. Cipriani.

The collection is catalogued by area, artist, printer, engraver and subject. Particular strengths are Rowlandson and eighteenth-century topographical watercolours, nineteenth-century social and narrative painting, twentieth-century Camden Town Group and 'etching revival' prints. Much of the collection is not on display but is housed in the reserve collection. This latter is open to researchers by appointment only through the Department of Paintings, Prints and Drawings.

THE MUSEUM OF THE ORDER OF ST JOHN
St John's Lane, Clerkenwell EC1M 4DA
Telephone: (071) 253 6644

ORDER OF ST JOHN
Open: Fri 2-5, Sat 10-4; Guided tours at 11 and 2.30
Closed: Public holidays, CE, CD, BD, NYD
Admission Free: Limited access for disabled

Underground: Farringdon, Barbican
Buses: 5, 55, 243, 277, 279 **30 B2**

This castellated gatehouse once formed the main entrance of the Grand Priory of the Order of the Hospital of St John of Jerusalem, the Knights Hospitaller of the Crusades (founded *c.*1130).

The objects were collected by the Order from Europe and the Middle East. They relate to its history and include portraits and topographical works of Jerusalem, Cyprus, Rhodes, Malta and other associated areas.

The Weston Triptych, two panels of a late fifteenth-century Flemish painting, represents St John the Baptist and the presentation of Christ in the Temple on one side and the Trinity and the Presentation of the Virgin on the other. In the Old Chancery are early nineteenth-century portraits of *The Count and Countess von Buxhoevden* by Borovikowski, a Russian court painter, and Jean Voille's portrait of *Czar Paul I*.

The Chapter Hall contains portraits of distinguished members of the Order and the Grand Priors such as *Elizabeth II* by Leonard Boden, a portrait of *George V*, *The Earl of Scarborough* by de Laszlo and William Dring's portrait of *Lord Wakehurst*.

NATIONAL ARMY MUSEUM
Royal Hospital Road,
Chelsea SW3 4HT
Telephone: (071) 730 0717

MINISTRY OF DEFENCE
Open: Mon-Sat 10-5.30, Sun 2-5.30
Closed: CE, CD, NYD, GF, May BH
Admission Free: Access for disabled

Underground: Sloane Square
Buses: 11, 39, 137 **30 D5**

The museum is dedicated to the history of the British Army. Seventeenth-, eighteenth- and nineteenth-century portraits and battle scenes by Reynolds, Romney, Lawrence, Raeburn and Beechey hang in the Art Gallery and in the corridors and staircases of the museum.

Wellington, Burgoyne, the Earl of Cardigan and Sir John Moore are among the personalities portrayed. There are huge John Wootton panoramas, *The Battle of Blenheim* and *George III in Command at Dettingen*. The *Siege of Bangalore* is shown in a canvas by Robert Home. Watercolours and prints depicting all aspects of military life can be seen in the Reading Room.

THE NATIONAL GALLERY
Trafalgar Square WC2N 5DN
Telephone: (071) 839 3321

TRUSTEES OF THE NATIONAL GALLERY
Open: Mon-Sat 10-6, Sun 2-6
Closed: CE, CD, BD, NYD, GF, May BH
Admission Free: Access for disabled

Underground: Charing Cross, Leicester Square
Buses: 1, 3, 6, 9, 11, 12, 13, 15, 23, 24, 29, 53, 77, 77A, 88, 159, 170, 172, 176, 500 **30 C4**

The Gallery's main building, completed in 1838 to the design of William Wilkins, has been extended repeatedly, notably by the Barry Rooms of 1872-6, which were restored to their original splendour in 1986. The Sainsbury Wing, now under construction, will house the Early Renaissance Collection of pre-sixteenth-century Italian and Northern European works.

The early Italian art is temporarily exhibited on the lower floor of the main building, along with the more marginal works from other areas of the collection. Duccio's Annunciation and Transfiguration panels from the *Maestà* of 1311 reveal a striking humanity and realism. Fra Angelico's *Christ Glorified in the Court of Heaven* has frieze-like multitudes of saints,

prophets, martyrs and patriarchs. Among other early works are the dramatic *St George and the Dragon* and *The Battle of San Romano* by Uccello, the dignified *Virgin and Child* by Masaccio, and Piero della Francesca's *Baptism of Christ,* as well as his incomplete *Nativity.*

A group of fine paintings by Botticelli includes his *Adoration of the Kings, Venus and Mars* and deeply personal *Mystic Nativity.* The Gallery also has major holdings of the works of Signorelli, Tura, Filippo and Filippino Lippi and Carlo Crivelli *(Annunciation).*

Among single great works should be noted Piero de Cosimo's *Mythological Subject,* Pisanello's *Vision of Saint Eustace* and Foppa's lovely *Adoration of the Kings.* The *Martyrdom of St Sebastian* and *Apollo and Daphne* are fine examples of the work of Pollaiuolo. Portraits include Baldovinetti's profile of *A Lady in Yellow.*

The rest of the Italian collection is chiefly contained in rooms on the main floor, beginning on the left of the main entrance.

A single room displays works by Mantegna and Giovanni Bellini. Among the Mantegnas are the *Agony in the Garden,* hanging near the Bellini *Agony in the Garden* which it probably inspired. Other Bellini works, among them the serene *Doge Leonardo Loredan* and *Madonna of the Meadow,* are found here, as is the small painting by Antonello da Messina, *St Jerome in his Study.*

The collection continues through the full flowering of the Italian Renaissance, with Michelangelo's *Entombment* and Leonardo's *Virgin of the Rocks* and cartoon of *The Virgin and Child with St Anne and St John the Baptist.*

Raphael's much-copied *St Catherine of Alexandra* and *Pope Julius II,* his tiny *Allegory with a Knight* and large *Crucified Christ with the Virgin, Saints and Angels,* is displayed with the 'Ansidei' Madonna. Sebastiano del Piombo's *Raising of Lazarus* was painted in competition with Raphael and with assistance from Michelangelo. Bronzino's *Allegory of Venus and Cupid* is accompanied by portraits by Bronzino and Andrea del Sarto.

Venetian art occupies the next room, which contains two of the largest paintings in the Gallery: Veronese's *Family of Darius before Alexander* and Tintoretto's *Christ Washing His Disciples' Feet.* The four paintings of the *Allegory of Love* by Veronese were designed to decorate a ceiling. On a smaller scale, Tintoretto's *St George and the Dragon* and *Origin of the Milky Way* demonstrate his gift for colour. The portrait of a *Poet* by Palma

Vecchio may be a portrait of Ariosto, author of *Orlando Furioso*.

The Gallery is particularly rich in works by Titian, from his early *Holy Family and Shepherd* to his late *Madonna and Child*. The *Portrait of a Man* may be a self-portrait; like the *Vendramin Family*, it once belonged to Van Dyck. Other superb Titians include *Noli me tangere*, *Bacchus and Ariadne* and *The Death of Actaeon*.

The sixteenth-century Italian collection also includes the *Adoration of the Magi* and *Sunset Landscape with Saints ('Il Tramonto')* attributed to Giorgione, Correggio's sensitive *Madonna of the Basket* and his *The School of Love*, which Charles I once owned. The Gallery owns Parmigianino's *Vision of St Jerome* and groups of paintings by Lorenzo Lotto (*A Lady as Lucretia*) and G. B. Moroni, including Moroni's famous portrait, *The Tailor*.

The seventeenth-century *Apollo* frescoes by Domenichino have been reassembled on the lower floor. Most of the seventeenth-century Italian collection is on the main floor: Caravaggio's dramatic *Supper at Emmaus*, the earliest of Bernini's rare paintings, *SS Andrew and Thomas*, Reni's very late *Adoration of the Shepherds* and his exquisite little oil on copper, *The Coronation of the Virgin*. The most impressive Reni is perhaps the *David with the Head of Goliath*, which, like the big Guercino *Elijah fed by Ravens*, is a loan. Smaller Guercinos which are owned by the Gallery include *The Incredulity of St Thomas* and *Angels Weeping over the Dead Christ*. Fresco cartoons (formerly on the lower floor) demonstrate the skills of the Carracci brothers Annibale and Agostino on a large scale; *The Dead Christ Mourned* and *'Domine, Quo Vadis?'* are oils by Annibale Carracci on the main floor. The Salvator Rosa *Self-Portrait* praises the virtue of silence. Beside it is Rosa's finest witchcraft painting, *Witches at their Incantations*.

Italian paintings from the later seventeenth century include Luca Giordano's *Homage to Velázquez* and his theatrical *Perseus turning Phineas and his Followers to Stone*. Eighteenth-century Italian works, also on the main floor, include a ceiling painting by G. B. Tiepolo, *An Allegory with Venus and Time*, surrounded by other, smaller paintings by the artist and his son Giovanni Domenico. The amusing *Rhinoceros at Venice* is by Longhi. One of the earliest acquisitions of the Gallery was Canaletto's *The Stonemason's Yard (Campo S. Vidal and S. Maria della Carità)*, the finest of several outstanding views of Venice and London by this artist in the Gallery. There are Guardi caprices and Venetian views. The scenes from the *Life of Moses* by Corrado Giaquinto are recent acquisitions.

The north-west extension to the Gallery houses Flemish, Dutch and German art. Supreme among the works here, and also to be numbered among the Gallery's most popular paintings, is Jan van Eyck's *Giovanni (?) Arnolfini and his Wife*, also known as the *Arnolfini Marriage*. It is one of many early Netherlandish paintings: Hieronymus Bosch's *The Crowning with Thorns*, a group of excellent works by Gerard David which includes *The Virgin and Child with Saints and Donor*, Rogier van der Weyden's *Magdalen Reading*, and Hans Memling's *Donne Triptych*. Portraits include some faces which are famous despite being anonymous: Jan van Eyck's *Man in a Red Turban*, Robert Campin's *Unknown Woman* and Rogier van der Weyden's *Portrait of a Lady*.

The sixteenth-century Flemish gallery contains Pieter Brueghel's and Mabuse's versions of the *Adoration of the Kings*, as well as Mabuse's charming *Little Girl* (Jacqueline de Bourgogne?).

In the collection of seventeenth-century Flemish art is a splendid range of works by Rubens, including the well-known *Chapeau de Paille* and the powerful early *Samson and Delilah*. English landscape painting owes much to *Autumn Landscape with a View of Het Steen* and to Rubens's smaller landscapes like *Shepherd with his Flock in a Woody Landscape*. Rubens's links with England produced *Peace and War* (the artist's gift to Charles I) and the portrait of *Thomas, Earl of Arundel*. His interest in ancient history - the antiquarian Ludovicus Nonnius was a friend - is evident in *A Roman Triumph*, which is based in part on Mantegna's *Triumph of Caesar* cycle at Hampton Court. The *Rape of the Sabines* is a work of the artist's later years.

The paintings by Anthony Van Dyck at the National Gallery are dominated by the huge *Charles I on Horseback*. Among the full-lengths are the exotic *Earl of Denbigh*, the dashing *Lords John and Bernard Stuart* and a group portrait from the artist's Genoese period, *The Balbi Children*. *Lady Elizabeth Thimbleby and Dorothy, Viscountess Andover* is a fine example of Van Dyck's half-length double portraits.

The Gallery's collection of German art is small, but contains some paintings of great quality. Early German works include Altdorfer's *Christ taking leave of his Mother* and *Landscape with Footbridge*, as well as paintings by Cranach and Hans Baldung Grien. The single work ascribed to Dürer is *Portrait of the Artist's Father*. Later German works are scattered through the Gallery: Holbein's popular *The Ambassa-dors* and his portrait of *Christina of Denmark, Duchess of Milan* hang with sixteenth-century Flemish paintings. Rottenhammer's *Coronation of the Virgin* and Elsheimer works including the *Baptism of Christ* are displayed with seventeenth-century Dutch art. A recent purchase, *Winter Landscape* by Caspar David Friedrich, is to be found in the midst of nineteenth-century French paintings, near the Gallery's new Scandinavian acquisition, Christian Købke's *Northern Drawbridge of the Citadel of Copenhagen*.

Among Dutch paintings, the National Gallery's large holding of Rembrandt's work is remarkably comprehensive, spanning his career and his chief interests. It includes the beautiful and moving *Woman taken in Adultery*, the robust *Woman Bathing in a Stream* and the dramatic *Belshazzar's Feast*. The many portraits range from the formality of *Margaretha Geer* and *Frederick Rihel* (unusually for Rembrandt, an equestrian portrait) to the intimacy of a portrait of the artist's mistress, *Hendrickje Stoffels*. Self-portraits include *The Artist at 34*, based on one of the Gallery's Titians, and the moving, late *Self-Portrait aged 63*.

The domestic interiors and landscapes of the Dutch school include many fine canvases. Vermeer's *Young Woman Standing at a Virginal* and *Young Woman Sitting at a Virginal* hang near a group of outstanding works by Pieter de Hoogh, among them *Courtyard of a House in Delft* and *A Musical Party*. The Gallery devotes a room to the finest known Dutch peepshow of the seventeenth-century, Samuel van Hoogstraten's *Views of the Interior of a Dutch House*. Equally entertaining are Hendrick Avercamp's roundel, *Winter Scene with Skaters near a Castle*, and Jan Steen's *Effects of Intemperance*.

The wide-ranging collection of Dutch landscapes includes Hobbema's *The Avenue, Middleharnis*, and several fine works by Aelbert Cuyp, notably the recently acquired *River Landscape*. A group of views by Jacob van Ruisdael, among them his *Extensive Landscape with Ruined Castle and Village Church*, is accompanied by examples of the work of Salomon van Ruysdael, Jan van Goyen (*Scene on the Ice near Dordrecht*) and Esaias van de Velde. These are complemented by maritime views by Jan Van de Cappelle and by paintings of Dutch architecture, of which Emanuel de Witte's two views of the *Interior of the Oude Kerk, Amsterdam* are good examples. Saenredam's *Interior of the Grote Kerk at Haarlem* features the same building which reappears in Berckheyde's *Market Place and the Grote Kerk at Haarlem*.

Dutch artists also painted mythological subjects; the Gallery's examples include

Roelandt Savery's *Orpheus*, Wtewael's *Judgement of Paris* and the horrifying *Two Followers of Cadmus Devoured by a Dragon*, by Cornelis van Haarlem. Pieter Lastman, who painted *Juno Discovering Jupiter with Io*, was Rembrandt's teacher.

Religious art is not confined to paintings by Rembrandt. Honthorst's candle-lit *Christ before the High Priest* and his *St Sebastian*, like the *Jacob Reproaching Laban* by ter Brugghen, are works of the Utrecht School. Rembrandt's influence is strong in Nicholas Maes's *Christ Blessing Children* and Dou's *Anna and the Blind Tobit*; both have been taken for his work.

Figure painting continues with ter Brugghen's *Concert*, Dou's *Poultry Shop* and Frans Hals's *Young Man Holding a Skull*. The largest of his portraits at the Gallery is the warm *Family Group in a Landscape*; the smallest, *Jean de la Chambre at the Age of 33*, demonstrates on a minute scale the free brushwork for which the artist is admired.

Self-portraits by artists include *Carel Fabritius* and *Frans Mieris the Elder*. Ter Borch's *Ratification of the Treaty of Munster* is of historical interest, as is Thomas de Keyser's portrait of *Constantijn Huygens and his Clerk*. Other outstanding portraits are Honthorst's *Elizabeth, Queen of Bohemia*, Bartholomeus van der Helst's *A Lady*, Ter Borch's little full-length of a highly fashionable *Young Man* and Emanuel de Witte's more prosaic *Adriana van Heasden and her Daughter at the New Fishmarket in Amsterdam*. The collection includes a Dutch guild group portrait, van der Eeckhout's *Officers of the Amsterdam Coopers' and Wine-Rackers' Guild*.

There is a large number of small canvases by Dutch masters, including works by Metsu *(Old Woman with a Book)*, van Mieris, van der Werff and Netscher. Van der Poel's view of Delft shows the city after the explosion of 1654 in which Carel Fabritius was killed. Van der Heyden's delightful little *Huis ten Bosch at the Hague* shows a home of the Dutch ruling family. Among the still lifes, Jan van Huysum's *Hollyhocks and other Flowers in a Vase* is a work of extraordinary sensitivity, showing how successfully the Dutch tradition of flower-painting continued into the eighteenth century.

The magnificent Spanish Collection includes the Velázquez masterpiece, *The Rokeby Venus*. The *Kitchen Scene with Christ in the House of Mary and Martha*, a combination of genre and religious art, is one of the artist's earliest works; the *Immaculate Conception* and its pendant *St John on Patmos* also date from the beginning of Velázquez's career. The artist's many portraits of the Spanish royal family are represented by two portraits of Philip IV: the full-length *Philip IV in Brown and Silver*, and a bust portrait of *Philip IV*, one of Velázquez's last images of his king. *Christ after the Flagellation Contemplated by the Christian Soul* is a subject rarely seen outside Spain.

The intensity of Zurbarán's *St Margaret* and *St Francis in Meditation* is balanced by Murillo's tranquil *Christ Healing the Paralytic at the Pool of Bethesda*, painted for a Seville church. The *Self-Portrait* by Murillo was painted for his sons.

The fine group of Goya's work includes the dramatic *Duke of Wellington* and the eerie *Scene from 'The Forcibly Bewitched'*. The beauty, *Doña Isabel de Porcel*, is painted over a portrait of a man.

On the lower floor is *Queen Mariana of Spain in Mourning*, a portrait of Philip IV's widow by Velázquez's son-in-law and successor, del Mazo. El Greco, Ribera and Valdes Léal are all represented in the collection. A recent addition is an eighteenth-century still life, Luis Meléndez's *Still Life With Oranges and Walnuts*.

British painting was included in the original Angerstein purchase, and is represented in the Gallery by works from Hogarth to Constable and Turner.

Hogarth's *Marriage à la Mode* series satirises mercenary marriage. His delightful group portrait of *The Graham Children* shares the same Hogarthian vitality as the sketch of *The Shrimp Girl*. The Gallery has good examples of the work of Stubbs and Richard Wilson, but Gainsborough and Reynolds dominate its collection of eighteenth-century English painting.

The group of works by Gainsborough begins with his most popular early painting, *Mr and Mrs Andrews*. A portrait of a young couple, it may be compared with the artist's equally famous *The Morning Walk*, which is painted in the loose manner of Gainsborough's last years. Nearby are examples of early and mature landscapes: *Cornard Wood* and *The Watering Place*. The two portraits of *The Artist's Daughters Chasing a Butterfly* and *The Artist's Daughters Holding a Cat* are unfinished. *Dr Ralph Schomberg* is a portrait of the doctor who attended one of the girls in an illness.

Reynolds, Gainsborough's great contemporary, is represented at the Gallery by three of his finest military portraits: *Captain Robert Orme*, *General Sir Banastre Tarleton* and *Lord Heathfield*, who is shown holding the key of Gibraltar, against a background of cannon smoke. Reynolds's gift for conveying strong character is visible in *Anne, Countess of Albermarle*.

Joseph Wright of Derby was an incisive portrait painter *(Mr and Mrs Colman)*, but is best known for dramatic light effects like those in *An Experiment on a Bird in the Air Pump*, a study of conflicting emotions.

The full-length portraits hanging at the intersection of the magnificent Barry Rooms include Thomas Lawrence's *Queen Charlotte* (painted when Lawrence was only 21), and the aristocratic *Lord Ribblesdale* by John Singer Sargent. Sargent's fellow American, Whistler, created the portrait of *Miss Cicely Alexander: Harmony in Grey and Green* (on loan from the Tate).

Among the Constables are *The Young Waltonians*, *The Haywain*, *Salisbury Cathedral from the Meadows* and *The Cornfield*. *The Cenotaph* is a memorial to Reynolds.

Turner's many sea-pieces include *The 'Fighting Téméraire' Tugged to her Last Berth to be Broken Up* and *Calais Pier*. The artist bequeathed to the Gallery his *Sun Rising through Vapour* and *Dido Building Carthage* - an imitation of Claude - with instructions that they be hung between Claude's *Seaport* and *The Mill*. The celebrated *Rain, Steam and Speed - The Great Western Railway* is one of Turner's late and highly impressionistic works.

French art, from the severe classicism of the seventeenth century to the revolutionary canvases of the late nineteenth century, is splendidly covered. One earlier work, the masterpiece known as the *Wilton Diptych*, originally part of the Earl of Pembroke's collection at Wilton House, may be of French origin, and is kept with the early Italian paintings on the lower floor. On the main floor is the Gallery's outstanding group of paintings by Poussin, covering his career from the early *Cephalus and Aurora*, through the *Triumph of Pan* and the great *Adoration of the Golden Calf* to the disquieting *Landscape with a Man killed by a Snake*. *The Finding of Moses* is a recent acquisition (jointly with the National Museum of Wales).

The Enchanted Castle (Landscape with Psyche Outside the Palace of Cupid) is one of several landscape canvases by Claude, the French landscape artist beloved of English collectors and long admired by English artists. *The Mill (Landscape with the Marriage of Isaac and Rebekah)*, the *Embarkation of St Ursula* and *Embarkation of the Queen of Sheba* all display his delicate handling of light over distance. Landscapes by other French artists include works by Poussin, Simon Vouet, Francisque Millet, Pierre Patel and Gaspard Dughet *(Landscape with Elijah and the Angel)*.

The mysterious Le Nain brothers were jointly or separately responsible for the austere *Four Figures at a Table*, brightly coloured *Woman and Five Children* and

the *Adoration of the Shepherds*, an unusually large work. French allegorical painting is represented by Laurent de la Hyre's graceful *Allegorical Figure of Grammar* and by the portrait of *The Marquise de Seignelay and Two of her Children*, by Pierre Mignard, Premier Peintre to Louis XIV. The *Dream of St Joseph* is an altarpiece by Philippe de Champaigne, better known in England for his portraits of his patron, *Cardinal Richelieu*, who is seen here in a *Triple Portrait* and in a full-length similar to that at Hampton Court. Other artists whose work is shown here include Valentin (*Four Ages of Man*) and Eustache Le Sueur.

The eighteenth-century art of Watteau, Boucher, Fragonard and Chardin is well represented. The superb portrait of *Jacobus Blauw* by Jacques-Louis David was recently acquired by the Gallery and is a rarity in England. *Mme de Pompadour*, by François-Hubert Drouais, was completed after the sitter's death. Fragonard's *Psyche Showing her Sister her Gifts from Cupid* is an early work. Chardin's *Young Schoolmistress* and *House of Cards* are subjects which Chardin repeated; the portrait of *A Gentleman with Two Girls in a Garden* is considered Lancret's masterpiece.

Ingres's *Madame Moitessier* is among the greatest of the nineteenth-century French works on display. Other fine portraits include Ingres's earlier *M. de Norvins* and Delacroix's full-length of *Baron Schwitter*. *The Execution of Lady Jane Grey* is a major work by Paul Delaroche, the popular history painter.

Courbet may have painted *Still Life with Apples and a Pomegranate* while imprisoned; his *Girls on the Banks of the Seine* is a sketch for *Les Demoiselles des Bords de la Seine* in Paris. Millet's *The Winnower* was his first large painting of peasant life.

The collection of Impressionist and Post-Impressionist art includes canvases given by Hugh Lane, among them works by Manet, Renoir, Seurat, Van Gogh and Cézanne. Manet's *Music in the Tuileries Gardens* is one of his earliest scenes of contemporary Paris life. *The Waitress* and the four fragments of *The Execution of the Emperor Maximilian* were cut from larger paintings.

The Gallery has an exceptional group of Degas works, including *The Young Spartans*, *Beach Scene* and *La La at the Cirque Fernando*. *Elena Carafa* was Degas's cousin; *Hélène Rouart*, the daughter of a friend. The *Maid Combing a Woman's Hair* and *After the Bath, Woman Drying Herself* are late works.

Renoir's *Les Parapluies* is one of the artist's most popular paintings. The Gallery also owns *Café-Concert (La Première Sortie)*, the late *Dancing Girls* and an outdoor boating scene, *Seine at Asnières (The Skiff)*.

Monet painted *Bathers at La Grenouillère*, an important early 'Impressionist' work pre-dating the first Impressionist exhibition in 1874 by five years. The huge *Waterlilies* is a late painting; like *Water-Lily Pond*, it celebrates the artist's garden at Giverny, and contrasts with his view of the *Gare St-Lazare*. *The Thames at Westminster* was painted during a visit to England, as was Pissarro's largest English painting, *The Avenue, Sydenham*. Pissarro also painted the *Boulevard Montmartre at Night*.

Puvis de Chavannes's works include his unfinished *Beheading of St John the Baptist*. Other works by Symbolist artists include Odilon Redon's *Ophelia among the Flowers* and Gustave Moreau's *St George and the Dragon*.

Cézanne originally painted *The Painter's Father* on a plaster wall at his family's house; it is now exhibited on the lower floor of the Gallery. The *Grandes Baigneuses* is a late work of the kind that inspired the early Cubists.

Seurat's important *Bathers, Asnières* predates his 'pointilliste' technique, although he later repainted passages in this manner. The famous *Sunflowers* by Van Gogh is one of a group of sunflower paintings planned by the artist. Van Gogh's *Chair and Pipe*, a type of self-portrait, is the pendant to a portrait by the artist of his friend Gauguin's armchair, now in the Rijksmuseum Vincent Van Gogh in Amsterdam. *Tropical Storm with a Tiger* was the Douanier Rousseau's first jungle painting.

Gustav Klimt paintings are rare in Britain; the Gallery owns a portrait of *Hermione Gallia*. The two sections of *Lunch at Villeneuve-sur-Yonne* by Vuillard were once a single painting, showing the garden of Misia Sert, whose portrait by Renoir is also in the collection. *The Chimneypiece* is a typically domestic Vuillard subject.

With Matisse's 1908 portrait of his pupil *Greta Moll*, and the Synthetic Cubism of Picasso's *Fruit Dish, Bottle and Violin*, which was painted in 1914, the Gallery ends its survey of European art. More modern works are to be found in the Tate.

See entry in main text, pages 45–57.

NATIONAL MARITIME MUSEUM
Romney Road, Greenwich SE10 9NF
Telephone: (081) 858 4422

Open: Mon-Sat 10-6 (10-5 in winter), Sun 2-6 (2-5 in winter)
Closed: CE, CD, BD, NYD, GF, May BH
Limited access for disabled

Underground: Surrey Docks (East London Section) then Buses 108B, 188
Train: Maze Hill
Buses: 53, 54, 70, 75, 177, 180, 228
Boat: from Westminster, Charing Cross and Tower Piers **7 A5**

The fine art in the National Maritime Museum is closely integrated within the general display of objects connected with British maritime history. The premises are extensively spread out on the south bank of the River Thames between Greenwich Hospital, which leads down to the edge of the river, and the Royal Observatory on the hill to the south.

The earliest paintings, including some of the finest, are in the Queen's House, in the centre of the Museum complex, which deals with maritime history of the seventeenth century and earlier. The ceiling decoration in the central hall is by James Thornhill, and there are portraits and battle scenes, among the latter Willem van de Velde's *Battle of the Texel*. There are numerous important works by this artist.

The Elizabethan period, more glorious in most respects, including maritime history, than the seventeenth century, is covered by a number of works, including portraits of *Elizabeth I* by Bettes, of *Sir Francis Drake* and *Sir John Hawkins*, and battle scenes of the Spanish Armada and of the Battle of Lepanto.

But it was during the seventeenth century that the foundations of the modern British Navy were laid, and this is amply reflected in the portraits of commanders, ships, ship-builders and designers, notable among which are Kneller's portrait of *Samuel Pepys*, whose role as a naval administrator was significant. Equally important was the position eventually acquired by *Greenwich Hospital*, shown in Canaletto's painting.

The lively and varied drama of English maritime history during the eighteenth, nineteenth and twentieth centuries is vividly portrayed through paintings of naval engagements and British naval heroes of which only the most superficial indication can be given by listing works, by Dance, *Portrait of Cook*, Reynolds, *Admiral Lord Keppel*, Hogarth, *Captain Lord George Graham in his Cabin*, and A.W. Devis, *The Death of Nelson*.

Throughout the Museum there are vivid and vigorous seapieces, recounting

naval engagements and other events, among them such famous works as Orchardson's *Napoleon on the Quarterdeck of Bellerophon, 23 July 1815*, Turner's *Battle of Trafalgar*, and Zoffany's *Death of Cook*.

See entry in main text, pages 74–5.

NATIONAL PORTRAIT GALLERY

St Martin's Place WC2H 0HE
Telephone: (071) 930 1552

TRUSTEES OF THE NATIONAL PORTRAIT GALLERY
Open: Mon–Fri 10–5, Sat 10–6, Sun 2–6
Closed: CE, CD, BD, GF, May BH
Admission Free: Limited access for disabled

Underground: Leicester Square, Charing Cross
Buses: 1, 3, 6, 9, 11, 12, 13, 15, 23, 24, 29, 53, 77, 77A, 88, 159, 170, 172, 176, 500 **7 B4**

The National Portrait Gallery is an intense intellectual and emotional experience, quite divorced from its fine art component. Although the collection is rich in works by leading painters, from Holbein's *Henry VIII* and *Henry VII* to Rodrigo Moynihan's commissioned portrait of *Margaret Thatcher*, the strictly chronological display of a selection of the Gallery's 10,000 or so images of the most important British men and women in history and public life reflects its emphasis on subject-matter rather than art. Efforts have been made, with considerable success, to arrange portraits by theme and to give informative background. Frequent temporary exhibitions are held, of photographs and sculpture as well as paintings; some incorporate films. The Gallery's annual competition for young painters, and the Trustees' policy of commissioning portraits of living sitters, has encouraged interest in contemporary portraiture.

A tour of the Gallery begins with the Tudor display on the top floor, best gained by lift. The vigorous reign of Henry VIII dominates the first rooms, with paintings of statesmen, clerics and Henry's wives. In this area is Michael Sittow's perceptive *Henry VII*, painted from life. Holbein's magnificent drawing of *Henry VIII and Henry VII* (part of a design for a lost Whitehall wall painting, a copy of which survives at Hampton Court, q.v.) is accompanied by William Scrots's intriguing *Edward VI*, an anamorphic portrait correctly seen from one point only. *Sir Thomas More and his Descendants* (another version is at Nostell Priory in West Yorkshire) is an historical composite group portrait by Rowland Lockey, based in part on a Holbein portrait of More's family. The artistically fine Gerlach Flicke of *Cranmer* is less sophisticated than the *Lady Jane Grey* attributed to Master John.

The splendours of the court of Elizabeth I are reflected in miniatures by Nicholas Hilliard (*Elizabeth I*, *Raleigh* and *Francis Drake*) and in the *Ditchley Portrait* by Marcus Gheeraerts – a full-length of the Queen. The portrait of *Shakespeare* was the Gallery's first acquisition, and may be from life.

As the visitor passes into the galleries covering the seventeenth century, the range of sitters expands beyond the politically important. Fine portraits by Daniel Mytens (*James I*), Cornelius Johnson (*The Capel Family*), Peake (*Henry, Prince of Wales*) and Larkin (*The Duke of Buckingham*) hang with works by Dobson, Honthorst and Robert Walker; all are outshone by Rubens's great portrait of the art-collecting *Earl of Arundel* and by a group of Van Dycks, including *Charles I* (a loan) and *Venetia, Lady Digby as Prudence*.

Later seventeenth-century portraits include examples of the incomparable skills of Samuel Cooper: among his miniatures here are the *Duke of Lauderdale* and *Oliver Cromwell*. Robert Walker's melancholic *John Evelyn*, Huysman's *Isaac Walton* and Hayls's *Samuel Pepys* accompany works by John Michael Wright, including *The Vyner Family*, and several by Lely, among them his *Earl and Countess of Essex*, and his great sketch of *James II*.

The Georgian Galleries reflect the fact that the eighteenth century was a golden era for British portrait-painting. The early Galleries are dominated by a selection of Kit-cat Club portraits, painted by Sir Godfrey Kneller over more than twenty years (a further selection is on loan to Beningbrough in Yorkshire). Among these are portraits of notable Georgian men of letters, and of *Jacob Tonson*, secretary of the Club. In an adjoining gallery is Kneller's fine *Sir Christopher Wren* and his own *Self-Portrait*. Other self-portraits by artists include one by Michael Dahl, and Hogarth's *Portrait of the Artist, Painting the Comic Muse*. Jonathan Richardson has contributed portraits of *Richard Boyle, Third Earl of Burlington*, and of *Alexander Pope*, crowned with laurel. Group portraits include Mercier's *Frederick, Prince of Wales and his Sisters*, and there are good examples of the work of Highmore, Hayman, Gawen Hamilton and Nathaniel Hone.

The Galleries devoted to the later Georgian era contain interesting works by Sir Joshua Reynolds: his early *Joseph Wilton* and *Self-Portrait* (the only one to show him actually painting), and his fine portrait of *Sir Joseph Banks* from the 1770s. Literary portraits by Reynolds include *Samuel Johnson* and *Laurence Sterne*. There is a small but engaging portrait of *Charles Burney*, and a double portrait of *Mr and Mrs Garrick*.

There are fewer Gainsboroughs; these include a *Self-Portrait* of 1759, lively portraits of his musical friends, *J. C. Bach* and *C. F. Abel*, and a freely painted portrait of the playwright *George Colman*. The delightful *Sharp Family* by Zoffany, Copley's celebrated *The Death of Chatham* and J. F. Rigaud's trio of artists (*Reynolds, Joseph Wilton and William Chambers*) are among group portraits owned by or on loan to the Gallery. There are few portraits of women (Hone's *Kitty Fisher* – with Kitty fishing – and *Fanny Burney* by her cousin Edward), but many self-portraits by Georgian artists: Allan Ramsay, Stubbs, Wright of Derby and James Barry among them. Imposing full-lengths include Thomas Hudson's *Handel*, Reynolds's *Third Earl of Bute* and John Singleton Copley's *First Earl of Mansfield*.

The early nineteenth century was dominated, in artistic terms, by the Prince Regent, later George IV, whose portrait sketch in profile by Sir Thomas Lawrence was the precursor of many more glossy versions. Far more moving, in a room of Regency portraits including Lawrence's *Canning* and *Lord Brougham*, is his unfinished *Wilberforce*. Familiar images of the Romantic poets, Byron, Shelley, Keats, Scott, Wordsworth and Coleridge, are part of the collection, as are Cassandra Austen's sketch of *Jane Austen*, and Branwell Brontë's *Charlotte, Emily and Anne Brontë*.

Daniel Maclise's *Dickens*, Gordigiani's *Elizabeth Barrett Browning* and portraits by the Pre-Raphaelites Rossetti, Millais and Holman Hunt are followed by Collier's posthumous *Darwin* and some of G. F. Watts's studies of his great contemporaries, including *Cardinal Manning* and *Alfred, Lord Tennyson*.

In the late Victorian and Edwardian galleries hang Tissot's debonair *Captain Frederick Burnaby*, Boldini's *Lady Colin Campbell* and Lavery's *Royal Family at Buckingham Palace 1913*. There are fine Sargents, among them oils of *Henry James* and *Ellen Terry as Lady Macbeth* (she also appears in Watts's charming *Choosing*), and drawings of *Ethel Smyth* (and *Nancy, Viscountess Astor*).

Royal portraits on the landings include Pietro Annigoni's *H. M. Queen Elizabeth II* and Bryan Organ's *Charles, Prince of*

Wales. In recent years the Gallery, pressed for space, has resorted to revolving turntables for part of its twentieth-century display. Sutherland's *Churchill* (a sketch for the destroyed portrait), Augustus John's *T. E. Lawrence,* Patrick Heron's *T. S. Eliot,* Duncan Grant's *Vanessa Bell* and Partridge's *George Bernard Shaw* mingle with modern portrait sculpture and the best of portrait photography.

In order to keep as much as possible of the collection on public view, and to make it more easily accessible, the Gallery has transferred parts of it to historically appropriate houses in other parts of Britain. Tudor and Jacobean portraits may be seen at Montacute House in Somerset, Stuart at Gawthorpe in Lancashire, Georgian at Beningbrough in North Yorkshire and Victorian at Bodelwyddan Castle in North Wales (qqv.).

See entry in main text, pages 67–70.

ORLEANS HOUSE GALLERY

Riverside, Twickenham TW1 3DJ
Telephone: (081) 892 0221

BOROUGH OF RICHMOND UPON THAMES
Open: Tues-Sat 1-5.30, Oct-Mar 1-4.30;
Sun 2-5.30, Oct-Mar 2-4.30; BHs 2-5.30
Closed: CE, CD, BD, GF
Admission Free: Limited access for disabled

Underground: Richmond
Train: St Margaret's, Twickenham
Buses: 33, 73, 90B, 202, 270, 290
Ferry: From Ham House **7 B6**

The Orleans House Gallery was part of an early eighteenth-century Thames-side villa. Its most famous occupant was Louis-Philippe, Duc d'Orléans, later King of France, who lived in the house 1815-17, and after whom it has been named.

It was bequeathed to Richmond by Nellie Ionides in 1962, together with her art collection, which is local to Twickenham and Richmond, and includes eighteenth- and nineteenth-century English paintings. There are works by Samuel Scott, William Marlow, Peter de Wint, Thomas Rowlandson.

The house is mainly used for local exhibitions, though the permanent collection 'is frequently incorporated'.

OSTERLEY PARK �001

Isleworth, Middlesex, TW7 4RB
Telephone: (081) 560 3918

NATIONAL TRUST
Open: Mar-Oct Wed-Sun and BH Mons 12-6; last admissions 5.30; Nov, Dec, Sat, Sun 12-4.

Closed: GF

Underground: Osterley
Buses: 91; Green line 704, 705 **7 B6**

Osterley is famous for its elegant Robert Adam neo-classical interior, designed for the Child family. Zucchi and Cipriani painted the delicate ceiling and inset paintings. The pictures in the Breakfast Room and Drawing Room include eighteenth-century English school and seventeenth-century Dutch school works by H. B. Chalon and Francis Cotes. Portraits by Reynolds include Thomas Middleton Trollope and Isabella Thorold. Many of the works have been introduced by the Victoria and Albert Museum.

There is an outstanding Tapestry Room containing work by Jacques Neilson, an artist of Scottish origin, who wove at the Gobelins works in Paris and did various commissions for Robert Adam. The tapestries at Osterley Park, signed and dated 1775, are after designs by Boucher, and represent the loves of the gods.

PALACE OF WESTMINSTER AND WESTMINSTER HALL

Westminster SW1A 0PW
Telephone: (071) 219 3107 (House of Lords);
(071) 219 4272 (House of Commons)

DEPARTMENT OF THE ENVIRONMENT
Visits can only be arranged by writing to your local MP, a Peer or officer of either House. It is advisable to telephone before writing to ascertain a suitable day and time. **30 C3**

Art at the Palace of Westminster is incidental to one's visit, but important, and includes nineteenth-century frescoes, inspired by the Prince Consort's interest in the use of art in public buildings and his belief in its regenerative impact on the human spirit.

Two of Daniel Maclise's most famous historical paintings, used in countless history books, are in the Royal Gallery. They are *The Death of Nelson* and *The Meeting of Wellington and Blücher after Waterloo*. Further works by him, in the Strangers' Gallery, include his *Spirit of Justice* and *Spirit of Chivalry*. Other artists represented with him are Horsley, Cope, Ward and Dyce, whose frescoes illustrating the virtues of chivalry are to be found in the Queen's Robing Room.

In the late 1920s further wall-paintings were commissioned, depicting the *Building of Britain*, by William Rothenstein, Monnington, Clausen, Sims, Philpot and Gill.

A number of statues are to be found, variously placed, including the impressive Gibson of Queen Victoria, and there are numerous portraits.

As most visitors are there for other purposes, and security is necessarily tight, 'loitering with intent to look at paintings' can at times seem like an offence to the official guardians.

THE QUEEN'S GALLERY

Buckingham Palace Road SW1A 1AA
Telephone: (071) 930 4832

HER MAJESTY THE QUEEN
Open: During exhibitions Tues-Sat, Easter Mon, Spring and Late Summer Holiday Mon 10.30-5, Sun 2-5
Closed CE, CD, GF
No access for disabled

Underground: Victoria
Buses: 2, 2B, 16, 25, 36, 36B, 38, 52, 55, 500 **30 C4**

The Queen's Gallery was opened in 1962 with the purpose of presenting temporary exhibitions of works of art from the Royal Collection. These are normally changed annually.

ROYAL ACADEMY OF ARTS

Burlington House, Piccadilly W1V 0DS
Telephone: (071) 439 4996

COUNCIL OF THE ROYAL ACADEMY
Open: during exhibitions daily 10-6
Closed: GF, CD

Underground: Piccadilly Circus, Green Park
Buses: 3, 6, 9, 12, 13, 14, 15, 22, 25, 38, 53, 55, 88, 159 **30 C4**

The principal purpose of the Royal Academy has always been the protection and promotion of its own interests through the annual exhibition of the works of members. It has played an additional and important role in the development, and to some extent the control, of taste, and it has done this through the teaching of art as well as through the assertion, during its two centuries of history, of its own primacy, a matter increasingly challenged during the twentieth century.

From the public's point of view, the Royal Academy is most famous for its spectacular loan exhibitions.

It has a wide-ranging collection of works of art, deriving from gifts and bequests, as well as from the diploma works which members since 1770 have been obliged to submit, as a condition of

their election. Though this has produced an interesting collection, illustrative of the development of British art, and including fine works, it is not permanently on display, and has to be seen here and there, or by appointment.

The Academy formerly owned the Leonardo cartoon, now in the National Gallery. Its greatest remaining treasure is the Michelangelo Tondo, *Madonna and Child with the Infant St John*, executed soon after the completion of *David*.

There are ceiling paintings by Benjamin West, done for Somerset House, for which Angelica Kauffmann also did four works depicting *Design, Painting, Composition* and *Genius*. Sebastiano Ricci's large canvases on the stairway are *The Triumph of Galatea* and *Diana and her Nymphs Bathing*. There are further works by Ricci in the building.

See entry in main text, pages 48–54.

ROYAL AIR FORCE MUSEUM

Hendon NW9 5LL
Telephone: (081) 205 2266

ROYAL AIR FORCE
Open: Daily 10-6
Closed: CE, CD, BD, NYD
Access for disabled

Underground: Colindale
Buses: 79, 266, 292 or 32, 142 **7 A6**

The collection of art in the Air Force Museum must be one of the largest of aviation art in northern Europe. The paintings reflect the story and development of aviation in peace and war. War artists included are Paul Nash, John Nash, Eric Kennington, Sir William Rothenstein, A. R. Thompson, Frank Woolton, and H. A. Oliver. Among the 460 paintings are also works by Dame Laura Knight, Sir John Lavery, A. Edgerton Cooper and Roy Nockolds.

ROYAL COLLEGE OF MUSIC

Prince Consort Road, South Kensington
SW7 2BS
Telephone: (071) 589 3643

ROYAL COLLEGE OF MUSIC
Open: Mon-Fri during term time 10-5, by arrangement with the Keeper of Portraits
No access for disabled

Underground: South Kensington
Buses: 9, 52, 73 **30 C8**

An important specialist collection of portraits of musicians, including paintings, drawings and watercolours, prints, and works of sculpture, including Epstein's *Vaughan Williams*.

ROYAL HOSPITAL

Royal Hospital Road, Chelsea SW3 4SR
Telephone: (071) 730 0161 ext 203

COMMISSIONERS OF THE ROYAL HOSPITAL
Open: Weekdays 10-12, 2-4; Sun 2-4 Apr to Sept; Oct-Mar, closed
Closed: BH weekends
Admission Free: Limited access for disabled

Underground: Sloane Square
Buses: 4, 11, 39, 137 **30 D5**

The fine brick buildings of the Hospital were designed by Wren (1682-92).

Works of art are to be seen in the Museum (which is on the East Road), in the Hall, the Chapel, and in the Centre Court, where Grinling Gibbons's statue of Charles II stands. It is wreathed in oak leaves on Oak Apple Day, which is also Founder's Day (29 May).

The Museum contains, in the Wellington Hall, Haydon's *Wellington Describing the Field of Waterloo to George IV*, and Jones's *The Battle of Waterloo*. In the Hall is *The Triumph of Charles II*, started by Antonio Verrio in 1687 and completed in about 1690 by Henry Cooke, whose signature it bears. Closterman's equestrian portrait of the Duke of Marlborough is also in the Hall. Sebastiano Ricci's *Resurrection* is in the Chapel.

SIR JOHN SOANE'S MUSEUM

13 Lincoln's Inn Fields WC2A 3BP
Telephone: (071) 405 2107

THE TRUSTEES OF SIR JOHN SOANE'S MUSEUM
Open: Tues-Sat 10-5; Lecture tours on Sat at 2.30; Groups must book
Closed: Sun, Mon, BHs
Admission Free: No access for disabled

Underground: Holborn
Buses: 8, 22, 25, 55, 68, 77, 77A, 170, 172, 188, 239, 501 **30 B3**

This early nineteenth-century *wunderkammer* provides an extraordinarily complete record of the diverse interests of its creator, the architect Sir John Soane (1753-1837). Amid the sculpture, vases, antiquities (including the superb sarcophagus of Seti I), architectural fragments, relics of the famous and oddities of nature is a fine collection of pictures. Hogarth's two series, *A Rake's Progress* and *The Election*, are kept in the Picture Room designed, like the rest of the house, by Soane. The attendants may open the hinged walls, to reveal Watteau's *Les Noces* and Piranesi's drawings of *Paestum*, hidden behind the Hogarths. Reynolds's *Love and Beauty*, Turner's *Admiral Van Tromp's Barge* and Canaletto's views of Venice hang with works by Soane's contemporaries. Some of Soane's vast number of architectural designs are on display, for buildings actually erected (the Bank of England) as well as unrealised projects and fantasies. Lawrence's portrait of *Sir John Soane* dominates the dining room.

SOUTH LONDON ART GALLERY

Peckham Road SE5 8UH
Telephone: (071) 703 6120

LONDON BOROUGH OF SOUTHWARK
Open: during exhibitions Tues-Sat 10-6, Sun 3-6
No access for disabled

Underground: Oval, then Buses 36, 36A, 36B; Elephant and Castle, then Buses 12, 171 **7 A5**

Though primarily used for loan exhibitions, the gallery has a small collection of Victorian and twentieth-century British art which may be seen on request. There is also a collection of graphic art.

THE SUFFOLK COLLECTION

Ranger's House, Chesterfield Walk,
Blackheath SE10 8QX
Telephone: (081) 853 0035

ENGLISH HERITAGE
Open: Daily, GF-end Sept 10-5,
1 Oct-end Mar 10-4
Closed: CE, CD
Admission Free: Access for disabled to ground floor

Underground: New Cross then Bus 53
Train: Blackheath or Greenwich (BR)
Buses: 53, 54, 75
River launches to Greenwich from Westminster Pier **7 B5**

The most splendid of the portraits in the Suffolk Collection are those by William Larkin. Seven of them constitute the so-called 'Berkshire Marriage Set'.

Beside this outstanding group of works are portraits by, or attributed to, Mor, Mytens, Johnson, Peake, Kneller, Lely, Wissing and Hudson.

The royal portraits once included the Nicholas Hilliard 'Pelican' portrait of Elizabeth I, now in the Walker Art Gallery, Liverpool, and other paintings have been dispersed. The works that remain are an average country house collection, among them a full-length *Charles I* after Van Dyck and a Studio of Van Dyck group portrait of Charles I's three eldest children.

The Old Master paintings have been depleted over many years, and through the sales of several generations. A fine Ferdinand Bol *The Falconer* remains, and there is *The Holy Family in the Carpenter's Shop* by Carracci, as well as works by Bloemaert and Sustermans.

See entry in main text, pages 86–7.

SYON HOUSE
Syon Park, Brentford
Telephone: (081) 560 0881

THE DUKE OF NORTHUMBERLAND
Open: 1 April or GF–28 Sept daily (except Fri and Sat) 12–5
Gardens open daily except CD, BD
Access for disabled

Underground: Boston Manor, Gunnersbury
Train: Syon Lane
Buses: 37, 117, 203, 237, 267, E1, E2 **7 A6**

Syon House, the London home of the Dukes of Northumberland, has an excellent family collection of portraits covering the period from the acquisition of the house by Henry Percy, 9th Earl of Northumberland, in the late sixteenth century. In addition, it has more general works, including Rubens's *Diana Returning from the Hunt*. Decorative sculpture, in keeping with the style of the house, was either commissioned by Robert Adam as part of his classical reconstruction of the house in the second half of the eighteenth century, or was bought at that time. In this latter category is the impressive bronze casting done in Rome by Valadier of *The Dying Gaul*.

Portraits at Syon include many seventeenth-century portraits of the Royal family: Sir Peter Lely's *Charles I*, his sister Princess Elizabeth who became *Queen of Bohemia,* 'The Winter Queen' or 'the Queen of Hearts', his daughter, *Henrietta, Duchess of Orleans, James, Duke of York,* and the King with the Duke of York. Portraits of the Royal family by Van Dyck, Gerard van Honthorst and Hanneman all hang in the Red Drawing Room.

The Percy family was ill-served by the first of the Stuarts, James I, who kept the Wizard Earl confined in the tower for alleged, but unproven, involvement in the Gunpowder Plot. The members of the family are all recorded in portraits down to the present, 10th Duke. These works include paintings by Gainsborough, Gilbert Stuart, Peter Lely, Philip de Laszlo.

TATE GALLERY
Millbank, SW1P 4RG
Telephone: (071) 821 1313
Recorded information: (071) 821 7128

TRUSTEES OF THE TATE GALLERY
Open: Mon–Sat 10–6, Sun 2–6
Closed CE, CD, BD, NYD, GF and May BH
Admission free: Access for disabled

Underground: Pimlico
Buses: 2, 2B, 36, 36A, 36B, 77A, 88, 185
30 D3

The Tate Gallery, one of the greatest modern art galleries in the world, was opened in 1897 as a 'modern' and 'British' subsidiary of the National Gallery. It is named after Sir Henry Tate, who provided funds for a separate gallery, and whose collection formed the nucleus.

The Clore Gallery, opened in 1987 as an addition to the Tate's main building, houses the nation's collection of Turners, bequeathed by the artist in 1851. The opening of the Tate Gallery in the North at Liverpool (q.v.) in 1988 has increased opportunities for people outside London to see works from the London Tate – particularly from its collection of modern art, unrivalled in the British Isles. The Tate's main London building is also undergoing a comprehensive re-hang, which opened in February 1990.

As well as putting on a wide variety of exhibitions, the Tate houses several distinct collections: British art from around 1600 to the early twentieth century; foreign art from Impressionism to the present; a selection of modern British art and a collection of works on paper. The Tate contains an extensive and growing archive, and its prints and drawings collection is particularly strong in the work of modern artists.

The historic collection of British art is arranged more or less chronologically, the earliest work being *Man in Black Cap* by John Bettes (1545). There are important works by native artists, among them a full-size portrait of *Elizabeth I* attributed to the miniaturist Nicholas Hilliard, J. M. Wright's *Sir Neill O'Neill* and William Dobson's *Endymion Porter*. Among the Gallery's most striking and popular works are David des Granges's *Saltonstall Family* and the unattributed *Cholmondeley Sisters*. Many of the portraits which inevitably dominate displays of early British painting are by foreign artists who either visited or settled in this country: Marcus Gheeraerts's *Captain Thomas Lee*, the Van Dyck and Lely portraits of ladies from the *Spencer* and *Lake* families, Gerard Soest's *Lady as a Shepherdess* and Kneller's *John Smith*.

Several rooms display the flower of eighteenth-century British art. The splendid Tate collection of works by William Hogarth includes his portraits of the bishops *Herring* and *Hoadly*, of his *Six Servants* and his *Self-Portrait with his Pug Dog*. Hogarth's lively sketch, *The Dance*, and typical *O, the Roast Beef of Old England* demonstrate his robust and independent style, a cornerstone in the construction of English painting.

The Scottish painter Allan Ramsay's *Mansel Family* is accompanied by part of Joseph Highmore's *Pamela* series, and by splendid examples of the work of Hayman, Mercier and Devis. Landscapes include Jan Siberecht's early *Landscape with Rainbow,* Samuel Scott's *An Arch of Westminster Bridge* and Richard Wilson's *Rome: St Peter's and the Vatican*.

The group of Stubbs's works in the Tate is especially fine, and includes the delicious rural canvases, *Haymakers* and *Reapers,* as well as sporting and animal subjects *(Mares and Foals in a River Landscape)*. His *Horse Attacked by a Lion* is painted in enamel on copper.

The Gainsboroughs include landscapes and portraits, among them *Sir Benjamin Truman,* the arresting Italian dancer *Giovanna Bacelli* (Gainsborough's other portrait of her is normally at Russborough House, Ireland) and *Pomeranian Bitch and Puppy.* Other striking portraits are Zoffany's *Mrs Wodhull* and Tilly Kettle's *Mrs Yates as 'Madane'.*

Several Reynolds portraits, including *Three Ladies Adorning a Term of Hymen* and the powerful *Admiral Viscount Keppel,* dominate the later eighteenth-century collection. This includes Wright of Derby's *Sir Brooke Boothby* and Romney's *Lady Hamilton as Circe.* American-born artists are represented by John Singleton Copley's *Death of Major Peirson* and Benjamin West's *Cleombrotus Ordered into Banishment.* Later figures include Barry and Fuseli *(Lady Macbeth Seizing the Daggers).*

William Blake's work is extensively displayed. Large colour prints, designed *c.*1795 and hand-finished by Blake in watercolour, depict subjects from the Bible *(Elohim Creating Adam),* English literature and Blake's own interpretations

of English history (Newton). His water-colour illustrations to Dante's *Divine Comedy*, such as *Beatrice Addressing Dante from the Car*, are beautifully preserved.

Work by 'The Ancients', Blake's young admirers, includes Samuel Palmer's dream-like *The Bright Cloud* and his largest oil, *Sheepshearers*. George Richmond's *The Creation of Light* was influenced strongly by Blake, as were Edward Calvert's minute etchings.

In landscape painting, De Louther-bourg's dramatic *Avalanche in the Alps* is followed by Francis Danby's *The Deluge* and by John Martin's *The Great Day of his Wrath*. The scale of nineteenth-century landscapes ranges from the intimacy of Norwich School works by Crome and John Sell Cotman to the huge *Gordale Scar* by James Ward.

The contemplative and serene vision of Constable is demonstrated in the calm realism of his canvases. The Tate's large holdings of Constable include *Flatford Mill (Scene on a Navigable River)*, *The Chain Pier at Brighton*, *The Valley Farm* and *Waterloo Bridge*. There are sketches of Dedham and Hampstead, *Salisbury Cathedral* and *Hadleigh Castle*, and some early portraits.

The Tate's superb holdings of nineteenth-century British figurative art fill further rooms. David Wilkie's *Blind Fiddler* and Daniel Maclise's *Scene from Twelfth Night* are followed by Frith's *Derby Day* and Augustus Egg's moral trilogy, *Past and Present*.

The collection of works by the Pre-Raphaelites and their contemporaries includes many of the most popular masterpieces of nineteenth-century British painting. Millais is particularly well-represented by his *Ophelia*, *Christ in the House of His Parents*, *The Order of Release*, *The Boyhood of Raleigh* and Millais's own favourite, *The Vale of Rest*. The works of Rossetti range from the austere *Ecce Ancilla Domini!* to the lush *Monna Vanna*. Other famous paintings include Holman Hunt's *The Awakening Conscience*, Burne-Jones's *King Cophetua and the Beggar-Maid* and Waterhouse's *Lady of Shalott*. Arthur Hughes's *April Love*, Henry Wallis's *Chatterton* and William Dyce's *Pegwell Bay* are further highlights.

Larger canvases by later Victorian painters include G. F. Watts's inspirational *Hope*, Leighton's big tondo, *And the Sea Gave Up the Dead which were in It*, Luke Fildes's *The Doctor* and Stanhope Forbes's *The Health of the Bride*.

Among the foreign-born artists who contributed to British art of this period are Tissot (*A Ball on Shipboard*), Sargent (*Carnation, Lily, Lily, Rose*) and above all

Whistler. His early *Nocturne in Blue-Green* and *Old Battersea Bridge* are on view, along with *Little White Girl: Symphony in White No. II* and works by his friends.

The Tate's large holdings of twentieth-century British art are displayed selectively in frequently changing arrangements. The older the artist, the more likely it is that their major works will be on long-term view, perhaps in more than one room of the Gallery, since paintings are currently grouped according to art-historical movements. Thus Ben Nicholson abstracts of the 1930s like *Painting 1937* and *White Relief, 1935* are hung with works by Mondrian, while his post-World War II abstracts are in an area of the Gallery devoted to Fifties paintings.

The Tate owns the biggest version of Sickert's *Ennui*, as well as Steer's *Beach at Walberswick* and Gilman's *Canal Bridge, Flekkefjord*. Gwen John's *Young Woman Holding a Black Cat* is displayed with works by Duncan Grant, Vanessa Bell and Augustus John. Different directions in British art are represented by Mark Gertler's *Merry-go-round*, David Bomberg's *Mud Bath*, Matthew Smith's *Nude, Fitzroy Street, No. 1* and works by Wyndham Lewis and William Roberts. Stanley Spencer paintings include his small *Self-Portrait*, nudes, *Swan Upping* and the huge *Resurrection, Port Glasgow*. On an even bigger scale is Graham Sutherland's *The Origins of the Land*

The Tate has sought to acquire representative examples of works by all the significant (and many more minor) British artists of the post-war period, from Kitchen Sink, through Pop, Op, Conceptual, the 'School of London' (Freud, Kossoff, Auerbach, Andrews) to the figurative painting of a younger generation in the 1980s.

Every major European movement of the twentieth century is represented in the Tate. Rooms are given to Cubism-Vorticism, Abstract art, European Expressionism and to the Dada and Surrealist painters.

The current arrangement of European art begins in the east side of the Gallery, with Post-Impressionism: Van Gogh's *Farms near Auvers*, Cézanne's early *Avenue at the Jas de Bouffan* and late *Gardener* and Gauguin's *Faa Iheihe* are of particular interest. Several large Bonnard interiors, including the *Bowl of Milk* and *Table*, accompany Derain's brilliant Fauve *Pool of London* and his portraits of his family and of Matisse.

The Picassos are spread throughout the modern side of the Gallery, reflecting the artist's versatility. They include the early *Girl in a Chemise* and *Head and Shoulders*

of a Woman, *The Three Dancers* of 1925 and his 1939 *Weeping Woman*. Matisse is similarly wide-ranging in his art; the *Interior of the Studio* being hung in the Post-Impressionist room of the Gallery, and the late *Snail* with post-World War II paintings.

The Cubist-Vorticist gallery displays fine works by Braque, among them *Clarinet and Bottle of Rum on a Mantelpiece*, as well as paintings by Picasso, Juan Gris, Fernand Léger (*Still Life with Beer Mug*), the French Robert Delaunay and the Russian Natalia Goncharova. Her compatriot Kasimir Malevich's paintings are shown with Mondrian's 1920-6 *Composition with Grey, Red, Yellow and Blue* and other pre-1940 abstracts, including works by Jean Hélion and Ben Nicholson (see above).

Expressionist paintings include Munch's *The Sick Child* and Kandinsky's *Cossacks*, as well as German art: works by Max Beckmann (*Carnival*), George Grosz and the 'Die Brücke' artists Kirchner and Schmidt-Rottluff (*Two Women*). Emil Nolde (*The Sea B*) was briefly a member of this group.

Among Dada and Surrealist art, are de Chirico's *The Uncertainty of the Poet* and fine examples of Max Ernst's work (*Celebes*, *Men Shall Know Nothing of This*). Marcel Duchamp's important, though small, *Coffee Mill* contrasts with the reconstruction of his *The Bride Stripped Bare by her Bachelors, Even* by Richard Hamilton. Salvador Dali works include *Metamorphosis of Narcissus* and *Mountain Lake*. The Magritte *Reckless Sleeper* and Delvaux *Sleeping Venus* are accompanied by paintings by Chagall, Klee and Miró.

Other outstanding modern European paintings include Rouault's *Three Judges*, Fernand Léger's *Acrobat and his Partner* and *Two Women Holding Flowers*, Dufy's *Kessler Family on Horseback* and Balthus's *Sleeping Girl*. Alberto Giacometti's paintings are hung beside his sculptures; works by Modigliani (*Little Peasant*) and Picabia are also on view with Klee's *They're Biting* and Chagall's *The Poet Reclining*.

Post-war European painting is represented by Jean Dubuffet's *Monsieur Plume with Creases in his Trousers* and by the 'Cobra' artists, among them Constant (*Après Nous La Liberté*). German art of this period includes works by Lupertz and Baselitz.

Controversial though some of the purchases were at the time, the Tate's investment in American painting has now an almost classical impact. Abstract Expressionist works include Arshile Gorky's *Waterfall*, and large-scale paintings by Jackson Pollock (*Yellow Islands*), de

Kooning and Franz Kline. The Colour Field painters are represented by Barnett Newman, Clyfford Still and above all by Rothko, whose nine canvases for the Four Seasons Restaurants in the Seagram Building, New York, may now be seen as an ensemble at the Tate in Liverpool.

As for the Sixties art, the Tate exhibits not only Op, Pop and Minimalist, but a wide range of abstract and representational art by British and foreign artists. Displays of the most recent works are most often subject to change; Morris Louis's *Alpha-Phi,* Warhol's *Marilyn Diptych* and Lichtenstein's *Whaam!* are among large canvases on view.

In 1987 the Clore Gallery, designed by James Stirling, was opened: officially a wing of the Tate, it is effectively a museum in itself, housing Turner's magnificent bequest of oils, works on paper (including all but four of his sketchbooks) and personal relics. (The National Gallery, which also benefited from the bequest, retains a few of Turner's most famous paintings.)

Turner's 1798 *Self-Portrait* is on display, as is his earliest important oil painting, *Fishermen at Sea* (1796). The young artist's explorations of English topography *(London from Greenwich)* and his sketches of the English countryside, such as *The Thames with Walton Bridges,* culminate in *Frosty Morning* (1813). Alongside these peaceful scenes are large canvases full of the rising storm of Turner's art: *Shipwreck, Deluge, Field of Waterloo* and *Snow Storm: Hannibal and his Army Crossing the Alps.*

The influence of Claude, which encouraged Turner to visit Italy in 1819, is already visible in his 1815 Devon view, *Crossing the Brook,* and in the 1817 *Decline of the Carthaginian Empire,* which was originally intended by Turner to hang beside *Dido Building Carthage,* now in the National Gallery. The Italian visit led to three large paintings at the Clore: *Rome, from the Vatican,* in which Turner expresses his veneration for Raphael, *Bay of Baiae, with Apollo and the Sibyl* and *Forum Romanum,* painted for the Soane Museum, but rejected by Sir John Soane.

In complete contrast are the sketches of *Petworth Park* and *Chichester Canal* made at Petworth during Turner's visits to his patron Lord Egremont; the final versions are still at Petworth. Turner's originality of vision is also evident in the famous *Concert at East Cowes Castle* and *Interior at Petworth.*

Venetian views include the jewel-like *Bridge of Sighs, Ducal Palace and Custom-House, Venice: Canaletto Painting* and a view from Turner's hotel: *The Dogana,*

S. Giorgio, Citella, from the steps of the Europa.

One of the most celebrated of these is *Peace: Burial at Sea,* commemorating the death of the painter David Wilkie, who influenced the young Turner greatly. Nearby is its pendant, *War: The Exile and the Rock Limpet,* a work which, like other paintings at the Clore, demonstrates Turner's limitations in figure painting – it refers to the fate of Napoleon. The Clore has other pairs of paintings by Turner. One is *Shade and Darkness: the Evening of the Deluge* (possibly influenced by the Francis Danby *Deluge* in the Tate's collection) and its companion, *Light and Colour (Goethe's Theory) – The Morning After the Deluge.* As well as Turner's last paintings (scenes from the *Aeneid*), the Clore displays the tranquil *Norham Castle – Sunrise* and the powerful and highly original *Snow Storm – Steam-boat off a Harbour's Mouth,* which may be based on the artist's own experience.

The reserve collection of Turner oils is usually accessible in three rooms above the main display areas. Watercolours are exhibited in an artificially lit room. Visitors may arrange to see works on paper by Turner and other pre-1900 British artists in the Study Room on the second floor.

See entry in main text, pages 61–6.

THOMAS CORAM FOUNDATION

40 Brunswick Square WC1N 1AZ
Telephone: (071) 278 2424

THOMAS CORAM FOUNDATION
Open: Mon-Fri 10-4, except when rooms are in use for conferences. Visitors are advised to telephone for details beforehand
Closed: Public holidays
No access for disabled

Underground: Russell Square
Buses: 17, 18, 45, 46, 68, 77, 77A, 77C, 170, 188, 239, 259 **30 A3**

Thomas Coram was a master mariner who petitioned George II on behalf of destitute and abandoned children and was given a Royal Charter for the foundation of a Hospital. One of its first governors was William Hogarth, himself a foster-parent, who persuaded other artists to donate works of art to the hospital; this had the additional effect of publicising their work, and led to the foundation of the Royal Academy in 1768.

Many of the works of art remain, the most splendid being Hogarth's own magnificent portrait of *Captain Thomas*

Coram. Less widely known but of exceptional quality is Allan Ramsay's portrait of *Dr Richard Mead;* there are also fine portraits of *Theodore Jacobsen,* by Thomas Hudson and *Thomas Emerson* by Joseph Highmore. The Hogarth painting of *The March to Finchley,* commemorating the Jacobite rebellion of 1745, hangs in the lobby to the Courtroom, a room from the original Foundling Hospital which contains an ensemble of Georgian religious art by Hogarth and his contemporaries. Major paintings on the theme of the protection of abandoned children are Hogarth's *Moses Brought before Pharaoh's Daughter,* Highmore's *Hagar and Ishmael* and Francis Hayman's *The Finding of the Infant Moses in the Bulrushes.* The accompanying roundels with views of London hospitals include Richard Wilson's *Foundling Hospital* and Gainsborough's *Charterhouse,* a small but important work in the history of English landscape painting.

The rest of the Foundation's collection fills its Picture Gallery and public hallways, interspersed with relics. There are works by Reynolds, Millais and George Lambert, and mementoes of famous supporters of the Foundling Hospital such as Handel.

VALENCE HOUSE MUSEUM

Becontree Avenue, Dagenham RM8 3HT
Telephone: (081) 592 4500

LONDON BOROUGH OF BARKING AND DAGENHAM
Open: By appointment only (not Sun or BHs)
Admission Free: No access for disabled

Underground: Becontree (District Line)
Buses: 62, 287 **7 A5**

The local history museum and gallery is housed in a seventeenth-century timber-framed and plastered manor house, still partly moated. The collection of Fanshawe family portraits is housed here and particularly good among the paintings are: *Anne, Lady Fanshawe* by Gheeraerts, *Sir Richard Fanshawe* by Dobson and *Sir Thomas Fanshawe,* and a double portrait of *Sir Thomas Fanshawe and his Wife, Margaret,* both by Lely. Other artists represented in the collection are Kneller, Wissing, J. M. Wright, Jervas and Hanneman. There are local Barking and Dagenham topographical works as well.

VICTORIA AND ALBERT MUSEUM

South Kensington SW7 2RL
Telephone: (071) 589 6371
Recorded information: (071) 581 4894

Open: Mon-Sat 10-5.50, Sun 2.30-5.50
Closed: CE, CD, BD, NYD, May BH
Access for disabled

Underground: South Kensington
Buses: 14, 30, 45, 49, 74, 264, C1
7 C/D6

The 'V & A' is the world's greatest museum of decorative art, yet contains much of interest to lovers of painting. It is virtually impossible to draw any clear division between fine art and applied or decorative art at the Museum, in spite of the fact that the Museum was originally founded on the cornerstone of such a distinction. Time, gifts, bequests, loans, changes in acquisition policy, have all eroded the clearer purpose of the 1850s (see main text, pp.38–40). So extensive is the collection it rapidly becomes bewildering to the average visitor who has not decided on a particular group of works to see. With this in mind, the following paragraphs indicate areas where visitors can find paintings and works on paper.

The seven Raphael *Cartoons* were designed and largely executed by Raphael for Pope Leo X, as tapestry designs for the Sistine Chapel in Rome. Among the greatest works of art of the Italian High Renaissance, the *Cartoons* date from Raphael's mature years and are his most important project outside Rome. They show scenes from the Acts of the Apostles. Charles I bought them in 1623; they originally hung at Hampton Court, where there are now tapestry copies. Queen Victoria and succeeding British monarchs have lent the *Cartoons* to the Museum.

John Constable's name is closely associated with the V & A, mainly through nineteenth-century bequests by John Sheepshanks, and by Constable's daughter Isabel, of the artist's paintings, oil sketches, drawings and notebooks. These constitute a full survey of his artistic output.

Finished paintings, intended for exhibition, include *Salisbury Cathedral*, *Dedham Mill* and *Hampstead Heath* (shown with the sketch for it). For some people Constable's sketches for paintings are as exciting as the finished work: the V & A has large oil sketches for *The Haywain* (the finished painting is at the National Gallery) and *The Leaping Horse* (Royal Academy), as well as smaller ones for *The Valley Farm* (Tate). Many of the small oils are now well known, although not intended by Constable for public view but as sketches for his own use. There are views of Constable's homes at East Bergholt and Hampstead, studies of clouds and carthorses, Brighton Beach and Salisbury Close. *Dedham Vale* is among the earliest of Constable's paintings here; it is based on Claude's *Hagar and the Angel* at the National Gallery. The vigorous *Flatford Mill from a Lock on the Stour* is one of several sketches of the Stour Valley.

The museum has over 300 works on paper by Constable, including nature studies like *Ash Trees* and preparatory drawings like *Cenotaph to Sir Joshua Reynolds* (for the National Gallery painting) and *Marine Parade and Chain Pier, Brighton* (for the painting at the Tate). A selection is exhibited under subdued lighting next to the Constable oils, in the Henry Cole Wing. Perhaps the most spectacular is Constable's *Stonehenge*, one of the few watercolours the artist exhibited in his lifetime.

Items in the V & A's enormous collection of works on paper may be seen on application in the Print Room, which is a study room rather than a public gallery. The Prints and Drawings Department contains the National Collection of British watercolours, an important collection of British, European and American twentieth-century works, Old Master drawings and a great collection of decorative drawings, which reflect the focus of the museum. A small selection, which changes every six months, is exhibited in the Henry Cole Wing. A few works are displayed alongside contemporary decorative arts in the primary galleries of the museum.

The portrait miniatures for which the Museum is famous are kept for conservation reasons in a darkened room in the Henry Cole Wing. There are English and Continental miniatures, silhouettes, enamels and limnings of the highest quality, from the sixteenth to twentieth centuries. Perhaps the best-known is Holbein's *Anne of Cleves*. The group of miniatures by Nicholas Hilliard includes his *Young Man among Roses*, *Self-Portrait*, portraits of *Elizabeth I* and *Mary, Queen of Scots* and the mysterious *Young Man against Flames*. The versatility of sixteenth-century miniaturists is demonstrated by Rowland Lockey's *Family of Sir Thomas More*, which like Lockey's full-scale version at the National Portrait Gallery is based on a Holbein cartoon. Continental miniatures include François Clouet's *Catherine de Médicis*.

The seventeenth-century miniatures are equally fine. Isaac Oliver's *Richard Sackville, 3rd Earl of Dorset*, is displayed in the primary galleries for 'Britain 1500–1715', but in the Cole Wing are Oliver's '*Frances Howard*' and his delightful portraits of sisters, *A Girl Aged Four* and *A Girl Aged Five*. Miniatures by Samuel Cooper, who was perhaps the greatest English portrait painter of his age on any scale, include *Henrietta, Duchess of Orléans* and *Anthony Ashley Cooper, 2nd Earl of Shaftesbury*. Later miniaturists are also well-represented, with outstanding works by Engleheart (*Unknown Woman, 1804*), Cosway and John Smart (*The Misses Binney*).

The European and British Painting Galleries in the Henry Cole Wing contain nineteenth-century paintings from the Sheepshanks, Ionides and Townshend collections, among others. The first room features British paintings on themes from Shakespeare, Molière and other literary sources, with Victorian history painting and portraits. Chief among the portraits is Frith's *Charles Dickens at the Age of 47*, painted by and for friends of Dickens. It was commissioned by John Forster, who waited in vain for Dickens to shave off his unbecoming moustache and ordered the portrait begun before Dickens could add whiskers. Forster, who gave the V & A his superb collection of Dickens manuscripts, appears himself in *Mr Forster as Kitely*, one of a large group of works by Daniel Maclise which includes *A Scene from Ben Jonson's 'Every Man in his Humour'*. The Shakespearean theme is epitomised by Thomas Stothard's *Shakespeare's Principal Characters*.

From literature and history the visitor passes to rural life and animal painting. *The Old Shepherd's Chief Mourner* is the most famous of the Landseer paintings which cover two walls. There are major paintings by George Morland (*Horses in a Stable*) and John Frederick Herring, Senior (*Seed-time*), but these are overshadowed by the great landscape by James Ward, *Bulls Fighting: St Donat's Castle in the Distance*.

The next theme may be loosely defined as women and children: paintings range from Francis Danby's dark *Disappointed Love* to William Etty nudes, Edmund Thomas Parris beauties and scenes of children studying and playing. More serious social comment is implied in William Powell Frith's sketch for his famous *Derby Day* (Tate). Well-known Victorian paintings of the 1840s include Richard Redgrave's *The Governess* and Thomas Webster's *A Village Choir*.

The tiny sketch by William Mulready of the head of John Sheepshanks is a study for Mulready's *Interior, with a portrait of Mr John Sheepshanks who gave pictures to the Museum*. In the same room are views by David Roberts, such as *The Gate of Cairo called Bâb-el-Metwalli*. There

follows a room of nineteenth-century continental painting from the bequest of the Revd C. H. Townshend, with such rarities in Britain as Swiss art by A. Calâme *(Lake of Lucerne, near Brunnen)*, Barthélemy Menn and F. L. D. Bocion. Here, too, is a powerful work by Francis Danby recently restored, *The Upas or Poison Tree of the Island of Java*.

The bequest of the Ionides Collection included paintings of the Ionides family by G. F. Watts; his portrait of little *Zoë Ionides* has much of the charm of Renoir's portraits of children. Italian paintings include Botticelli's *Smeralda Brandini*, the *Coronation of the Virgin* by Nardo di Cione, a Tintoretto self-portrait and Domenico Tiepolo's sketch for the ceiling decoration, *St Leo in Glory*, of the church of St Leo in Venice. The Botticelli was once owned by Rossetti, whose own *The Day Dream* is accompanied by Burne-Jones's *The Mill*. Among the Dutch paintings are Rembrandt's *Departure of the Shunamite Woman* and small subjects by Jan van Goyen, Adriaen Ostade and Adriaen Brouwer. The French art includes Louis Le Nain's *Landscape with Figures*, Delacroix's sketch for *The Shipwreck of Don Juan* and his *The Good Samaritan*, together with a group of Barbizon paintings. There are Fantin-Latour flower-paintings and the modern-looking *A Flower-Garden* by Henri de Braekeleer. A particular treasure is *The Ballet Scene from Meyerbeer's Opera, 'Roberto il Diavolo'* by Degas. The Turner view of Venice in the next room is in unusually fine condition, thanks to the ingenious airtight frame, designed in the nineteenth century.

The V & A also owns the glass paintings for Gainsborough's 'Exhibition Box', and the *Panorama of Rome* by L. Carracciolo, which in the past has been displayed with other panoramas.

A few of the museum's paintings are incorporated in decorative arts displays throughout the building. The 'Spain 1450–1550' room features a huge fifteenth-century retable attributed to the Valencian painter Marzal de Sas: *Scenes from the Life of St George*. Nearby is Rodrigo de Osona the Younger's *Adoration of the Magi*, and part of a German altarpiece of *c.*1400, *The Apocalypse*, in the style of Meister Bertram of Hanover.

The Italian Renaissance Galleries concentrate on the museum's magnificent collection of Italian sculpture, with masterpieces by Donatello, the Della Robbia family and Bernini. As well as a few small panel paintings, including *St Jerome* and *St Catherine* from an altarpiece by Carlo Crivelli's brother Vittorio, there are Italian frescoes such as *The Nativity*, by

Raphael's teacher Perugino, in the Raphael Cartoon Court.

The primary galleries, 'Europe 1600–1800', contain Boucher's *Madame de Pompadour*, Charles Le Brun's *Descent from the Cross* and Lancret's *The Swing*. 'Europe and America 1800–1890' Galleries house an unusual single-species study by Fantin-Latour of *Nasturtiums*. The 1890s posters include famous designs: Alphonse Mucha's *Job* and *Lorenzaccio*, Toulouse-Lautrec's *Eldorado: Aristide Bruant* and Steinlen's *La Rue*.

The British decorative arts galleries contain a few British paintings, some of them well-known; Arthur Devis's *The Duet*, Batoni's *Edward Howard and his Dog*, Lawrence's *Caroline of Brunswick* and Raeburn portraits of Mr and Mrs Hobson of Markfield are of particular interest. Also important are Francis Hayman's *Milkmaids' Garland* and his other decorative painting for Vauxhall Gardens.

Some beautiful examples of Indian painting are currently in the small 'India 1550–1850' gallery. More extensive exhibition of the V & A's fine and decorative art from the Indian sub-continent – the greatest collection outside the region – is planned.

The sculpture collections of the Victoria and Albert Museum are beyond the scope of this book, but should not be missed by visitors; the museum is rich in sculpture from many countries and all periods. The Cast Court, housing plaster casts of famous sculptures including part of Trajan's Column, is a rare survival of a kind of museum display once common in Europe.

The scope of the Victoria and Albert Museum's decorative arts collections is unmatched and the National Art Library here is the largest of its kind in the world.

See entry in main text, pages 38–44.

WALLACE COLLECTION
Hertford House, Manchester Square W1M 6BN
Telephone: (071) 935 0687

The 4th Marquess of Hertford's collection, which forms the core of the Wallace Collection in Manchester Square, is the greatest personal collection open to the

public in Britain. It is particularly strong in eighteenth-century French paintings and bronzes, displayed with superb French furniture, porcelain and other decorative arts. The strongest impact of all is made by the large room on the first floor, where Lord Hertford's catholic taste in English, Dutch, Flemish, Spanish and Italian masterpieces has created one of the finest displays of art in the world.

Frans Hals's *Laughing Cavalier*, Rembrandt's *Titus* portrait, Rubens's *Rainbow Landscape*, Velázquez's *Lady with a Fan*, Titian's *Perseus and Andromeda*, Poussin's *Dance to the Music of Time*, several Murillos, including the *Adoration of the Shepherds*, and Van Dyck's *Le Roy* portraits share the room with Sassoferrato's *Mystic Marriage of St Catherine* and with exquisite works by Philippe de Champaigne, including the *Annunciation*. Outstanding among famous British portraits are Reynolds's *Nelly O'Brien*, and three paintings of the actress *'Perdita' Robinson*, by Romney, Gainsborough and Reynolds. Among several portraits done by Lawrence of his greatest patron, the *George IV* here was Lawrence's favourite, and singular for its relaxed and intimate interpretation. There are also top-quality works by Salvator Rosa, Hobbema and Van de Velde. Above these are magnificent still lifes and animal subjects by Weenix, de Heem, Snyders and Hondecoeter.

In French art, François Boucher is more richly represented at the Wallace than elsewhere in Britain: a group of his large works includes the *Rising* and *Setting of the Sun*, the *Rape of Europa* and *Infant Bacchus Entrusted to the Nymphs of Nysa*. A single room contains Fragonard's *The Swing* and *Gardens of the Villa d'Este*, Watteau's *Music Party* and his *Halt During a Chase*, alongside fine examples of Lancret and Pater. There are Greuzes, including *Innocence*, superb animal paintings by Desportes and Oudry and portraits by Nattier and Mme Vigée-Lebrun. Lord Hertford had a favourite contemporary artist, Decamps, whose works are part of an unusual collection of nineteenth-century French Salon painting: Delaroche, Vernet, Meissonnier and Ary Scheffer (*Francesca da Rimini*). Delacroix's *Execution of Marino Faliero* is complemented by a superb collection of paintings by Richard Parkes Bonington.

The Dutch and Flemish art is outstanding. Rubens sketches include designs for the unfinished *Henri IV* cycle and for a *Constantine* tapestry. There are good examples of Gonzales Coques's work. Downstairs are the Jordaens–Snyders *Riches of Autumn* and paintings by Frans and Pieter Pourbus. Highlights of the

Dutch rooms include De Hoogh's *Boy Bringing Pomegranates*, E. Boursse's *Woman Cooking* and Jan Steen's *Harpsichord Lesson* and *Christening*. Nicolaes Maes, Willem Drost, Ferdinand Bol and Govaert Flinck are well represented, as are the 'fine painters' Dou, Metsu, Ter Borch and Netscher. There is a small Paulus Potter, and excellent Dutch landscape paintings by the Ruisdaels, Hobbema, van der Heyden, and the 'Italianates': Jan Both, the Berchems, Pynacker and Cuyp (*Avenue at Meerdervoort*).

Italian paintings range from Foppa's fifteenth-century fresco *Young Cicero Reading* to Venetian views by Guardi and Canaletto. Downstairs are more English portraits, including Reynolds's *Miss Bowles* and *Mrs Richard Hoare and Son* and Lawrence's *Countess of Blessington*. There are English and Continental miniatures (among them, Lucas Horenbout's *Hans Holbein* and over thirty examples by J. B. Isabey), sixteenth-century Italian and French bronzes, ivories and woodcarvings, maiolica, medallions, wax portraits, enamels and all manner of *objets d'art*. The arms and armour are outstanding. The Sèvres is spectacular. The furniture, which adds much to the luxurious atmosphere of the galleries, includes Riesener pieces made for Marie-Antoinette.

THE WELLINGTON MUSEUM
Apsley House, 149 Piccadilly W1V 9FA
Telephone: (071) 499 5676

VICTORIA AND ALBERT MUSEUM
Open: Tues-Sun 11-5
Closed: Mon, Fri, CE, CD, BD, NYD, GF, May Day BH.
Access for disabled

Underground: Hyde Park Corner
Buses: 2, 2B, 9, 9A, 14, 16, 16A, 19, 22, 25, 26, 30, 36, 36A, 36B, 38, 52, 73, 74, 137, 500, 506 **30 C5**

The collection of fine and decorative art formed by the 1st Duke of Wellington at Apsley House is second only to the Wallace Collection for size and magnificence among surviving personal collections in London. It includes paintings, sculpture and furniture, memorabilia, military orders and superb porcelain and presentation silver.

Canova's huge marble nude of Napoleon occupies the stairwell; disliked by Napoleon, it was presented to Wellington by the Prince Regent. The Piccadilly Drawing Room holds fine Dutch and Flemish paintings, among them De Hoogh's *Musical Party*, Jan Steen's *Physi-*

cian's Visit, Teniers's unusual industrial *Lime Kiln* and works by Maes, Adriaen Brouwer, Netscher and Van Poelenbergh. The Duke commissioned David Wilkie's *Chelsea Pensioners Reading the Waterloo Dispatches* to commemorate his finest hour. John Burnet's pendant of *Greenwich Pensioners* hangs nearby.

The Portico Room, with copies commissioned by Wellington of Raphaels in the Spanish Royal Collection, Landseer's *Illicit Still*, French Napoleonic portraits and a posthumous portrait of the assassinated *Spencer Perceval* by Joseph, leads to the Waterloo Gallery. This great room is crowded with paintings, although far fewer than originally hung here. A copy of Van Dyck's equestrian *Charles I* (Buckingham Palace) dominates, but original masterpieces abound: Velázquez's *Water-Seller of Seville*, his *Young Men Eating at a Table*, Jan Steen's *Dissolute Household*, *Egg Dance* and *Wedding Party*, Rubens's *Ana Dorotea*, Correggio's *Agony in the Garden* (Wellington's favourite), Goya's *Wellington*, Coello's *St Catherine*, Sassoferrato's *Holy Family*, Murillo's *Unknown Man* and Ribera's *Santiago* vie for attention. Many of these paintings were looted from the Spanish Royal Collection by Joseph Bonaparte, who abandoned them to Wellington at the Battle of Vitoria. Ferdinand VII of Spain subsequently presented them to the Duke.

The Yellow Drawing Room, with Swebach's *Passage of the Danube by Napoleon*, a pair of Luca Giordanos from the Buen Retiro Palace in Madrid and Peyron's neo-classical *Athenian Girls Drawing Lots* (to be sacrificed to the Minotaur), contains Wilkie's *William IV*, a contrast to the elegant Lawrences in the Striped Drawing Room. There Lawrence's full-lengths, including *Viscount Beresford*, *Lord Lynedoch* and the *Marquess of Anglesey*, accompany the dashing *Duke of Wellington*.

In the Dining Room, Navez's *William I, King of Holland* and his fellow monarchs, including a replica of Wilkie's *George IV* (Holyrood), look down on the silver Portuguese Service.

THE WILLIAM MORRIS GALLERY
The Water House, Lloyd Park, Forest Road E17 4PP
Telephone: (081) 527 5544

LONDON BOROUGH OF WALTHAM FOREST
Open: Tues-Sat 10-1, 2-5; First Sun in Month 10-12, 2-5
Closed: Mon and all BHs

Admission Free: Limited access for disabled and by prior arrangement

Underground and train: Walthamstow Central then Buses W21, 69, 269
Buses: 34, 55, 123, 275, 276, 278 **7 A5**

The gallery was one of the earliest public institutions to commemorate the life and work of a single artist. The house had been William Morris's home from 1848-1856, and was given to Walthamstow in 1898.

Plans for showing the house dated from 1908, only twelve years after Morris's death, and when his fame and influence were still considerable. Yet it took until 1950 to open to the public, the ceremony being performed by Clement Attlee.

The house contains designs and work by Morris, Burne-Jones, Rossetti and other members of the firm of Morris and Company. Sir Frank Brangwyn, who worked under Morris at one time, donated many paintings. As well as paintings and drawings by Brangwyn, there are Pre-Raphaelite paintings, and works by various twentieth-century artists. Sculpture includes examples by Rodin, Dalou, Legros and others.

——— GREATER ——— MANCHESTER

ASTLEY CHEETHAM HALL ART GALLERY
Trinity Street, Stalybridge
Telephone: (061 338) 2708

TAMESIDE METROPOLITAN BOROUGH
Open: Mon, Tues, Wed, Fri 1-7.30, Sat 9-4
Closed: Sun and Thurs
Admission Free: No access for disabled

Stalybridge is east of Manchester via the A635 and A6018. **11 C2**

John Frederick Cheetham (1836-1916), a local mill owner and MP, built the library and art gallery. His collection ranges from the fourteenth to the nineteenth century and includes *Portrait of a Gentleman* by Alessandro Allori, *Madonna and Child with Saints* by the Master of the Straus Madonna and several other fifteenth-century Madonna and Child paintings of the Italian School. G. F. Watts is represented by *Sir Perceval*.

BOLTON MUSEUM AND ART GALLERY

Le Mans Crescent, Bolton, BL1 1SE
Telephone: (0204) 22311

BOLTON METROPOLITAN BOROUGH COUNCIL
Open: Mon-Fri 9.30-5.30, Sat 10-5
Closed: Wed, Sun and BHs
Admission Free: Access for disabled

Bolton is north-west of Manchester and can be reached via the M61 or A666.
11 B2

The present museum and art gallery opened in 1939, though there had been an art gallery at Mere Hall since 1890, with a collection, both presented by J. P. Thomasson. The present building, with classical portico and Ionic columns, was designed by the Bolton firm of Bradshaw, Gass and Hope.

The collection contains good watercolours, a number of modern oils and works of sculpture by twentieth-century British artists, and some seventeenth-century works, including *The Adoration of the Shepherds,* an early work by Romanelli, and Giordano's *Death of Seneca.*

The watercolour collection is particularly fine, and includes examples by Gainsborough, Paul Sandby, Francis Towne, David Cox, Peter de Wint, Ruskin and Turner.

The modern British collection derives, in part, from the bequest of Frank Hindley Smith, a mill-owner, who was associated with members of the Bloomsbury Group. He gave works by Roger Fry, Vanessa Bell and Duncan Grant. A fine example of William Roberts's work is *The Wash.* Much of the gallery's recent purchasing policy has concentrated on twentieth-century British art, and the category includes sculpture by Epstein, Moore, Hepworth and Paolozzi. Recent additions include paintings by Henry Lamb, Edward Burra and Graham Sutherland.

FLETCHER MOSS MUSEUM

Old Parsonage, Wilmslow Road,
Didsbury M20 8AU
Telephone: (061 445) 1109

MANCHESTER CITY COUNCIL
Open: Mon-Sat 10-6
Closed: Oct-Mar
Limited access for disabled

Didsbury is five miles south of the city centre. **11 B2**

Besides the collection of local history, furniture and pottery, pictures include

Oxford Road by Adolphe Valette, *An Island* by Lowry and *A Young Gentleman at a Drawing Table* by Devis.

HEATON HALL

Heaton Park, Prestwich, M25 5SW
Telephone: (061 773) 1231

MANCHESTER CITY ART GALLERIES
Open: 1st Apr-last Sun in Sept Mon-Sat 10-1, 2-5.45, Sun 2-5.45
Closed: all day Tues
Admission Free: Limited access for disabled

Six miles north of city centre in Heaton Park. Access from M62 Exit 18, then M66, A576, Middleton Road entrance.
11 B2

This house was the former seat of the Earls of Wilton but is now owned by Manchester City Art Galleries. It has a number of English paintings by Lely, Reynolds and Romney and a display of drawings for the decorative arts by James Wyatt.

MANCHESTER CITY ART GALLERY

Mosley Street M2 3JL
Telephone: (061 236) 9422

MANCHESTER CITY ART GALLERIES
Open: Mon-Sat 10-6
Admission Free: Limited access for disabled

Mosley Street is close to the Town Hall in the City centre. **11 C2**

The Manchester City Art Gallery is strongest in British painting, but also has some interesting foreign works. The Gallery recently acquired an important *Crucifixion* by Duccio or his school. Seventeenth-century Italian paintings include Reni's *St Catherine,* Guerrieri's *Lot and his Daughters* and G. B. Gaulli's *St John the Baptist.* Other Italian artists represented in the collection include Batoni and Bellotto, the former by a Grand Tour portrait of *Sir Gregory Page-Turner,* the latter by two magnificent views of the *Courtyard of the Castle of Königstein.* Bellotto's uncle Canaletto was responsible for the views of Venetian churches, *S. Giorgio Maggiore* and *The Church of the Redentore.*

There are several fine Dutch and Flemish works, among them a beautiful *Holy Family* from the studio of Van Dyck and the tranquil *Men of War at Anchor in a Calm* by Willem van de Velde. Jan van

Goyen's *Winter Scene* of 1653 hangs with small landscapes and maritime views by Salomon van Ruysdael, his nephew Jacob van Ruisdael, Aelbert Cuyp, Simon de Vlieger and Jan van der Heyden. The Gallery has benefited from local donations like the Assheton-Bennett bequest of seventeenth-century Dutch seascapes, genre interiors and portraits by Ochtervelt, Ter Borch and van Mieris, Jan Steen, Teniers and Paulus Potter. The exquisite *Flowers and Fruit* by Jan van Huysum should not be missed.

The German baroque artist Januarius Zick, whose work is rare in Britain, painted *Christ Healing the Sick.* Another German artist was Conrad Kiesel, born in 1846, whose *Marguerites* looks at home among the Victorian paintings in the collection.

French paintings include Claude's *Adoration of the Golden Calf,* Boucher's *Le Pecheur* and a ceiling design for a London house by Charles de la Fosse, painter to Louis XIV. The Gallery owns a Fantin-Latour self-portrait and a few Impressionist works, including Pissarro's *A Village Street, Louveciennes.* Later paintings are *La Ville Petrifiée* by Max Ernst and *Painting 1926* by Léger.

British painting, especially nineteenth-century work, is well represented in galleries which have been richly decorated to suit them. Earlier paintings begin with portraits of exceptional quality from the sixteenth and seventeenth centuries: from George Gower's *Mary Cornwallis,* John Michael Wright's *Murrough O'Brien, First Earl of Inchiquin* to John Souch's *Sir Thomas Aston at the Deathbed of his Wife,* which commemorates Sir Thomas's 'immeasurable' grief in striking fashion. The eighteenth-century British collection is dominated by Stubbs's *Cheetah and Stag with Two Indians,* and Gainsborough's *Peasant Girl gathering Faggots in a Wood.* The ambitious *Birth of Pandora* by James Barry has been in Manchester collections since 1856.

There are eighteen idealized portraits of historical figures such as Homer and Voltaire by William Blake, from about 1800. Other nineteenth-century paintings include Thomson's *Aeolian Harp,* a huge view of the Thames at Richmond by Turner, and his virtuoso seapiece, the *Pas de Calais.* Etty is represented by vigorous figure-painting in *The Destroying Angel and Demons of Evil Interrupting the Orgies of the Vicious and Intemperate,* which fulfils all the promise of its title. In contrast to the Romanticism of the figurative paintings, the landscapes include Bonington's subtly coloured *Pays de Caux: Twilight* and a sunny, impressionistic sketch by

Cox, *Rhyl Sands*. There are further good landscapes from John Crome, John Linnell and Samuel Palmer *(The Bright Cloud)*, as well as paintings by de Wint and John Frederick Lewis. The portraits include a Lawrence and Northcote's painting of the black actor *Ira Aldridge as Othello*.

The Pre-Raphaelite school is strong, with large groups of Ford Madox Brown and Holman Hunt paintings. One of the most famous is Brown's complicated allegory, *Work*. Holman Hunt's *The Hireling Shepherd* is in the collection, with his *The Shadow of Death* and versions of *The Scapegoat*, *The Lady of Shalott* and *The Light of the World*. Among paintings by Millais is his celebrated *Autumn Leaves*. Visitors may find intriguing the attitudes to women shown in *Hylas and the Nymphs* by J. W. Waterhouse, *The Bower Meadow* and *Astarte Syriaca* by Rossetti and *Vivien* by Frederick Sandys. Arthur Hughes's *Ophelia* is roughly contemporary with Millais's very different painting of the same subject in the Tate. There are excellent coastal views by John Brett and Henry Moore, and a cottage interior by the minor Pre-Raphaelite James Collinson, *Answering the Emigrant's Letter*.

The Pre-Raphaelite treasures represent only a part of the Gallery's wealth of Victorian painting, as is apparent on entering the room dominated by Lord Leighton's *Captive Andromache*. Nearby hang *The Last Watch of Hero* by Leighton, *Sibylla Delphica* by Edward Burne-Jones, and works by the artists they influenced. *The Good Samaritan* by Watts was presented in honour of a Manchester prison philanthropist; very different is the 'Social Realism' of Herkomer's *Hard Times*. *The Dinner Hour, Wigan* by Eyre Crowe is unusual in its straightforward approach to working-class life. Daniel Maclise's *A Winter Night's Tale*, Frith's *Claude Duval* or Dicksee's *Funeral of a Viking* may be more to modern tastes than Maclise's *Origin of the Harp*, but they share a highly romantic approach to history and literature. All have a strong emotional impact, the strongest of all being arguably made by the thrilling panorama by A. von Wagner, *The Chariot Race*.

The sheer variety of subjects here is fascinating: chivalric fantasy in Briton Riviere's *'In Manus Tuas, Domine'*, grim reportage in Lady Butler's *Balaclava* or sentimentality in Orchardson's *Her Idol*. *A Spate in the Highlands* by Peter Graham is Victorian landscape painting at its most heroic, and convincingly three-dimensional.

Smaller paintings by these artists and their contemporaries hang in the Entrance Hall, a Greek Revival interior by Sir Charles Barry. Among the best are Alma-Tadema's *Silver Favourites*, Tissot's *The Concert*, Poynter's *Ides of March* and Faed's *Evangeline*. The landscapes here, though few, are worth examining: Leighton's sketches of the *Isle of Chios*, Landseer's *Bolton Abbey* and a version of Farquharson's *The Sun had Closed the Winter's Day*.

Works by the local artist Lowry include *An Accident*, *St Augustine's Church* and *Waiting for the Shop to Open*; these are complemented by an exhibition reconstructing his studio. Other twentieth-century paintings of note include such modern British masterpieces as Wyndham Lewis's *Portrait of the Artist as the Painter Raphael* and Orpen's *Homage to Manet*.

See entry in main text, pages 104-7.

OLDHAM ART GALLERY

Union Street, Oldham OL1 1DN
Telephone: (061 678) 4651/4653

OLDHAM METROPOLITAN BOROUGH
Open: Mon, Wed, Thurs, Fri 10-5; Tues 10-1; Sat 10-4
Admission Free: Access for disabled

Oldham Art Gallery houses a collection of late nineteenth- and twentieth-century paintings and drawings; a small decorative arts collection; a contemporary print collection and an expanding contemporary photography collection; and notable works by Rossetti, Holman Hunt, Millais, Val Prinsep and Lowry. Of particular interest is the Charles E. Lees Bequest of Watercolours, which includes works by Turner, Constable, Girtin, Bonington, Cox, Cozens, Sandby, Prout and Samuel Palmer.

The modern collection contains works by Paul Nash, Patrick Heron, Frank Auerbach, Graham Sutherland, Carel Weight, David Hockney (etchings) and Howard Hodgkin.

The Gallery also owns many works of local or regional importance, including paintings by William Stott of Oldham, F. W. Jackson (Rochdale) and Helen Bradley.

During the year the Gallery exhibits work from the permanent collections: historical, thematic, group and one-man temporary exhibitions. It also organises educational events and provides an information service.

ROCHDALE ART GALLERY

The Esplanade
Telephone: (0706) 342154

ROCHDALE METROPOLITAN BOROUGH
Open: Mon-Fri 10-5, Wed 10-1, Sat 10-4
Admission Free: Access for disabled by arrangement on arrival

Rochdale is north of Oldham, off the M62 at Junctions 20 and 21. **11 C1**

Rochdale Art Gallery's current policy – predominantly one of temporary exhibitions displaying contemporary British art – has established it as one of the best galleries in the Manchester area (and at times highly controversial) for the exposure of current trends in art. It does not have the funds to follow this up with purchases, but it does place the main emphasis of the gallery's activities on shows from outside. The exhibitors themselves vary, from relatively local artists to those of national stature, as well as researched historic exhibitions which take a radical look at art history. Overall, the quality of the shows both in terms of content and display methods is of a high standard.

The gallery's own collection, though not often on permanent display, contains an interesting mixture of works. On the one hand they reflect the more conservative tastes of provincial entrepreneurs in the early twentieth century, in the form of the Handley and Ogden bequests to the gallery at its inception in 1903; and the Thomas Kay bequest that went to Rochdale in 1974 though it had been put together many years previously. In contrast, recent purchases reflect the gallery's current policy and its stress on contemporary British art.

There is Giovanni di Paolo's altarpiece (in 1987 undergoing restoration work). It is an exceptional and rare item among north-west museums and galleries. However, the collection is made up largely of early seventeenth- and eighteenth-century European works along with a selection of Victorian landscape and narrative paintings. In this last category is Charles Burton Barber's *A Special Pleader*. Lancelot Glasson's *The Young Rower*, a fine study of youth and vigour and Royal Academy 'Picture of the Year' in 1932, represents the academic taste of the 1930s.

Recent acquisitions include Anthony Green's *Our Tent, the Fourteenth Wedding Anniversary*, *Mons Graupius* by Gillian Ayres, Frank Auerbach's *St Pancras Steps* and Steve Willat's *Means of Escape*.

SALFORD MUSEUM AND ART GALLERY

The Crescent, Peel Park, Salford
Telephone: (061 736) 2649

CITY OF SALFORD

Open: Mon–Fri 10–5, Sun 2–5
Admission Free: Limited access for disabled

Salford is on the western side of Manchester. **11 B2**

The art collection is made up of sculpture, paintings, drawings and watercolours dating from the fourteenth century to the present day. The major areas of the collection are Victorian oils and twentieth-century works which cover all the aspects listed above. There is a large permanent display from the works of L. S. Lowry, as well as a gallery devoted to Victorian paintings and decorative arts. Other sections of the collection go on temporary display during the year.

One of the most important works in the collection is a mid-fourteenth-century triptych, *Madonna Enthroned*. Major paintings by L. S. Lowry include *Coming from the Mill*, *Market Scene Northern Town*, *Head of a Man with Red Eyes*, *The Cripples*, *The Funeral Party*, and *The Lake, 1937*. Also from the twentieth century are two major paintings by William Roberts, *The Control Room* and *The Munitions Factory*, as well as works by Walter Sickert, Vanessa Bell, Matthew Smith and Duncan Grant. Although there is a fairly large collection of Victorian paintings few are of major importance.

See entry in main text, pages 110–11.

WAR MEMORIAL MUSEUM STOCKPORT

Wellington Road South, Stockport
Telephone: (061) 474 4453

STOCKPORT COUNCIL
Open: Mon, Tues, Thurs, Fri 11–5, Wed 11–7, Sat 10–5
Closed: Sun
Admission Free: Access for disabled to lower galleries

Stockport is south of Manchester reached via the A6 or A560. **11 C2**

The gallery was built in 1920 primarily as a war memorial. Funds were subscribed to build the Art Gallery section. The majority of the small collection was given to the corporation by many different people. The result is a mixture of late Victorian oils and watercolours and is exhibited in parts throughout the year. Works range from *Crowther Street* by Lowry, and *Thames Evening* attributed to Whistler, to *A Head of Yehudi Menuhin* by Epstein.

Exhibitions change on a monthly basis.

THE WHITWORTH ART GALLLERY

Oxford Road, Manchester M15 6ER
Telephone: (061 273) 4865

UNIVERSITY OF MANCHESTER
Open: Mon–Sat 10–5, Thurs 10–9
Closed: Sun, GF
Admission Free: Access for disabled

South of the City Centre, on Oxford Road, beyond the main university buildings. **11 C2**

The Whitworth Art Gallery was created from funds put at the disposal of the Legatees of Sir Joseph Whitworth, a leading inventor and industrial engineer of the Victorian era. The Gallery was chartered in 1889 and became part of the University of Manchester in 1959.

From the beginning, when G. F. Watts donated a version of his *Love and Death*, the Gallery has collected contemporary British art. It also has a major collection of watercolours, which for conservation reasons are exhibited for limited periods, often in combination with oil paintings. The Gallery's extensive print collection – over 11,000 items – features much British work, but also sixteenth- and seventeenth-century Italian prints and Japanese prints. The Gallery tries to make any material not on view available with the minimum of notice.

The Whitworth's mezzanine floor is used for temporary exhibitions from the collection, the galleries on the ground floor for more permanent displays. Victorian art is often displayed in the North Gallery. Pre-Raphaelite artists include Rossetti (*La Donna della Finestra*), Ford Madox Brown (*Romeo and Juliet*) and Burne-Jones. The Gallery owns fine drawings and watercolours by Ruskin and artists he favoured, among them William Henry Hunt (*Bird's Nest and Hawthorn*), John Brett (*River Scene near Goring-on-Thames*) and Myles Birket Foster (*The Old Mill*).

The Pilkington Room exhibits a selection of the Whitworth's eighteenth- and nineteenth-century landscapes, many referring to the Grand Tour, notably the seven Grand Tour sketchbooks of J. R. Cozens. There is a large group of Turner watercolours, from early architectural studies like *The Chapter House, Salisbury* to later light-filled views such as *The Lake of Lucerne, Moonlight*, *The Rigi in the Distance*. These are balanced by art from Turner's predecessors and contemporaries: Girtin's *Durham Cathedral and Bridge from the River Wear*, Cox's *Bolton Abbey* and Samuel Palmer's *The Sailor's Return*. One

of the most famous is *The Ancient of Days* by William Blake, and one of the most extraordinary *Manfred and the Witch of the Alps* by John Martin, who never saw the Alps but evokes them in Byronic splendour. The few oil paintings in the historic collection include landscapes by Dughet, Wootton and Joos de Momper, and Lawrence's portrait of *Richard Payne Knight*.

In the Gulbenkian Room a choice of oils and works on paper from the Whitworth's Impressionist and Post-Impressionist collection is often shown; this may include Van Gogh's *Fortifications of Paris* and Picasso's Blue Period drawing, *Poverty*.

The twentieth-century British collection is a comprehensive one, with major works by most of the leading artists. There are fine drawings by Augustus and Gwen John, and by Wyndham Lewis. Oils include Sickert's *Horses of St Mark's* and Camden Town paintings, notably Spencer Gore's *Spring in North London, 2, Houghton Place*. *The Whiteleaf Cross* is one of Paul Nash's most attractive landscapes, and there are works by Christopher Wood, Lucien Pissarro and Ben Nicholson (*A Window in Cornwall*). On view from time to time are Edward Burra's disturbing *John Deth (Hommage à Conrad Aiken)*, Stanley Spencer's *Soldiers Washing* and war-time work by Henry Moore, John Piper, Edward Ardizzonne, Edward Bawden and Eric Ravilious (the amusing *Corporal Stediford's Mobile Pigeon Loft*).

The post-war collection overflows from the Gulbenkian Room into the South Gallery. Francis Bacon's full-length *Portrait of Lucian Freud*, the first of a series, is accompanied by the powerful self-portrait of 1963 by Freud: *Man's Head, Portrait I*. There are striking paintings from the 1960s – Peter Blake's *Got a Girl*, with its collage of pop-star photographs and pop records, *Trout for Factitious Bait* by R. B. Kitaj, and works by Richard Hamilton and Patrick Caulfield. Among modern drawings are David Hockney's *Peter Schlesinger* and Anna-Maria Pacheco's bold *The Endeavours of a Certain Poet*. The Whitworth has recently acquired Howard Hodgkin's *Interior at Oakwood Court* and Christopher LeBrun's *Portrait of L as a Young Man*.

See entry in main text, pages 108–9.

——— HAMPSHIRE ———

AVINGTON PARK
Winchester
Telephone: (096 278) 202

MR J. B. HICKSON

Open: May-Sept Sat, Sun, BHs 2.30-5.30;
Special openings for coaches by appoint-
ment any day
Limited access for disabled

In Itchen Abbas, south of the B3047,
which joins the A33 and A31 north-east
of Winchester. **5 B3**

Interesting wall and ceiling paintings,
principally in the main hall, decorated in
the late eighteenth and early nineteenth
century, and in the Ballroom. This, the
finest room in the house, includes work
by Valdre and possibly Verrio. A small
collection of paintings includes works by
Matisse and Turner.

BEAULIEU PALACE HOUSE
Beaulieu
Telephone: (0590) 612345

LORD MONTAGU OF BEAULIEU
Open: Easter-Sept daily 10-6; Oct-Easter
10-5; last admission 40 minutes before
closing
Access for disabled

The house is on the B3056, seven miles
from Lyndhurst. It is 13 miles south of
Southampton. **5 C3**

Though principally famous for its motor
museum, the Palace House, which has
been the family home since 1538, does
contain an extensive collection of family
portraits, beginning with the Earls of
Southampton. There are portraits by
Hudson, Jervas and Wissing; and there
are two sets of views of Naples by Joli, a
follower of Canaletto, and of southern
European ports.

BREAMORE HOUSE
Breamore, Near Fordingbridge
Telephone: (0725) 22468

SIR WESTROW HULSE
Open: Apr Tues, Wed, Sun; May, June,
Sept Tues, Wed, Thurs, Sat, Sun; July,
Aug every day; and all Holidays 2-5.30
Limited access for disabled

Eight miles south of Salisbury and three
miles north of Fordingbridge off the
A338. **5 C4**

Dutch family connections are probably
responsible for the strong representation
of works by David Teniers the younger,
among them *The Coming of the Storm*
together with other seventeenth-century
works by Dutch artists. A group of these
hanging in the dining room are by Peter

Andreas Rysbrack and Jan Fyt. They
show dead game and other hunting
subjects. Other Dutch or Flemish artists
include Van Dyck, Johnson, Mytens and
Jan Miel.
 There is an unusual group of works
painted in Mexico by the illegitimate son
of Murillo.
 See entry in main text, page 216.

BROADLANDS
Romsey SO51 9ZD
Telephone: (0794) 516878

LORD ROMSEY
Open: 23 Mar-1 Oct 10-4
Closed: Mon, except for Aug, Sept and
BHs
Access for disabled

Immediately south of Romsey off the
A31, seven miles north-west of
Southampton. **5 C3**

Broadlands is associated with the families
of two prime ministers, Lord Melbourne
and Lord Palmerston, as well as with a
later politician of stature, Lord Louis
Mountbatten.
 Portraits include seventeenth-century
works by Van Dyck and Lely.
 Works by Sir Thomas Lawrence include
portraits of the 3rd Viscount Palmerston
and Emily Lamb, aged 16, later Palmer-
ston's wife. Works by John Hoppner
include *William Lamb, Second Viscount
Melbourne*, Emily Lamb's brother, and
those by George Romney include *Lady
Hamilton*. Among some fine portraits of
the Palmerston family are *The First
Viscount and his wife Anne Houblon*, by
Michael Dahl.
 The 2nd Viscount's portrait is by
Angelica Kauffmann, who also painted
the ceiling panels in the Drawing Room.
Emily Lamb was painted by John Lucas
in 1840, and the 3rd Viscount, Henry
John Temple by H. Barraud in 1865.
There is a portrait by Sir Edwin Landseer
of *William, Second Viscount Melbourne*,
brother of Emily Lamb. This was painted
at Woburn Abbey in 1836 and given to
her as a present. Two other portraits of
Sir William Temple and his wife Mary
Hammond, ancestors of the Palmerstons,
are by Marcus Gheeraerts.
 Modern portraits include works by
Philip de Laszlo. There is an interesting
collection on the North Staircase. Lord
Mountbatten put together portraits, gen-
eration by generation, of his ancestors in
the Hesse family, going back to Prince
Philip I, *c.*1550. Here the artists include
Glaeser, Fiedler, Strecker and Tischbein.

The Iron Forge is an outstanding example
of the work of Joseph Wright of Derby.
It was bought by the 2nd Viscount
Palmerston from the artist in 1772.
 See entry in main text, page 214.

GOSPORT MUSEUM AND ART GALLLERY
Walpole Road, Gosport
Telephone: (0705) 588035

GOSPORT BOROUGH COUNCIL
Open: Tues-Sat 9.30-5.30; May-Sept 1-5
Admission Free: Access for disabled

Gosport is west of Portsmouth. From the
M27 take the A32 south at Junction 10.
5 C2

The fine art collection at Gosport's local
history museum is comprised mostly of
local topographical paintings and drawings
together with some etchings and engrav-
ings. The majority of paintings are by
members of the Snape family, especially
Martin Snape (1852-1930), who worked
extensively around Portsmouth Harbour
and the Solent.

HINTON AMPNER 🌿
Bramdean, near Alresford
Telephone: (096279) 361

NATIONAL TRUST
Open: 1 Apr-end Sept Tue, Wed 1.30-
5.30, Aug Tues, Wed, Sat, Sun; last
admission 5
No access for disabled

On A272, one mile east of Bramdean
village, eight miles east of Winchester.

After Hinton Ampner was gutted by fire
in 1960, Ralph Dutton bravely set about
recreating his fine collection of pictures,
porcelain and Regency furniture. Among
the paintings that demonstrate his con-
noisseur's taste is Giuseppe Marchesi's
Achilles Takes Leave of the Centaur Chiron.

MOTTISFONT ABBEY 🌿
Romsey SO51 0LP
Telephone: Romsey (0794) 40210

NATIONAL TRUST
Open: 1 Apr-end Sept Wed 2-5; timed
tickets, check with property beforehand
No access for disabled

Half a mile west of the A3057 between
Stockbridge and Romsey, four miles
north-west of Romsey. **5 B4**

The saloon of Mottisfont Abbey contains Rex Whistler's last major decorative work, a *trompe l'œil* Gothick fantasy, with trophies on martial and musical themes, and delicate stuccowork all simulated in paint.

See entry in main text, page 217.

PORTSMOUTH CITY MUSEUM ART GALLERY

Museum Road, Old Portsmouth PO1 2LJ
Telephone: (0705) 827261

PORTSMOUTH CITY COUNCIL
Open: Daily 10.30-5.30
Limited access for disabled

From the M275 to the city centre follow signs for Southsea. **5 C2**

The museum's main emphasis is on decorative arts representing the history of British taste since the seventeenth century. Fine art, especially of the twentieth century, constitutes a part of the collection. Specialist areas include works from the Omega Workshops, the Vorticist period, the Camden Town group and 1930s surrealism. Among the more contemporary artists represented in the collection are David Hockney, Richard Hamilton, Patrick Caulfield, Boshier, Norman Ackroyd, Norman Stevens and Terry Wilson. There are over 300 works by Benjamin Haughton, a collection presented by his widow.

Sculpture includes work by Hepworth *Figure in a Landscape,* Leighton *Athlete and Python* and Boshier *Light Box.*

The museum also houses the Portsmouth Gallery, whose local history department owns a number of marine paintings by, among others, E. W. Cooke, J. Callow, G. Chambers and C. Stanfield.

SOUTHAMPTON CITY ART GALLLERY

Civic Centre, Southampton
Telephone: (0703) 832277

CITY OF SOUTHAMPTON
Open: Tues-Fri 10-5, Sat 10-4, Sun 2-5, Thurs 10-8
Admission Free: Access for disabled

In the Civic Centre on Commercial Road in Southampton. **5 C3**

The collection falls into four main groups: portraits and landscapes from the seventeenth and eighteenth centuries; nineteenth-century French paintings; modern British paintings and sculpture and the British contemporary collection.

There are distinguished English paintings, including works by Turner, Gainsborough, Reynolds, Hayman and Wright of Derby.

Ruisdael, Francesco de Mura, Marco Ricci, Weenix, Goossen van der Weyden and Jordaens may also be seen.

The Gallery possesses an outstanding British twentieth-century collection, Stanley Spencer's powerful portrait of his second wife, *Patricia Preece,* the aggressive splendour of *Red Landscape* by Graham Sutherland as well as a major collection of works by Sickert and other Camden Town artists.

The gallery owns an important series of ten paintings by Burne-Jones.

There are good examples of nineteenth- and twentieth-century sculpture, including Rodin's *Eve* and *Crouching Woman,* and *Woman Putting on her Stocking* by Degas (also bronze).

The contemporary collection is outstanding, with examples by Gilbert and George, Richard Long, Bill Woodrow, Anthony Gormley, Stephen Campbell, Adrian Wiczniewski, Boyd Webb and Barny Flanagan.

See entry in main text, pages 217–19.

STRATFIELD SAYE HOUSE

Reading RG7 2BT
Telephone: (0256) 882882

DUKE OF WELLINGTON
Open: 1 May-last Sun in Sept daily except Fri 11.30-5
Access for disabled

Between Reading and Basingstoke off the A33 on the Hampshire side of the county boundary. **5 A2**

Stratfield Saye has been the country home of the Dukes of Wellington for a century and a half, and contains an interesting family collection, with particular emphasis on the 1st Duke's life.

The house contains portraits by James Thorburn, Hoppner, Lawrence and William Owen. There are three fine works by Jean-Baptiste Pillement.

A study of Pope Clement XIII by Anton Raphael Mengs was purchased by Gerald, the 7th Duke, in 1956 for £25. There are drawings by Thomas Hickey, the Irish artist, of officers who served in the Duke's regiment in the fourth Mysore war of 1799.

Works of sculpture include portrait figures of contemporaries of the Duke. In Roman dress, they are by Rauch, Campbell, Sir Francis Chantrey and Pistrucci.

Outside the house is a sculpture of a horse and dragon by Matthew Cotes Wyatt. Bought by the 2nd Duke in 1865, the work was not completed (St George is missing). The Stables house an exhibition of objects associated with the 1st Duke and include his massive funeral carriage.

See entry in main text, page 216.

THE VYNE ✤

Sherborne St John, near Basingstoke
RG26 5DX
Telephone: Basingstoke (0256) 881337

NATIONAL TRUST
Open: 1 Apr-21 Oct daily except Mon, Fri 1.30-5.30; GF, BH Mons 11-5.30, closed Tues following; last admissions 5
Limited access for disabled

Four miles north of Basingstoke off the A340 between Bramley and Sherborne St John. Nearest exit from M3 is Exit 6. **5 A2**

A Tudor house built around 1500 and furnished in eighteenth-century taste. The paintings include a portrait of John Chute holding a Gothicised version of designs for the south front by Gabriel Mathias. There are several works by J. H. Muntz, a Swiss engineer, including a view of The Vyne from across the lake. A portrait of Francis Whithed by Rosalba Carriera hangs in the Large Drawing Room.

WESTGATE MUSEUM

High Street, Winchester
Telephone: (0962) 848269

WINCHESTER CITY COUNCIL
Open: Apr-Sept Mon-Sat 10-5, Sun 2-5; Oct-Mar Tues-Sat 10-5, Sun 2-4
Admission Charge: No access for disabled

Winchester can be reached from the M3, A33 and A34. **5 B3**.

The Painted Ceiling was commissioned by Warden John White (Headmaster and Warden of Winchester College until 1554, when he became Bishop of Lincoln) in anticipation of a visit by Queen Mary Tudor and her husband Philip of Spain on the occasion of their marriage in Winchester (1554). In fact the couple only visited the college (staying at Wolvesey Palace) and received some verses written by the scholars.

In 1885 a portion of the wainscot in the Tenth Chamber was removed and found to be reused painted oak. The wood was discovered to be the remains of a flat-boarded wooden ceiling divided

into square and rectangular coffering. Some thirty feet of frieze were also found to have survived. In 1976 the College agreed to the extensive cleaning and repairs which were necessary for the ceiling's preservation, and in 1980 it was installed in the Westgate Museum, there being no appropriate site available within the College.

The design was applied in grisaille, with black and brown shading on a white ground. This is enhanced by *sgraffito* work. Maintaining a style popularised by Henry VIII, 'Antique' or 'Grotesque', the ceiling is ornamented with acanthus leaves and varieties of other foliage; much prominence, however, is given to the Tudor Rose. Each section of the coffering has a medallion enclosing within it a portrait head. Some are male, pictured in classical costume or extravagant helmets; others are female, in contemporary (sixteenth-century) head-dress.

HEREFORD AND WORCESTER

BERRINGTON HALL ❧
Near Leominster HR6 0DW
Telephone: Leominster (0568) 5721

NATIONAL TRUST
Open: April, Sat, Sun, Easter Mon 1.30-5.30; May-end Sept, Wed-Sun BH Mon 1.30-5.30; Oct, Sat, Sun, 1.30-4.30

On west side of the A49 three miles north of Leominster. **9 C2**

The principal works of art are the four large battle scenes, three by Thomas Luny, which commemorate the naval engagements of Admiral Lord Rodney at the Battle of Martinique in 1780 and the Battle of the Saints in 1782. There are ceiling paintings by Biagio Rebecca. Little else, in the way of art, was left when the Rodney family sold Berrington in 1901.

CHURCHILL GARDENS MUSEUM (THE HATTON GALLERY)
Venn's Lane, Hereford
Telephone: (0432) 267409

HEREFORD CITY MUSEUMS
Open: Tues-Sun 2-5 and BH Mons
Closed: Mon also Sun Oct-Mar CD, BD, GF
Limited access for disabled

In a park on the outskirts of the city. **9 C3**

The museum has the Brian Hatton Memorial Gallery attached to it, and it is used mainly for changing displays of work by this Hereford artist. The collection includes drawings and paintings up to the time of his death, in Egypt, during the First World War (1916).

Hatton was much thought of as a young man, receiving praise from Watts. The turn-of-the-century spirit in English art, deriving from the Slade, is apparent in Hatton's draughtsmanship.

THE COMMANDERY
Sidbury, Worcester WR1 2HU
Telephone: (0905) 355071

WORCESTER CITY COUNCIL
Open: Mon-Sat 10.30-5, Sun 2-5
Limited access for disabled

At Sidbury in Worcester. **9 D2**

Founded before 1220, the timber-framed building was first a hospital and later the home of the Wylde family.

Fifteenth-century wall paintings decorate the Painted Chamber. The ceiling painting represents the Trinity, three panels on the north wall represent the saints, Michael, Godwald and Etheldreda. The painting on the south wall depicts the martyrdom of St Erasmus and below it is the martyrdom of St Thomas à Becket. St Anne and the Virgin are depicted over the original doorway.

Local historical and topographical works from the collections of the Worcester City Museum and Art Gallery are also on exhibition.

CROFT CASTLE ❧
Near Leominster HR6 9PW
Telephone: Yarpole (056 885) 246

NATIONAL TRUST
Open: Apr and Oct Sat, Sun 2-5; Easter Sat, Sun, Mon 2-6; May-end Sept Wed-Sun and BH Mons 2-6; last admissions 30 mins before closing
Access for disabled

Five miles north-west of Leominster. Turn west off the A49 or east off the A4110 on to the B4362. **9 C2**

The 2nd Baron Croft began his modern art collection in 1935, with six large Kokoschka watercolours of Polperro and fifteen by Paul Nash. These are not usually on view but may be seen on occasions.

Vanessa Bell, Duncan Grant, Graham Sutherland and Henry Moore are also represented in the collection.

The family collection includes portraits by Hanneman and Lawrence, an early Gainsborough of Elizabeth Cowper painted at Bath, and Philip de Laszlo portraits of the 1st Lord Croft, and Lady Croft. The Drawing Room contains late Stuart portraits in carved baroque frames and late seventeenth-century Italian works. There are watercolours by John 'Warwick' Smith, Buckler and Varley in the 'Gothic' Bay Room.

EASTNOR CASTLE
Ledbury, HR8 1RN
Telephone: (0531) 2305

EASTNOR CASTLE ESTATES COMPANY
Open: BH Mons; Easter and two May BHs; 31 May-30 Sept Suns; July and Aug Wed, Thurs, Sun 2.15-5.30
Limited access for disabled

Two miles east of Ledbury off the A438 Hereford to Tewkesbury Road in Eastnor village. **9 D3**

George Frederick Watts was a good friend of the 3rd Earl Somers, and it is as a result of this friendship that we find the five frescoes in the Staircase Hall. They were originally in the Somers London House in Carlton Terrace but were rescued and installed in Eastnor in 1976. They depict the four Elements: Earth, Air, Fire and Water illustrated through Greek mythology. Other works include the *Last Supper* by Bassano in the state bedroom and *Baptism of our Lord* by Tintoretto.

HANBURY HALL ❧
Near Droitwich WR9 7EA
Telephone: Hanbury (052 784) 214

NATIONAL TRUST
Open: Apr and Oct Sat, Sun, BH Mon 2-5; Easter Sat, Sun, Mon 2-6 May-end Sept Wed-Sun and BH Mon 2-6; last admissions 30 minutes before closing
Evening visits by arrangement
Access for disabled

Three miles east of Droitwich, one mile north of the B4090, six miles south of Bromsgrove through Hanbury village. **4 A/B5**

The house contains decorations by Thornhill. The ceiling of the Staircase Hall shows an assembly of classical deities and

the walls are scenes from the life of Achilles.

In the Drawing Room are several family portraits, including two three-quarter-length portraits of Thomas Hanbury and his wife by Kneller. The large bird painting is by Melchior de Hondecoeter. Several portraits hang in the Parlour and there is a collection of flower paintings in the bedrooms upstairs.

See entry in main text, pages 167–8.

HEREFORD CITY ART GALLLERY

Broad Street, Hereford
Telephone: (0432) 268121 Ext 207

HEREFORD CITY COUNCIL
Open: Tues, Wed, Fri 10-6, Thur 10-5; Sat 10-4 (winter), 10-5 (summer)
Admission Free: Access for disabled

Hereford is reached from the M50 via the A49 or A438. **9 C3**

Hereford's gallery places special emphasis on the late eighteenth and nineteenth centuries. Watercolourists include David Cox, J. Scarlett Davies, Girtin and the Varleys. There are five works by Turner, including one of Hereford Cathedral. The twentieth-century collection is added to where possible on a local and national basis. Exhibitions change monthly – some part of the collection is always on show.

David Cox taught at a young ladies' academy in the city for some years, early in his career, and it allowed him easy access to Wales, where he loved painting.

KIDDERMINSTER ART GALLERY AND MUSEUM

Market Street, Kidderminster
Telephone: (0562) 66610

WYRE FOREST DISTRICT COUNCIL
Open: Daily 11-4
Closed: Wed, Sun and BH
Access for disabled

Kidderminster is south-west of Birmingham Centre and can be reached from the M5, A456, A449, A442 or A448. **9 D2**

The collection of local works range in time from works by William Stukeley and Samuel and Nathaniel Buck to the present day: from topographical drawings and prints by such artists as Edward Dayes, Paul Sandby and H. H. Lines to good amateur work. It includes a number of local drawings by Cuthbert Bede (born in Kidderminster), the nineteenth-century *Punch* contributor.

Effort is made to acquire representative works by good local amateur painters, not necessarily of local subjects. Other than this collection, there are works by David Cox and Frederick Lord Leighton (drawings). Some of the best work represented is by lesser known painters, such as F. H. Henshaw, F. E. Hodges, H. B. Brabazon and J. E. Southall.

Because of the Gallery's programme of temporary loan exhibitions, parts of the permanent collection are only occasionally on view in the Gallery.

WORCESTER CITY MUSEUM AND ART GALLERY

Foregate Street, Worcester WR1 1DT
Telephone: (0905) 25371

WORCESTER CITY COUNCIL
Open: Mon-Fri 9.30-6, Sat 9.30-5
Closed: Thurs and Sun
Admission Free: Limited access for disabled

Worcester is on the A38 or A44 from the M5. **9 D2**

The emphasis of the collection is on local subjects and local artists with a predominance of early nineteenth-century watercolours and late nineteenth-century oils. There are several Newlyn School artists represented, including Stanhope Forbes, and quite a large number of watercolours by David Cox.

The presentation of contemporary art within a sympathetic framework of educational activities is the cornerstone of the Gallery's exhibitions policy. Exhibitions encompass a wide range of style and medium, from traditional easel painting to video, installation and performance.

——— HERTFORDSHIRE ———

GORHAMBURY HOUSE

St Albans AL3 6AH
Telephone: (0727) 54051

EARL OF VERULAM
Open: May-Sept Thurs only 2-5
No access for disabled

Two miles west of St Albans off the A414. **6 D6**

Gorhambury House is of interest for its Francis Bacon associations, which survive, though indirectly, to the present day. The collection contains portraits of the philosopher and of relations, and works by his half-brother, Nathaniel.

The portrait of Charles II by Sir Peter Lely was given by the King to Sir Harbottle Grimston, 2nd Baronet, who inherited the estate through the female line, and from whom the present Lord Verulam is descended. Next to it hangs the portrait of his wife, Queen Catherine of Braganza, by Jacob Huysmans. Of a later date is the fine equestrian portrait of George I by Sir Godfrey Kneller.

Also displayed in the Great Hall are two late sixteenth-century enamelled glass windows which were found in fragments in the stables and restored in the 1930s by the Victoria and Albert Museum. Enamelled glass was a great rarity at this time and the windows, depicting scenes from mythology and Aesop's *Fables*, are one of the greatest treasures of the House.

The Yellow Drawing Room opens off the Ball Room and most of the pictures are contemporary with the House. Outstanding among them is the painting by Sir Joshua Reynolds of *The Four Children of James, 2nd Viscount Grimston*, as well as another portrait by Reynolds of *The Hon. Mrs Walter*.

Also displayed here is the contemporary bronze of *A Girl in the Rain* by Sidney Harpley, bought by the present family.

See entry in main text, page 220.

HATFIELD HOUSE

Hatfield AL9 5NQ
Telephone: (070 72) 62823

MARQUESS OF SALISBURY
Open: 25 Mar-11 Oct daily 12-4.15, Sun 1.30-5; Also Easter, May Day, Spring and Aug BH Mons 11-5
Closed: Mon and GF
Access for disabled

21 miles north of London on the A1000. Easy access from the M1 and A1. **6 D6**

The main collection is of portraits, and includes works by Reynolds, such as the wife of the Marquess of Salisbury, George Richmond, *The Third Marquess of Salisbury*, who was three times Prime Minister, a portrait of Mary Queen of Scots, attributed to Hilliard's pupil, Rowland Lockey, an interesting 'double' portrait by Wissing and earlier Salisbury family portraits by, or attributed to, Gheeraerts and John de Critz.

The house is splendidly furnished, and contains tapestries, painted decorations, and other works of art.

Important portraits of Elizabeth I include the Nicholas Hilliard known as *The Ermine Portrait*.

KNEBWORTH HOUSE

Knebworth
Telephone: (0438) 812261

HON DAVID LYTTON COBBOLD
Open: 4 Apr–27 Sept, booked parties
only; Apr and May weekends and BHs
only 12–5; 23 May–13 Sept daily 12–5
Closed: Mon except BH
Limited access for disabled

One mile south of Stevenage, off the A1
at Junction 7. **6 D6**

The most important work of art in the
house is Daniel Maclise's *Edward IV
Visiting Caxton's Printing Press at West-
minster*. It reflects the strongly nine-
teenth-century and literary character of
the house's associations. It was left to the
Lytton family by Dickens's biographer,
John Forster, a frequent visitor when
Bulwer-Lytton, the Victorian novelist,
lived and worked there. Maclise's portrait
of the writer hangs on the landing outside
the State Drawing Room.

Earlier family portraits include the
original builder of Knebworth, Sir Robert
Lytton, and the sixteenth-century portrait
of Sir Rowland Lytton in armour, with
further seventeenth-century and later
portraits.

See entry in main text, pages 220–2.

SHAW'S CORNER

Ayot St Lawrence, Welwyn AL6 9BX
Telephone: (0438) 820307

NATIONAL TRUST
Open: Apr–Oct Wed–Sat 2–6; Sun and
BH Mons 12–6; last admissions 5.30;
Group visits by written appointment Mar–
Nov Wed–Sun 11–6
Closed: GF

Limited access for disabled

Three miles north-west of Welwyn in
Ayot St Lawrence at the south-west end
of the village. **6 D6**

George Bernard Shaw moved into the
New Rectory in 1906, but it was not
renamed Shaw's Corner until after the
Second World War. He lived here until
his death in 1950. A Rodin bronze bust
of Shaw and a portrait of him by Augustus
John are among the works of fine art on
view. In the Hall is a painting by Shaw's
friend Dame Laura Knight, *First Night in
the Stalls*. There are several bronzes by
Prince Paul Troubetskoy and some intri-
guing Shaw memorabilia.

WATFORD MUSEUM

194 High Street, Watford WD1 2HG
Telephone: (0923) 32297

WATFORD BOROUGH COUNCIL
Open: Mon–Sat 10–5
Admission free: Access for disabled

Watford is approached off the M1, A41
or M25. **7 A6**

A variety of local benefactors have laid
the basis of the collections. Sir Hubert
von Herkomer figures strongly with
portraits, watercolours, prints and draw-
ings as well as material relating to his
students (Lucy Kemp-Welch, George
Harcourt, Ernest Borough Johnson, Al-
gernon Talmage and Daniel Wehrsch-
midt).

The collection of material relating to
the Monro 'Academy', with particular
reference to activities in the area, includes
works by Hearne, Edridge, Dr Thomas
Monro and Alexander Monro. There are
also paintings and prints by J. C. Buckler,
Turner, W. H. Hunt, Thomas Girtin and
William Alexander, as well as bronzes by
Jacob Epstein. The artistic patronage of
the Earls of Essex at Cassiobury is also
featured.

——— HUMBERSIDE ———

BEVERLEY ART GALLERY AND MUSEUM

Champney Road, Beverley
Telephone: (0482) 882255

BEVERLEY BOROUGH COUNCIL
Open: Mon–Fri 10–12.30, 2–5; Thurs
10–12; Sat 10–12, 1–4
Admission Free: No access for disabled

Beverley is eight miles north of Kingston-
upon-Hull on the A1079 road to York.
15 C6

The paintings are mostly local works, but
the gallery's speciality is the collection of
more than fifty works by Fred Elwell
RA, an artist from Beverley.

BURTON AGNES HALL

Driffield YO25 0ND
Telephone: (026 289) 324

MR M. WICKHAM-BOYNTON
Open: 1 Apr–31 Oct 11–5 daily
Limited access for disabled

Burton Agnes Hall is on the road to
Flamborough Head, the 'nose' on the
Yorkshire coast. It is the home of Marcus

Wickham-Boynton. The collection is
refreshing, modern and varied, containing
good examples of the main Impressionist
and Post-Impressionist artists, from Boudin
on. They hang in the eighteenth-century
elegance of the upper drawing room as
well as in the Garden Gallery; Renoir,
Cézanne, Utrillo, Gauguin, Pissarro, Der-
ain, Matisse, Vlaminck and Bonnard are
all represented. There are works also by
lesser known artists, including Henri
Lebasque and Maximilien Luce.

The splendid, bold composition of
Women Resting is the work of André
Minaux, born in 1923, who is also
responsible for *Church at Salins*. He
exhibited at the Tate Gallery in 1955 with
Ginette Rapp, two of 'Four Realists'. *The
Potato Gatherers*, by the latter artist, is also
in the collection.

Works to be more readily anticipated
in an Elizabethan house hang in other
rooms, and include portraits of the
Boynton family, a study of Oliver
Cromwell ascribed to Robert Walker,
landscapes by Gainsborough, Mercier and
William Marlow, and portraits by Rein-
agle, Reynolds, Cotes, Kneller and Lely.

BURTON CONSTABLE HALL

Sproatley, near Hull
Telephone: (0964) 562400

MR J. CHICHESTER-CONSTABLE
Open: Easter Sun, Sun–Thurs 1–5
Limited access for disabled

At Burton Constable, one and a half miles
from Sproatley and ten miles south-east
of Beverley on the A5035 and about
seven miles from Hull (A165). **15 D6**

This Elizabethan house was remodelled in
the eighteenth century. In the Great Hall
is a picture of Burton Constable *c* 1700
and a number of family portraits. Among
them is William Constable, who made
the eighteenth-century changes, and his
sister *Winifred Constable* by Anton Maron.
In the Muniment Room is a collection of
architectural drawings.

The Upper Passage is hung with late
nineteenth-century Spy cartoons. Most of
the paintings in the Long Gallery and
Library are portraits of members of the
Constable family. There are two by
Marcus Gheeraerts and a portrait, *William
Constable, in the Clothes of J. J. Rousseau*,
by Liotard. Lady Jane Dormer, Lady-in-
Waiting to Mary Tudor, is portrayed in
a painting attributed to Zuccaro. The
Staircase Hall contains many portraits,
including *Charles II* and *James II* by

Kneller and a large painting, *Coriolanus* by Casali.

CARLTON TOWERS
Carlton
Telephone: (0405) 861662

DUKE OF NORFOLK
Open: May, June, Sept, Sun only; July, Aug Sun, Mon, Wed; Easter Sat-Tues; Early May BH Sun and Mon; Spring BH Sat-Tues; Aug BH Sat-Wed;
All 1-5; last admission 4.30
Access for disabled

Off the A104 due west of Goole. **15 B6**

Carlton is the Yorkshire home of the Duke of Norfolk. The Tempest Collection, which is the main Carlton Towers collection hanging in the Picture Gallery, came by marriage from Broughton Hall (q.v.) and is mainly European seventeenth century, with an emphasis on religious subject matter. There are canvases by Carracci, Sassoferrato and Lanfranco; Norwich School and other English works also hang here.

In keeping with the strongly Gothic atmosphere of the house, the Venetian Drawing Room contains painted panels by Westlake of characters from *The Merchant of Venice*. Canaletto views of Venice hang with the family portraits (mainly modern) in the Bow Drawing Room.

FERENS ART GALLERY
Queen Victoria Square, Kingston-upon-Hull Hull HU1 3RA
Telephone (0482) 222750

HULL CITY COUNCIL
Open: Mon-Sat 10-5, Sun 1.30-4.30
Admission Free: Access for disabled

In the centre of Hull, which is on the north side of the Humber estuary, approached on the south side by way of the M180 and the A55 or from the west by the M62/A63. **15 D6**

Housed in a neo-classical building, this is a good general collection, strong in Dutch and Flemish paintings, the most striking of which is the *Portrait of a Young Woman* by Frans Hals. There are good examples of works by Ruisdael, Van Goyen, Van der Helst, Gysbrechts and Daniel de Blieck and a particularly fine Barent Fabritius, *The Expulsion of Hagar*. Additional Dutch works, on loan from the National Gallery, include works by Pieter Neeffs.

Italian paintings include *A Bishop Saint* by Bartolommeo di Giovanni, Maffei's *The Annunciation*, a Philippe de Champaigne of the same subject, a smaller version of a similar work in the Wallace Collection, and good examples by Guardi and Ribera.

British painting of the seventeenth and eighteenth centuries includes portraits by Dobson, Riley, Cotes, Hogarth and Devis, who was a North Country artist, and whose *Sir George and Lady Strickland in the Grounds of Boynton Hall, Bridlington* is a local work.

There are interesting landscapes, including Richard Wilson's *Italian Landscape with Stone Pine* and works by Constable and Ibbetson.

Victorian art is well represented, notably by Hall's *The Vacant Cradle*, a work of obvious sentiment, and Draper's more dramatic classical subject, *Ulysses and the Sirens*.

Nineteenth-century French painting includes works by Legrand, Carriera, Ribot, Meissonnier, Le Prince, Tissot, and other minor painters.

British art in the twentieth century is reasonably comprehensive, with good examples of Sickert, Smith, Gore, Ginner, Grant, Wadsworth, Penrose and Tristram Hillier. There is a good collection of portraits, including Lewis's *Self-Portrait as a Tyro*, and works by Brangwyn, Fergusson, Spencer, Brockhurst, Dunlop, Rutherston and McEvoy.

Post-war art includes a strong group of abstract paintings of the St Ives school, there are good examples of pop art and kinetic art, and recent experiments in figurative paintings. A busy temporary exhibition programme often displaces the modern collections which can usually be made available by appointment in advance.

The gallery owns an interesting collection of marine paintings by the Hull artist, John Ward.

See entry in main text, pages 126–7.

NORMANBY HALL
Normanby DN15 7BD
Telephone: (0724) 720215

SCUNTHORPE BOROUGH COUNCIL
Open: Apr-Oct Mon-Fri 11-5 Sun 2-5.30
Closed: Sat throughout year
Access for disabled by prior appointment, ground floor only

Four miles north of Scunthorpe on the B1430 in Normanby village. **12 C1**

The Hall, a branch of the Scunthorpe Museum, is decorated in Regency style,

the paintings chosen to suit the period. Many of the works are part of the Scunthorpe Art Gallery collections and some are on loan from other collections. Among the paintings are a portrait of Mrs Alice Wood by Thomas Lawrence and works attributed to Kneller, Kauffmann, and Jan Fyt.

SCUNTHORPE MUSEUM AND ART GALLERY
Oswald Road, Scunthorpe DN15 7BD
Telephone: (0724) 843533

SCUNTHORPE BOROUGH COUNCIL
Open: Mon-Sat 10-5, Sun 2-5
Access for disabled by prior appointment

Scunthorpe is north of the M180, off the A18. **12 C2**

Among the paintings, mostly local views by local artists, are *Aqueduct of the Emperor Valeno* and *St Sophia, Constantinople* by Sir Frank Brangwyn; *The Smug and Silver Trent* by J. A. Arnsby and *View near Swanage* by Clarkson Stanfield.

SEWERBY HALL ART GALLERY AND MUSEUM
Sewerby Park, Bridlington
Telephone: (0262) 678255

BOROUGH OF NORTH WOLDS
Open: Sun-Fri 10.30-12.30, 1.30-6; Sat 1.30-6
Admission Free: No access for disabled

Two miles north-east of Bridlington off the B1255 Bridlington-Flamborough Road; it may also be reached from the cliff path. **15 D5**

The fine art consists of a mixed collection of portraits of local gentry, marine paintings by H. Redmore and other nineteenth-century local marine painters, and some early nineteenth-century watercolours of Bridlington. There are several portraits of the pioneer airwoman Amy Johnson and her family, by John Berry in the Amy Johnson Collection.

SLEDMERE HOUSE
Sledmere, Driffield YO25 0XQ
Telephone: (0377) 86208

SIR TATTON SYKES
Open: Easter weekend; 2 May-27 Sept daily except Mon and Fri 1.30-5.30; BH Mons 1.30-5.30 (last admission 5)
Access for disabled

On the scenic route between York and Bridlington, 23 miles from York, 16 miles from Bridlington. **15 C5**

Built in 1751 and later enlarged, the house was gutted by fire in 1911. It was rebuilt to the original designs using the eighteenth-century plasterwork moulds. It contains paintings, including a number of family portraits, and classical sculpture.

WELHOLME GALLERIES

Welholme Road, Great Grimsby, DN32 9LP
Telephone: (0472) 242000

GREAT GRIMSBY BOROUGH COUNCIL
Open: Tues-Sat 10-5
Closed: Christmas period and BHs
Admission Free: Access for disabled

Grimsby is at the mouth of the River Humber and can be reached via the A16, A18, A1136 and A180. **12 D2**

The collection is well endowed with marine paintings by eighteenth- and nineteenth-century artists. These include Tudgay, Knell, Condy, Whitcombe and Mitchell.

There are also marine works by Carmichael and Huggins, and a large number of amateur or anonymous marine and local topographical subjects. English School portraits, mostly unprovenanced and unattributed, make up a further part of the collection.

The works were allowed to deteriorate following the death of W. V. Doughty, the principal collector, but since 1974 there has been a gradual and continuous restoration programme and the best of the paintings have undergone extensive conservation.

WRAWBY MOOR ART GALLERY

Elsham Hall, Near Brigg, DN20 0Q2
Telephone: (0652) 688698

ELSHAM COUNTRY PARK
Open: Easter-Oct daily 11-5; Oct–Easter Sun and BHs 11-4
Closed: CD, BD, GF
Access for disabled

The entrance to the Country Park in which the Hall is situated is on the Brigg to Barton-on-Humber road (B1206). It is eight miles south of the Humber Bridge. **12 C2**

The permanent collection of works by Sir William Russell Flint is often displaced by other exhibitions but when it can be seen it contains the contents of his studio, as well as book illustrations, etchings, drawings, oils and watercolours.

Summer exhibitions change every two months.

——— ISLE OF MAN ———

MANX MUSEUM

Douglas, Isle of Man
Telephone: (0624) 75522

MANX MUSEUM SERVICES
Open: Mon-Sat 10-5; Tynwald Day (5 July) 2-5
Closed: Sun

About a mile from the promenade. **16**

The Manx Museum, which dates from 1922, was formerly a hospital. Its fine art collection is mainly of topographical works, though it does possess portraits by Romney. Local artists include John Millar Nicholson, who studied under Ruskin, and Archibald Knox, an art nouveau designer.

There is some prehistoric Celtic art in the collection.

——— ISLE OF WIGHT ———

OSBORNE HOUSE

East Cowes PO32 6JY
Telephone: (0983) 200022

ENGLISH HERITAGE
Open: 13 Apr-end Sept daily 10-6; Oct daily 10-5
Limited access for disabled

On the Isle of Wight one mile southeast of East Cowes. **5 C3**

Bought by Prince Albert and Queen Victoria as a retreat, the house contains portraits by or after Winterhalter and German and British sculptures and bronzes. One corridor contains paintings of the Queen's Indian soldiers, many by Rudolf Swoboda, a Czech.

The house, built like an Italian villa, was designed by Prince Albert, and furnished in the period when he was most directly involved in promoting British craft and design. It was kept unchanged by Queen Victoria after her Consort's death, and has been largely unchanged since, making it a rare and revealing period piece.

THE RUSKIN GALLERIES

Bembridge, PO35 5PH
Telephone: (098387) 2101

BEMBRIDGE SCHOOL
Open: By appointment
Some access for disabled

Bembridge is on the eastern tip of the island. **5 D2**

The largest collection of Ruskin material in the world was begun by John Howard Whitehouse, the founder of the Bembridge School, where the drawings, letters, manuscripts, notebooks, and books from John Ruskin's library, as well as books by and about him, are housed. There is an extensive collection of drawings and watercolours by Ruskin's associates and from his own collection. George Richmond, J. E. Millais and Samuel Lawrence all painted portraits of Ruskin which hang here.

——— KENT ———

HEVER CASTLE

Edenbridge TN8 7NG
Telephone: Edenbridge (0732) 865224

BROADLAND PROPERTIES LIMITED
Open: 8 Apr-5 Nov daily, 11-6; last admission 5 (Castle opens 12 noon)
Access for disabled to gardens and ground floor of Castle

Seven miles south of Sevenoaks and two miles east of Edenbridge, signposted off the B2026. M25: 6-20 minutes. **7 C5**

This well-managed house, with its moat and splendid gardens, was the childhood home of Anne Boleyn. It contains an extensive collection of mainly Roman sculpture, collected in the late nineteenth century. There are good illustrated guides to the castle and gardens.

The contents of the castle attractively combine Tudor and later periods of art and furnishings. There are family and historical portraits, including those of the house's most famous inhabitant and her royal husband.

See entry in main text, pages 223–4.

KNOLE ❧

Sevenoaks TN15 0RP
Telephone: Sevenoaks (0732) 450608

NATIONAL TRUST
Open: Apr-end Oct Wed-Sat BH Mon and GF 11-5, Sun 2-5; last admissions 4; extra rooms shown on Connoisseurs' Day
Limited access for disabled

At south end of Sevenoaks just east of the Tonbridge Road (A225 linking with the A21) and 25 miles from London. **7 B5**

The collection at Knole is on the same vast scale as the house itself: almost 300 pictures on view in the State Rooms, and another fifty to be seen in the private apartments on Connoisseurs' Day.

Many of the original paintings at Knole were lost during the Civil War, but the 6th Earl of Dorset did much to rebuild the collection in the late 17th century, a process continued by his son, who commissioned decorative paintings from Mark Anthony Hauduroy. The Brown Gallery is hung with rows of sixteenth- and seventeenth-century portraits in uniform eighteenth-century frames, which include not only members of the Sackville family but leading figures from northern European history. Knole is famous for three other groups of paintings: the copies of the Raphael *Cartoons* (on loan to the V & A from the Royal Collection), thought to have been produced in the workshop of Franz Cleyn; an impressive collection of works by Reynolds, including the unusual *Ugolino and his Sons in the Dungeon at Pisa* and the portrait of the 3rd Duke of Dorset's Chinese page; and, in the Poet's Parlour (private apartments), a number of portraits of literary figures.

One room is given over to Netherlandish cabinet pictures. These include genre works by Teniers the Younger. There is Cornelius Johnson's portrait of *Lady Margaret Sackville*. Lely and his studio are represented among the portraits, as is Kneller.

See entry in main text, page 223.

LEEDS CASTLE
Maidstone, ME17 1PL
Telephone: (0622) 765400

THE LEEDS CASTLE FOUNDATION
Open: Easter to end Oct daily 11-5; open for groups by arrangement all year
Access for disabled

Six miles south-east of Maidstone at junction of the M20/A20 and on the B2163 near Leeds village. **7 B3**

Leeds must, from the outside, be one of Britain's most spectacularly beautiful castles: built of golden stone, islanded upon a flat, calm lake in a wooded and undulating park. It houses a diverse collection of paintings from the fifteenth century to the nineteenth century, and including some interesting Impressionist works.

Pictures in the medieval rooms include an early sixteenth-century triptych by the Master of the Saint Ursula Legend. Other religious works include panel paintings by Davide Ghirlandaio and others which are pseudo Pier Francesco Fiorentino, and a large, attractive *Adoration of the Shepherds* by Fray Juan Bautista del Mayno. Then come the Cranach *Adam and Eve*, and a Caprioli.

Among family and associated portraits are two by Vanderbank, a three-quarter-length by Riley, and the group of miniatures: another Riley, and the *Duchess of Buckingham* by Cooper. With these is a vast enthroned *Richard II* in pinks, reds and golds, dating from about 1570.

See entry in main text, page 224-5.

LULLINGSTONE CASTLE
Eynsford DA4 0JA
Telephone: (0322) 862114

MR GUY HART-DYKE
Open: Apr-end Oct Sat, Sun and BHs 2-6
Limited access for disabled

On the A225 Dartford to Sevenoaks road near the village of Eynsford. **7 B5**

The most interesting of the family portraits is the triptych in the Great Hall of Sir Percyval Hart wearing the ceremonial knife as the King's Chief Server with his three sons (dated 1575). A portrait of Sir John Bramston, Lord Chief Justice of the King's Bench, by Daniel Mytens hangs in the State Drawing Room. A large painting of the house and grounds by a journeyman painter depicts the house and grounds prior to alterations during Queen Anne's reign.

MAIDSTONE MUSEUM AND ART GALLERY
St Faith's Street, Maidstone, ME14 1LH
Telephone: (0622) 54497

MAIDSTONE BOROUGH COUNCIL
Open: Mon-Sat 10-5.30; Sun 2-5, BH 11-5
Admission Free: No access for disabled

For Maidstone take Exit 9, 10 or 11 from M20. **7 B4**

The Art Gallery areas have been extensively refurbished and a new ceramics gallery was opened in 1986.

There are examples of Italian, Dutch and Flemish painting of the sixteenth to the eighteenth centuries in this collection, which dates from the mid-nineteenth century. These works include a pair of classical ruins by Panini, and *Port Scene with Fishermen*, attributed to Francesco Zuccarelli.

The association of Maidstone with Hazlitt, reflected in the collection here, is also of great interest.

A small sculpture gallery has recently been created which contains, among others, work by Augustin Bocciardi, Joseph Nollekens and Francis Chantrey.

See entry in main text, pages 226-7.

PENSHURST PLACE
Penshurst
Telephone: Penshurst (0892) 870307

VISCOUNT DE L'ISLE VC, KG
Open: 1 Apr-4 Oct daily except Mon 12.30-6; Open BHs; last admissions to the house 5
Limited access for disabled

32 miles from London in Penshurst village, seven miles south of the Sevenoaks-Tunbridge Wells Road on the B2176. **7 C5**

This fine medieval house is one of the finest extant examples of fourteenth-century craftsmanship. A fine Gheeraerts conversation piece, painted *c.* 1595, of Lady Sidney with her two sons and four daughters, hangs in the State Dining Room. The Long Gallery contains seventeenth- and eighteenth-century Sidney portraits as well as a portrait of *Elizabeth I*, which hangs above her death mask.

The first Duke of Buckingham was given a Royal grant of the manor but, after he was beheaded by Henry VIII, it passed to the King. Edward VI bestowed it on Sir William Sidney, who married Lady Mary Dudley. Their son, Sir Philip Sidney, was born at Penshurst and wrote much of his poetry there. He died of wounds following the Battle of Zutphen in 1586.

THE ROYAL MUSEUM AND ART GALLERY
The Beaney Institute, High Street, Canterbury
Telephone: (0227) 452 747

CITY OF CANTERBURY
Open: Mon-Sat, 10-5
Closed: Sun
Admission Free

The museum is near the city centre.

A small collection, mainly of works of local interest, such as *Hops* by Laura Knight, *A Huntsman* by Ben Marshall and *Reculver* by James Ward. Local artists are also represented, the most famous of whom was Thomas Sidney Cooper, the painter of rural landscapes and cattle. A large canvas of a single bull, entitled *Separated but not Divorced*, is interesting.

SQUERRYES COURT
Westerham, TN16 1SJ
Telephone: (0959) 62345

MR J. ST A. WARDE
Open: Mar, Sun and BHs, also Apr–Sept Wed, Sat, Sun and BHs 2–6; last admission 5.30
No access for disabled

25 miles from London on the A25, on the western side of Westerham. **7 B5**

A small but interesting collection, it illustrates the tastes and growth of the Warde family which formed it, and which has lived in the house for the past 250 years. It includes Dutch and Flemish paintings, among them the striking *Still Life* by Pieter de Ring, and family portraits by Romney, Opie, Dahl, Devis, Lely, Barraud, Kneller, Stubbs and Benjamin West.

There is a *St Sebastian* attributed to Van Dyck, and a large version of Rubens's commemorative portrait of *Philip II of Spain* which hangs at Windsor Castle. Together with these are two immense Giordanos, a Dolci *St Lucy* and other works by, or attributed to, Salvator Rosa, Ribera, and Veronese.

Among the family portraits, the best are a charming Opie of *Mrs George Warde*, and the Stubbs painting of a foxhunting John Warde, his Arab horse set against a distant landscape. A huge family group by Wootton shows the first Warde owner of Squerryes, his children and animals, with a panoramic view of the house and estate. In a room dedicated to General Wolfe, friend of George Warde, are portraits of the latter (Opie), of Wolfe (Benjamin West), and of Wolfe's mother (Hudson). Other Wardes and connections (by Kneller, Dahl and van der Vaart) hang in the hall, in a fine set of carved frames.

See entry in main text, pages 225–6.

TUNBRIDGE WELLS MUSEUM AND ART GALLERY
Civic Centre, Mount Pleasant, Tunbridge Wells TN1 1NS
Telephone: (0892) 26121 Ext 3171

TUNBRIDGE WELLS BOROUGH COUNCIL
Open: Mon–Fri 10–5.30, Sat 9.30–5
Closed: Sun, BH and Easter Saturday
Admission Free: No access for disabled

In the Civic Centre in the Central Library Building in Mount Pleasant. Tunbridge Wells is south of London via the A21. **11 B1**

The main collection at Tunbridge Wells came from the Ashton Bequest, which was left to Tunbridge Wells in 1952. Otherwise, the contents are mainly portraits of local dignitaries, local scenes, and works by local artists, especially Charles Tattershall Dodd (father and son). They were acquired variously, by loan, gift, and purchase.

There is a large view of Bayhall, near Pembury, seat of Charles Selby Amherst, painted in about 1740, artist unknown. There are three landscapes by Charles Tattershall Dodd, Senior (1815–78; like his son of the same name, drawing master at Tonbridge School): *Rusthall Common*, *The Timber Wagon* and *Standings Mill*. They are part of the large holding of local scenes, mostly of more topographical than aesthetic interest, by the two Dodds. There are also originals by the Edwardian postcard-painter F. W. Burton.

See entry in main text, page 226.

——— LANCASHIRE ———

ASTLEY HALL
Chorley
Telephone: (025 72) 62166

CHORLEY BOROUGH COUNCIL
Open: Apr–Sept 12–5.30; Oct–Mar Mon–Fri 12–3.30, Sat 10–3.30, Sun 11–3.30
No access for disabled

Two miles from Chorley town centre, off the A6, well signposted. **11 B1**

The house contains an art gallery which hosts changing exhibitions. The Hall itself contains a number of interesting seventeenth-century portraits of Queen Elizabeth, Christopher Columbus, Francis Drake and others, painted on wood panels. There are Brooke and Townley Parker family portraits throughout the rest of the house.

BLACKBURN MUSEUM AND ART GALLERY
Museum Street, Blackburn BB1 7AJ
Telephone: (0254) 667130

BLACKBURN BOROUGH COUNCIL

Open: Tues–Sat 10–5
Admission Free: Access for disabled

Blackburn is east of Preston. **11 B1**

The bulk of the collection comprises, as one might expect, nineteenth- and early twentieth-century landscapes and genre paintings, and a few history subjects. The collection is largely English, but includes a good group of nineteenth-century Dutch landscapes. There are a few Old Masters, and some eighteenth-century paintings by Reynolds and Romney.

The watercolours of the English School, mostly dating from 1790–1930, include work by Cox, Albert Goodwin, W. H. Hunt, Thorburn and Turner. Some of the more notable paintings are *The Loves of the Winds and of the Seasons* by Albert Moore, *Cherries* by Lord Leighton, *Pastoral Scene* by Nicolaes Berchem and *River Landscape* by a follower of Nicolas Poussin. There is a major collection of Japanese prints and several Greek and Russian icons dating from the seventeenth century.

BROWSHOLME HALL
Near Clitheroe
Telephone: (025 486) 330

MR R. PARKER
Open: Easter Sat, Sun and Mon, May BH weekends; Aug BH and preceding week; Sats in June, July and Aug 2–5
Parties at other times by arrangement
Limited access for disabled

Off the B6243, five miles north-west of Clitheroe. **14 C6**

Apart from a selection of Parker family portraits by or attributed to Devis, Batoni, Reynolds, Lely and Kneller, of primary interest is the collection of James Northcote paintings, including a portrait of his patron Thomas Lister Parker and *Grouse Shooting in the Forest of Bowland* depicting William Assheton of Cuerdale Hall and the Rev T.H. Dixon Hoste.

BURY ART GALLERY AND MUSEUM
Moss Street, Bury BL9 0DR
Telephone: (061 705) 5878

BURY BOROUGH COUNCIL
Open: Mon–Fri 10–6, Sat 10–5
Admission Free: Limited access for disabled

Bury is just north of Manchester on the M66 and the A56. **11 B2**

The main collection was donated by children of Thomas Wrigley, a local Victorian businessman.

There are approximately 300 mostly nineteenth-century oils and watercolours and about 100 twentieth-century works. Wrigley's collection includes *A Random Shot* by Landseer, *Calais Sands* by Turner, *Hampstead* by Constable, and other works by David Cox, John Linnell, David Roberts, Birket Foster, Mulready, Muller, William Holman Hunt, Copley Fielding, De Wint, T. S. Cooper and E. W. Cooke.

GAWTHORPE HALL

Padiham, near Burnley BB12 8UA
Telephone: (0282) 78511

NATIONAL TRUST
Open: 1 Apr-end Oct daily except Mon,
Fri (open GF) 1-5
Limited access for disabled

On eastern outskirts of Padiham; three-quarters of a mile drive to house on north of A671.

Recently completely restored, Gawthorpe displays a group of Civil War and Restoration period paintings on loan from the National Portrait Gallery, including the *Self-Portrait* by the woman painter Mary Beale.

GRUNDY ART GALLERY

Queen Street, Blackpool, FY1 1PX
Telephone: (0253) 23977

BLACKPOOL BOROUGH COUNCIL
Open: Mon-Sat 10-5
Closed: BHs
Admission Free: Access for disabled

Blackpool is on the coast north of Liverpool and west off the M6 on to the M55. **11 A1**

The Grundy Art Gallery displays late nineteenth- and early twentieth-century English oils and watercolours, many in Royal Academy style. Works include *Number One Dressing Room* by Laura Knight, *Girl Waiting* by Harold Knight, *Air Mechanic Shaw*, better known as T. E. Lawrence, by Augustus John, *The Yellow Funnel* by Eric Ravilious, *Sanctuary Wood* by Paul Nash and *Falling Leaf and Falling Tree* by Stanhope Forbes.

HARRIS MUSEUM AND ART GALLERY

Market Square, Preston PR1 2PP
Telephone (0772) 58248

BOROUGH OF PRESTON
Open: 10-5 Mon-Sat
Admission Free: Access for disabled

Preston is on the M6 north-west of Manchester. From Manchester take the M61 to M6. **11 B1**

The fine art collection comprises an extensive group of paintings, watercolours, drawings and prints by nineteenth- and twentieth-century British artists.

Its nucleus is based on two bequests donated to Preston by Richard Newsam, a local banker and mill owner, in 1883, and the Rev. John Haslam in 1924. In addition the Harris Museum and Art Gallery has representative examples of the works from the Royal Academy in almost every year from 1891 to the early 1970s.

There is also a collection of works by Arthur Devis, the eighteenth-century conversation piece painter who was born in Preston in 1712, his half-brother Anthony, known for his topographical landscapes, and his son Arthur William, the portrait painter.

Works in the collection include: *Francis Vincent, his wife Mercy, and Daughter Ann, of Weddington Hall, Warwickshire* by Arthur Devis, *Kidwelly Castle* by J.M.W. Turner, *The Dawn of Life* by Samuel Palmer, *The Bey's Garden* by John Frederick Lewis, *The Hill of Zion* (from the 'Resurrection' series) by Stanley Spencer, *Why War?* by Charles Spencelayh and *Pauline in the Yellow Dress* by James Gunn.

THE HAWORTH ART GALLERY

Manchester Road,
Accrington
Telephone: (0254) 33782

HYNDBURN BOROUGH COUNCIL
Open: Daily except Fri 2-5
Admission Free: Limited access for disabled

Accrington is on the A680 and the A679 between Blackburn and Burnley. **11 B1**

As well as hosting exhibitions, the gallery owns a well-preserved collection of Edwardian and Victorian paintings. Oils include a Claude Vernet, *The Tempest*, and works by Lord Leighton, Verboeckhoven and Cooper. Watercolours by Birket Foster, Sam Prout, David Cox, Paul Sandby, Sydney Cooper, de Wint, Copley Fielding, Thorne Waite, Carlton

Smith, Ford Hughes and Barker of Bath are also part of the collection.

The gallery also houses one of the finest collections of Tiffany glass in the world together with a fine collection of modern glass.

LANCASTER CITY MUSEUM

Market Square, Lancaster LA1 1HT
Telephone: (0524) 64637

LANCASTER CITY COUNCIL
Open: Mon-Sat 10-5, Sun 2-5
Admission Free: Limited access for disabled

Lancaster is reached from the M6, A6, A683 or A589. **14 B5**

The Lancaster City Museum's collection of local watercolours includes work by Gideon Yates, Robert Freebairn, Samuel 'Lamorna' Birch, Reginald Aspinwall, William Woodhouse and Robert Rampling. Of note are five Romney portraits, a fine sixteenth-century Court portrait of a young woman by Pantoja de la Cruz and an attributed Guercino, *Sacrifice of Isaac*. The modern collections are less well represented but do include works by Claude Harrison and Ivon Hitchens.

LEIGHTON HALL

Carnforth
Telephone: (052 473) 4474

MR AND MRS R. G. REYNOLDS
Open: May-Sept Tues-Fri, Sun,
BH Mon 2-5
Closed: Mon and Sat
Access for disabled on ground floor

The house is two miles west of the A6 through the village of Yealand Conyers, which is due north of the 35A junction on the M6 which links with the A6. **14 B4**

The Gillow family home is beautifully situated with the Lakeland mountains in the background. The paintings are few, but interesting as a nineteenth-century family collection.

In the Dining Room hangs a portrait of Richard Gillow, who founded the furniture-making firm of Gillow & Company, of Lancaster. There are other family portraits, including the large Edward Seago of Mrs J. R. Reynolds. A small *Bathing Scene* by Gaspard Poussin, two scenes by Morland, a pair of Venetian views by Guardi, a Wouwermans, a Richard Wilson, a Palamedesz Stevaerts, and a large Jacob Jordaens of a flautist and his companions. These hang in the

Drawing Room. Among the pictures on the staircase is a *Rural Scene* by August Bonheur.

ROSSENDALE MUSEUM

Whitaker Park, Rawtenstall, Rossendale
BB4 6RE
Telephone: (0706) 217777

ROSSENDALE BOROUGH COUNCIL
Open: Mon–Fri 1–5; Sat 10–12, 1–5; Sun 1–4 (Nov–Mar), 1–5 (Apr–Oct)
Admission Free: No access for disabled

Rawtenstall is six miles south of Accrington on the A680 and north of Manchester via the M66. **11 B1**

The fine art is predominantly nineteenth-century and illustrative of the history of the area.

TOWNELEY HALL ART GALLERY AND MUSEUM

Burnley, BB11 3RQ
Telephone: (0282) 24213

BURNLEY BOROUGH COUNCIL
Open: Mon–Fri 10–5; Sun 12–5
Admission Free: Limited access for disabled

On the outskirts of Burnley, to the southeast, off the A646 road to Todmorden. **11 C1**

Home of the Towneley family, the Hall was opened as an art gallery and museum in 1903. The collection consists mainly of eighteenth- and nineteenth-century English watercolours and nineteenth-century oils. It derives from a bequest from Edward Massey to Burnley Corporation.

Fantin-Latour is represented here, as are Harpignies, Lépine and Charles-Emile Jacque. The watercolours form a representative collection of English painting and of particular interest are those painted by Turner of the Hall and the district in the 1790s.

Works include *Charles Towneley and his friends in the Park Street Gallery, Westminster* by Zoffany, *The Picture Gallery* by Alma-Tadema, *Destiny* by J. W. Waterhouse, the Towneley Altarpiece, and *Towneley Hall* by Turner.

—— LEICESTERSHIRE ——

BELGRAVE HALL

Thurcaston Road, Belgrave
Telephone: (0533) 554100

LEICESTERSHIRE MUSEUMS SERVICE

Open: Mon–Sat 10–5.30, Sun 2–5.30
Admission Free: Limited access for disabled

In Belgrave on Church Road off Thurcaston Road, two miles on the A6 from Leicester City Centre. **12 B6**

The Hall is furnished and decorated as an eighteenth-century home. It is a branch of the Leicestershire Museum and Art Gallery.

BELVOIR CASTLE

Grantham, Lincolnshire
Telephone: (0476) 870262

DUKE OF RUTLAND
Open: 24 Mar–4 Oct daily except Mon, Fri 12–6; BH Mons 11–7
Access for disabled by prior appointment

Seven miles south-west of Grantham. **12 B5**

A well-balanced and well-displayed collection of fine art. There are good works of sculpture, both inside the castle and in the gardens, a rich and varied collection of miniatures, family portraits, including splendid Reynolds portraits of the 4th and 5th Dukes of Rutland, and a general collection of paintings with good examples of Dutch genre scenes and seascapes.

Pride of place belongs to the series, *The Seven Sacraments*, by Nicolas Poussin. Two hang in the chapel, either side of the altar, above which is a fine Murillo of the Holy Family; three hang in the Picture Gallery, which contains the principal works of art.

Among these is an extensive work, *The Proverbs*, by David Teniers, Jan Steen's *Grace Before Meat* and Gainsborough's *The Woodcutter's Return*, as well as other works by Gainsborough. A portrait of Henry VIII, attributed to Holbein, was bought in 1787 from Lord Torrington's collection.

The house has good Gobelins tapestries with scenes from Don Quixote. Sculpture includes Canova's *The Three Graces*, and a series of portrait busts by Nollekens. In the gardens are displayed five statues by Caius Gabriel Cibber, dating from the late seventeenth century.

See entry in main text, page 162.

LEICESTERSHIRE MUSEUM AND ART GALLERY

New Walk, Leicester
Telephone: (0533) 554100

LEICESTERSHIRE COUNTY COUNCIL
Open: Mon–Sat 10–5.30, Sun 2–5.30
Admission Free: Access for disabled

On the New Walk which runs parallel to Princess Road, which has access to restricted parking area. It is reached via the A6, A47, A46/M1, A50/M1 and A426. **12 B6**

Leicester Art Gallery has a good collection of eighteenth- to twentieth-century British art, a small but significant collection of Old Master paintings and the most comprehensive collection of German Impressionist and Expressionist art in any British gallery.

The Georges de la Tour *Choirboy* and Poussin *Holy Family with the Infant St John* have been attributed to these artists relatively recently. Dutch and Flemish paintings include Michael Sweert's *A Girl* and works by Ruisdael, Aert van der Neer and Nicolaes Maes. Italian art is represented by Lorenzo Monaco's small *St John the Baptist Going into the Wilderness*, Annibale Carracci's *Youthful Bacchus* and G. B. Pittoni's grisaille *Assumption*.

Fine Georgian portraits include Thomas Hudson's *Mrs Matthew Michell and her Children*, theatrical portraits by Benjamin Vandergucht and Samuel de Wilde (*Mr Bannister Jr and Mr Parsons as Scout and Sheepface in 'The Village Lawyer'*) and works by Wright of Derby, Lawrence and Constable. Artists with Leicestershire links include Ben Marshall, who painted his friend *Daniel Lambert* in one of the Gallery's most popular portraits, and John Ferneley, who had a studio at Melton Mowbray. *Mr Greene's Bay Mare* is one of Ferneley's finest horse paintings. His portrait of *Sir John Palmer with his Shepherd John Green* includes Palmer's favourite mare and prize Leicester longwool sheep. There are further sporting paintings in the Melton Carnegie Museum, a branch at Melton Mowbray, and in another branch, the eighteenth-century Belgrave Hall (q.v.).

Among Victorian paintings are Leighton's large tondo *Perseus on Pegasus*, Frank Dicksee's *Foolish Virgins* and G. F. Watts's *Orlando Pursuing the Fata Morgana*, presented by the artist as one of his best works. The Gallery owns versions of *The Meeting of Jacob and Rachel* by William Dyce and *The Railway Station* by W. P. Frith, as well as Shakespearean paintings by Augustus Egg and Clarkson Stanfield from the collection of the Victorian engineer Brunel.

Paintings and drawings by members of the Camden Town group, founded in 1911, are hung together: Spencer Gore's *Harold Gilman's House at Letchworth* and Robert Bevan's *From the Artist's Window*, Malcolm Drummond's *Chelsea Public Library* and works by Sickert. *Three*

Clowns is from a Bertram Mills Circus series by Dame Laura Knight. Other fine modern paintings include Gertler's *Fruit Sorters*, William Roberts's *At the Hippodrome* and Spencer's *Adoration of Old Men*. *Industrial Landscape* by Lowry was commissioned for the Festival of Britain in 1951. A recent addition, a portrait of *Sir Richard Attenborough*, is by the Leicester artist Bryan Organ.

French Impressionist works include *En Hiver, Moret-sur-Loing* by Sisley and *La Route, Effet de Neige* by Pissarro. *La Rentrée du Troupeau* by Degas is an unusual subject for this artist.

The Gallery's outstanding German collection was begun during the Second World War. Paintings of special interest include Franz Marc's *Red Woman* of 1912, Lotte Laserstein's *Self-Portrait* of 1925 and Lyonel Feininger's *Behind the Church*. There are portraits by Max Liebermann and Louis Corinth *(Carl Ludwig Elias aged 7¼)*, a brilliant gouache of *Red Poppies in a Vase* by Christian Rohlfs and paintings by Max Pechstein, Fritz Schwarz-Waldegg and Ludwig Meidner. Among the wide range of works on paper are woodcuts by Karl Schmidt-Rottluff and Erich Heckel, drawings and set designs by George Grosz *(Kristallnacht)* and lithographs by Max Ernst, Max Beckmann and Kokoschka. The Gallery owns Emil Nolde's striking *Head with Red-black Hair* and a set of *Visions* lithographs printed in 1917 by Max Slevogt as a protest against war. Famous etchings by Käthe Kollwitz include her *Death and Woman* of 1910.

See entry in main text, pages 160–62.

ROCKINGHAM CASTLE
Market Harborough LE16 8TH
Telephone: (0536) 770240

COMMANDER SAUNDERS WATSON
Open: Easter Sun–end Sept Sun, Thurs, BH Mons and Tues following and Tues during Aug 1.30–5.30; other times throughout the year by appointment
Limited access for disabled

Two miles north of Corby on the B670. **12 B/C6**

Rockingham Castle has a number of Old Master paintings, including *Francis I* by Joos van Cleve, and a rare contemporary portrait of *Queen Elizabeth I*. The family portraits date from the sixteenth century and contain fine examples of the work of Lely, *2nd Earl of Rockingham*, Reynolds, *Elizabeth, wife of 3rd Lord Sondes*, and Zoffany, *Children of First Lord Sondes*. There are several paintings by Ben

Marshall, including *The Sondes Brothers in Rockingham Park*, and George Morland's *Shooting in Rockingham Park*.

There is also a modern collection, including works by Sickert, Matthew Smith, Stanley Spencer, Augustus John and Paul Nash.

See entry in main text, pages 162–3.

STANFORD HALL
Lutterworth LE17 6DH
Telephone: (0788) 860250

THE LADY BRAYE
Open: Easter–end Sept Thurs, Sat, Sun, BH Mon and Tues following 2.30–6
Limited access for disabled

Seven miles north-east of Rugby, off the B5414, three miles east of the A5 (M1 Exits 18 and 20, M6 Exit 1). **4 A2**

Portraits belonging to Henry Stuart, Cardinal Duke of York, the last in the line of Stuarts, were bought by Sarah Baroness Braye, and now hang in the Ballroom. They include two portraits of *James II*, and a Lely likeness of *Charles II* and a portrait of Prince Charles Edward, the 'Young Pretender' by L. Pecheux.

The ceiling paintings depict sporting scenes. Among the collection of Stuart relics is a miniature of Mary Queen of Scots, which belonged to Marie de Medici.

The Green Drawing Room is hung with two paintings attributed to Van Dyck, one of *Charles I* and one of *Henrietta Maria*. There is a Cornelius Johnson of *Lady Cave*. There are Cave, Verney and Braye portraits throughout the house. A Bosschaert flower painting hangs in the Grey Drawing Room. There is a Kneller portrait in the Marble Passage.

———— LINCOLNSHIRE ————

BELTON HOUSE ✼
Grantham NG32 2LS
Telephone: Grantham (0476) 66116

NATIONAL TRUST
Open: 1 Apr–end Oct Wed–Sun and BH Mon 1–5.30; last admissions 5
Closed: GF

Three miles north-east of Grantham, on the A607, easily reached from A1. **12 B4**

An outstanding Restoration house, dating from 1685–6, Belton was given to the National Trust in 1984 by Lord Brownlow, together with some of the contents.

The huge paintings by Melchior de Hondecoeter of garden scenes were

installed in the Hondecoeter Room in 1877, and are among this seventeenth-century Dutch artist's finest achievements. Jan Weenix's *Dead Swan* is over the fireplace in the same room.

There is a good selection of family portraits. Many members of the family sat more than once. *Dorothy Mason* appears as one of the set of full-lengths by John Riley in the Saloon, dating from about 1685, and as a Kneller full-length on the stairs, facing the beautiful *Adelaide, Countess Brownlow* by Lord Leighton. *Lord and Lady Tyrconnel*, an early conversation piece, was one of Philippe Mercier's first English commissions. The group portrait of *Lady Cust and her Children* was Enoch Seeman's last work and includes a son who was painted by Reynolds as *Sir John Cust, Speaker of the House of Commons*. Other family members are portrayed in oils by Romney, Hoppner and G. F. Watts, and in pastels by William Hoare.

In the Red Drawing Room, among the small subject paintings that remain at Belton, is a *Madonna and Child* attributed to Fra Bartolommeo.

Lely's full-length *Charles II* is in the Marble Hall and in the Blue Bedroom is a view of the incomplete *Palace at Greenwich* in about 1729, by Robert Griffier. The fine portrait of a *White Bull* in the East Corridor is by John Ferneley.

On the West Staircase is a striking seventeenth-century view of Belton House. Henry Bug, 'Young' Sir John Brownlow's porter, is depicted in it holding the mace that now hangs besides the painting.

BOSTON GUILDHALL MUSEUM
South Street, Boston PE21 6HT
Telephone: (0205) 65954

BOSTON BOROUGH COUNCIL
Open: all year, Mon–Sat 10–5; Apr–end Sept Mon–Sat 1.30–5; Conducted tours by arrangement
Closed: CE, CD, BD, NYD
Access for disabled to ground floor only

The Guildhall Museum is in the centre of the town. **12 D4**

On view at the Guildhall are oils by William Etty, George Morland, T. S. Phillips, Richard Wilson and watercolours by Wainwright, Pearson and W. B. Thomas.

DODDINGTON HALL
Doddington LN6 4RU
Telephone: (0522) 694 308

MR AND MRS A. G. JARVIS
Open: May–Sept Wed, Sun, BH Mon,
2–6 also Easter Mon
Access for disabled to ground floor only

In Doddington, five miles west of Lincoln
on the B1190. **12 B3**

Robert Smythson built the Hall, which
houses paintings collected by four families.
One of the finest portraits in the collection
is Sarah, Lady Pollington with her husband
and son, dressed for the Coronation of
George III, by Reynolds.

Equally delightful is *Sarah Gunman* by
Sir Thomas Lawrence. The full-length
portrait of Sir Francis Delaval by Reynolds
on the Front Stairs should also not be
missed.

Cymon and Iphigenia by Lely and *Meg
of Meldon* by Gheeraerts hang in the
Parlour. There is a collection of late
seventeenth- and early eighteenth-century
nautical pictures on the Upper Stairs.

GUNBY HALL �
Near Spilsby, PE23 5SS

NATIONAL TRUST
Open: 1 Apr–end Sept Wed 2–6; last
admissions 5.30; also Tues, Thurs, Fri by
written appointment
Closed: Public holidays
No access for disabled

Seven miles west of Skegness near the
village of Candlesby, south of the
A158. **13 A3**

Tennyson's description of the house as 'a
haunt of ancient peace' hangs in the hall
in his handwriting. This Lincolnshire
squire's home was built by Sir William
Massingberd, whose family lived there
until 1963.

There are two Reynolds portraits, one
of Bennet Langton and the other of his
wife, the Countess of Rothes. The same
couple are also portrayed by Carl Frederick
von Breda, a student of Reynolds. The
collection of Stuart miniatures includes
the Old and Young Pretenders and Marie
Sobieski.

USHER GALLERY
Lindum Road, Lincoln
Telephone: (0522) 27980

LINCOLNSHIRE COUNTY COUNCIL
Open: Mon–Sat 10–5.30, Sun 2.30–5
Access for disabled

The Gallery is near the centre of Lincoln,
which can be reached from the A46, A57
or A158. **12 C3**

The Lincolnshire jeweller James Ward
Usher began the collection in the late
1800s, purchasing with the fortune he had
made selling replicas of the 'Lincoln Imp'.
His contributions to the present fine art
collection are the English and Continental
Miniatures.

The most important works in the Usher
Gallery collection are those by Peter de
Wint. In addition, there is a good
collection of local and topographical work
associated with Lincolnshire.

Peter de Wint was born in Staffordshire
and met William Hilton, who brought
him to Lincoln. The Gallery houses a
large selection of his work as well as
many of his manuscripts and personal
items. Paintings by de Wint include *Gleam
of Sunshine After Rain, Dock Leaves, Dieppe
Castle, Newark Castle* and *Cottage at
Aldbury*.

Among the artists associated with
Lincolnshire and represented in the collec-
tion are William Hilton, James Bourne,
Charles Haslewood Shannon, William
Logsdail and William Warrener.

Several examples from Italian, Dutch
and Flemish Old Master Schools and a
selection of contemporary British works
are also part of the collection. There is a
large selection of Lincolnshire topograph-
ical paintings and watercolours and
drawings by local people. A permanent
collection of portraits and memorabilia
relating to Tennyson are housed in the
gallery.

MERSEYSIDE

ATKINSON ART GALLERY
Lord Street, Southport PR8 1DH
Telephone: (0704) 33133

SEFTON METROPOLITAN BOROUGH
COUNCIL
Open: Mon–Fri 10–5, Thurs and Sat 10–1
Admission Free: Access for disabled

Southport is on the coast north of
Liverpool and can be reached via the
A565 or A570. **11 A1**

The Atkinson's strength is undoubtedly
its fine collection of Victorian paintings,
which includes interesting landscapes as
well as genre painting. There is also a
small but well-chosen collection of eight-
eenth-century painting, good Scottish
School art, and a group of British

twentieth-century art by artists associated
with the New English Art Club and
Bloomsbury.

Paintings and sculptures include *The
Duchess of Portsmouth* by Lely, *The Little
Theatre* and *Sinn Feiners* by Sickert, *Three-
Way-Piece-Points* by Moore, *Maria Donska*
by Epstein and *Street Scene* by L.S. Lowry.

There are watercolours by Cotman,
Rowlandson, Fielding, Crome, Boning-
ton, Cox and Lewis. Other works are by
Richard Ansdell, Thomas Sidney Cooper,
Thomas Creswick and Benjamin Williams
Leader.

See entry in main text, pages 99–100.

CROXTETH HALL
Croxteth
Telephone: (051 228) 5311

LIVERPOOL CITY COUNCIL
Open: all year, ring for times
Limited access for disabled

Signposted from the A580 and A5058 five
miles north-east of Liverpool City Centre.
11 A2

Croxteth was the home of the Molyneux
family, Earls of Sefton. It passed into
public ownership in 1973, and has been
furnished in the Edwardian style. It has
an extensive collection of paintings from
the Walker Art Gallery, including a
number of portraits of members of the
Molyneux family.

The works of art include *Lady Mary
Molyneux* by Jacob Huysmans, *The Quorn*
by John Ferneley, *Mischief in a Park* and
The Monarch of Pastureland by Charles
Towne, *A Dead Hare* by Richard Ansdell,
Partridge Shooting by Samuel Alken, *Scottish
Loch with Black Grouse* by F. R. Lee, and
Eve of the Battle of Edge Hill by Charles
Landseer.

THE LADY LEVER ART
GALLERY
Port Sunlight, Merseyside L62 5EK
Telephone: (051 645) 3623

NATIONAL MUSEUMS AND GALLERIES ON
MERSEYSIDE
Open: Mon–Sat 10–5, Sun 2–5
Admission Free: Limited access for disabled

The gallery is in the centre of Port
Sunlight which is due south of Birkenhead
and the Mersey Tunnel on the A41 and
10 miles north of Chester. **11 A3**

The Gallery and its remarkable collection
of English art, beautifully displayed, were
given to the public by William Hesketh,

1st Viscount Leverhulme (1851–1925), and opened in 1922. The collection records, almost entirely, his taste, and is housed in a charming neo-classical building in the middle of the model village of Port Sunlight. It is named after Leverhulme's wife, Elizabeth Ellen, Lady Lever.

The central gallery is one of the most beautiful ensembles of Victorian art in the country. Holman Hunt is represented by his masterpiece, the enigmatic *The Scapegoat,* and by *May Morning on Magdalen Tower. Sir Isumbras at the Ford* and *Spring (Apple Blossoms)* by Millais hang close to Lord Leighton's luxurious *The Garden of the Hesperides.* At one end of the gallery is his vast processional, *The Daphnephoria,* balancing Sargent's *On His Holidays* at the other end.

There are major paintings by Burne-Jones: *The Annunciation, The Tree of Forgiveness* and *The Beguiling of Merlin,* as well as Rossetti's *Blessed Damosel* and Leighton's *Fatidica: The Prophetess.* A side gallery of Burne-Jones's works on paper includes one of his life-size watercolours, *Sponsa di Libano.*

Good examples of Millais's several specialities are to be seen: historical subjects like *The Black Brunswicker* and *An Idyll of 1745,* the sentimental *The Nest* and a portrait of *Lord Tennyson; Lingering Autumn* reveals his skill as a landscapist.

The less famous Victorians are well-served by the Gallery, which owns works showing them at their best, notably Herkomer's *The Last Muster* and Joseph Farquharson's *The Shortening Winter's Day.* There are highly decorative paintings by Luke Fildes and E. J. Gregory – one of the most attractive is Alma-Tadema's *The Tepidarium.* Ford Madox Brown's historicism is to be seen in *Cromwell on his Farm, St. Ives, 1630.*

In the eighteenth-century gallery are impressive portraits by Reynolds: *The Sacrifice of Hygeia (Mrs Peter Beckford)* and *Elizabeth Gunning, Duchess of Hamilton and Argyll;* also a glamorous portrait of *Lady Hamilton as a Bacchante* by Mme Vigée-Lebrun. In an adjoining room are Stubbs's *Haymakers* and *Haycarting,* wonderfully delicate examples of his work.

Landscapes by Richard Wilson in the eighteenth-century gallery include the tranquil *Lake Scene: Castel Gandolfo* and the tempestuous *The Unransomed: Rocky Waterfall with Bandits.* Among other fine landscapes are Gainsborough's *The Gad's Hill Oak, Rochester,* Constable's *The Gamekeeper's Cottage* and *The Falls of Clyde* by Turner. Many excellent watercolours by Turner, de Wint, Cox and Constable can be seen in a side gallery,

along with W. H. Hunt's revealing sketch of Turner.

In other side galleries are Ramsay's *Dinwiddie Sisters* and Zoffany's *Robert Baddeley as Moses in 'The School for Scandal'.* The group of works by Etty reflects his interest in Rubens.

In the upstairs galleries are twentieth-century British paintings as well as paintings bought by Lord Leverhulme to advertise his soap. Frith was particularly dismayed when his *The New Dress* suffered this treatment.

See entry in main text, pages 97–9.

LIVERPOOL MUSEUM

William Brown Street, Liverpool
Telephone: (051 207) 0001

NATIONAL MUSEUMS AND GALLERIES ON MERSEYSIDE
Open: Mon–Sat 10–5; Sun 2–5
Admission Free: Access for disabled

William Brown Street is in the centre of the city; the museum is beside the Walker Art Gallery. 11 A2

There are two fine art holdings at the William Brown Street museum: the collection of marine paintings, and the Ince Blundell collection of classical sculpture.

The collection of marine paintings contains over 600 works in oil, watercolour and other graphic media. They include work by Liverpool artists from the late eighteenth century to the present.

Liverpool had a flourishing Marine School, as it did of artists more generally, and works by Robert Salmon, Jenkinson, Samuel Walters and Joseph Heard demonstrate the high quality of art produced. Less well-known painters like W. H. Yorke, Joseph Witham, Parker Greenwood and others are included in the collection, a representative showing of which is on display.

The Ince Blundell collection of classical sculpture was assembled in the late eighteenth century, and is one of the few major collections which has been kept together. Its importance can hardly be overestimated.

The strength of the collection lies in its diversity, ranging over statuary, urns, reliefs and portrait busts. A significant number of the works are Greek, with a larger holding of Roman, and of Roman copies of Greek works. The collection is well catalogued.

ST HELENS MUSEUM AND ART GALLERY

College Street, St Helens, WA10 1TW
Telephone: (0744) 24061

BOROUGH OF ST HELENS
Open: Tues–Fri 10–5, Sat 10–4
Admission Free: Access for disabled

The museum is at the corner of College Street and Corporation Street. It can be reached via the A580, the M6 or M62.
11 A2

The selection of works on view from the permanent collection includes watercolours and oils by local artists of the nineteenth and twentieth centuries. There are twenty works from a special collection, *The Spirit of St Helens.*

Of more general interest, the group of oil paintings donated by Alderman Beecham includes some of the 'Pears' pictures from the turn of the century. In a sense these inspired Lord Leverhulme's collecting, since his first acquisitions were bought in order to use as competitive advertising in the 'soap war' between the two manufacturers.

The Guy and Margery Pilkington collection of nineteenth-century watercolours includes works by Copley Fielding, Birket Foster, Peter de Wint and Daniel Cox among others, as well as quite a few landscapes.

SUDLEY ART GALLERY

Mossley Hill Road, Liverpool
Telephone: (051 724) 3245

MERSEYSIDE COUNTY COUNCIL
Open: Mon–Sat 10–5, Sun 2–5
Admission Free: Limited access for disabled

The house is on the outskirts of Liverpool.
11 A2

This early-nineteenth-century house and grounds, together with its collection of pictures, was bequeathed to the city of Liverpool by Miss Emma Holt in 1944. She had inherited them from her father George Holt (1825–96), a member of an influential Liverpool merchant family.

The 148 works in the bequest formed a major part of her father's collection. He had begun collecting in the later 1860s, choosing contemporary British artists of the academic school. Later he bought prints, watercolours and miniatures and finally turned to the great names in English art of the eighteenth and early nineteenth centuries.

See entry in main text, pages 95–6.

TATE GALLERY IN THE NORTH

Albert Dock L3 4BB
Telephone: (051) 709 3223

TRUSTEES OF THE TATE GALLERY
Open: Tues–Sun 11–7
Admission Free: Access for disabled

By the River Mersey, next to Pier Head, about 10 minutes' walk from city centre. **7A2**

For many years the Tate Gallery has been unable to show more than a small fraction of its permanent collection at its London headquarters because of lack of space. There has also been a strong feeling that the gallery ought to make its collections more widely available outside London. The Tate Gallery in the North was opened in 1988 to answer these needs. One of the magnificent former warehouses in Liverpool's Albert Dock has been converted with considerable success by James Stirling to show regularly changing exhibitions of works from the Tate's permanent collection of British and international modern art. These exhibitions have included important surveys of British Surrealism and Minimalist art, and the gallery now occupies a central place in the lively artistic life of the city.

UNIVERSITY OF LIVERPOOL GALLERY

3 Abercromby Square, Liverpool
Telephone: (051) 794 2000

UNIVERSITY OF LIVERPOOL
Open: Wed and Fri 12–4; Mon, Tues, Thurs 12–2
Closed: Public holidays and August
Admission Free: No access for disabled

The University is east of the city centre along Mount Pleasant. Abercromby Square is in the University precinct. **7 A2**

There is a significant group of portraits painted by Augustus John through the first 30 years of this century, probably as a result of his teaching in the University School of Architecture and Applied Art in 1901–2. Also important are oils and watercolours by John James Audubon, probably the best collection of original works by this artist in the British Isles; he visited Liverpool in 1826. There are good collections of early English watercolours and porcelain, also Greek and Russian icons, and paintings from the early eighteenth century to the present.

See entry in main text, page 97.

WALKER ART GALLERY

William Brown Street Liverpool L3 8EL
Telephone: (051) 207 0001

NATIONAL MUSEUMS AND GALLERIES ON MERSEYSIDE
Open: Mon–Sat 10–5; Sun 2–5
Admission Free: Limited access for disabled

William Brown Street is in the centre of the city. **7 A2**

The Walker Art Gallery has the richest collection of all English municipal galleries outside London, and stands comparison with the Fitzwilliam in Cambridge, the Ashmolean in Oxford and the galleries in Edinburgh and Dublin.

The earliest Italian works here include the Simone Martini *Christ discovered in the Temple*, a late work, Sienese in spirit but painted in Avignon in the first half of the fourteenth century, highly expressive and human. The fifteenth-century *Pietà* by Ercole de' Roberti is another masterpiece, this time from Ferrara, the source of several early works in the collection. Florentine art is also well represented, with paintings like Spinello Aretino's *Salome*. The drawing, *Christ and the Woman of Samaria*, is attributed to Michelangelo, and there is a *Votive Painting* which may be an early Raphael. The chronological range is wide, from Camaldolese and Rosselli to Giovanni Bellini *(Young Man)*, Jacopo Bassano and Veronese.

The vast holding of Italian art includes seventeenth-century works, among them Salvator Rosa's *Landscape with a Hermit*, Solimena's *Naming of St John the Baptist*, and large paintings by Pittoni and Mattia Preti. Nineteenth-century artists include Giovanni Segantini, whose *Punishment of Luxury* is one of the most bizarre paintings here.

Joos van Cleve's *Virgin and Child with Angels* is an early work by a major Antwerp artist. The Gallery owns the wings of a Cologne altarpiece by the Master of the Aachen Altarpiece, and displays them with the central panel, *The Crucifixion*, on loan from the National Gallery. Jan Mostaert's *Portrait of a Young Man* and Rubens's *Virgin and Child with Saints Elizabeth and John the Baptist* are also in the collection.

In German art, there is the delectable *Nymph of the Fountain* by Lucas Cranach the Elder and *Mercenary Love* by Hans Baldung Grien. *Apollo and Coronis* by Elsheimer is one of the smallest but also one of the most beautiful paintings at the Walker. The eighteenth-century *Self-Portrait* by Mengs shows the artist in his working clothes.

Dutch paintings include a rare early panel by the Master of the Virgo inter Virgines, a 1630 *Self-Portrait* by Rembrandt and an austere *Mary Magdalene* by Paulus Bor. There are other good Dutch paintings by Jan Steen and Salomon van Ruysdael *(River Scene with Ferry Boat)*.

Early French paintings include *A Lady with a Parrot*, from the workshop of Clouet. *Landscape with the Ashes of Phocion* by Poussin was formerly in the Derby collection and is one of a pair, the other being in the National Museum of Wales at Cardiff. It now hangs with Charles Le Brun's tapestry design, *Atalanta and Meleager*, and with works by Dughet and Monnoyer. *The Guitar Player* by Jacob van Schuppen is a delightful family portrait of the early eighteenth century. Later French painting is spread through the Gallery. On the heroic scale, there are Louis Daguerre's *Ruins of Holyrood Chapel* and Delaroche's *Napoleon Crossing the St Bernard*. The later nineteenth-century art is more intimate, with a cross-section of painting from Courbet to Vlaminck. One of the most fascinating pieces in the Gallery is a dark and violent sketch by Cézanne, *The Murder*, in his early style. Degas's *Woman Ironing* and Vlaminck's *Surroundings of Rouen* are among the highlights here; also of interest are paintings by Vuillard, J.-H. Marchand and Matisse – his near-abstract *The Bridge*.

The fine collection of British art traces its development from the reign of Henry VIII to the present. In seventeenth-century painting, Dobson's *Executioner with the Head of John the Baptist* is an unusual example of his work, a copy of a painting by Mathias Stomer. There are handsome portraits by Paul van Somer and John Riley. The Knellers include *Alexander Pope* and a full-length *Charles II*, painted in the last year of the King's life.

The eighteenth-century portraits are outstanding: Hogarth's *David Garrick as Richard III*, Dahl's graceful *Henrietta, Countess of Ashburnham* and Gainsborough's full-length *Isabella, Viscountess Molyneux, later Countess of Suffolk*. Of special interest are the many paintings by Stubbs and Wright of Derby. In *The Lincolnshire Ox*, Stubbs aligns a gigantic ox with a gamecock and a man in an amusing juxtaposition. *The Green Monkey* demonstrates his genius for painting the exotic. Paintings by Wright of Derby include the fireworks scene, *Easter Morning at Rome: La Girandola*, the chilling *The Old Man and Death*, and a portrait of the formidable character, *Richard Gildart*.

The Walker is exceptionally strong in nineteenth-century British painting. This includes Millais's haunting *Lorenzo and Isabella*, the more conventionally appealing *Faithful unto Death* by Poynter and that great example of Victorian history painting, *'And When Did You Last See Your Father?'* by W. F. Yeames. Some of the other outstanding paintings here are *Echo and Narcissus* by Waterhouse, *Perseus and Andromeda* by Lord Leighton and *The Coat of Many Colours* by Ford Madox Brown. The classical world is recreated in Albert Moore's *A Summer Night* and Poynter's *On the Terrace;* the medieval in Maclise's *Madeline after Prayer* and Rossetti's vast *Dante's Dream*. Worth noting, too, is the group of smaller paintings by G. F. Watts which includes *Hope* and the set of the *Four Riders of the Apocalypse*.

The sheer intensity of *Samson* by Solomon J. Solomon and of *Venus and Anchises* by Sir W. B. Richmond may be too much for modern taste, but the social message of von Herkomer's *Eventide* is still powerful. The Gallery owns two interpretations of *The Death of Nelson*, by Benjamin West and Daniel Maclise. There are remarkably fine paintings by less well-known artists, like A. W. Hunt, W. L. Windus and William Davis, and scenes of Victorian rural life by F. G. Cotman, John Linnell, Richard Ansdell and William Huggins. The Mediterranean and Middle Eastern side of Victorian art is represented by Edward Lear's *Bethlehem* and David Roberts's *Baalbec*.

Among the British paintings of the later nineteenth and early twentieth centuries are good portraits: Tissot's *Catherine Smith Chapple Gill and Two of her Children* and Lavery's *Hazel in Rose and Gold*. There are characteristic works by Dicksee, Fildes and Holl, and masterly examples of the art of Stanhope Forbes, including *A Street in Brittany*. *Vespers* is one of Sargent's superb subject paintings. He was an admirer of Anne Swynnerton, who is represented in the collection, along with better-known artists like Sickert. Indeed, one of the pleasures of the Walker is the quality of the work by artists who are no longer familiar names to most gallery-goers.

Among the Camden Town group paintings, Gilman's *Camden Town* and *Mrs Mounter* with her teapot take pride of place. There is an outstanding *Landscape of the Moon's Last Quarter* by Paul Nash, Christopher Wood's *Still Life with Tureen and Fruit* and Stanley Spencer's *Villas at Cookham*. Portraits include Augustus John's *Two Jamaican Girls*.

Contemporary art includes the *Interior in Paddington* painted by Lucian Freud in 1952 and David Hockney's well-known *Peter Getting Out of Nick's Pool*. *The Red Banquet* by R. B. Kitaj and works by Patrick Caulfield and Victor Pasmore are also in the collection. Mary Martin's *Cross* was a prizewinning entry in the 1969 John Moores competition at Liverpool; the collection is rich in Liverpool artists and in bequests from Liverpool citizens - an expression of the city's proud status in the eighteenth, nineteenth and twentieth centuries.

See entry in main text, pages 91-5.

WILLIAMSON ART GALLERY AND MUSEUM

Slatey Road, Birkenhead L43 4UE
Telephone: (051 652) 4177

WIRRAL BOROUGH COUNCIL
DEPARTMENT OF LEISURE SERVICES & TOURISM
Open: Mon-Sat 10-5; Thurs 10-9; Sun 2-5
Admission Free: Access for disabled

The Art Gallery is in Oxton, just outside Birkenhead. Leave the M53 at Junction 3 and follow signposts to Preston and then to the gallery. If approaching from Liverpool, travel through Birkenhead tunnel, turning right at the traffic lights on Borough Road. **11 A2**

The Williamson Art Gallery houses an excellent collection of eighteenth- and nineteenth-century watercolours. Collections of British oil paintings include work by Victorian artists (Evelyn de Morgan, Moore, Alma-Tadema, Sandys) and Liverpool artists (Bond, Huggins, Oakes, Tonge, etc.) as well as an important collection of works by Philip Wilson Steer, who was born in Birkenhead in 1860.

See entry in main text, page 101.

———— NORFOLK ————

BLICKLING HALL 🌿

Blickling, Norwich NR11 6NF
Telephone: Aylsham (0263) 733084

NATIONAL TRUST
Open: 31 Mar-28 Oct daily except Mons, Thur 1-5; also BH Mons
Closed: GF
Access for disabled

15 miles north of Norwich on the north side of the B1354, one mile north-west of Aylsham. **13 C5**

This splendid Jacobean house was built for Sir Henry Hobart and his son John between 1619 and 1627 and designed by Robert Lyminge, who was also responsible for Hatfield House.

Its art consists mainly of a collection of family portraits, among them Daniel Mytens's excellent *Henry Hobart, 1st Baronet*. Michael Dahl's delightful *Henrietta Howard, Countess of Suffolk* shows the mistress of Marble Hill House, Twickenham (q.v.) in masquerade dress. It is one of a noteworthy group of full-length portraits of Whig aristocrats, including *Sir Robert Walpole* and *'Turnip' Townshend*, commissioned by the 1st Earl of Buckinghamshire from William Aikman and his contemporaries. Most of these have recently been rehung in the Great Hall.

Earlier portraits at Blickling include Zucchero's sixteenth-century *Queen Elizabeth I*, anonymous seventeenth-century portraits of *Anne of Austria* and *Sir John Maynard* and a beautiful *Mary Howard* from the studio of Van Dyck. There are Miereveldt portraits of the *7th Earl of Derby* and his Countess, and a double portrait of *Lady Drury and Her Daughter Mary*, attributed to Ramsay. The equestrian *George II* is by John Wootton and Charles Jervas; the full-lengths of the *2nd Earl of Buckinghamshire* and his wife by Gainsborough. Kneller, Benjamin West and Reynolds are represented in the collection, as is the Victorian artist John Leslie (*Constance, Lady Lothian*).

A lovely Canaletto view of *Chelsea from the Thames*, painted in the late 1740s, is only half of a divided work, the other half being in a private collection in Cuba. A 1760s view of the unfinished *Blackfriars Bridge* is attributed to Samuel Scott. The set of drawings by Christoph Heinrich Kniep commemorates the journey he made with Goethe which was recorded in the latter's *Italian Journal*.

CASTLE MUSEUM, NORWICH

Norwich NR1 3JU
Telephone: (0603) 611277

NORFOLK MUSEUMS SERVICE
Open: Mon-Sat 10-5, Sun 2-5
Access for disabled

The museum is on Castle Meadow or Bell Avenue in Norwich. **13 C5/6**

The Castle Museum in Norwich is famous for its collection of paintings and drawings of the Norwich School, with particularly good examples of the two major figures in the movement, John Sell Cotman and John Crome.

The Cotman Room, like the Crome Gallery part of the Colman Bequest, is devoted to landscapes by Cotman from Norfolk, Wales, Yorkshire and Normandy. These include a comprehensive collection of his oils, among them *Silver Birches*, and his unfinished last oil, *From my Father's House at Thorpe*. Cotman's famous watercolours include views from the Greta River and dramatic late works like *Storm on Yarmouth Beach* (1831). A selection of these are on display, with some of his early etchings.

The Museum's holdings of oils by John Crome, among them versions of *Yarmouth Jetty* and *New Mills: Men Wading*, are accompanied by works on paper. The Museum also owns the copper plates of Crome's etchings.

The Norwich School is further represented by oils by Crome's pupil James Stark and by the Stanford family, watercolours of Norwich by Cotman's brother-in-law John Thirtle and by Henry Ninham, and other Norwich artists.

A room of Dutch and Flemish paintings serves to put into context the Norwich School and shows the influence of Dutch landscape artists like Hobbema and Ruisdael upon East Anglian painters. Of particular interest is Jan van Goyen's *River Landscape*, a large *Tower of Babel* attributed to Tobias Verhaecht and the anonymous *Yarmouth Collection*. This magnificent still life records treasures owned by the Paston family in the mid-seventeenth century. Rembrandt etchings from the Percy Moore Turner Bequest are also exhibited.

British eighteenth-century paintings include a group of works by the Antwerp-born Peter Tillemans, Richard Wilson's *The Thames at Twickenham* and Benjamin West's *Venus comforting Cupid stung by a Bee*. There are conversation-piece portraits by Francis Wheatley and Henry Walton (*Sir Robert and Lady Buxton and their Daughter*). The colourful *Autumn* is by the Norwich Pre-Raphaelite Frederick Sandys, and the large tempera *Annunciation* by Edward Burne-Jones.

Sir Alfred Munnings is represented by a group of oils including *Gravel Pit in Suffolk*. There are examples of work by Edward Seago and Sir Arnesley Brown.

There is a small collection of mainly British paintings in the Modern Art Gallery, ranging from a street scene by Sisley to oils by Sickert and Gwen John (*Girl in a Blue Dress Holding a Piece of Sewing*). There are characteristic works by David Bomberg, Ivon Hitchens, Anne Redpath (*Spanish Village*), John Piper, Edward Middleditch and Bridget Riley. Lowry selected *Landscape with Farm Buildings* for presentation in 1955. Paintings

with Norwich connections include Tom Phillips's *The Castle, Norwich...The Splendour Falls*, a crowd portrait by Michael Andrews of *The Lord Mayor's Reception in Norwich Castle Keep* and a recent acquisition, *The Life Room* by John Wonnacott, which celebrates the local art school.

See entry in main text, pages 188-91.

EUSTON HALL

Near Thetford IP24 2QW
Telephone: (0842) 766366

DUKE OF GRAFTON
Open: 24 June-2 Sept; Thurs only 2.30-5.30
Limited access for disabled

Three miles south-east of Thetford on the A1088 road to Bury St Edmunds. **6 B3**

Lord Arlington's collection includes portraits of Charles I and his court. Among those by Van Dyck is an outstanding portrait of *Queen Henrietta Maria*, and a very fine group portrait of their five eldest children, which hangs in the Outer Hall.

The other seventeenth- and eighteenth-century full-length portraits are *Henry Bennett, Lord Arlington* by Sir Peter Lely, *George Villiers, Duke of Buckingham* by Daniel Mytens and *James, Duke of Monmouth* by William Wissing. There is a Lely portrait of Barbara Villiers, Duchess of Cleveland and her son, later first Duke of Grafton, in a Madonna and Child pose.

The Stubbs *Mares and Foals by the River at Euston* hangs in the Small Dining Room. With it is a view of Euston in the eighteenth century with a deer hunt in progress.

Among the pictures on the Staircase is a splendid painting of the great Ball at The Hague, the night before Charles II's return to England in 1660.

See entry in main text, page 188.

FELBRIGG HALL ☙

Felbrigg, Norwich NR11 8PR
Telephone: West Runton (026 375) 444

NATIONAL TRUST
Open: 31 Mar-28 Oct daily except Tues, Fri 1.30-5.30
Closed: GF
Access for disabled

On the south side of the A148 two miles south-west of Cromer and 22 miles due north of Norwich. **13 C4**

Felbrigg contains a remarkably intact Grand Tour collection, assembled by the

Georgian owner William Windham II, and still hung as he arranged it after inheriting the house in 1749.

The Drawing Room features Willem van de Velde's *Battle of the Texel*, one of the seventeenth-century Dutch marine paintings acquired by Windham on his continental travels or soon thereafter. The large Samuel Scott views of *The Tower of London* and *Old London Bridge* may have been commissioned for this room. Windham remodelled the Cabinet in 1751 for his Grand Tour paintings: gouache and oil views of Italy by G. B. Busiri, bought in Rome in 1739-40, flower paintings by Karel van Vogelaer, and Simon de Vlieger's *Blockade of Amoy*.

Family portraits hang throughout the house. Kneller's *Sir James Ashe, Bt.* and *Sir William Paston Bt.* (attributed to Dobson) are in the Great Hall; the particularly impressive *William Windham I*, attributed to John Greenhill, is in the Dining Room. Frans van der Mijn painted *Benjamin Stillingfleet*, the scholar who accompanied William Windham II to Italy in 1738, and inspired the term 'bluestocking'. In the Rose Bedroom is an entertaining caricature of 1778 by Humphry Repton, showing the politician *William Windham III* condemning Lord North for the continuing war with America. The late Reynolds portrait of *George James Cholmondeley* was exchanged by the sitter for a Reynolds of his friend Windham, now in the National Portrait Gallery, London.

See entry in main text, page 187.

GREAT YARMOUTH MUSEUMS EXHIBITION GALLERIES

Central Library, Off South Quay,
Great Yarmouth NR30 2SH
Telephone: (0493) 858900

NORFOLK MUSEUMS SERVICE
Open: Summer Sun-Fri 10-5.30
Winter Mon-Fri 10-5.30
Admission Free: Access for disabled

Great Yarmouth is 19 miles from Norwich on the A47. **13 D6**

The collections chiefly comprise landscape and marine pictures from the nineteenth and twentieth centuries. These are mainly local scenes, by local artists. There is a small collection of Norwich School pictures, some oils and watercolours and a sketch book by the Joy Brothers.

Among the Norwich School works are George Vincent's *The Dutch Fair on Yarmouth Beach, Yarmouth Jetty, On the Seashore* and *Tetley Water*, all by A.

Stannard, and works by Ladbrooke and others.

A small permanent display of the Museums' pictures can be seen at the Elizabethan House Museum, Great Yarmouth, including *The Dutch Fair* by George Vincent and *Burgh Castle* by A. Stannard.

See entry in main text, page 193.

HOLKHAM HALL

Wells-next-the Sea NR23 1AB
Telephone: (0328) 710227

VISCOUNT COKE
Open: June–Sept Sun, Mon, Thurs 1.30–5; July and August Sun, Mon, Wed, Thurs 1.30–5; BH Mons 11.30–5
Access for disabled

Two miles west of Wells, off the A149 Hunstanton road. **13 B4**

Holkham Hall, the Norfolk home of the Earls of Leicester, has a fine collection of paintings and sculpture, and was built, in part, for the display of these works, with an extensive Statue Gallery. It contains the fine Greek bust of *Thucydides*, a statue of *Diana*, by tradition believed to have been owned by Cicero, and an outstanding standing figure of *Seilenos*.

In the Drawing Room is a splendid Claude, *The Flaying of Marsyas*, Pietro de Pietri's *Madonna in Gloria* and a Nicolas Poussin storm scene.

A late Gainsborough portrait, *William Coke, First Earl of Leicester,* hangs above the fireplace in the Saloon, and close by it is the most distinguished work at Holkham, *Return of the Holy Family*, by Rubens. There are portraits by Maratta, Van Dyck, Kneller, Johnson and Richmond.

A Batoni portrait of Thomas William Coke ('Coke of Norfolk') hangs in the South Dining Room, together with works after Titian and Holbein.

In the Landscape Room hang several Claudes, and works by Nicolas Poussin and his brother-in-law, Gaspard Dughet.

The Brown State Bedroom contains Sangallo's copy of the Michelangelo cartoon for the Hall of the Great Council in Florence, of which the original has been destroyed.

HOUGHTON HALL

Houghton, Norfolk
Telephone: (048 522) 569

THE MARQUESS OF CHOLMONDELEY
Open: Easter–Sept Sun, Thurs and BHs 1–5.30

Access for disabled

13 miles east of King's Lynn, 10 miles west of Fakenham; turn off the A148 in East Rudham, follow signs to Great Bircham. **13 B5**

Houghton Hall, which was designed by Colen Campbell, formerly contained the splendid collection of paintings assembled by Sir Robert Walpole at the beginning of the eighteenth century, and which now forms the nucleus of the magnificent Hermitage Collection in Leningrad.

One of them, Kneller's portrait of *Juan Carreras*, Spanish poet and chaplain to Catherine of Braganza, became available for re-purchase in 1972, and now hangs where it originally was, in the early 1700s. It serves to underline the thinness of the fine art, set against the truly magnificent house, with its decorations by William Kent, who also painted the Great Staircase murals.

A striking John Wootton portrait of *Sir Robert Walpole* hangs in the impressive Stone Hall, and another, by Van Loo, in the Maratti Parlour. The White Drawing Room, once known as the Carlo Maratti room, since it contained no less than ten canvases by this, Walpole's favourite painter, now contains works by Oudry, Rosalba Carriera, and a Hoppner portrait of *The First Marquess of Cholmondeley.*

A Cholmondeley married Walpole's daughter, Mary, and Houghton was inherited by the 1st Marquess from the 4th Earl of Orford, who died unmarried.

If Houghton Hall inclines towards being an example of that familiar story, a house magnificent in everything except its paintings, this is in part redeemed by William Orpen's early masterpiece, *The Play Scene from Hamlet*, bought by the 5th Marquess's wife, Sybil Sassoon, from the Slade. It hangs in the Saloon. Apart from its splendour as a canvas, it has some of the qualities of a *roman-à-clef* since it contains portraits of Orpen's contemporaries, including Rothenstein and John.

There are also splendid Gainsborough canvases, including a spirited *Self-Portrait*, and an early Suffolk family group in a landscape.

LYNN MUSEUM

King's Lynn, Norfolk
Telephone: (0553) 775001

NORFOLK MUSEUMS SERVICE
Open: Mon–Sat 10–5

The Lynn Museum is above the Bus Station. **13 A5**

The art collection is mainly of local and topographical works, in oil, watercolour and other graphic media. Mainly in store, researchers welcome on appointment.

OXBURGH HALL ✥

Oxborough, Near King's Lynn PE33 9PS
Telephone: Gooderstone (036 621) 258

NATIONAL TRUST
Open: 31 Mar–Apr, Oct Sat, Sun 1.30–5.30; BH Mon 11–5.30; May–end Sept Sat–Wed 1.30–5.30. Closed: GF
Limited access for disabled

Seven miles south-west of Swaffham off the road to Stoke Ferry which is 14 miles south of King's Lynn. **13 A6**

The house was built in 1482 by the Bedingfeld family, who still live there. *Charlotte Jerningham* by John Opie and *The Third Baronet Paston-Bedingfeld as a Boy* are among the ancestral portraits on view at the Hall.

The most important work of art here is the Altarpiece in the Chapel, recently purchased by the National Trust. Made in Antwerp in *c.* 1515–25, it has a carved central section and painted wings showing scenes from the passion and life of St James of Compostela. Full-length figures of Four Fathers of the Church are painted on the backs of the wings.

THE SAINSBURY CENTRE FOR VISUAL ARTS

University of East Anglia
Norwich NR4 7TJ
Telephone: (0603) 56060

UNIVERSITY OF EAST ANGLIA
Open: Tues–Sun 12–5
Closed: Mons and BHs and during Christmas University holidays
Access for disabled

In the University of East Anglia. **13 C5/6**

The collection, given to the University of East Anglia by Sir Robert and Lady Sainsbury in 1973, is wide-ranging and modernist, embracing European and tribal art.

There are works by Arp, Bacon, Degas, Epstein, Giacometti, Modigliani, Moore, Picasso and by young contemporary artists. The Henry Moore and Giacometti sculptures, particularly, are complemented by studies and other drawings.

Among the antiquities are Egyptian faience and bronze figures, Greek Cycladic sculpture, Etruscan and Roman bronzes as well as medieval and oriental sculpture, Indian and Japanese painting.

See entry in main text, pages 191–2.

SANDRINGHAM HOUSE

King's Lynn
Telephone: (0553) 772675

HER MAJESTY THE QUEEN
Open: 29 Apr-30 Sept Sun-Thurs
11 (12 on Sun) to 4.45
Closed: 16 Jul-4 Aug and when Royal Family is in residence
Access for disabled

Eight miles north-east of King's Lynn. Signposted off the A149 and A148. **13 A5**

The part of the Royal Collection at Sandringham is essentially Victorian and Edwardian, with portraits by Winterhalter of Queen Victoria and the Prince Consort, and by August Schiatt, Heinrich von Angeli, Bauerle, Gilbert, Martino, Koberwein and others of different members of the Royal Family.

A Big Shoot at Sandringham, by Thomas Jones Barker, captures some of the atmosphere which must have prevailed on sporting occasions so beloved of the then Prince of Wales, the future Edward VII, who is shown with friends, including the Earl of Chesterfield and Major Teesdale, VC.

NORTHAMPTONSHIRE–

ALFRED EAST GALLERY

Sheep Street, Kettering
Telephone: (0536) 410333

KETTERING BOROUGH COUNCIL
Open: Daily 9.30-5
Closed: Sundays
Admission Free: Access for disabled

Kettering is north-east of Northampton on the A43, and can also be reached via the A6 and A6003. **4 A1**

As well as seventy or so pictures by Sir Alfred East, the permanent collection includes a sizeable group of paintings by T. C. Gotch, William Gash and W. T. Wright. Ivon Hitchens and Howard Hodgkin are among the other artists whose work is represented.

ALTHORP

East Haddon, near Northampton
Telephone: (0604) 770006

EARL SPENCER
Open: Daily Sept-Jun 1-5, July-Aug 11-6
No access for disabled

On the A428 from Northampton to Rugby and well signposted. It is five miles from M1 exit 16 and ten miles from exit 18. **4 A2**

Arrangements at Althorp are more satisfactory for those seriously interested in art on connoisseurs' day (Wednesday), when a more comprehensive tour is arranged. At other times certain rooms and important works can only be seen obliquely, and at a distance.

This is not the case, however, with the fine Woottons of Lord Spencer and others riding with the Althorp and Pytchley hunts, and hung in the entrance hall, known as the Wootton Hall.

Nor is it so with the excellent collection of family and other portraits in the Picture Gallery, and in the Saloon and Staircase. These include magnificent examples of Reynolds's best period, among them his portraits of *Lady Anne Bingham* and her sister *Lavinia, Countess Spencer*, both before and after her marriage. There is an earlier Reynolds of the celebrated *Georgiana Spencer*, who became Duchess of Devonshire and traded kisses for votes on behalf of Charles James Fox. Gainsborough is represented by the splendid portrait of *William Poyntz*, with gun and waterspaniel.

The portrait collection is rich and diverse, with good examples ranging from Van Dyck to William Orpen, William Nicholson and later twentieth-century artists such as Roderigo Moynihan. There is also an interesting collection of artists' self-portraits.

The original library of 40,000 volumes, including 58 Caxtons, was sold entire to Manchester University, leading to the formation of the John Rylands Library.

See entry in main text, page 165.

BOUGHTON HOUSE

Near Kettering
Telephone: (0536) 82248

DUKE OF BUCCLEUCH
Open: Aug daily 2-5.30; last admission 4.30
Parties by written arrangement
Access for disabled

Three miles north of Kettering on the A43. **4 A1**

Boughton House contains part of the superb collection of the Duke of Buccleuch, including works by Van Dyck, El Greco, Carracci, Murillo, Solimena and Cuyp.

In addition to a religious work by Van Dyck, there are important grisaille portrait sketches of his contemporaries.

El Greco is represented by an *Adoration of the Shepherds*, Murillo by *St John the Baptist* and Teniers by a large landscape. The Carracci is of *A Young Man in a Plumed Hat*.

There are portraits by Lely, Closterman, Kneller, Jervas, Van Loo, Gainsborough and Beechey. The Batoni, *The Marquis of Monthermer*, is a fine and dramatic work.

See entry in main text, page 164.

CANONS ASHBY HOUSE ✾

Canons Ashby, Daventry NN11 6SD
Telephone: (0327) 860044

NATIONAL TRUST
Open: 1 Apr-end Oct Wed-Sun and BH Mons 1-5.30 or dusk if earlier (closed GF); Last admission 5
Access for disabled difficult

On B4525 Northampton-Banbury road.

The home of the Dryden family from the 1550s, Canons Ashby contains painted decoration of considerable interest. Chivalric scenes painted in grisaille were recently found beneath panelling in the Spencer Room, and the panels decorated with crests and other devices in the Winter Parlour date from the 1590s. Elizabeth Creed, a cousin of the Drydens, probably painted the Hall overmantel with an array of cannons, muskets and drums. The series of family portraits includes the poet *John Dryden*, after Kneller.

LAMPORT HALL

Lamport NN6 9HB
Telephone: (060 128) 272

LAMPORT HALL PRESERVATION TRUST
Open: Easter–end Sept each Sun and BH Mon; also Thurs in July and Aug 2.15-5.15; at other times by appointment
Access for disabled

Half-way between Northampton and Market Harborough on the A508. **4 A2**

Lamport Hall was the home of the Isham family from 1560 to 1976. It contains an impressive collection of paintings many of which are family portraits, collected by this Royalist family. There are a

number of Italian works of art brought back by Sir Thomas Isham from the succession of Grand Tours of Europe that he made between 1675 and 1681. Sir Thomas, the 3rd Baronet, was the outstanding collector of the family.

One of the notable paintings in the house is the *Adoration of the Shepherds* by Guido Reni which hangs in the Cabinet Room along with the *Christ and St John the Baptist as Infants* by Van Dyck. Other outstanding paintings include: a School of Van Dyck *Charles I on Horseback*, portrait by Van Somer of *Anne of Denmark*, two portraits by Miereveld of *Spinola* and *George Villiers, Duke of Buckingham*, a portrait of *Sir Thomas Isham, Third Baronet*, painted in Rome by Maratta, and *Charles II* by Lely.

NORTHAMPTON CENTRAL MUSEUM AND ART GALLERY

Guildhall Road, Northampton NN1 1DP
Telephone: (0604) 34881 ext 391

NORTHAMPTON BOROUGH COUNCIL
Open: Mon-Sat 10-5 (excl. Thurs), Thurs 10-8
Admission Free: Access for disabled

The museum is on the Guildhall Road in Northampton. From the M1 exit at Junction 15 or 16 **4 B2**

Northampton Museum possesses fine seventeenth- and eighteenth-century Italian works. These include *Piazza San Marco* by Guardi, *Belshazzar's Feast* by Francesco Fontebasso and Fumiani's *Christ with the Doctors in the Temple*.

The earliest work is probably the *Madonna and Child* by a Flemish Master of 1518. A little triptych of the marriage of Edward IV and Elizabeth Woodville is of interest, and there is a portrait of Elizabeth I's Chancellor, Christopher Hatton, who lived at Holdenby House, nearby.

The collection of British art includes a large James Ward. A matching painting by him is in the Birmingham City Art Gallery. There are works by Norwich School artists, including John Crome, paintings by W. R. Sickert, C. R. W. Nevinson, John Nash, Ethelbert White, John Bratby and Edward Bawden. Watercolourists are represented by Peter de Wint and G. S. Shepherd and there are paintings by contemporary local artists as well. The Museum contains the five-inch bronze bust dating from the second half of the second century AD of the Emperor Lucius Verus which was found nearby during the late 1860s.

—NORTHUMBERLAND—

ALNWICK CASTLE

Alnwick
Telephone: (0665) 602207

DUKE OF NORTHUMBERLAND
Open: 6 May-28 Sept, Mon-Fri 1-5, Sun 1-5; last admission 4.30
No access for disabled

On the A1 35 miles north of Newcastle-upon-Tyne. It is on the east side of the town. **21 C1**

Alnwick Castle, the home of the Duke of Northumberland's family, the Percys, since 1309, has a highly important collection of paintings. It is particularly strong in Venetian art, with three splendid Titians, including a triple portrait and the portrait of the *Bishop of Armagnac with his Secretary* and works by Palma Vecchio and Tintoretto.

The extensive collection of family portraits includes works by Van Dyck and another unusual triple portrait by William Dobson of himself with Nicholas Lanier and Sir Charles Cotterell. Other artists are Gainsborough, Reynolds, Cosway, Magnard, Dance, Grant, de Laszlo and Birley. There is also Turner's *The Temple of Aegina*.

See entry in main text, pages 129–31.

BAMBURGH CASTLE

Bamburgh
Telephone: (066 84) 208

LORD ARMSTRONG
Open: Daily Apr, May, June, Sept 1-5; July, Aug 1-6; Oct 1-4.30
Access for disabled

On the Northumberland coast five miles east of the A1 at Belford, 50 miles north of Newcastle-upon-Tyne. **21 B1**

Though mainly a museum for decorative and applied art, the collection does include views of the castle by Richard Wilson and Thomas Miles Richardson, a Jan Brueghel II country scene, and *The Card Players* by Rombouts. Portraits of people connected with the castle's history hang in the King's Hall.

BERWICK-UPON-TWEED MUSEUM AND ART GALLERY

The Clock Block
Berwick Barracks
Berwick-upon-Tweed
Telephone: (0289) 306332 ext 253
(0289) 308473

BOROUGH OF BERWICK
Open: Summer: Mon-Sat 10-12.30, 1.30-6; Sunday 11-1, 2-6; Winter: Tues-Sat 9.30-12.30, 1.30-4

The early 18th-century barracks attributed to Vanbrugh and recently restored by English Heritage house the splendid Burrell Collection, which includes glass, porcelain, medieval wood carvings, Chinese bronzes and notable nineteenth-century French paintings. There are also English portraits by Ramsay and Raeburn and *Group of Peasants* attributed to Le Nain. The French works include *A Wounded Cavalry Officer* by Géricault, Daubigny's *Cap Gris Nez*, and works by Degas, Monticelli, Anton Mauve, Boudin and Fantin-Latour.

CRAGSIDE ✣

Rothbury, Morpeth NE65 7PX
Telephone: Rothbury (0669) 20333

NATIONAL TRUST
Open: 1 Apr-end Oct daily except Mon (open BH Mons) 1-5.30; Last admissions 5
Access for disabled

13 miles south-west of Alnwick (B6341) and 15 miles north-west of Morpeth-Wooler road turn left on to B6341 at Moorehouse Crossroads. **21 C2**

Cragside, built between 1864 and 1866, is the creation of Sir William Armstrong (later Lord Armstrong), scientist and industrialist. It currently displays the De Morgan Foundation collection of late nineteenth-century paintings, formerly shown in Old Battersea House. The artists, Evelyn De Morgan and her uncle, John Roddam Spencer-Stanhope (christened Roddam after the neighbouring estate), both have North Country roots.

There are about sixteen works by De Morgan: the typical Pre-Raphaelite subjects are allegorical, mythical and biblical. Paintings by H. H. Emmerson, a local artist and a favourite of Lord Armstrong, works by T. M. Richardson, Senior, and Clarkson Stanfield in the Watercolour Gallery, are some of what remains of the Armstrong collection, the cream of which was sold in 1910.

See entry in main text, pages 133–4.

LINDISFARNE CASTLE ✣

Holy Island, Berwick-upon-Tweed TD15 2RX
Telephone: Berwick (0289) 89244

NATIONAL TRUST
Open: Apr-30 Sept daily except Fri

(open GF) 1-5.30; Oct Sat, Sun 1-5.30;
Last admissions 5
No access for disabled

55 miles north of Newcastle-upon-Tyne
and six miles east of the A1. A causeway
at Beal links the mainland to Holy Island.
21 B2

Romantically situated on a tiny island,
the interior of this sixteenth-century castle
was restored by Sir Edwin Lutyens. There
are several engravings by Johann Elias
Ridinger and Philip Galle. In the East
Bedroom are three nineteenth-century
sepia watercolours of ships.

WALLINGTON �
Cambo, Morpeth NE61 4AR
Telephone: Scots Gap (067 074) 283

NATIONAL TRUST
Open: 1 Apr-31 Oct daily except
Tues 1-5.30; Last admissions 5
Limited access for disabled

20 miles north-west of Newcastle-upon-
Tyne, off the A696 on the B6342. **21 D2**

The collection records the close associations
which Pauline, Lady Trevelyan, wife of
the 6th Baronet, had with Ruskin, William
Bell Scott, who painted the central hall
at Wallington, and many of the Pre-
Raphaelite Brotherhood whom she met
through her literary activities.

Portraits of members of the Trevelyan
family by Hoppner and Romney hang in
the Entrance Hall along with some
Blackett family portraits. The Dining
Room contains a portrait of the 3rd
Baronet by Hudson, a Cornelius Johnson
and a portrait of Susannah Trevelyan,
painted in part by Gainsborough but
altered later, possibly by Reynolds, at the
request of Sir Walter Blackett. Also to be
noted are the Reynolds portrait of Sir
Walter in the Saloon, and John Wootton's
Dancing Dogs on the stairs.

There are watercolours by Turner and
Ruskin, and by friends and associates of
Lady Trevelyan, in what was her parlour.
The fine collection of porcelain includes
rare Bow figures. Lady Wilson's Cabinet
of Curiosities should not be missed.

See entry in main text, pages 131-3.

─NOTTINGHAMSHIRE─

MANSFIELD MUSEUM AND ART GALLERY
Leeming Street, Mansfield
Telephone: (0623) 22561

MANSFIELD DISTRICT COUNCIL
Open: Mon-Fri 10-5, Sat 10-1, 2-5
Admission Free: Access for disabled

From the M1 take the A38 to Mansfield
at Junction 28. **12 A3/4**

Of principal interest are the 140 water-
colours of town life, most of which are
on display, by the late Albert Sorby
Buxton, former head of Mansfield Art
College.

NEWSTEAD ABBEY
Linby
Telephone: (062 34) 3557

NOTTINGHAM CITY COUNCIL
Open: Good Fri-30 Sept 2-6, including
Sun and BHs; last admission 5. Other
times by arrangement
Limited access for disabled

12 miles north of Nottingham on the
A60. **12 A4**

The Abbey is now given over to pictures,
furniture and literary material relating to
the poet Byron, who lived here. Portraits
of him by Thomas Phillips, G. Sander
and Gilchrist hang in the house as well as
pictures of his family, including Admiral
Byron by Reynolds. The Roe collection
of Byron's letters, first editions and
manuscripts is kept here.

NOTTINGHAM CASTLE MUSEUM
Nottingham
Telephone: (0602) 411881

NOTTINGHAM CORPORATION
Open: Oct-Mar daily 10-4.45; Apr-
Sept daily 10-5.45
Admission Free except Sun and BHs
Access for disabled

The museum is in the castle in the centre
of Nottingham, which is off the M1 at
exits 25 and 26. **12 A4**

The fine art collection at Nottingham
Castle has benefited from several important
gifts and bequests. One was that of
Charles Le Brun's *Hercules and Diomedes*,
painted for Cardinal Richelieu, which
came to England from the collection of
the Duc d'Orléans in the eighteenth
century before being left to the Museum
in 1983. It hangs at one end of a long
gallery lined with British and European
paintings, imaginatively arranged. At the
opposite end is *Homer Singing his Iliad at
the Gates of Athens*, by Guillaume Guillon
Lethière.

Dutch and Flemish works here include
a seventeenth-century view of Nottingham
by Jan Siberechts, who is himself portrayed
by Largillière. The museum owns paint-
ings by Hondecoeter and van der Werff,
as well as the large *River Scene with Boats
and Figures* by Klaes Molenaer.

Bonington's *Transept of the Abbey of St-
Bertin*, *St Omer* and *Fisherfolk on the Coast
of Normandy* come from the Museum's
large collection of oils, drawings and
watercolours by this native artist. It also
owns many works by Thomas and Paul
Sandby, including Paul Sandby's gouache
Moonlight Effect.

British landscapes range from Richard
Wilson's *Snowdon* and Francis Wheatley's
Harvest Waggon to large academic canvases
like Joseph Farquharson's *Winding Dee*.

Outstanding among the figure paintings
are John Michael Wright's *Apotheosis of
Charles II*, originally a ceiling painting,
and Daniel Maclise's *Robin Hood and his
Merry Men Entertaining the Lionheart in
Sherwood Forest*. James Collinson's *For
Sale*, J. F. Herring's *Feeding the Horses* and
Marcus Stone's *In Love* are popular
Victorian images. Less familiar are the
accomplished genre and historical subjects
by Alfred Elmore, John Calcott Horsley,
James Hayllar (*The Invalid*) and the
Nottingham artist Laslett J. Pott.

The Museum's small collection of Italian
art contains, unusually, major oils by
nineteenth-century artists Filadelfo Simi
and Gioacchino Pagliej.

The modern British holdings include
fine works by Dame Laura Knight, who
came from Nottingham: *Gypsy Splendour*,
the circus painting *Elsie on Hassan*,
drawings and watercolours like *Ballet
Dancer*. Sickert's *Noctes Ambrosianae*, Wil-
liam Roberts's *Return of Ulysses* and
Matthew Smith's *Still Life with a Blue and
White Jug* are among the highlights of a
collection which features works by Ben
Nicholson, Spencer, Hitchens and Pas-
more.

See entry in main text, pages 158-9.

─── OXFORDSHIRE ───

ASHDOWN HOUSE ⚫
Lambourn, Newbury, Berks RG16 7RE

NATIONAL TRUST
Open: Hall, Stairway and Roof only;
Apr-end Oct Wed, Sat 2-6; closed Easter
and BH Mons; last admissions 5.15
Limited access for disabled

Three miles north of Lambourn, two
miles south of Ashbury on the west side
of the B4000. **4 D4**

Ashdown, high on the Berkshire downs, is one of the most unusual of English country houses. It was built by William, 1st Earl of Craven. An eccentric figure, he was remarkable for his devotion to Charles I's sister, Elizabeth, who, in 1619, reigned as Queen of Bohemia and was known ever afterwards as the 'Winter Queen'.

A precise and clearly defined collection of portraits was acquired by the Treasury at the time of the dispersal of the large Craven Collection of paintings by auction in 1968. It was presented to the National Trust to hang at Ashdown. The paintings are principally the work of two Dutch artists, Gerard van Honthorst and Michiel Miereveld. In addition there is a fine early conversation piece by William Dobson.

The works reflect Lord Craven's romantic attachment to the Winter Queen. The portraits are in two groups: those by Miereveldt date from before 1632; those by Honthorst, or after him, are generally later. The paintings, so far as it is known, were originally bequeathed to Lord Craven by Elizabeth on her death in 1662. Portraits of the Queen and of her family, also of the Earl and his mother, are included.

See entry in main text, pages 174–6.

ASHMOLEAN MUSEUM
Beaumont Street, Oxford OX1 2PH
Telephone: (0865) 278000

OXFORD UNIVERSITY
Open: Tues–Sat 10–4, Sun 2–4
Admission Free: Access for disabled

The museum is in the north of the city centre near the corner of Beaumont Street and St Giles. **4 D3**

This, the oldest surviving public museum in Britain, celebrated its tercentenary in 1983. The Tradescant Room holds exhibits from its earliest collection, much of it assembled by John Tradescant the Elder, gardener to Charles I. The Tradescant collection passed to Elias Ashmole, who gave it to Oxford University. Further bequests and gifts followed, a major nucleus of works came from the Bodleian Library and paintings and drawings – including the great collection of drawings by Michelangelo and Raphael, purchased by subscription for the University – were placed in the University Galleries. These were combined with the Ashmolean Museum at the end of the nineteenth century.

Ashmole's portrait by John Riley, in its Grinling Gibbons frame, hangs in the Founders Room, with Ashmole's gold medals nearby. The surrounding portraits of the Tradescant family are by Emmanuel de Critz, and include an unusually informal *John Tradescant the Younger,* a working gardener with a spade.

The Fortnum Gallery commemorates the 'second founder' C. D. E. Fortnum (1820–99). It contains superlative examples of early Italian art, some collected by William Fox-Strangways, later 4th Earl of Ilchester, whose gift of 1850 included Paolo Uccello's *A Hunt in the Forest.* Some of the other masterpieces here are Piero di Cosimo's *A Forest Fire,* Bronzino's *Giovanni de' Medici* and Alessandro Allori's *Portrait of a Young Man,* Jacopo Bassano's *Christ Disputing with the Doctors* and Tintoretto's *Resurrection of Christ. The Virgin and Child* is attributed to Giotto, *St Jerome in the Desert* to Giovanni Bellini and the beautiful *Virgin and Child with a View of Venice* to Giorgione. There are fine examples of the art of Paolo Veronese, Fra Filippo Lippi and Moroni *(Mystic Marriage of St Catherine).* Some of the most interesting paintings are by less famous artists: *The Flight of the Vestal Virgins* by Biagio di Antonio da Firenze and the unfinished *Holy Family with the Infant St John* by Tommaso Manzuoli are among these. Many, like Bicci di Lorenzo's *St Nicholas of Bari Rebuking the Storm,* painted in 1433, were once part of large altarpieces, divided for sale in the eighteenth and nineteenth centuries.

Next door is the Mallet Gallery, displaying some of the Ashmolean's great collection of Raphael and Michelangelo drawings – many formerly owned by Sir Thomas Lawrence. They are part of the Museum's outstanding holdings of works on paper by old and modern masters; the Eldon Gallery is used for displays of prints and drawings, and the McAlpine Gallery for temporary exhibitions, including paintings.

In the Braikevich Room are some of the most unusual items in the museum: nineteenth- and twentieth-century Russian drawings and watercolours. These include not only the Léon Bakst designs which are well known to Westerners, but works on paper by Alexandre Benois, Konstantin Somov and Valentin Serov.

The Fox-Strangways Gallery is devoted to seventeenth-century Dutch and Flemish paintings. There are small oil sketches by Rubens, among them designs for the Jesuit Church ceiling in Antwerp, and Van Dyck portrait sketches of *A Man Wearing a Ruff* and *Portrait of a Man.* Highlights include Salomon van Ruysdael's *A Scene at a Well* and a Philips de Koninck panorama, *A View over Flat Country,* as well as *A Man Playing the Bagpipes* by ter Brugghen, a Dutch admirer of Caravaggio. Willem Drost's moving *Ruth and Naomi* and Gerbrand van den Eeckhout's *Infant Samuel brought by Hannah to Eli* reflect the fact that the artists were pupils of Rembrandt.

The second-floor Ward Collection of Dutch and Flemish still lifes, mostly of the seventeenth and eighteenth centuries, was bequeathed in memory of Daisy Linda Ward, herself a still life painter. Among the most beautiful are Rachel Ruysch's *Still Life with a Snake,* Abraham van Beyeren's *Still Life with a Silver Wine-Jug* and a *Reflected Portrait of the Artist,* and a magnificent flowerpiece by Willem van Aelst. It is an extraordinarily comprehensive display, sympathetically shown with contemporary Dutch decorative arts.

In the Weldon Gallery on the first floor is more seventeenth- and eighteenth-century European art: Poussin's *Exposition of Moses,* a powerful *Deposition* by Van Dyck and Rubens's *Gemma Tiberiana,* an enlarged copy of a Roman cameo. Most of the pictures are Italian, like Domenichino's *Landscape with Tobias and the Angel* and Bernini's *A Young Man,* the handsome portrait of *An Unknown Man and his Secretary* attributed to Jacopo Bassano, and works by Paolo de' Matteis and Barocci. *The Lacemaker* is by the Italo-Dutch painter Bernhard Keil, and there are two fine paintings of mysterious origin: an *Allegory of Justice and Vanity* formerly attributed to Nicolas Tournier and a delightfully natural *Dog Outstretched upon a Ledge,* which may be Spanish.

The adjoining Landscape Room illustrates the development of landscape painting from the seventeenth to the nineteenth centuries, beginning with a Domenichino landscape and two superb Claudes: the poetic *River Landscape with a Goatherd Piping* and the late work, *Landscape with Ascanius Shooting the Stag of Sylvia.* Dughet's *View of Tivoli with Rome in the Distance* is followed by landscapes by Wilson, Wright of Derby and Vernet, a cloud study by Constable, and Corot's beautiful *Le Petit Chaille, near Ville d'Avray.*

On the second floor, the Chambers Hall Room contains Guardi's *Pope Pius VI Blessing the Multitude on the Campo SS. Giovanni e Paolo,* a Canaletto view of *Dolo on the Brenta,* and a Panini capriccio of Rome. The charming *Lady Holding a Macaw* by Tiepolo is accompanied by a Batoni portrait of *Garrick,* Reynolds's portrait of the architect *James Paine and his Son,* and of the diminutive *Penelope Boothby* (one of Reynolds's best-known child portraits). The museum also owns

Gainsborough's unfinished sketch of his daughter *Mary Gleaning* and Hogarth's *The Enraged Musician*. French paintings here include Watteau's *Le Repos Gracieux* and a Chardin *Still Life of Kitchen Utensils*.

British art of the nineteenth century is well represented in the Combe Gallery, with an excellent group of Pre-Raphaelite canvases, among them Holman Hunt's *A Converted British Family Sheltering a Christian Missionary from the Persecution of the Druids* and *The Return of the Dove to the Ark* by Millais. These, like C. A. Collins's *Convent Thoughts*, formerly belonged to *Thomas Combe*, who was himself painted by Millais. The group of Holman Hunt paintings includes *A Nosegay*, *The Festival of St Swithin* and *The Afterglow in Egypt*. His *London Bridge at Night* commemorates the 1863 marriage of the future Edward VII. Also of interest are Arthur Hughes's *Home from Sea*, J. W. Inchbold's *In Early Spring*, Sandys's *Gentle Spring* and the many small canvases by Bonington, Calvert, Ford Madox Brown, Leighton and Bastien-Lepage. A central cabinet displays some of the Ashmolean's works on paper by Samuel Palmer; in its collection, strong in Palmer's Shoreham period work, are Palmer's self-portrait and *Man Reading in a Cornfield*, as well as several oils like *Evening Landscape*.

In the first-floor Hindley Smith Gallery are nineteenth and early-twentieth century French and British paintings. The Ashmolean was given the Pissarro archive of paintings, works on paper and documents of the Pissarro family by the artist's relatives. There are several fine oils by Camille Pissarro in the Museum, among them *Vue de ma Fenêtre, Eragny, Le Jardin des Tuileries, Temps de Pluie* and that utterly English scene, *Bedford Park, Bath Road, Londres*. Camille's son Lucien painted *Genets de Malaginesta, Le Brusq*, and *Six-Fours from Chemin de l'Hulsac*. The Dutch landscape, *Un Moulin près de Zaandam*, is by Monet, and *Restaurant de la Sirène, Asnières* by Van Gogh. Other outstanding works in the collection, which includes paintings by Daubigny, Courbet, Renoir, Cézanne and Marie Laurencin, are Toulouse-Lautrec's *La Toilette*, and a double portrait by Leonid Pasternak.

The Ashmolean continues to collect and display the art of modern British artists like Lucian Freud, adding to its fine examples of the work of Orpen, Sickert (notably a version of *Ennui)*, Gilman, Gwen John, John Nash and Stanley Spencer. One of the most attractive is *The Steps of the Church of SS. Domenico e Sisto* by John Singer Sargent. There are a number of paintings and drawings associated with the life of T. E. Lawrence, an Oxford graduate, including Augustus John's portrait of *The Emir Feisal*.

See entry in main text, pages 29–33.

BLENHEIM PALACE

Woodstock
Telephone: (0993) 811325

DUKE OF MARLBOROUGH

Open: Mid-Mar–31 Oct daily 10.30–5.30; last admission 4.45
Access for disabled

On the outskirts of Woodstock, south of the A34 from Oxford to Stratford-upon-Avon, eight miles from Oxford. **4 C3**

For a house in the first rank, the collection of paintings and sculpture, while extensive, is not rich in masterpieces. Its great works are in portraiture, with pride of place going to the splendid family groups, stretching from Closterman's of the 1st Duke, painted in 1693, before the granting of the title, to the Sargent group portrait of the 9th Duke and his family, painted in the early part of the twentieth century.

The 9th Duke's wife, Consuelo, a Vanderbilt, was also painted by Duran, in Paris, at the time of her engagement. Opposite, in the same room, is the Reynolds portrait of the 4th Duke and his family. In each of these three the wife is in the centre, surrounded by her children, the Duke seated to the left; possibly the poses adopted by Closterman were followed successively by Reynolds and Sargent.

Vanderbilt money no doubt helped pay for the other twentieth-century family portraits by McEvoy and Orpen, Sargent's successor as leading London portrait painter.

Earlier works of note include Van Dyck's portrait of *Lady Morton and Mrs Killigrew* and Kneller's best known version of the *First Duke of Marlborough*, John Churchill, together with a portrait of his Duchess, Sarah.

A sensitive, late portrait by Van Dyck of the artist's mistress, *Margaret Lennon*, finished shortly before his death, hangs in the Red Drawing Room, which contains the best pictures.

There is *The Adoration of the Magi* by Carlo Dolci, a masterly work the quality of which was recently revealed by cleaning.

The Long Library, originally intended as a picture gallery, has two fine Rysbrack sculptures, one of them a full-length of *Queen Anne*. A number of full-length portraits hang high above the bookcases. In the chapel is a splendid Rysbrack memorial sculpture of the first Duke's family.

Louis Laguerre was responsible for the fine walls and ceilings in the Saloon. In the adjacent state rooms hang the splendid tapestries of the 1st Duke's campaigns.

See entry in main text, pages 173–4.

BROUGHTON CASTLE

Banbury
Telephone: (0295) 262624

LORD SAYE AND SELE

Open: 18 May–14 Sept Wed and Sun, also Thurs in July and Aug and BH Sun and Mon 2–5
Limited access for disabled

Two miles south-west of Banbury off the B4035. **4 B3**

Sir John de Broughton built a manor house on the existing site in 1300. In 1554 Richard Fiennes completed a huge reconstruction in the 'Court' style of Edward VI, thus transforming the medieval manor house into a Tudor mansion.

The art collection consists principally of Fiennes family portraits. Among the portraits in the Great Hall are *William Fiennes, First Viscount Saye and Sele*, and full-length portraits of *Baroness Saye and Sele* and her husband, *George Twisleton*, who eloped with her when she was fifteen.

In the Oak Room hangs a portrait by Lely of *Mrs Nathaniel Fiennes*, mother of Celia, who was famous for her extensive travels throughout England in the seventeenth century. She was one of the earliest travellers to note collections, and is an invaluable source of such information.

There is a seascape by Johannes Peeters of *Charles II returning to England from Holland* in 1660. There are two portraits by Adam de Cologne in the Gallery and a contemporary portrait of Queen Anne of Denmark which hangs in the room where she stayed.

CHRIST CHURCH PICTURE GALLERY

Christ Church, Oxford
Telephone: (0865) 276172

CHRIST CHURCH

Open: Mon–Sat 10.30–1, 2–4.30 (Oct–Mar), 5.30 (Apr–Sept); Sun 2–4.30 (Oct–Mar), 5.30 (Apr–Sept)
Limited access for disabled

The gallery is in the Canterbury Quadrangle at Christ Church. **4 D3**

The Picture Gallery is famous for its collection of over 2,000 drawings and works on paper, many by Raphael, Leonardo, Michelangelo and Rubens, with examples from every major Italian school. Exhibits are changed approximately every two months. Attractively displayed in a modern setting is a notable collection of paintings that charts the progress of Italian art from the fourteenth to seventeenth centuries. The bulk of the Italian works was bequeathed to Christ Church by General John Guise in 1765, whose portrait by Reynolds hangs in the Gallery.

Among religious paintings of the fourteenth and fifteenth centuries are Filippino Lippi's *A Wounded Centaur* and the *Madonna and Child with Six Saints* and *Madonna and Child with Saints and Angels* by Sano di Pietro. Later Italian pictures include Tintoretto's *Martyrdom of St Lawrence,* and Veronese's *Marriage of St Catherine.* On a secular theme are two memorable works by Annibale Carracci, *The Butcher's Shop* and *A Man Drinking.* Carracci also painted *The Virgin and Child in the Clouds with a View of Bologna.* Salvator Rosa, idealised in the nineteenth century as the epitome of the 'Romantic Artist' is represented by his *Rocky Landscape with Three Figures.* There is a highly coloured *Birth of the Virgin* by the eighteenth-century artist Corrado Giaquinto.

Also on display are some fine Dutch paintings, including a fragment of *The Lamentation* by Hugo van der Goes, one of the most gifted of all early Netherlandish painters, and a *Deposition of Christ* by the sixteenth-century Master of Delft.

Paintings by Van Dyck include *The Continence of Scipio, Mars Goes to War* and *The Martyrdom of St George.* There is also a delightful landscape by Jan Vermeer II of Haarlem.

See entry in main text, pages 176–7.

FAWLEY COURT HISTORIC HOUSE AND MUSEUM (DIVINE MERCY COLLEGE)
Henley-on-Thames
Telephone: (0491) 574917

DIVINE MERCY COLLEGE
Open: Wed and Sun 2–5; July and Aug Thurs 2–5
Closed: June, Christmas, Easter, Whitsun
Access for disabled by arrangement

The College is one mile north of Henley-on-Thames via the A4155 to Marlow. **4 D2**

Father Joseph Jarzebowski, a member of the Marian Fathers, an ancient Roman Catholic religious order of Polish origin, brought back items of religious and secular significance from Japan, Mexico and South America, where he had spent much of his career. During the Second World War he arranged for many objects of Polish historical value to be removed to the security of Western democracies and these are at Fawley.

The design of the present house is thought to have been influenced by Christopher Wren and was completed in 1684. Grinling Gibbons contributed a superb ceiling and the architect James Wyatt designed the outstanding ceiling in the library. 'Capability' Brown designed the park in 1771. The property is now a Catholic School.

There are a number of paintings and sketches by Polish artists. Included are a portrait of *John III Sobieski,* saviour of Vienna from the Turks in 1674. There is material on the Polish uprising against Russia in 1863 and modern portraits of Pope John Paul II and Cardinal Wyszinski.

MAPLEDURHAM
Mapledurham, near Reading RG4 7TR
Telephone: (073472) 3350

MR J. J. EYSTON
Open: Easter Sun–30 Sept Sat, Sun, BHs 2.30–5.30; last admission 5
Open for groups of 30 and over Tues, Wed, Thurs
Limited access for disabled

Off the A4074 Caversham to Wallingford road four miles north of Reading. **5 A2**

This house, just inside the Oxfordshire border, is a showcase for distinguished portraits of the Blounts. William Dobson's fine portrait, *Sir Charles Blount,* hangs in the Entrance Hall. Michael Blount and his first and second wife, painted by Romney, hang in the Library together with Andrea Soldi's portrait of the composer *Johann Adolph Hasse.*

In the Chapel is *Flight into Egypt,* the landscape painted by John Rathbone and the figures by Henry Howard. The Staircase Hall contains a fine *Boy with a Staff* by Gilbert Jackson as well as portraits by J. M. Wright, George Gower and Robert Peake. A gigantic painting by Jan Fyt hangs in the Saloon along with portraits by Huysmans and a fine double portrait of Martha and Theresa, daughters of Lyster Blount, by Charles Jervas.

In the Boudoir are two fine portraits, *Alexander Pope* by Kneller and *Young Girl*

with a Rattle by Cornelius Johnson. Paul van Somer's full-length portrait of *Lord Mountjoy* hangs on the staircase. A portrait by William Larkin of the beautiful *Lady St John of Bletso,* dressed in her mourning clothes, is in the Dining Room. It includes an English landscape background, of rolling wooded hills, with the subject standing under an equally finely painted oak tree.

MILTON MANOR
Abingdon
Telephone: (0235) 831287

MRS E. J. MOCKLER
Open: Easter Sat–21 Oct weekends and all BHs 2–5.30
Access for disabled

In the village of Milton off the A34, four miles south of Abingdon. **4 D3**

A portrait of *Bryant Barrett and his Family* by Joseph Highmore hangs in the Library, appropriately, as it was Barrett who added the Strawberry Hill Gothick room. On the Staircase is a portrait by Kneller of *The Churchill Sisters.*

The Chapel contains *The Assumption* by Murillo and a Flemish triptych, as well as paintings of the four evangelists.

ROUSHAM PARK
Steeple Aston
Telephone: (0869) 47110

MR C. COTTRELL-DORMER
Open: Apr–Sept Wed, Sun and BHs 2–5.30; last admission 4.30; groups at other times by arrangement; garden open daily 10–4.30
No access for disabled

12 miles north of Oxford on east side of the A423 Banbury Road. Turn off at Hopcrofts Holt Hotel. **4 C3**

The house and garden are the work of William Kent. The Entrance Hall contains six early Kneller portraits as well as portraits by Johnson, Lely, Sanchez Coello and J. M. Wright.

An Italian family, the Adlemare Caesars, brought to Rousham many of the portraits which hang up the Staircase.

In the Drawing Room hangs a portrait of *Lady Cottrell-Dormer* by Sir Joshua Reynolds and portraits by Dobson painted during the siege of Oxford (1645) of *Sir Charles Cottrell* and *Lady Cottrell.* The Painted Parlour was designed by Kent and has a ceiling by him.

The Dining Room contains an allegorical painting, *The Civil Wars of France* by Dobson, and a portrait of *Sir Charles Cottrell-Dormer* by Benjamin West.

STONOR HOUSE
Stonor Park, Henley-on-Thames RG9 6HF
Telephone: (049 163) 587

LORD AND LADY CAMOYS

Open: Apr Sun 2-5.30; May-Sept Wed, Thurs and Sun 2-5.30; Aug Sat only; BH Mons 11-5.30
Access for disabled by prior arrangement

Five miles north of Henley-on-Thames, five miles south-east of Watlington off the B480. **4 D2**

Stonor House has remained in the same family for over 800 years. The paintings are mainly family portraits by Michael Wright and Sir Godfrey Kneller, or portraits of people of historical importance with whom the family had connections. There are also drawings by Tintoretto, Tiepolo (father and son) and paintings and drawings by the Carracci brothers.

SULGRAVE MANOR
Sulgrave, Banbury OX17 2SD
Telephone: (029 576) 205

SULGRAVE MANOR BOARD

Open: Feb-Dec daily except Wed; Apr-Sept 10.30-1, 2-5.30; other months 10.30-1, 2-4
Limited access for disabled

Eight miles east of Banbury on the Northampton Road and seven miles north-west of Brackley. **4 B3**

The Rev. Lawrence Washington, whose son Colonel John Washington bought the land in Virginia that later became Mount Vernon, was born here. John Washington was the great-grandfather of George Washington. Portraits of the first President hang throughout the house, together with works by Gilbert Stuart, Charles Willson Peale and Archibald Robertson. There is also a copy of Houdon's bust.

——— SHROPSHIRE ———

ATTINGHAM PARK ✹
Shrewsbury SY4 4TP
Telephone: Upton Magna (074 377) 203

NATIONAL TRUST

Open: 31 Mar-end Sept Sat-Wed 1.30-5; BH Mons 11-5; Oct Sat and Sun 1.30-5; groups at other times by arrangement; last admissions 4.30
Closed: GF
Limited access for disabled

Four miles south-east of Shrewsbury on the north side of the A5 at Atcham, well signposted. **11 B5**

A mixed and uneven collection, the focus of interest often being minor and unusual works, such as the grisailles in the entrance hall, bought in Italy from the Irish artist Robert Fagan.

An Italian character is emphasized by certain paintings and sculpture, including works by Hackert and Angelica Kauffmann, but the splendid picture gallery really offers only a faint echo of the collection made by the 2nd Lord Berwick in the late eighteenth and early nineteenth centuries, much of it dispersed in the 1827 sale. George Steuart's architectural drawings for the house are preserved, and there is a painted boudoir, attributed to Louis-André Delabrière.

DUDMASTON HALL ✹
Quatt, nr Bridgnorth WV15 6QN
Telephone: (0746) 780866

NATIONAL TRUST

Open: 1 Apr-30 Sep Wed and Sun 2.30-6; last admissions 5.30; Thurs p.m. for pre-booked parties only
Access for disabled

Off the A442, four miles south-east of Bridgnorth. **11 B6**

The principal interest at Dudmaston Hall is art of the second half of the twentieth century, collected by the former owner, Sir George Labouchere. He was British Ambassador to Brussels from 1955-60 and to Spain after that, and collected works of art representative of the countries in which he worked.

His earlier interest, as far as contemporary art was concerned, was in British abstract painting, and pictures by Davie, Armitage, Ben Nicholson, as well as works of sculpture by Moore, Hepworth and Chadwick, are in the collection.

He acquired American modern art, and in the early 1960s bought Spanish paintings by such artists as Serrano and Rivera. Earlier works in his collection include minor Impressionists, topographical works, mainly related to his travels, and botanical watercolours.

Among works not acquired by Sir George are Dutch flower paintings by Jan van Os and Jan van Huysum.

ROWLEY'S HOUSE MUSEUM
Barker Street, Shrewsbury
Telephone: (0743) 61196

BOROUGH OF SHREWSBURY AND ATCHAM

Open: Mon-Sat 10-5; Sun Apr-Sept 12-5
No access for disabled

Shrewsbury is reached via the A49, A5 and A458. **11 A5**

Although the main collections are of decorative art and archaeology, there is a good collection of topographical watercolours of Shrewsbury and Shropshire by Paul Sandby, David Cox, Joseph Farington, William Williams, and others.

WESTON PARK
Shifnal
Telephone: (095 276) 207

EARL OF BRADFORD

Open: Apr, May, Sept weekends only; June, July, Aug daily except Mon and Fri 1-5.30; all BHs; last admission 5
Access for disabled

Seven miles west from the M6/A5 interchange at Junction 52 on the A5 at Weston-under-Lizard or 3 miles north of Junction 3 on M54. **11 B5/6**

A good collection of portraits and Old Master paintings, including the splendid Van Dyck of *Thomas Killigrew*, the Restoration playwright, and also the portrait of *Thomas Hanmer*. There are portraits also by Wright, Lely, Hoppner and Constable.

Two striking full-length portraits of young children, by Anguisciola, hang in one of the Salons, and there are works by Moro and Miereveld.

In the Entrance Hall is a lively Stubbs painting of two horses.

——— SOMERSET ———

THE BISHOP'S PALACE
Wells
Telephone: (0749) 78691

THE BISHOP OF BATH AND WELLS

Open: Easter-Oct Sun, Thurs, every afternoon in Aug 2-6
Limited access for disabled

The Palace is about 20 miles south of Bristol, in Wells. **3 D1**

The portraits of the bishops of Bath and Wells, from the fifteenth century to the

in 1727, there are works by his contemporaries.

Gainsborough's own works permanently on display include mainly portraits, of *Thomas Vere*, *Abel Moysey* and *John Henderson*, among others. Full programme of temporary exhibitions throughout the year.

HAUGHLEY PARK

Near Stowmarket
Telephone: (0359) 40205

MR AND MRS A. J. WILLIAMS
Open: May–Sept Tues 3–6
Access for disabled

Four miles west of Stowmarket, signposted on A45. **6 B/C3**

The thirty or so paintings range from the Dutch and Flemish schools, sixteenth to nineteenth century, to a pair of Venetian boating scenes by the Norwich artist Alfred Stannard.

ICKWORTH ✄

The Rotunda, Horringer, Bury St Edmunds
IP29 5QE
Telephone: Horringer (028 488) 270

NATIONAL TRUST
Open: 31 Mar–end Apr: Sat, Sun, BH
Mon 1.30–5.30; May–end Sept daily except
Mon, Thurs 1.30–5.30; Oct Sat, Sun 1.30–5.30
Closed: GF
Access for disabled

Three miles south-west of Bury St Edmunds on west side of the A143 at Horringer. **6 C3**

This splendid house was started in the late eighteenth century for the Hervey family, Earls of Bristol, and never completely finished. It contains an outstanding collection of family portraits and Old Master paintings. Many were acquired by the Bishop of Derry, the 4th Earl of Bristol, but important works were also bought and commissioned by the Earl-Bishop's brothers. These include *Infante Baltasar Carlos* by Velázquez, Titian's *Portrait of an Unknown Man*, and Flaxman's neo-classical sculpture group, *The Fury of Athamas*, which was commissioned by the Earl-Bishop.

Among English portraits and portrait-groups is Hogarth's *Holland House Group*, Another fine portrait-group, *The Hervey Family*, is mainly by Hubert François Gravelot.

Other portraits, by Zoffany, Gainsborough, Hugh Douglas Hamilton, Reynolds, Angelica Kauffmann and others are in the house. There is also Madame Vigée-Lebrun's sympathetic seated portrait of *Frederick, Fourth Earl of Bristol and Bishop of Derry*, as well as her own *Self-Portrait*.

See entry in main text, pages 195–7.

LITTLE HALL

Market Place, Lavenham, Sudbury
Telephone (0787) 247179

SUFFOLK PRESERVATION SOCIETY
Open: Easter Sat–mid Oct Sat, Sun, Wed,
Thurs and BHs 2.30–6; other times by
appointment
No access for disabled

Lavenham is south of Bury St Edmunds off the A1141 and north of Sudbury off the B1071. **6 C3**

The Hall is a fourteenth- and fifteenth-century building which was restored and furnished by the Gayer-Anderson twin brothers, who bought the house in 1924. There is a fourteenth-century Italo-Byzantine *Madonna and Child*, probably from Crete or southern Italy, and a *Madonna and Child* by Ribera.

There are several sculptures by the Gayer-Andersons.

MELFORD HALL ✄

Long Melford, Sudbury CO10 9AH
Telephone: Sudbury (0787) 880286

NATIONAL TRUST
Open: 31 Mar–end Apr Sat, Sun, BH
Mon 2–5.30; May–end Sept Wed, Thurs,
Sat, Sun, BH Mon 2–5.30; Oct Sat, Sun
2–5.30
Closed: GF
Limited access for disabled

14 miles south of Bury St Edmunds on east side of the A134, three miles north of Sudbury, in the village of Long Melford. **6 C3**

Melford Hall is one of the finest Elizabethan houses to be found in East Anglia.

Formerly owned by the Cordell and Parker families, it has an interesting collection which includes a number of Dutch works as well as portraits of the two families.

Dutch works include *The Finding of Moses* by Stalbemt, landscapes by Vollaerdt, and other works by Kessel and Gallis.

In the Library is Romney's portrait *Vice-Admiral Sir Hyde Parker, Fifth Baronet*, an admirable characterisation of this bluff and decisive naval commander, some of whose exploits are the subject of further paintings depicting engagements with the Dutch and the French.

Further Dutch paintings on the Staircase include works by Siberechts, Wouwermans and B.G. Cuyp.

MOYSE'S HALL MUSEUM

Cornhill, Bury St Edmunds
Telephone: (0284) 763233

BURY ST EDMUNDS BOROUGH COUNCIL
Open: Mon–Sat 10–5; Sun 2–5
Closed: Winter BH
Admission Free: Limited access for disabled

Bury St Edmunds can be reached from the A143, A134 and A45 from Ipswich. **6 B/C3**

Local to Bury St Edmunds, the museum contains three eighteenth-century oil paintings of the town. There are Robert Adam's designs for the local theatre, and about forty seventeenth- to nineteenth-century miniatures of two local families, the Cullums and the Priggs. Various watercolours, engravings and maps are also on view.

THE NATIONAL HORSERACING MUSEUM

99 High Street, Newmarket CB8 8JL
Telephone: (0638) 667333

REGISTERED CHARITY
Open: Spring–mid Dec Tues–Sat 10–5,
Sun 2–5
Closed: Mon other than BHs and Mons
in Aug
Access for disabled

Newmarket is east of Cambridge on the A11 and A142. **6 B/C4**

The museum tells the history of horseracing from the time of Charles II to the present day. Works of art all relate to racing history – the horses, the courses, famous races and characters associated with the Turf.

There are groups of bronzes by John Skeaping and a Munnings of Gordon Richards on Sun Chariot.

Long-term loans include works by Sawrey Gilpin, J. F. Herring and George Stubbs.

NETHER HALL MUSEUM AND ART GALLERY
Cavendish
Telephone: (0787) 280221

B. T. AMBROSE
Open: Daily 11-4
No access for disabled

The art gallery is at Cavendish between Clare and Long Melford on the A1092. **6 C4**

The gallery, part of the Cavendish Manor Vineyards complex, contains nineteenth- and twentieth-century English landscape and wild bird pictures mostly by East Anglian artists.

Watercolours are by Nixon, Beaumont, Raymond Watson, J. R. Harrison, Terence James Bond, Andrew Haslem, L. S. M Prince, C. Madgwick, H. Collier, D. Warren, J. Dodgson, Dorothy Shepherd and J. Cooke. Oils are by John Arnold Wheeler, C. Madgwick and C. Osborne.

SOMERLEYTON HALL
Somerleyton, near Lowestoft NR32 5QQ
Telephone: (0502) 730224

LORD AND LADY SOMERLEYTON
Open: Easter Sun-29 Sept Thurs, Sun and BHs; Tues, Wed in July and Aug 2-5.30
Access for disabled

Seven miles from Yarmouth off the A143 and five miles north-west of Lowestoft off the B1074. **6 A1**

This splendid Victorian hall houses many interesting paintings. The Dining Room contains a J. M. Wright, two Clarkson Stanfield paintings of scenes of the Peninsular War commissioned for Somerleyton, a biblical study by Guido Reni and a portrait of *Admiral Sir Thomas Allin* by Sir Godfrey Kneller. *Deer and Fawn* by Sir Edwin Landseer, *Highland Cattle* by Davies and several paintings by John Frederick Herring hang in the Front Hall. An intriguing Doll's House model of Somerleyton Hall in the seventeenth century is on display in the Drawing Room.

SURREY

CLANDON PARK ❧
West Clandon, Guildford GU4 7RQ
Telephone: Guildford (0483) 222482

NATIONAL TRUST
Open: 1 Apr-end Oct daily except Thurs, Fri (but open GF) 1.30-5.30; BH Mons

and preceding Sun 11-5.30; last admission 5
Access for disabled

At West Clandon, on A247 three miles east of Guildford. **5 A1**

Three of the members of the Onslow family, owners of Clandon Park, became Speakers of the House of Commons. Sir James Thornhill, with his son-in-law William Hogarth, painted *The House of Commons with Speaker Onslow in the Chair* in 1730, which hangs in the Morning Room. In the Hunting Room is an oval conversation piece by Daniel Gardner of Edward Onslow playing chess with Lord Fitzwilliam. A Negro servant looks on.

The stone staircase landing is hung with a series of equestrian portraits by John Ferneley of the 3rd Lord Gardner's stud. There are large bird paintings by Francis Barlow and portraits by Kneller, John Russell, who came from Guildford, Daniel Gardner, and others.

The outstanding Gubbay Collection of porcelain, furniture and mirrors originally at Little Trent Park in Hertfordshire, and left to the National Trust by Mrs Gubbay, is shown here.

GUILDFORD HOUSE GALLERY
155 High Street, Guildford GU1 3AJ
Telephone: (0483) 503406

GUILDFORD BOROUGH COUNCIL
Open: Mon-Fri 10.30-4.50, Sat 10.30-4.15
Admission Free: Limited access for disabled

Guildford is reached via the A3. **5 B1**

The small permanent collection, which is periodically on show, includes works by the Guildford-born artist John Russell (1745-1806). These include male portraits full of character, the actress Dorothy Jordan, and pretty female and child portraits. There are also nineteenth- and twentieth-century paintings and drawings by British artists, as well as topographical pictures.

Temporary exhibitions are arranged each month ranging from children's art to touring exhibitions and important one-man or historical exhibitions.

HAM HOUSE ❧
Ham, Richmond TW10 7RS
Telephone: (01) 940 1950

NATIONAL TRUST
Note: opening times may be subject to alteration in 1990 as conservation work may be taking place. Access for disabled

Underground: Richmond, then Bus 65 or 71
Green Line Bus: 714, 716, 716A
Ferry: To and from the N. bank of the river. **5 A1**

Ham House, a beautifully restored seventeenth-century building which retains much of the atmosphere of the period, contains an impressive collection of portraits, many by Lely.

Specially attractive is his early *Duchess of Lauderdale* in the Round Gallery; she reappears as a mature woman in his double portrait, *The Duke and Duchess of Lauderdale*, in the same room.

Among the fine portraits lining the beautiful Long Gallery are Lely's *Countess of Dysart with a Black Servant*, his *Duke of Rothes* and one of John Michael Wright's greatest portraits, *Colonel John Russell*.

Elsewhere in the house are Kneller's *Henrietta Cavendish* and Cornelius Johnson's *Duke of Hamilton and Earl of Lauderdale*, as well as a pair of portraits by Constable, painted early in his career when he was a frequent visitor to the house.

In the collection of miniatures there is Isaac Oliver's *Unknown Man against a Background of Flames*, with works by Nicholas Hilliard and Samuel Cooper.

The ceiling paintings in the Green Closet by Franz Cleyn, in tempera on paper, may have been tapestry cartoons. Like the inset paintings in the Marble Dining Room they are based on sixteenth-century paintings by Polidoro Caldara. There are ceiling paintings by Verrio in the White Closet and the Duchess's Bedchamber, where the fine overdoors are by Willem van de Velde the Younger.

HATCHLANDS ❧
East Clandon, Guildford GU4 7RT
Telephone: Guildford (0483) 222787

NATIONAL TRUST
Open: Apr-14 Oct Tues, Wed, Thurs, Sun, BH Mons 2-6; Aug, also Sat; last admission 5.30
Closed: GF
Limited access for disabled

North of the A246 Leatherhead to Guildford Road, east of East Clandon. **5 A1**

The red brick house was built for Admiral Boscawen by Robert Adam and has recently been much embellished by Alec Cobbe, who has restored the interior and

lent his collection of musical instruments and Old Master paintings, including a large altarpiece by Allori.

LOSELEY PARK
Guildford GU3 1HS
Telephone: (0483) 571881

MR J. R. MORE-MOLYNEUX
Open: BH Mon May-last Sat Sept Wed-Sat; summer BH 2-5; groups at other times by arrangement
Farm tours by appointment for booked parties, 2-5
Limited access for disabled

Between Guildford and Godalming off the A3000 or A3100. **5 B1**

Sir Christopher More bought the Manor of Loseley in the reign of King Henry VII. His son, Sir William More, one of the Queen's most trusted advisers, built the present house during 1562-68. The high positions of state held by members of the family would account for the royal connections of many of the early paintings, and possibly the portable panels, painted on canvas and mounted on wood, of gods and mythical figures by Toto del Nunziata, which were used as decoration in Henry VIII's banqueting tents.

Elizabeth I and James I stayed at Loseley and there are full-length portraits of James and of Queen Anne by John de Critz. There is an attractive Holbein school portrait of *Edward VI*. Anne Boleyn and Charles II are also represented.

The Great Hall is dominated by a vast picture of Sir More Molyneux, his wife and eight of his eleven children. It was painted by van Somer in the hall in 1739. In the drawing room there are Stuart family portraits by Cornelius Johnson and a later one of the *Duchess of Chandos* by Kneller. A large seascape by Willem van de Velde also hangs here.

In the Great Hall there is a fine minstrels' gallery carved by Grinling Gibbons and unusual perspective panelling which was originally at Nonsuch Palace.

POLESDEN LACEY ❧
Bookham, near Dorking RH5 6BD
Telephone: Bookham (0372) 52048/58203

NATIONAL TRUST
Open: Mar and Nov Sat and Sun 1.30-4.30; Apr-end Oct Wed-Sun (including GF) 1.30-5.30; BH Mons and preceding Sun 11-5.30
Access for disabled

Three miles north-west of Dorking, two miles south of Great Bookham, off A246 Leatherhead-Guildford road. **7 A6**

The greater part of the collection is to be found in the corridors surrounding the central courtyard. Among the fine Dutch Old Masters are Ter Borch's *The Introduction* and Salomon van Ruysdael's *River Scene*. There are magnificent British portraits, including *The Paterson Children*, by Raeburn, *The Masters Pattison* by Lawrence, and *Venus and Piping Boy* by Reynolds in the dining room.

On the stairs is a portrait of *Mrs Greville* by the French artist Carolus-Duran, an outstanding example of the work of Sargent's teacher.

Marble busts of Mrs Greville's family by John Hutchinson are to be found in the lobby. The house is well furnished, and there is a collection of china and tapestries formed by this celebrated Edwardian hostess.

See entry in main text, pages 228-9.

THE PICTURE GALLERY
Royal Holloway and Bedford New College, Egham Hill, Egham TW20 0EX
Telephone: (0784) 34455

UNIVERSITY OF LONDON
Open: By appointment
Access for disabled

The gallery is part of the University of London in Egham. **5 A1**

The initial collection was assembled very rapidly by Thomas Holloway, who founded Royal Holloway College. It contains impressive examples of mostly Victorian art, notably such major Social Realist works as Luke Fildes's *Applicants for Admission to a Casual Ward* and Holl's *Newgate; Committed for Trial*. It also includes *Going to Market, Early Morning* by Gainsborough, *View on the Stour* by Constable, *Van Tromp Going About to Please his Masters* by Turner, *Travellers in a Storm, Winchester* by Copley Fielding, *The Princes in the Tower* by Millais, and *The Railway Station* by Frith.

THE WATTS GALLERY
Compton, Guildford GU3 1DQ
Telephone: (0483) 810235

TRUSTEES OF THE WATTS GALLERY
Open: Daily except Thurs 2-6 (summer), 2-4 (winter), also Wed, Sat 11-1, 2-6
Admission Free: Access for disabled

The gallery is in Compton, three miles from Guildford to the south of the Hog's Back. From the A3 follow the Compton road. **5 B1**

The Gallery is a memorial to George Frederick Watts. The collection includes a full representation of his portraits and landscapes, a group of 'Realist' pictures, and a good number of the religious, mythological and allegorical works which Watts considered his proper subject matter.

There are examples of sculpture by Watts. The full-size model of *Physical Energy* may be seen by appointment. And there are many drawings and sketchbooks, as well as personal effects, and paintings by some of his contemporaries.

See entry in main text, pages 227-8.

——— SUSSEX (EAST) ———

BENTLEY
Halland
Telephone: (082 584) 573

MRS ASKEW AND EAST SUSSEX COUNTY COUNCIL
Open: Easter onwards, May, June, Sept, Oct 12-5; July, Aug 12-5.30
Access for disabled

Seven miles from Lewes, one mile off the A26, two miles off the B2192 and one mile off the A22. **7 D5**

The collection includes excellent sporting pictures, as well as natural history works, notably wildfowl species by the Sussex artist Philip Rickman.

Mary Askew was a devotee of Italian art, in particular the architecture of Palladio and his English followers. To this interest are owed the many pieces of painted Italian furniture of the middle of the eighteenth century and the gilt furniture in the style of William Kent.

BRIGHTON MUSEUM AND ART GALLERY
Church Street, Brighton
Telephone: (0273) 603005

BRIGHTON BOROUGH COUNCIL
Open: Tues-Sat 10-5.45, Sun 2-5; BHs 2-5
Closed: BH Mons
Admission Free: Limited access for disabled

The gallery is in Church Street in Brighton. **7 D5**

The Gallery has a twentieth-century collection of mainly British art. Notable is Glyn Philpots's *Acrobats* and his portrait of *Mrs Basil Fothergill and Daughters*, also a nude by Christopher Wood, and Robert Bevan's *Cab-Yard, Night*.

Further modern works upstairs are by Duncan Grant, Matthew Smith, Ginner, Conder and others; while earlier English paintings include Thomas Lawrence's portrait of *George IV* in his Garter robes. There are also two works by Francis Wheatley, *Encampment at Brighton* and *Mother and Child*. There is a tiny tempera *Adoration* by William Blake; two Alma-Tademas and an early Burne-Jones triptych.

Among the Netherlandish paintings is *The Raising of Lazarus* by Jan Lievens; Aert de Gelder's expressive *Marriage Contract*; a serene Van de Cappelle, and Van der Helst's *Still Life with Carnations*.

French works include *Saint Veronica's Veil* by Philippe de Champaigne, and a Vigée-Lebrun *Self-Portrait*. Among Italian works are a Crivelli diptych, a Giordano, and two Zuccarelli pastoral scenes.

There is a good collection of watercolours, from Sandby, Turner, Cozens and Cotman to Birket Foster and Edward Lear. There are two contrasting studies by Girtin and Shotter Boys of mellow brickwork and stone; Samuel Palmer's large *Dell of Comus*, and a luminous painting by Peter de Wint of haystacks and a harvest wagon. Also some scenes of local interest, including Rowlandson's *Brighton Races* and a sketch by Constable of the beach in early morning light.

See entry in main text, pages 231–3.

FIRLE PLACE

Firle
Telephone: (079 159) 335

VISCOUNT GAGE
Open: June–Sept Sun, Wed and Thurs, BH Sun, Mon, Easter, May Day 2–5; extra rooms shown first Wed of each month
Limited access for disabled

Five miles south-east of Lewes on the A27 road to Eastbourne. **7 D5**

One of the most important collections in south-east England, the works of art at Firle Place are drawn from four family sources, especially the Cowper Collection.

From this collection, the Van Dyck group of *John, Count of Nassau and his Family* dominates the Great Hall. The Upstairs Drawing Room contains important Italian paintings including the *Holy Family and Infant St John* by Fra Bartolommeo, two portraits by Domenico Puligo, the *Crown of Thorns* by Correggio and *Head of a Bearded Man* by Rubens.

Among the several Dutch paintings in the collection is a splendid *Landscape with Windmill* by Philips de Koninck and the *Wine Harvest* by David Teniers the younger.

See entry in main text, pages 229–31.

GLYNDE PLACE

Lewes
Telephone: (079 16) 71743

VISCOUNT HAMPDEN
Open: June–Sept Wed and Thurs 2.15–5.30
No access for disabled

Four miles south-east of Lewes on the A27. **7 D5**

A typical family collection of the seventeenth and eighteenth centuries. There are quite a few Trevor family portraits by Johnson, and others by Lely, Gainsborough, Hoppner, Kneller and Zoffany.

There is a splendid portrait of the Bishop of Durham, whom George III called 'The Beauty of Holiness'.

HASTINGS MUSEUM AND ART GALLERY

Cambridge Road, Hastings TN34 1ET
Telephone: (0424) 721202

HASTINGS BOROUGH COUNCIL
Open: Mon–Sat 10–1, 2–5; Sun 3–5
Admission Free: Access for disabled

Hastings is reached via the A259 and A21. **7 D3**

The Museum and Gallery, founded in 1890, is situated at John's Place, where it has been since 1928. The collection of eighteenth- and nineteenth-century watercolours by Hearne, Farington, Daniell, Cristall, Samuel Prout, W. H. Hunt and others is mainly local.

Twentieth-century British artists represented in the collection include Sickert, Sylvia Gosse, A. S. Hartrick, Thomas Hennell, Sidney Causer, Mark Fisher, Margaret Fisher, Prout and others. Examples from the European Schools include Sebastiano Mazzoni, Panini and Dutch and French works.

HOVE MUSEUM AND ART GALLERY

19 New Church Road, Hove BN3 4AB
Telephone: (0273) 779410

HOVE BOROUGH COUNCIL
Open: Tues–Fri 10–5, Sat 10–4.30, Sun 2–5
Admission Free: Access for disabled

Hove is west of Central Brighton on the A259. **7 D6**

A fine all-round collection covering all areas of fine and decorative art. The eighteenth-century portraits by John Russell, Tilley Kettle, Francis Cotes and Robert Edge Pine are all particularly lively examples of these artists' work. The twentieth-century collection includes Hilda Carline's *Elsie*, probably her best painting, and the replica of Dod Proctor's *Early Morning*, popularly voted Picture of the Year in 1927. These works are displayed along with period furniture, glass, ceramics, silver, textiles and toys among others. The history of Hove is also represented. The schedule of exhibitions embraces regular shows of photography, contemporary craft and new work by younger artists as well as historical exhibitions.

See entry in main text, page 233.

MONK'S HOUSE ✖

Rodmell, Lewes BN7 3HF

NATIONAL TRUST
Open: Apr and Oct Wed and Sat 2–5, May–end Sept Wed and Sat 2–6; last admissions 30 mins before closing
No access for the disabled

Four miles south-east of Lewes, off former A275 (now C7) in Rodmell village, near Church.

Monk's House was the country home of Leonard and Virginia Woolf from 1919, and contains numerous reminders of their own lives and those of their friends, including many portraits and paintings by other members of the Bloomsbury circle, such as a *Portrait of Virginia Woolf* painted c.1912 by her sister Vanessa Bell.

PRESTON MANOR

Preston Park, Brighton BN1 6SD
Telephone: (0273) 603005 ext 59

BOROUGH OF BRIGHTON
Open: Wed-Sat 10-5, Tues & Sun 10-5
Closed: GF, CD, BD
No access for disabled

Two miles north of Brighton centre just off the A23 at Preston Village. **7 D5**

Preston Manor is maintained as an Edwardian residence. There are Dutch, Flemish and English paintings, including family portraits, one of which is by Etty. There are topographical watercolours and nineteenth-century English landscapes.

The interest of the collection lies in its unusual period: the closely integrated art, taste and everyday items of Edwardian England.

THE ROYAL PAVILION

The Old Steine, Brighton
Telephone: (0273) 603005

BRIGHTON BOROUGH COUNCIL
Open: Daily 10-5, June-Sept 10-6
Closed: CD, BD
Limited access for disabled

In the centre of Brighton. **7 D5**

The interior of the Royal Pavilion is as exotic as, and even more splendid than, its onion-domed exterior; and since it has been cleansed of mid- and late nineteenth-century accretions and distortions, it once more accurately mirrors the stimulating taste of its creator, the future George IV. As Nigel Nicolson says, this former royal palace 'is by far the greatest, almost the only, example of a style that flashed across English architectural history at the beginning of the nineteenth century to die out like a rocket in a trail of sparks.'

The Prince Regent actively directed the design of the smallest details, including the pictures which decorate the interior; and although the collection of easel paintings is small, these, and the murals inside the State Rooms, are as interesting for their part in the overall decorative scheme as for their intrinsic appeal.

The murals comprise figurative panels, *trompe-l'œil*, and purely ornamental paintings, spanning the scale between the fine and decorative arts.

The Banqueting Hall contains fourteen large panels of life-size Chinese figures, single and grouped, one of which belongs to the 1823 work by the Regent's painter-designer Robert Jones, the others being Victorian restorations. They are true murals, painted in light, clear colours. The Music Room, in contrast, is covered with delicate chinoiserie landscapes by the painter Lambelet.

The Pavilion is also hung with Chinese easel paintings, dating from around 1800, from a set of about twenty belonging to the Brighton Art Gallery. Some of these were acquired as part of the original decorations; the rest are export pictures in the same style. One addition is a Cantonese watercolour, *The Feast of the Dragon*.

Apart from these original and orientalising works, the collection is complemented by a roomful of eighteenth- and early nineteenth-century engravings and aquatints. These include interiors of the Pavilion by Rowlandson and Pugin, and views and plans by Nash. There are satirical cartoons of George IV and his family.

Paintings include a portrait by Angelica Kauffmann of *Mrs Marriot*, and two pastels by John Russell of the Regent's servants, *Old Smoaker Miles*, his bathing attendant, and *Louis Weltje*, his agent.

Rex Whistler's *HRH the Prince Regent Awakening the Spirit of Brighton* was painted as a mural in 1944. It is worth a trip to the Pavilion for the wicked glinting eye of the plump Prince, clad only in patent pumps, Garter and Sash, as he unveils a sensuous, sleeping nude.

See entry in main text, pages 231-2.

RYE ART GALLERY

Ockmans Lane, East Street, Rye TN31 7JY
Telephone: (0797) 223218

FRIENDS OF RYE ART GALLERY.
Open: Tues-Sat 10.30-1,
2.15-5; Sun 2.30-5
No access for disabled

Rye is east of Hastings on the A259. It can be reached from the north via the A268 from the A21. **7 C3**

The Rye Art Gallery is in extensive premises in a former grain store, with space for the active exhibitions policy which has led to a number of interesting loan exhibitions.

The permanent collection includes works by Edward Burra, Paul Nash, Piper, Epstein and Banting. Burra lived in the Rye area for most of his life.

TOWNER ART GALLERY

High Street, Old Town, Eastbourne
BN22 8BB
Telephone: (0323) 21635/25112

BOROUGH OF EASTBOURNE

Open: Mon-Sat 10-12, 2-5, Sun 2-5
Closed: Mons between Nov and Mar
Limited access for disabled

The Old Town of Eastbourne is reached via the A259 and A22. **7 D4**

The Gallery is named after Alderman John Chisholm Towner (1840-1920), whose bequest of twenty pictures and £6,000 enabled it to be opened. The permanent collection is mainly of nineteenth- and twentieth-century British art, including works by Eric Ravilious, Sickert, Steer, La Thangue and Christopher Wood. There are also some local paintings and topographical works of Sussex, and paintings by the Bloomsbury artists Duncan Grant and Vanessa Bell, who lived nearby at Charleston Farmhouse.

The Gallery runs a wide-ranging programme of temporary exhibitions and related events.

─── SUSSEX (WEST) ───

ARUNDEL CASTLE

Arundel
Telephone: (0903) 883136

DUKE OF NORFOLK
Open: 1 Apr-last Fri Oct Sun-Fri 1-5;
open at 12 during June, July, Aug and all BHs; last admission 4
Limited access for disabled

In Arundel half-way between Worthing and Chichester on the A27. **5 C1**

The collection is principally of family portraits, of an impressive range and continuity, and of high quality. In addition there are religious and genre works, including the popular historical painting of the Earl of Surrey defending his allegiance to Richard III after the Battle of Bosworth. It was painted in 1797 by Mather Brown, an American artist who worked in England.

There 'is a fine Mytens portrait of *Thomas Howard, Fourteenth Earl of Arundel*, the 'Collector Earl', dating from 1616, and the Van Dyck double portrait of him with his wife, Alethea.

The general collection is rich, none the less. There is a fine portrait of Henry Howard, the poet Earl of Surrey, featured against a Mannerist background possibly associated with Inigo Jones. The portrait was probably Italian and Inigo Jones's architectural framework might have been designed for Arundel House. Nineteenth-

and twentieth-century portrait painters are also represented.

See entry in main text, pages 238–9.

GOODWOOD HOUSE
Chichester
Telephone: (0243) 774107

GOODWOOD ESTATE COMPANY
Open: May-Oct 2-5 most Suns and Mons and extra days in Aug; open all year round for groups
Access for disabled

Off the A27 north-east of Chichester, three and a half miles from the town. **7 C1**

Canaletto's superb two *Views of London from Richmond House,* with the sporting pictures, dominate the Goodwood collection. The 1st, 2nd and 3rd Dukes of Richmond all played a part, the last of these being responsible for bringing Stubbs to Goodwood.

Lely's portrait of Frances Stewart, Duchess of Richmond, was the model for Britannia on British coins. *Queen Caroline* by Vanderbank is one of his best works.

There are two seascapes by Samuel Scott. Among other portraitists represented are Dahl, Wissing, Van Loo, Lawrence, Hudson, Hoppner and Grant.

The present generation's acquisitions include a bronze by John Skeaping of Lester Piggott mounted and racing. Elizabeth Frink was commissioned to create a bronze horse for the racecourse: the maquette is in the house.

See entry in main text, pages 240–41.

LITTLEHAMPTON MUSEUM
12a River Road, Littlehampton BN17 5DN
Telephone: (0903) 715149

ARUN DISTRICT COUNCIL
Open: Tues-Sat 10.30-1, 2-4
Admission Free: Limited access for disabled

Littlehampton is on the coast, west of Worthing – off the A259. **5 C1**

Maritime paintings of Littlehampton's shipping history, as well as details of the harbour and river, form a major part of the collection. The two ground-floor galleries contain oils and watercolours such as *A View of Littlehampton with Windmill* by R. H. Nibbs; *The Esplanade* by J. Webb; *The Paddle Steamer* by Leslie Wilcox; *Harbour with Ships* by G. Poulson; *View of Arundel* by Paul Sandby and *Shipbuilding* by G. Burn.

PALLANT HOUSE GALLERY
9 North Pallant, Chichester
Telephone: (0243) 774557

PALLANT HOUSE GALLERY TRUST
Open: Tues-Sat daily 10-5.30 Limited access for disabled

Chichester is 15 miles west of Portsmouth on the A27. **7 C1**

Pallant House contains Dean Walter Hussey's private collection. It includes a number of interesting modern English works with important examples of the art of Ceri Richards and Graham Sutherland.

There is a further selection of loaned public and private collection paintings on view in this beautifully restored Queen Anne town house, which also contains good collections of porcelain, furniture and glass, and has special display space for exhibitions.

See entry in main text, page 241.

PETWORTH HOUSE ✂
Petworth GU28 0AE
Telephone: Petworth (0798) 42207

NATIONAL TRUST
Open: 1 Apr-end Oct daily except Mon and Fri 1-5; last admissions 4.30; Tues, Wed, Thurs Connoisseurs' Day, extra rooms shown; GF, BH Mons 1-5, closed Tues following
Access for disabled

In the centre of Petworth (A272/A283) five miles east of Midhurst. **5 C1**

Petworth House contains the best collection of pictures in the care of the National Trust. The ancient house of the Percy family, it was rebuilt in 1688 by Charles Seymour, 6th Duke of Somerset, and in 1750 passed by marriage to the Wyndham family. Charles Wyndham, 2nd Earl of Egremont, was responsible for the acquisition of many fine paintings. His son George, the 3rd Earl, added works by contemporary British artists and was a patron of Turner.

There are many canvases by Turner, who frequently stayed in the house, using a library as his studio. He painted Petworth itself, and scenes which were of interest to the family. *Chichester Canal, The Lake, Petworth: Sunset, Fighting Bucks* and its companion *The Lake, Petworth: Sunset, A Stag Drinking* are among his canvases in the Turner Room.

There are also numerous notable English portraits. The unrivalled collection of portraits by Van Dyck in the Square Dining Room was acquired by Algernon Percy, 10th Earl of Northumberland, who is shown with his first wife and daughter in a popular portrait by Van Dyck. *Sir Robert Shirley* and his Circassian wife *Lady Shirley* were painted full-length in exotic Eastern dress. Other outstanding Van Dycks include *Thomas Wentworth, Earl of Strafford* and the 'Wizard Earl' *Henry Percy, Ninth Earl of Northumberland.* Some of the most beautiful portraits of women at Petworth are in this room, among them Van Dyck's *Catherine Bruce, Countess of Dysart* and Lely's *Lady Anne Percy, Countess of Chesterfield.*

The early group painting by Lely of *The Three Youngest Children of Charles I,* painted in 1647, hangs in the Oak Staircase Hall, with earlier family portraits including George Gower's *Thomas Percy, Seventh Earl of Northumberland.*

The Beauty Room is named for the set of Dahl and Kneller portraits of ladies of Queen Anne's court, which surrounds Kneller's painting of *Queen Anne.* The wife of the 6th Duke of Somerset, who attended the court, appears in a triumphal chariot in murals on the Grand Staircase, decorated by Louis Laguerre after a fire in 1714 that probably inspired the choice of *Scenes from the Story of Prometheus* for part of the walls. An *Assembly of the Gods* is painted on the ceiling.

The Duke of Somerset introduced Claude's *Jacob with Laban and his Daughters,* now in the Somerset Room with paintings by Paul Brill, Cuyp (*Landscape near Nijmegen*) and some of the finest works in the house: eight tiny oils of *Saints* by Elsheimer, exquisitely painted on copper. There are paintings by Hobbema and Ruysdael, Teniers and Van der Meulen, an unusual Philips de Koninck - a portrait - and a nightmarish *Allegory of the Martyrdom of Charles I* by Cornelis Saftleven. Other Old Masters are spread through the house, beginning in the Oak Staircase Hall with a fine version of Teniers's *Archduke Leopold's Gallery.*

Titian's *A Man in a Black Plumed Hat* and the Le Nain brothers' *Peasant Family* are in the Beauty Room, with Bernardo Bellotto's *Piazza del Campidoglio, Rome* and works by Ruysdael and Bonifazio de' Pitati. Rogier van der Weyden's *St James with a Donor* and *Virgin Annunciate* hang in the Little Dining Room, alongside an *Adoration of the Kings* attributed to Hieronymus Bosch. The portrait of *Isabella Clara Eugenia* is by the Spanish artist Juan Pantoja de la Cruz, and *The Selling of Joseph* by Sebastien Bourdon.

The Carved Room contains a full-length *Henry VIII* by the school of Holbein, William Larkin's *Lady Seymour of Trowbridge* and Joshua Reynolds's *Kitty*

Fisher. Watercolours by the Hon. Mrs Percy Wyndham show these rooms as they were in the nineteenth century.

The North Gallery contains the antique sculptures collected by the 2nd Lord Egremont, but chiefly reflects the taste of the 3rd Earl for the art of his own time. The 3rd Earl is shown here amid his collection in one of many portraits painted for him by Thomas Phillips. *The Egremont Seapiece,* the earliest painting by Turner at Petworth, hangs in the Gallery with Gainsborough's quietly distinguished *A Setter,* Richard Wilson's *View on the Arno,* Zoffany's *An Actress* and paintings by Northcote, Augustus Callcott, Wilkie, Thomas Patch and de Loutherbourg. Versions by Reynolds and Fuseli of *Macbeth and the Witches* may be compared.

One of the largest British works at Petworth, Benjamin West's cartoon for a window of *The Nativity* at St George's Chapel, Windsor, is on the Oak Staircase. In scale it contrasts with the small, meticulous works by William Blake in the Chapel Corridor.

On Tuesdays visitors may see the White and Gold Room, with beautiful Van Dyck portraits of the Countesses of Bedford, Sutherland, Carlisle and Devonshire, as well as the White Library, where Bronzino's *A Florentine Youth* and Kneller's portrait of *Isaac Newton* are on show.

See entry in main text, pages 233–8.

STANDEN ✿

East Grinstead RH19 4NE
Telephone: East Grinstead (0342) 323029

NATIONAL TRUST
Open: 1 Apr–end Oct Wed–Sun and BH Mons (including GF) 1–5.30;
last admissions 5
Limited access for disabled

Two miles south of East Grinstead, signposted from the B2110. **7 C5**

The house was designed and decorated by Philip Webb. He was a great friend of William Morris, whose influence is clearly evident.

Much of the original fine art has been dispersed but the replacements have been chosen with care, to coincide with the atmosphere Webb intended for the house. In the Hall is a portrait of *Margaret Beale* by William Nicholson. The Billiard Room contains a portrait of her husband, *James Beale,* also by Nicholson. On the Staircase is a sculpture by Alfred Drury, a large cartoon by Ford Madox Brown and a tapestry by Burne-Jones. There are in the

house a number of paintings and watercolours by Pre-Raphaelite artists.

WORTHING MUSEUM AND ART GALLERY

Chapel Road, Worthing BN11 1HD
Telephone: (0903) 39999 ext 121 (Sats 204229)

WORTHING BOROUGH COUNCIL
Open: Apr–Sept 10–6; Oct–Mar 10–5
Closed: Sun
Admission Free: Access for disabled

Worthing is west of Brighton, reached by the A27, A24 and A259. **7 D6**

A somewhat limited collection of British paintings and watercolours of the eighteenth, nineteenth and twentieth centuries.

—— TYNE AND WEAR ——

THE HATTON GALLERY

The Quadrangle, Newcastle-upon-Tyne
Telephone: (091) 2328511

UNIVERSITY OF NEWCASTLE-UPON-TYNE
Open: Mon–Fri 10–5, Sat 10–4
Admission Free: No access for disabled

The gallery is in the quadrangle of the University in Newcastle-upon-Tyne. **15 A1**

Most interesting among the modern works here is Kurt Schwitters's large wall relief, the *Elterwater Merzbaum,* which the artist assembled in a barn in the Lake District, just before his death in 1948. The entire wall was removed to the Hatton Gallery.

The collection includes seventeenth-century Italian paintings, among them *The Drunkenness of Noah* by Procaccini, a landscape by Salvator Rosa and *The Descent from the Cross* by Domenichino.

There are some early twentieth-century British drawings and recent British art as well as the Fred and Diana Uhlman Collection of African Sculpture, but the gallery has regular visiting exhibitions limiting the display of the permanent collection.

LAING ART GALLERY

Higham Place, Newcastle-upon-Tyne
Telephone: (091 232) 6989/7734

TYNE AND WEAR MUSEUMS SERVICE
Open: Tues–Fri 10–5.30, Sat 10–4.30, Sun 2.30–5.30
Closed: Mon
Admission Free: Access for disabled

Off New Bridge Street, in the city centre. **15 A1**

The eighteenth-century collection is dominated by portraits, including *James Adam* by Ramsay, *Mr and Mrs Lawrence Monck of Caenby, Lincolnshire* by Wright of Derby, *The Countess of Northampton* by Thomas Hudson, and a Joshua Reynolds, *Mrs Elizabeth Riddell.*

There are comic and genre scenes, landscapes, and good history paintings, notably *Alfred in the Tent of Guthrum the Dane* by Daniel Maclise.

Good examples of landscape painting include Gainsborough's *Peasant Ploughing with Two Horses.*

The nineteenth century is increasingly well represented as it progresses, though there is the exceptional early nineteenth-century collection of works by John Martin, the Newcastle painter of apocalyptic biblical scenes.

There are fine examples of Landseer's work, including his violent *Otter Hunt* and his vast *The Wild White Cattle of Chillingham,* commissioned by Lord Tankerville for Chillingham Castle, in Northumberland.

The Pre-Raphaelites are well represented with Burne-Jones's *Laus Veneris* and Holman Hunt's *Isabella and the Pot of Basil,* as well as works by William Bell Scott, who taught in Newcastle.

Renewed interest in classicism, at the end of the nineteenth century, represented in work by artists like Alma-Tadema, contrasts with the greater realism of painters like Atkinson Grimshaw, which led directly to the beginning of British modernism, with the New English Art Club. Work from this period in British art is particularly strong in the collection, including Clausen and Orpen, Stott, Sickert, and Laura Knight.

There is a reasonably good collection of twentieth-century British art.

See entry in main text, page 134.

SHIPLEY ART GALLERY

Prince Consort Road South, Gateshead NE8 4JB
Telephone: (0632) 4771495

TYNE AND WEAR MUSEUMS SERVICE
Open: Tues–Fri 10–5.30; Sat 10–4.30;
Sun 2–5
Closed: Mon
Admission Free

Near the centre of the town, which lies on the River Tyne just south of Newcastle. **15 A1**

This gallery opened in 1917 as the result of a bequest from Joseph Shipley, a solicitor, of £30,000 and a collection of pictures. This contains a small but important group of Dutch and Flemish sixteenth- and seventeenth-century paintings, including B. G. Cuyp's *The Adoration of the Shepherds*, Abraham Janssen's *Diana and her Companions* and Wtewael's *The Temptation of Adam and Eve*. David Teniers's superb *Tavern Scene* was a National Art-Collections Fund gift. Other highlights include Tintoretto's *The Washing of Feet*, part of an altarpiece by Hans Schäuffelein, and Richard Redgrave's *The Poor Teacher*.

In recent years the gallery has been developed as a major regional centre for the collection and exhibition of contemporary craft and a continual programme of exhibitions covers this and a range of other related areas.

SOUTH SHIELDS MUSEUM AND ART GALLERY
Ocean Road, South Shields
Telephone: (091 456) 8740

TYNE AND WEAR MUSEUMS SERVICE
Open: Tues-Fri 10-5.30, Sat 10-4.30, Sun 2-5
Closed: Mon
Admission Free: Access for disabled

South Shields is at the mouth of the River Tyne, east of Newcastle and eight miles north of Sunderland. **15 A1**

There is a local bias to the paintings which are mostly nineteenth- and twentieth-century oils and watercolours. Particularly worthy of note are C. N. Hemy's *Limehouse Bargebuilders* and marine paintings by John Scott.

SUNDERLAND MUSEUM AND ART GALLERY
Borough Road, Sunderland SR1 1PP
Telephone: (091 514) 1235

TYNE AND WEAR MUSEUMS SERVICE
Open: Tues-Fri 10-5.30, Sat 10-4, Sun 2-5
Closed: Mon
Admission Free: Access for disabled

In the centre of Sunderland, at the junction of Borough Road and Burden Road. **15 A1**

This is a collection of British nineteenth- and twentieth-century art, as well as topographical works, and works by Sunderland painters. There are several marine paintings by John Wilson Carmichael. Other painters represented include J. F. Lewis, D. G. Rossetti and Thomas Miles Richardson, indicating the character of the collection. Two splendid oil paintings by Clarkson Stanfield are worthy of note: *Castle of Ischia* and *Chasse Marée off the Gulf Stream Light*. The collection also contains more modern work, by Lowry and Allen Jones among others.

Carmichael's *Sunderland Harbour*, painted in 1864 and showing shipping in a lively sea at the harbour mouth, is a good local example of the British maritime painting tradition.

WASHINGTON OLD HALL ❧
The Avenue, Washington Village, District 4, Washington NE38 7LE
Telephone: Washington (091) 4166879

NATIONAL TRUST
Open: 1 Apr-Sept daily except Fri (open GF) 11-5; Oct Wed, Sat, Sun 11-5; last admissions 4.30; Nov-Mar by appointment only
Limited access for disabled

Five miles west of Sunderland, two miles east of A1, south of Tyne Tunnel. Follow signs for Washington New Town, then Washington village. **15 A1**

An example of Anglo-American co-operation, this house was rescued from a condemned state, restored, given to the National Trust, and is now used and maintained by Sunderland Metropolitan Council. It has a long association with George Washington's family, and some of its contents have been given by American benefactors.

A Copley painting of Washington and a drawing on a drumhead parchment hang in the Great Hall. There are some Dutch paintings in the Panelled Room as well as local views by the Sunderland artist George Price Boyce.

—— WARWICKSHIRE ——

ARBURY HALL
Windmill Hill, Astley
Telephone: (0676) 40529

MR H. FITZROY NEWDIGATE
Open: Easter-first Sun in October every Sun; also BH Mon and Tues 2-5; other times by arrangement
Limited access for disabled

Outside Nuneaton to the south-west four miles north of the M6 (Junction 3). Approach from A444 or B4112. **4 A3**

The Arbury Hall collection is principally of portraits, mostly of the Newdigate Family, but including also *Elizabeth I* by Thomas Bettes the Younger and *Mary Fitton*, who was the Queen's maid-of-honour and sister-in-law to Sir John Newdigate. Reputedly, she was the 'Dark Lady' of Shakespeare's sonnets.

Peter Lely, Michael Dahl and Mary Beale are among the early painters represented in the collection. A Reynolds, *John the Baptist as a Youth*, is in the Saloon. George Eliot grew up on the estate, for which her father was agent, and used Sir Roger Newdigate as model for Sir Christopher Cheverel. He was also founder of the prize at Oxford named after him.

CHARLECOTE PARK ❧
Wellesbourne, Warwick CV35 9ER
Telephone: Stratford-upon-Avon (0789) 470277

NATIONAL TRUST
Open: 1 Apr-end Oct daily except Mon, Thurs 11-6; BH Mon; last admissions 5
Closed: GF
Access for disabled

On the north side of the B4086, five miles to the east of Stratford-upon-Avon. **4 A3**

The house has been the home of the Lucy family since the twelfth century. In 1823 George Hammond Lucy married Mary Elizabeth Williams, an heiress, and they began to restore the house and its surroundings to their former Elizabethan glory. Many works of art were purchased by them from dealers both in England and abroad between 1829 and 1842. However, a number of the better paintings which they bought, including some from the Fonthill sale of William Beckford's collection of 1823, are gone. What remains is a comprehensive series of seventeenth- and eighteenth-century family portraits.

There are two documented portraits by William Larkin, an early Gainsborough of George Lucy, two Raeburns of Sir Ewen Cameron of Fassifern and Katherine Ramsay, a fine portrait by Batoni, and others after Titian, Van Dyck, Holbein, Eworth, Greuze and Guido Reni. There is a Frans Snyders, *The Spoils of the Chase*.

See entry in main text, page 169.

COUGHTON COURT ❧

Near Alcester B49 5JA
Telephone: Alcester (0789) 762435

NATIONAL TRUST
Open: Apr Sat and Sun 2-6, Oct Sat
and Sun 2-5; Easter Mon-Thurs 2-6;
May-Sept daily except Mon, Fri 2-6;
BH Mon 2-6
Limited access for disabled

25 miles south of the centre of Birmingham
and two miles north of Alcester east of
the A435. **4 B4**

Coughton Court was begun by Sir George
Throckmorton in the early sixteenth
century and the family have always had
a strong allegiance to Roman Catholicism.

The finest of the paintings at Coughton
Court are the Nicolas de Largillière
portraits of *Sir Robert Throckmorton, Fourth
Baronet*, and of *Anne Throckmorton*, daugh-
ter of Sir Francis, the 2nd Baronet. She
was a nun, Abbess of the Augustinian
convent in Paris 1720-28.

There are two Batoni portraits, of
Robert Throckmorton and *Thomas Peter
Giffard*. In the Drawing Room are many
fine miniatures of the Acton family.

Worth mentioning is an interesting set
of six large gouache drawings by Abraham
Rodolphe Ducros. They are scenes in the
vicinity of Castellamare and were probably
commissioned by Sir John Acton, who
was Prime Minister of Naples at the time
of Nelson's Mediterranean campaign.
There are portraits of the family by
Johnson, Lely and George Knapton.

FARNBOROUGH HALL ❧

Near Banbury, Oxfordshire OX17 1DU
Telephone: (029 589) 202

NATIONAL TRUST
Open: Apr-Sept Wed, Sat and May
Day BH Sun and Mon 2-6
Closed: GF
No access for disabled

Half a mile west of the A423 and six
miles north of Banbury, Oxon. **4 B3**

Home of the Holbech family since 1684;
reconstructed in the eighteenth century.
William Holbech enjoyed a protracted
Grand Tour from 1730 to 1745, when he
collected classical marble statuary. Busts
of Roman emperors and classical goddesses
are placed in niches around the Entrance
Hall.

He also commissioned Canaletto to
paint four pictures of Venice for his new
dining room, where they remained for
200 years until they were sold in 1928.

Copies of these, as well as three Paninis
and two family portraits by Nathaniel
Dance, remain in the house.

LEAMINGTON SPA ART
GALLERY AND MUSEUM

Avenue Road, Leamington Spa CV31 3PP
Telephone: (0926) 426559

WARWICK DISTRICT COUNCIL
Open: Mon-Sat 10-1 and 2-5,
also Thurs 6-8
Admission Free: Access for disabled

The art gallery is on Avenue Road in
Leamington Spa, which is south of
Coventry. It can be reached via the
A445 or A452. **4 A4**

The permanent collection of paintings
consists of some Dutch and Flemish artists
of the seventeenth and eighteenth centu-
ries. The twentieth-century oils and water-
colours are mainly English. The main
works include: *The Prodigal Son* by
Bloemaert, *Self-Portrait by Candlelight* by
Schalcken, Richard Wilson's *Faustulus
finding Romulus and Remus*, Kemp Welch's
Winter's White Silence, *The Mission Room*
by Lowry, *Cookham Rise* by Spencer, and
Ivon Hitchens's *The Green Walk*.

There is a collection of landscape and
topographical work by Thomas Baker of
Leamington.

MEAD GALLERY

The Arts Centre,
The University of Warwick
Coventry CV4 7AL
Telephone: (0203) 523523

UNIVERSITY OF WARWICK
Open: Term time only Mon-Fri 12-8,
Sat 10-8
Closed: Sun
Admission Free: Access for disabled

On the University's central campus,
reached by Gibbet Hill Road off the
Kenilworth to Coventry road. **4 A3/4**

There are three galleries devoted to
exhibitions. The Rugby Borough Council
collection of twentieth-century British art,
on loan to the University, is shown
periodically. It includes work by L. S.
Lowry, Wyndham Lewis, Christopher
Wood and Barbara Hepworth.

NUNEATON MUSEUM AND ART
GALLERY

Riversley Park, Nuneaton CV11 5TU
Telephone: (0203) 376473

NUNEATON AND BEDWORTH BOROUGH
COUNCIL
This museum is closed until Autumn 1990
for extensive rebuilding.
Open: Winter 12-5 weekdays, 10-5 Sat
and Sun; Summer 12-7 weekdays, 10-7
Sat and Sun
Admission Free: Limited access for disabled

Approach Nuneaton from the M6 at
Junction 3; take the A444. **4 A3**

A small local museum with a strong
ethnography collection and other items of
archaeological and historical interest. The
fine art consists of 105 oil paintings, 116
watercolours and nine pieces of sculpture.
Of special interest is the collection of 26
miniatures by Lady Stott and a large oil
Before the Deluge by Roelandt Savery.

There are personal effects of the locally
born writer George Eliot.

RAGLEY HALL

Alcester
Telephone: (0789) 762090

MARQUESS OF HERTFORD
Open: Apr-Sept Tues-Thurs, Sat, Sun and
BH Mons 12-5; July, Aug grounds only
open
Closed: Mon, Fri
Access for disabled

Eight miles west of Stratford-upon-Avon
and two miles south-west of Alcester on
the A435. **4 B5**

The home of the Marquess of Hertford,
Ragley Hall has been lived in by the
Seymour family since it was built in 1680.
It has a good country house collection of
mainly eighteenth-century French and
English pictures. Hoppner, Astley and
Kneller are all well represented and there
is a good landscape by Claude Joseph
Vernet. There is an interesting, and
uncharacteristic Morland equestrian por-
trait of the 1st Marquess, and several other
sporting works, including *Lady Conway's
Spanish Jennet* by Wootton. There is a
portrait of Horace Walpole by Reynolds.

There are also Dutch religious works,
The Raising of Lazarus by Van Haarlem,
and *The Holy Family* by Schut.

A splendid large modern canvas, *The
Defeat of the Spanish Armada*, by Ceri
Richards, hangs in the North Staircase
Hall, at the top of the stairs.

In a sense the house is interesting for what it does not have, since the estates were inherited by the 4th Marquess in 1842, who lived in Paris, and was arguably the greatest collector of his age, being responsible for the greater part of the Wallace Collection (q.v.). But he left it to his illegitimate son, Richard Wallace, who bequeathed it to the State. So occupied was he by purchasing works of art that the Marquess neglected totally his Ragley estates.

ROYAL SHAKESPEARE THEATRE GALLERY

Memorial Theatre, Stratford-upon-Avon
CV37 6BB
Telephone: (0789) 296655

SHAKESPEARE MEMORIAL THEATRE
Open: Mon–Sat 9.15–6, Sun 11–4

At the River Avon's edge in the centre of Stratford, part of the Memorial Theatre complex. **4 B4**

The art gallery, as one would expect, is concerned with paintings, watercolours and graphic art connected with the theatre, and with both William Shakespeare and his plays. This makes it the most comprehensive theatre collection in these islands readily available to the public, and it offers a wide diversity of subject-matter.

There are numerous portraits of Shakespeare, none of them authentic, and some, such as Angelica Kauffmann's *Ideal Portrait of Shakespeare*, giving a strange enough interpretation of the playwright.

Many portraits of actors and actresses are owned by the gallery, and there are a number of representations of scenes from plays, including Daniel Maclise's portrait of *Miss Priscilla as Ariel*.

RUGBY LIBRARY GALLERY

St Matthew Street, Rugby
Telephone: (0788) 73959

RUGBY BOROUGH COUNCIL
Open: Mon, Tues, Thurs, Fri 9.30–8,
Wed 9.30–5, Sat 9.30–4
Admission Free: No access for disabled

Approach Rugby from the M1 taking the A428, or from the M6 taking the A426. **4 A3**

The collection has been built up since 1946 by Rugby Borough Council, and Warwickshire County Library has co-operated in its housing and administration since re-organisation in 1974. Acquisitions and allocations have come from the

Sickert Trust, the War Artists' Advisory Committee and the Contemporary Art Society. Today the collection amounts to 122 paintings.

The collection has been carefully chosen and there have been some generous local gifts.

Works of art include *The Fig Tree* by Lucian Freud, *Nude* by Duncan Grant, *Farm Buildings* by Ivon Hitchins, and an unusual Louis Le Brocquy, *Ageing Man Washing*. *Beach Babies* is an interesting Wyndham Lewis, and there are works by Lowry, Minton, Paul Nash, C. R. W. Nevinson, Ceri Richards and Sidney Nolan.

Other modern works include Ruskin Spear's *In the Dope Shop of an RAF Mosquito Aircraft Factory,* Stanley Spencer's *Portrait of Richard Carline,* Graham Sutherland's *Round Hills, The Towpath, Berkhampsted* by Carel Weight and *Bankshead, Cumberland* by Christopher Wood.

The gallery is, at the time of writing, in need of a permanent home.

SAINT JOHN'S MUSEUM

Saint John's, Warwick
Telephone: (0926) 410410

WARWICKSHIRE COUNTY COUNCIL
Open: Tue–Sat 10–12.30, 1.30–5.30;
Sun (May–Sept only) 2.30–5
Admission Free: Limited access for disabled

The museum is at the junction of Smith Street and Coventry Road, on the west side of Warwick. **4 A4**

Among the portraits and local views is the Loveday Collection of Allan Ramsay portraits of Dr John Ward, Vice-President of the Royal Society, and his sister Abigail Ward, as well as Timothy Goodwin. If these are removed from display pending building alterations, they may be viewed in store by appointment.

The museum also houses the Warwickshire Regiment's collection, including a portrait of *Viscount Montgomery of Alamein* by Salisbury, and a small portrait of *General John Guise,* who was a major eighteenth-century collector of paintings and drawings, the basis of the collection in Christ Church, Oxford (q.v.).

WARWICK CASTLE

Warwick, CV3 4QU
Telephone: (0926) 495421

WARWICK CASTLE LIMITED
Open: Mar–Oct daily 10–5.30; 1 Nov–28 Feb daily 10–4.30 (except Christmas Day)
Access for disabled difficult

In Warwick, 21 miles south-east of Birmingham. **4 A4**

The Earls of Warwick, until very recently, inhabited this majestic medieval castle which was founded by William the Conqueror in 1068. About seventy pictures, mostly oil paintings, are on view to the public.

Many of the works are either from the studios of, or are copies of works by, Rubens, Van Dyck, Kneller, Lely, Dobson, and Janssens. Several portraits by Dahl hang among the many family portraits in the Green Drawing Room.

There is an interesting *Two Lions* from the studio of Rubens, in which Frans Snyders had a hand, and a version of the Van Dyck equestrian portrait of Charles I. Noteworthy paintings include a portrait of King Henry VIII from the studio of Holbein, *Jeanne D'Aragon* from the studio of Raphael, probably completed by Romano, and *Princess Beatrice of Lorraine* by Van Dyck.

English portraits include *Frederick, Prince of Wales* by Jonathan Richardson, and *Augusta, Princess of Wales* by Charles Phillips. Queen Anne's Bedroom contains a full-length portrait of the Queen, after Kneller.

Madame Tussaud's *Royal Weekend Party, 1898* is a highly entertaining and original exhibition.

UPTON HOUSE ❧

Near Banbury, Oxfordshire OX15 6HT
Telephone: Edgehill (029 587) 266

NATIONAL TRUST
Open: Apr and Oct Sat, Sun, BH Mon 2–6; May–end Sept Sat–Wed 2–6; Last admissions 5.30.
Closed: GF

One mile south of Edgehill and seven miles north-west of Banbury on the west side of the Stratford-upon-Avon road, the A422. **4 B3**

Given to the National Trust by the 2nd Lord Bearsted, who made considerable alterations to the house to accommodate his superb collection of paintings and china, in 1948.

The range of paintings is very wide: from Flemish and early Netherlandish School to French and Dutch genre scenes, English sporting pictures of the eighteenth and early nineteenth centuries and eighteenth-century English portraits and conversation pieces. There are works by Stubbs, Canaletto, Reynolds, Devis, Hogarth and El Greco.

Of particular interest are three fine works by George Stubbs, *Haymakers*, *Reapers* and *Labourers*. There is the *Adoration of the Magi*, a triptych by Bosch, a sombre *Dormition of the Virgin* by Brueghel the Elder, a characteristic church interior by Saenredam, *El Espolio* by El Greco, and *Morning* and *Night* (from the series engraved as the 'Four Times of Day') by Hogarth.

─── WEST MIDLANDS ───

ASTON HALL
Trinity Road, Aston
Telephone: (021 327) 0062

CITY OF BIRMINGHAM
Open: Mar–Oct 2–5
Closed: all winter
Admission Free: Limited access for disabled

Two miles north-east of Birmingham centre on Trinity Road or Witton Lane. **11 C6**

The paintings, which belong to the City of Birmingham, are not part of the original collection of the Holte family, whose possessions were auctioned in 1817. Nevertheless, certain family portraits, *Sir Charles Holte* by Gainsborough, and *Lady Holte* by Romney, are included.

Other works of art are mainly portraits of the seventeenth and eighteenth century, designed, along with more general furnishings, to reflect the period of family ownership.

THE BARBER INSTITUTE OF FINE ART
The University, Birmingham B15 2TS
Telephone: (021 472) 0962

BIRMINGHAM UNIVERSITY
Open: Mon–Fri 10–5, Sat 10–1
Closed: Statutory hols and on the University's five closed days
Admission Free: Access for disabled

In the Birmingham University campus, in Edgbaston, south-west of the city centre, off the A38. **11 C6**

This collection is intended to serve the purposes of the University of Birmingham and is not, strictly speaking, a public institution, although it is normally open to the public. The range of work to be seen is very wide, and of the highest quality.

There are a number of early Italian works, examples of Venetian art, a wide range of seventeenth-century Dutch paint-ing and a lovely group of Rembrandt drawings. Poussin, Claude, Watteau, Lancret, Courbet are all represented and there is a good selection of English art, including Gainsborough's *The Harvest Wagon*, regarded as one of his best works.

See entry in main text, pages 145–6.

BILSTON MUSEUM AND ART GALLERY
Mount Pleasant, Bilston
Telephone: (0902) 353830

WOLVERHAMPTON BOROUGH COUNCIL
Open: Mon–Sat 10–5
Admission Free: Access for disabled to ground floor

In the centre of Bilston, off the A41. **11 C6**

Bilston Art Gallery has a permanent collection of mainly British works of art, but frequent temporary exhibitions mean that it is not often on view.

CITY OF BIRMINGHAM MUSEUM AND ART GALLERY
Chamberlain Square, Birmingham B3 3DH
Telephone: (021 235) 9944

BIRMINGHAM CORPORATION
Open: Mon–Sat 9.30–5, Sun 2–5
Admission Free: Access for disabled

The Art Gallery and Museum overlooks the Town Hall, in the city centre, just north-west of New Street station. **11 C6**

The Birmingham City Art Gallery is one of England's great provincial galleries, famous for its Pre-Raphaelite paintings. Fashionable attention to these should not, however, obscure other good things in the collection.

Much of the Gallery's superb collection of works by the Birmingham-born Sir Edward Burne-Jones are on paper and cannot, for conservation reasons, be permanently displayed. The series of oil paintings, *Pygmalion and the Image*, is usually on view, along with a huge watercolour commissioned in 1887 by the City of Birmingham for its then-new gallery, *The Star of Bethlehem*, the cartoon for *King Cophetua and the Beggar Maid*, the early work, *The Merciful Knight*, the fine *Phyllis and Demophoön*, the large unfinished canvas, *The Story of Troy*, and one of Burne-Jones's last paintings, *The Wizard*.

The Gallery owns outstanding examples of the work of Holman Hunt, Millais and Rossetti, which are displayed with paint-ings by artists like Ford Madox Brown with whom they were closely associated. His *An English Autumn Afternoon* and *The Last of England*, with Millais's *The Blind Girl*, Holman Hunt's *The Finding of the Saviour in the Temple* and Arthur Hughes's *The Long Engagement*, are among the most famous paintings here. Smaller works are of high quality, too: Millais's *Waiting*, Ford Madox Brown's *Pretty Baa-Lambs* and Holman Hunt's portrait of *Rossetti*. A self-portrait by Holman Hunt is nearby. Sandys's luxurious *Medea* can be compared with Rossetti's *Proserpine* and *Beata Beatrix*. There are fine examples of the work of Henry Wallis *(The Stonebreaker)*, Augustus Egg, R. B. Martineau and John Byam Shaw, whose *Boer War* of 1900 echoes the style of the Pre-Raphaelite generation.

Earlier British painting is also on view: Lely's *Oliver Cromwell* and his early subject painting *Susannah and the Elders*, and Hogarth's *The Distressed Poet*, as well as good Georgian portraits like Gainsborough's *Isabella Franks*. Another children's portrait is *The Blunt Children*, shown precociously haymaking by Zoffany. There is a late Ramsay portrait, *Mrs Martin*, a Reynolds group, *The Roffey Family*, and a large Fuseli painting of a scene from *Henry IV*. Also of interest are Richard Wilson's *Okehampton* and Turner's dramatic *Pass of St Gotthard*.

The impressive Round Room displays academic Victorian art like the beautifully lit *Phidias and the Frieze of the Parthenon* by Alma-Tadema, Albert Moore's *Dreamers* and Lord Leighton's *A Condottiere*. The Gallery is fortunate in owning excellent works by John Frederick Lewis *(The Hareem* and *The Doubtful Coin)*. Victorian landscapes include the popular *February Fill Dyke* by Benjamin Williams Leader, a group of David Cox paintings surrounding a portrait of the artist by Sir John Watson Gordon and a brilliant seascape by John Brett. Joseph Southall, a Birmingham painter, produced the frescoes on the Museum's staircase.

To some extent the later English school paintings lack the fire and stimulation of other galleries, and concentrate on the moody work of Newlyn artists and the austerity of painters like Paul Nash. The Edwardian Tea Room contains Stanhope Forbes's *The Village Philharmonic* and the sentimental *Never morning wore to evening but some heart did break* by W. Langley, with – unusually – a fine French maritime scene by A. Chevallier Taylor. More modern works in the Birmingham collection include Henry Tonks's *Hat Shop*, Sickert's *The Miner* and Gwen John's *Woman Holding a Flower*. There are fine landscapes such as Paul Nash's *Landscape*

of the Moon's First Quarter, Stanley Spencer's Cookham Moor and David Bomberg's Bab-es-Siq, Petra. Spencer's religious side is represented by The Resurrection − Tidying, and his portraits by The Psychiatrist. Another interesting portrait is Graham Sutherland's Edward Sackville-West.

Early Italian painting in the Gallery includes some exceptional works, among them an octagonal panel by Simone Martini, Saint Holding a Book, Giovanni Bellini's Madonna and Child with Saints and Donor and an altarpiece designed by Botticelli: Descent of the Holy Spirit. The Adoration of the Shepherds by Bonifazio de' Pitati is another of the highlights.

The seventeenth-century collection features Guercino's sparkling Erminia and the Shepherd and an exceptionally fine Rest on the Flight into Egypt by Orazio Gentileschi. St Andrew Praying before his Execution is by Carlo Dolci, The Vision of St Anthony by Murillo. A sketch-like landscape by Pietro da Cortona accompanies two small but exquisite Claude landscapes: The Embarkation of St Paul and Landscape near the Ponte Molle. Works by Solimena, Luca Giordano, Strozzi and Pellegrini, as well as such historic pieces as The Holy Family, painted by Gennari for the Catholic wife of James II, round out this part of the collection.

Eighteenth-century Venetian scenes, including Luca Carlevaris's Arrival of the Fourth Earl of Manchester in Venice in 1707 and Canaletto's views of Warwick Castle, with portraits by Batoni and Appiani (Napoleon's court artist in Italy) give an overall representation of Italian art which is impressive.

There are several fine early Flemish paintings, beginning with Man of Sorrows by Petrus Christus, and a Memling Nativity. The Adoration of the Magi triptych by Adriaen Isenbrant contrasts in style with the triptych by Jan van Scorel, Noli me tangere. Dutch art, hung with Flemish work, is fairly comprehensively represented. Landscapes include Paul Brill's Christ Tempted in the Wilderness and a van Goyen River Scene of 1642. There is a fine portrait by Nicolaes Elias (Pickenoy) and a seascape by Willem van de Velde with the ship Hampton Court tossed in the waves, as well as good examples of the art of Ochtervelt, Daniel Seghers and Matthias Stomer.

Modern continental painting includes A Roman Beggar Woman, a fine early Degas and a trio of French landscapes: Sisley's La Vieille Eglise de Moret par la pluie, Pissarro's Le Pont Boieldieu à Rouen and Derain's Landscape near Cagnes.

See entry in main text, pages 142-5.

DUDLEY MUSEUM AND ART GALLERY

St James's Road, Dudley
Telephone: (0384) 456000

DUDLEY METROPOLITAN BOROUGH
Open: Mon-Sat 10-5
Admission Free: Limited access for disabled

The art gallery is in St James's Road in Dudley, west of Birmingham off the M5 at Junction 2. 11 C6

The collection of eighteenth- and nineteenth-century watercolours, and the mixed collection of nineteenth- and twentieth-century oils concentrates frequently on local views and local artists.

There is a Turner watercolour of Dudley, Cromwell at the Blue Boar by Crofts, Primitive Methodists by Titcomb, Dudley Castle by David Cox, Sale of Old Dobbin by Reid, David Hockney's Self-portrait with Picasso, Dymchurch by Paul Nash, Roger Fry's Olive Trees, and John Piper's two watercolours of the bombing of the House of Commons.

HAGLEY HALL

Stourbridge DY9 9LG
Telephone: (0562) 882408

VISCOUNT COBHAM
Open: Jan-Feb daily, BH Sun and Mon, 2-5
Access for disabled

Twelve miles west of Birmingham, off the A456 road to Kidderminster. Access from the M5 at Junctions 3 and 4. 4 A5

The glory of Hagley is due to the 1st Lord Lyttelton (1709-73). In the Drawing Room, 'Athenian' Stuart paintings are surrounded by marvellous Vassali plasterwork. Portraits include works by Van Loo, Ramsay and Shackleton.

The White Hall contains busts of Van Dyck and Rubens by Rysbrack. Two small landscapes by Zuccarelli hang in the Library along with family portraits; one is of the 1st Viscount Falkland attributed to Van Somer. In the Boudoir, among the works of interest are a portrait of The Tenth Viscount Cobham by the Australian painter William Dargie, and a drawing by Queen Victoria, given to Sarah Lyttelton, who was governess to the royal children.

The West Staircase is hung with landscape paintings, an Arcadian scene by Cipriani and Supper at Emmaus by Lafosse. In the Dining Room hangs one of Richard Wilson's few portraits, a picture

of the 1st Lord Lyttelton's half brother, Admiral Thomas Smith. A portrait of Lord Lyttelton by Benjamin West, paintings by Ramsay and Wootton, and a full-length Batoni can be seen in the same room.

Many of the paintings in the Gallery were left to Sir Charles Lyttelton by the 3rd Viscount Brouncker, whose portrait by Lely hangs here. Many of the seventeenth-century paintings have carved mahogany and boxwood frames, some carved by Thomas Johnson. The Van Dyck room is hung with paintings by Van Dyck and his school, including The Children of Charles I and a portrait of the 2nd Earl of Carlisle.

HERBERT ART GALLERY AND MUSEUM

Jordan Well, Coventry CV1 5RW
Telephone: (0203) 25555

COVENTRY CITY COUNCIL
Open: Mon-Sat 10-5.30, Sun 2-5
Admission Free: Access for disabled

The art gallery is in the city centre, close to the cathedral. 4 A4

The gallery has an important collection of British figure drawings from 1880, British landscape watercolours and paintings from 1770, and many good examples of local topographical works.

It also has Graham Sutherland's studies for the tapestries in Coventry Cathedral. The collections of modern British and contemporary art are being extended. Sculptures include a bust of Rabindranath Tagore by Epstein, Figure in Walnut by Barbara Hepworth and a statue of Elizabeth Frink by F. E. McWilliam.

Lady Godiva, as one would expect, features in a number of works of art, among them Landseer's Lady Godiva's Prayer, in which the main interest centres on the horse, Lady Godiva's Ride by John Collier and works on the Godiva theme by David Gee.

WALSALL MUSEUM AND ART GALLERY

Lichfield Street, Walsall WS1 1TR
Telephone: (0922) 650000

WALSALL METROPOLITAN BOROUGH COUNCIL
Open: Mon-Fri 10-6, Sat 10-4.45
Admission Free: Access for disabled

The museum is in Lichfield Street. Walsall is reached from the A34 and M6 from Birmingham and Coventry, and the A454 from Wolverhampton. 11 C6

The Garman-Ryan Collection was formed by Lady Kathleen Epstein (née Garman) and her friend the American sculptress Sally Ryan during the period from 1959 to 1973, after which it was presented to Walsall. Lady Epstein also donated many works by her husband, Sir Jacob Epstein.

The works are generally French or English, late nineteenth or early twentieth century. They concentrate on the figurative (there is only one abstract work in the collection). They are displayed according to subject matter rather than by school, or chronologically.

The main works include *Sorrow* by Van Gogh, William Blake's *Christ in the Carpenter's Shop*, *Portrait of Marguerite* by Degas, *Woman Bearing Sacks*, a plaster low-relief by Gaudier-Brzeska, *Le Chemin Creux dans la Falaise à Varengeville* by Monet and *Hagar at the Well* by Rembrandt.

WEDNESBURY ART GALLERY AND MUSEUM

Holyhead Road, Wednesbury
Telephone: (021 556) 0683

SANDWELL CORPORATION
Open: Mon, Tues, Wed, Fri 10-5; Thurs and Sat 10-1

In the town centre. 11 C6

The gallery contains the Edwin Richards collection of Victorian paintings and watercolours.

WIGHTWICK MANOR ✿

Wightwick Bank, Wolverhampton WV6 8EE
Telephone: Wolverhampton (0902) 761108

NATIONAL TRUST
Open: All year except Feb, Thurs, Sat, BH Mon and preceding Sun 2.30-5.30; pre-booked parties May-Sept, Wed 2.30-5.30, also Wed and Thurs evenings
Limited access for disabled

Three miles west of Wolverhampton up Wightwick Bank (A454) beside the Mermaid Inn. 11 C6

Sir Geoffrey Mander gave Wightwick Manor, a Victorian house, to the National Trust in 1937. Lady Mander, an authority on the Pre-Raphaelites, lived in the house until her death in 1989. All the artists involved in 'The Brotherhood' are well represented. Also to be seen are works by Ford Madox Brown, John Brett, A.W. Hunt and Frederick Sandys.

Of special interest is *Portrait of Mrs Nassau Senior* by Watts and *Love among the Ruins* by Burne-Jones.

WOLVERHAMPTON ART GALLERY

Lichfield Street, Wolverhampton
WV1 1DU
Telephone: (0902) 312032

WOLVERHAMPTON CORPORATION
Open: Mon-Sat 10-6
Closed: BHs
Admission Free: ground-floor access for disabled.

The Central Art Gallery, as it is also known, is in the centre of Wolverhampton, near the station. 11 C6

The Art Gallery is an imposing Victorian building designed by architect Albert Chatwin and presented to the town by the industrialist Philip Horsman in 1884.

On permanent display are fine collections of eighteenth- and nineteenth-century British painting, including examples by Gainsborough, Turner, Zoffany and Landseer. Of particular interest is a collection of narrative paintings by F. D. Hardy and other artists of the Cranbrook Colony; the finest in the UK.

In contrast, the Gallery houses an outstanding collection of British and American Pop Art, including major works by Andy Warhol, Roy Lichtenstein and Richard Hamilton. More recent developments can be seen in newly acquired exhibits by Gilbert and George, John Bellemy and the Brazilian sculptor Ana Maria Pacheco.

Also on display are fine examples of oriental decorative arts, including Japanese and Chinese ceramics, ivory and weapons.

There is a regular programme of temporary exhibitions with the emphasis on contemporary paintings and sculpture.

——— WILTSHIRE ———

AVEBURY MANOR

Avebury, near Marlborough
Telephone: (067 23) 203

MR AND MRS NEVILL-GLIDDON
Open: Mar-Oct 10-6 daily; other times by appointment
No access for disabled

West of Marlborough, at the junction of the A361 and B4003; it is nine miles from the M4 Swindon exit. 5 A4

The house has a small collection of portraits. The earliest is the 1532 panel of *Sir Edward Seymour*, brother to Queen Jane Seymour. He later became Duke of Somerset.

His great-grandson – whose portrait is also in the house – married Arabella Stuart without permission, and was imprisoned for it, a fate which also befell another member of the Seymour family, the Earl of Hertford, who married Lady Jane Grey's sister, Catherine, without asking Queen Elizabeth.

Portraits of the Marquess of Ailesbury's family begin in the seventeenth century and run through to the twentieth, though the more recent works are not exhibited.

BOWOOD HOUSE

Calne SN11 0LZ
Telephone: (0249) 812102

EARL OF SHELBURNE
Open: 31 Mar-14 Oct daily 11-6
Access for disabled

Between Chippenham and Calne, off the A4. 5 A5

Bowood House has a good and well-presented collection of fine art and there is a comprehensive catalogue to the paintings by James Miller. The contents of the house comprise the remainder of two famous eighteenth- and nineteenth-century art collections made by the 1st and 3rd Marquesses of Lansdowne. Some of the original Lansdowne (classical) marbles are complemented by fine examples of nineteenth-century sculptures by Westmacott, Theed and Bell.

English paintings of the eighteenth and nineteenth centuries include works by Reynolds and Gainsborough, among them the latter's *Landscape with Cattle Returning Home*. The Reynolds works include portraits of *The Countess of Ilchester, Mrs Baldwin, Hope Nursing Love, Horace Walpole* and the *First Marquess of Lansdowne*. There are a number of nineteenth-century land- and seascapes by Eastlake and Clarkson Stanfield. Dutch and Italian artists are also represented.

Of particular note for specialists is the extensive collection of English watercolours. An important group of pencil, wash and watercolour drawings by Richard Parkes Bonington was bought from the artist's studio sale in 1829 by the 3rd Marquess; it comprises views of France and Italy as well as studies after other artists. The present Earl of Shelburne has added to the family collection and there are good examples or groupings of work

by Turner, Lear, Cox, Varley, Roberts and Buckler. (A comprehensive collection of watercolours of Wiltshire churches and houses, some by Buckler, is held at Devizes Museum.) A superb group of nineteenth-century watercolours by the Italian painter Bossoli should also be mentioned.

The 5th Marquess was Viceroy in India from 1888 to 1894 and among a number of paintings of that country is a group by Major-General Sir Matthew Gosset.

The Bowood collection is principally the work of the 3rd Marquess of Lansdowne, whose love of Bonington echoes that of the Marquess of Hertford for the same artist, reflected in the splendid collection of Boningtons in the Wallace Collection.

See entry in main text, pages 254–5.

CORSHAM COURT
Corsham
Telephone: (0249) 712214

LORD METHUEN
Open: Jan-30 Nov Tues-Sun and BHs 2-4 (2-6 June-Sept and all BHs); last entry 5.30; other times by arrangement
Access for disabled

South of the A4, eight miles north-east of Bath and four miles south-west of Chippenham. **5 A5**

The splendid and diverse collection accumulated at Corsham during the eighteenth and nineteenth centuries is displayed with a genuine desire to allow ready and close access to the paintings.

The main works are spread between the magnificent triple-cube Picture Gallery and the Cabinet Room, in which hangs one of the most beautiful paintings in any English country house: *The Annunciation* from the studio of Fra Filippo Lippi.

The Picture Gallery contains Van Dyck's moving *Betrayal of Christ*, Bernardo Strozzi's *St Mark amd St John* and *David and Solomon* and Cortona's *Tancred and Erminia. Charles I on Horseback* is an early copy of the Van Dyck in the National Gallery. The sixteenth-century Sofonisba Anguisciola, a woman artist famous in her day, is represented by the striking and popular *Three Gaddi Children*. Other works of note include Reni's *Pope Paul V*, Carlo Dolci's *Christ in the House of Simon the Pharisee* and *Pope Clement ordaining St Denis* by Ninet de Lestain. *A Mathematician* is attributed to Ribera, and there are coastal landscapes by Salvator Rosa as well as *A Wolf and Fox Hunt* by the studio of Rubens, a replica of the

version in the Metropolitan Museum, New York.

Works on paper include a large cartoon of *Flying Cherubs* by the Cavaliere d'Arpino, Giuseppe Cesari, and a tapestry design by Bronzino, *The Meeting of Jacob and Joseph.*

The Octagon Room is hung with small works by Roelandt Savery, Teniers and others; outstanding are Andrea del Sarto's *St John the Baptist in the Wilderness* and Claude Lorrain's *St John in the Wilderness.*

Among the many portraits in the house are the anonymous *Allegorical Portrait of Elizabeth I*, showing the old Queen flanked by Time and Death, Dobson's *A Knight* and *Colonel Richard Neville,* Van Dyck's *Man in a Ruff* and Cornelius Johnson's *Penelope Noel.* Family portraits in the Dining Room include *Thomas Methuen as a Child* and *Paul Cobb Methuen and his Sister Christian as Children,* both by Reynolds. Christian reappears as the adult *Lady Boston* with her husband *Frederick, Lord Boston* in portraits by Romney. (Van Dyck's *Paul Cobb Methuen* and Gainsborough's *Paul Methuen* are occasionally on view.)

The corridors are hung with portraits by Lely, Frank Holl, and de Laszlo (the artist *Paul Ayshford, 4th Lord Methuen*). Still lifes include works by Frans Snyders – his spirited *Fox Hunt* is in the Dining Room – and the Italians Maltese and Campidoglio. The big *Judgement of Paris* and its companion the *Judgement of Midas* are collaborations by Gerard de Lairesse and Adam Pynacker.

In the Music Room are Gioacchino Assereto's *Christ and the Woman Taken in Adultery*, Albani's *Rape of Europa* and works by Francesco Bassano and Carlo Dolci. The pair of *Heroic Landscapes* is by Gaspard Dughet.

See entry in main text, pages 252-3.

DEVIZES MUSEUM
41 Long Street, Devizes SN10 1NS
Telephone: (0380) 77369

WILTSHIRE ARCHAEOLOGICAL AND NATURAL HISTORY SOCIETY
Open: Mon-Sat 10-5 (4 in winter months)
Limited access for disabled

Devizes is twenty miles south of Swindon on the A361. Can also be reached via the A342 and A360. **5 A5**

The museum has a good local and topographical collection, including a number of watercolours of Stonehenge, among them an outstanding example of Copley Fielding's work. Other English watercol-

ourists in the collection include Prout, Cattermole, Wheatley, John Sell Cotman and W. H. Bartlett.

The museum possesses a substantial collection of watercolours of Wiltshire churches and houses by John Buckler, dating from around 1805. There are 690 of these, and a further 256 watercolours by Robert Kemm of Wiltshire churches, executed in the mid-nineteenth century.

LACOCK ABBEY 🏛
Lacock, near Chippenham SN15 2LG
Telephone: (024 973) 227

NATIONAL TRUST
Open: 1 Apr-4 Nov daily except Tues 1-5.30; last admissions 5
Closed: GF
Limited access for disabled

Just off the A350 Road from Chippenham to Melksham, three miles south of Chippenham. **5 A5**

William Sharington converted the Abbey, originally a nunnery, into a private home. His portrait and that of his third wife, Grace, attributed to Antonio Mor, hang in the South Gallery.

The house came into the Talbot family through the marriage of Sharington's niece and was eventually the home of William Henry Fox Talbot, the famous photographer. Portraits in the Stone Gallery include John Ivory Talbot and his wife Mary by Dahl. In the Dining Room hangs *Peace and the Arts* by Cornelius van Haarlem and copies after Van Dyck and Rubens. The Painting Room contains watercolours by Fox Talbot's two younger daughters.

LONGLEAT HOUSE
Warminster BA12 7NN
Telephone: (098 53) 551

MARQUESS OF BATH
Open: Easter-Oct daily 10-6, rest of the year 10-4
Limited access for disabled

Four miles south-west of Warminster off the A362. **5 B6**

Longleat House, the Wiltshire home of the Marquess of Bath, began as a monastic establishment. At the dissolution of the monasteries it passed to the Crown and, in 1540, was sold for £53 to Sir John Thynne, who is believed to have been his own architect. It is a fine example of the Italianate architecture of Elizabeth I's reign.

The house has a substantial collection of family portraits, from Larkin and Gower, in the sixteenth century, to Graham Sutherland, John Singer Sargent and William Orpen, in the twentieth. It is not otherwise richly endowed with works of art, though there are Flemish, Dutch and Italian paintings, including *Rest on the Flight into Egypt* attributed to Titian.

An oval portrait of Bishop Ken hangs in the Red Library. He was a friend of the 1st Viscount Weymouth, and spent the last twenty years of his life at Longleat, after having been deprived of his See in 1691 for refusing to take the Coronation Oath to William III. He wrote the hymn, 'Awake, my soul, and with the sun' at Longleat, and it was sung at dawn, at his burial in Frome churchyard, in 1710. The hymn, together with 'Glory to thee, my God, this night', was composed for the boys of Winchester College, to sing or recite at their bedsides, morning and evening. It is perhaps the only association of a hymn-writer with a country house art collection.

LYDIARD PARK

Lydiard Tregoze, Swindon SN5 9PA
Telephone: (0793) 770401

BOROUGH OF THAMESDOWN
Open: Mon-Sat 10-1, 2-5.30; Sun 2-4.30
Admission Free: Access for disabled

North of the A420 and five miles west of Swindon, well signposted. **4 D4**

The house is hung with a fine collection of predominantly seventeenth- and eighteenth-century St John family portraits, including works by or attributed to George Hoppner, Isaac Whood, Michael Wright, John Riley and Jonathan Richardson. The schools of Lely, Kneller, Van Dyck and Jervas are also represented. A striking portrait of Barbara Villiers, Countess of Castlemaine, by Lely has recently been added to the collection.

MOMPESSON HOUSE ❧

Cathedral Close, Salisbury SP1 2EL

NATIONAL TRUST
Open: 1 Apr-4 Nov Sat-Wed 12-5.30
Closed: GF
Limited access for disabled

In Salisbury on the north side of Choristers' Green, in the Cathedral Close near High Street Gate. **5 B4**

Barbara Townsend, a member of one of the families which have lived at Mompes-son, has provided the house with a number of delicate watercolours. Other paintings are on loan from Stourhead. The Turnbull collection of drinking glasses is on display here.

NEW HOUSE

Redlynch, Downton
Telephone: (0725) 20055

MR AND MRS G. JEFFREYS
Open: Easter Mon and BH Mons 2-6; First Sun in May-last Sun Sept 2-6
Limited access for disabled

South of Salisbury, off the B3080, and three miles from Downton. **5 C4**

New House contains an interesting fantasy painting, by an unknown artist of the seventeenth century, showing hares behaving as humans, with humans as their victims. Supposedly a satire dating from the period of Charles I, the picture is part of the universal mythology surrounding the hare.

SALISBURY AND SOUTH WILTSHIRE MUSEUM

The King's House, 65 The Close, Salisbury SP1 2EN

SALISBURY AND SOUTH WILTSHIRE MUSEUM TRUST
Open: Apr-Sept Mon-Sat 10-5; Suns July and Aug 2-5; Oct-Mar Mon-Sat 10-4
Access for disabled

The museum is in the centre of Salisbury, in the Cathedral Close. **5 B4**

The collection is essentially topographical, covering Salisbury and South Wiltshire, with a strong emphasis on the city, the Cathedral and Stonehenge. It has over 100 oils and 2,500 prints and drawings.

There are portraits of local historical figures. Temporary exhibitions, both from the museum's own collection, and on loan, are held.

STOURHEAD ❧

Stourton, Warminster BA12 6QH
Telephone: Bourton (0747) 840348

NATIONAL TRUST
Open: 1 Apr-4 Nov Sat-Wed 12-5.30 or dusk if earlier; last admissions 5; other times by written appointment
Limited access for disabled

North of the A303, on the borders of Somerset and Dorset; off the Frome-Mere Road, B3092, in the village of Stourton, three miles north-west of Mere. **5 B6**

Stourhead, a Hoare family property until it passed to the National Trust, has a splendid collection, mainly paintings of the seventeenth and eighteenth century. The Georgian taste for copies of Italian Old Masters is evident; some of these, like Pompeo Batoni's *Salome with the Head of John the Baptist* reproducing the Reni now in the Art Institute, Chicago, are of interest in themselves. There are also original works of art in plenty.

In the Picture Gallery are several fine paintings: Poussin's *The Choice of Hercules*, Cigoli's *Adoration of the Magi* (formerly a Florentine altarpiece) and Gaspard Dughet's *Landscape with Eurydice*. Anton Mengs's *Caesar and Cleopatra* was commissioned by a Hoare in 1759 as a companion to Carlo Maratta's *The Marchese Pallavicini and the Artist* of 1705. The large paintings by Henry Thomson, *Distress by Land* and *Distress by Sea*, illustrate James Thomson's *Seasons*.

The Entrance Hall is lined to the ceiling with family portraits by artists as diverse as Dahl, Ramsay, Samuel Woodforde and Lord Leighton. *Henry Hoare on Horseback*, a joint effort by Michael Dahl and John Wootton, depicts the creator of Stourhead's gardens, and the founder of the picture collection. Wootton also painted *Sir Richard Hoare as Lord Mayor*, which hangs in the Saloon.

Delicate pastels by the unrelated Bath artist, William Hoare, including portraits of the Hoare children, and the particularly fine *Sleeping Child*, are a delight.

See entry in main text, pages 255-7.

SWINDON MUSEUM AND ART GALLERY

Bath Road, Swindon
Telephone: (0793) 26161

THAMESDOWN BOROUGH COUNCIL
Open: Mon-Sat 10-6, Sun 2-5
Admission Free

The art gallery is in Bath Road, Swindon. From the M4 exit at Junction 15 or 16. **4 D4**

The permanent collection, which shares a gallery with travelling exhibitions, is principally of twentieth-century British art. Much of the finest work derives from the gift of H. J. P. Bomford and includes works by Lowry, Martin, Moore, Nicholson and Sutherland. Among other

artists represented are Bomberg, Hamilton, Hilton, Long, Nash, Wadsworth and Wood.

Regrettably, the museum's policy of holding a succession of visiting exhibitions, and its limited space, mean that this splendid collection of work is only ever partially shown, and often is not to be seen at all.

WILTON HOUSE
Wilton
Telephone: (072 274) 3115

EARL OF PEMBROKE
Open: 7 Apr-11 Oct Tues-Sat and BHs 11-6; Sun 1-6; last admissions 5.15
Access for disabled

Two and a half miles west of Salisbury, off the A30 in the town of Wilton. **5 B4**

Wilton House has been the seat of the Earls of Pembroke for over 400 years. Built in the mid-sixteenth century, it was redesigned after a fire in 1647 by Inigo Jones, who died before the house was finished. It was finally completed by John Webb, Inigo Jones's nephew. The house has many literary associations and Sir Philip Sidney wrote his *Arcadia* in the Tudor predecessor to the present house, of which only the gatehouse now remains.

The art at Wilton House constitutes another of the great and unspoilt collections of paintings and sculpture in British country houses. Among its chief glories is the collection of royal and Pembroke family portraits by Van Dyck, housed in Wilton's finest chamber, the remarkable Double Cube Room, designed especially to receive them.

The Single Cube Room also contains Van Dyck portraits, together with portraits by Lely, Wissing and Jonathan Richardson.

Ceiling paintings in these two splendid rooms are by Thomas de Critz and Giuseppe Cesari respectively, showing the story of Perseus in the larger of the two rooms, and the legend of Daedalus and Icarus in the smaller room, where Emmanuel de Critz, brother of Thomas, worked on wall friezes of scenes from Sir Philip Sidney's *Arcadia*.

Sidney, whose sister married the Second Earl of Pembroke, represents one of many of the literary associations with the house, which is said to have been the setting for a production of *As You Like It*, with Shakespeare taking part.

Old Master paintings include an early Rembrandt, *Portrait of the Artist's Mother*, Ribera's *Democritus*, *Madonna* by Sassoferrato, and works by Van de Velde, Honthorst, Rubens, Claude, del Sarto and Lotto.

See entry in main text, pages 249-52.

– YORKSHIRE (NORTH) –

BENINGBROUGH HALL ❧
Near Shipton YO6 1DD
Telephone: York (0904) 470666

NATIONAL TRUST
Open: Apr weekends only and Easter week 12-6; May-Oct daily except Mon, Fri; Open BH Mons 12-6;
last admissions 5.30
Limited access for disabled

Eight miles north of York and two miles west of Shipton, two miles south-east of Linton-on-Ouse, on the A19. **15 B5**

Beningbrough is a remarkable baroque house. Completed by 1716, it was supervised by William Thornton (1670-1721), a carpenter-architect from York, who was responsible for the magnificent woodcarvings to be seen in the house. After the Bourchier line died out in 1827, the house passed to the Dawnay family and later became the home of the 10th Earl and Countess of Chesterfield.

Beningbrough is one of several houses owned by the National Trust in which a substantial number of paintings from the collection of the National Portrait Gallery have been placed on permanent exhibition.

They are generally of outstanding quality, and are by the most renowned portraitists of the period. The Kit-cat portraits in the Dining Room were painted by Godfrey Kneller between 1697 and 1721 for the Kit-cat Club (a group of Whig writers and politicians).

Reynolds, Gainsborough, Closterman, Highmore, Mercier, Charles Jervas and Richard Wilson are some of the painters represented in the collection.

See entry in main text, page 121.

CASTLE HOWARD
Coneysthorpe
Telephone: (065 384) 333

THE HON MR AND MRS SIMON HOWARD
Open: 25 Mar-31 Oct daily 10-5;
last entry 4.30
Access for disabled

North of the A64 between York and Malton, approximately six miles from Malton. Well signposted. **15 B5**

Castle Howard is one of Britain's finest country houses. Charles Howard, 3rd Earl of Carlisle, invited John Vanbrugh to produce designs for a new house in 1699. This was to launch the former soldier and dramatist on a new architectural career. His coadjutor was Nicholas Hawksmoor, who was responsible for the famous Mausoleum at Castle Howard, and who was to play an important part in the realisation of Vanbrugh's ideas.

The collection is diverse, ranging from Roman mosaic art of the first century AD to the twentieth-century murals painted by Felix Kelly after the television production of Evelyn Waugh's *Brideshead Revisited*. Murals and ceiling paintings, damaged by fire and since restored, are to be seen in the Great Hall.

The Tapestry Room contains several paintings by Reynolds, a portrait by Romney and one by Gainsborough. One of the Reynolds portraits is a full-length of Omai. Known as the 'Gentle Savage', he was entertained by George III, and returned to Tahiti with a barrel organ among his gifts. The Music Room contains a group portrait of the 5th Earl of Carlisle with his family, painted by Francis Wheatley.

In the Orleans Room hang pictures bought by the 5th Earl of Carlisle: the *Music Master* by Domenico Feti; *Herodias and Salome* by Rubens, which formerly belonged to Sir Joshua Reynolds; *The Duke of Ferrara*, attributed to Parmigianino, and works by Marco Ricci, Gaspard Poussin, Bourdon, Bassano, Veronese and Carracci.

See entry in main text, pages 121-2.

CONSTABLE BURTON HALL
Leyburn
Telephone: (0677) 50428

MR C. WYVILLE
Open: For one month in summer, telephone for information
No access for disabled

On the A684 15 miles west of Northallerton.

The Wyville family collected some of the paintings during the eighteenth century. Others were also acquired from Denton Hall near Otley, an Ibbetson family home which the Wyvilles inherited in the nineteenth century.

Dutch and Italian works include *Herdsman and Cattle in a Roman Landscape with a Peacock and Peahen and Other Fowl* by Philip Pieter Roos, *A Roman Landscape with Peasants and Animals by a Fountain* by

Jan Baptist Weenix and works by Castiglione, Cavaliere d'Arpino, Frans Snyders and Peter Boel.

The three-quarter-length portrait, *Lady Ibbetson*, is by Philippe Mercier. Other portraits are by Kneller, Soldi and Hoppner.

SCARBOROUGH ART GALLERY

The Crescent,
Scarborough
Telephone: (0723) 374753

SCARBOROUGH BOROUGH COUNCIL
Open: Tues–Sat 10–1, 2–5; Sun 2–5
from spring BH to end Sept
Admission Free: Limited access for disabled

Scarborough is on the coast, reached via the A165, A170 or A171. **15 C4**

The permanent collection is chiefly of local interest and consists in the main either of views of Scarborough or pictures by Scarborough painters.

The Laughton Gift consists of nineteenth-century narrative paintings and portraits by British artists from the seventeenth century. Notable pictures include a large and early work by Lord Leighton and several characteristic night scenes with moonlight by Atkinson Grimshaw. The nineteenth-century watercolourist Henry Barlow Carter is particularly well represented.

Also there is a programme of monthly temporary exhibitions showing all aspects of contemporary art, touring exhibitions and a selection of historical retrospective shows.

EBBERSTON HALL

Scarborough
Telephone: (0723) 385516

MR AND MRS DE WEND FENTON
Open: GF–1 Oct daily 10–5
No access for disabled

On the A10 Scarborough to Pickering Road, eleven miles south-west of Scarborough. **15 C4**

The house was built in 1718 by William Thompson, M.P. for Scarborough, whose architect was Colen Campbell, pioneer of the Palladian Revival in England. The elaborate woodwork includes carved friezes, the work of the same craftsmen who had worked at Castle Howard and Beningbrough.

The contents of the house are mainly eighteenth and nineteenth century, including family portraits of the de Wend

Fenton family. There is a collection of nineteenth-century watercolours by the Honourable Mrs Richard Boyle ('E.V.B.'), a friend and contemporary of the Pre-Raphaelites.

HARROGATE ART GALLERY

Library Buildings, Victoria Avenue,
Harrogate
Telephone: (0423) 503340

HARROGATE DISTRICT COUNCIL
Open: Mon–Sat 10–4 (during exhibitions)
Admission Free: No access for disabled

The art gallery is in the town centre. **15 A5**

The main collection is of nineteenth-century British art, including works by Frith, Herring, Turner and Watts. The Herring is a splendid, large, genre painting *Barnet Fair* and is on permanent display. Likewise on permanent show is *Many Happy Returns of the Day* by W. P. Frith, which is perhaps the most popular and the most famous painting in the collection. There are also two paintings by Atkinson Grimshaw to be seen, *Silver Moonlight* and *A Yorkshire Home*.

The first half of the twentieth century is well represented by the leading artists of this period. Also on permanent show is the recently acquired collection of paintings by Joseph Baker Fountain, a Knaresborough naïve artist, described as having qualities akin to the style of the school of Brueghel in his canvases.

In addition, the gallery also maintains a regular programme of contemporary art exhibitions throughout the year.

Unfortunately, it is necessary to close for short periods between exhibitions.

KIPLIN HALL

Near Richmond
Telephone: (0748) 818178

KIPLIN HALL TRUST
Open: 20 May–end Aug Wed and Sun 2–5
No access for disabled

North of the River Swale on the B6271, off the A1 at the B1263 Richmond-Scorton road junction. **15 A3**

The house, now run as a Charitable Trust, was built by George Calvert, 1st Lord Baltimore and founder of the State of Maryland. Although presently undergoing restoration work, fine art contents on view include pictures from the seventeenth

to the nineteenth century. One of the eighteenth-century inhabitants, Christopher Crowe, was British Consul in northern Italy, where he collected some of the Italian works.

NEWBY HALL

Boroughbridge, near Ripon HG4 5AE
Telephone: (090 12) 2583

MR AND MRS R. COMPTON
Open: House: Easter–2 Oct; Gardens: Easter–30 Oct
Limited access for disabled

Four miles south-east of Ripon, three miles west of the A1 off the B6265. **15 A5**

William Weddell, an ambitious 'Grand Tour' collector, is responsible for the presence of many of the works, including a full-length portrait of himself by Batoni.

The Drawing Room contains a portrait of *Lady Theodosia Vyner* by Sir Thomas Lawrence. Five portraits by Van Loo hang in the Dining Room. They include the group portrait of the Empress Maria Theresa, with her mother, and her husband, as well as the 1st Lord Grantham with his wife. A conversation piece, of *Lord Grantham's Children*, by Jan Mytens, also hangs here.

The Entrance Hall is decorated with wall paintings by Rosa de Tivoli and *Saint Margaret* by Annibale Carracci. A large and excellent collection of classical sculpture is housed in the Sculpture Gallery.

NORTON CONYERS

Melmerby, near Ripon
Telephone: (076 584) 333

LADY GRAHAM
Open: Suns in June, July, Aug; The first Sun in Sept also Sun and Mon BHs; 23 July–4 Aug daily 2–5.30; any time to pre-booked groups
Access for disabled

One and a half miles from the A1, three miles north of Ripon near Wath. **15 A5**

The Graham family have occupied the house, thought to be the model for 'Thornfield Hall' in Charlotte Bronte's *Jane Eyre*, since 1624 and the collection dates from then. *The Quorn Hunt* by John Ferneley hangs in the Hall along with a Beechey of *Sir Bellingham Graham*, who won the Hunt portrait on a dice throw.

In the Parlour hangs a portrait of *The Sixth Baronet, Sir Bellingham Graham, and his Family* by Henry Walton, a Norwich

painter. Romney and Batoni are also represented in the collection.

NUNNINGTON HALL ✤
Nunnington, Ryedale YO6 5UY
Telephone: Nunnington (043 95) 283

NATIONAL TRUST
Open: Apr Sat, Sun Easter 2–6; May, June, Sept–28 Oct daily except Mon, Fri 2–6; July–Aug Tues–Thurs 2–6, Sat, Sun 12–6; BH Mons 12–6; last admissions 5.30
Limited access for disabled

Four and a half miles south-east of Helmsley, one and a half miles north from the B1257 in Ryedale.

Nunnington, a National Trust property, is most famous for the Carlisle Collection of 22 Miniature Rooms which are furnished in periods ranging from William and Mary to the present day. There is a collection of nineteenth-century British watercolours.

PANNETT ART GALLERY
Pannett Park, Whitby
Telephone: (0947) 602908

WHITBY TOWN COUNCIL
Open: May–Sept daily 9.30–5.30, Sun 2–5; Oct–Apr Mon–Tues 10.30–1 Weds–Sat 10.30–4, Sun 2–4
Admission Free

Pannett Park is in the centre of Whitby. **15 C3**

Alderman Pannett left money to build this gallery, which owns mostly nineteenth-century oils and some watercolours, including works by Turner, Bonington, Girtin and Constable.

SHANDY HALL
Coxwold
Telephone: (034 76) 465

THE LAURENCE STERNE TRUST
Open: June–Sept Wed 2–4.30 and Sun 2.30–4.30 all year round by appointment
No access for disabled

Seven miles south-east of Thirsk on the edge of Coxwold village 20 miles north of York. **15 A4**

Shandy Hall was the home of the comic writer and clergyman Laurence Sterne, and was called after Shandy Hall in the novel *Tristram Shandy*. Sterne had the living of Coxwold from 1760 to 1768.

The house contains an interesting and varied collection of books, paintings, drawings and sculpture, illustrative of the books, and of Sterne and his family and friends.

YORK CITY ART GALLERY
Exhibition Square, York
Telephone: (0904) 623839

YORK CITY COUNCIL
Open: Mon–Sat 10–7, Sun 2.30–5
Admission Free: Access for disabled

The art gallery is in the centre of York, close to the Minster. **15 B5**

The York City Art Gallery was transformed by the gift of the Lycett Green collection in 1955 from a good provincial collection to one of the major art galleries in Britain.

York was the birthplace of William Etty, that contradictory Victorian painter whose lusciously erotic nudes were painted with a purity of mind and heart that amounted almost to religious fervour. Among the good cross-section of his work here are nudes with titles such as *Venus and Cupid* and *The Toilet of Venus*, and his Venice subject-picture, *The Bridge of Sighs*. Etty was a fine portraitist: his portrait of the famous actress *Mlle Rachel* is particularly striking

Early Italian works include panel paintings of the fourteenth and fifteenth centuries, of which *The Dead Christ with Mary and St John* by the Master of the Lucchese Altarpiece is a good example. Later Italian paintings include Domenichino's vivid portrait of his friend *Cardinal Agucchi*, another portrait attributed to Parmigianino, and a Procaccini *Annunciation*. The witty *Parable of the Mote and the Beam* is by Domenico Feti.

An unusual feature of the Gallery is the superb eighteenth-century Spanish *Still Life with Citrus Fruits* by Luis Egidio Meléndez. Note also the Valdez Léal *Spanish Repentence*.

Northern European art includes *A Sleeping Soldier* by Bernhard Strigel, painter to the Emperor Maximilian, and some outstanding Flemish and Dutch paintings of the seventeenth century. These include a *Venus and Cupid* by Joachim Wtewael and *Roman Charity (Cimon and Pero)*, a curious subject popular in the seventeenth century, by the Dutch Caravaggist Theodore van Baburen. *Peasants and Horsemen at an Inn* is a major example of Jan van Goyen's 1630s style. *A Game Stall* by Frans Snyders was one

of a set of still lifes representing the seasons.

Among the French paintings of the seventeenth and eighteenth centuries are a scene from Cibber's '*The Careless Husband*' by Philippe Mercier, and paintings by Gravelot, Greuze, Watteau and Millet. Since 1950, when it acquired Daubigny's *The Waterfall*, the Gallery has taken a special interest in nineteenth-century French art. It owns Isabey's *Boat in a Storm* and works by Corot, Courbet and Boudin. The Fantin-Latour still lifes include the beautifully lit *White Roses*.

The early British paintings are few but among them are Lely's enchanting *Lady Charlotte Fitzroy, later Countess of Lichfield*. There are portraits by Van Dyck and by his servant, Edward Bower, and what may be Francis Cotes's masterpiece: *Lady Stanhope and the Countess of Effingham as Diana and her Companion*. Reynolds's portrait of *Captain John Foote of the Hon. East India Company* shows the sitter in Indian dress. Other artists in the Georgian collection include Sawrey Gilpin, whose *Election of Darius* (an Emperor elected by the neighing of a horse) proved that animal painters could tackle historical subjects.

Upstairs are some of the first paintings to come to the Gallery, those of the 1882 Burton Bequest of Victorian art, including *Hogarth's Studio in 1739* by E. M. Ward. It is shown with the placid *Canterbury Meadows* by Thomas Sidney Cooper, famous for his paintings of sheep and cows. The powerful *Christ Stilleth the Tempest* by John Martin is of another order altogether, and is accompanied by Francis Danby's *Deluge* of about 1828. Albert Moore was born in York and the Gallery owns typical examples of his work: *Kingcups* and *A Venus*.

The bequest of the Very Revd E. Milner-White is remarkable for the consistency of taste it reveals: paintings in the Whistlerian mood by Greaves (*Nocturne in Blue and Gold* may have been begun by Whistler), Watts's *Ararat*, Gwen John's *Girl in a Red Shawl*, and paintings by Sickert, Gilman, Steer and Spencer Gore. Milner-White also gave the Stanley Spencer *Deposition and Rolling Away of the Stone,* complemented in the Gallery by a version of Watts's *Progress* and by Carel Weight's 1954 *Betrayal of Christ*. It is characteristic of the Gallery that, having received the austere *Winter Sea* by Paul Nash, it should display as well the very different seascape, *The Wave*, painted in 1898 by the Irish artist Roderic O'Conor. The Gallery also owns paintings by Yorkshire artists and of Yorkshire places,

by artists from William Marlow to Lowry.

See entry in main text, page 120.

— YORKSHIRE (SOUTH) —

BRIAN O'MALLEY CENTRAL LIBRARY AND ARTS CENTRE
Walker Place, Rotherham
Telephone: (0709) 382121/3259

ROTHERHAM METROPOLITAN BOROUGH COUNCIL
Open: Tues–Sat 10–5
Closed: Mon, Sun, BHs
Admission Free: Access for disabled

Rotherham is north-east of Sheffield via the M18 or M1. **12 A2**

The fine art collection has been treated as secondary to the applied arts; as a result it is miscellaneous in nature and unexceptional in quality, although it does, nevertheless, contain several pleasing and interesting pictures. There are roughly 200 oil paintings, 200 watercolours and 2,000 prints and drawings.

Most of the oil paintings are Victorian and Edwardian in date and reflect popular taste. Artists represented include E. J. Niemann, Copley Fielding, Henry Redmore, George Chambers, J. T. Peele, E. C. Barnes, G. Cattermole, T. B. Hardy, and D. W. Wynfield.

The gallery has a small number of eighteenth-century oil paintings, including a dozen fine portraits (on loan) of members of the Walker family. These were at one time attributed to Zoffany but are certainly by a provincial portrait painter.

The watercolours and prints are largely topographical and include many eighteenth-century prints of picturesque scenes, ruins and country seats. The Buckler watercolours are particularly worthy of note.

The gallery actively collects works by one artist, William Cowen (1797–1861), who was born in Rotherham. He worked in Switzerland, Italy and Corsica.

CANNON HALL
Near Cawthorne, Barnsley
Telephone: (0226) 790270

METROPOLITAN BOROUGH OF BARNSLEY
Open: Weekdays 10.30–5, Sun 2.30–5
Admission Free: Limited access for disabled

West of Barnsley off the A635. Also west of M1 (Junction 37 or 38). **12 A2**

The Cannon Hall collection of pictures is mainly of the eighteenth century, with one or two earlier works, and nineteenth-century paintings and drawings by generally minor artists.

The most popular work, and perhaps also the most important, is John Constable's portrait of *Mrs Tuder*, purchased in 1958 with a grant from the Victoria and Albert Museum. There are also watercolours and drawings, including works by Sickert, Ruskin and Birket Foster. Of interest in this second group are the Roger Fry *Portrait of Edith Sitwell*, *Samurai* by Miró, *Shadowy Shelter* by Henry Moore, *Butcher's Shop* by Coker and Gwen John's *A Corner of the Artist's Room*.

Some attempt is to be made to build up the collection of modern art.

CLIFTON PARK MUSEUM
Clifton Park, Rotherham
Telephone: (0709) 382121, ext 3569/3519

ROTHERHAM METROPOLITAN BOROUGH COUNCIL
Open: Apr–Sept Mon–Thurs, Sat 10–5; Sun 2.30–5; Oct–Mar Mon–Thurs, Sat 10–5; Sun 2.30–4.30
Admission Free: Limited access for disabled

The museum is in a house in Clifton Park. **12 A2**

This good general museum contains a collection of nineteenth- and twentieth-century, mainly English paintings, including a fine portrait by George Romney.

COOPER GALLERY
Church Street, Barnsley
Telephone: (0226) 242905

BARNSLEY METROPOLITAN BOROUGH COUNCIL
Open: Tues 1–5.30; Wed–Sun 10–5.30
Admission Free: Limited access for disabled

Barnsley is between Leeds and Sheffield, just east of the M1, reached via the A628, A61 or A635. **12 A2**

The fine art collection at the Cooper Gallery includes Dutch seventeenth-century paintings, Italian and French eighteenth- and nineteenth-century paintings and English drawings and watercolours from the eighteenth to early twentieth centuries. Many were donated to the Cooper Collection by Sir Michael Sadler,

through the National Art-Collections Fund.

DONCASTER MUSEUM AND ART GALLERY
Chequer Road, Doncaster
Telephone: (0302) 734287

DONCASTER METROPOLITAN BOROUGH COUNCIL
Open: Daily 10–4; Sun 2–5
Admission Free: Access for disabled

Doncaster is east of the A1(M) and north of Junction 2 on the M18. **12 B2**

A collection of paintings, watercolours and prints of the nineteenth and twentieth centuries. There are sporting pictures, appropriate to this racing area of England, and including works by J. F. Herring, Senior.

Among the watercolours are examples of the work of Rowlandson, de Wint, Crome, Prout and Frank Brangwyn, who is extensively represented. *Sybil Thorndike as Saint Joan* by Epstein, *Head of Sir Edward Marsh,* a benefactor, by William Dobson, and a work by Gaudier-Brzeska are among the sculptures.

Some seventeenth-century European works are included in the collection, among them landscapes and genre scenes by Ruisdael, Van Goyen, Van Os, and Tiepolo.

GRAVES ART GALLERY
Surrey Street, Sheffield
Telephone: (0742) 734781

SHEFFIELD METROPOLITAN DISTRICT COUNCIL
Open: Daily 10–8, Sun 2–5
Admission Free: Access for disabled

In the city centre, in the Central Library building. **12 A2**

Alderman John Graves and John Newton Mappin were the two major benefactors of art to the city of Sheffield, leaving it with a pair of outstanding galleries (see Mappin Gallery), both now administered by Sheffield Arts Department, an amenities department of the Council.

Other donations and bequests have made valuable additions. Dutch, French and Spanish paintings are well represented, and one of the earliest Dutch paintings in the gallery is the portrait *Johanna de Witt* by Michiel van Miereveld. Pynacker, Hobbema and Salomon van Ruysdael are also represented by good examples of their work.

Spanish painting includes *The Infant Christ Asleep on the Cross* by Murillo and *Man with a Skull* from the school of Ribera. There are Italian works, including a Tiepolo, *The Arts,* and religious subjects by Pittoni, Procaccini and Ludovico Carracci.

The group of French paintings includes work by Boudin, Corot, Harpignies and Bastien-Lepage and a loan group of Impressionist paintings.

There are a number of good British painters represented, including *Sheffield Buffer Girls,* by William Rothenstein, indicating the artist's interest in his northern origins (he came from Bradford). The gallery is strong in modern British painting, with examples of Allen Jones, David Hockney and Kitaj. The city collection of watercolours is held at the Graves.

MAPPIN ART GALLERY
Weston Park, Sheffield
Telephone: (0742) 726281/754091

SHEFFIELD METROPOLITAN DISTRICT COUNCIL
Open: Tues-Sat 10-5, Sun 2-5
Admission Free: Access for disabled

North-west of the city centre, beyond the university, on the way to the Manchester Road (A57). **12 A2**

The gallery was built with money left by the Rotherham brewer John Newton Mappin. The collection concentrates on British painting of the eighteenth, nineteenth and twentieth centuries. It is particularly strong in the Victorian period with a large number of conventional, good-quality pictures bought by the gallery's benefactor, mostly from the Royal Academy.

There is also a comprehensive collection of English watercolours with Cozens, Gainsborough, Cotman, Girtin, Palmer, Constable and Turner all well represented. Among the Turner works is his *Festival of the Vintage at Mâcon.* There is a fine David Cox, *Crossing the Heath.*

Among Victorian paintings is a good Sargent group portrait, *The Vickers Sisters,* and *The Hours* by Burne-Jones. There is a strong group of contemporary British art.

THE RUSKIN GALLERY
(Collection of the Guild of St George)
101, Norfolk Street, Sheffield
Telephone: (0742)734792/734781

SHEFFIELD METROPOLITAN DISTRICT COUNCIL

Open: Mon-Fri 10-6.30, Sat 10-5
Closed: Sun
Admission Free: Limited access for disabled

Norfolk Street is in the city centre, close to the Graves Art Gallery. **12 A2**

After almost a century, the collection which John Ruskin sought to establish for the benefit of working people in Sheffield has now re-opened. It includes paintings and drawings by him, as well as by other artists. Among the latter is William Parrott's *Turner on Varnishing Day,* painted in 1846. Early works include Cosimo Rosselli's *Virgin and Child with Angels.*

The Museum did have a brief life in the late nineteenth century, when Ruskin sought to establish and teach certain principles about museums and art galleries in the service of community life. The experiment failed for lack of public support. The collection is owned by the Guild of Saint George and administered by the Sheffield Arts Department.

— YORKSHIRE (WEST) —

BANKFIELD MUSEUM AND ART GALLERY
Akroyd Park, Halifax
Telephone: (0422) 54823/52334

CALDERDALE BOROUGH COUNCIL
Open: Mon-Sat 10-5, Sun 2.30-5
Admission Free: Limited access for disabled

Bankfield is on the Boothtown Road in Halifax which is south-west of Leeds off the M62. **11 C1**

The collection contains a group of Victorian oils, eighteenth- and nineteenth-century watercolours, local topographical works and twentieth-century British works.

Paintings include *Sarah Cullen Playing the Harp* by William Beechey, *Man Goeth Forth to his Labours* by Philip Calderon, *Inside of a Kanaree Cave at Salsette* by Thomas Daniell, *The Mitherless Bairn* by Atkinson Grimshaw, *Rolling Easter Eggs* by E. A. Hornel, *Flowers* by Jan van Huysum, *Shelter Figures* by Henry Moore, and *The Actress* by Matthew Smith.

BOLLING HALL
Bolling Hall Road, Bradford
Telephone: (0274) 723057

BRADFORD CITY ART GALLERY
Open: Apr-Sept 10-6; Oct-Mar 10-5
Closed: Mon except BH
Admission Free: Limited access for disabled

Overlooks Bradford and is off the A650 to the south. **11 D1**

The collection changes from time to time, and originates from the Bradford City Art Gallery at Cartwright Hall (q.v.). Portraits of the Lindley and Wood families, on loan from Lord Halifax, are hung together with Flemish and British paintings in keeping with a house dating mainly from the seventeenth century, but remodelled in the late eighteenth century.

BRAMHAM PARK
Boston Spa, Near Wetherby LS23 6ND
Telephone: (0937) 844265

MR AND MRS LANE FOX
Open: 17 June-30 Aug Tues, Wed, Thurs, BH Mons Sun 1.15-5.30; last admissions 5
Access for disabled

Off the A1 at Bramham due south of Wetherby. **15 A6**

The collection is mainly of portraits but with a pleasant leavening of landscape watercolours of the park and house by Ziegler. There are hunting scenes by Sartorius, Wootton and Cooper-Henderson, and animal studies by Agasse. A number of classical scenes and subject paintings by Campidoglio, Jordaens and Pourbus are also in the collection. There is a powerful Reynolds portrait of *The Duke of Cumberland* and a not terribly flattering portrait of *Queen Anne* by Godfrey Kneller.

CARTWRIGHT HALL
Lister Park, Bradford
Telephone: (0274) 493313

BRADFORD METROPOLITAN COUNCIL
Open: Oct-Mar 10-5; Apr-Sept 10-6
Closed: Mon except BHs
Admission Free: Access for disabled on request

Lister Park is to the west of the city centre. **11 D1**

Built as a memorial to Edmund Cartwright, the inventor of the power loom,

and opened in 1904, the main areas of the collection include late nineteenth-century genre painting, much of it dealing with Eastern and classical subject matter, in keeping with the prevailing fashion. It gives an unusually integrated character to the main works, many of which are large and impressive. Victorian eroticism is also apparent.

There is a good collection of late nineteenth- and early twentieth-century landscapes and genre scenes by British artists associated with the New English Art Club, influenced by Clausen, Stanhope Forbes, La Thangue and Edward Stott.

The La Thangue portrait *The Connoisseur* is particularly distinguished: the artist spent much time in Bradford. His friend Mitchell is the subject of the painting. A later NEAC stalwart, Wilson Steer, is represented by *The Last Chapter*. There is sculpture by artists associated with this movement, including works by Thomas, Frampton and Drury.

There is a large collection of international contemporary prints, including works by Blake, Caulfield, and Tilson.

Cartwright Hall offers a varied exhibition programme, which includes shows relating to the permanent collections and exhibitions of contemporary art – local (Bradford), regional (Yorkshire), national and international.

See entry in main text, pages 118–20.

CLIFFE CASTLE MUSEUM AND ART GALLERY
Keighley
Telephone: (0535) 664184

CITY OF BRADFORD METROPOLITAN COUNCIL
Open: Apr-Sept Tues-Sun 10-6;
Oct-Mar Tues-Sun 10-5
Admission Free: Limited access for disabled

Keighley is north-west of the Bradford/Leeds complex on the A629. **14 D6**

Cliffe Castle, once the home of a local worsted manufacturer, Henry Butterfield, is a general museum with some fine decorative art reflecting the period of the building's construction (1875-85) and Mr Butterfield's taste. The paintings include Old Masters and interesting Victorian works. Frequent temporary exhibitions.

EAST RIDDLESDEN HALL ⚓
Bradford Road, Keighley BD20 5EL
Telephone: Keighley (0535) 607075

NATIONAL TRUST
Open: Apr Sat, Sun 2-5.30; Easter 12-5.30; May, June, Sept, Oct Wed-Fri 2-5.30; Sat, Sun, BH Mon 12-5.30; July, Aug daily except Mon, Tues 12-5.30;
Last admissions 5
Access for disabled

One mile north-east of Keighley on the south side of the A650, on north bank of River Aire 50 yards from Leeds/Liverpool Canal. **14 D6**

The pictures are few and do not originate from this National Trust property, but there are some of topographical interest.

In the Rose Room hang two wings from a sixteenth-century (possibly Flemish) altarpiece, with the donor and his family, and, on the reverse, their patron saints. There is a picture of the magnificent *Airedale Heifer*, bred by Mr Slingsby in 1830. (A most impressive figure, she measured 11 feet 10 inches from nose to tail; 10 feet 6 inches in girth and was eleven inches deep in fat on the ribs.) The balance of the collection is seventeenth- and early eighteenth-century portraits, with a recently acquired portrait of Mrs Starkie, attributed to a follower of John Riley.

HAREWOOD HOUSE
Harewood
Telephone: (0532) 886225

EARL AND COUNTESS OF HAREWOOD
Open: 1 Apr-31 Oct daily: gates and bird garden 10, house 11; Feb, Mar, Nov Suns only
Access for disabled

At the junction of the A61 and the A659 on the Leeds to Harrogate Road, five miles from the A1 at Wetherby. **15 A6**

Edwin Lascelles began to build Harewood House in 1759, choosing as his architect John Carr of York. Later he was to involve the young Robert Adam, who collaborated with Carr on designs for the house. The interior is considered to be one of Adam's greatest achievements.

The richest additions to the art collection were made by the 6th Earl who, in 1916, inherited not only his great-uncle's fortune but also his collection of Italian and Flemish paintings.

Now it is a fine but uneven collection, from which a number of important Old Master paintings have been, and continue

to be, sold, the most famous being Titian's *Death of Actaeon*. The Old Masters were mainly collected by the 6th Earl, the 1st Earl being responsible for the impressive collection of watercolours.

Among the Old Master paintings of importance are a *Madonna* by Giovanni Bellini, a fine El Greco of *A Man, a Woman and a Monkey*, and portraits by Tintoretto, Veronese and Titian. Other religious works include a Vincenzo Catena, *Saint Jerome*. There are paintings by Cima da Conegliano and Pollaiuolo.

The Long Gallery contains an impressive collection of English portraits, many of them full-length, by Gainsborough, Reynolds, Hoppner, Lawrence, Winterhalter and Romney. Particularly notable are the two Reynolds portraits which hang above the twin fireplaces.

See entry in main text, pages 116–18.

HUDDERSFIELD ART GALLERY
Princess Alexandra Walk,
Huddersfield
Telephone: (0484) 513808 ext 216

KIRKLEES METROPOLITAN COUNCIL
Open: Mon-Fri 10-6, Sat 10-4
Admission Free: Access for disabled

Huddersfield is south-west of Leeds and south of the M62. **11 D1**

The collection is fairly representative of the development of British art over the last hundred years. There is a good collection of paintings by members of the Camden Town Group which includes *Tea in the Bedsitter* by Harold Gilman, and Sickert's *View of Ramsgate*.

Other artists represented include Graham Sutherland, Francis Bacon, Lowry and Henry Moore. There is a Stanley Spencer, *The Garden at Cookham Rise*.

A variety of work by artists in the Kirklees area is on view.

LEEDS CITY ART GALLERY
Municipal Buildings, Leeds
Telephone: (0532) 462495

CITY OF LEEDS
Open: Mon-Fri 10-6 (Wed until 9),
Sat 10-4, Sun 2-5
Admission Free: Access for disabled

In the centre of Leeds, opposite the Town Hall. **11 D1**

Leeds City Art Gallery has concentrated on building up the strengths of its collection, which are, broadly speaking, from the nineteenth and twentieth centu-

ries. There is also a good collection of English eighteenth- and nineteenth-century watercolour painting.

Nineteenth-century French art includes Courbet's *Les Demoiselles du Village*, a fine open landscape study for the large canvas in the Metropolitan Museum of Art in New York. Later nineteenth- and twentieth-century French painting is comprehensively represented, with particularly good examples of Derain, Signac, Bonnard, Vuillard and Marquet.

The Shadow of Death, William Holman Hunt's overstated piece of Pre-Raphaelite symbolism, is a powerful example, nevertheless, of English painting of the second half of the nineteenth century, represented perhaps by too many superficial works of a sentimental or heroic kind.

With the beginning of the twentieth century, Leeds comes firmly into prominence as a major repository. Works by Orpen, Gore, Gwen John, Gilman, Ginner, Steer, Clausen, Brangwyn and Epstein include many given by a local businessman, Sam Wilson.

Outstanding works by Bomberg, Nevinson, Gaudier-Brzeska, Wadsworth, Roberts, Wyndham Lewis, Moore and Burra point forward towards the sustained representation of British twentieth-century art which makes the City Art Gallery so stimulating a collection to visit.

See entry in main text, pages 114–16.

LOTHERTON HALL

Aberford, Leeds
Telephone: (0532) 813259

LEEDS CITY ART GALLERIES
Open: Tues–Sun daily and BH Mons 10.30–6.15 (or dusk in winter)
Limited access for disabled

On the B1217 Leeds to Towton Road, one mile east of the A1. **15 A6**

The Hall, part of the Leeds City Art Galleries, is first and foremost a museum of the decorative arts but still retains its Gascoigne family character with *Sir Thomas Gascoigne with his Art Collection*, painted in Rome in 1778 by Pompeo Batoni. There is also a portrait of *Sir Edward Gascoigne, the Sixth Baronet*, attributed to Francesco Trevisani.

The Irish House of Commons by Francis Wheatley derived from the long and successful visit to Ireland by the artist at the end of the eighteenth century, and is one of his major works.

English sculptors represented in the collection are Christopher Hewetson, Thomas Banks, Joseph Gott and Henry

Weekes. There is a good group of Flemish paintings and changing displays of paintings from the Leeds Collections, usually of early twentieth-century British painting.

NOSTELL PRIORY ✄

Doncaster Road, Nostell, near Wakefield WF4 1QE
Telephone: Wakefield (0924) 863892

NATIONAL TRUST
Open: Apr, May, June, Sept, Oct Sat 12–5, Sun 11–5; July, Aug daily except Fri 12–5, Sun 11–5; BH Mon 11–5, Tues following Easter Mon, Spring BH, Aug BH 12–5
Closed: GF
Access for disabled

Six miles south-east of Wakefield on the north side of the A638. **11 D1**

Originally a medieval priory, the estate was acquired by the Winns in 1650 who have held it ever since. Sir Roland Winn built the present house around 1735 and the 5th Baronet, who succeeded in 1765, commissioned Robert Adam to complete the interior.

The most famous work of art is a version of Holbein's *Sir Thomas More and Family*.

On the North Staircase hangs *Angelica Hesitating between the Arts of Music and Painting*, a self-portrait by Angelica Kauffmann. She married Antonio Zucchi, who did much of the wall painting in the house. The carved gilt frames of the Amber Room paintings, as well as the paintings themselves, are worthy of note, especially the rococo frame on the portrait of *The Duke of Monmouth*.

A landscape by Richard Wilson, flower-pieces by Nicolas van Verendael and Jean-Baptiste Monnoyer, and a still life by Abraham Janssens hang here as well. In the Breakfast Room are two versions of *Flight into Egypt*, one by Claude and the other after Salvator Rosa. There are further works by Dutch artists. The house also contains works by Pieter Brueghel the Younger, Mytens, Henry Pickering and a version of Poussin's *Bier of Phocion* as well as his *Landscape with Figures*.

See entry in main text, pages 125–6.

SMITH ART GALLERY

Halifax Road, Brighouse
Telephone: (0484) 719222

CALDERDALE BOROUGH COUNCIL
Open: Mon–Sat 10–5, Sun 2.30–5
Closed: Sun Oct–Mar

Admission Free: Limited access for disabled

On the hill out of Brighouse, leading to Halifax. **11 D1**

Only a small selection of paintings from the permanent collection is on view, but the collection is quite extensive and consists mainly of paintings by Victorian artists such as Frith, Lord Leighton, Millais, Mulready and Herring. There are also some watercolours by Whistler, David Cox, and Samuel Prout.

There are some works by local Yorkshire painters, including canvases by Henry Raphael Oddy.

TEMPLE NEWSAM HOUSE

Leeds
Telephone: (0532) 617321

CITY OF LEEDS
Open: Tues–Sun 10.30–6.30 (dusk in winter); BH Mons
Access for disabled

Five miles south-east of Leeds. **11 D1**

Temple Newsam is one of the three art museums administered by Leeds City Council. The others (qq.v.) are Leeds City Art Gallery and Lotherton Hall. The house was bought in 1622 by Sir Arthur Ingram, who rebuilt it, and whose family remained in ownership until the late nineteenth century. It was sold to Leeds, with the surrounding land, in 1922.

It is the most impressive Tudor-Jacobean house in West Yorkshire, and its collection, which is being expanded, reflects the life, the history, the various owners, as well as containing fine art generally.

Among works of importance are portraits of owners, including *Sir Arthur Ingram* by George Geldorp, Leonard Knyff's *Arthur, Third Viscount Irwin*, and portraits of *Henry, Seventh Viscount Irwin and his Wife*, by Philippe Mercier.

There is a fine, full-length portrait by Reynolds, *Isabella, Lady Hertford*. Roubiliac's *Alexander Pope* is also in the collection.

Other important works include the lovely *Portrait of a Child with Rattle* by Paul van Somer, and *Portrait of a Man* by Frans Pourbus the Younger.

WAKEFIELD ART GALLERY

Wentworth Terrace, Wakefield WF1 3QW
Telephone: (0924) 370211

WAKEFIELD METROPOLITAN DISTRICT COUNCIL

Open: Mon-Sat 10.30-5; Sun 2.30-5
Admission Free: Limited access for disabled

From the M1 take the A636 or A638, from the M62 take the A655 or A638 to Wakefield. **11 D1**

The main emphasis of the permanent collection at Wakefield Art Gallery is on twentieth-century British painting and sculpture. Barbara Hepworth and Henry Moore, born and brought up in Wakefield and Castleford respectively, are well represented in the collections. Notable are Hepworth's *Mother and Child* 1934 and Moore's *Elmwood Reclining Figure* 1936.

Sickert, Harold Gilman, Charles Ginner, Spencer Gore, Roger Fry, Duncan Grant, L. S. Lowry, Alan Davie, Terry Frost, Patrick Heron, Martin Froy and Euan Uglow are represented in the collections, among others. The Gallery actively collects contemporary work. Recent acquisitions include work by John Maine, Bill Pye, Bryan Kneale, Terry Setch, Norman Adams and Helaine Blumenfeld.

There is a small Old Master collection, with notable Flemish seventeenth-century still lifes by Van Verendael and Van Os, and a painting by Philip Reinagle of Wakefield Bridge and Chantry Chapel in 1793. There is also a good collection of topographical drawings and paintings, some of which are housed in the ten volumes of the Gott Collection, acquired in 1930.

Also in Wakefield is the Elizabethan Exhibition Gallery, a branch of Wakefield Art Galleries and Museums, which shows a changing programme of exhibitions of art, craft, photography, etc. For further details contact Wakefield Art Gallery.

WALES

CLWYD

BODELWYDDAN CASTLE
Near St Asaph, Bodelwyddan LL18, 5YA
Telephone: (0745) 583539

CLWYD COUNTY COUNCIL
Open: Jan-8 Apr, Sat, Sun 11-4 (Shut 1-19 Jan); 8 Apr-Nov, daily except Mon 11-5; Nov-Dec, Sat, Sun 11-4
Access for disabled

Just off the A55 near St Asaph.

Having served for many years as a girls' school, the Castle has recently been lavishly redecorated to create an appropriate period setting for Victorian portraits from the National Portrait Gallery. G. F. Watts's famous series of 26 portraits of eminent Victorians is hung together and there is also a collection of the work of the North Wales sculptor, John Gibson. Outstanding individual portraits include William Charles Ross's outsize miniature of the philanthropist, *Angela Burdett-Coutts*.

BODRHYDDAN
Rhuddlan
Telephone: (0745) 590414

LORD LANGFORD
Open: June-Sept Tues-Thurs 2-5.30
Limited access for disabled

Between Rhuddlan and Dyserth, four miles south-east of Rhyl. **10 D3**

Among the pictures in Lord Langford's collection is *The Earl of Chatham's Dog* by Stubbs. Family portraits include works by Allan Ramsay, Hudson, Vanderbank, Wheatley and Arthur Devis.

CHIRK CASTLE ❧
Chirk LL14 5AS
Telephone: Chirk (0691) 777701

NATIONAL TRUST
Open: 1 Apr-30 Sept daily except Mon, Sat (open BH Mons); 6 Oct-4 Nov Sat, Sun 12-5
Last admissions 4.30
Very limited access for disabled

Off the A5 half-mile west of Chirk village, seven miles south-east of Llangollen and 20 miles west of Shrewsbury. **11 A4**

Chirk is one of a chain of border castles built in the thirteenth century to maintain the conquests of Edward I in Wales. It is alone among Welsh Edwardian fortresses in having been occupied continuously since it was built. It passed through many hands until, in 1595, it was purchased by Thomas Myddelton. His descendant still lives in the castle.

The portraits of Anne Myddelton and Mary Myddelton by Peter Tillemans are quite rare examples of this artist's portrait work. He worked more generally as the painter of landscapes, of which there are a few examples.

There are good portraits by J. M. Wright, Dahl, and Ramsay, and one or two Lelys. The balance of the collection of 70 oil paintings consists of portraits of the Myddelton family and associates, predominantly English School of the seventeenth and eighteenth centuries.

ERDDIG ❧
Wrexham LL13 0YT
Telephone: Wrexham (0978) 355314

NATIONAL TRUST
Open: 1 Apr-30 Jun and 1 Sept-14 Oct daily except Thurs and Fri; 1 July-30 Aug daily except Fri 11-5. GF and BH Mons. Limited access for the disabled

Two miles south of Wrexham off the A525 or A483/A5152. **11 A4**

Erddig was built by Joshua Edisbury in 1684 and designed by Thomas Webb of Middlewich. When the owner became bankrupt, the estate was bought by a London lawyer, John Mellor, in 1716. His descendants, the Yorke family through Mellor's nephew Simon Yorke, lived here continuously until 1973 when the house passed to the National Trust.

Among the 120 or so paintings in the collection are a series of portraits of servants, which, along with the portraits of Erddig's owners, provide a fascinating record of social history.

Portraits of the Yorke family, *Philip Yorke I* by Gainsborough and *Elizabeth Yorke* by Cotes, hang in the Dining Room. There are Knellers in the Entrance Hall and landscapes in the Drawing Room by Jan van Goyen, Francisque Millet, Paulus Potter and P. van der Voorde. Portraits of the Royal Family of Bohemia and of Gustavus Adolphus are among the paintings in the Gallery.

See entry in main text, pages 270-1.

DYFED

THE GRAHAM SUTHERLAND GALLERY
The Rhos, Haverfordwest
Telephone: (043 786) 296

PEMBROKESHIRE MUSEUMS
Open: Apr–Sept 10.30–12.30 and 1.30–5;
other times by arrangement
Closed: BH Mons

Off the A40, five miles east of Haverford-
west; signposted. **8 B4**

This well-planned, modern gallery, which
was opened in 1976, is devoted almost
entirely to the works of Graham Suther-
land and has the largest collection of his
work permanently available to the public.

It ranges from the early etchings to
some of his last work painted in 1979,
and the exhibition is changed regularly to
show different aspects of his art. He had
a particular affection for Pembrokeshire,
visiting it regularly from 1934 until his
death in 1980.

The gallery has sketches for portraits,
prints from the Bestiary series, the Bees
and the Apollinaire, early watercolours
and works in oil which he painted
specially for the gallery, many relating to
Pembrokeshire.

Special summer exhibitions are held at
the gallery.

NATIONAL LIBRARY OF WALES
Penglais, Aberystwyth
Telephone: (0970) 623816

NATIONAL LIBRARY OF WALES
Open: Mon–Fri 9.30–6, Sat 9.30–5
Admission Free

On Penglais Hill. **8 D1**

The National Library of Wales houses
one of the premier art collections in
Wales. It has acquired, over the years,
valuable portraits and topographical works
which predominantly relate to Wales and
the border shires. Artists represented in
the collection include Samuel H. Grimm,
Julius Caesar Ibbetson, John Ingleby,
Thomas Rowlandson, Paul Sandby and
John 'Warwick' Smith. Recent acquisi-
tions include important examples of the
work of John Glover, Richard Wilson
and Kyffin Williams.

PARC HOWARD ART GALLERY
Llanelli
Telephone: (05542) 3538

BOROUGH OF LLANELLI
Open: Mar–Nov, Mon–Sat 10–7, Sun 2–6
Closed: Dec–Feb
Admission Free

The gallery is in parkland overlooking
the town. **8 C5**

The collection, which is mainly of British
paintings of the nineteenth and early
twentieth centuries, is a good one. It
contains works by James Dickson Innes,
who was born in the town, and who was
a friend of Augustus John. His early death
at the age of 27 cut short a promising
career as a colourist.

Early paintings by him are in the
collection, together with Newlyn School
paintings, among them *The Little Smithy*
by Stanhope Forbes. Brangwyn is also
represented.

TENBY MUSEUM & PICTURE GALLERY
Castle Hill, Tenby
Telephone: (0834) 2809

AN INDEPENDENT, COMMUNITY MUSEUM
Open: Easter–Oct daily 10–6; Winter
hours from 1 Nov
Limited access for disabled

13 miles east of Pembroke on the
A4139. Also reached via the A40, then
the A478. **8 B4**

A local museum which has over 300
works by Charles Norris, topographical
artist (1779–1858), together with oils and
watercolours by local artists of the last
200 years.

Augustus John was born in Tenby and
his sister Gwen was brought up there.
Nina Hamnett was also Tenby born. The
gallery contains representative works,
including Augustus John's portrait of
Richard Hughes and a portrait by Gwen
of their sister Winifred. Only a small
portion of the total collection can be
displayed at any one time.

– GLAMORGAN SOUTH –

NATIONAL MUSEUM OF WALES
Cathays Park, Cardiff
Telephone: (0222) 397951

Open: Tues–Sat 10–5, Sun 2.30–5
Admission Free: Access for disabled

The Museum building is on Park Place,
in the city centre, beside City Hall. **9 B5**

The National Collection of Wales is rich
in the work of Welsh artists, in portraits
of famous Welsh people, and in paintings
and drawings of Wales. It has a notable
collection of paintings by Wales's most
famous landscape artist, Richard Wilson,
and it has important portraits of Dylan
Thomas, Augustus John and Lloyd
George.

The foreign collections are dominated
by magnificent Impressionist and Post-
Impressionist French art, collected by
Gwendoline and Margaret Davies in the
early years of the century. To all intents
and purposes they acquired virtually
everything in the collection between 1908
and 1924. The highlights include Millet's
La Famille du Paysan, Cézanne's *Montagnes,
L'Estaque* and *Nature Morte à la Théière*,
Monet's *Cathédrale de Rouen*, and Renoir's
La Parisienne.

Additionally, there are good early
European paintings in a collection which
is reasonably representative of the main
Schools of Western art. British painting
from the seventeenth to the twentieth
centuries is well covered. Sculpture,
including a number of important works
in the Davies Collection, has works by
twentieth-century artists in particular,
among them Archipenko, Epstein and
Gaudier-Brzeska.

Wilson, whose portrait by Mengs is in
the collection, is represented by a number
of landscapes, British and Italian. Some of
these are of distinctly romantic subject-
matter, such as *Landscape with Banditti
Round a Tent* and *Landscape with Banditti:
a Murder*; others are more restrained,
notably the classical treatment of Welsh
landscape subjects and castles, among them
Caernarvon Castle. But in all his work the
fundamental impact he made on eight-
eenth-century landscape painting is appar-
ent in its diverse and evolving form. And
the major canvases are supported by a
collection of drawings and documents.
Other Welsh artists, including Wilson's
pupil, Thomas Jones, are represented, as
are artists such as David Cox, who
worked frequently in Wales, which he
loved to paint.

English art includes landscape painting
by Turner and Constable, portraits by
Reynolds, Gainsborough, Raeburn and
Devis, later nineteenth-century art of the
Pre-Raphaelite Brotherhood, and twen-
tieth-century paintings which include an
understandably substantial cross-section of
work by both Augustus and Gwen John.

See entry in main text, pages 267–8.

ST FAGANS CASTLE
Welsh Folk Museum, near Cardiff

NATIONAL MUSEUM OF WALES
Open: Mon–Sat 10–5, Sun 2.30–5
Access for disabled

In the Welsh Folk Park, four and a half
miles west of the city centre. **9 B5**

The Castle, restored to its seventeenth-century appearance, is part of the Welsh Folk Museum. There is a painting of a gamekeeper in the Hall and four paintings of Dinefwr Castle dated about 1700 on the staircase.

TURNER HOUSE
Penarth, South Glamorgan
Telephone: (0222) 708870

NATIONAL MUSEUM OF WALES
Open: Tues-Sat 11-12.45, 2-5, Sun 2-5
Closed: Mon
Admission Free

Penarth is south-west of Cardiff. **9 B6**

The Turner House Art Gallery is owned and administered by the National Museum of Wales. The house and collection, which were previously the property of a local industrialist, James Pyke, were bequeathed by him to the museum. No permanent collection is housed there now. It is used as a temporary exhibitions gallery which displays works from the museum's main collection and elsewhere.

── GLAMORGAN WEST ──

BRANGWYN HALL
The Guildhall, South Guildhall Road,
Swansea
Telephone: (0792) 655006

SWANSEA CITY COUNCIL
Open: Mon-Fri 10-5
Admission Free

The Guildhall is about a mile west of Swansea City centre. **8 D5**

Swansea Council provided a home for Brangwyn's *Empire Panels*, originally commissioned for the Palace of Westminster in 1924, to hang in the Royal Gallery, but rejected on completion as being too frivolous.

Brangwyn had looked on them as the crowning endeavour of his career, and then had difficulty finding a place for them, eventually being offered space in the Swansea Guildhall, which was at the time nearing completion.

They are displayed with numerous drawings and sketch designs in other parts of the building, arguably the most significant display of Brangwyn's work anywhere.

THE GLYNN VIVIAN ART GALLERY AND MUSEUM
Alexandra Road, Swansea
Telephone: (0792) 55006/51738

SWANSEA MUSEUM SERVICE
Open: Mon-Sun 10.30-5.30
Admission Free: Limited access for disabled

For Swansea take exits off the M4. **8 D5**

The collection of Richard Glynn Vivian, who built the Gallery in 1909, is the basis of the gallery's holdings. The collection includes prints, watercolours and paintings of Welsh character, particularly contemporary works. There are notable works by Richard Wilson, Ceri Richards, Evan Walters and James Harris. A continually changing exhibition programme shows the best from around the world.

── GWENT ──

NEWPORT MUSEUM AND ART GALLERY
John Frost Square, Newport NPT 1HZ
Telephone: (0633) 840064

NEWPORT BOROUGH COUNCIL
Open: Mon-Thurs 9.30-5, Fri 9.30-4.30, Sat 9.30-4
Admission Free: Access for disabled

In the pedestrian shopping precinct in the centre of the town. **9 B5**

There is some emphasis here on the work of Welsh and local artists, but the gallery is best known for its collection of English nineteenth-century watercolours. Pyne, Dadd, Rowlandson and Shepherd are all represented, also Turner and Roberts.

TREDEGAR HOUSE
Coedkernew, Newport
Telephone: (0633) 62275

NEWPORT BOROUGH COUNCIL
Open: Apr-Sept Wed-Sun and BH 1-5
Limited access for disabled

Off the M4 at Junction 28, two miles west of the centre of Newport. **9 B5**

The seventeenth-century interiors at Tredegar House are arguably the finest in Wales. They include nine inset overmantel canvas paintings and a series of panel paintings.

There are a number of late seventeenth- and eighteenth-century portraits. Here also are interesting late nineteenth-century portraits and the early twentieth-century

portraits relating to Evan Morgan, Viscount Tredegar and his mother, Katherine, who were both patrons of the arts, and who were painted by Augustus John and McEvoy.

The sculpture includes an eighteenth-century marble bust of Inigo Jones after Rysbrack, a marble maquette and two plaster busts (1841) of Sir Charles Morgan by J. E. Thomas, a portrait bust by W. Goscombe John of the 1st Viscount Tredegar (1909), and a bronze portrait bust of the last Viscount Tredegar by Prince Bira (1943).

See entry in main text, page 269.

── GWYNEDD ──

PENRHYN CASTLE ✾
Bangor LL57 4HN
Telephone: Bangor (0248) 353084

NATIONAL TRUST
Open: 1 Apr-4 Nov daily except Tues 12-5; July-Aug 11-5; Last admissions 4.30
Access for disabled

Off the junction of the A5 and A55, a mile east of Bangor, at Llandegai on A5122. **10 B3**

It was the intention of George Hay Dawson, who had Penrhyn Castle built, that a good collection of paintings should be compiled for his heirs. This was more than achieved as a result of the efforts of Colonel Douglas Pennant MP (1800-86), who, being a lover of art, favoured seventeenth- and eighteenth-century Dutch, Italian, Spanish and English Schools.

This extensive collection at Penrhyn Castle includes an outstanding portrait of *Catrina Hoogsaet* by Rembrandt which hangs in the Breakfast Room. An important painting, *Virgin and Child with St Luke*, from the Studio of Dieric Bouts, can be seen in the Ebony Room.

The collection also contains works by Van de Velde, Wouwermans, Van der Neer, Canaletto, Guardi, Paceco de Rosa, Del Vaga, Teniers the Younger, Richard Brompton and Gainsborough.

PLAS NEWYDD ✾
Llanfairpwll, Anglesey LL61 6EQ
Telephone: (0248) 714795

NATIONAL TRUST
Open: 1 Apr-30 Sept daily except Sat 12-5; 5 Oct-4 Nov Fri, Sun 12-5; last admissions 4.30
Access for disabled

One mile south-west of Llanfairpwll and the A5 (and two miles from the Menai Bridge) on the A4080. **10 B3**

The house contains Rex Whistler's finest *trompe-l'œil* oil (to be seen in the long dining room) together with a permanent exhibition about the artist, including smaller works.

The Gothick Hall contains a sixteenth-century portrait of the 1st Lord Paget of Beaudesert, the house in Staffordshire, now demolished, from which many of the works of art came to Plas Newydd. There are sporting pictures by Snyders.

The Music Room contains portraits. A Ben Marshall, *Rough Robin*, hangs in Lord Anglesey's Bedroom.

In the Saloon hang large pastoral scenes by Ommeganck, as well as a Richard Barret Davis of the young Queen Victoria riding in Windsor Great Park, in 1837, the year of her accession.

Two fine naval pictures, by Peter Monamy, one depicting the return of George II from Hanover, hang in the Breakfast Room, and there are two of John Thomas Serres's marine works, as well as Pocock watercolours.

See entry in main text, page 273.

—— POWYS ——

POWIS CASTLE ❧
Welshpool SY21 8RF
Telephone: (0938) 554336
NATIONAL TRUST
Open: 1 Apr-end June, 1 Sept-4 Nov Wed-Sun 12-5; July, Aug daily except Mon 12-5, BH Mons 11-6; last admissions 5.30
Limited access for disabled

A mile south of Welshpool, on the A483, pedestrian access from High Street, A490. **10 D6**

This thirteenth-century castle was largely inhabited by members of the Herbert and Rochford families. It has associations with Clive of India through Henrietta Antonia Herbert. As a result of her marriage in 1784 to Edward Clive, the collections formed by his father, the 1st Lord Clive, during his military triumphs in India, came to Powis.

The most famous painting in the castle is the Isaac Oliver miniature *Lord Herbert of Cherbury*. Eighty-five oil paintings, mostly portraits of the family and associates, also hang in the house. There are fine examples from eighteenth-century painters, including Reynolds, Batoni, Gainsborough, Romney and Nathaniel Dance. An outstanding still life by Jan Weenix hangs in the Ballroom, and Bellotto's *View of Verona* is in the Oak Drawing Room.

See entry in main text, pages 271 2.

—— SCOTLAND ——

—— BORDERS ——

BOWHILL
Selkirk
Telephone: (0750) 20732

DUKE OF BUCCLEUCH AND QUEENSBERRY
Open: 4 July-16 Aug daily 1-4.30, Sun 2-6
Access for disabled

Off the A708, three miles west of Selkirk. **21 B4**

This is a very fine collection indeed, rich in the best works of English portraiture, of Italian painting from the sixteenth to eighteenth centuries, including a magnificent Canaletto, and with works of exceptional quality by Claude, including *The Judgment of Paris*, and by Ruisdael.

Scottish painters are well represented, with good portraits by Wilkie, and the splendid Raeburn, *Sir Walter Scott*. Scott was a kinsman, and his association with Bowhill was close. His sobriquet, 'Sweet Bowhill', is eminently suitable when applied to the extensive and impressive art collection.

There are also good examples of Reynolds and of other eighteenth-century British portrait and landscape artists.

Bowhill has a superb collection of miniatures.

See entry in main text, pages 291–3.

FLOORS CASTLE
Kelso
Telephone: (0573) 23333

DUKE OF ROXBURGHE
Open: Easter Sun and Mon and early May-late Sept Sun-Thurs, except July and Aug when it is open Sun-Fri 10.30-5.30, Oct Sun and Wed
Limited access for disabled

At Kelso, on the A6089 north-west of the town. **21 B3**

There are a fine Gainsborough, *Captain Henry Roberts, the Cartographer*, several works by Reynolds, and two attributions to George Jamesone. *Peg Woffington* by Hogarth, and portraits by J. M. Wright, Beechey and Northcote are among the other works.

There are a number of interesting landscapes; a large Hendrick Danckerts, *Charles II and His Courtiers Walking in Horse Guards Parade*, several views of houses by Peter Tillemans, a river scene by Ruisdael and a seascape by Van der Velde. English landscape and sporting

artists represented include John Ferneley and William Wilson.

MANDERSTON
Duns
Telephone: (0361) 83450

MR AND MRS A. PALMER
Open: 14 May-27 Sept Thurs, Sun 2-5.30 and BHs

Limited access for disabled

On the A6105 road from Berwick-on-Tweed to Duns and Lammermuir, two miles east of Duns.

The house was virtually rebuilt at the beginning of the twentieth century, with no expense spared. It was to some extent modelled on Kedleston Hall (q.v.), since Sir James Miller was married to Lord Scarsdale's daughter, and wanted to impress his father-in-law.

The collection is unusual and diverse, and particularly worth seeing on account of the Edwardian splendour, including the unusual twentieth-century ceilings, in the classical manner, by Robert Hope.

In the Tea Room hangs a charming group portrait of *Sir William Miller's Children and their Dog 'Lion'*; the children are the work of Charles Lutyens, father

of the architect Sir Edwin Lutyens, and 'Lion' was painted by Sir Edwin Landseer. Other paintings are by or attributed to Murillo, Kneller and Kauffmann.

MARY QUEEN OF SCOTS HOUSE
Queen Street, Jedburgh
Telephone: (083 56) 3331

ROXBURGH DISTRICT COUNCIL
Open: GF–mid Nov 10–5 daily; last admission 4.45
No access for disabled

In Queen Street, Jedburgh, which is on the A68, south of the junction of the A68 and A698.

The sixteenth-century turreted building where Mary Queen of Scots once lived is now a museum dedicated to her. Two portraits hang in the Banqueting Hall, one of Mary herself by George Jamesone painted in 1635, called *The Breadalbane Portrait*, the other of *James Hepburn, the Earl of Bothwell*, her third husband. There is also a miniature of Mary and *The Antwerp Portrait*, of her when she was Queen of France and wife of Francis II. The Guard Room contains a series of portraits relating to Jedburgh and its history.

THIRLESTANE CASTLE
Lauder
Telephone: (057 82) 254

CAPTAIN THE HONOURABLE GERALD MAITLAND-CAREW
Open: May, June, Sept, Wed, Thurs and Sun; July and Aug daily except Sat 2–5; booked parties any time Apr–Oct. No access for disabled

At Lauder between the A68 and the A697, 27 miles south-east of Edinburgh.

The castle is medieval, though with magnificent State Rooms and ceilings from the time of the restoration of Charles II.
The portraits range from the sixteenth to the twentieth century. They include works by Romney, Reynolds, the Elder Scougall, Sir Thomas Lawrence, John Hoppner, the school of Canaletto and Guardi.
Thirlestane Castle also contains the Border Country Life Museum.

TRAQUAIR HOUSE
Innerleithen EH44 6PW
Telephone: (0896) 830323

MR P. MAXWELL STUART
Open: 14 Apr–22 Apr 1.30–5.30, May–end Sept daily 1.30–5.30
Limited access for disabled

Twenty-nine miles from Edinburgh at the junction of the B709 and B7062, one mile from Innerleithen and six miles from Peebles.

The house has an intriguing history involving Mary Queen of Scots and the Jacobite Risings. It has been a Roman Catholic stronghold since the time of the Reformation. At one time it was a royal hunting lodge in the ancient Ettrick Forest.
The portrait collection includes *John Dryden* by John Riley, and a group portrait of Lady Anne Hay and her children by George Jamesone, though repainted by his descendant, John Alexander, in the mid-eighteenth century. There are two full-length portraits of children attributed to Cornelius Johnson.
The Dining Room contains a portrait of *The First Earl of Traquair as Lord High Treasurer of Scotland,* and portraits by Lindo, Sir John Medina and George Chalmers. Above the door is a portrait of *Sir Charles Erskine of Cambo*. The Library is decorated with a frieze depicting busts of classical authors. The ceiling cove was repainted by James West, an Edinburgh painter, in 1823. The Lower Drawing Room is hung with paintings by John and Cosmo Alexander.

DUMFRIES & GALLOWAY

BROUGHTON HOUSE
High Street, Kirkcudbright
Telephone: (0557) 30437

BROUGHTON HOUSE TRUST
Open: Apr–Oct Mon–Sat 11–1, 2–5; Sun 2–5
No access for disabled

In High Street, Kirkcudbright, in the south-east of Scotland.

Broughton House was the home of the painter Edward Atkinson Hornel. His works are on view as well as his fine library, all of which were left in trust, to be available to the public. Hornel was contemporary with the late nineteenth-century Glasgow School, which included such artists as George Henry, some of whose works are also on view.

DRUMLANRIG CASTLE
Thornhill
Telephone: (0848) 30248

DUKE OF BUCCLEUCH AND QUEENSBERRY
Open: 5 May–19 Aug 11–5;

last admissions 45 minutes before closing
Closed: Thurs
Access for disabled

18 miles north of Dumfries and three miles north of Thornhill off the A76. It is 16 miles from the A74 at Elvanfoot.

The collection of the Duke of Buccleuch and Queensberry is spread among three properties open to the public, the other two being Bowhill, also in the Borders, and Boughton House, in Northamptonshire (q.v.). It is one of the outstanding private art collections in these islands.
It includes at Drumlanrig Rembrandt's *Old Woman Reading*, painted in 1655, and Holbein's *Sir Nicholas Carew* together with Leonardo da Vinci's *The Madonna with the Yarnwinder*.
There are works by Joost van Cleef and Mabuse, Murillo's *Mother and Child*, and a good selection of Dutch paintings.
Numerous family portraits fill the house, with Allan Ramsay and Godfrey Kneller prominent among the artists. There is also an interesting collection of portraits by the Scottish painter John Ainslie, of the Buccleuch household.

——— FIFE ———

FALKLAND PALACE
Falkland
Telephone: (033 757) 397

HER MAJESTY THE QUEEN
NATIONAL TRUST FOR SCOTLAND
Open: Apr–Sept Mon–Sat 10–6, Sun 2–6; Oct Sat 10–6, Sun 2–6; last admissions 5.15
Access for disabled

The Royal Palace of Falkland is in the village of that name, eleven miles north of Kirkcaldy on the A912.

One of the earliest examples of Renaissance architecture in Britain, the palace was first the home of the Macduffs, Earls of Fife, and then a dwelling for the monarchs of Scotland. Both James IV and James V lived here and Mary Queen of Scots spent some of her happiest days here.
The Royal Chapel is decorated with painted ceilings. The gallery contains a Venetian school painting, *The Marriage of Saint Catherine of Alexandria*. The King's

Bedchamber is richly decorated and there are portraits on the shutters of *James V* and *Mary of Guise*.

HILL OF TARVIT
Near Cupar
Telephone: (0334) 53127

NATIONAL TRUST FOR SCOTLAND
Open: Easter weekend May–Sept daily 2–6; Apr and Oct Sat, Sun 2–6; last admissions 5.30
Limited access for disabled

On the A916, two and a half miles south-west of Cupar.

The house was built in 1696 and is attributed to Sir William Bruce. The building was remodelled by Sir Robert Lorimer in 1906 to house the collection of Mr F. B. Sharp, a Dundee jute manufacturer and contemporary of Sir William Burrell and Lord Leith at Fyvie Castle.

The collection is particularly strong in seventeenth-century Dutch paintings by Brueghel, Teniers, Weenix, Cuyp, Wyck, Molenaer and Van de Velde. It also contains distinguished eighteenth-century portraits by Ramsay and Raeburn, and a pair of seascapes by Samuel Scott.

KELLIE CASTLE
Near Pittenweem
Telephone: (033 38) 271

NATIONAL TRUST FOR SCOTLAND
Open: Easter weekend and May–Sept daily 2–6; Apr and Oct Sat and Sun 2–6; last admissions 5.30
No access for disabled

Off the B9171 three miles north north-west of Pittenweem.

The Castle's origins go back to the eleventh century. It was bought and restored, however, by the Lorimer family in 1948. John and Mary Lorimer were both artists and are represented by several canvases.

The ceiling of the Principal Bedroom is decorated with a painting, *Mount Olympus,* by De Wet and the Dining Room walls are decorated with romantic landscapes. Robert Stodart Lorimer, the architect, is commemorated in an exhibition in a room near the stairs leading to the Entrance Hall.

KIRKCALDY DISTRICT COUNCIL
War Memorial Grounds, Kirkcaldy
Telephone: (0592) 260732

KIRKCALDY TOWN COUNCIL
Open: Mon–Sat 11–5, Sun 2–5
Admission Free: No access for disabled

Next to the railway station in Kirkcaldy, which is across the Firth of Forth from Edinburgh, reached via the A92.

The permanent collection mainly covers the period 1880 to 1940. It is particularly strong in the works of William McTaggart, S. J. Peploe, the group known as The Glasgow Boys, and a small collection of Camden Town artists, among them works by Sickert, Gore and Gilman.

There are four rooms of oils on permanent display; the watercolours are on view less frequently. J. W. Blyth, a Kirkcaldy linen manufacturer and trustee of the National Gallery of Scotland, was the main collector.

Continual temporary exhibition programme including Scottish art.

——— GRAMPIAN ———

ABERDEEN ART GALLERY
School Hill, Aberdeen
Telephone: (0224) 646333

CITY OF ABERDEEN DISTRICT COUNCIL
Open: Mon–Sat 10–5, Thurs 10–2, Sun 2–5
Admission Free: Access for disabled

The art gallery is in the centre of Aberdeen, on School Hill.

After Edinburgh and Glasgow, the third city in Scotland, in fine art terms. Its collection concentrates on Scottish painting from the seventeenth century to the present, and includes works by Aberdeen artists, among whom the leading figures were William Dyce, represented by *Titian's First Essay in Colour* as well as other works, John Phillip, George Reid and James McBey; there is a *Self-Portrait* by the seventeenth-century painter George Jamesone.

The gallery has a fine collection of Glasgow School paintings, including John Lavery's early masterpiece, *The Tennis Party*, and James Guthrie's *To Pastures New*. There are twentieth-century works by Peploe, Cameron, Anne Redpath, Muirhead Bone and Joan Eardley.

A good representative collection of British art of the nineteenth century includes works by Millais, Waterhouse,

Holman Hunt, Watts, Alma-Tadema and Rossetti.

There is a good nineteenth-century collection of French paintings, mainly of works popular in their own time. But these include such masterpieces as *Going to School* by Jules Bastien-Lepage.

Aberdeen is rich in Camden Town Group paintings, and has other good modern British works.

See entry in main text, pages 287–9.

BALMORAL CASTLE
Ballater
Telephone: (033 84) 334

HER MAJESTY THE QUEEN
Open: May–July Mon–Sat 10–5
Access for disabled by arrangement

Eight miles south-west of Ballater on the A93.

Queen Victoria and Prince Albert, who built Balmoral in the middle of the nineteenth century, did not hang pictures there. Those that are now in the Castle had originally hung at Osborne and Buckingham Palace and were brought up by Queen Mary and King George VI. A changing exhibition in the Ballroom contains a selection from them and a display of works of art from within the Castle. Among the painters employed by Queen Victoria and Prince Albert to record their love of the Highlands, Landseer is pre-eminent.

Given the prodigious wealth of the Royal Collection, paintings are not Balmoral's strong point, although the works are in keeping with the Castle's history. There are views of Balmoral, including the earlier castle, shooting scenes, such as Landseer's *Royal Sports*, and paintings depicting events at Balmoral, for example, the arrival there of Czar Nicholas II, in 1896.

BRODIE CASTLE
Near Forres, Moray
Telephone: (030 94) 371

NATIONAL TRUST FOR SCOTLAND
Open: Easter weekend and May–Sept weekdays 11–6, Sun 2–6; last admissions 5.15
Limited access for disabled

Off the A96 between Nairn and Forres.

Brodie Castle dates from the sixteenth century, by which time the Brodie family had already been in Moray for 500 years. It was substantially remodelled, and greatly

enriched by prudent marriages, so that today it has a fine and unusually diverse collection.

The run of family portraits, including works by Opie, Martin, Downman, Northcote and Gordon, is mixed, refreshingly, with early twentieth-century French works, like Raoul Dufy's *Boats by a Pier* and Gustave Loiseau's *Spring at Vaudreuil*. These are part of a collection of over three hundred paintings covering three centuries. Included in this is one by Van Somer, *Henry, Prince of Wales*, elder brother of Charles I, and a collector of works of art who had considerable influence on Charles's taste.

The main family portrait collection hangs in the Dining Room, with further portraits by Opie and James Currie in the Drawing Room, in which there also hangs a Cuyp *Self-Portrait*.

There is a pleasant genre scene, *The Philosopher and his Pupils*, by Willem van Vliet, on the Main Staircase.

CASTLE FRASER
Kemnay
Telephone: (033 03) 463

NATIONAL TRUST FOR SCOTLAND
Open: May–Sept daily 2–6; last admissions 5.15
Limited access for disabled

Three miles south of Kemnay off the B993 and sixteen miles west of Aberdeen.

The castle contains family portraits from the seventeenth and eighteenth centuries, including a Raeburn of *Charles Fraser*. There are also several charming watercolours by the Aberdeenshire artist James Giles, in particular two of Castle Fraser itself.

CRAIGIEVAR CASTLE
Alford

NATIONAL TRUST FOR SCOTLAND
Open: May–Sept daily 2–6; last admissions 5.15
Groups by appointment
No access for disabled

26 miles west of Aberdeen and six miles south of Alford on the A980.

The castle is dramatically situated on the side of the Hill of Craigievar. Three rare George Jamesones and two Watson Gordons hang in the house. *The Fifth Baronet*, and his wife, *Lady Sarah Sempill*, early portraits by Raeburn, hang beside

the 1788 receipts, 16 guineas for the paintings and 9s. 6d. for the frames.

CRATHES CASTLE
Crathes, Banchory
Telephone: (033 02) 525

NATIONAL TRUST FOR SCOTLAND
Open: May to Sept daily 11–6; Easter weekend and Sat, Sun in Apr and Oct 11–6; last admissions 5.15; Groups at other times by prior arrangement

15 miles west of Aberdeen, three miles east of Banchory on the A93.

Crathes Castle is famous for its series of painted ceilings, which were executed in the late sixteenth century and represent possibly some of the finest surviving examples of this popular form of decoration in Scotland. There is a collection of various Burnett portraits, many ascribed to George Jamesone.

DRUM CASTLE
Drumoak, by Banchory, Kincardine and Deeside
Telephone: (033 08) 204

NATIONAL TRUST FOR SCOTLAND
Open: May–Sept daily 2–6; last admissions 5.15
Limited access for disabled

Ten miles west of Aberdeen off the A93.

Drum consists of a Jacobean mansion built beside a medieval tower. The Irvine portraits include *James Hamilton* and *Mary Irvine* attributed to Raeburn and *Miss Bianca* attributed to Reynolds. Hugh Irvine was a painter and his work hangs in the Library and a view of Castlegate, Aberdeen, hangs below his portrait in the Drawing Room.

FYVIE CASTLE
Turriff
Telephone: (065 16) 266

NATIONAL TRUST FOR SCOTLAND
Open: May–Sept daily 11–6; last admissions 5.15

Off the A947 eight miles south-east of Turriff.

The castle, which has had five owners, the last being Lord Leith of Fyvie, who took the title after making a fortune in America in steel and railways, passed to the National Trust for Scotland in 1986.

The collection, mainly of portraits, includes works by Batoni, Raeburn, Ramsay, Gainsborough, Opie and Hoppner.

HADDO HOUSE
Tarves
Telephone: (065 15) 440

NATIONAL TRUST FOR SCOTLAND
Open: 30 Apr–28 Oct daily 2–6; last admissions 5.15
Access for disabled

19 miles north of Aberdeen off the B999, 4 miles north of Pitmedden.

A house entwined in the history of the Earls of Aberdeen, accounting for their presence in many of the works. Of primary interest is the Pompeo Batoni *Lord Haddo* and the Domenichino of *David and Goliath* in the Drawing Room. There is a fine portrait of *Lord Aberdeen* as a young man and a Paul de la Roche portrait of *Guizot*.

The Ante-room contains a small collection of marble busts including Baron Marochetti's *Queen Victoria* and busts of the 4th Earl of Aberdeen, the Marquis of Abercorn, the Marquis of Londonderry and the Duke of Wellington by Sir Francis Chantrey.

The Morning Room contains a collection of watercolours by Countess Ishbel, her tutor, N. E. Green, and the topographical artist James Giles. In the Entrance Hall, the wall panels from *Aesop's Fables* were painted by John Russell, an artist from Aberdeen.

LEITH HALL
Kennethmont
Telephone: (046 43) 216

NATIONAL TRUST FOR SCOTLAND
Open: May–Sept daily 2–6; last tour 5.15
No access for disabled

One mile west of Kennethmont on the B9002 and 34 miles north-west of Aberdeen.

The Leith-Hay family's strong military tradition is apparent in the large collection of militaria covering the Forty-Five Rising – the family was a Jacobite one – as well as the Napoleonic Wars, including the Peninsular Campaign, the Crimean War, and the Relief of Lucknow.

This is reflected in the art collection.

Notable family portraits include two, *Sir Andrew Leith-Hay* and *Lady Leith-Hay*, by Northcote, and a study by Hayter for

a composite picture of the House of Commons.

——— HIGHLAND ———

CAWDOR CASTLE

Cawdor, Nairn
Telephone: (066 77) 615

EARL OF CAWDOR
Open: May-Oct daily 10-5.30; last admission 5
Limited access for disabled

Near the village of Cawdor, which is on the B9090, six miles south-west of Nairn.

There is a colourful and often bloody history of Cawdor Castle, including its association with Macbeth (who is depicted in an etching by Dali).

The collection of paintings is a good one, with particular emphasis on late eighteenth-century English portraits, six of which are by Francis Cotes. There is a fine full-length of *John Campbell* by Joshua Reynolds, who also painted a portrait (in the collection) of *Charles Greville*, the connoisseur who advised Campbell in his Grand Tour collecting.

The association was part of Campbell's development as a collector. This in turn led to the formation of a museum of antiquities at his London house, in Oxford Street. The collection was of very high quality, but had to be sold, along with the house, in 1800. Residual works from this collection remain at Cawdor, including two excellent coastal scenes by Vernet.

More modern works include watercolours by John Piper and a Stanley Spencer.

DUNROBIN

Golspie
Telephone: (040 83) 3177

COUNTESS OF SUTHERLAND
Open: May Mon-Thurs 10.30-12.30
1 June-15 Sept Mon-Sat 10.30-5.30,
Sun 1-5.30; last admission 5; Groups all year by appointment
Limited access for disabled

Half a mile north-east of Golspie on the A9.

Dunrobin is the largest and most northerly great house in Scotland's Highlands. The 2nd Duke of Sutherland quadrupled its size in 1845-50 and filled the Castle with objects.

One of the more magnificent paintings is no doubt the portrait of an Irish chieftain, probably *Hugh O'Neil, Second*

Earl of Tyrone, by Michael Wright. *The Duchess Eileen*, by Philip de Laszlo, in the Library is a striking example of his work. · There is a portrait of *William, the Eighteenth Earl of Sutherland* by Allan Ramsay in the Dining Room.

The 1st Duke was painted by Romney and there are several portraits of his wife, by Hoppner, Lawrence and Reynolds. A painting of the 3rd Duke of Sutherland, his sister and their pets, by Landseer, hangs in the Entrance Hall. Other artists represented include Winterhalter, Phillips, Anetsev and Nattier.

——— LOTHIAN ———

CITY ART CENTRE, EDINBURGH

1-4 Market Street, Edinburgh
Telephone: (031) 225 1131

EDINBURGH CITY COUNCIL
Open: Mon-Sat 10-5 (Oct-May 10-6);
also Sun 2-5 during Festival
Admission Free: Access for disabled

Market Street is in the city centre.

The city's permanent art collection is housed here and of course much of the work is of local Edinburgh and Scottish historical interest. The paintings, drawings, sculptures and prints date from the seventeenth century to the present.

Late nineteenth- and early twentieth-century artists are well represented as the city was given a gift of much of the Scottish Modern Arts Association's collection in 1964. Artists represented include J. H. Lorimer, John Duncan, George Henry, and E. A. Hornel. More contemporary artists, including Anne Redpath and Eduardo Paolozzi, were recently added to the collection as a result of the bequest of Miss Jean Watson.

The Centre also has a busy programme of temporary exhibitions, ranging from contemporary artists to major international exhibitions. Because of this, the City's own collection is not always on display, and visitors should contact the Centre beforehand if they are intending to visit the Centre specifically to see the collection.

DALMENY HOUSE

South Queensferry
Telephone: (031) 331 1888

EARL OF ROSEBERY
Open: May-Sept Sun-Thurs 2-5.30;
at other times by appointment
Access for disabled

Seven miles west of Edinburgh by the A90 and then the B924. Follow Forth Road Bridge signs through south Queensferry.

Fine art at Dalmeny divides into two parts: the Rosebery collection of British eighteenth-century portraits, and the Napoleonic collection, which consists of paintings, prints and memorabilia of the Emperor and his family, collected by the 5th Earl of Rosebery including *Napoleon on 'Marengo'* by François Dubois.

The Rosebery collection of English portraits is especially fine. The subjects are from various walks of life – literary, political and society figures. Romney, Raeburn, Reynolds, Gainsborough and Lawrence are among the artists. One of the best examples is the portrait of *Lady Vincent* in a pink carnival dress, painted in Rome by Anton Raffael Mengs.

THE GEORGIAN HOUSE

7 Charlotte Square, Edinburgh
Telephone: (031) 225 2160

NATIONAL TRUST FOR SCOTLAND
Open: Apr-Oct Mon-Sat 10-5, Sun 2-5;
Nov Sat 10-4.30, Sun 2-4.30; last admissions half an hour before closing
Limited access for disabled

Charlotte Square is in the city centre.

Number 7 Charlotte Square has been furnished and arranged to reflect the likely taste of the original occupants of 1796. Portraits were chosen to suit what was then the 'New Town' of Edinburgh.

The Drawing Room contains the most varied collection of works; Van Goyen and Nasmyth landscapes, *A Tavern Interior* and *Monkeys Smoking* by David Teniers, a pair of seascapes by Thomas Luny and *Venus and Cupid* by Ferdinand Bols. Other paintings are by Allan Ramsay, J. M. Wright, Hoppner, Henry Raeburn, Thomas Barber, Northcote, Thomas Duncan Rae, Mercier and George Morland.

GLADSTONE'S LAND

Royal Mile, Edinburgh
Telephone: (031) 226 5856

NATIONAL TRUST FOR SCOTLAND
Open: Apr-Oct Mon-Sat 10-5, Sun 2-5;
Nov Sat 10-4.30, Sun 2-4.30;
last admissions half an hour before closing
No access for disabled

At 483 Lawnmarket in the centre of Edinburgh.

Thomas Gledstanes, a textile merchant, owned this seventeenth-century tenement. He lived on the third floor, where, on the ceiling, is painted a gled, or hawk, probably a pun on the family name. The Green Room contains a group of seventeenth-century Dutch paintings; flower studies by F. G. Gysaerts, a skating scene and another winter scene by Claes Molenaer, a still life by Pieter Claesz and works by Jacob Ruisdael, Karel du Jardin, Dominicus van Tol and Van der Neer. Watercolours by Anthony Claesy, dated 1690, hang in the Little Chamber.

HOPETOUN HOUSE
South Queensferry
Telephone: (031 331) 2451

HOPETOUN HOUSE PRESERVATION TRUST
Open: 13 Apr-30 Sept daily
11-5.30
Limited access for disabled

Ten miles west of Edinburgh on the south side of the Firth of Forth, off the A904.

The collection of paintings at Hopetoun dates from early eighteenth-century Tideman paintings, commissioned by the 1st Earl of Hopetoun, to the twentieth-century murals which were commissioned by his descendant, the 3rd Marquess of Linlithgow, painted on the panels on the staircase of the original house designed for the family by Sir William Bruce in 1699.

The early eighteenth-century enlargement of the house by William Adam, with the interior décor supervised by his son, John, allows the unique chance to view the paintings displayed, not only against the background and furnishings appropriate to their times, but in the manner in which such paintings would be hung.

A large collection of family portraits, many in the Dining Room, include *The Countess of Hopetoun* by Gainsborough; *The Second Earl* by Raeburn; *The Fourth Earl* and *The Fifth Earl* by Watson Gordon; *General Charles Hope* by Raeburn and *The First Earl* by David Allan.

The Yellow Drawing Room includes *The Temptation of Saint Anthony* by Teniers and a 1636 version of Rembrandt's *Portrait of an Old Woman*, the original of which is in the National Gallery, London.

The Red Drawing Room contains a Canaletto *The Doge's Palace and Accademia*;

full-length portraits of the family and a conversation piece by Nathaniel Dance. There is Passarotti's *Four Brothers of the Manaldini Family* and a picture of two boys and a strange hybrid animal called the Parma Boar-Dog by Emilio Tartuffi.

An important discovery in 1984 was the existence of an early eighteenth-century baroque ceiling painting above the main stairway. This work, now restored, may be compared to the large-scale paintings on plaster found in English houses of the period, where Louis Laguerre, Antonio Verrio and James Thornhill were acknowledged masters. There are no similar works still extant in Scotland.

See entry in main text, pages 294–6.

THE HOUSE OF THE BINNS
Linlithgow
Telephone: (0506) 834255

NATIONAL TRUST FOR SCOTLAND
Open: Easter weekend (exc GF) and May-Sept daily except Fri 2-5; last admissions 4.30
Access for disabled

Family portraits and *Charles II*, a portrait by Kneller, hang here. In addition to some early nineteenth-century portraits of the Dalyell family, there are sketches by David Wilkie, and *Eclipse*, the famous race horse, by Sartorius. Foaled in 1764, the year of the Great Eclipse, it was never beaten and earned £600,000 for its owner.

HUNTLY HOUSE
142 Canongate, Edinburgh
Telephone: (031) 225 2424

CITY OF EDINBURGH
Open: Mon-Sat 10-5 (June-Sept 10-6); Suns 2-5 during Edinburgh Festival
Limited access for disabled

In Canongate, in the centre of Edinburgh.

This is a restored sixteenth-century house which now houses local history collections. They include topographical paintings of Edinburgh and portraits of eminent citizens.

LADY STAIR'S HOUSE
Lady Stair's Close, Lawnmarket, Edinburgh
Telephone: (031) 225 2424

CITY OF EDINBURGH
Open: Oct-May Mon-Sat 10-5; June-Sept Mon-Sat 10-6; Suns during Edinburgh Festival

Admission Free: No access for disabled

In Lady Stair's Close, Lawnmarket.

The collection includes portraits, personalia and manuscript items relating to Robert Burns, Sir Walter Scott and Robert Louis Stevenson.

LENNOXLOVE HOUSE
Haddington, East Lothian
Telephone: (062 082) 3720

DUKE OF HAMILTON
Open: Easter-Sept Wed, Sat, Sun 2-5; Easter Weekend; other times by arrangement
No access for disabled

Eighteen miles east of Edinburgh, one mile south of Haddington on the B6369 to Gifford.

The house was named after the Duchess of Lennox, who was known as *La Belle Stewart*, and was the original model for Britannia.

Most of the furnishings are from the demolished Hamilton Palace. Among the pictures are portraits by Mytens, Van Dyck, Lely, Kneller and Raeburn and Gavin Hamilton's neo-classical group of *The Eighth Duke of Hamilton in Rome with his Tutor and his Son*. Works by Raeburn include *The Eleventh Duke as a Child* and *The Eighth Duke in Riding Coat*. The 8th Duke is also portrayed by Gerrard, riding from Edinburgh to Hamilton.

The Yellow Room contains the most distinguished works, including Van Dyck's portrait of *The Third Duke*, and a double portrait by Cornelius Johnson of *The Second Duke of Hamilton* and *The Duke of Lauderdale*. There is also a pair of full-lengths by Peter Lely of *The Duke and Duchess of Lennox*. The silver casket, death mask and sapphire ring of Mary Queen of Scots are also on view.

NATIONAL GALLERY OF SCOTLAND
The Mound, Edinburgh
Telephone: (031) 556 8921

TRUSTEES OF THE NATIONAL GALLERIES OF SCOTLAND
Open: Mon-Sat 10-6, Sun 11-6
(extended during Festival)
Admission Free (except during major loan exhibitions)
Access for disabled

The Mound is close to the main railway station.

The National Gallery of Scotland is the most important public art gallery in Britain outside London. It is under joint trusteeship with the Scottish National Gallery of Modern Art and the Scottish National Portrait Gallery (qq.v.). A sensible distribution of works of art between these galleries means that the National Gallery collection covers European painting from the fourteenth century up to about 1900. The collection is richly representative of all schools, and contains many masterpieces.

Raphael's *Holy Family with a Palm Tree* and *The Bridgewater Madonna* are two of the thirty works generously loaned to the Gallery since 1946 by the Duke of Sutherland. The Verrocchio *Madonna and Child* and Matteo di Giovanni's *Madonna and Child with Saints Sebastian and Francis* once belonged to Ruskin; other paintings came from the collection of the Duc d'Orléans. Of particular interest are the *Crucifixion Triptych* by Daddi, Perugino's *The Court of Apollo* and a portrait of *Domenico di Jacopo di Matteo* by Andrea del Sarto. There are works by Lorenzo Monaco, Filippino Lippi, Cima da Conegliano, Cosimo Rosselli and the early northern Italian artist Vitale da Bologna.

Later Italian painting includes the beautiful Titians, *Diana and Actaeon* and *Diana and Callisto*, painted for Philip II of Spain, as well as his *The Three Ages of Man*. There are works by Tintoretto, among them *The Deposition of Christ*, and by Veronese (*St Anthony Abbot as Patron of a Kneeling Donor*). The lively *Adoration of the Kings* is a splendid example of Jacopo Bassano's work.

The gallery is also rich in seventeenth-century Italian art, from paintings by G. C. Procaccini of Bologna to Guercino's *St Peter Penitent* and Guido Reni's late, unfinished *Moses with Pharaoh's Crown*. *The Adoration* by Domenichino is a copy of a lost original by Annibale Carracci.

Eighteenth-century Italian paintings include Bellotto's *Verona with the Ponte delle Navi*, G. B. Pittoni's *St Jerome with St Peter of Alcantara*, and G. B. Tiepolo's *The Finding of Moses*.

The Spanish paintings are of high quality: El Greco's earliest version of *The Saviour of the World*, Velázquez's *An Old Woman Frying Eggs*, Zurbarán's *Virgin of the Immaculate Conception with St Anne and St Joachim* and El Greco's *El Medico*. A recent acquisition is the enigmatic *A Fable* by El Greco.

Dutch, Flemish and German art constitute a considerable strength in the Gallery's collection. Among the great examples of Rembrandt's work are his *Woman in Bed* and *Self-Portrait Aged 51*.

The Vermeer, *Christ in the House of Mary and Martha*, which sold in Bristol for just £8 in the last century, was discovered to be the Dutch artist's work at the beginning of this century, when cleaning revealed the signature. A display of smaller paintings includes *The Stoning of St Stephen* by the German artist Elsheimer, Holbein's *Allegory of the Old and New Testaments* and the earliest dated painting by Gerrit Dou, *Interior with a Young Violinist*. On a far larger scale is the monumental *The Grote Kerk at Haarlem,* Saenredam's biggest work; it was a gift from the Dutch to Charles II at the Restoration.

Other fine Dutch works are Jan Lievens's *Young Man* (who is shown wearing golden velvet), a version of *The Singing Practice* by Ter Borch, and Pieter de Hoogh's *Woman carrying a Bucket in a Courtyard*. *The School for Boys and Girls* is Jan Steen's most ambitious lesson on indiscipline, while Frans Hals's *Verdonck*, shown brandishing a jawbone, is a portrait of outspokenness. There are beautiful landscapes: the early *Banks of a River* by Jacob Ruisdael, an evening view of *The Valkhof, Nijmegen* by Cuyp and a *Wooded Landscape* by Hobbema.

Early Flemish paintings include *The Trinity Altarpiece* by Hugo van der Goes (a loan from the Royal Collection); originally painted for an Edinburgh church, it features King James III of Scotland and his Queen on the reverse. *The Three Legends of St Nicolas* by Gerard David is accompanied by a handsome *Portrait of a Man* by Quentin Massys. Rubens's *Feast of Herod* and *Study of a Head (St Ambrose)* are highlights of the Flemish collection, which includes Rubens's sketch for *The Adoration of the Shepherds* and Van Dyck's early *The Lomellini Family*.

The French collection is comprehensive, with Poussin's second series of *Seven Sacraments,* painted in 1644–8 for his friend Fréart de Chantelou (much of the first series survives at Belvoir Castle, q.v.). Other Poussin works are the *Mystic Marriage of St Catherine* and another loan from the Duke of Sutherland, *Moses Striking the Rock*. Claude's *Landscape with Apollo and the Muses* dates from 1652.

Watteau's splendid *Fêtes Vénitiennes* is among the eighteenth-century French paintings which include Chardin's *Vase of Flowers*, a portrait of *Mme de Pompadour* attributed to Boucher and *Boy with a Lesson Book*, exhibited by Greuze at the Salon of 1757. The portrait by Baron Gérard of *Marie-Laetitia Bonaparte*, the mother of Napoleon, is the only one outside France. Courbet's *A River in a*

Mountain Gorge and one of his many versions of *The Wave* are hung as examples of the work of Delacroix, Bonington and Corot (*Ville d'Avray – entrance to the wood*).

The collection of French art of the Impressionist era includes Degas's superb portrait of *Diego Martelli*. *Seascape, Shipping by Moonlight* is a rare night scene by Monet, whose *Church at Vétheuil* is accompanied by canvases of poplars and haystacks, and by paintings by Renoir, Pissarro, Sisley, Berthe Morisot and Bastien-Lepage. The Gallery owns a Seurat study for *Une Baignade, Asnières* (in the National Gallery in London), and Seurat's painting of an alfalfa field, *La Luzerne – St Denis*. Gauguin paintings include his well-known *Vision of the Sermon*, and *Three Tahitians*. Among works by Van Gogh are *Olive Trees* (1889) and *Head of a Peasant Woman*. There is a painting by Cézanne of his beloved *Montagne Sainte-Victoire*, and another scene of *Olive Trees*, this time by Paul Guigou, a precursor of Cézanne.

British art in the Gallery includes a range of outstanding portraits, from Hogarth's small sketch of the murderess *Sarah Malcolm* (painted in Newgate Gaol in 1732) to magnificent full-lengths by Raeburn and Gainsborough. English portraits include Reynolds's *The Ladies Waldegrave*, Romney's *Mrs Wilbraham Booth*, and *Lady Robert Manners* (aged 89) by Sir Thomas Lawrence, who excelled with older sitters. One of Gainsborough's loveliest full-lengths is *The Hon. Mrs Graham*: the Gallery also owns his early *Landscape with a Distant view of Cornard Village, Suffolk*. Other fine landscapes by English painters include Constable's *Dedham Vale*, James Ward's *The Eildon Hills and the Tweed* and Turner's misty *Modern Rome: Campo Vaccino 1839*. Landseer appears in Scottish mood in *Rent Day in the Wilderness*.

Scottish artists are naturally well-represented, with superb portraits by Allan Ramsay and Raeburn. Ramsay's *The Painter's Wife* and *J. J. Rousseau* are well-known, but his portraits of *Lord and Lady Inglis* are also fine. Among the Raeburn portraits, are splendid full-lengths such as *Colonel Alastair Macdonell of Glengarry* and *Sir John Sinclair Bt*. Raeburn's skilful handling of light and shadow is evident in smaller portraits as well, like the romantic *Mrs Scott Moncrieff*, while '*The Skater': Revd Robert Walker Skating on Duddingston Loch* is one of the best known of all Scottish portraits.

The neo-classical artist Gavin Hamilton painted *Achilles Lamenting the Death of Patroclus;* his *Andromache Bewailing the*

Death of Hector was a design for the first of his illustrations of *The Iliad*. The group of works by Sir David Wilkie includes his early *Pitlessie Fair*, the ambitious *Josephine and the Fortune-Teller*, and genre scenes like *The Irish Whiskey Still* and *Distraining for Rent*. There are important works by other fine Scottish painters: Sir Joseph Noel Paton's fantasy piece, *The Reconciliation of Oberon and Titania*, William Dyce's *Christ as Man of Sorrows* and Andrew Geddes's *Summer*. Among the more modern works are Orchardson's *Voltaire*, Joseph Crawhall's *The White Drake* and the wonderfully free *The Storm*, a late work by William McTaggart.

The Gallery's American paintings include Benjamin West's *Alexander III of Scotland Rescued from the Fury of a Stag*, and one of John Singer Sargent's most beautiful portraits, *Lady Agnew of Lochnaw*. A great rarity in Britain is the magnificent view of *Niagara Falls* by the nineteenth-century artist Frederick Edwin Church.

The National Gallery of Scotland has one of the finest Departments of Prints and Drawings outside London, and it is especially strong in Scottish and Italian works. The Vaughan bequest of Turner watercolours is displayed in January each year.

See entry in main text pages 275–7.

PALACE OF HOLYROODHOUSE
Royal Mile, Edinburgh
Telephone: (031) 556 7371

HER MAJESTY THE QUEEN
Open: All year except for two weeks late May and three weeks late June (actual dates depend on annual Royal Visit)
Ticket Office: open approx. 1 Apr-25 Oct, weekdays 9.30-5.15, Sun 10.30-4.30; winter weekdays 9.30-3.45
Limited access for disabled

At the foot of Canongate.

The Palace of Holyroodhouse is the Queen's official residence in Scotland and contains part of the Royal Collection, with considerable emphasis on its Scottish dimension. There are eighty-nine portraits of Scottish monarchs in the Long Gallery and a number of overmantels and ceilings all by Jacob de Wit.

The Royal portraits by Van Somer, Van Dyck, Lely, Hayter and Wilkie hang in various rooms. Later portraits include Elwell's of *George V*, David Jagger's of *Queen Mary*, and David Donaldson's of the present Queen and Sir William Hutchinson's *Queen Mother*.

PORTRAIT GALLERY
1 Queen Street, Edinburgh
Telephone: (031) 556 8921

TRUSTEES OF THE NATIONAL GALLERIES OF SCOTLAND
Open: Mon-Sat 10-6; Sun 11-6 (extended opening hours during Festival)
Admission Free: Access for disabled

In the centre of the city, parallel to, but north of, Princes Street.

The Scottish National Portrait Gallery was founded over a century ago with the avowed intention 'to illustrate Scottish history by means of authentic contemporary portraits' and this gave it unrivalled opportunities to acquire important portraits, many of the highest artistic quality.

Mary, Queen of Scots is depicted in a portrait commissioned thirty years after her death but based on a Hilliard miniature painted while she was imprisoned. Hans Eworth's *Lord Darnley as a Boy*, Marcus Gheeraerts's portrait of King James I and VI's cupbearer, *The First Viscount Stormont* and an anonymous portrait of *George, Fifth Lord Seton* are among the early Scottish subjects, which include Adam de Cologne's *Lady Napier* and George Jamesone's *The Marchioness of Argyll*. Jamesone, teacher of John Michael Wright, also painted *Anne, Countess of Rothes and her Daughters*.

The seventeenth-century collection is unusually good; a recent acquisition is Daniel Mytens's magnificent full-length portrait of *James, First Duke of Hamilton*. The group of works by John Michael Wright includes a sensitive portrait of the architect *Sir William Bruce of Kinross* and the full-length of *Mungo Murray*, shown wearing the Scottish dress of his day. The Gallery owns William Dobson's most important royal commission, *Charles II when Prince of Wales* (painted to commemorate the battle of Edgehill) and Simon Verelst's *The First Marquess of Lothian*. There are two sets of husband-and-wife portraits of outstanding quality: Lely's *James II* and *Anne Hyde*, and Kneller's *John, Sixth Earl of Mar with his Son Thomas, Lord Erskine* and *Frances, Countess of Mar*.

With the eighteenth century comes one of the Gallery's strengths: its large collection of fine portraits by Raeburn. This includes the popular *Neil Gow the Fiddler* and full-lengths like *William Forbes of Callendar* and *John Wilson*. Many of Raeburn's sitters, like *Robert Cunninghame Graham of Gartmore*, are given natural poses, and the artist displays a fine feel for character. The Gallery also owns Allan

Ramsay's portrait of his first wife, *Anne Bayne*, John Singleton Copley's *Hugh, Twelfth Earl of Eglinton* and a golden full-length of *John, Fourth Duke of Argyll* by Gainsborough. Gavin Hamilton painted *William Hamilton of Bangour* in a pose derived from classical sculpture, while Henri-Pierre Danloux showed the admiral *Adam, First Viscount Duncan of Camperdown* in action aboard ship.

Figures in Scottish literature and thought are the subject of numerous works in the collection, for example Ramsay's *David Hume*, Alexander Nasmyth's *Robert Burns*, Runciman's *Robert Ferguson* and *Sir William Chambers* by Francis Cotes. There are romantic portraits of *Flora Macdonald* by Richard Wilson, *Sir David Wilkie* by Andrew Geddes and *Sir Walter Scott* by Raeburn. Girolamo Nerli's *Robert Louis Stevenson*, painted in Samoa, is considered the best likeness of the writer. *Sir Alexander Morison* by Richard Dadd is of the artist's psychiatrist.

In the modern collection are self-portraits by the Scottish artists Peploe and Anne Redpath, *Charles Rennie Mackintosh* by Francis Newbery, and paintings by Sargent, Augustus John and Lavery (*Hokusai and the Butterfly*). Contemporary works include *Sir Adam Thomson*, seen against an industrial background, by John Wonnacott.

See entry in main text, pages 278–9.

ROYAL MUSEUM OF SCOTLAND
Chambers Street, Edinburgh
Telephone: (031) 225 7534

TRUSTEES OF THE NATIONAL MUSEUMS OF SCOTLAND
Open: Mon-Sat 10-6, Sun 11-6
Admission Free: Access for disabled

Between South Bridge and George IV Bridge.

The main fine art interest of the collection is in the sculpture, oriental and western, Egyptian and African, including Benin bronzes. There is good German wood sculpture of the sixteenth and seventeenth centuries.

SCOTTISH NATIONAL GALLERY OF MODERN ART
Belford Road, Edinburgh EH4 3DR
Telephone: (031) 556 8921

TRUSTEES OF THE NATIONAL GALLERIES OF SCOTLAND
Open: Mon-Sat 10-6, Sun 11-6 (extended hours during Festival)
Admission Free: Access for disabled

The Scottish National Gallery of Modern Art is the only British national museum entirely devoted to twentieth-century art. Most of the collection has been acquired since the Gallery was founded in 1960, apart from a limited number of works transferred from the National Gallery of Scotland at that time. In 1984 the Gallery moved to its permanent home, a neo-classical building, formerly John Watson's School.

The Gallery contains a good cross-section of twentieth-century British and European art. French painting from the early years of the century includes an interesting group of paintings by Vuillard, among them *The Open Window*. André Derain's landscape *Collioure* dates from 1905, while *The Painting Lesson* is a Matisse of 1919. Representative examples of Cubism include Braque's *The Candlestick* and Picasso's *Guitar, Bottle and Gasjet*; the Gallery also owns *L'Equipe de Cardiff* by Robert Delaunay. There are fine works by Léger, including the semi-abstract *Woman and Still Life* of 1921 and *Les Constructeurs: L'Equipe en Repos* from 1950. Post-war French art is represented by a major Balthus, *Le Lever*, and by Jean Dubuffet's *Villa sur la route*. Among other artists in the French collection are Soutine (whose *Les Gorges du Loup sur Vence* dates from his important Céret period), Rouault (represented by *Head*) and Bonnard.

The holdings of inter-war art include Max Ernst's *Le Grand Amoureux I* and his *Mer et soleil*, and *The Black Flag* by the Belgian Surrealist painter Magritte. There are interesting examples of German Expressionism, including Kirchner's *Japanisches Theater*, Emil Nolde's *Kopf* and the Russian-born Alexei Jawlensky's *Head of a Woman*. Two rarities are *Relief with Red Pyramid* by Kurt Schwitters, and *Gelmeroda III* (1913) by Lyonel Feininger. In a completely different style is Otto Dix's disturbing *Nude Girl in a Fur* of 1932.

The collection of Russian art includes *Soldier in a Wood* by Larionov and *The Forest* by Goncharova, with work by Lyubova Popova and by El Lissitzky. *Lake Thun and the Stockhorn Mountains* by Ferdinand Hodler and *Threatening Snowstorm* by Paul Klee represent Swiss art, while a 1932 *Composition* by Mondrian – owned by Winifred Nicholson in the 1930s – *Cross on Grey* by the Spanish artist Tapiès and *Courageous Boys at Work* by the Italian artist Sandro Chia are also in the Gallery. The American artist Roy Lichtenstein painted *In the car*, a Pop Art painting of the Sixties.

Modern British, and more particularly modern Scottish art are well represented, with beautiful examples of work by the Scottish Colourists: Leslie Hunter's impressionistic *Reflections, Balloch*, J. D. Fergusson's night scene of fireworks at *Dieppe, 14 July 1905*, and Samuel Peploe's characteristic *Roses*. A group of works by Francis Cadell, another Colourist, includes his pre-1914 *The Model*, fine still lifes like *The Grey Fan* and the striking *Lady in Black: Miss Dora Wauchope*. There are interesting paintings by more recent Scottish artists: Sir William McTaggart's glowing *Poppies against the Night Sky* and Sir William Gillies's *Still Life with Black Fishes*. *Catterline in Winter* (1963) was the last major landscape by Joan Eardley; among paintings by Anne Redpath is *The Indian Rug or Red Slippers*. Contemporary Scottish artists include John Bellany and Alan Davie; there is a comprehensive post-Second World War collection of the best Scottish painters.

Gwen John's *A Young Nun* and Vanessa Bell's *Portrait of Iris Tree* are among the portraits in the collection. *A Reading of Ovid (Tyros)* is a satire by Wyndham Lewis, while Sickert paintings include not only the late *High steppers* of c.1938 (based on a newspaper photograph), but earlier works such as *Israel Zangwill*. Ben Nicholson is represented by a group of works, including *White Relief* of 1935, while in *Black Ground* (1938) John Piper's gift for abstraction is evident. The version of Paul Nash's *Landscape of the Vernal Equinox* in the Gallery was painted for Nash's wife. Also of interest are Stanley Spencer's *Christ Delivered to the People*, and Lowry's *Canal and Factories*. Roger Hilton is represented by *Dancing Woman, December 1963* which resembles the Tate Gallery's *Oi yoi yoi*. There is also Francis Bacon's *Triptych Inspired by the Oresteia of Aeschylus*, a *Landscape with Two Bathers* by Keith Vaughan, and a photo piece, *Exhausted*, by Gilbert and George. Contemporary artists also include R. B. Kitaj (*If not . . . not*) and David Hockney (*Rocky Mountains and Tired Indians*).

——— ORKNEY ———

THE PIER ARTS CENTRE
Victoria Street, Stromness
Telephone: (0856) 850209

THE PIER ARTS CENTRE TRUST
Open: Tues–Sat 10.30–12.30, 1.30–5;
Sun 2–5

The island can be reached via car ferry from Scrabster and by air from Wick, Aberdeen, Inverness, Edinburgh and Glasgow.

The Pier Arts Centre began with the gift to Orkney of about seventy modern paintings and sculptures. The Gallery was opened in 1979 in the pier stores, once owned by an agent of the Hudson's Bay Company.

The collection includes work by a number of mid-twentieth-century British artists who also worked in Cornwall. Reliefs by Ben Nicholson, sculpture by Barbara Hepworth and Naum Gabo constructions are on view. Others represented include Patrick Heron, Roger Hilton, Alfred Wallace, William Scott, Simon Nicholson and Peter Lanyon.

The Centre also has a changing programme of temporary exhibitions.

——— STRATHCLYDE ———

BRODICK CASTLE
Isle of Arran
Telephone: (0770) 2202

NATIONAL TRUST FOR SCOTLAND
Open: Apr and mid-Oct Mon, Wed and Sat, Easter and May–Sept daily 1–5; last admissions 4.40
Limited access for disabled

On the Isle of Arran one and a half miles north of Brodick Pierhead.

Part of the collection came from William Beckford, part from the acquisitions of the Dukes of Hamilton and the Earls of Rochford.

It includes an outstanding collection of sporting pictures, among them racing scenes by Pollard and J. F. Herring.

A Turner watercolour of Fonthill Abbey, two small works by Watteau, a portrait by Fragonard and sketches by Gainsborough are among the other paintings on view. The religious panel by Teniers and the portrait *Anne, Duchess of Hamilton* by David Scougall should not be missed.

See entry in main text, pages 296–7.

THE BURRELL COLLECTION
Pollok Country Park, 2060 Pollokshaws Road, Glasgow
Telephone: (041) 649 7151

CITY OF GLASGOW DISTRICT COUNCIL:

GLASGOW MUSEUMS AND ART GALLERIES
DEPT
Open: Mon–Sat 10–5, Sun 2–5
Admission Free: Access for disabled

Three miles to the south of Glasgow city
centre.

The Burrell Collection was given to the
nation in 1944 by the shipping magnate
Sir William Burrell and his wife, but
augmented until his death in 1958. A
modern museum, incorporating architec-
tural details, and even whole rooms, from
the collection, was built in the park of
Pollok House (q.v.) on the outskirts of
Glasgow and opened to widespread
acclaim in 1983. Only part of the enormous
collection, which includes thousands of
objects from East and West, ranging from
antiquities, medieval tapestries and stained
glass to twentieth-century paintings, can
be displayed at any one time.

A highlight of the paintings collection
is Giovanni Bellini's panel of the *Virgin
and Child*. Among other early paintings
are Memling's *Virgin of the Annunciation*
and *Flight into Egypt* and Lucas Cranach
the Elder's *Venus and Cupid* and *Stag
Hunt*.

The collection is strongest in French art
of the nineteenth century, but there is a
Rembrandt *Self-Portrait* of 1632, a Le
Nain oil-on-copper of *Peasant Children*,
Oudry's charming *The Dog* of 1751 and
a Hogarth portrait. The landscape of
Scheveningen is by Anton Mauve, a major
figure in nineteenth-century Dutch art.

Courbet is represented by *The Charity
of a Beggar at Ornans* and Boudin by
sunny coastal views including *The Beach
at Trouville – The Empress Eugénie*. There
are fine still lifes by Fantin-Latour:
Chrysanthemums and *Spring Flowers*. A
group of outstanding works by Degas
includes his great portrait of *Edmond
Duranty*, a famous ballet scene, *The Rehearsal*,
and *Jockeys in the Rain*. The *Château de
Médan* by Cézanne is accompanied by
Manet's pastel *At the Café* and his fresh
little sketch of *Roses in a Champagne
Glass*.

Items from the Burrell's large collection
of works on paper are shown in temporary
displays, for conservation reasons. They
include works of a high standard, such as
Gauguin's *Breton Girl*, Renoir's *Girl with
Auburn Hair* and Daumier's *Bons Confrères*.
There are good examples of the art of
Ingres and of Vuillard, and of the only
contemporary British artists whose work
Burrell collected: Joseph Crawhall and
Phil May; the museum owns outstanding
collections of their work.

See entry in main text, pages 284–6.

CULZEAN CASTLE

Maybole
Telephone: (065 56) 274

NATIONAL TRUST FOR SCOTLAND
Open: Apr Mon–Fri 12–5, Sat, Sun 10–6;
Easter weekend and May–Sept daily 10–6;
Oct daily 12–5; last admission half-hour
before closing
Access for disabled

Twelve miles south of Ayr off the A719.

It is not surprising to find paintings of
the sea in a castle so magnificently placed
on the edge of a cliff looking out over
the Firth of Clyde. Among the paintings
are *HMS London in a Breeze off Shakespeare
Cliff, Dover* by Luny, seascapes by Van
de Velde the younger, Peter Monamy,
Thomas Elliot, and a pair by Charles
Brooking.

The two large Alexander Nasmyth
views of Culzean Castle in the Picture
Room are impressive examples of his
work. There are several Dutch genre
paintings. The Kennedy family portraits
in the castle are by Batoni, Gavin
Hamilton, William Owen, J. M. Wright
and Mather Brown. The fine full-length
Mossman of *Thomas, Ninth Earl* hangs in
the First Drawing Room.

THE DICK INSTITUTE

Elmbank Avenue, Kilmarnock
Telephone: (0563) 26401

KILMARNOCK AND LOUDON DISTRICT
COUNCIL
Open: Apr–Sept Mon, Tues, Thurs, Fri
9–8; Wed and Sun 10–5; Oct–Mar
Mon–Sat 10–5
Admission Free; Access for disabled

Near Kilmarnock town centre.

The Dick Institute owns a good collection
of paintings, mainly of the Scottish
schools, but provides insufficient space for
the display of more than a small
proportion.

Robert Colquhoun was born in Kil-
marnock, and there is a large work by
him, *Women in Ireland*.

There are major examples of work by
Lord Leighton and Lawrence Alma-
Tadema.

GLASGOW ART GALLERY AND MUSEUM

Kelvingrove, Glasgow G3 8AG
Telephone: (041) 357 3929

CITY OF GLASGOW DISTRICT COUNCIL:
GLASGOW MUSEUMS AND ART GALLERIES
DEPT
Open: Mon–Sat 10–5, Sun 2–5
Admission Free: Access for disabled

The gallery is in Kelvingrove Park, west
of the city centre on the north side of
the Clyde.

Glasgow Art Gallery and Museum is one
of the outstanding public collections in
these islands, although it is a civic rather
than a national collection. Indeed the
collection was in existence many years
before there was a gallery in which to
house it. Its first home was the McLellan
Galleries, which had been purchased by
the Council. It is rich in all schools,
notably Dutch paintings, and contains
some splendid masterpieces. Probably the
most famous of these are Whistler's great
portrait, *Arrangement in Grey and Black
No. 2: Thomas Carlyle*, and Salvador Dali's
unforgettable *Christ of St John of the Cross*,
which was a daring purchase of 1952.

Italian works include the magnificent
Women Taken in Adultery by Giorgione;
a fragment of the same painting hangs
beside it (*Head of a Man*). Other northern
Italian paintings include Bellini's *Virgin
and Child*. From Florence there are a
tempera tondo by Filippino Lippi, Botti-
celli's *Annunciation* and works by Alessan-
dro Allori and Carlo Dolci. There are
also interesting paintings by the Cavaliere
d'Arpino, the Venetians Vicenzo Catena
and Guardi, and Garofalo, Sassoferrato
and Balestra. Romantic examples of
Salvator Rosa landscapes include *The
Baptism in the Jordan*. An early painting
by the Spanish artist Ribera, *St Peter
Repentant*, hangs with the Italian works.

Among the Flemish paintings are van
Orley's *Virgin and Child by a Fountain*,
and Jordaens's *Fruit Seller*. In *Nature
Adorned by the Graces*, Rubens collaborated
with Jan Brueghel I, Brueghel painting
the vegetation.

The Gallery is particularly rich in Dutch
paintings of the seventeenth to nineteenth
centuries. The outstanding Dutch work is
Rembrandt's *The Man in Armour*; the
Gallery also owns *Carcase of an Ox*, now
attributed to Fabritius. Saenredam's tiny
Interior of the Church of St Bavo, Haarlem
contrasts with his enormous painting of
the same subject at Edinburgh's National
Gallery. These are accompanied by fine
paintings by Jan van Goyen, Caspar
Netscher, Govaert Flinck and Bartholo-
meus van der Helst. Landscapes include
Jacob Ruisdael's *View of Egmond aan Zee*
and Egbert der Poel's *A Fire at Night*.

The still lifes are of high quality, from Rachel Ruysch's *Arrangement of Flowers by a Tree Trunk* and a Willem van Aelst *Still Life* of 1680 to the huge *Flowers in a Terracotta Urn* by Jan van Huysum, similar to that in the National Gallery in London. Also represented are Cuyp, Wouwermans, Hobbema, Berchem, Ochtervelt and Frans van Mieris I, Jan Wijnants and Luttichuijs, to name only some of the artists in this remarkably comprehensive collection. Later Dutch art includes *The Frugal Meal* by the nineteenth-century artist Josef Israëls; the Gallery owns oils or works on paper by Bosboom, Jacob Maris and Anton Mauve.

The French collection begins with a fifteenth-century *St Maurice or Victor with a Donor* by the Master of Moulins, but its strength lies in nineteenth- and twentieth-century art. Millet's *Going to Work* and his pastel of *The Sheepfold*, as well as Courbet's *Flowers in a Basket*, are among the highlights, which include Corot's late *Pastorale – souvenir d'Italie* (a huge work which was one of the first Corots in Scotland). These are complemented by a rarity for a British public collection, *The Reapers*, a major painting by Jules Breton, and by fine works by Bastien-Lepage, Troyon, Daubigny and Harpigny. Paintings by Fantin-Latour include typical flowerpieces (*Chrysanthemums, Larkspur*) and the less familiar *The Dance*. Boudin, better known for coastal views, has contributed *A Street in Dordrecht*. Particularly impressive are the oils and works on paper by Le Sidaner (*Nemours*) and by Léon Lhermitte (*Ploughing with Oxen*).

The Impressionists are represented as well, with a freely painted *Vétheuil* by Monet, Pissarro's *The Towpath*, Renoir's portrait of *Mme Charles Fray* and paintings by Sisley. There is a pastel by Degas of *Dancers on a Bench* and Mary Cassatt's charming *The Sisters*. A Van Gogh portrait of *Alexander Reid* depicts the Glasgow dealer who promoted Scottish artists and sold Van Gogh's *Le Moulin de Blute-Fin, Montmartre*, also in the collection. Cézanne works include a landscape and an exquisite small still life, *Overturned Basket of Fruit*. There is an impressionistic *Oestervold Park, Copenhagen* by Gauguin, Emile Bernard's *Landscape, Saint-Briac* and good paintings by less famous artists like Charles Camoin and Antoine Vollon. Seurat's sketches of *House Among Trees* and *River Banks*, as well as his remarkably modern *Boy Sitting on the Grass, Pontaubert* – all of the early 1880s – are accompanied by works by his follower Signac.

The Flower-seller by Picasso dates from 1901. Matisse's highly decorative *The Pink Tablecloth* is in the collection, as is André Derain's *Blackfriars* and an excellent group of works by Vuillard, among them *Interior of the Drawing Room*. Unusual items include Juan Gris's *The Glass* of 1918 and Marcoussis's *Table on the Balcony*. There are also Vlaminck's *Woody River Scene*, a Braque *Still Life* of 1926, and Rouault's *Circus Girl*, as well as paintings by Utrillo and Dufy. *Head of a Young Girl* by Matisse makes an interesting comparison with a fine head of a *Negress* by André Lhote.

The British painting has the predictable Scottish flavouring, with eighteenth- and nineteenth-century painting well-represented. Ramsay's impressive full-length of *Archibald, Third Duke of Argyll* is balanced by the more intimate *A Lady* by the same artist. The many Raeburn portraits include *Mrs Anne Campbell of Park*. There are handsome landscapes by John Knox (*The First Steamboat on the Clyde*), Alexander and Patrick Nasmyth and, above all, by Horatio McCulloch, the most successful of Victorian Scottish landscape artists, who is represented here by his magnificent *Glencoe*. Another fine landscape is William McTaggart's *The Paps of Jura*.

A group of works by John Faed includes the illusionistic *View of Gatehouse of Fleet*, and a portrait of *The Artist's Wife*. Thomas Faed painted *The Last of the Clan* in 1865. The Gallery also owns *A Fairy Raid*, another of the fantasy pieces of Joseph Noel Paton, and the famous Orchardson, *Le Mariage de Convenance*.

Not surprisingly, the Glasgow Boys' art is strongly represented. The collection includes George Henry's *A Galloway Landscape* and *Japanese Lady with a Fan*, James Paterson's *The Last Turning, Winter, Moniaire* and Sir James Guthrie's *Old Willie – A Village Worthy*. *The Druids: Bringing in the Mistletoe* was painted by Henry with E. A. Hornel, and there is work by the gifted Joseph Crawhall. The selection of Scottish Colourist work is similarly excellent: still lifes and portraits by Samuel Peploe (*Old Duff*, 1921), Leslie Hunter's *Flowers in a Chinese Vase* and paintings by J. D. Fergusson ranging from the early *Grey Day, Paris Plage* to the 1918 *Damaged Destroyer*. *Reflections* by Francis Cadell is displayed with his superb *Interior: The Orange Blind* and *Lady in Black*. More modern Scottish paintings include Anne Redpath's *Pinks* and Sir William Gillies's *Still Life – Blue and Brown*.

British painting other than Scottish begins with an outstanding portrait by Gerard Soest, *The Second Marquess of Tweedale*. Other good portraits are Zoffany's *A Family Party: The Minuet*, Augustus John's *W. B. Yeats* and Wyndham Lewis's *The Artist's Wife*. The Gallery owns Millais's *The Ornithologist*, which the artist considered his best work. *A Quiet Day in the Studio* by Lavery contrasts with the formality of his huge *State Visit of Queen Victoria to the Glasgow International Exhibition*, 1888, for which the Gallery has a sketch as well. The modern collection includes a Sutherland landscape, and a postwar *Still Life* by Ben Nicholson.

See entry in main text, pages 282–4.

HUNTERIAN ART GALLERY

Hillhead Street, Glasgow University, Glasgow
Telephone: (041) 330 5431

GLASGOW UNIVERSITY
Open: Mon-Fri 9.30-5, Sat 9.30-1
Admission Charge (for Mackintosh House only) Access for disabled

To the west of the city, Hillhead Street runs off University Avenue.
Underground: Hillhead.

The Hunterian Art Gallery, opened in 1980, contains the University of Glasgow's art collection. It is named after the physician William Hunter (1718–83), whose collections in 1807 formed the Hunterian Museum, Scotland's first public museum. Paintings from the Museum form an impressive nucleus of French, Italian, Dutch, Flemish and British paintings, to which subsequent benefactors, like Miss Ina J. Smillie, have added.

Hunter had the foresight to purchase three masterpieces by Chardin at a time when the artist was little regarded in these islands; *The Scullery Maid*, *The Cellar Boy*, and *A Lady Taking Tea*. Sisley's *Church of Moret-sur-Loing. Rising Weather. In the Morning* is one of a group of nineteenth-century French landscapes.

Rembrandt's sketch of *The Entombment* is a highlight of the Dutch and Flemish collection, along with *The Fortune Teller* by Jan Steen, a panoramic landscape by Philips de Koninck and a striking *Still Life with a Gun and Fowling Equipment* by the little-known Johannes Leemans.

The older British paintings include Stubbs's *The Moose* and portraits by Allan Ramsay, among them *Mrs Tracy Travell*, a full-length of *Lady Anne Campbell* and *Dr William Hunter*, founder of the collection. There are several Raeburn portraits, including *John Scott of Gala*, as well as portraits by Hudson, Reynolds and Romney. Gavin Hamilton's *Hector's*

Farewell to Andromache is a recent acquisition.

The Gallery is famous for its Whistler and Charles Rennie Mackintosh collections. The contents of Whistler's studio passed to the University, making it one of the two most comprehensive collections of Whistler's work in the world (the other being the Freer Gallery in Washington). There are self-portraits and portraits, including the full-lengths *Rose et Or – La Tulipe* and *Red and Black – The Fan*. The Hunterian owns the *Cartoon for the South Wall of 'Harmony in Blue and Gold': The Peacock Room*, Whistler's great decorative scheme of 1876. Nearby are paintings by artists influenced by Whistler: Sickert, Lavery, Ambrose McEvoy, Mortimer Menpes and Walter Greaves. *Reading Aloud* by Albert Moore is a study in oil on glass for his painting in Glasgow Art Gallery.

The Gallery also owns the largest single collection of works by Mackintosh: over 600 watercolours, drawings and designs, with archival material and furniture. A selection of items is exhibited in the Mackintosh Gallery. Much of the furniture is displayed in a reconstruction of the principal interiors from the architect's Glasgow house.

There is an understandable emphasis on Scottish art in the modern British collection. Of particular interest are Robert McGown Coventry's *Mending the Nets,* Cadell's *The Red Chair,* Stanley Cursiter's *Girl with a Pewter Jug* and art from the Sixties, including Sir William Gillies's *Winter Dusk* and Joan Eardley's *Salmon Nets and the Sea.*

The Hunterian contains the most comprehensive Scottish collection of prints, which with its drawings and watercolours forms the basis of the Gallery's temporary exhibition programme.

See entry in main text, pages 286–7.

INVERARAY CASTLE

Inveraray
Telephone: (0499) 2203

DUKE OF ARGYLL
Open: First Sat in Apr to second Sun in Oct; Apr, May, June, Sept, Oct weekdays except Fri 10–1 and 2–6, Sun 2–6; July and Aug 10–6, Sun 2–6
Limited access for disabled

A mile north-east of Inverarary on Loch Fyne.

A pleasant collection of family portraits, including an attractive triple portrait of

The Campbell of Ardkinglas Brothers by Adam de Cologne, and Opie's portrait of the 6th Duke as a boy sketching.

Queen Victoria's daughter, Princess Louise, was married to the 9th Duke, and the wedding is commemorated in various works in the Victorian Room, among them Winterhalter's portrait of the Princess, and Sydney Hall's study of the wedding, showing Disraeli in the foreground.

Hoppner, Batoni, Gainsborough, Ramsay, Cotes and Raeburn are among the artists whose portraits hang in the castle.

LILLIE ART GALLERY

Station Road, Milngavie, Glasgow
Telephone: (041) 956 2351

BEARSDEN AND MILNGAVIE DISTRICT COUNCIL
Open: Tues-Fri 11–5, 7–9; Sat and Sun 2–5
Admission Free: Access for disabled

Milngavie is north of Glasgow on the A81.

Mainly twentieth-century Scottish art with works by The Glasgow School painters and The Scottish Colourists. There are also paintings by Alan Davie, Sir Robin Philipson, Dr David Donaldson, Duncan Shanks, Ian Fleming, Barbara Balmer and Joan Eardley.

THE PAISLEY MUSEUM AND ART GALLERIES

High Street, Paisley
Telephone: (041) 889 3151

RENFREW DISTRICT COUNCIL (NOW COMES UNDER STRATHCLYDE)
Open: Mon-Sat 10–5
Admission free: Access for disabled

In the town centre.

The collection of paintings includes good French, English and Scottish work. Courbet, Boudin, Fantin-Latour and Corot are included, with a number of Barbizon canvases, including works by Diaz, Troyon and Rousseau.

Scottish painting ranges from Allan Ramsay to Joan Eardley, with good representative work of the Glasgow School, including portraits by John Lavery.

POLLOK HOUSE

2060 Pollokshaws Road, Glasgow
Telephone: (041) 632 0274

CITY OF GLASGOW DISTRICT COUNCIL: GLASGOW MUSEUMS AND ART GALLERIES DEPT
Open: Mon-Sat 10–5, Sun 2–5
Admission Free: Access for disabled

Three and a half miles from the city centre.

The house is a branch of Glasgow Museums and Art Galleries. It was given to the city by Mrs Anne Maxwell MacDonald in 1966, together with 361 acres of parkland and gardens.

Sir William Stirling Maxwell was responsible for the mainly Spanish art collection at Pollok House. He acquired most of the works in the 1850s, slightly earlier than the main Spanish acquisitions by John and Josephine Bowes, with which the Pollok House paintings should be compared. Stirling Maxwell also wrote *Annals of the Artists of Spain.*

The finest works in the collection, as at Barnard Castle, are two El Greco canvases, his *Portrait of a Man,* painted in 1590, and *Lady in a Fur Wrap,* dating from the late 1570s.

Works by Spanish court painters of the seventeenth century include royal portraits by Alonzo Sánchez Goello and by Juan Carreño de Miranda, who was introduced to the court by Velázquez. There is also Alonzo de Tobar's *Saint John and the Lamb, Adam and Eve* by Alonso Cano, and works by Luis de Morales, Antonio de Pereda and Juan Fernandez Navarrete.

Important Spanish works of a later period include a fine Murillo *Madonna* as well as *Madonna and Child with Saint John,* and works by Goya, as well as a set of *Los Proverbios.*

The collection has other European and British paintings, including several works by William Blake, among them *Sir Jeffrey Chaucer and the Nine and Twenty Pilgrims on Their Journey to Canterbury.*

———— TAYSIDE ————

ARBROATH ART GALLERY

Public Library, Hill Terrace, Arbroath
Telephone: (0241) 72248

ANGUS DISTRICT COUNCIL
Open: Mon-Fri 9.30–6
Sat 9.30–5
Admission Free: Limited access for disabled

In the centre of the town.

The collection, of mainly Scottish and local works of art, is probably the best and most extensive of the Angus District public collections. It includes a large number of watercolours by James Watterson Herald, a local artist.

THE BLACK WATCH MUSEUM
Balhousie Castle, Perth
Telephone: (0738) 21281

BLACK WATCH REGIMENT
Open: Easter-Sept Mon-Fri 10-4.30; Sun and public holidays 2-4.30; Oct-Easter Mon-Fri 10-3.30
Admission Free: Limited access for disabled

North of the city centre, beside the North Inch.

Most of the paintings at the regimental museum are nineteenth- and twentieth-century works. An Angelica Kauffmann portrait of *Archibald Montgomerie*, painted in about 1790, and two other portraits by unknown artists, are the eighteenth-century exceptions. Watson Gordon, Lady Butler, Thomas Shaw and W. B. Wollen are among the other artists represented in the collection.

BLAIR CASTLE
Blair Atholl, Pitlochry PH18 5TH
Telephone: (079 681) 356

DUKE OF ATHOLL
Open: 1 Apr-26 Oct daily 10-6 except Apr, May, Oct Suns 2-6
Limited access for disabled

Off the A9 Perth-Inverness Road, 35 miles north of Perth.

Blair is the home of the Dukes of Atholl. Their collection of portraits and Scottish landscapes is spread over thirty-two rooms.
The Stewart Room contains miniatures of *Mary Queen of Scots* and *Lady Dorothea Stewart. The First Marquis of Atholl* is portrayed by de Wit in a classical Julius Caesar pose in a magnificent full-length on the Picture Staircase.
The Tea Room contains several portraits by Honthorst. Two conversation pieces, *The Fourth Duke and his Family* by David Allan and *The Third Duke and Duchess with their Children* by Zoffany, hang in the 4th Duke's Corridor and the Drawing Room, respectively.
There is Hoppner's portrait of *The Fourth Duke* and a study by Landseer of the young James C. P. Murray and John McMillan, a fisherman. Other portraits

are by Ramsay, Lely, Lawrence, Raeburn and Wilkie.

DUNDEE ART GALLERIES AND MUSEUMS: MCMANUS GALLERIES
Albert Square, Dundee DD1 1DA
Telephone: (0382) 23141 ext 136

CITY OF DUNDEE DISTRICT COUNCIL
Open: Mon-Sat 10-5
Admission Free: Access for disabled

Dundee is on the north bank of the Firth of Tay.

The fine art collection contains over 2,500 items including approximately 800 oil paintings.
The collection's main strength lies in the holdings of nineteenth- and twentieth-century Scottish art. There are good examples of the Scott Lauder Group – Robert Scott Lauder himself and his pupils – McTaggart, Chalmers, Pettie, Orchardson, Peter Graham and others. The Glasgow School and The Scottish Colourist groups are also represented.
Individual works include Thomas Faed's *The Visit of the Patron and the Patroness to the Village School,* John Blake Macdonald's *Lochaber No More, A Lowland Church* by Fergusson, and works by John Phillip and Cadell.
Frank Brangwyn is also extensively represented in the collection, with some sixteen oils and 300 graphic works.
John Everett Millais's *Puss in Boots,* and *Dante's Dream on the Day of the Death of Beatrice* are among the English works in the collection.
The European works include attractive seventeenth-century Dutch landscapes and still lifes and some good Italian oils and drawings by minor masters of the seventeenth and eighteenth centuries.
See entry in main text, pages 289–91.

GLAMIS CASTLE
Glamis, Angus
Telephone: (030 784) 242/3

EARL OF STRATHMORE AND KINGHORNE
Open: 13 Apr-15 Oct 12-5.30;
last tour 4.45
Limited access for disabled

A mile due north of Glamis, east of the A928.

This is a castle with many royal connections, most notably with Queen Elizabeth The Queen Mother, who grew up here. It has been the home of the

Strathmore and Kinghorne family since 1372. Glamis also has associations with Macbeth, as Duncan was supposedly murdered by Macbeth here. The fine art treasure is the Chapel.
A portrait of the dashing *John Grahame of Claverhouse, Viscount Dundee* known as 'Bonnie Dundee', and Elizabethan portraits, as well as a copy of a Van Dyck of Charles I hang in the Drawing Room.
The 9th Lord Glamis (1st Earl of Kinghorne) aged eight, painted by an unknown artist of the School of Clouet, hangs in the same room. On the reverse is painted George Boswell, his secretary.
In Duncan's Hall are portraits of *James V* and his wife, *Queen Mary of Guise,* parents of Mary Queen of Scots. The Billiard Room contains the luscious *Fruit Market,* attributed to Rubens and Frans Snyders, together with a Mortlake tapestry *The Life of Nebuchadnezzar.*
See entry in main text, page 298.

MONTROSE MUSEUM
Panmure Place, Montrose
Telephone: (0674) 73232

ANGUS DISTRICT MUSEUMS
Open: Nov-Mar Mon-Fri, 2-5 Sat 10.30-1, 2-5; Apr-Oct Mon-Sat 10.30-1, 2-5, July, Aug Suns 2-5
Admission Free: Limited access for disabled

In the town centre.

A small collection of works mainly by local artists, and covering the town's maritime history and Angus views. There are works by George Paul Chalmers and sculpture by William Lamb, who was born in Montrose.
His work is more fully exhibited in his studio, which is now a memorial museum (see p.440).

PERTH MUSEUM AND ART GALLERY
78 George Street, Perth
Telephone: (0738) 32488

PERTH AND KINROSS DISTRICT COUNCIL
Open: Daily 10-5 except Sun
Admission Free: Access for disabled

The Literary and Antiquarian Society of Perth was founded in 1784 and by 1818 a decision was made to build a monument to Thomas Hay Marshall, a former Lord Provost of the City, in the form of a museum and library. A fund was started and by public subscription money was raised and the building was opened in 1824.

Initially paintings formed a very small part. The first painting was Alexander Runciman's *The Earl of Buchan*, donated by the Earl. The Marquis of Breadalbane gave the first collection, in 1833, of six seventeenth- and eighteenth-century works. The more striking are Ribera's *Saint Andrew*, Giordano's *Esau Selling his Birthright* and Vanvitelli's *The Forum Romanum*.

The R. Hay Robertson and Mr Robert Brough collection were donated in 1925 and consist of Scottish, English, French and Dutch paintings. Among the works are Jean-François Millet's *Les Coutrières* and Courbet's *Peaches*. Paintings by Sir D. Y. Cameron and Charles Mackie were given in other donations. There are Italian seventeenth-century paintings, and Dutch and French paintings of the eighteenth and nineteenth centuries.

The strength of the painting collection lies in Scottish work, from the eighteenth century to the present day. All the major schools are represented. There are also a few, mostly late, English works. The limited sculpture collection includes works by Sir Alfred Gilbert.

SCONE PALACE
Scone
Telephone: (0738) 52300

EARL OF MANSFIELD
Open: Easter–mid Oct Mon–Sat 9.30–5,

Sun 1.30 July and Aug 10–5; groups by appointment all year

One mile north of Perth on the A93 Blairgowrie Road.

First a monastery, Scone then became the site for the inauguration of Scottish kings, from the days of the High Kings of the Picts onward. Since 1604 it has been in the possession of the Murray family.

Allan Ramsay's portraits of Queen Charlotte and George III hang in the Drawing Room. The Ambassador's Room contains *The Second Earl of Mansfield* by Batoni. The Earl was Ambassador in Paris from 1772–8. There is a Zoffany portrait, *Lady Elizabeth Murray and Dido*; Dido was the daughter of her uncle's West Indian housekeeper.

Dutch paintings include works by Teniers, Koninck and Seghers.

WILLIAM LAMB MEMORIAL STUDIO
24 Market Street, Montrose, Angus
Telephone: (0674) 73232

ANGUS DISTRICT COUNCIL
Open: July and Aug Sun 2–5 or by arrangement
Admission Free: Limited access for disabled

Close to the centre of Montrose.

The Montrose sculptor William Lamb had his studio near the museum in the town where he lived and worked. He did society portraiture, but also sculpted local fishermen and their wives, in a rugged and effective style, examples of which are on display.

—— WESTERN ISLES ——

DUNVEGAN CASTLE
Dunvegan, Isle of Skye
Telephone: (047 022) 206

JOHN MACLEOD OF MACLEOD
Open: Apr–end Oct daily 10–5
Closed: Sun
Access for disabled

On the Isle of Skye, one mile from Dunvegan village, 23 miles west of Portree.

The home of the Chiefs of MacLeod for over 700 years, Dunvegan Castle is magnificently situated on the coast of the Isle of Skye.

MacLeod portraits include *The Twenty-Second Chief and his Wife* by Allan Ramsay, *The Twenty-Third Chief and his Wife* by Sir Henry Raeburn, and the latter two again by John Zoffany, painted in India. The earliest portraits, dating from about 1685, of *Iain Breac, Eighteenth Chief and his Wife*, hang in the Entrance Hall.

—— NORTHERN IRELAND ——

—— ANTRIM ——

ARTS COUNCIL OF NORTHERN IRELAND GALLERY
Bedford Street, Belfast
Telephone: (0232) 321402

Open: Mon–Sat 10–6 during exhibition dates
Admission Free: Limited access for disabled

The Arts Council Gallery is in central Belfast.

As part of its policy to help living Irish artists, the Arts Council of Northern Ireland has purchased works of art over the past quarter-century which now form a permanent collection. Parts of it are on view from time to time.

LISBURN MUSEUM
The Assembly Rooms, Market Square, Lisburn
Telephone: (084 62) 72624

LISBURN BOROUGH COUNCIL
Open: Tues–Fri 11–4.45 (Oct–Mar) and Sat (Apr–Sept)
Admission Free: Limited access for disabled

Lisburn is south-west of Belfast, off the M1.

The collection of fine art in the museum includes watercolours by S. McCloy (1831–1904), a William Hincks 1783 coloured edition of illustrations for the Irish Linen Industry and a selection of local topographical views and works by local artists.

ULSTER MUSEUM
Botanic Gardens, Belfast
Telephone: (0232) 381251

TRUSTEES OF THE ULSTER MUSEUM
Open: Mon–Fri 10–5, Sat 1–5, Sun 2–5
Closed: 12 July, CD
Admission Free: Access for disabled

The museum overlooks the Botanic Gardens, in the university district of the city.

The Ulster Museum, although it displays a variety of subject matter, specialises in exhibits related to Ireland. The Department of Fine Art contains some Old Master paintings, an extensive collection of Irish art, and about 2,000 drawings, watercolours and prints.

Italian works include paintings by Agostino Tassi, Sebastiano Ricci, Panini, and il Todeschini. Dutch and Flemish

works include *Portrait of a Woman* by Nicholas Maes, *St Christopher Carrying the Christ Child* by Jacob Jordaens, *The Raising of Lazarus* by Cornelis de Vos and *Landscape with Windmills* by Jan 'Velvet' Brueghel.

Twentieth-century British artists are represented by Sickert, Stanley Spencer, Matthew Smith, Robert Bevan, Francis Bacon, William Scott, Patrick Caulfield, Jack Yeats and Edward Burra. There is a collection of paintings by Sir John Lavery given by the artist to the museum.

Helen Frankenthaler, Morris Louis, Kenneth Noland, Heinz Mack, Jean Dubuffet, Victor Vasarély, Gunther Uecker and Julio Le Parc are among the international modern artists.

Eighteenth-century British paintings include portraits by Gainsborough and Reynolds. Landscape painting has examples of Richard Wilson and J. M. W. Turner. Contemporary Irish portrait and landscape artists are also represented.

See entry in main text, pages 314–318.

ARMAGH

THE ARGORY
Moy, Dungannon BT 71 6NA
Telephone: Moy (08687) 84753

NATIONAL TRUST FOR NORTHERN IRELAND
Open: Easter week daily 2-6; 28-29 Apr, May-June, Sept, Sat, Sun, BHs 2-6; July-Aug daily except Tues 2-6
Access for disabled to ground floor only

Moy is due north of Armagh city, on the A29.

The Argory contains a small but interesting collection of paintings, mainly copies after Old Masters. The Lobby is decorated with a fine array of early nineteenth-century engravings in period gilt frames.

ARDRESS HOUSE
64 Ardress Road, Annaghmore, Portadown BT 62 13Q
Telephone: (0762) 851236

NATIONAL TRUST FOR NORTHERN IRELAND
Open: Easter daily 2-6, 28-29 April, May, & Sept weekends and BHs, 2-6; July-end Aug daily except Tues 2-6, Sun 2-7
Limited access for disabled

Due west of Portadown, off the B28 road to Moy.

The collection, on loan from Castle Stewart, is described as 'suitable to a modest country house'. It consists of seventeenth- and eighteenth-century work, Italian, Flemish and British in origin.

ARMAGH COUNTY MUSEUM
The Mall East BT61 9BE
Telephone: (0861) 523070

A REGIONAL BRANCH OF THE ULSTER MUSEUM
Open: Mon-Sat 10-1, 2-5
Closed: Certain BHs
Admission Free: No access for disabled

The museum is in the centre of Armagh city, on the Mall.

The Armagh Museum's collection of fine art includes pictures of topographical and historical interest to Armagh, portraits of local men and women and works by contemporary Irish artists, in particular George Russell (AE), who came from Lurgan, and James Sleator, the most noted painter from Armagh itself.

Sleator was trained in Dublin, and later became studio assistant to Orpen. He was asked to instruct Winston Churchill in painting.

The Armagh collection of works by the mystic, George Russell, includes fine examples of his realistic painting, as well as the slightly fey landscapes with sexless figures dancing in pure and everlasting adolescence.

Sturdier topographical works include the splendid *City of Armagh in 1810* by James Black.

DERRY

SPRINGHILL
20 Springhill Road, Moneymore, Magherafelt BT45 7NQ
Telephone: (064 87) 48210

NATIONAL TRUST FOR NORTHERN IRELAND
Open: Easter week daily 2-6; 28-29 Apr; May; June, Sept weekends and BHs 2-6; July-Aug daily except Thurs 2-6
Access for disabled

One mile from Moneymore on the B18.

The Springhill property was in the Conyngham family from the early seventeenth century, though the house dates from the last quarter. Most of the paintings in the house are family portraits of the Conynghams and Lenox-Conyng-

hams, though there are subject-pictures and sporting paintings.

DOWN

CASTLE WARD
Strangford, Downpatrick BT30 7LS
Telephone: (039 686) 204

NATIONAL TRUST FOR NORTHERN IRELAND
Open: Easter week daily 1-6; 28-29 Apr, Sept-Oct weekends and BHs 1-6; May-Aug daily except Thurs 1-6
Limited access for disabled

On the shores of Strangford Lough, on the Strangford-Downpatrick Road.

This splendid house, one side classical Palladian in design, the other Gothick, contains a collection of family and other portraits, many of them copies.

MOUNT STEWART
Newtownards BT22 2AD
Telephone: (024 774)387

NATIONAL TRUST FOR NORTHERN IRELAND
Open: Easter week daily 1-6; 28-29 Apr-May, Sept-Oct Weekends and BHs 1-6; June-Aug daily except Tues 1-6
Limited access for disabled

Five miles south-east of Newtownards and fifteen miles east of Belfast on the north side of the Belfast-Portaferry road (A20).

Mount Stewart contains the finest country house art collection open to the public in Northern Ireland, and includes one great Stubbs masterpiece, *Hambletonian*. The horse was painted by Stubbs for its owner, Sir Henry Vane-Tempest, father-in-law of the 3rd Marquess of Londonderry, after it had won the match with Diamond at Newmarket in 1799. The painting shows the thoroughbred being rubbed down after the race. It was exhibited at the Royal Academy in 1800.

The remaining pictures are principally family portraits, by artists ranging from Batoni to Lavery and de Laszlo, a couple of battle pieces, and pastels.

FERMANAGH

FERMANAGH COUNTY MUSEUM
Castle Barracks, Enniskillen
Telephone: (0365) 25050 Ext 244

ENNISKILLEN BOROUGH COUNCIL
Open: All year Mon-Fri 10-1, 2-5, in
summer Sat 2-5; July and Aug Sun 2-5;
most BHs
Closed: Suns and some BHs
Admission Free: Limited access for disabled

The museum has rooms in the castle keep,
sharing space with the regimental museum
for the Inniskilling Fusiliers.

Essentially a general museum, with Belleek
Pottery and porcelain, folklore, craft and
history, it nevertheless has a modest
collection of paintings, watercolours and
graphics, mainly of local interest.

FLORENCE COURT
Florencecourt near Enniskillen
Telephone: (036 582) 249

NATIONAL TRUST FOR NORTHERN
IRELAND
Open: Easter week daily 2-6; 28-29 Apr-
May, Sept weekends and BHs 2-6; June-
Aug daily except Tues 2-6
Disabled facilities

One mile west of Florencecourt village
and seven miles south-west of Enniskillen
via the A4 and A32.

A modest collection of paintings, including
portraits of the Westenra family by
Brocas, has been lent to the National
Trust for Northern Ireland by Lord
Rossmore, for display in the house, which
is itself an exciting example of mid-
eighteenth-century architecture.

Two sporting works by J. F. Herring,
Senior are also in the collection.

REPUBLIC OF IRELAND

———— CLARE ————

DE VALERA LIBRARY AND MUSEUM
Harmony Row, Ennis
Telephone: (65) 21616

Open: Mon, Wed, Thurs 11-5.30, Tues,
Fri 11-8
Closed: Sat, Sun, BHs
Admission Free: Access for disabled

The Library and Museum, housed in a
former Presbyterian Church, contains a
collection of twenty or so seventeenth-
and eighteenth-century paintings, mostly
Flemish, which were presented by Canon
J. Hanon.

———— CORK ————

BANTRY HOUSE
Bantry
Telephone: (27) 50047

MR AND MRS EGERTON SHELSWELL-WHITE
Open: Summer daily 9-8; Winter daily
9-6
Limited access for disabled

On the outskirts of Bantry town, 56
miles from Cork city.

A modest collection of paintings, which
includes some interesting minor Irish
portraits and landscapes, and a large
Snyders oil.

The house did have much more, which
originally came to Ireland from France at
the time of the revolution. Good paintings
have been sold, however, as recently as
the 1960s. Echoes of former glories derive
from furniture, and from fine Aubusson
tapestries.

CRAWFORD MUNICIPAL ART GALLERY
Emmet Place, Cork City
Telephone: (21) 965033

CITY OF CORK VOCATIONAL EDUCATION
COMMITTEE
Open: Mon-Sat 10-5
Admission Free: Public Lift: Limited access
for disabled

Emmet Place is close to the centre of the
city, by the Lee.

The building contains thirteen large
galleries on three floors. The ground floor
includes two great sculpture galleries,
where paintings, sculptures and casts from
the Vatican collection are exhibited. The
main core of the collection is shown in
four galleries on the first floor, and
contains British and Irish paintings mainly
from 1850 to 1950. There is a good
collection of Newlyn School paintings.
Most of these paintings were purchased
with the Joseph Stafford Gibson Bequest
Fund. The five Modern Galleries on the
third floor include the Harry Clarke
Room (stained glass), the Print Room
(including a representative collection of
twentieth-century wood engravings) and
galleries devoted to showing works from
the collection of twentieth-century Irish
art. Temporary exhibitions are also
normally located in these galleries.

Paintings of importance include *Ulysses
and Polyphemus* by James Barry, *The
Falconer* by Daniel Maclise, *Domino!* by
Frank Bramley, *Men of the South* by Sean
Keating and *Off the Donegal Coast* by Jack
B. Yeats.

The gallery is the centre of the city's
cultural life, and many societies use the
library and lecture theatre for meetings.
Musical concerts are a frequent part of
the programme.

DUNKATHEL
Glanmire
Telephone: (21) 821014

MR AND MRS RUSSELL
Open: May-end Oct Wed, Thurs, Sat,
Sun 2-6
No access for disabled

Three and a half miles from Cork city
off the Cork/Youghal road.

The modest collection at Dunkathel
consists mainly of the watercolours by
Beatrice Gubbins, who lived all her life
in the house. She travelled and painted
extensively, so that there are many
continental scenes. But local landscapes
and character studies revealing of Irish life
during the first half of the twentieth
century are a major feature of the large
number of works by her in the house.

There are also nineteenth-century oils,
and a number of embossed Dixon bird
prints.

FOTA HOUSE
Fota Island, Carrigtwohill
Telephone: (21) 812555

MR RICHARD WOOD
Open: 6 Apr-30 Sept daily 11-6,
Sun 2-6; rest of year Sun and BHs 2-6;
groups at other times by prior arrangement
Access for disabled

Nine miles from Cork city on the Cobh
road.

Fota contains an outstanding collection of
Irish landscape paintings of the eighteenth
and nineteenth centuries. They were
assembled by Richard Wood, a Cork
businessman, as part of the furnishing of
this fine Regency house, which stands in

the middle of an island estate outside Cork which has an extensive collection of rare trees.

The pictures include *Idealised Landscape* by Thomas Roberts, who worked in the second half of the eighteenth century, *Landscape with Hunt* by George Barret, the figures painted by Ross, and William Ashford's *Cloughouter Castle*.

Nineteenth-century Irish paintings include good examples of James Arthur O'Connor, in his *View of the Dargle in the Powerscourt Estate*, and works by other romantic artists, such as Richard Rothwell and Daniel Maclise.

European painting in the house includes works by Jakob Bouttats and Jan Breughel. The house is well restored and richly furnished and was also a winner of a European Museum of the Year Award.

RIVERSTOWN HOUSE

Glanmire
Telephone: (21) 821722

MR AND MRS DOOLEY
Open: May-Aug Thurs-Sat 2-6
Limited access for disabled

Four miles from Cork city on the Cork-Dublin road.

There is a collection of pictures, including portraits and landscapes, in this mid-eighteenth-century house, rebuilt in 1745 with fine Francini plasterwork.

——— DONEGAL ———

THE GLEBE GALLERY AND ST COLUMB'S

Churchill, Letterkenny
Telephone: (74) 37071

OFFICE OF PUBLIC WORKS
Open: Easter, June-Sept Tues-Sat 11-6.30, Sun 1-6.30
Closed: Mons except BHs
Limited access for disabled
Access to St Columb's by guided tour only

On the outskirts of the village of Churchill.

The Glebe Gallery and St Columb's house the collection of the English painter Derek Hill.

In the house, Chinese and Japanese prints, William Morris fabrics and wallpapers, De Morgan tiles, Wemyss ware and Islamic ceramics and textiles form a wonderfully imaginative and colourful display. The house itself, an old rectory, is beautifully situated on the shores of Lough Gartan, and its gardens contain many rare and interesting plants.

The Derek Hill Collection also contains some 300 works of art, acquired over the past 40 years. Among the British artists represented are Victor Pasmore, Lawrence Gowing, John Bratby and Mary Kessell. Irish artists include Roderic O'Conor, Evie Hone, Camille Souter, Louis Le Brocquy and a few works by Derek Hill himself.

Hill spent part of his life in Italy, working for a time as artistic director of the British School in Rome, and here he collected works by both British and Italian artists, the latter including Pietro Annigoni and Renato Guttuso.

Derek Hill was responsible for giving early help to Tory Island primitive artists, among them Patsy Dan Rodgers and James Dixon, and examples of their work are in the collection.

——— DUBLIN ———

THE ABBEY THEATRE

Lower Abbey Street
Telephone: (01) 787179

IRISH THEATRE COMPANY
Open: Daily Mon-Sat 10.30-7
Admission Free: Access for disabled

The theatre is in Abbey Street, close to the centre of Dublin.

The collection of art in the Abbey Theatre consists mainly of portraits of actors and playwrights, among them W. B. Yeats, Lennox Robinson, Lady Gregory and John Millington Synge.

Actors, such as Micheal MacLiammoir, are also portrayed.

THE BANK OF IRELAND EXHIBITION CENTRE

Head Office, Lower Baggot Street
Telephone: (01) 785744 ext 2265

BANK OF IRELAND
Open: Mon-Fri 10-5 (incl. lunch hour)
Admission Free

The headquarters of the Bank, with its collection and exhibition areas, are in Lower Baggot Street, near to St Stephen's Green.

The Bank owns an interesting collection of recent Irish painting carefully built up during the past two decades. As the paintings are distributed throughout the offices and public areas of the Bank, access to the collection is by guided tour arranged in advance. A variety of exhibitions are held in the exhibition areas throughout the year.

CHESTER BEATTY LIBRARY

20 Shrewsbury Road
Telephone: (01) 692386

GOVERNMENT OF IRELAND
Open: Tues-Fri 10-1, 2.30-5.15;
Sat 2-5
Admission Free: Access for disabled

In Shrewsbury Road, on the south side of the city.

Sir Alfred Chester Beatty left an internationally important collection of Islamic, Chinese, Japanese, Persian, Turkish and Indian books and artefacts and a sizeable collection of beautiful Qur'an and other manuscripts to the Irish nation.

Among the exhibits are paintings and Western manuscripts. The collection is so large that only part of it is displayed at a time.
See entry in main text, pages 313 314.

DUBLIN CIVIC MUSEUM

South William Street
Telephone: (01) 794260

DUBLIN CORPORATION
Open: Tues-Sat 10-6, Sun 11-2
Admission Free: Access for disabled

South William Street runs parallel to Grafton Street, near the city centre.

Mainly a museum of Dublin life, the fine art content is limited, but includes topographical works and engraved views and maps.

HUGH LANE MUNICIPAL GALLERY OF MODERN ART

Parnell Square
Telephone: (01) 741903

DUBLIN CORPORATION
Open: Tues-Sat 9.30-6, Sun 11-5
Access for disabled

Parnell Square is due north of the city centre.

The Hugh Lane is the only Gallery in Dublin displaying a permanent collection of modern art. The great art collector Sir Hugh Lane is responsible for the presence of many of the paintings, which include Impressionist and Post-Impressionist works. The most important of these are divided into two groups which are

exchanged between London and Dublin on a basis agreed between the two Governments to resolve the dispute over the unwitnessed codicil of Lane's Will. Best-known paintings among the Lane masterpieces are Renoir's *Les Parapluies* and Manet's *Eva Gonzalès* and *Music in the Tuileries Garden*. Additionally, works by Boudin, Corot, Daumier, Ingres, Fantin-Latour, Boldini and Mancini sustain the atmosphere of a turn-of-the-century gallery.

This is reinforced by the strong presence of English and Irish paintings either acquired by Lane, or given to the gallery by those he could persuade to donate works; and it is alleviated only partially by a small and eclectic collection of works from the second half of the twentieth century. John Butler Yeats, Jack Yeats, William Orpen, John Lavery, Augustus John, Sargent, Shannon, William Leech and Sean Keating are among the more notable earlier names represented.

See entry in main text, pages 310–313.

MALAHIDE CASTLE
Malahide
Telephone: 452655/452337

DUBLIN COUNTY COUNCIL
Open: Mon-Fri 10-5; Apr-Oct Sat 11-6; Sun and BHs 2-6; Nov-Mar Sat, Sun and BHs 2-5
No access for disabled

Nine miles north-east of Dublin.

The castle contains an extensive collection of Irish portraits from the National Gallery of Ireland, and constitutes an embryonic 'National Portrait Gallery' on the London and Edinburgh models. The castle is not the ideal location for the research and historical purposes such collections generally invite, but the paintings provide an interesting addition to this sombre, mainly eighteenth-century castle.

There are also portraits purchased from the collection of Lord Talbot, the last owner of the castle, and other paintings, including battle scenes, sporting pictures and topographical works.

NATIONAL GALLERY OF IRELAND
Merrion Square
Telephone: (01) 615133

GOVERNORS AND GUARDIANS OF THE NATIONAL GALLERY
Open: Mon-Sat 10-6 (Thurs 10-9), Sun 2-5
Admission Free: Access for disabled

In Merrion Square, close to the city centre on the south side of the River Liffey.

The National Gallery of Ireland houses the nation's collection of Irish and international paintings. Benefactors include Hugh Lane, Alfred Chester Beatty and George Bernard Shaw. In particular, Shaw made the gallery a beneficiary under his will, which brought substantial funds from royalties used in the purchases of works of art.

The Italian School is well represented by, among others, Mantegna, Perugino, and Signorelli. Venetians include Bellini, Tintoretto, Titian and Veronese. The portrait of *Cardinal Antonio Ciocchi del Monte Sansovino,* by Sebastiano del Piombo, is especially remarkable. The strength of the Italian collection, now hanging for the first time completely together in a major group of rooms, lies substantially in later paintings; sixteenth century and later works include fine examples of Strozzi, Tiepolo *(The Immaculate Conception)*, Procaccini and Panini *(Fete in the Piazza Navona)*.

Dutch and Flemish works include two Rembrandts, *Portrait of a Young Woman* and *Rest on the Flight into Egypt*. There are works by several of his pupils as well as Frans Hals, Cuyp, Ruisdael and Dutch genre and landscape artists. Rubens, Jan Brueghel, Van Dyck and Brouwer are also represented in the collection.

Works from the Spanish School include El Greco's *Saint Francis in Ecstasy, St Procopius* by Ribera, three works by Goya including *Lady in a Black Mantilla* and *Portrait of El Conde del Tago*, and four works by Murillo.

The French School includes *The Annunciation*, by Jacques Yverni. The French collection is strongest in seventeenth-century works. These include three fine examples of Poussin and a Claude *Landscape*.

Eighteenth-century artists include Boucher, Chardin and Greuze. The nineteenth century is less well represented but includes Corot, Géricault, Delacroix and Courbet. Impressionists are represented by one Monet, a Berthe Morisot and a Sisley, a Pissarro and two Degas.

There is a large collection of British works, earliest being portraits of Raleigh and the Earl of Essex and two Lelys. There are Knellers, some fine Hogarth and Reynolds portraits, and landscapes by Gainsborough among the extensive collection of British art.

The collections of Irish paintings are very strong and include George Barret, James Barry, Martin Archer Shee, Na-

thaniel Hone, Francis Danby, William Mulready, Daniel Maclise, William Orpen, Roderic O'Conor, Walter Osborne, John Butler Yeats and Jack B. Yeats.

See entry in main text, pages 303–10.

PEARSE MUSEUM
St Enda's Park, Rathfarnham

Open: Daily Dec-Jan 10-12.30, 2-3.30; Feb and Nov 10-12.30 and 2-4.30; Mar, Apr, Sept, Oct open until 5.30; May-Aug open until 6
Admission Free: Access for disabled

In Rathfarnham, on the south side of the city.

The fine house dates from the eighteenth century, and was the home of Padraig Pearse, a leader of the 1916 Rising who was executed.

The museum was primarily established to commemorate his life. It contains a representative display of the work from the family business, Pearse & Sons, Monumental Sculptors, and of objects relating to Willie Pearse's career as an artist. These include four plaster figures modelled by him, a sketch and a painting.

There is a watercolour by Patrick Tuohy, the Irish artist and pupil of William Orpen, painted while he was a pupil at Saint Enda's.

——— KERRY ———

MUCKROSS HOUSE
Killarney
Telephone: (64) 31440

TRUSTEES OF MUCKROSS HOUSE
Open: Mar 17-June 30, Sept-Nov 9-6; July and Aug 9 a.m.-7 pm.; during other months 9-5
Limited access for disabled

Four miles from Killarney on the Kenmare Road.

The house was given to Ireland by the Bourne Vincent family.

The collection includes two portraits of the last owners by Sargent, together with many other portraits of members of the family.

The collection also includes oils and watercolours of local scenes by a number of Irish artists, mainly of the nineteenth century.

KILDARE

CASTLETOWN HOUSE
Celbridge
Telephone: (01) 288252

IRISH GEORGIAN SOCIETY
Open: Apr–Sept Mon–Fri 10–6, Mar Sat,
Sun 2–5, Oct Wed, Sat, Sun 2–5
Limited access for disabled

13 miles from Dublin off the road to
Sligo and Galway; fork left for Celbridge
beyond Lucan.

This magnificent house, built for 'Speaker'
Thomas Conolly in the 1720s, badly needs
an art collection to match its early
Georgian splendour.

There is a Mengs portrait of Conolly,
and displays of graphics, mainly of
topographical interest. The house is the
headquarters of the Irish Georgian Society.

KILKENNY

BUTLER GALLERY
Kilkenny Castle
Telephone: (56) 61106

KILKENNY ART GALLERY SOCIETY
Open: mid-Mar–mid-May daily 10–5.15;
mid-May–mid-Oct daily 10–7, mid-Oct–
mid-Mar Tues–Sun 10–12.25, 2–5
Admission Free: No access for disabled

In the basement of Kilkenny Castle, in
the city centre.

The nucleus of the collection of paintings
was begun in 1943 by George and Helen
Pennefeather (painters themselves), who
founded the Kilkenny Art Gallery Society
in the hopes that it would be the beginning
of a Municipal Picture Gallery for
Kilkenny. In 1975, the collection found a
permanent home in Kilkenny Castle, in
what is now one of the best modern
galleries in Ireland.

The Gallery was re-named later in
honour of two of its most faithful
supporters, Hubert and Susan Butler. The
Society collects modern paintings, mainly,
but not exclusively Irish. The collection
includes work by Jack Yeats, Brian
Bourke, Louis Le Brocquy, Barrie Cooke,
Gerard Dillon, Nathaniel Hone, Evie
Hone, Miceal Farrell, AE, Mildred Butler,
Paul Henry, Mainie Jellett, John Lavery,
Charles Harper, David Nash, Walter
Osborne, Victor Pasmore, John Piper,
William Rothenstein, Nano Reid, Clifford
Rainey, Camille Souter and Mary Swanzy.

The permanent collection is on exhibi-
tion three or four times a year. Otherwise
the Gallery is used to show exhibitions of
work by contemporary Irish and interna-
tional artists.

KILKENNY CASTLE
Telephone: (56) 21450

OFFICE OF PUBLIC WORKS
Open: mid-Mar–mid-May daily 10–5.15;
mid-May–mid-Oct daily 10–7; mid-Oct–
mid-Mar Tues–Sun 10–12.25, 2–5
Limited access for disabled

In the city centre.

The collection, mainly of Ormonde family
portraits, is not very distinguished. There
are some hopeful attributions, and among
them, by minor artists, one or two
interesting portraits, notably Gandy's full-
length *Queen Henrietta Maria*. There is a
reasonable portrait of *Honour Burke,
Duchess of Berwick*, attributed to Lely.

Both the 1st and 2nd Dukes of Ormonde
developed what was, at the time, an
extensive art collection, which included
350 pictures in Ireland, 250 in England.
Its dispersal, which followed the attainder
of the 2nd Duke in 1716, took place after
that, and the present whereabouts of many
of the works is the subject of current
research.

LIMERICK

GLIN CASTLE
Glin
Telephone: (061) 34173

THE KNIGHT OF GLIN
Open: Daily during May 10–12, 2–4;
groups at other times by appointment

On the Foynes-Tarbert road nine miles
west of Foynes and three miles east of
Tarbert.

The collection includes family portraits,
and Irish paintings, among them Sir
Oswald Birley's Sargent-like *Countess
Annesley* of 1907 and Jeremiah Hodges
Mulcahy's *Panoramic View of Glin and the
Shannon Estuary* of 1839.

The family portraits date from the
seventeenth century, and include John
Michael Wright's of *The First Lord
Kingston, Lord Fitzgerald and Vesey*, by
Martin Archer Shee, *Richard Fitzgerald,
Knight of Glin, with his Servant*, by
Herman van der Myn and *Nesta Fitzgerald*
by the Norwegian *haute époque* portrait

painter Christian Meyer Ross. Portraits
by Philip Hussey, John Lewis, Robert
Hunter and Joseph Haverty are also in
the collection.

Eighteenth- and nineteenth-century
landscape and topographical art in the
collection reflects the lively and discrimi-
nating taste of the present Knight of Glin,
who, with Anne Crookshank, is the
author of *Painters of Ireland 1660-1920*.
Recent additions to the collection include
The Courthouse at Ennis, County Clare, by
William Turner 'de Lond', a lively
interpretation of an Irish market town in
the mid-nineteenth century, and his *View
of the Customs House, Limerick* of 1821.

There is also an extensive collection of
topographical views of Irish country
houses, which can be seen by appoint-
ment.

THE HUNT MUSEUM
Plassey House, Limerick
Telephone: (61) 43644

NATIONAL INSTITUTE FOR HIGHER
EDUCATION
Open: Apr–Sept daily 9.30–5; Oct Sat and
Sun 10–5
Access for disabled

On the outskirts of Limerick, off the
Dublin road; the collection is in the main
administrative building; entrance via Bian-
coni Tower, off Car Park 2.

Though mainly of applied art, there are
interesting works of medieval and Ren-
aissance sculpture in this well-displayed
collection put together by John Hunt, and
bequeathed to Limerick.

KNEAFSEY GALLERY
Plassey House, Limerick
Telephone: (61) 43644

NATIONAL INSTITUTE FOR HIGHER
EDUCATION
Open: Mon–Fri 9–5; Sat and Sun by
arrangement only
Admission Free

NIHE, on the outskirts of Limerick, off
the Limerick-Dublin road; the collection
is in the main administrative building.

A collection of self-portraits by Irish artists
was begun with the acquisition of fifteen
such works from John Kneafsey in 1977.
Each year, on the first Saturday in May,
new additions to the collection are
announced. At present there are over one
hundred self-portraits of leading Irish
artists in the collection.

LIMERICK MUNICIPAL ART GALLERY

Pery Square, Limerick
Telephone: (61) 48931

LIMERICK CORPORATION
Open: Mon-Sat 10-1, 2-6; Thurs 2-7
Admission Free: Access for disabled

Pery Square is on the south side of the city, off the road leading to Cork and Killarney.

The Municipal Gallery's collection consists mainly of Irish paintings from the nineteenth century onwards. Work by Grace and Paul Henry, Daniel Maclise, James Arthur O'Connor, Walter Osborne, Mainie Jellett, Evie Hone, Nathaniel Hone and Sean Keating are on view.

LIMERICK MUSEUM

John's Square North, Limerick
Telephone: (61) 47826

LIMERICK CORPORATION
Open: Tues-Sat 10-1, 2.15-5
Admission Free: Access for disabled

John's Square is in the city centre.

The Limerick Museum has acquired paintings and sculpture relevant to local history or the men and women of the city. Paintings include *Arthur's Quay, Limerick* and *View of the Castle of Limerick and Part of the City from the Distillery, 1865* by Charles Mills A.R.H.A., and *The New Bridge at Limerick*, attributed to Samuel Brocas.

There is a portrait of *Michael Hogan, Bard of Thomond*, by Dermod O'Brien. Miniatures include: *Self-Portrait* by William Palmer (1763–90); *William Smith O'Brien*, artist unknown (*c.* 1848); *Daniel O'Connell*, artist unknown (*c.* 1830) and *Military Figure* by Frederick Buck (1771–*c.* 1840).

—— MAYO ——

WESTPORT HOUSE

Westport
Telephone: (98) 25404

LORD ALTAMONT
Open: mid May-mid Sept 2-5; Jun-Aug Mon-Fri 11.30-6, Sat, Sun 2-6
Closed: mid Oct-Mar
Limited access for disabled

On the outskirts of Westport town.

The collection includes interesting landscapes, portraits of the Marquess of Sligo's family, and other Irish works. Major paintings, once in the collection, were sold in the last century, further works of art going at subsequent sales.

In the early nineteenth century, the Marquess of Sligo commissioned several paintings of the locality from the Irish landscape artist James Arthur O'Connor. They were his most notable commissioned series, and total seventeen works, the largest such collection of O'Connor paintings on display anywhere.

Family portraits, which hang in the Long Gallery, include paintings by, or attributed to, Reynolds, Opie, Cotes, Beechey, Boilly and Huysmans.

—— MEATH ——

SLANE CASTLE

Slane
Telephone: (41) 24207

EARL OF MOUNT CHARLES
Open: 31 Mar-31 Oct Mon-Sat 11-6, Sun 2-6; rest of year Sun and BHs 2-6
Access for disabled

28 miles from Dublin on the Carrickmacross road.

Slane Castle, the home of Henry Mount Charles, and a popular venue for pop concerts, has a mainly nineteenth-century collection, reflecting the Gothick Revival style of this well-sited edifice. The collection includes family portraits and nineteenth-century Irish paintings.

Thomas Lawrence's *George IV* is the major work in the collection, and recalls his visit to Ireland in 1819. Similar portraits of the King, by Lawrence, are in the Royal Collection at Windsor Castle, and at Chatsworth (qq.v.). The visit is recorded in Thompson's *The Arrival of George IV at Kingstown*, which portrays all the leading figures in Irish society at the time, gathered on the pier to greet the monarch.

George IV was a guest at Slane Castle. There was a romantic liaison between him and Lady Conyngham, whose portrait, also by Lawrence, is in the collection, as well as a large oil by Hugh Douglas Hamilton, showing her with her eldest son, the First Earl of Mount Charles, on her back, crossing a stream.

Other works of interest include Gilbert Stuart's portrait of *William Burton Conyngham*, painted during the American artist's period in Ireland, and portraits by, or attributed to, Wissing and Lely. The present owner has added to the collection an important pair of Thomas Roberts views of the River Boyne.

—— MONAGHAN ——

CASTLE LESLIE

Glaslough
Telephone: (47) 88109

MR DESMOND LESLIE
Open: Daily Aug 2-6; tours every hour; groups at other times by arrangement
Limited access for disabled

Six miles north-east of Monaghan town.

The castle was rebuilt by Sir John Leslie, great-grandfather of the present owner, and a collector and artist, most of whose works remain. There are family portraits and landscapes.

—— ROSCOMMON ——

CLONALIS HOUSE

Castlerea
Telephone: (903) 20014

THE O'CONOR DON
Open: May and June Sat and Sun 2-5.30; 1 July-8 Sept daily 11-5.30; open BHs and other times by arrangement
Limited access for disabled

On the outskirts of Castlerea.

Clonalis is the ancestral home of the O'Conor family, descended from the last High Kings of Ireland, with documentary information on its genealogy going back almost 2,000 years.

The present building is a Victorian mansion housing, among other treasures, the extensive collection of family portraits. These are by a diversity of artists, including Irish and continental painters. Among them are Walter Osborne, the two Catterson Smiths, Van Medeghem as well as others.

—— SLIGO ——

LISSADELL HOUSE

Lissadell
Telephone: (71) 63150

THE GORE-BOOTH FAMILY
Open: Daily May-Sept except Sun 2-4.30
Limited access for disabled

Eight miles north of Sligo off the Sligo-Bundoran road.

The house, which has always been in the Gore-Booth family, has associations with W. B. Yeats, who wrote of the two sisters, Eva and Constance. The latter,

while studying art in Paris, met Count Markiewicz, also an artist, and married him. Paintings by both are in the house. His work is particularly striking.

Sarah Purser painted a portrait of the two sisters, and other works in the collection include *Children on a Connemara Hillside* by the nineteenth-century Irish landscape and genre painter Patrick Joseph Haverty, *Couple sitting in Twilight* by George Russell and a number of Italian paintings, recently restored, collected by Sir Robert Gore-Booth on his Grand Tour.

SLIGO COUNTY MUSEUM AND ART GALLERY
Stephen Street, Sligo
Telephone: (71) 42212

SLIGO COUNTY COUNCIL
Open: Apr–Sept 10.30–12.30, 2.30–4.30; limited morning opening off season
Admission Free: Access for disabled

In the centre of the town, near the Garavogue estuary.

The art gallery, best known for its Yeats collection, contains about fifty paintings and drawings by Jack Yeats. Unrivalled by other holdings in the museum, and much appreciated by the town of Sligo, they are given generous space, and include a diverse and interesting cross-section of his work, from early drawings and watercolours to the late paintings.

Notable among the Sligo views, which occupied Yeats as a young man, are *The Metal Man, A Sunday Morning in Sligo* and *Shruna Meala, Rosses Point*. A later and more powerful work is *The Island Funeral*, dating from 1923, and *Communicating with Prisoners* of 1924. Jack Yeats portraits include those of his father and brother.

Other modern Irish artists represented in the collection include W. J. Leech, Evie Hone, William Orpen, Paul Henry and Norah McGuinness.

See entry in main text, pages 320–21.

─── TIPPERARY ───

TIPPERARY S.R. COUNTY MUSEUM
Parnell Street, Clonmel
Telephone: (52) 22715

TIPPERARY S.R. COUNTY COUNCIL

Open: Tues–Sat 10–1, 2–5
Admission Free: Limited access for disabled

Parnell Street is in the centre of Clonmel.

The museum's art collection includes works by William J. Leech *The Market, Concarneau*, Sarah Purser *Disdain*, Charles Lamb *A Galway Harbour*, John Butler Yeats *John O'Leary*, and others. Recent additions to the collection include works by Robert Ballagh, Patrick Pye and a collection of works from the 1970s and 1980s.

─── WESTMEATH ───

TULLYNALLY CASTLE
Castlepollard
Telephone: (044) 61130/61252

MR AND MRS PAKENHAM
Open: 14 July–18 Aug daily 2.30–6
Other times for groups by arrangement
Limited access for disabled

One mile outside Castlepollard on the Granard road, 13 miles from Mullingar.

A diverse small collection, which includes family portraits, a classical subject attributed to Angelica Kauffmann, and paintings by Henry Lamb, who was uncle of the present owner.

─── WATERFORD ───

GARTER LANE ARTS CENTRE
5 O'Connell Street, Waterford
Telephone: (51) 55038/77153

WATERFORD CORPORATION
Open: Tues–Thurs 10–6, Fri, Sat 10–9
Admission Free: No access for disabled

At the eastern end of the town.

The gallery is in an eighteenth-century building and accommodates major national and international touring exhibitions.

Works on permanent display include a portrait bust of *Vaughan Williams* by Epstein and a number of landscape paintings and items of sculpture by local artists.

─── WICKLOW ───

KILRUDDERY HOUSE
Bray
Telephone: (01) 683405

EARL AND COUNTESS OF MEATH

Open: Apr–Oct by arrangement for groups
Limited access for disabled

One mile from the town of Bray on the south side off the Greystones road.

An interesting house, altered by Morrison in the early nineteenth century, it contains family portraits, among them a copy of the National Portrait Gallery Orpen of *The Earl of Meath*, one of Orpen's more dramatic society pictures.

Hercules Brabazon Brabazon, the English watercolourist, was a member of the family.

RUSSBOROUGH HOUSE
Blessington
Telephone: (45) 65239

ALFRED BEIT FOUNDATION
Open: Easter–end Oct Suns and BHs and daily Jul and Aug 2.30–5.30
Access for disabled

22 miles from Dublin on the road from Blessington to Baltinglass, two miles from Blessington.

This is the most outstanding country house art collection in Ireland.

Its chief glory is the Vermeer, *The Letter*, but it has magnificent examples of Dutch and Flemish painting generally, including lovely Metsu interiors, a Frans Hals, *The Lute Player*, and works by Ruisdael and Steen.

The six Murillo paintings, depicting *The Parable of the Prodigal Son*, are among the artist's greatest works. The collection includes other notable Spanish works, an early Velázquez, *The Moorish Kitchenmaid,* and a Goya, *Dona Antonia Zarate.*

British painting includes the splendid Raeburn *Sir John and Lady Clerk of Pennycuik* and the appealing Gainsborough *Cottage Girl with a Dog and Pitcher.*

It has been the practice over the years to exhibit a selection of paintings from the Beit Art Collection in the National Gallery of Ireland and in exchange the National Gallery of Ireland lends paintings to Russborough. There are full-size reproductions in the house of some of the paintings on exhibition in the National Gallery of Ireland and elsewhere and full-size reproductions of several of the eleven paintings stolen on 21 May 1986.

See entry in main text, pages 318–20.

ACKNOWLEDGEMENTS

Many books and guides are written about museums, art galleries and country houses open to the public, and the staff of such institutions receive a constant stream of requests for information. Conscious of this at the outset, I prepared and sent out a two-page questionnaire which formed the basis of all subsequent research and visits. The generally careful completion of this initial data, together with the answering of queries and the furnishing of further detail, must be acknowledged, and I am very grateful to those who carried out this work.

A very large number of people recognised from the start the difficulty of what was being attempted and went beyond the formal requirements to provide further details in the form of pamphlets, books, copies of documents, photographs and other information. I would like to acknowledge the special help given by the following:

Avon: Francis Greenacre (City of Bristol Museum and Art Gallery); Philippa Bishop (Holburne of Menstrie Museum); P. F. Driscoll (1, Royal Crescent, Bath); Jill Knight (Victoria Art Gallery Bath). *Bedfordshire:* Halina Grubert (Cecil Higgins Art Gallery); Denis Garrod (Woburn Abbey). *Berkshire:* Marjorie Cocke (Henry Reitlinger Bequest); Alec Gardner-Medwin (Stanley Spencer Gallery). *Cambridgeshire:* J. D. Culverhouse (Burghley House); B. M. Giddens (Cromwell Museum); Sara Pappworth (Kettle's Yard). *Cheshire:* P. J. Boughton (Grosvenor Hall); A. Leigh (Warrington Museum and Art Gallery). *Cornwall:* Brian Smith (Barbara Hepworth Museum). *Cumbria:* Cherrie Moorby and V. A. J. Slowe (Abbot Hall Art Gallery); David Clarke (Carlisle Museum and Art Gallery); Patrick Gordon-Duff-Pennington (Muncaster Castle). *Derbyshire:* Eric Oliver (Chatsworth House); Alan Clark (Derby Art Gallery).

Dorset: Graham Teasdill (Russell-Cotes Art Gallery and Museum). *Durham:* Elizabeth Conran and Brian Crossling (Bowes Museum). *Essex:* C. Lemming (Beecroft Art Gallery); Jeremy Theopholis (The Minories); M. Garwood (Sir Alfred Munnings Art Museum).

Greater London: Malcolm Rogers (National Portrait Gallery); John Summerson (Sir John Soane's Museum); John Jacob (Ranger's House); Sir Oliver Millar, former Surveyor of the Queen's Pictures. Greater Manchester: Francis Hawcroft (Whitworth Art Gallery). *Hampshire:* B. A. Pullin (Broadlands); Michael Goodall (Southampton City Art Gallery). *Hereford and Worcester:* A. E. Sandford (Churchill Garden Museum [The Hatton Gallery] and Hereford City Art Gallery). *Hertfordshire:* R. H. Harcourt Williams (Hatfield House); Marion Hudson (Knebworth House).

Humberside: Roy Gregory (Beverley Art Gallery and Museum); John Chichester-Constable (Burton Constable Hall); Louise West (Ferens Art Gallery). *Leicestershire:* Robin Paisey (Leicestershire Museum and Art Gallery); L. M. M. Saunders-Watson (Rockingham Castle). *Lincolnshire:* R. H. Wood (Usher Gallery). *Merseyside:* E. F. Greenwood (Merseyside County Museums); Timothy Stevens (Walker Art Gallery); Janice Carpenter (University of Liverpool Art Gallery); Bryan Lucas (Williamston Art Gallery).

Norfolk: Graham Beal (Sainsbury Centre for the Visual Arts); Lord Somerleyton (Somerleyton Hall). *Nottinghamshire:* Ann Gunn (Nottingham Castle Museum). Oxfordshire: R. B. Winter (Ashmolean Museum); Joanna Woodall (Christ Church Picture Gallery). *Surrey:* Wilfrid Blunt (Watts Gallery); *East Sussex:* J. M. A. Dinkel (Brighton Museum and Art Gallery). *West Sussex:* R. W. Puttock (Arundel Castle); David Legg-Willis (Goodwood). *West Midlands:* Patrick Day (Herbert Art Gallery). *Wiltshire:* Sally Crossland (Bowood House); Lord Methuen (Corsham Court); Veronica Quarm (Wilton House).

Yorkshire: Edmond Lamb (Castle Howard); Richard Green (York City Art Gallery); Ruskin Gallery; N. C. Herring (Bankfield Museum and Art Gallery); Caroline Krzesinska (Cartwright Hall); Barbara Baker (Harewood House); Brian Pearson (Huddersfield Art Gallery); Les Buckingham (Leeds City Art Gallery).

Wales: Gordon Bennett (Graham Sutherland Gallery); Hywel Rees (National Museum of Wales).

Scotland: Janice Fox (National Galleries of Scotland); Ian Urquhart (Burrell Collection); Patricia Bascom (Glasgow Museums and Art Galleries); Pamela Reekie (Hunterian Art Gallery); Clara Young (Dundee Art Galleries and Museums).

Ireland: Brian Kennedy, John Nolan and Ted Hickey (Ulster Museum); Derek Hill (Glebe Gallery and St Columb's); Eithne Waldron (Hugh Lane Municipal Gallery of Modern Art); Homan Potterton (National Gallery of Ireland); Desmond Fitzgerald, Knight of Glin (Glin Castle); Aideen Gore-Booth (Lissadell House).

In compiling acknowledgements of this kind one is conscious, always, of the other side of the coin. Inescapably there were people who were less than helpful, chose not to understand what was being attempted, failed to answer letters and requests for information, and were in other ways obstructive and difficult. If, in my turn, I was less than polite, I apologise. I am aware of the vast amount of work involved in running art institutions, no matter of what kind, and the general shortage of funds and staff.

The staff of the National Trust gave me considerable help during my visits to the many collections in National Trust houses. In coordinating this, and in research generally, I was helped by the

late Robin Wright, during a period when he was under considerable personal stress and in physical pain. I would like to pay tribute to his memory. More recently, I have had the understanding and help of Margaret Willes, who took on responsibility for certain aspects of the Art Atlas at a time when she was heavily involved in other duties.

I recruited a team of researchers for preliminary fieldwork, and then for the writing of reports, and their work was helpful and perceptive. I acknowledge, in particular, the assistance of Martin Agnew, Rosemary Abayazied, Anne Appleton, B. Bainbridge, Pat Bray, Mary Cook, Judith Cureton, Pauline Duckels, Donna Fordyce, Major H. M. Hall, Marion Heathcote, Jennifer Henry, Stella Hunt, Valerie Jackson, Andrew Lambirth, Sybil Macnaughton, Emmanuel Matera, Leela Meinertas, Mark Murphy, Jill Passenger, Fiona Richardson, Barry Sherratt, Patience Ewart Smith, Anne Tapper, Jeane Walker and Rowan Walker.

Cordelia Crampton, who worked with me as research assistant for a year, coordinated this early work and carried out a considerable amount of general research work on collections. She was an enormous help, and I am much in her debt.

At a later stage Anne O'Mahony worked on the text, reading and correcting various drafts, and carrying out the preliminary indexing work. I am also in her debt.

In certain respects the book would not have been possible without modern technology, and a computer was chosen specially for the job. Even then, there was no ready-made software system suitable to the project. My son, Hugo Arnold, worked on this and established a framework for information that not only stood up to the considerable tests of subsequent developments in the shape and design of the Art Atlas, but also makes possible continued updating in the future, a vital requirement in a book of this kind. In addition, he helped also with the preparation of maps, and planned with considerable administrative ability the various journeys around the British Isles to visit properties and collections. He was a stimulating companion on a number of journeys to look at collections. My daughter, Polly Arnold, and my other son, Samuel Arnold, also helped in travels to see collections.

I received considerable help in the later stages of the book from Anne Thackray, who worked on many of the more important entries and brought valuable new insights to the final draft of the book.

The assistance of those at Penguin involved in the massive task of bringing the book to completion is greatly valued, particularly the help of my editor there, Eleo Gordon.

A great deal of the work of writing and revising entries, of organising the balance between text and gazetteer, of corresponding with the vast number of people who were drawn into the project, devolved on my wife, Mavis Arnold, who had her own book to write, and her own profession as a journalist to pursue. She was a careful and considered critic, an enlightened and wise judge of collections and individual works of art, and a priceless companion in the many enjoyable pilgrimages that made the Art Atlas such a pleasure to do.

PICTURE ACKNOWLEDGEMENTS

Unless otherwise stated, the illustrations have been supplied by the museum, art gallery, private collection, county council or other institution in whose collection the painting or work of art is found. Specific acknowledgements and credits are (in order of the first illustration):

Reproduced by permission of the Trustees of the Wallace Collection, London: frontispiece, 76, 77; Bridgeman Art Library: 7, 11, 20, 165, 173; English Heritage, The Iveagh Bequest, Kenwood: 9, 88; Arundel Castle Trustees Ltd: 16, 238, 239 (photo: National Portrait Gallery); reproduced by Gracious Permission of Her Majesty The Queen: 19, 24, 26, 27, 207, 209; reproduced by courtesy of the Trustees of the British Museum: 36, 37, 38; reproduced by courtesy of the Board of Trustees of the Victoria and Albert Museum: 41, 42, 43; Trustees of the Imperial War Museum: 71, 72; by permission of the Governors of Dulwich Picture Gallery: 81, 82; by courtesy of the Trustees of Sir John Soane's Museum: 83; Merseyside County Museums, Liverpool: 92, 93, 94 (above), 96, 98; Wirral Borough Council: 101; The National Trust: 102, 103, 125 (photo: WPS, courtesy of Lady and Lord St Oswald), 132 (Northumbria Regional Office), 133, 151, 166, 171, 172, 174, 175, 184, 187, 196 (below, photo: James Austin), 211, 213 (courtesy of Waddesdon Manor), 223, 235, 236, 237, 249, 257, 261, 264 (above), 265 (photo: National Portrait Gallery), 271, 272, 274, 297; City of Manchester Art Galleries: 106, 107; Bradford Art Galleries and Museums: 119; Chatsworth House Trust: 154, 155; Trans Global Ltd: 156; Kettle's Yard, University of Cambridge: 183; Norfolk Museums service (Norwich Castle Museum): 189, 190; by kind permission of the Marquess of Tavistock and the Trustees of the Bedford Estates: 203; courtesy of the Earl of Pembroke, Wilton House, Salisbury: 250, 251; The Bowood Estates (photo: Photographic Records Ltd): 255; Falmouth City Council: 263; Dundee Art Galleries and Museums: 290, 291; Buccleuch Recreational Enterprises Ltd: 292, 293, 294; Hopetoun House Preservation Trust: 295.

Index

Page numbers in medium type indicate text references; page numbers in **bold** type indicate principal entries in the main text, the gazetteer section, or in both; page numbers in **bold italic** type indicate illustrations.